Richard Krautheimer

EARLY CHRISTIAN AND
BYZANTINE
ARCHITECTURE

Penguin Books

Penguin Books Ltd, Harmondsworth, Middlesex, England
Penguin Books Inc., 7110 Ambassador Road, Baltimore, Maryland 21207, U.S.A.
Penguin Books Pty Ltd, Ringwood, Victoria, Australia

Set in 'Monophoto' Ehrhardt
Manufactured in the United States of America

First published 1965
First paperback edition, extensively revised, 1975
Copyright © Richard Krautheimer, 1965, 1975
Library of Congress Catalog Card Number: 72-93453

Designed by Gerald Cinamon and Paul McAlinden

CONTENTS

PREFACE

This book was difficult to write, and I can truthfully say that I have never faced a harder task. The comprehensive presentation of any subject must address itself to a broad spectrum of prospective readers, from the educated public to students and specialists, and thus must attempt to condense the largest possible amount of material into the framework of a few guiding ideas and historical lines as well as tracing, if sketchily, the political, intellectual, and religious forces which determine this development. This is never easy. In the area discussed in this volume, the difficulties increase. The scattering of the monuments over many lands and the difficulty of access make it next to impossible even for the specialist to have visited, far less to know thoroughly, more than a limited number. Reports on the monuments are often fragmentary, and not infrequently published in periodicals not easily available and requiring a linguistic knowledge surpassing that of the author as he moved into regions east of Greece. Providing illustrative material proved difficult in an area where few commercial photographers have been active. The natural unfamiliarity of the general reader with the political and religious background of the periods and territories under discussion, and of even the more important monuments, forces the author into a treatment at times more prolix than desirable. The state of preservation of the monuments – many known only in plan, others in ruins and fragmentary, hardly any preserving their original decoration and few serving their original function – requires a continuous appeal to the visual imagination and a constant effort on the part of the reader. Finally, in discussing an area as scantily known and so far from settled as Early Christian and Byzantine architecture, the summing up will always be a task even more hazardous than in other fields.

But if it has been difficult to write this book, it has also been rewarding. It was possible to spread its preparation over a number of years and to test my views in my teaching, in publications, and in discussions with colleagues and students. The numerous discoveries of Early Christian and Byzantine buildings and sites and the new interpretations of monuments and classes of monuments proffered in recent times, together with the ensuing scholarly discussion, had brought into flux the seemingly stable picture of Late Antique, Early Christian, and Byzantine architecture. Thus it was possible, I hope, to gain new insights into the involved problem and, though much remains obscure, to try out new ways of interpreting the historical sequences and of presenting the subject in its interrelations with the liturgical and political facets of the period. The reader will have to decide whether or not I have succeeded. Further studies will, I hope, again change the picture. I can but present the problems as I see them today, and I shall be content if the reader gains as much from his perusal of the book as I did from writing it.

One final word about the way in which the book relates its material to larger historical questions. The reader will find that the accent is on Early Christian and Byzantine architecture not as a prelude to medieval church building, but as essentially a last phase of Late Antique building. Contrary to many historians, I do not see Early Christian architecture as a fundamentally Western development, but rather as the final expression of the architectural concepts

which were dominant in both the Western and Eastern Mediterranean centres and coastal areas of the Late Roman world. The timber-roofed, hall-like basilica, taken over from Roman civil architecture, pervades church building in the East and West up to the time of Justinian, later re-emerging in the West as part of a renascence movement. In the East, on the other hand, the building principles of the Late Empire – in this case, the vaulted, centrally-planned buildings of palace halls, funerary structures, and thermae buildings – come to the fore in the period of Justinian and continue to determine the character and development of religious building in the East for a thousand years or more. In brief, Christian architecture in the East preserves and continues principles of Late Antique building in a natural development, while in the West an Antique building type of comparatively early date dies out only to be consciously resuscitated as part of a revival movement. Consequently in the present volume I am dealing with Christian architecture in the East from the beginnings to the fall of Constantinople, while in the West I am presenting the development to the end of the sixth century, but not further. Building of pre-Carolingian and early Carolingian times represents a different trend, and must therefore be treated separately.

Like anyone, I have profited enormously from talks both with friends, too numerous to list, and with my students, and I am greatly indebted to them. The staffs of institutes and libraries have patiently supported my work, and I want to mention with particular thanks: in Rome, the libraries of the American Academy, of the Bibliotheca Hertziana, of the Pontificio Istituto Orientale, and the Vatican Library; in New York, the libraries of Union Theological Seminary, of the Metropolitan Museum of Art, of Columbia University, particularly Avery Library, and of our own Institute; in Washington D.C., the Dumbarton Oaks Byzantine Research Institute and Library of Harvard

University. My more special thanks are due to Dr Djurdje Stričević and Dr Ivanka Nikolajević of the Byzantine Institute of the Serbian Academy of Sciences at Belgrade, who on inter-library loan lent me books missing from Roman libraries. Friends and colleagues from many lands, whose patience I must have all but exhausted, have nevertheless with the greatest generosity sent me photographs for publication and, in still greater numbers, for study. I list them with gratitude: Professor and Mrs Robert J. Alexander of the University of Iowa; Mrs Selina Ballance, Eton; Dr Carlo Bertelli, Rome; Professor Luigi Crema, Soprintendenza ai Monumenti, Milan; Professor Friedrich Wilhelm Deichmann, German Archeological Institute, Rome; Professor Gerhard H. Evers, Technische Hochschule, Darmstadt; Professor George H. Forsyth, University of Michigan, Ann Arbor; Miss Alison Frantz, Athens and Princeton, whom I want to thank very particularly for the numerous special trips she made to distant monuments; Dr Hildegard Giese, Bibliotheca Hertziana, Rome; Dr Nelson Glueck, Hebrew Union College, Cincinnati; Dr Richard Goodchild, Department of Antiquities, Cyrene; Professor Josephine Harris, Wilson College, Chambersburg, Penn.; Dr Martin Harrison, Lincoln College, Oxford; Dr Vera Ivanova, National Museum, Sofia; Dr G. Kerff, Hamburg; George Kidder-Smith, New York; Professor Ernst Kitzinger, Dumbarton Oaks Byzantine Research Institute, Washington, D.C.; Professor Johannes Kollwitz, University of Freiburg; Professor Jean Lassus, Algiers; Dr H. Lenger, Liebighaus, Frankfurt am Main; Mr Lawrence Majewski, Institute of Fine Arts, New York; Professor Cyril Mango, University of California, Berkeley; Professor Mario Mirabella Roberti, Soprintendenza alle Antichità, Milan; Dr Ernst Nash, Fototeca, American Academy, Rome; Professor Neborov, Sofia; Dr Norman Neuerburg, Fototeca, Rome; Dr Ivanka Nikolajević, Byzantine Institute, Ser-

bian Academy of Sciences, Belgrade; Professor Dimitri Pallas, Athens; Dr Walter Schumacher, Freiburg; Dr Hellmuth Sichtermann, German Archeological Institute, Rome; Dr Gerda Soergel, Landesdenkmalamt, Bonn; Professor Richard Stillwell, Princeton University; Dr Djurdje Stričević, Byzantine Institute, Serbian Academy of Sciences, Belgrade; Mr Cecil L. Striker, Vassar College, Poughkeepsie; Professor A. Tonev, Bulgarian Academy of Sciences, Sofia; Professor Paul Underwood, Dumbarton Oaks Byzantine Research Institute; finally, the librarians of the photographic collections of the German Archeological Institute in Istanbul, of the Metropolitan Museum in New York, and of the drawings collection of the R.I.B.A. in London. Nor should the so-called 'commercial' photographers be forgotten, who, like Olga Ford, Josephine Powell, Max Hirmer, and Antonello Perissinotto – for love more than for gain – have provided splendid pictures of rarely photographed buildings.

Finally, I want to express my warm gratitude to those who helped me to beat the work into final shape. Mr Paul Lampl, a busy New York architect, generously sacrificed many hours of his time to see to the bulk of text figures, working out reconstructions, drawing and re-drawing plans and isometric perspectives, and generally adjusting the illustrations. In an end phase, Miss Sheila Gibson in London ably supplemented his work. Finally, Mrs Debra Dienstfrey, my assistant at the Institute of Fine Arts, New York, went with a critical eye over every sentence of the manuscript, supervised the typing, and took care of the appendices.

Institute of Fine Arts
New York University
1 December 1963

PREFACE TO THE SECOND EDITION

The preparation of this second edition in paperback – nine years after delivering the manuscript of the first hardback edition – has given me the opportunity to go thoroughly over the volume and to amend, revise, and correct where necessary text, notes, and illustrations. I have also looked with an eye sharpened by distance at the broader aspects of my handiwork: the overall planning and the selection, accentuation, and interpretation of the material. In this task I have been assisted by advice and suggestions proffered orally or in writing by helpful friends, often former students; and by criticism on the part of more and less benevolent reviewers.

The change in format of the new edition forced us to abandon the attempt made in the first edition to preserve common scales for the plans and elevations. The relative scales marked on each drawing will have to suffice.

Amendments and revisions of a substantive nature became necessary in the new edition through new findings made and published since the original manuscript went to the publishers in 1963. Wherever such discoveries concerned key buildings, the amendments have been incorporated into the text, footnoted, and, where possible, illustrated. Examples are: Constantine's basilica at the Holy Sepulchre in Jerusalem and the Anastasis Rotunda – the excavation of the former not yet terminated; St Peter's in Rome – the low transept and its lower wings; the Lateran basilica – the raised inner aisle; S. Tecla in Milan and the Menas Basilica at Abu Mina – both now fully excavated and redated; H. Polyeuktos in Constantinople – now in the course of final publication; the two churches at Hosios Lukas, where the relative and absolute chronology have been reversed; in Constanti-

nople, the Fenari Isa Camii, the Myrelaion church, the Kariye Camii, and the Kalenderhane Camii – the last still under study, but all cleaned up, restored, newly investigated, and precisely dated. Such findings in a number of cases have modified for large groups of buildings either the chronology or the stylistic roots or the liturgical functions formerly envisaged and led to changes in the new edition. Such is the case at Hosios Lukas, where M. Chatzidakis has correctly assigned a tenth-century date to the smaller Theotokos church and thus by implication pushed back by almost a century the appearance in Greece of the cross-in-square plan, of *cloisonné* masonry, and of 'cufic' ornament. Similarly, R. M. Harrison's work at H. Polyeuktos has led not only to the discovery of a huge, 'domed basilica' in Constantinople, precisely dated; it also brings out convincingly the Sassanian character of large parts of the ornament and thus raises basic questions as to the origins and style of architectural decoration in sixth-century Constantinople. These questions will be answered in due time by Mr Harrison; in the present edition I could but hint at their having been posed. Fresh interpretations of material, but insufficiently known heretofore, raise comparable questions. For North Africa, P.-A. Février, N. Duval, and J. Christern have not only established a new chronology; Duval's research has also provided new insights into the liturgical factors of local church planning, while Février calls attention to the social and economic background. C. L. Striker's work on the Kalenderhane Camii has established beyond doubt the survival into the twelfth century of the cross-domed type. Again, Thomas F. Mathews, by re-evaluating the archaeological and liturgical evidence, has changed the picture, heretofore held, of the interplay of church building and liturgy in Justinian's Constantinople, in particular in the H. Sophia. So much for major amendments and the corresponding changes in the text of this edition. Supplementary evidence, such as ad-

ditional buildings discovered of a known type or additional bibliography, have been relegated, in selection, to footnotes.

Suggestions and criticism have fastened on a number of mistakes which inadvertently had crept into the text. Such oversights are hard to avoid in a book encompassing a vast field; attention to detail is apt to flag under the pressure of formulating concisely one's ideas. Nonetheless they are annoying and I apologize for not having caught them at least in proof. A number I had marked myself over the past years for future correction; others were pointed out by friends and critics. I have striven conscientiously to eliminate from the present edition such blemishes and, if I have done so without footnoting the specific source of the corrections, I nonetheless remain grateful.

Basic questions, too, concerning the overall planning of the book have risen in my mind or been voiced by friends and reviewers. Some shortcomings of a general character are built into the nature of the book and its place within a series. If, for instance, the interplay of architecture and mosaic decoration in Ravenna or in Middle Byzantine Greece is insufficiently stressed, it is because – contrary to the original intention of the editor – the two fields for reasons beyond his control had to be assigned separate volumes. Still, I feel unhappy about thus divorcing two aspects of what might have been treated as an integral design. Likewise, there is some justification to my having assigned but limited space to secular building of Early Byzantine times. It continues, after all, traditions of Late Antiquity as outlined in another volume of this series. Within the limits of the space available it thus seemed preferable to focus on secular architecture in Middle and Late Byzantine times where both literary and archaeological evidence could be integrated into a somewhat consistent and, I trust, new picture. Even so, secular architecture throughout the volume remains on the sidelines and the focus is on church building.

This, I admit, is a serious shortcoming. One could well envisage a future history of Early Christian and Byzantine architecture giving secular building equal place with church building, as we are used to seeing it done in the Renaissance. Russian and Bulgarian historians of art even today are inclined, indeed, to give secular building precedence. At this point, though, I doubt the possibility of achieving even as much as a fair balance in the period we are concerned with. Much opposes it: the sheer quantity of well-preserved churches as against secular structures; the poor state of conservation of the latter – except the village houses of Syria; the lack of preliminary work done on the subject, save Tchalenko's on Late Antique and Early Christian Syria, Orlandos' on monastic architecture in Middle Byzantine Greece and on Paleologue palaces and houses at Mistra, Bulgarian scholars' on Middle Byzantine palaces and housing at and near Pliska and Preslav. Lastly there is the conservative element inherent in secular building during Early Christian and Byzantine times: fortifications, palaces, urban planning, and – most outspokenly – ordinary housing resist by sheer inertia the changes which transform plan and design of church building. As it is, church building simply is a better gauge for tracing the history of architecture from Late Antiquity to the fall of Constantinople. I must leave it to future historians to redress the admittedly unfair balance.

There is perhaps an element of unfairness built into all writing of history. It means by definition to choose from a mass of material the essential and to organize the selection by placing accents – all this within the framework of a development as charted by the author in accordance with the factual historical evidence. Whoever has attempted the task knows the difficulties: charting the current; deciding what within its limits is essential; what beyond can be included without obscuring the mainstream. The difficulties naturally increase proportionately to the span of the subject – in our specific case over a thousand years of architectural history in an area comprising first all of the Mediterranean countries and eventually shrinking. Given the underlying overall concepts, numberless issues important in themselves had to be dealt with slightly or omitted outright: provinces retaining obsolete architectural concepts; regional forms, developed on the periphery of the mainstream; creations never reaching fruition. At times such shortcuts hurt badly. Armenian architecture is fascinating in its inventiveness and complexity of both design and origin, the latter far from being clear; but it still is a side branch of the mainstream. Scholars are bound to disagree on what is and what is not essential; the decision and responsibility must lie with the author who to the best of his knowledge has charted main currents and branches.

The currents, once charted, dictate also the placing of accents. As presented here, Early Christian building both in the Latin West and in the inland countries of the East must give precedence to contemporary architecture in the Aegean coastlands. There, in the core of the Eastern Empire, the new Byzantine architecture evolves, closely linked both to local antecedents, architectural and liturgical, and to Imperial demands. At the same time, in the West and the inland countries the development is cut off – by economic, social, and political collapse in the West, the Muslim conquest in the East. Hence the greater stress placed on the architecture of the coastlands seems to me historically justified and the same obtains on similar grounds regarding the stronger accent placed in Middle Byzantine times on Constantinople and her immediate dependencies as against provincial architecture.

In charting the main and side currents, in choosing and in placing accents the historian, I fear, cannot avoid giving some play to personal predilections. I will not deny that the both monumental and complex design of the H.

Sophia and its sister buildings appeals to me more strongly than the delicate design of even the best Paleologue architecture – in Constantinople, Salonica, Serbia under Milutin; that, outside these court centres, it seems to me receptive rather than inventive; that even the parekklesion of the Fetiyeh Camii or the Holy Apostles in Salonica do not compare in quality with the Katholikon of Hosios Lukas; that, indeed, Late Byzantine architecture seems to me best understood as an epilogue: decorative rather than architectural; often subtle, but lacking the vigour and inventiveness of Middle Byzantine building under the Macedonians, not to speak of Justinian. Nonetheless, I think I have been unfair in the first edition in restricting unduly the space assigned to and passing all too severe judgement on Paleologue architecture. In this new edition I have tried to correct some of these shortcomings by rewriting the entire chapter. Byzantinists, if their interest is focused mainly or exclusively on the end phase of Byzantine art, will still remain dissatisfied. Within the context of a history of architecture reaching from Constantine I to Constantine XI the outlook cannot but differ from that of a historian of Late Byzantine painting.

Warm thanks go to the many who have assisted in preparing and, I trust, improving the new edition. I list them as they come to mind, disregarding titles and alphabetical order: Cecil L. Striker for much information gained over years of close connection in enjoyable talks in the monuments of Istanbul and in frequent correspondence as well as for photographs and plans of the Bodrum and Kalenderhane Camii; R. Martin Harrison for pleasant discussions on his finds at H. Polyeuktos in Istanbul and their implications; Nezih Firatli for manifold help during recent visits to Istanbul; Semavi Eyice for kindly providing me with his numerous publications; Thomas F. Mathews for many questions regarding Byzantine liturgy and architecture in Constantinople, jointly and singly, thrashed out in long discussions and letters; Robert L. Van Nice for a new photograph and a friendly corrective note on H. Sophia; Slobodan Ćurčić for invaluable help in the field of Late Byzantine architecture both in Yugoslavia whence he procured information, photographs and plans and in Salonica where on a recent renewed visit we spent an instructive three days together; Vojislav Korać, who through Slobodan Ćurčić sent photographs and reprints on Serbian churches; Charilabis and Laskarina Bouras for numerous reprints which otherwise I might have missed, for photographs of Hosios Lukas, yet unpublished, and for help during that same visit to Salonica; Alison Frantz for acting as a permanent contact with Greece and for the generous help given time and again with camera and pen; Anastasios K. Orlandos for providing access to the first preliminary publications on the new excavations at the Holy Sepulchre in Jerusalem; Fr. Bellarmino Bagatti, OFM, for a long guided tour through the new finds at the Anastasis Rotunda; Moshe Barash and Gustav Kühnel for providing transportation to places in Palestine not accessible on previous visits; Noël Duval, Jürgen Christern, Paul-Albert Février, and Margaret Alexander and her team for numerous photographs of the North African material, for many reprints from Noël Duval and for a delightful tour through Tunisia three years ago arranged by Margaret Alexander; James Morganstern for photographs and detailed reports on Dere Ağzi and Myra; Mario Mirabella Roberti for detailed information on S. Tecla in Milan; W. Eugene Kleinbauer for extensive correspondence and for permission to peruse the first parts of the manuscript of his book, *The Aisled Tetraconch*; George C. Miles and Sir Nikolaus Pevsner for corrective notes; lastly, Friedrich Wilhelm Deichmann for a helpful – if harsh and petty – review (*B.Z.*, LXV, 1972, 102 ff., and my reply *ibid.*, 441 ff.).

To conclude I cannot thank sufficiently the indefatigable crew which has coped with the

physical production of the revised manuscript and the book: in Rome, Betsy Emerick, an invaluable assistant, bright, meticulous, patient and good-humoured even when bored; in London, Susan Stow who takes care of missing photographs; Sheila Gibson and Paul White, whose drawings and redrawings of plans and sections speak for themselves; H. A. Shelley, who redrew the maps; finally, Judy Nairn who holds all the threads in her competent, firm hands.

Rome
6 July 1972

POSTSCRIPT. The review by Mr Hallensleben in *B.Z.*, LXVI (1973), 120 ff., dealing with Parts 6 and 7 of the first edition of the present volume, comes to my attention as I am reading proof. I have been able to revise a few mistakes kindly pointed out by the reviewer and not caught previously by myself. But I cannot enter into a controversy over the essential points he makes – the 'standing' of Late Byzantine architecture and the place held within its development by Salonica.

Rome
6 July 1973

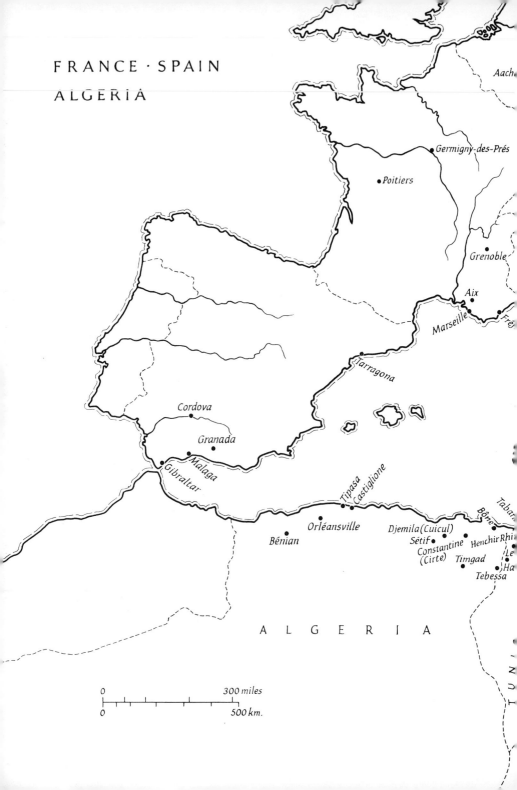

FRANCE · SPAIN
ALGERIA

Aach

Germigny-des-Prés

Poitiers

Grenoble

Aix

Marseille

Fré

Tarragona

Cordova

Granada

Malaga

Gibraltar

Tipasa

Castiglione

Bône

Taban

Orléansville

Djemila (Cuicul)

Bénian

Sétif

Henchir Rhi

Constantine

(Cirte)

Timgad

Le

Ha

Tebessa

A L G E R I A

T U N I

0 300 miles
0 500 km.

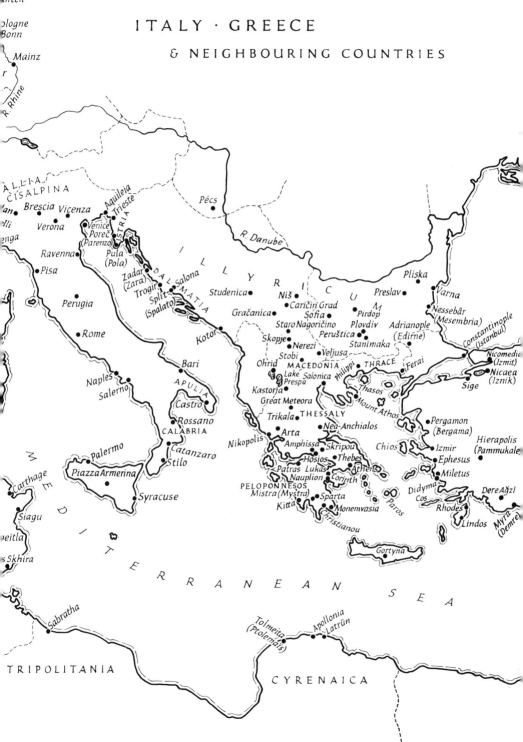

ITALY · GREECE

& NEIGHBOURING COUNTRIES

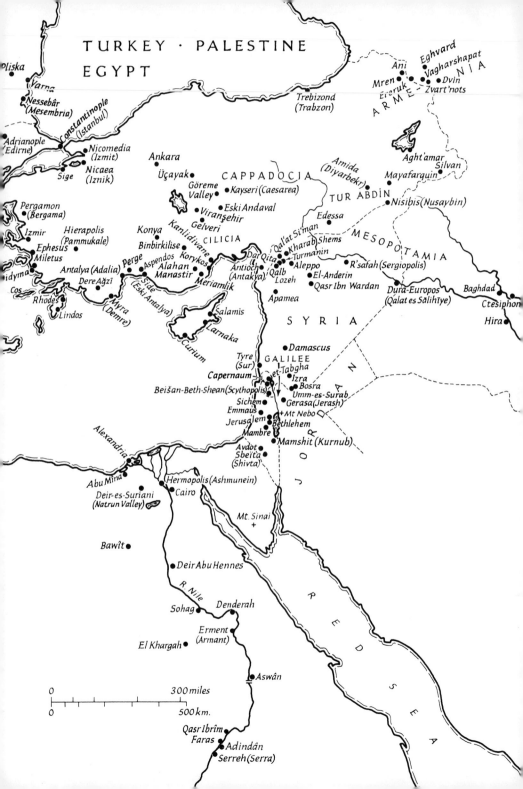

TURKEY · PALESTINE
EGYPT

Pliska
Varna
Nessebâr
(Mesembria)
Constantinople
(Istanbul)
Adrianople
(Edirne)
Nicomedia
(Izmit)
Sige
Nicaea
(Iznik)
Ankara
Üçayak
CAPPADOCIA
Göreme
Valley
Kayseri (Caesarea)
Eski Andaval
Virangehir
Gelveri
Pergamon
(Bergama)
Izmir
Hierapolis
(Pammukale)
Ephesus
Miletus
Konya
Kanlidivane
Binbirkilise
CILICIA
Antalya (Adalia)
Perge
Aspendos Korykos
Alahan
Manastir
Dere Ağzı
Meriamlik
Side
(Eski Antalya)
idyma
Cos
Rhodes
Myra
(Demre)
Lindos
Salamis
Larnaka
Curium
Dar Qita
Qal'at Si'man
Kharab Shems
Turmanin
Aleppo
Antioch
(Antakya)
Qalb
Lozeh
El-Anderin
Qasr Ibn Wardan
Apamea

Trebizond
(Trabzon)

Ani
Eghvard
Mren
Ererub
Vagharshapat
Dvin
Zvart'nots
ARMENIA

Aght'amar
Silvan
Amida
(Diyarbekr)
Mayafarquin
TUR ABDIN
Edessa
Nisibis (Nusaybin)
MESOPOTAMIA
R'safah (Sergiopolis)
Dura-Europos
(Qalat es Sâlihîye)
Baghdad
Ctesiphon
Hira

SYRIA

Tyre
(Sur)
Capernaum
Beisân-Beth-Shean (Scythopolis)
Sichem
Emmaüs
Jerusalem
Mambre
Avdot
Sbeita
(Shivta)
Damascus
GALILEE
et-Tabgha
Izra
Bosra
Umm-es-Surab
Gerasa (Jerash)
+Mt Nebo
Bethlehem
Mamshit (Kurnub)
JORDAN

Alexandria
Abu Mina
Hermopolis (Ashmunein)
Deir-es-Suriani
(Natrun Valley)
Cairo
Mt. Sinai
+
Bawît
Deir Abu Hennes
R. Nile
Sohag
Denderah
Erment
(Armant)
El Khargah
Aswân
RED SEA
Qasr Ibrîm
Faras
Adindân
Serreh (Serra)

0 _____ 300 miles
0 _____ 500 km.

EARLY CHRISTIAN AND
BYZANTINE ARCHITECTURE

CHRISTIAN BUILDING PRIOR TO CONSTANTINE

THE BEGINNINGS OF CHRISTIAN ARCHITECTURE

A.D. 50–150

During the first three centuries of the Christian era, two elements determine the position of Christianity: that it evolved a new faith, and that it did so primarily within the social, cultural, and religious framework of the Late Roman Empire. Christianity's organization, its needs, and even its conflicts with Rome were largely determined by conformity with or by opposition to this framework; and its architecture, as far as we know it, must be seen within the context of the Roman-Hellenistic world.[1]

Religion in Imperial Rome had split into two spheres. Public worship of the gods that guaranteed the welfare of the Empire – Jupiter, the Invincible Sun, or the Emperor's Divine Majesty – was a civic duty performed according to state ritual; worship was required only of those in the sphere or under the scrutiny of officialdom. Spiritual needs were satisfied by divinities of one's personal choice: either native tribal gods or saviour gods, frequently of oriental origin. All these cults, whether centred on Mithras, on the Great Mother, or on Isis, guaranteed salvation after death to the initiated – small, select, and segregated groups in which the brethren might forget social distinctions. No conflict need arise as long as the cult of the Emperor and the cults of personal salvation were not mutually exclu-

sive, or as long as the mandatory worship of officialdom could be avoided. And for the poor, the latter was not difficult.

Within the sphere of Late Antique saviour religions, Christianity grew almost unnoticed for at least a generation after Christ's death. Indeed, were it not for St Paul, the first Christian congregations might well have remained insignificant heretical groups within the Jewish communities of Palestine – that obstreperous Aramaic-speaking backwater. Paul planted the seeds of a world religion in Christianity. He spread the gospel to both Jews and heathens living in the hellenized cities of Greece, along the coast of Asia Minor, and in Rome. He severed Christianity's ties to Judaism and to Jewish nationalism. And he laid down a policy of evading the social and political demands of Roman society. Converts were recruited largely from the metropolitan proletariat, with an occasional member of the middle classes – a retired non-commissioned officer, a freedman, or the like. By A.D. 100, the new faith, while largely centred in the big cities, had spread all over the East to small towns and even to villages.[2] Within the congregations a loose organization gradually developed. Business and other practical matters were taken care of by a group of volunteer administrators, the overseers (*episkopoi*, bishops), and stewards (*diakonoi*, deacons). Religious

inspiration came from migrating preachers, first from the Disciples, later from 'apostles' and 'prophets'. Ritual was also loosely organized, even at the beginning of the second century. The congregation would assemble at sunrise on Sunday for prayer, and towards evening for a meal (*agape*) – recalling the Jewish meal on the Eve of the Sabbath. This evening ritual opened with a blessing over the breaking of the bread and ended with a second blessing over a cup of wine. Prayers were offered either during the meal or after, hymns were sung, and at times a spiritual discourse evolved. A 'prophet', if present, would deliver a sermon or would speak ecstatically in tongues.[3]

These early believers had neither the means, the organization, nor the slightest interest in evolving an ecclesiastical architecture. They met in whatever place suited the occasion. To win proselytes, a group might assemble in a Jewish place of worship – in Jerusalem the Temple precinct, elsewhere a synagogue. But with the widening gap between old and new believers, such mission meetings became increasingly difficult.[4] Christians might assemble at a street corner, as did St Paul and his listeners in the market place at Athens. Rarely would they be able to hire a public hall, as did the congregation at Ephesus at the time of St Paul's visit.[5]

In contrast to such mission meetings – which ceased with the death of the Disciples – regular gatherings would of necessity be held in private, in the house of one or the other of the brethren, 'breaking the bread from house to house'.[6] Since the core of the service was a meal, the given place of the meeting would be the dining-room. And as the congregations were recruited by and large from the lower and middle classes, their houses would have been typical cheap houses. Such houses are known to us, if not from the first and second centuries, at least from the fourth and fifth. In the Eastern provinces, they were apparently one-family buildings up to four storeys high. The dining-room on top

was the only large room, and often opened on a terrace. This is the upper floor, the *anageion* or *hyperöon* frequently mentioned in the Acts,[7] the room 'high up, open to the light', of which Tertullian still speaks after A.D. 200.[8] The furnishings would simply consist of a table and three surrounding couches, from which the dining-room takes its name in Latinized Greek – the *triclinium*. The main couch opposite the entrance was presumably reserved for the elder, the host, and the speaker as honoured guest. The congregation might crowd the room, including the window sills, so that at Troas – from the heat of the many lamps and the length of the sermon – a young man fell from the fourth floor (the *tristegon*), only to be resurrected by the preacher, St Paul.[9] In Rome, where tenement houses with horizontal apartments were the rule, not necessarily including a dining-room, any large chamber may have served for these gatherings.[10] No other rooms would have been required by the congregations. *Postulants*, desiring to be converted, and *catechumens*, converts not yet baptized, were not admitted to 'breaking the bread', and may have left the room before that climax of the meeting. Baptism, originally administered only in flowing water, was performed in standing water, either warm or cold, as early as the beginning of the second century; it took place presumably at a fountain or well in the courtyard of the house, in a bathroom, or in a small, privately owned public bath.[11]

Until A.D. 200, then, a Christian architecture did not and could not exist. Only the state religion erected temples in the tradition of Greek and Roman architecture. The saviour religions, depending on the specific form of their ritual and the finances of their congregation, built oratories above or below ground, from the simplest to the most lavish but always on a small scale. Christian congregations prior to 200 were limited to the realm of domestic architecture, and further, to inconspicuous dwellings of the lower classes. This limitation,

and particularly the evasion of the architecture of official worship, is something that becomes decisive for the early development of Christian architecture.

A.D. 150–250

The position and outlook of Christianity changed radically after the middle of the second century. By 250, Asia Minor was sixty per cent Christian. The congregation in Rome numbered thirty to fifty thousand. North Africa counted hundreds of small-town congregations.[12] Through the continuous controversies with pagans and Jews as well as among its own members, dogma became more clearly defined. The last years of the second and the first half of the third century saw the first great Church fathers: Tertullian and Cyprian in Africa, Hippolytus in Rome, Clemens and Origen in Alexandria. Men of wealth and rank rose to leadership: Calixtus, a freedman and wealthy banker, held the office of deacon in Rome, then that of bishop from 217 to 222. By 230, the congregations counted among their members high civil servants and courtiers; Christians, so says Tertullian, have penetrated town councils, the palace, the senate, the forum; and bishops, so says another Church father, had become stewards of the Emperors.[13] The congregations had become increasingly organized and expanded their activities of divine worship and care of souls to include charity, the tending of cemeteries, the administration of property, and instruction classes for proselytes. Bishops, elders (presbyters), and deacons grew into the hierarchy of a professional ordained clergy, each degree entrusted with different spiritual and administrative functions. In Rome, Bishop Dionysius (259–68) established a parochial organization and a similar set-up prevailed throughout the Empire, one bishop presiding over the Christians in each town. As early as 220, the bishops of the metropolitan centres - Rome, Carthage,

Alexandria, Ephesus, and possibly Antioch - had gained actual leadership in their respective provinces.

The new strength of Christianity was bound to lead to conflicts with the State.[14] Christianity found it increasingly impossible to evade the demands and avoid the challenges of officialdom. As early as the second century, the self-segregation of the Christians and their voluntary exclusion from official worship and government service had led to suspicion and to sporadic pogroms. By and large, however, the authorities were inclined to consider the Christians harmless sectarians. Persecutions remained localized and far apart: in Rome in 64, at Smyrna in 117, at Lyons in 177. But by 250 the situation had changed. The Christian segment of the population had grown large and influential. Their refusal to participate in sacrifice, prayer, and public rejoicing for the welfare and success of the Emperor's Divine Majesty forced the government into action. Millions of citizens were obviously subversive, refused to take an oath on the Emperor's godhead, could not be called up for military and civil service, and, indeed, began to claim future secular and political power. Closing both eyes would not do. Two bloody general persecutions, in 250 and 257–60, led to the arrest and execution of Christian leaders in Carthage, Alexandria, and Rome, and to the enforcement of sacrifice, the prohibition of assembly by Christian congregations, and the confiscation of Christian property. But the organization of the Church was too strongly built, and the trust of the faithful in ultimate salvation too strong. The Emperor Gallienus ended the persecution in 260 and restored to the Churches their property, their buildings of worship and cemeteries, and their right of assembly.[15]

The holding of property by Christian communities both before and after the persecutions, then, is assured. The legal basis for such holdings remains a moot question. Possibly the con-

gregations were incorporated as funeral associations and held property under that title. More likely, they purchased and held property by proxy, through a member of the congregation or the bishop. All in all, except for short times of persecution, Christianity was tolerated by Roman practice, if not by law. The large Christian congregations of the Empire, by 250, certainly did not live in hiding. They held services, proselytized, baptized, buried their dead, assisted their needy – and to these ends owned property, either legally or by sufferance.[16]

The structures wanted by the congregation were to serve two purposes: the spiritual needs and social welfare of the living and the cult of the dead. Outside the cities, cemeteries had to be established and maintained where the dead could rest undefiled by neighbouring pagans, where tombs of martyrs were marked by monuments, and where the living could assemble in appropriate structures for memorial services and funeral banquets. Within the cities, congregations needed buildings suitable for assembly of the faithful, administration of the community, and distribution of charities. Poor congregations might well continue to meet in private houses; leaders of large communities too would revert to this practice in times of persecution, or else assemble in the less conspicuous buildings in cemeteries. This latter apparently occurred in 250 when the Roman bishop and his deacons were arrested 'on the cemetery of Callixtus'. But as a rule, from the early third century, congregations must have held structures of their own for their manifold needs – structures within the local tradition of domestic building in the Roman-hellenistic world, yet adapted to the new needs of the Christian congregations.

These needs, both religious and social, had expanded rapidly. A rich and clear liturgy had evolved by A.D. 200. The common meal had been relegated to rare occasions: meals offered to the poor (agapai), or funeral and memorial banquets (refrigeria) held in cemeteries near sites hallowed by martyrs. The regular service consisted of two parts. The first was attended by both the faithful and catechumens and comprised scriptural readings, sermon, and common prayer (Mass of the Catechumens). The second part (Mass of the Faithful) was reserved for fully-fledged members in good standing. It consisted of three parts: the procession of the faithful bringing offerings for the Sacrifice and contributions for the maintenance of the poor and the church; the Sacrifice proper – the Eucharist; and the communion.[17] The assembly room, no longer a dining-room, had to be large, easily accessible, and divided between clergy and laymen.[18] The bishop, flanked by his presbyters, would preside over the assembly from a platform (tribunal, solium), seated in an armchair like a Roman magistrate. The congregation was seated outside this presbytery, supervised by the deacons and arranged in a set order. A Syrian church order of c. 250 places children in front, then men, and finally women. In Rome, men apparently occupied one side of the room, women the other, as continued to be the custom in later times.[19] The furniture was simple, presumably wooden and movable: the bishop's chair, a table (mensa) for the Eucharist, and a second table for the offerings (the first table within or in front of the presbytery, the second to one side). A low wooden railing might separate the clergy from the laymen, and this railing, or another, was used to enclose the altar. An anteroom (vestibulum) was needed for catechumens and penitents who, dismissed after the first part of the Mass, were to hear, but not see, the Mass of the Faithful.[20] Baptism had also evolved an elaborate liturgy, preceded by anointment and followed by confirmation, requiring both a baptistery and a confirmation room (consignatorium).[21] All these rooms, varying in size, had to communicate with each other and allow for a smooth sequence of baptism, confirmation, and regular assembly. Moreover, auxiliary chambers had to be provided: class-

rooms for instruction of neophytes; a dining-room for celebration of *agapai*; a vestry in which to store altar vessels; and, at times, a library as well. The charities of the Church required the storage, distribution, and administration of food and clothing. Offices and living quarters were needed for the clergy, their families, and the clerical staff. These manifold ends could not be met either by a private house, taken over unchanged, or by an apartment temporarily at the disposal of the congregation. They could be met only by a regular meeting house, owned by the congregation in practice, if not in fact. Such a structure would be called a *domus ecclesiae*, an *oikos ekklisias*, or, in the local parlance of Rome, a *titulus*;[22] community centre or meeting house best renders the meaning of the various terms. Once purchased, the structure would as a rule have to be altered to fit the congregation's needs. Occasionally community houses may even have been built *ex novo*. But all known community houses remain bound in plan and design to the tradition of utilitarian domestic architecture, as well as subject to the regional variations of third-century building within the Roman Empire. Christianity thought of its practical needs along purely utilitarian and private lines. It shied away from the official sphere and from official and religious architecture, which was nearly all loaded with pagan connotations in third-century Rome. Temples were dedicated to the gods of the State; sanctuaries were sacred to pagan saviour gods; and public assembly halls were linked to the worship of the Emperor or the Welfare of the State. 'We have no temples, we have no altars', says Minucius Felix.[23] Inconspicuousness was both prudent and ideologically desirable for Christianity, and could be best achieved behind the façade of domestic middle-class architecture.[24]

Christian community houses of this description, formerly known only dimly from literary evidence, have come to light during the last forty years. None among those known dates from after 400, none from prior to 230. The oldest known building stood at Dura-Europos (Qalat es Sālihīye), near the eastern border of the Empire, and is representative of the position and requirements of a small-town congregation in hellenized-Mesopotamian surroundings. The community houses found in Rome, tenements remodelled in the third and fourth centuries for use by Christian congregations, are typical of the needs and position of the large Christian community in the capital of the Empire.

The meeting house at Dura-Europos is securely dated [1]. It was destroyed with the neighbouring Jewish synagogue and other houses when the town wall was reinforced in 257.[25] When built on the edge of the town, it was an ordinary town dwelling of the customary peristyle type: a courtyard, entered from an alley through a narrow passage, was surrounded on

1. Dura-Europos (Qalat es Sālihīye), Christian community house, shortly after 200 and *c.* 230. Isometric view

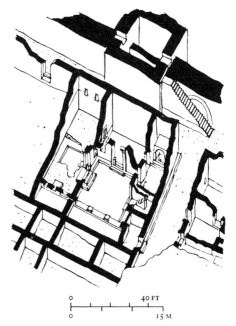

```
0                          40 FT
├──────┼──────┼──────┼──────┤
0                          15 M
```

three sides by rooms of varying sizes, and on the fourth side by a portico; into the fresh plaster of one of the rooms a bored workman scratched the year: A.D. 231/2. Whether or not this house was used as such by the Christian congregation for its assemblies is uncertain. But the structure was certainly in the hands of the congregation between 240 and 250. At that time it underwent alterations designed to adapt it better to its functions as a community house. The *divan* in the south wing – the reception room, surrounded on three sides by benches – was merged with the adjoining south-west room. The enlarged room – 5 by 13 m. (16½ by 43 ft) – would have seated a congregation of fifty or sixty. A dais for the bishop occupied the short east wall. Near by, a door led into a small room with wall niches which was apparently a vestry. Large doors, taken over from the older building, opened into the courtyard and into a good-sized room – 4 by 7 m. (13 by 23 ft) – in the west wing. This room, offering space for roughly thirty, would have been an ideal place for the catechumens to hear but not see the Mass of the Faithful, to receive instruction, and to prepare themselves for baptism. Its three doors open into the courtyard, the meeting hall, and into a smaller rectangular baptistery to the north. A tub surmounted by a canopy leans against the west wall of the baptistery; and the murals centre on the ideas of original sin, salvation, and resurrection – ideas closely linked in Early Christian thought to the symbolism of baptism.

Presumably community houses were similarly adapted from private residences in small towns all over the Empire.[26] The minutes of a confiscation of Christian property in a North African country town in 303 vividly reflect the plan of such a *domus ecclesiae* and the function of its several rooms. Moving through the house, the police impound chalices, lamps, and chandeliers in the meeting room; wearing-apparel for the poor in a store room; bookcases and chests in the library; chests and large jugs in a dining-room.[27] Nor were private residences only assimilated to Christian meeting houses. In Dura itself, but a few blocks from the Christian building, the remnants of a Jewish community centre prove that around 200 the Jews also housed their meeting room and needed annexes in a structure much like an ordinary Dura house: a small courtyard enclosed by smaller and larger rooms, among the larger the synagogue, among the smaller a sacristy and two divans, of which one possibly served as a dining-room and the other as a court room.[28] This building was replaced in 245 by a new community centre in which the rooms were larger, the synagogue preceded by a regular forecourt and lavishly decorated with wall paintings – the oldest surviving Old Testament cycle. But all this remained hidden behind windowless walls. Seen from the street, both the Jewish community centres of about 200 and 245 and the Christian *domus ecclesiae* were indistinguishable from any other house in the neighbourhood. This was only natural. Both congregations were small minorities, and although the environment was not necessarily hostile, there was no reason to call attention to an alien element through a conspicuously different structure. Nor is it surprising that both congregations installed their community centres in the district near the city wall, traditionally the quarter of the poor. Financial limitations, the social background of their membership, and the natural desire to be inconspicuous would have made them prefer such a location.

Community houses in the large cities of the Empire – whether Jewish or Christian – would differ from those in country towns for a number of reasons: the greater wealth and larger size of the congregations, the metropolitan surroundings, and the tradition of large-city domestic architecture. But like their country cousins, the *domus ecclesiae* in the metropolitan centres of the Empire were rooted in domestic architecture and would preserve their unobtrusive presence

among the ordinary houses of a large city. Metropolitan architecture, by the early third century, had indeed developed two distinct types, each with a number of variations. The private residences of the wealthy, the *domus*, followed the plan of the old hellenistic or Italo-hellenistic peristyle house. Far more numerous were the buildings designed for the teeming masses of the urban population: tenement houses of up to five or more storeys – either tower-like, as in Alexandria, the apartments heaped on top of each other, or forming large blocks (*insulae*), as in Rome and Ostia, with shops, small thermae, or warehouses at street level and numerous apartments on each of the upper floors.[29] Crowded along narrow, shady, smelly streets bustling with life and noise, these tenements must have looked very much like their late descendants in present-day Rome or Naples.

The Christian communities of Rome installed their *domus ecclesiae* in just such tenements. Their resemblance to ordinary tenements would have made these *tituli* as hard to identify as the meeting rooms of contemporary sects installed in the tenements of New York's Harlem or London's East End. The term *titulus* is a legal one, derived from the marble slab which bore the owner's name and established his title to a property. By the early fourth century the parish organization of Rome rested on twenty-five *tituli*, known under such names as *titulus Clementis, titulus Praxedis, titulus Byzantis*, and the like. These *tituli* exist to this day in name and law, with 'saint' prefixed to the owner's name, or with the original *titulus* name replaced by that of a saint; and each *titulus* is assigned to one of the cardinals of the Roman Church as his title church. Most of these *tituli* are now regular church buildings, laid out from the fourth to the ninth centuries, and often remodelled later. However, incorporated into their walls or preserved below their floors are, almost without exception, the remnants of large tenement houses or private thermae dating from the

second or third centuries, or at least from the period before Constantine. Hence it becomes very likely that the pre-Constantinian structures were used as *domus ecclesiae* until replaced much later by regular church buildings which retained the original names of *titulus Clementis*, and so forth.[30]

It is tempting to assume that a large number of these pre-Constantinian structures incorporated into present-day title churches were Christian community centres as early as the third century. But such generalization is hazardous, since no *titulus* can yet be traced beyond the early fourth century by documentary evidence. Concomitantly, the mere presence of a pre-Constantinian tenement incorporated into a fourth-century or later title church constitutes no proof that the structure was a *domus ecclesiae* prior to Constantine. Such proof exists only where the building was remodelled for Christian use in pre-Constantinian times, either structurally or in decoration. Even where a *titulus* was installed in a pre-Constantinian structure as late as the fourth century, however, this use of a tenement or a thermae building is presumably a survival of earlier times when Christian architecture was still fully rooted in domestic architecture.

The structure incorporated into the early-fifth-century church of SS. Giovanni e Paolo offers an example of a second-century tenement house of customary type, with shops on the ground floor and apartments above, which was merged with a small neighbouring thermae, probably shortly before 250. Early in the fourth century, the ground floor – obviously no longer used for shops – was decorated with murals including Christian subjects. The building at that time must have served as the *titulus Byzantis*, as it appears in documents. However, the evidence furnished by the distribution of windows over the third-century façade, and the strengthening of ground-floor walls and the construction of a monumental staircase (both

in the third century), suggest the existence of a large hall on the upper floor. The hypothesis that the building served as a Christian community house as early as the third century thus becomes admissible. In the last third of the fourth century, a *confessio*, sheltering relics of martyrs, was inserted on a mezzanine landing of the staircase and marked the position of the altar near the east wall in the large hall above. The structure survived until replaced after 400 by the present basilica.[31]

The situation may have been similar in other Roman *tituli*. At S. Clemente, a third-century tenement with shops and what may have been a factory hall on the ground floor gave way in the late fourth century to a basilica [132]. At the same time, a second-century thermae hall was remodelled into the basilica of S. Pudenziana.[32] Conclusive proof is lacking as to the previous use of these structures by Christian congregations, but the likelihood is undeniable. Notwithstanding uncertainty in specific cases, then, the *domus ecclesiae* of third-century Rome appear to have been installed in tenement houses and other utilitarian structures, only slightly adapted, along purely practical lines, to their new function.

Correspondingly, the funeral structures of the early-third-century Christian congregations were utilitarian in design, evolved from Roman funeral architecture of the simplest kind. Christian funeral ritual, like pagan, required both a burial place and a place for memorial services. The services included a funeral banquet at which family and friends assembled round the tomb, feasting and pouring libations into the grave through an opening, the *cataract*. The standard architectural elements were a clearly identified tomb, occasionally provided with a table top, and for the banquet either a tomb chamber with mourners' benches or couches, or a separate room.

Christian custom required slight modifications of Roman traditions, which favoured burial in family groups (including slaves and freedmen) regardless of personal religious belief. Christian usage, at least by A.D. 200, required burial of the faithful uncontaminated by pagan neighbours. Burial near the mausoleum of a pagan patron became gradually impossible. Moreover, Christianity abhorred cremation, which remained standard for the poor in Rome even after the well-to-do had returned – around 150 – to the custom of burial. Hence Christians could not use the mass graves of the Roman lower classes, the *columbaria* crowded with urns on shelves or in niches along the walls of a chamber. Finally, despite the relative wealth of Christian congregations, most members were poor in the early third century; since funeral expenses were private, arrangements for burial had to be simple. And whatever arrangements were to be made, the size of the congregations required that they be made on a large scale.

A solution was found by constructing large communal cemeteries, either open to the sky or underground. Underground cemeteries – catacombs – were advantageous in certain cases: if property values above ground were high, if a terrain of soft rock below a thin layer of soil guaranteed low labour costs, and especially if a previous excavation, quarry, or cistern offered a starting-point. The rare coincidence of such conditions limited catacombs to a few Christian sites in Sicily, North Africa, Naples, and Rome. The beginnings go back to the last quarter of the second and the early third centuries. But catacombs were enlarged throughout the fourth century and occasionally laid out anew. They went out of use during the later fifth century and early sixth century under the impact of political and economic catastrophes with resulting decreases in the labour force and collapse of land values.[33]

Regional differences among catacombs are marked. In Syracuse, broad galleries formed a spider's web with narrow branches tightly

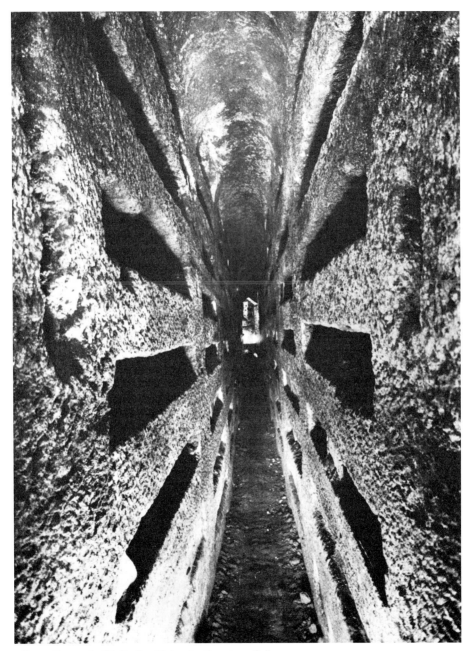

2. Rome, Catacomb of S. Panfilo, third or fourth century. Gallery

packed with floor tombs (*formae*), and with an occasional tomb niche (*arcosolium*) in the wall of a gallery. In Naples and North Africa, a straight broad gallery forms the core of the catacomb, occasionally widened into a plaza on which rock piers support the ceiling and form a free-standing baldacchino. In Rome, narrow galleries form a tight gridiron scheme, starting frequently with an older hypogaeum group, or a tufa quarry or sandpit (*arenarium*). Two, three, or even four storeys are superimposed and connected by narrow ramps or stairs. Into the walls are hollowed narrow shelf tombs (*loculi*), sealed with tiles or marble slabs inscribed with a name and blessing [2]. Square or polygonal chambers (*cubicula*) branch off from the corridors. Intended for affluent individuals or families, their walls were set out with *arcosolia* and niches for lamps; ceilings and walls were decorated with frescoes. This archetype is preserved in the oldest portions of the Callisto Catacomb in Rome. The first cemetery of the Roman congregation, it was apparently established before 217 by one of the great organizers of the Church, Calixtus, and enlarged in the course of the third and early fourth centuries. The same simple gridiron type prevails in the other early catacombs around Rome. Only with the increasing demand for space in the fourth century was the network of corridors converted into the maze which impresses and frightens the modern visitor.

The plain archetype derives from the pagan group hypogaeum, which is simplified, regularized, depersonalized, and enlarged for the benefit of a sizeable congregation. The congregation would pay out of its own funds for the ground and the labour of cutting galleries. The individual, poor as he might be, could at least afford a *loculus* of his own. Needless to say, no catacomb was ever intended or used for holding regular services in hiding from persecution. The idea of Roman Christians, thousands strong by 220, marching to the catacombs for Sunday services unbeknown to the police is preposterous. Moreover, the catacombs were damp, dark, intricate, and the largest *cubiculum* would take not even fifty people. Only memorial services were held in catacombs, and if attendance exceeded a bare minimum, even they and the accompanying funeral banquets had to be held above ground. In times of emergency, small groups may have occasionally tried to meet for regular services in a catacomb chamber, but even then the subsidiary buildings above the catacomb were preferred.

By and large, however, third-century Christians preferred to bury their dead in open-air cemeteries (*areae*) rather than in catacombs. Such cemeteries are known to have existed from about A.D. 200. Later ones dating from the third to the sixth century have been found all over the Christian world, in North Africa, Asia Minor, the Balkans, Dalmatia, Rome, Spain, and the Rhineland. Simple graves, often topped by funeral banquet tables (*mensae*), alternated with free-standing sarcophagi. In between rose small mausolea (*cellae*); some have survived, transformed into crypts, in some medieval churches in France.[34] Funeral banqueting halls of varying size were at times enclosed buildings; at other times they were open to the sky; or they were porticoes bordering the area and sheltering a few *mensae* [5, 6].[35]

Such purely practical layouts gave way to slightly more monumental designs when a structure was to serve more than a private memorial function: e.g., the public cult of a *martyrium* – the grave of a martyr and a witness for Christ and the Faith, or a place which bore witness through memory of a martyr's sufferings or by the Godhead's manifestation. The worship of such sites and the structures built to shelter them are closely linked to pagan antecedents and contemporary pagan custom.[36]

From time immemorial, pagan antiquity had divinized its great and occasionally its minor dead. An elaborate cult had evolved around

mythical heroes, rulers – from tribal chiefs to hellenistic kings and Roman emperors – and members of well-to-do Roman families. The sites linked to their deeds and their deaths had been marked by *heroa*: structures which fused the function and design of temples and sanctuaries with those of mausolea. In their simplest form such heroa were areas open to the sky, terminated by a niche sheltered under an aedicula. In more elaborate form they were enclosed structures: either rectangular halls, longitudinal or transverse, provided with apses; or rotundas, domed like the heavens, raised on high platforms, and preceded by colonnaded deep porticoes. In the course of time, the distinction between heroa and mausolea became obliterated, and by way of heroa, the panoply of the vocabulary of pagan religious architecture – classical orders and all – enriched the realm of Roman funerary building.

Heroa and the hero cult are the roots from which Christian martyria and the martyr cult sprang, apparently as early as the second century. The finds underneath St Peter's in Rome have unearthed what appears to be the oldest known martyrium. In the midst of a cemetery occupied by lavish monuments of well-to-do followers of oriental cults – all dating from *c*. A.D. 120-60, except for one late-third-century intruder – a small area has survived. It measures 5 by 7 m. (16½ by 23 ft) and contains a few mean graves, possibly the remnant of a poor graveyard which preceded the luxury cemetery. The area is terminated by a wall which oversails one of the poor graves. From brick stamps, the wall can be roughly dated *c*. A.D. 160. Above the grave a niche was hollowed into the wall, either when built or at least before 200. An aedicula was placed in front of the niche, formed by two columns carrying a stone plaque 1·50 m. (5 ft) from the ground [3]. The upper part of the niche continued above the aedicula, perhaps flanked by half-columns and surmounted by a gable.[37]

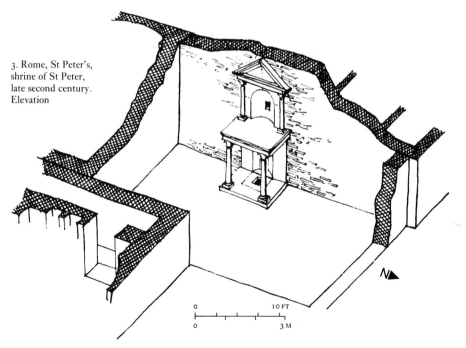

3. Rome, St Peter's, shrine of St Peter, late second century. Elevation

0 10 FT

0 3 M

The archaeological evidence tallies with historical tradition. As early as *c.* 100, local Christian belief held that the apostle Peter had suffered death in Rome; by 200, his *tropaion*, the monument of his victory over death and paganism, was venerated on the Vatican Hill. This is apparently the aedicula now unearthed. Imprecations scratched into an adjoining wall leave no doubt that to Christians of the mid third and presumably the late second century, this was the shrine of the apostle. By 320 the lower part of the niche was buried; but its upper part was retained, and on it Constantine's architects focused the enormous mass of their basilica. To this day, it forms the centre of veneration in the church of St Peter's below the high altar. Whether this shrine covered Peter's grave or merely a cenotaph (a fictitious tomb), or whether it simply commemorated his martyrdom, are questions the historian of architecture may well leave open.[38]

A.D. 250–313

Simple martyria abounded after the collapse of Decius's persecution in 260, and after that, of Diocletian's of 303–5. Two chambers inside the Callisto Catacomb – prepared before 207 for the common burial of Roman bishops and in use until 314 – were joined together by 250 and decorated, if modestly, by two attached columns [4]. Inscriptions mark the enlarged room, the 'Chapel of the Popes', as a martyrium, and indeed in the fourth century it was provided with an altar and chancel screens.[39] Martyria above ground were designed as precincts, resembling

4. Rome, Catacomb of S. Callisto,
Chapel of the Popes, *c.* 250

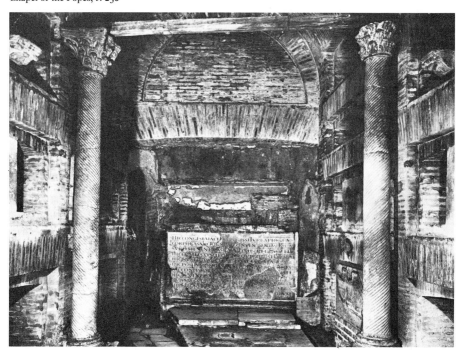

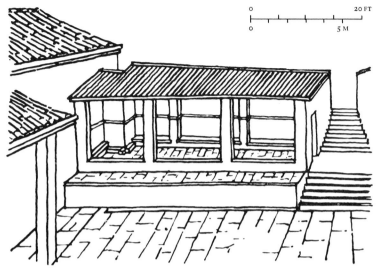

0 20 FT

0 5 M

5. Rome, S. Sebastiano, triclia, *c*. 258. Reconstruction

the one at the shrine of St Peter but along quite simple lines. On the site of S. Sebastiano on the Via Appia, a festival commemorating St Peter and St Paul was celebrated from A.D. 258. At that time, an open courtyard was laid out, terminated on one side by an open loggia – a funeral-banquet hall (*triclia*) [5]. Were its walls not covered with invocations of the Apostles (one dated 260) and with records of feasts in their honour, the loggia might be the *pergola* of an ordinary *osteria*. Inside the courtyard, a niche with marble revetment formed the cult centre.[40] A much simpler martyrium precinct

6. Bonn, memoria, *c*. 250

0 10 FT

0 3 M

was set up at roughly the same time on a Christian cemetery found below the medieval cathedral at far-away Bonn [6] – a rectangular bench under the sky, surrounding two masonry blocks rising over two tombs, one block prepared for offering libations.[41]

Numerous small martyria precincts have been found in the cemeteries of Salona on the Dalmatian coast.[42] They show half a dozen variants: simple apses with a bench along their curve, the floor raised and slightly projecting so as to cover the martyr's tomb in front; walled-in square courtyards terminated by an apse and sheltering the graves, both of the martyrs and others; precincts, their front wall opening in an arcade and centred on a banquet mensa, with the martyr's tomb sheltered by a canopy. At times the precinct is surrounded by porticoes with projecting apses – their number multiplies during Constantine's reign into a maze of apsed chapels. At Salona-Marusinac an elaborate tomb precinct was laid out: a long porticoed courtyard, terminated by an apse and two mausolea projecting sideways. Superficially the

plan recalls a basilica with transept, and indeed, the structure at Salona has been termed a 'basilica discoperta' and interpreted as an ancestor of all church building [143].[43] Both the precinct's late date, 426, and the rarity of basilicas with transepts make this thesis untenable. On the contrary, the plan represents a precinct plan barely monumentalized beyond the most practical needs, and old-fashioned by fifth-century standards.

Open-air precincts apparently gave way during the fourth century to more monumental types of martyria. The Anastasius Mausoleum in Salona, dated c. 305-10, is an example [143]. Others are found in places as far distant as Pécs in Hungary and Alberca in Spain. All are small two-storeyed buildings, rectangular and provided with interior apses, barrel-vaulted and strengthened by exterior buttresses.[44] At Salona, the underground tomb vault sheltered the martyr's body under the apse, the founders' sarcophagi under the nave. The upper chamber, also barrel-vaulted, was presumably used for funeral banquets and memorial services. The type obviously derives from Roman two- and three-storeyed mausolea and heroa, but the placement of an altar over the tomb of the martyr for memorial services introduces a new element, important for the later development of Christian architecture. Simultaneously, elaborate martyria and banqueting halls were built in Rome amidst open-air graveyards above the catacombs. Some were triconchs (cellae trichorae), the centre bay vaulted, the façade open in a wide arch or a triple arcade or preceded by a short nave [7]. The martyr's tomb was either below the floor or in a chamber of the catacomb.[45] Other martyria were cross-shaped, the centre square groin-vaulted, and the tomb apparently hidden underground in a circular vault enlarged by cross arms. The martyrium above the catacomb of St Praetextatus, perhaps as late as the second half of the fourth century, was a hexagon structure with low niches projecting between high buttresses, the centre room domed and lighted by narrow windows above the apses.[46]

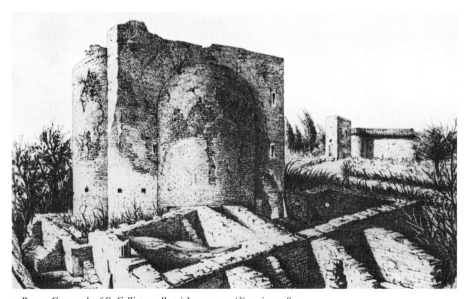

7. Rome, Catacomb of S. Callisto, cella trichora, c. 300(?), as in c. 1850

Judged by their masonry, all these buildings would seem to date from the first quarter of the fourth century; some may be pre-Constantinian. All are closely linked in plan and design to the tradition of pagan Roman mausolea and heroa of an elaborate type. In exceptional cases, Christian martyria of pre-Constantinian date seemingly absorbed an even more pretentious type of mausolea, customary in the Eastern provinces: the *tetrapylon*, a four-arched vaulted structure, recalling a canopy such as those rising over the Emperor's throne. The connotations are significant to the placement of such a tetrapylon over the grave of St John the Evangelist at Ephesus perhaps as early as 300.[47]

Monumental forms seem to have penetrated more easily into Christian funerary architecture than into other fields of Christian building. Pagan funeral building was by and large in the private domain and therefore lacked the religious overtones inherent in all monumental public architecture. It had absorbed from this latter the vocabulary and often the plan, but it was considered neutral and not truly religious architecture. Hence the forms of classical architecture could easily slip into Christian funerary building – whether private mausolea, banqueting halls, or martyria – when deprived of their religious and therefore unacceptable connotations.

On the other hand, the buildings where congregations met for regular services and for the administration of their affairs clung much longer to the concepts of purely utilitarian architecture. Houses, legally or practically in private hands, were used for services even in the early fourth century in North Africa. In Rome *domus ecclesiae* were purchased and remodelled far into the fourth century.[48] Occasionally, however, in the last decades of the third and the first years of the fourth century, a bishop and his congregation felt dissatisfied with the unobtrusive, utilitarian character of the community centres. Against the strong opposition of his brethren, as early as 265 the bishop of Antioch, Paul of Samosate, claimed

8. Rome, S. Crisogono,
first church,
early fourth century(?).
Reconstruction

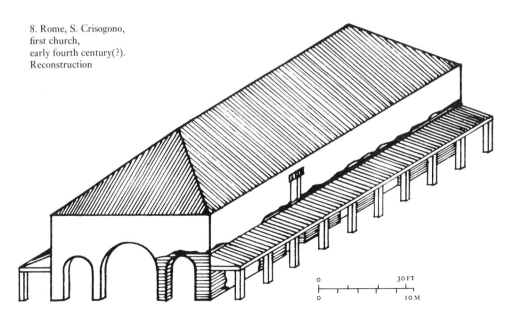

30 FT

10 M

more showy quarters and the appurtenances, both architectural and ceremonial, of a Roman ranking magistrate: a 'lofty throne' atop a dais, an audience chamber, and the performance of acclamations upon entering the meeting room for services.[49] Dais, throne, and chambers could have been installed, no doubt, in a community house of the old type. Complaints were raised by pagan opponents against what were felt to be pretentious Christian meeting places, such as the one in Nicomedia (Izmit), 'high up amidst large buildings'. However, this structure might still have been an old fashioned *domus ecclesiae*.[50] On the other hand, the contemporary accusation levelled against the Christians of erecting 'huge buildings thus imitating the structures of temples' can refer only to a meeting hall of public appearance.[51] The walls of at least one pre-Constantinian Christian hall may have survived in Rome in the first church of S. Crisogono, alongside and far below the twelfth-century basilica. It was rectangular, aisleless, and obviously truss-roofed, its right flank possibly skirting a portico and a courtyard [8]. The brickwork suggests a date very early in the fourth century. At the same time, the size of the structure, 15·50 by 27 m. (51 by 89 ft), and the three-arched opening in the façade proclaim its public and to some extent monumental character.[52] The even more impressive S. Sebastiano on the Via Appia may have been laid out just prior to Constantine's occupation of Rome in 312 [20].[53] Yet while such structures have departed from the pseudo-domestic, modest utilitarianism of previous Christian building, they are still far from the concepts of Roman-hellenistic monumental architecture. Not before Constantine are Christian concepts expressed in the language of the official architecture of Late Antiquity.

THE FOURTH CENTURY

CHAPTER 2

CONSTANTINIAN CHURCH BUILDING

With the Edict of Milan in 313 at the beginning of his reign, Constantine recognized Christianity with open favour and granted it official standing.[1] Through word and deed during the following twenty-four years of his life he established the Church as the dominant religious power within the Roman Empire. Church and Empire became closely wedded, and the political as well as the social position of the Church changed radically, in the eyes of the world and in her own eyes. Her hierarchical organization, already strengthened in the decades of peace between 260 and 305, was tightened. It paralleled the administrative organization of the Empire. Villages and parishes had their own clergy; each town had its bishop. The bishops of provincial capitals strengthened their spiritual and administrative leadership previously held by custom. Major sees rose above them: Carthage, Trier, Aquileia, Antioch, Caesarea in Cappadocia, Milan. A few emerged as the dominant ecclesiastical centres of the Empire: Alexandria, the leading centre of Christian thought during the third century; Rome, the old capital of the world; Constantinople, from 330 the new capital and the seat of the court.

The position and organization of the Church during the decisive years from 313 to 337 pivots round the person of Constantine. Layman though he was, and baptized only on his deathbed, he considered himself the thirteenth Apostle, Christ's vicar on earth, and like his pagan predecessors - a thought abhorrent to later generations - an aspect of the Divinity incarnate, the Invincible Sun, the Seat of Justice. As he saw it, he had been divinely appointed to lead Christ's Church to victory. He presided in person at Church Councils, pressed for the settling of dogmatic controversies, and used the machinery of the government to implement decisions of the Councils. He employed the unlimited means of Imperial power to raise the standing of the Church and to draw towards it the pagan world. The Church became an official body closely linked to the Imperial administration and a political power as well. Ladies of the Imperial family, including the Empress Dowager Helena herself, had been devout Christians for some time, as were many women from aristocratic houses. Christian officials were numerous at the court, and the Imperial favour shown to Christianity led large numbers of civil servants and aristocrats to embrace the new religion. By the time of Constantine's death in 337 this interpenetration of ecclesiastical and Imperial power was complete. Christianity, under the Emperor's own auspices, had attained the highest political and social standing. In the decades preceding Diocletian's persecution Christian leaders, anticipating victory, had occasionally arrogated to

themselves the insignia of officialdom. Now under Constantine bishops were granted rank, privileges, and the insignia of the highest government officials.[2]

Her new position was bound to affect the liturgy of the Church. A permanent and unchangeable liturgy was required; indeed, minor divergencies notwithstanding, the liturgy of the Mass as established in the early fourth century became nearly uniform all over the Empire. The basic lines remained those of old: the division into the Mass of the Catechumens and of the Faithful; the rite of the oblation; the separation of congregation and clergy; the presiding position of the bishop. But the ritual grew more strict and more solemn. Christ was no longer, as even in the third century, primarily the god of the humble, the miracle-worker and saviour. As Constantine viewed himself as God's vicar on earth, so God was viewed increasingly as the Emperor of Heaven.[3] Hence the liturgy became a ceremonial performed before the Lord or before his representative, the bishop, just as rigidly adhered to as the ceremonial performed before the Emperor or his magistrate. Indeed, the liturgy began to borrow an ever greater number of features from the ceremonial of Roman officialdom and the Imperial court. The bishop, clad in the garments of a high magistrate, entered the church in solemn procession, preceded by the insignia of his official rank, candles and book. Flanked by his presbyters, he was seated on a throne, the *sella curulis* of a Roman official. Every act performed in the church was permeated by this new, official flavour.

Hand in hand with the new public connotations of the ritual goes a strengthening of the hieratic element. Throughout the third century the service had increasingly eliminated the participation of laity and concomitantly insisted on the sacred solemnity of the ritual. Under Constantine, the Mass was further elaborated. At the start of the service, bishop and clergy performed their ceremonious entry into the church. The rite of the oblation at the end of the Mass of the Catechumens became a solemn procession of the congregation depositing their offerings on the altar or a near-by table. The altar, formerly a wooden table easily carried in for the Mass of the Faithful, gradually became a stable structure, often covered with gold and precious stones. Occasionally it was accompanied by a *fastigium*, an arched and pedimented lintel colonnade, like that under which the Emperor revealed himself to his subjects at court, as it survives in Diocletian's palace at Spalato (Split). The graves of the martyrs and their places of martyrdom became the object of a solemn cult and of pilgrimages. In Constantine's late years, this veneration extended to the sites where the gospels and tradition place Christ's life and sufferings.

Christian architecture of the Constantinian period developed within this framework, where practical features were inextricably interwoven with ideological elements. The new official and hieratic character of the Church required a new ground plan. The sanctuary where Mass was said and where the clergy were assembled had to be architecturally distinct from the lay part. All ecclesiastical architecture had to be differentiated from and raised above ordinary buildings. Finally, the official and hieratic overtones of the Church and the dignity of her Imperial patron demanded an architectural vocabulary corresponding to the highest class of public buildings, palaces, and temples.

The large numbers of new Christians required larger church buildings, particularly in urban centres. Concomitantly, the tighter organization of the new liturgy required a stricter differentiation between the various ecclesiastical building types and between the various sections of an individual building. Structures designed for the regular assemblies of the faithful had to be clearly set off from those primarily intended for the cult of venerated sites, and both had to

be distinguished from buildings set aside for the baptismal rite or for burial. A forecourt (*atrium*) or a precinct court had to be provided, accessible even to non-believers and postulants, while other provisions had to be made for the large number of catechumens. Under instruction but not yet baptized, the catechumens could remain during the first part of the service, but during the Mass of the Faithful were required to withdraw to a segregated part of the building: entrance, aisles, atrium, or rooms attached to the flanks of the church, or to a second structure near by. The clergy also required a separate area, and this was provided, raised above the congregation, segregated by screens from the laity, and containing the altar.[4]

Church building under these new conditions could no longer remain in the realm of domestic architecture, where it had been rooted for the last two hundred and fifty years. Community centres had no future once the Church had become the Establishment of the Empire. They were too small to accommodate the thousands of new converts. Too many functions were crowded into them, religious, administrative, social, utilitarian. Situated in the slums and hidden indiscriminately behind the plain façade of an ordinary house, they were incompatible with the dignity of the Church and of its Imperial patron. For want of other facilities, the old *domus* continued to be used and occasionally even new ones were purchased. But Christianity under Constantine had to find a new architecture of a higher order, public in character, resplendent in material, and spacious in layout.

For both practical and ideological reasons it was impossible that this new Christian architecture should evolve from the religious architecture of pagan antiquity. Christianity obviously saw in paganism and all its works the very opposite of its own intentions. It shied away from pagan temples to such a degree that neither they nor even their sites were occupied by the Church before the late fourth century in

the East or before the sixth century in the West.[5] Just as important, no pagan religious building was adaptable to the needs of Christian worship. The temples of the old gods, an obsolete type by 320 in any event, had been designed to shelter an image, not to accommodate a congregation of both laymen and clergy. To be sure, the sanctuaries of the Neo-Pythagoreans, of Baal, Mithras, the Great Mother, and Attys, all oriental cults, were designed to hold small congregations numbering twenty or thirty, assembled along a central passageway and subordinate to a priest officiating at an altar. The Christian communities of Constantine's time, however, comprised hundreds or thousands of members, and had to evolve their churches within a different framework.

Given her new official standing under Constantine and her new concept of Christ the King, the Christian Church in search of an architecture was bound to turn to the realm of public, official architecture.[6] Within it, she would inevitably single out a building type which combined religious connotations with the criteria of official building. Such a building type existed: the basilica. Since the second and first centuries B.C., basilicas had been built all through the Roman world. In modern architectural parlance, a basilica is a building divided into a nave and two or more aisles, the former higher and wider than the latter, and lit by the windows of a clerestory. But Roman basilicas were rarely, if ever, of this type. In their simplest form they were aisleless halls, occasionally subdivided by supports. In more elaborate form, the nave was enveloped by aisles or by aisles and galleries; or aisles and galleries were doubled; or they ran parallel to the nave instead of enveloping it. The clerestory might be high or low, the entrance could be either on the long or short side, or on both. The tribunal, the seat of the magistrate, rose on a plain dais either inside the nave or in the aisles, or in an apse of rectangular or semicircular plan. Again, this

apse might project either from one of the short sides or from the long side, or the number of apses might be doubled or tripled. Open timber roofs or flat ceilings were the rule.[7]

By A.D. 300 this variety had increased even further. Much in contrast to temple architecture the basilica remained immensely alive and prone to change in plan under the impact of other building types. The Basilica of Maxentius was designed as a huge vaulted nave flanked by niches, resembling a thermae hall. Throne basilicas in Imperial palaces occasionally seem to have adopted central plans. Sometimes, though rarely, an open area surrounded by porticoes may have served as a basilica. The most common type, however, at the turn of the fourth century was apparently a longitudinal, timber-roofed hall without aisles, terminated and thus dominated by a raised apse. Huge windows in single or double rows along the flanks lit the interior. The palace basilica at Piazza Armerina, the basilica at Trier, two forum basilicas at Sétif in Algeria, and the hall, now SS. Cosma e Damiano, on the forum in Rome are examples.[8] In conformity with general contemporary practice, the exterior was dominated by plain stretches of wall, the interior was resplendent with marble revetments and gilded capitals and ceilings.

However, in Roman parlance, the term basilica applies to the function rather than to the design of the building, and despite variation the function of Roman basilicas is easily described: a basilica was but a large meeting hall.[9] The forum basilica, found in any Roman town, was but a covered extension of the adjoining market-place – a hall to transact business and to exchange town gossip and news from the Empire, a *souk* to display wares, much like the *galleria* in any modern Italian town. On a dais, the tribunal, the magistrate and his assessors would sit in court; surmounting it, a shrine sheltered the effigy of the Emperor in whose presence alone law could be dispensed and business contracts validly concluded.[10] In large cities a number of basilicas might be assigned different functions: stock and money exchanges, clothing bazaars, florists' arcades, special law courts, each designated by an explanatory epithet. Army camps had their riding and drill basilicas, opening on to a sanctuary where the eagles of the legion and the Emperor's effigy were kept. Large thermae might boast a basilica, where clients could disport themselves.[11] Beginning in the second century A.D., basilicas adapted to the demands of the specific ritual had come to be used by religious sects: the large hall in the sanctuary of Isis and Osiris at Pergamon; the basilica of the Tree Bearers in Rome; a group of synagogues in Galilee. Or again, a funerary college might gather in a tiny funerary basilica.[12] Large reception rooms in wealthy houses were likewise termed basilicas. Outstanding among these were the audience halls, within or near the Imperial palaces, where the Emperor's divine Majesty, enthroned in the apse, would solemnly appear to his subjects.[13]

At the same time, the direction Christian architecture was to take was determined by the religious connotations which all such basilicas had carried for centuries. These sacred overtones grew stronger with the growing import of the cult of the Emperor's divinity. The palace basilica in which he sat enthroned was *ipso facto* a religious building. The drill basilica of a barracks became religious ground as the garrison paraded and swore loyalty before the Emperor's bust. In forum basilicas, his divine effigy consecrated official and private business. Even in thermae basilicas, the image of the godhead received the homage of those gathered. The borderline between the secular and religious functions of the basilica is fluid throughout Late Antiquity, and the wide variety of purposes for which the buildings served fluctuated between these two poles.

It was almost inevitable that the Church under Constantine would develop, within the frame-

work set by the genus basilica, the buildings she specifically required for the solemn celebration of Mass amidst an assembled congregation presided over by her high dignitaries, bishop and clergy. Clearly, however, the newly-built Christian basilicas were not derived from any specific type of Roman basilica – be it the forum basilica, the Imperial audience hall, or a funerary or a religious basilica. On the contrary, the Christian basilica both in function and design was a new creation within an accustomed framework. In the eyes of contemporaries this was nothing extraordinary. The Christian assembly halls simply represented one more type of basilica created by a new demand. In Constantine's time, the Christian basilica was viewed as just another monumental public meeting hall with religious overtones. Its function had to be explained by a distinctive epithet, such as '*basilica id est dominicum*', an assembly hall that is a house of the Lord, or, 'a basilica for the Apostolic and Catholic congregation'. Or else, Constantine himself refers to the church on Golgotha as 'a basilica more beautiful than all others anywhere', and thus places it on a level with any other assembly hall built for whatever purpose.[14]

Modest basilicas may already have been built by Christian congregations in the years preceding the Peace of the Church: S. Crisogono in Rome is an example. But only under Constantine did architects meet the requirements of the Christian ritual by creating new variations on the ever variable type of the genus basilica. From this background, the Christian basilica drew three or four features which by A.D. 300 had become essential characteristics common to the majority of basilicas whatever their function: the oblong plan; the longitudinal axis; the timber roof, either open or concealed by a flat ceiling – vaulting, as in the Basilica of Maxentius, having remained exceptional in Roman basilicas; finally, the terminating tribunal, whether rectangular or in the form of an apse. Division into

nave and aisles and a high clerestory with large windows became preponderant, but they remained optional; galleries remained rare. Within this framework, the Christian basilica had to be brought in line with the demands for greater dignity and monumentality newly created by the Constantinian spirit of Christianity and had to be adapted to specific liturgical requirements, to the financial means and the social standing of the patron, and to local building practice – all widely diverging. The patron might be a poor country congregation, a wealthy bishop, or the Emperor himself. Local building practices might prescribe stone, brick, or concrete construction. The liturgy, while uniform in its general lines, varied locally in implementation. As a result, the clergy might be seated in the apse or in front of it; the altar might be in the apse or in the nave; the offering tables near the altar or in adjoining rooms; the catechumens might withdraw to a forechurch, to the atrium, to the aisles, or to a separate building. Conditions varied further where a building was intended not for the regular services of a congregation, but for the sporadic meetings of local congregations and pilgrims at the tombs of their dead or at the graves of a martyr or at a holy site. Indeed, prior to 350 there was no such thing as *the* Christian basilica; there were only a large number of variants on the theme basilica, adapted to liturgical requirements, building practice, and the wishes of patrons.[15]

Churches from various provinces, built under varying patronage, illustrate the vast variety of Constantinian church planning. The cathedral at Aquileia, replacing a *domus ecclesiae*, was formed by three buildings, completed prior to 319 and perhaps as early as 313: two main halls, running parallel east and west, were connected at their western end by a transverse hall; a small, square room off the transverse hall served as baptistery [9]. The walls and the rich mosaic floors of both the north and south halls survive in large parts underneath and adjoining the

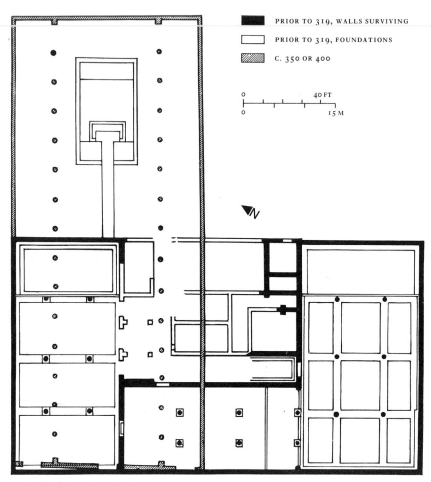

PRIOR TO 319, WALLS SURVIVING

PRIOR TO 319, FOUNDATIONS

C. 350 OR 400

```
0                    40 FT
├──┼──┼──┼──┤
0                    15 M
```

9. Aquileia, twin cathedral, plan,
stages of *c*. 313–19 and *c*. 350 or 400

eleventh-century cathedral and incorporated into its walls.[16] Each main hall, measuring roughly 20 by 37 m. (66 by 122 ft) and capable of seating several hundred, was divided into three naves of equal width. The six piers or columns of the naves supported flat ceilings; only the east bay of the south hall was surmounted by a transverse coffered barrel-vault built of cane. Set off by a marble screen and a

separate floor mosaic, this rectangular bay sheltered the bishop's throne, his *cathedra* (hence cathedral, the building which houses the cathedra), and the bench for the clergy. The altar itself rose farther west, in the nave. From the exterior, the structures must have looked plain. Inside, however, mosaic floors composed of geometric panels framing donors' portraits and Christian symbols, and wall paintings with

garden scenes, made for a colourful, if inexpensive decor. Singly, these halls, whether or not subdivided by supports, resemble pre-Constantinian meeting houses, such as S. Crisogono in Rome. Yet, doubled into a complex of buildings, they form a distinct local group. A large number of Constantinian and slightly later churches in the Adriatic provinces were laid out as such 'twin cathedrals'.[17]

Like Aquileia, Orléansville (El-Asnam) in North Africa was an important, although minor, episcopal see. Yet its cathedral, founded perhaps as early as 324 and thus nearly contemporary with Aquileia, shows very different features [10]. Comparatively small – it measures but 16 by 26 m. (53 by 85 ft) clear, corresponding to less than half the surface of either hall at Aquileia – it was a single, isolated building. Its rectangle

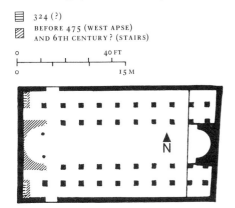

▤ 324 (?)
▨ BEFORE 475 (WEST APSE)
 AND 6TH CENTURY? (STAIRS)

0 40 FT

0 15 M

▲
N

10. Orléansville (El-Asnam) Cathedral, founded perhaps in 324. Plan

was divided by four rows of square piers into four narrow aisles and a wide nave, the nave presumably higher and lit by clerestory windows. Mosaics covered the floors. An apse sheltering a small crypt rose high above the floor level, pulled into the body of the building rather than projecting from it. Galleries may have surmounted the aisles; but if so, they were possibly added in the sixth century; certainly the western

apse was added, perhaps about 400 and certainly before 475.[18]

The cathedral of Tyre (Sur) on the Lebanese coast, consecrated in 316/17, represents still another approach. Eusebius's description, although rhetorical, outlines the plan with some clarity, and it certainly reflects the impression a lavish church building was designed to make.[19] A *propylaeum*, a monumental colonnade, faced east towards the street, '...great and raised aloft, turning the gaze even of strangers to the faith towards the first entrance. . . .' It led to a forecourt, an atrium, enclosed by four colonnaded porticoes, its centre occupied by a fountain.[20] Three portals opened from the atrium into the church. The nave, well lit by windows, towered above the two dark aisles, covered by the gilded beams of a timber roof. Colonnades, whether carrying arches or an architrave, supported the clerestory walls. At the far, western end of the nave rose the altar inside a chancel, while the clergy sat still farther west. A baptistery may have stood somewhere inside the vast precinct wall which enclosed the entire structure, including its forecourt.

Tyre, Aquileia, and Orléansville, then, represent variant types of Constantinian cathedrals. In all three, material and workmanship continued century-old local building practices: in Aquileia the walls were built of small ashlar stone, in Orléansville of small stone held in place by horizontal and vertical stone chains, in Tyre presumably of large stone blocks. The doubling of structures in the Istrian cathedrals may also be a local tradition (double temples had been frequent in that province), and the precinct wall at Tyre enclosing the church and its annexes is but the old hellenistic and ancient Near Eastern *temenos*. Of greater importance than such traditions of construction and planning were local liturgical customs, which by 300 had determined the position of altar, clergy, catechumens, and faithful within Christian meeting rooms for nearly two centuries. The clergy at

Orléansville were enthroned in an apse high above the lay folk. At Aquileia they remained at the same level as the congregation, though sheltered by a vault and segregated by screens. The altar at Aquileia and Tyre was placed between clergy and congregation. At Tyre, the catechumens withdrew either into adjoining rooms or into the aisles, possibly curtained off during the Mass of the Faithful. In the Istrian twin cathedrals, the segregation of catechumens during the Mass of the Faithful apparently determined the layout of the entire building complex. Thus at Aquileia, the transverse hall would have been assigned to the catechumens for withdrawal, while the north hall may have served both as an entrance lobby and as a classroom for instruction. The south hall was the church proper where faithful and clergy remained through the entire service.[21]

In other respects, however, the cathedral at Tyre stands out in comparison with its sister buildings at Orléansville and Aquileia. The proplyaeum, the atrium, and the high nave filled with light are all elements which the basilica at Tyre shares with Imperial palace architecture. Eusebius's description of the building lays particular emphasis on these features. None were unknown in Late Roman architecture, but the context was different. Syrian temples were frequently preceded by propylaea and by the year 300 such colonnaded porches, their trabeation rising over the centre bay in a pedimented arch, a fastigium, had become a characteristic feature of Imperial palace architecture as well. The atrium at Tyre also has Imperial references: it is derived in all likelihood from the colonnaded courts (*xystoi*) which preceded the audience hall in Imperial palaces and villas – witness the one at Piazza Armerina. Even the high, well-lit nave may have been linked to a tradition of buildings dedicated to the Emperor's cult. To be sure, Roman basilicas with large clerestory windows had not been unknown; but the emphasis on a flood of light

grows strongest where a fourth-century building shelters the Emperor, the Invincible Sun, the Sun of Justice, either in person or in effigy, as in the audience hall at Piazza Armerina, in the Basilica of Maxentius, in the Sedes Justitiae at Trier.[22] Such Imperial connotations of church design were strongly felt. After all, Christ too was identified with the Sun of Justice; He had risen at sunrise; His second coming was expected from the East; He was the light of the world. Hence, the mysticism of light would lead fourth-century Christians to think of Imperial audience halls as well as of churches filled with light. Not that Constantinian churches were derived from palace basilicas: but Christian leaders and their architects quite naturally transferred to their church buildings large parts of the architectural panoply surrounding the Emperor's Divine Majesty. Not by chance does Eusebius view the axis of the church complex – from the propylaeum to the altar and clergy section – as a royal path: along it the congregation approaches the altar of Christ, King of Heaven.

Connotations of the Imperial cult are most patent in churches subsidized by the Imperial house. But they too were far from uniform. In Rome, possibly as early as 313, Constantine had donated an Imperial palace, the Lateran, to the Church as a residence worthy of the bishop of Rome's standing in the official hierarchy. The cathedral of Rome, the Basilica Constantiniana, now S. Giovanni in Laterano, was laid out on an adjoining site, formerly occupied by the barracks of the Horse Guard which were razed and filled in.[23] Despite fires, earthquakes, and rebuildings – the most incisive the addition of a long chancel (1876–87), the most impressive Borromini's superb remodelling (1645–9) – enough has survived of foundation and other walls and old drawings and descriptions to give an idea of the Constantinian structure [11]. A vast nave, running east and west and flanked by two aisles on either side, was supported by two rows of fifteen huge columns, surmounted by

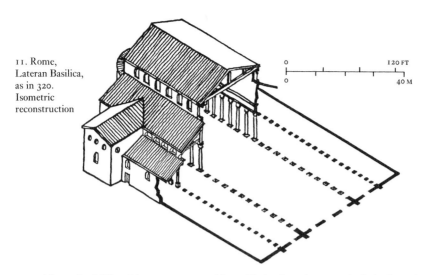

11. Rome, Lateran Basilica, as in 320. Isometric reconstruction

an architrave [14]. The aisles were separated by low arcades, each resting on twenty-two columns of green marble placed on high pedestals. Large windows lit the outer, semicircular windows the inner, higher aisles, and the general practice of Constantinian architecture makes it

likely that the nave had similar windows. A towering projecting apse terminated the nave to the west; its foundation wall is well preserved below the entrance to the nineteenth-century chancel, as are the foundation walls of the nave and aisles in their entire length [12, 13]. The

12. Rome, Lateran Basilica, begun c. 313. Foundation wall of apse

13. Rome, Lateran Basilica, begun c. 313. Foundation wall of nave

14. Rome, Lateran Basilica, begun *c.* 313.
Reconstruction of nave erroneously arcaded;
fresco by F. Gagliardi, *c.* 1650.
Rome, S. Martino ai Monti

tall, wide transept, however, is a medieval ad-
dition; in the Constantinian church, the inner
aisles continued to the springing of the apse
while the outer aisles were each cut short by a
low wing. Projecting sideways, these wings may

well have been repositories for the offerings; in
modern parlance we would call them sacristies.
The nave and aisles would be given to the con-
gregation, the outer aisles possibly curtained off
for the withdrawal of the catechumens. In the

western section of the nave a chancel in front of the apse and in line with the sacristies, would shelter the altar; a long pathway, enclosed by parapets, extended from the chancel into the nave. The apse held seats for bishop and clergy. Across its opening a huge fastigium of silver may have extended, supported by a double row of columns. Standing below were silver statues: the congregation saw Christ the Teacher seated and flanked by His apostles, while the clergy were faced by a Christ Resurrected, enthroned between four angels. Like the Emperor, then, Christ revealed himself under the upswept lintel in different but complementary aspects to the people and, as it were, to the high officials of His court.[24]

In size the Lateran basilica was not enormous. Yet with the nave and aisles 75 m. long and 55 m. wide (250 by 180 ft), it would have held a congregation of several thousand. The sanctuary, an additional 20 m. (65 ft) long, would accommodate a clergy of two hundred or more, as would indeed attend the Roman bishop on high holidays. Construction followed local building practice. Foundation walls, the bottom sections built of large fragments of stone and marble and 1·70 m. (5 ft 6 in.) thick, were sunk 10 m. (30 ft) into and below the pre-existing barracks foundation; the top was evened out by concrete masonry faced by *opus listatum* and brick. The foundation of the apse, concrete masonry faced more solidly with brick, went down even farther to reach to the bottom of a slope in the terrain. The upper walls were all concrete masonry with brick facing.

Neither the plan nor the construction of the building, however, was as decisive as its decoration. Nothing survives, but the lists of donations incorporated into the *Liber Pontificalis* speak a clear language. Contrasting with the plainest of exteriors, the interior fused colour, light, and precious materials into a resplendent design. The ceiling, whether open timber or coffered, and the half-dome of the apse shimmered with gold foil high above the yellow, red, and green-spotted marble columns of nave and aisles and the marble revetment of the arcade spandrels. Seven golden altars, six of them probably offering tables, stood in the sanctuary and presumably in the sacristies; the fastigium was of hammered silver. Five chandeliers lit the sanctuary, forty-five the nave, forty the right-hand aisle, twenty-five the left, not to mention the sixty candlesticks, all of gold or silver. The outer walls may well have been plastered, as were those of Constantine's basilica at Trier.[25]

At Trier, where Constantine's father had resided, a cathedral was laid out, some time after 326. It occupied the site of a slightly earlier Imperial palace and apparently was also an Imperial donation. Athanasius, exiled from Alexandria, tells of attending Easter Mass in the unfinished structure in 340. The original foundations of two huge halls have been traced – to the north, below the eleventh-century cathedral; to the south, below the Gothic church of Our Lady [15].[26] Apparently linked to North Italian custom, the church at Trier was designed as a twin cathedral. The two halls were connected by annexes, one of them a large, square baptistery. Chancels, rectangular and set off by screens as in the south hall of Aquileia, terminated the nave in both halls at Trier and were divided into a centre section and small flanking compartments. In other respects, however, the cathedral of Trier differed vastly from the modest bishop's church at Aquileia. Its two halls with a length of 73 and a width of 30 and 38 m. (240 by 100 and 125 ft) were designed to seat a total congregation not much smaller than the Lateran's. Like the Lateran and the cathedral at Tyre, both halls at Trier were also basilicas, divided by supports into a wide and presumably high nave with two aisles on either side. Finally, again recalling Tyre, the Trier complex included a vast atrium in front of each

AFTER 326,
WALLS EXCAVATED

AFTER 326,
RECONSTRUCTION

—— 11TH-13TH CENTURY
CHURCHES, OUTLINED

0 120 FT

0 40 M

N

15. Trier, twin cathedral,
after 326. Plan

hall. Colonnaded porticoes seem to have flanked rather than surrounded these courts, and the one to the north was entered through a monumental structure facing the street. Moreover, in both halls a section near the entrance was apparently screened off, possibly for the withdrawal of the catechumens. Hence, notwithstanding the resemblance of the plan, the two halls presumably did not have the same functions as at Aquileia.[27]

The wide differences in Constantinian church building, with plans varying according to local custom, become more strongly marked where a church did not serve a regular congregation. In the Sessorian Palace in Rome, the Imperial House or possibly the Empress Dowager Helena herself established S. Croce in Gerusalemme as a palace church and perhaps herself endowed it with a relic of the True Cross. A huge, rectangular hall dating from about A.D. 200 was remodelled for the purpose: an apse

was added to one of its short walls and the interior was divided high up by two transverse parallel walls. These interior walls were supported by arches, presumably triple and resting on paired columns. The design fits the concept and function of a court chapel: highly monumental, its three transverse bays – narrow, wide, narrow – lent themselves to a sequence of three sections, for the servants, the court, and the altar, with the clergy presiding in the apse [16].[28]

But palace churches in Constantinian times remain fascinating exceptions. They are far less significant in the overall picture than cathedrals and parish churches. And they are less significant than buildings associated with the cult of the dead, or martyria linked to the veneration of martyrs and of holy sites. These last two groups of buildings become increasingly important in church architecture during the course of Constantine's reign. To a large degree funeral archi-

16. Rome, S. Croce in Gerusalemme, as in c. 329.
Isometric reconstruction

60 FT

20 M

tecture continued along lines laid down in the decades prior to 313, and both catacombs and open-air cemeteries were simply enlarged as the demand increased. Indeed, in Rome as well as in North Africa the great majority of cemeteries, below and above ground, date from Constantine's times and later. Inside the cemeteries, however, the new standing and wealth of the Church, the bounty of the Emperor, and the increased veneration of the martyrs led to significant changes. The tomb of a venerated martyr, such as St Lawrence in his catacomb on the Via Tiburtina, just outside the walls of Rome, was isolated from the rock of the catacomb wall; a sizeable tomb chamber was created around it to form an underground martyrium. A ring enclosing a hollow tube (*cataract*) was placed over the grave, allowing the faithful to peer down, to offer libations of oil and wine, and to lower linen strips, which would acquire the power of a relic through contact with the martyr. Imperial gifts of silver railings, lamps, and candlesticks were placed around the tomb and inside the chamber.[29] Similar changes took place near venerated graves in cemeteries under the open sky. The new spirit of Constantinian Christianity increased the desire to partake of the martyr's blessed status by burial near his tomb, and well-to-do families vied with each other in building semicircular enclosures (*exedrae*) as family tomb chapels, as close as possible to the resting place of a martyr. This was the case at the cemetery of Manastirine at Salona, where an early-fourth-century *area* was nearly doubled in size and surrounded by new exedrae, including one attached to the older apse behind the martyr's tomb [17].[30] Pre-Constantinian custom also continues where funeral halls were built on Constantinian cemeteries for memorial services and funeral meals. Different in size, but always simply rectangular in plan and obviously timber roofed, such halls are found from Dalmatia and North Italy to the Rhineland.[31]

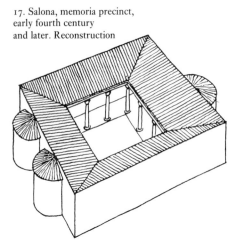

17. Salona, memoria precinct, early fourth century and later. Reconstruction

Different solutions had to be devised, however, by the Christian congregations in the large centres of the Empire. The space available near the shrine of a martyr either in a catacomb or on an open-air cemetery was insufficient to accommodate the huge gatherings expected for memorial services and commemorative banquets. Nor was there room for the hundreds who wanted to be buried near the martyr, coveting that vicinity as an efficacious guarantee of salvation. The funeral banquets had grown into monster kermesses. Naturally the mobs would get out of hand, and drunkenness and dancing, brawls, bawdy songs, and gobbling all became part of the revelry. The celebration of Mass in the early morning hours did little to dampen the excitement. Hence, a new type of structure was required near the tomb of the martyr, one that could accommodate burials and commemorative services as well as funeral banquets culminating in the celebration of the Mass. Large, roofed, their floors covered with graves, these buildings would shelter mensae for funeral banquets, including a mensa for the martyr which also served as an altar during commemorative services held on his feast day.

Constantine's contemporaries may have considered such structures not so much churches as funeral banqueting halls and covered cemeteries. But the distinction is fluid, and in the course of the fourth and fifth centuries, these *coemeteria subteglata* absorbed more and more the functions and features of regular churches for the suburban population living near the cemeteries outside the city.[32]

These funeral halls seem to have varied in plan, again following local custom, but all were variants on the age-old genus basilica. Most extraordinary is a group of huge buildings which in recent years has come to light outside the walls of Rome. One, at S. Sebastiano on the Via Appia, is well preserved below a Baroque remodelling; others, at S. Lorenzo on the Via Tiburtina, S. Agnese on the Via Nomentana,

and SS. Marcellino e Pietro on the Via Labicana, are known from excavations. Only S. Agnese seems to date from after Constantine's death. The others are all Constantinian, mainly from the early years of his reign; S. Sebastiano, while completed possibly after 337, may even have been started prior to 313. All rose either near a site hallowed by the presence of the Apostles, as at S. Sebastiano, or near the grave of a great martyr, such as Lawrence or Agnes, situated in a neighbouring catacomb [18]. The martyrs' graves were still enclosed in underground martyria, to be replaced only later by the tomb churches, now surviving for example at S. Lorenzo and S. Agnese. The floors in all were covered with graves from wall to wall, and mausolea crowded around the building, among them at SS. Marcellino e Pietro that of Con-

18. Rome, S. Lorenzo fuori le mura, basilica and underground memoria as in *c.* 330. Isometric reconstruction

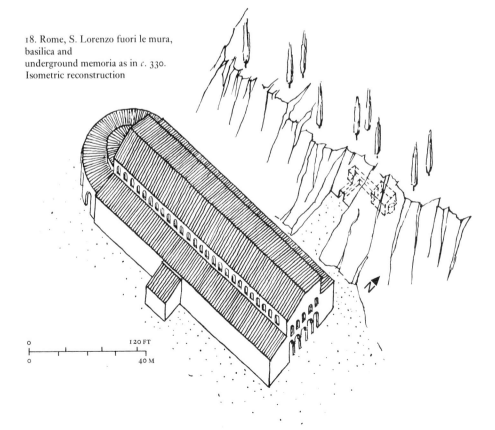

0 120 FT

0 40 M

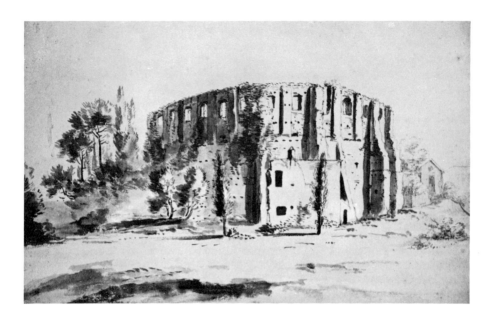

stantine's mother, Helena, at S. Agnese that of his daughter Constantina, S. Costanza. All were huge, between 80 and 100 m. (260 and 340 ft) long [19]. All were basilicas, with nave, aisles, and, as a rule, an entrance porch (*narthex*). Piers or columns supported the clerestory walls. The decor seems to have been uniformly plain. Finally, the aisles in all these halls enveloped the apse and formed an ambulatory – a feature long known in pagan mausolea, but never on a large scale and never merged with a basilican plan [20]. Thus, these funerary halls of Constantinian Rome, intended for mass burial, seem to have fused into a homogeneous design elements from two very different realms: the ambulatory from funerary buildings, and the basilican plan from public architecture.

The focus of veneration – the martyr's grave (*martyrium*), surmounted by an altar – in all these buildings remained in the catacomb and thus outside the structure where the faithful sought burial and assembled for funeral banquets and services commemorating the martyr.

In the last fifteen years of Constantine's reign, however, the ever-growing cult of martyrs and holy sites made it imperative to merge the martyrium with the basilica. At times this merger may have been achieved by adapting an ordinary basilica to its new funeral function. On the graveyard of the Five Martyrs at Salona-Kapljuč, the martyrium dating from about 350 shows such adaptation very clearly.[33] The rear half of the structure adopted the plan of a basilica with nave, aisles, apse, and altar enclosure, providing room for the martyrs' graves and for services; the front half served as a covered graveyard for the faithful, bordered on all sides by mausolea. A bishop's tomb could also form the focus of veneration. At Tipasa, on the Algerian coast, a local bishop, Alexander, about 400 endowed the building of a covered cemetery over his tomb, making use of the precinct walls of an older, open-air graveyard. A basilica, very irregular in plan, nave and aisles filled with graves, was built, including one with a semicircular couch for funeral meals. The apse, at

19 (*opposite*). Rome, S. Agnese, *c.* 350. Wall of ambulatory; drawing by B. Breenbergh

20 (*below*). Rome, S. Sebastiano, 312/13(?). Model

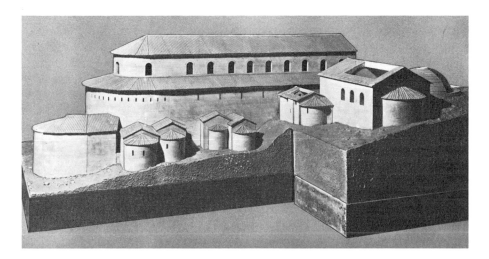

the west end, contained only another tomb.[34] The building may reflect early custom, for the solutions characteristic of Late Constantinian times were quite different. The old basilica of St Peter's in Rome is the outstanding example. It was replaced between 1505 and 1613 by the present church, but the excavations and old descriptions, drawings, and paintings give a clear picture of the old building and the history of its construction.[35]

It remains unknown exactly when Constantine decided to house the shrine of St Peter in a huge basilica which would hold thousands of pilgrims; nor is it known when actual construction began. But the decision was taken before 324 – possibly in 319–22.[36] At that time the tomb chambers of the large necropolis surrounding the second-century memoria of the Prince of the Apostles were filled in and their tops cut off. On the new level, a large terrace was driven from east to west and from south to north into the slope of the Vatican Hill. Only the top of the apostle's monument was left, rising near the

western end of the site, the church being occidented, not oriented. On the terrace a vast basilica was laid out, enclosing the shrine and covering the entire site. In order to overcome the obstacles of the terrain, the foundation walls of nave and aisles to the south had to be built up some 8 m. (25 ft) from the slope of the hill, while those to the north and the west were correspondingly sunk into the uphill slope. Construction proceeded quickly notwithstanding the size of the building and the difficulty of the task; by 329 it was completed, and by the time of Constantine's death in 337, if not before, the dedicatory mosaic inscriptions on the arch of the apse and on the triumphal arch were in place. The murals of the nave, still visible in the sixteenth century, dated from the middle of the fifth century. But the original plan of the architects seems to have remained unchanged during execution: the foundation walls are of one build, apparently laid out at the very outset. In width – over seven feet – as well as in construction they recall the foundation of the Lateran, even

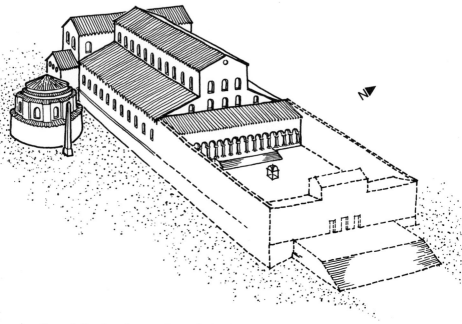

21 and 22. Rome, St Peter's, as in *c*. 400. Isometric view (*above*) and plan (*below*)

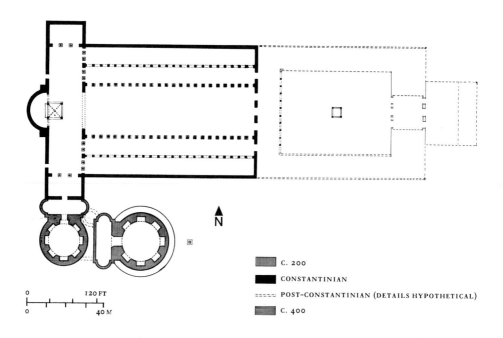

C. 200

CONSTANTINIAN

POST-CONSTANTINIAN (DETAILS HYPOTHETICAL)

C. 400

though at St Peter's the position on the steep slope forced the masons to face the concrete from the very bottom with *opus listatum* or brick.

The expense and labour incurred in overcoming the obstacles of the site are proof in themselves, if no other existed, that the basilica was laid out to house the memoria of the apostle long since held in veneration, making it accessible to the crowds and offering space for services held over it or near by. At the same time, the building served as a covered graveyard and a funeral banqueting hall. Its floors, excavated in the sixteenth century, were found carpeted with graves, some holding fourth-century sarcophagi. Wealthy mausolea, of later fourth-century date, including the mausoleum of the Anicii adjoining the apse and an Imperial tomb of about 400 built against the south end of the transept, lined the outer walls; and as late as 400 we hear of funeral banquets being held in the church.[37] This double function as both martyrium shrine and funeral hall underlies the size as well as the plan of the structure. The quick and the dead required the largest possible space: huge crowds, Romans as well as pilgrims, assembled to venerate the apostle and to attend services, hundreds desired burial near his memoria, and their relatives were wont to gather for funeral meals. Hence St Peter's had to be laid out on a grander scale than any other Constantinian church building. With a total inner length of 119 m. (391 ft), a nave length of 90 m. (300 ft), and a width of 64 m. (208 ft), it would hold a congregation one fourth larger than the Lateran basilica, the cathedral of Rome; but this had to shelter only the resident congregation of the capital [21, 22].

Likewise, the double function of St Peter's determined its exceptional plan. True, the tall, long nave and flanking aisles, two on either side, recall the Lateran's plan, despite their additional funerary functions. At St Peter's, however – in contrast to the Lateran or to any other Constantinian cathedral or parish church – the nave and aisles did not simply terminate in a chancel part. Instead they were met by a transverse structure, lower than the nave, and projecting still lower beyond the width of the aisles: a continuous transept, undivided except for the lower end sections. Opposite the nave the transept terminated in a huge apse. Together, they formed an area separate in function and marked off as a distinct part of the basilica. Transept and nave were separated by a triumphal arch, transept and aisles by column screens.[38] Primarily, the transept enshrined the memoria of the apostle, the very focus of the entire construction. Rising on the chord of the apse, his monument was set off by a bronze railing. A baldacchino, resting on four spiral vine scroll columns, rose above it; two more architraved columns linked the baldacchino to the corners of the apse, the openings into the apse being closed by curtains [23].[39] The vast space of the transept would hold the crowds come to venerate the shrine. Only during commemorative services, it seems, was the transept given over to the clergy as a chancel. The altar, presumably movable, was separated from the shrine; it may have stood within the railing; or it rose near the

23. Rome, St Peter's, begun *c.* 319–22. Shrine and baldacchino represented on an ivory casket from Pola

triumphal arch, where it would have been easily accessible to the communicants. Behind the altar and on either side of the shrine, the assisting clergy would line up during services, bishop and high clerics emerging through the curtains of the apse. The transept was common ground for congregation and clergy, and it served as the site for all rites in which both actively participated: veneration of the shrine, communion, and oblation, the latter possibly taking place inside the low ends of the transept wings where column screens, otherwise unexplained, support dividing walls. Transept

and apse, then, served as the site of martyr's shrine, altar, clergy seats, and oblation tables – all in one and poorly separated.[40] Nave and aisles, on the other hand, were a covered cemetery. Thus it recalled covered graveyards, such as S. Lorenzo and S. Sebastiano; yet St Peter's was fundamentally different: the martyrium had emerged, as it were, from the catacomb. Fused with the chancel part into the transept, it had been rendered both visible and accessible to the crowds assembled in the nave and aisles. Transept and apse on one hand, nave and aisles on the other, were different in nature, both

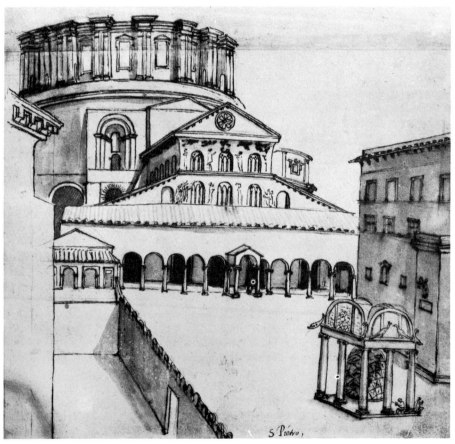

24. Rome, St Peter's, begun c. 319–22. Atrium; drawing by G. A. Dosio. *Formerly Florence, Uffizi*

functionally and architecturally, and the diversity in function of the two structures is apparent in the awkwardness with which they are loosely attached, rather than joined, to each other.

As in all Constantinian architecture, precious, colourful materials and furnishings focused attention on the interior and led the visitor in a crescendo towards the goal of his pilgrimage. From the river, the street, flanked by Roman tomb monuments, ascended over a slight incline to the triple entrance gate of the atrium. The pilgrim proceeded across the atrium, past the *cantharus*, the fountain. This was a second-century bronze pine cone placed under a splendidly furnished canopy: six porphyry columns, all second-, third-, and early-fourth-century spoils, carried four bronze arches curtained with grilles and surmounted by bronze peacocks [24]. At the west end of the atrium, the pilgrim would see the façade of the nave, plain like all Constantinian exteriors. Entering the nave [25], he moved between two rows of twenty-two huge columns, all spoils, ranging in material and colour from green serpentine and yellow giallo antico to red and grey granite, in diameter from 0·92 to 1·18 m. (36¼ to 46½ in).

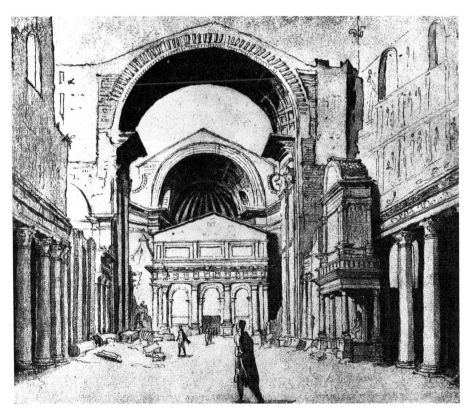

25. Rome, St Peter's, begun *c.* 319–22. Interior of nave facing west; drawing by M. van Heemskerck. *Berlin, Kupferstichkabinett*

Placed at distances of only 2·50 m. (15 ft), in a proportion not very different from the Parthenon colonnade, their monumentality must have been overwhelming. Like the shafts, the capitals were spoils differing in height and type – Corinthian or composite. Likewise the entablature was composed of spoils, its cornice wide enough to serve as a catwalk for the lamp lighters, and, indeed, protected by a railing. The upper wall of the nave rose to a total height of over 32 m. (105 ft). The double tier of Old Testament frescoes, preserved as late as the sixteenth century, and their stucco framing were evidently of fifth-century date; Constantine's architects may well have envisaged a non-figural decoration. Eleven wide windows, one to every second inter-columniation, lit the nave. As in the Lateran, the colonnades between the aisles resting on pedestals supported, above an arcade, a wall to carry the roof of the aisles. A row of openings high up in this wall lessened the weight bearing down on the columns. In contrast to the Lateran, however, the aisles seem to have been of equal height, and the inner aisles remained dark. On the other hand, the outer aisles and transept were well lit. In the transept was the shrine of St Peter, the very goal of the pilgrimage. Thus the Constantinian basilica of St Peter's was not an ordinary church, but a martyrium, bound to remain exceptional throughout Early Christian times, unless warranted by an object of veneration as sacred as St Peter's shrine. In the fourth century its plan was taken up in Rome but once – at the shrine of St Paul in 385. Outside Rome it remained equally rare. Not before the Carolingian revival did the basilica with continuous transept come into general use both in Rome and north of the Alps.[41]

St Peter's is the only large Constantinian church enclosing the shrine of a martyr. Otherwise, martyria in Constantine's day were limited to the sites where the Godhead had revealed itself. These sites were naturally all in

the Holy Land. The Empress Dowager Helena had visited them on a pilgrimage as early as 325-6. Presumably at her behest, the Emperor donated church buildings on these sites during the last twelve years of his reign: at the Grotto of the Nativity, on the site of the Resurrection and Crucifixion, at the place on the Mount of Olives and at Mambre where Christ had taught the Disciples, and near the terebinth at Mambre where the Lord had spoken to Abraham.[42] Possibly at the same time, possibly slightly later, relics of the True Cross may have been brought from Jerusalem to more distant sites – to represent, vicariously as it were, the sacred site of Golgotha.

Following the pattern set by early Constantinian funeral halls in Rome, the object of veneration in the christological martyria of the Holy Land remained outside the main hall where the faithful gathered. At the Ramet El Khalil near Mambre, the terebinth of Abraham, enclosed in a large precinct wall, had been venerated by pagans, Jews, and Christians from time immemorial. Shortly before 330, a small church was built at Constantine's behest against one wall of the old enclosure. The plan is far from clear, but a nave, an apse, aisles, and projecting side chambers recalling those of the Lateran have been traced. A long, narrow portico dividing the enclosure served as an entrance hall for the church and the two flanking courtyards. The tree where the Lord had spoken to Abraham stood in a corner of the larger plaza in the front half of the enclosure.[43]

Planning was very different at the great sanctuaries built by Constantine to commemorate Christ's Life and Passion. At the Grotto of the Nativity at Bethlehem, as early as 333, a pilgrim from far-away Gaul saw 'a basilica built on orders of Constantine'; apparently its walls, but not its decoration, had been completed by then.[44] It was replaced in the sixth century by the present structure, but its original foundation walls built of huge limestone blocks

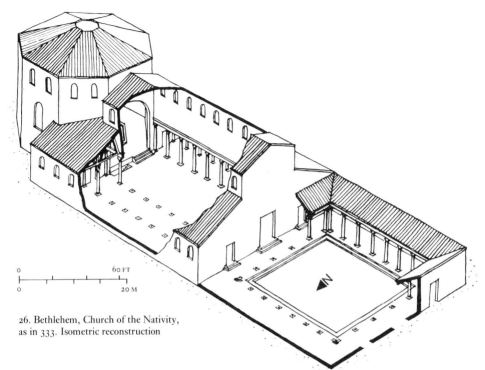

0 ————— 60 FT

0 ————— 20 M

26. Bethlehem, Church of the Nativity,
as in 333. Isometric reconstruction

and its mosaic floor were excavated some thirty
years ago. A forecourt, a full 30 m. (100 ft) long,
led towards an atrium of 45 by 28 m. (148 by
92 ft), terminated in front of the church by a
colonnade raised one step as a propylaeum [26].
The nave and its four aisles covered roughly a
square, 28·30 by 29 m. (93 by 95 ft), divided by
four colonnades, as in the sixth-century build-
ing extant on the site. Possibly the shafts of the
present columns are spoils from Constantine's
church; certainly their capitals copy fourth-
century models. Attached to the east side of
this basilica hall rose an octagon, raised three
steps and flanked on either side by shorter
rooms and intermediate triangular bays. Nave
and aisles communicated with this sanctuary
presumably through arches. In the centre of
the octagon, three steps led up to a railing which
protected a wide, circular opening. Piercing the

rock ceiling of the grotto, it allowed visitors to
gaze into the cave where tradition places the
birth of Christ. The octagon may have been lit
from above by an opening in its pyramidal roof.

Much remains to be clarified regarding the
history and the details of Constantine's church
of the Nativity: the splendid mosaic pavements,
in the octagon and the hall, were probably not
laid until the end of the fourth century; the
original access to the grotto may have been in
front of the octagon, replacing half of the
ascending steps. But the plan of the structure
suggests the functions of its principal parts.
The outsized forecourt would have served as a
resting place for pilgrims and a place for trades-
people catering to their needs. The atrium, too,
was large and possibly open to believers and
non-believers alike. On the other hand, nave
and aisles were barely sufficient to hold a con-

gregation one quarter of that envisaged by the architects of the Lateran basilica. The Christian community in Palestine during the entire fourth century was, after all, small, and pilgrimages were still rare; in Constantine's day the land of Christ was missionary country. In the comparatively small space of the nave and aisles at Bethlehem, then, the congregation and pilgrims would attend services. The altar would have been set in the nave, some distance from the steps leading to the octagon. The clergy may have occupied the octagon, but it served mainly as a martyrium sheltering the site where Christ was born. The *opaion* in its roof and the opening in its floor connected the place of His birth with the sky to which He had risen. Before and after services the faithful could circulate in the octagon and look over the railing down into the grotto. As at St Peter's in Rome martyrium and basilica, then, are attached to each other, but they remain distinct both in plan and function. This distinctness of the two sections is more important than the different designs of the martyria, a continuous transept there, an octagon here.

Likewise in Constantine's basilica on Golgotha a basilica and a centrally-planned martyrium were joined to one another. The Empress Dowager Helena, when visiting in 325, was shown a rock tomb in the heart of Roman Jerusalem as the Holy Sepulchre. Constantine's attention was attracted; an imperial rescript enjoined the bishop of Jerusalem to build on the site 'a basilica more beautiful than any on earth'. A reliable if late source mentions the names of the architects, Zenobius, a Syrian name, and the presbyter Eustathios from Constantinople. Begun in 325/6, the basilica – the martyrium as its contemporaries called it – was consecrated in 336 by an assembly of bishops, ordered to Jerusalem from Tyre where they had been gathered for a synod.[45]

Only scant fragments have survived of Constantine's buildings on Golgotha. The sepulchre in all likelihood was originally one of a number of tomb chambers of traditional Jewish type in a rocky cliff, its entrance facing the rising sun. The fourth-century builders isolated it, cut it into conical shape, and decorated it with twelve columns supporting a baldacchino. The huge circular structure enclosing the sepulchre whence Christ had risen – hence Anastasis Rotunda – may or may not have been planned from the outset; we shall speak of it later. The ground extending from the sepulchre to the colonnaded Roman main street, 120 m. (400 ft) to the east, was levelled. The Rock of Calvary some 30 m. (100 ft) south-east of the tomb was shaped into a cube. Between Calvary and the Sepulchre and its rotunda extended a courtyard, enveloped by porticoes on three sides. The one to the east and, behind it, the apse of Constantine's basilica have recently been found. At the opposite, the eastern end of the entire complex, the basilica was preceded by an atrium and a colonnaded propylaeum [27]. Part of the atrium wall and two columns survive and turn out to be remains of a second-century street and adjoining structures. While not on axis with basilica and Sepulchre, they yet establish the width of the complex at roughly 40 m. (130 ft). Given the distance of the atrium façade to the newly found apse, 74 m. (243 ft), and the depth of the atrium, the basilica, restricted as it further was by the Rock of Calvary to the west, could be but short and wide. Interior and decoration are described by Eusebius but in vague terms. The nave, he says, rested on huge columns – but their hugeness is open to question – and was flanked on either side by double aisles. These in turn were separated either by piers or by a row of short columns rising on pedestals, as at the Lateran. Galleries apparently surmounted both aisles. There is no evidence for clerestory windows; but there was a coffered ceiling and it may have run all across nave and galleries. All this was crowded into a small interior one third the size of the Lateran basilica

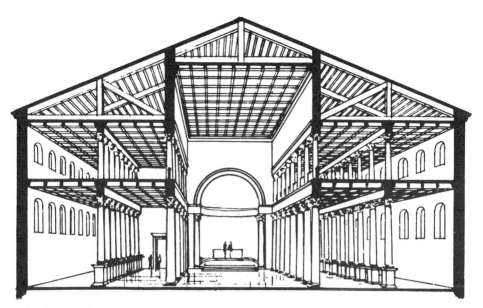

27(A). Jerusalem, basilica
and Anastasis Rotunda on Golgotha. Hypothetical
reconstruction of basilica as c. 326

and the amassing of marble columns, gilded capitals, and ceiling coffers overwhelmed the faithful, as did the polished stone walls and gilded bronze tiles of the exterior. The apse, flanked by side chambers, backed by a straight wall and semicircular inside (or nearly so), was but 8·20 m. wide. It is hard to envision it as the 'head piece of the whole', as described by Eusebius, 'encircled as a wreath by twelve columns, like the number of the apostles', each carrying a silver vessel, the whole topped by a *hemisphairion*, a dome or half-dome. Somewhere Eusebius or – this is more likely – we got confused in trying to interpret the layout. It is not impossible, after all, that after describing the atrium he switched back to the Sepulchre and the enclosing rotunda.

The plan, though, remains clear. Propylaeum, atrium, basilica, and the porticoed courtyard beyond led to the climax of the whole: the Tomb of Christ. Services were divided between the various sites and led from one to the other. Mass, except during Passion week, was said in the basilica. But sermons were delivered and hymns sung in the open courtyard as well, and processions moved from the basilica to the Rock of Calvary, to the Holy Sepulchre whence He had risen, and back into the basilica, the martyrium. The entire complex, then, including basilica, Sepulchre, and courtyard, was the martyrium of Christ's sacrifice and resurrection. There seems to be no reason to set apart the area enclosing Golgotha and the Sepulchre as a *basilica discoperta*.[46] All parts of the complex served their specific functions within the curious peripatetic service of the fourth century, more peripatetic than elsewhere at the holy sites, where the regular services of a local congregation were merged with the veneration of the testimonials of Christ's Resurrection by pilgrims come from afar, like Aetheria from Aquitaine, who has described them for us.

27. Jerusalem, basilica
and Anastasis Rotunda on Golgotha
(B) Plan of fourth-century remains
and later structures
(C) (*opposite*) Hypothetical volumetric
reconstruction as *c.* 340

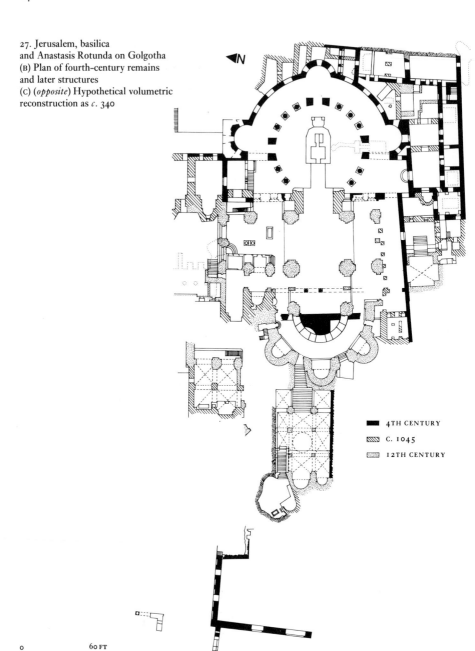

▲N

■ 4TH CENTURY

▨ C. 1045

▤ 12TH CENTURY

0 ⊢ ⊢ ⊢ ⊢ 60 FT
0 ⊢ ⊢ ⊢ ⊢ 20 M

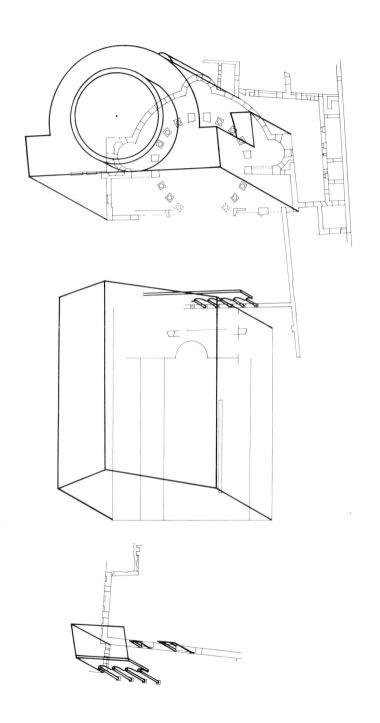

St Peter's in Rome, the Church of the Nativity in Bethlehem, and the basilica on Golgotha are parallel solutions to a similar problem: merging within one building complex a meeting hall for the congregation with a monumental shelter over the martyrium. Yet the differences are equally clear. St Peter's, like the covered cemeteries of Rome, was primarily a graveyard and a funerary banqueting hall, and the shrine of St Peter enclosed in the transept represented his tomb. Hence St Peter's rose outside the town, on a graveyard. It had no permanent clergy; mass was celebrated only sporadically for pilgrims' gatherings rather than for a resident congregation. In the Palestinian sanctuaries, on the other hand, no burials ever took place. They rose inside the city limits, and they served as cathedrals where the resident congregations gathered throughout the year. And the shrines which they enclosed were not graves but, in one case, the grotto of Christ's birth, and in the other, the site of the Resurrection, the trophy of His victory.

The differences in function were rooted in different traditions, and they resulted in differences in planning. An octagonal structure, as it terminated the Constantinian church at Bethlehem, is easily traced back to the large Imperial mausolea of Late Antiquity, all of which rise on a central plan. Diocletian's mausoleum at Spalato (Split) comes first to mind: octagonal on the outside, circular on the inside, it is surmounted by the hemisphere of a dome. Eight columns stand against the walls and carry projecting entablatures. Obviously neither Diocletian's mausoleum nor any of the other Imperial mausolea of the late third and early fourth centuries were just tombs. They were heroa, tomb temples designed to commemorate the dead Emperor, raised to the Gods, and to pay him divine honours. Hence, heroa easily adopted from religious buildings such as the Pantheon the round or circular plan, the

enveloping niches, the heavenly dome, and the architectural vocabulary. Christianity in Constantinian times, while omitting the actual cult of the Emperor, changed the concept of deification very little. Concomitantly, the function of Imperial heroa was shifted only so far as to attach them preferably to the flanks or the porch of cemetery basilicas. The mausoleum of Helena, until 329 perhaps intended for Constantine himself, was thus attached to the basilica of SS. Marcellino e Pietro; the mausoleum of Constantina, about 350, was attached to the basilica of S. Agnese in Rome; and the mausoleum of the Honorian dynasty, in about 400, to the south transept of St Peter's.[47] But Constantine's contemporaries must have thought it natural to adapt the plan of Imperial mausolea to the commemoration of Christ – Man, God, and King – and to make such centrally-planned heroa the focus of churches commemorating Christ's Life and Passion. The basilican hall only houses the faithful and directs them towards the heroon-martyrium which enshrines the testimony to Christ's presence on earth. Thus it is but natural that the merger of centrally-planned martyrium and basilica at the height of Constantine's reign remained confined to those churches in the Holy Land which commemorated Christ – human born, risen as God, and reigning in Heaven. Conversely, in this light the transept of St Peter's appears as an emergency solution, newly invented because the Imperial heroon type reserved for Christ was not considered appropriate for any martyr, not even St Peter.

Constantinian church planning knows of no norm. A standard type of church building, what we might call 'the normal Early Christian basilica', evolves only during the second half of the fourth and the fifth century. The most striking feature of Christian architecture during Constantine's reign remains its variety. Christian leaders and architects experiment with the most

diverse types: aisleless halls, basilicas, and centralized buildings; basilicas with and without apses; basilicas with projecting wings as at the Lateran; basilicas with ambulatories; basilicas attached to structures of central plan or to continuous transepts; twin cathedrals; structures enclosed within a precinct wall; basilicas with and without atria. Such variations were largely determined by the variety of functions as cathedrals, martyria-basilicas, and covered cemeteries. But even within one category the plans vary. Among cathedrals founded by the Emperor, buildings as different as the Lateran church and the cathedral at Trier stand side by side. Similarly provincial cathedrals and parish churches include such different structures as Orléansville and Aquileia, while martyria-basilicas include the Church of the Nativity at Bethlehem, St Peter's in Rome, and the martyrium on Golgotha.

Contemporary sources intimate some of the reasons for such variety. For the church at Mambre, upon Constantine's behest, a gathering of provincial bishops drew up specifications, obviously taking into account local liturgical custom and the function of the sanctuary as martyrium. For the structures on Golgotha, an Imperial rescript provided that simple materials and workmen were to be supplied by the local governor. Local building practices would then have determined the construction. The plan, on the other hand, may have been the work of Eustathios from Constantinople; and one is tempted to view his fellow architect Zenobius as the local supervisor.

Whether or not Eustathios brought a plan from the Imperial court, Constantine, at least by indirection, exerted his influence on the design of his churches. His letter regarding the buildings on Golgotha advises the bishop to draw on the Imperial treasury for marble columns and the gilding of coffered ceilings. No official, when offered such Imperial bounty,

would have hesitated. At Mambre, Constantine enjoins the gathered bishops to plan a church 'worthy of my generosity and worthy of the catholic and apostolic church'. In one of his speeches he envisages the Christian Church as a building preceded by a façade with twelve snow-white marble columns and surmounted by a fastigium.[48] By implication, then, the Emperor recommends a religious architecture coincident with the design of public architecture of the highest class, expressive of his own power and dignity, and absorbing the panoply of the architectural vocabulary proper to Imperial palaces and to public buildings. In the same terms Eusebius had described the cathedral at Tyre: a straight path leads from the propylaeum through the atrium to the 'royal house', the nave, and culminates in the chancel, where behind the altar enclosure, bishop and clergy were enthroned. The church architecture of Constantine must be viewed within the framework of Constantinian public architecture. The massing in one complex of several structures, different in function and often in plan, is basic to Constantinian thermae and palaces no less than to twin cathedrals, martyria-basilicas, and covered cemeteries surrounded by mausolea. Similarly, in public and church complexes alike, courtyards preceded the main building as a xystos or atrium, or surrounded it as a precinct court. More often than not, the principal parts follow each other on a longitudinal axis, but at times longitudinal and transverse elements intersect as in palace buildings and in churches with projecting wings or in twin cathedrals. In church design this grouping is linked both to the variety of functions assigned to the various parts of the building and to the peripatetic character of the service: the clergy entered the church in procession; catechumens and others excluded from communion left the building; the faithful brought their offerings in procession to the sanctuary part; bishop, clergy,

and congregation, in martyria churches, such as the structures on Golgotha, filed by the holy site, stopping for prayers and hymns. Today's Christmas procession from Jerusalem to Bethlehem is a last survival of such peripatetic services.

Despite this planning of elaborate complexes, the exteriors of Constantinian churches, as has been seen, were quite simple. All lavishness was concentrated on the interior: gilded ceilings, gold and silver furnishings, variegated marble columns, mosaic decoration. Columns, capitals, and architraves in the Western provinces more often than not were spoils – heterogeneous in type and material, different even in size and design. In the East, decoration apparently remained more homogeneous. But even here the concept of structural order, still prevailing throughout the third century, was gradually being replaced by a new visual approach. To be sure, colonnades supporting architraves remained the rule, as witness St Peter's, the Lateran, and presumably the church at Bethlehem. Even superimposed or giant orders occurred, as in the basilica on Golgotha. But such residuals of the classical, static concept of orders are more frequent in the East and there, too, they are subordinated to a colouristic design which encompasses the entire wall. Constantine's churches, surviving as they do, if at all, under remodellings, have preserved this new design at best in fragments. But the design is known almost in its entirety in the mausoleum of Constantine's daughter Constantina, now S. Costanza, built about 350 against the narthex of the great covered cemetery of S. Agnese in Rome [28]. Here the round domed centre room rises from an arcade carried by twelve pairs of composite columns with splendid impost blocks. Twelve huge clerestory windows flood the centre with light. A dark, barrel-vaulted ambulatory encircles it, interrupted opposite the entrance by a high, well-lit bay, a kind of baldacchino. The 'baldacchino' rises above a porphyry plaque which, below the middle arch

of the centre room, once seems to have carried the princess's sarcophagus. Of the decoration, the mosaics of the ambulatory vault have survived: in a crescendo, they lead from geometric patterns in and near the entrance bay, to panels with vine scrolls and putti, culminating in the dark area flanking the sarcophagus with panels strewn with branches and gilded vessels used for libations. These in turn led to the mosaics of the baldacchino, which represented the Heavenly Jerusalem, the Apostles as lambs, and the golden dome of Heaven. These last mosaics are known from sixteenth-century drawings, as is the decoration of the dome, where Old Testament scenes on a blue ground were framed by gilded caryatids with Bacchic panthers crouching at their feet. Between and below the windows, the walls of the centre room were sheathed with a multicoloured marble revetment. Lavish materials, light, and colour were fused into a design clear, but based on visual, not structural elements. The arches in the main axes of the centre room are imperceptibly wider and higher than the others, and again those on the longitudinal axis, above and opposite the sarcophagus, are slightly wider and higher than those on the transverse axis. The small niches in the wall of the ambulatory do not correspond to the arcades; only when seen from the arch opposite the sarcophagus do they become fully visible.[49]

The interiors of the great Constantinian churches must have looked similar to S. Costanza or, for that matter, to the Imperial audience hall at Trier. Visual rather than structural relationships determined the picture. The colonnades in the Lateran and at St Peter's stood against the dimly-lit foil of the aisles; the lower colonnades between the aisles in both churches also obey the laws of a visual order; the huge windows of the nave alternate with dark window piers.[50] The Constantinian decoration on the vast expanse of wall at the Lateran and at St Peter's between colonnade and clere-

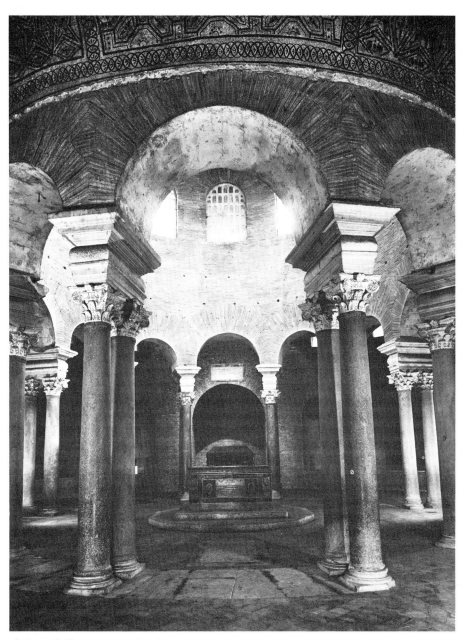

28. Rome, S. Costanza, *c.* 350. Interior

story is lost, if ever it existed: Constantine's architects may well have envisaged marble or imitation revetment surmounted by ornamental mosaics. Yellow and red columns in the nave of the Lateran contrasted with the green speckled columns of the inner arcade, the apse vault shimmered in gold foil. Colour and light more than anything else brought this architecture to life. Light, shining through the wide windows of the nave or during night services flickering from thousands of oil wicks and candles, shimmered on and was reflected by marble columns, revetments, mosaics, gilded ceilings, and precious metal furnishings. The lists of Imperial donations to the Roman churches abound with gold and silver chandeliers, lamps and candlesticks, chalices, patens, jugs, and jars, and with jewelled altar cloths. The rays of the sun shining through the windows of a nave, the reddish glinting of ceilings and mosaics, the shimmering marble columns are recurrent *topoi* in contemporary prose and poetry.

All these features had been increasingly characteristic of all Late Antique architecture since the second century; Constantinian Christian architecture turned out to be the last phase of the architecture of Late Antiquity.

CHRISTIAN ARCHITECTURE IN THE CAPITALS: 335-400

The political changes in the Roman Empire during the seventy years following Constantine's death were minor. Until 395, his successors ruled over an Empire united by a centralized administration and increasingly christianized. This is true notwithstanding the pagan reaction under Julian the Apostate (360-3) and the prolonged passive resistance of pagan aristocrats, notably in Rome, as well as of pagan scholars in the East. Even the division of the Empire after Theodosius I (379-95) was more in name than in fact. But, as had been the case since the third century, the defence of the frontiers and the administration of the far-flung territories forced the emperors to move their headquarters frequently. Alongside the Constantinian capitals in the East – Constantinople, Antioch, and Nicomedia – new capitals came to the fore in the West. Rome lost her political status. But Milan, Trier, and Cologne gained importance as imperial residences and, witness Milan under St Ambrose, as the sees of powerful Church leaders. At the same time, three cities became paramount in the fourth century as religious centres and pilgrimage goals: Jerusalem, with the holy sites of Christ's Resurrection and Ascension; to a lesser degree, Alexandria, the see of the Egyptian patriarch and supposedly the burial place of St Mark; finally, Rome, now insignificant as a political capital but increasingly important both as the burial place of Peter, Paul, and other martyrs, and as the see of the papacy – the latter, since the fall of the Western Empire, the only unifying political and spiritual power in the Occident.

No wonder that these secular and ecclesiastical capitals became leading architectural centres as well. The court and powerful Church leaders were eager to finance residences and churches for local use and to commemorate the sites of Christ's life and passion, and the graves of His martyrs. In the case of some of the capitals – such as Nicomedia and Alexandria – no monuments, and few sources, survive to document this building activity. Elsewhere – as in Constantinople, Jerusalem, and Antioch – the monumental material is scarce in comparison to the literary evidence available. In Rome, Milan, and Trier, on the other hand, both the monuments and the literary sources abound. Yet wherever evidence is available, it leads to the conclusion that the architects in charge of the new buildings had frequently come from abroad, presumably in the suite of the court. On the other hand, masons, as a rule, were home-bred. Hence the stylistic concepts and the vocabulary of church and palace architecture remain closely linked throughout the political and religious capitals of the Roman world. Differentiations, often conditioned by local traditions of construction technique, are ever present but they play a minor part. Certainly no marked contrast can be seen between stylistic concepts prevailing in the East and West on this highest level of Christian building in the sphere of the court. (The churches built by the congregations outside this sphere follow different lines; but we shall have to postpone their discussion.) In the stratum of the court, the architectural vocabulary likewise remained anchored firmly in the classical tradition of Late Antiquity. The strength of this tradition in the East rested with the scholars and rhetoricians, whether Christian or pagan, attached to the universities and the Imperial court. Through them Church and court were permeated by a classical spirit; and as a result,

emperors, courtiers, court bishops, and court architects remained the mainstays of the classical heritage of the new Christian Empire far into the fifth century. Indeed, the classical spirit, weakened in the course of the third and the early fourth centuries, was rekindled in the ambience of the court in the course of the later fourth and the early fifth centuries. It remains obscure whether or not the Greek East led these renascences.[1] Certainly in Rome, except for a small aristocratic (and largely pagan) circle, the classical spirit remained weak for a long time. The Church in Rome remained indifferent to classical learning and culture for the better part of the fourth century; and this position changed only when, in the fifth century, the papacy replaced the weakened Imperial power in the West as a cultural force.[2]

Beginning with the last years of Constantine's reign and continuing through the rest of the fourth century, the increasingly complex requirements of the ecclesiastical services and the close links between Church and Empire led to the development of new church types in the political and spiritual capitals of the Empire. Martyria rise over venerated sites, no longer joined to basilican naves but independent and cross-shaped, circular, or oval in plan; in or near the precincts of Imperial palaces rise tetraconch or octaconch churches. All these types serve also for the regular assemblies of urban congregations, and they appear with only slight variations in the various new capitals of the Empire, from Constantinople to Jerusalem and Cologne, designed and promoted presumably in the migratory ambience of the court, its patrons, theologians, and architects. The majority of the new types disappeared in their original form after two or three hundred years. But their rise in the fourth century demonstrates more than anything else the creative fertility of a Christian architecture which was still firmly rooted in the stylistic concepts and the construction techniques of classical Late Antiquity.

CONSTANTINOPLE

Of Constantine's church buildings in his new capital, hardly a trace has survived. The cathedral he began next to his palace – the first H. Sophia, completed only in 360 – may have been a large basilica with double aisles and galleries. Short, as compared to its presumably great width, it was apparently enclosed in a precinct and preceded by a shallow atrium with perhaps a propylaeum facing the street.[3] Thus it would have resembled the basilica at the Holy Sepulchre, except of course for its larger size. Neither is there any trace left of the fourth-century Church of the Holy Apostles, which was replaced in 536 by Justinian's church, and in 1469 by the Mosque of the Conqueror, the Fatih. However Eusebius's description of the first structure, written shortly after it had been laid out by Constantine, brings out its salient points.[4] The church rose in the centre of a wide courtyard, skirted by meeting halls, baths, and pools. It was cross-shaped, the entrance arm perhaps slightly elongated. Gilded and coffered ceilings covered all four arms, but it remains to be decided whether they were all aisleless, or divided into nave and aisles. The walls were covered with marble revetment. A drum, well lit by bronze-grilled windows, rose over the crossing and was apparently surmounted by a conical roof. Below this drum stood the sarcophagus of the Emperor, flanked by piers or cenotaphs inscribed to the Twelve Apostles. The sarcophagus and piers stood within an enclosure where Mass was read at an altar. Thus, ostensibly, the building was the mausoleum of the Emperor and a martyrium dedicated to the apostles. Its connotation, however, was that of the heroon-martyrium of the Emperor himself: where he rested in the sign of the cross – as suggested by the plan of the structure; where he was venerated as the thirteenth of the Disciples, in the company of the Twelve Apostles themselves; and where he was the centre, if not of devotion, of

attention, as much as or more than the Eucharist celebrated near by. Such an unorthodox outlook apparently became intolerable when, in 356/7, real relics of apostles were brought into the church and Constantine's remains were transferred into a separate, adjoining mausoleum of traditional plan, circular, and domed. From the outset, the Apostoleion was a martyrium, much as the basilicas at the Holy Sepulchre, at Bethlehem, and at the tomb of St Peter. But in its plan Constantine's Church of the Apostles marks a new departure. The martyrium section – rather than being appended to the nave and aisles of a basilica, as at Bethlehem, or hidden underground in a catacomb, as at S. Lorenzo in Rome – becomes the very core of the structure. To this core the four arms are appended to shelter the faithful. A new type of martyrium has sprung up, a self-sufficient structure centred on the focus of veneration.

Dozens of churches during the later fourth and the early fifth centuries copied the plan of Constantine's Apostoleion – as the term 'copy' was understood from Antiquity throughout the Middle Ages.[5] From the original Apostoleion they take over at least two paramount features: the plan with its connotation of the True Cross and the dedication to the Apostles. At times a great saint, a local apostle as it were, takes the place of the True Disciples. We shall encounter such 'copies' of late-fourth- and early-fifth-century date at Milan and Ravenna, at Ephesus and Antioch, at Gaza and Sichem; likewise, the Apostoleion of Constantine seems to have exerted at least a collateral impact on the formation of basilicas with cross transept, such as that in the city of Menas. The types East and West differ in plan: in the East the four arms radiate from a central nucleus, while in the West two lateral arms issue from a continuous longitudinal nave.[6] However, the far-reaching impact exerted by Constantine's Church of the Apostles need not mean that already in his own day Constantine's capital was a major architectural centre. Nothing survives of the palaces, squares, colonnaded streets, and public buildings which contemporary and later writers have attributed to his building activity. In fact, what fourth-

29. Constantinople, triumphal arch of Theodosius I, 393

30. Constantinople, palaces north of the hippodrome, early fifth century with later additions. Plan

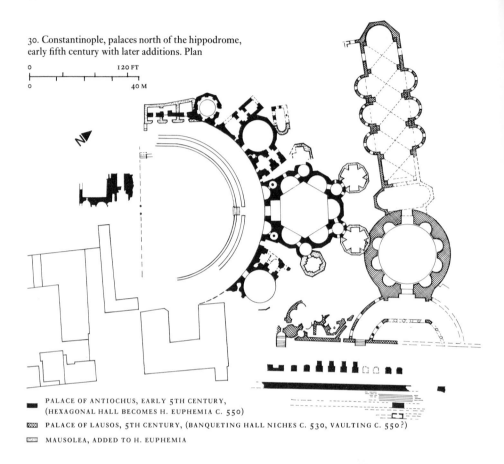

PALACE OF ANTIOCHUS, EARLY 5TH CENTURY, (HEXAGONAL HALL BECOMES H. EUPHEMIA C. 550)

PALACE OF LAUSOS, 5TH CENTURY, (BANQUETING HALL NICHES C. 530, VAULTING C. 550?)

MAUSOLEA, ADDED TO H. EUPHEMIA

century buildings are left in Constantinople date from the very end of the period. But these mark the Constantinople of A.D. 400 as a centre of the first magnitude. There is the hippodrome, as enlarged by Theodosius I (379–95), its impressive substructure dropping twenty-odd metres (60–70 ft) into the valley. There is the base and capital of the colossal column which carried his equestrian statue; there are the remnants of a huge triumphal arch, dating from 393, supported by four clusters of columns, their shafts marked by 'tear drops' in imitation of the trunk of a cypress tree [29]. Finally, the remains of two adjoining palaces have been found north

of the hippodrome, both dating probably from the first decades of the fifth century. In both, flights of steps ascend to a colonnaded curved façade, behind which lie the reception rooms. In the smaller palace the reception room is round, its wall hollowed by ten niches; a door opposite the entrance leads into a longish hall, apsed and flanked on either side by three niches: a banqueting hall of a type customary in Constantinople, as witness the (lost) Hall of the Nineteen Couches in the Imperial Palace, each couch assigned to a niche, with the apse holding the Imperial High Table. In the second palace, a hexagonal hall occupies the centre – each of its

sides over 10 m. (30 ft) wide and enlarged by a deep niche; small roundels separate the niches, opened, it seems, towards the outside in colonnaded arcades. (The hall in the sixth century became the church of H. Euphemia.) Circular reception rooms, quite sizeable, follow the hexagon hall on either side, and were followed farther along the hemicycle of the façade by smaller octagonal rooms. The combination of hemicycles, rotundas, hexagons, and octagons gives a faint idea of the inventiveness of Late Antique palace architecture still in fifth-century Constantinople [30]. Another circular, niched and domed palace hall of somewhat later date has come to light near the Myrelaion church: well preserved to a height of five-odd metres (about 16 ft), and preceded by a colonnaded porch, its interior diameter was 29·60 m. (100 Roman, or about 97 English feet), its walls 6·10 m. (20 ft) thick. In the tenth century it was transformed into a multi-columnar cistern, whose vaults served to carry a small palace.[7]

Better than anything else, utilitarian building in Constantinople attests to her position as an architectural centre of the first rank in the decades at the turn of and throughout the fifth century. Cisterns were built all over the city and her suburbs, the major ones open to the sky,

others certainly as early as the fifth century vaulted over dense rows of columns. Most impressive among open cisterns is the Fildami cistern recently freed at Bakirköy, 127 metres long, and 75 wide (416 by 246 ft); its façade, buttressed by niches, still rises nearly to its full original height, roughly ten metres [31]. The most outstanding utilitarian structure was of course the land walls of Constantinople, laid out in 412/13. Four and a half miles long, the main wall rises to 30 ft; it is 16 ft thick and preceded by an advanced wall and a 60-ft-wide moat [32]. Ninety-six towers, square or polygonal in plan, project from the main wall, and six major gates gave access to the city. Barring repairs of eighth- and twelfth-century date, the whole is remarkably well preserved. It gives a splendid idea both of the working organization – the main wall was apparently completed in little more than a year – of fifth-century military engineering, and of the building techniques of Constantinople at the time. While Roman fortifications as a rule had been limited to a towered main wall and a moat, the insertion of an advanced wall creates, perhaps for the first time in military history, a *double enceinte*: a system of fortifications which in the later Middle Ages plays a large part in the military history of

31. Bakirköy, Fildami cistern, fifth century

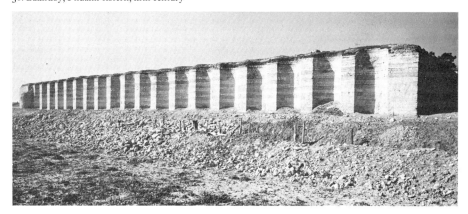

Western Europe. The walls are constructed in a technique which is found in the palaces of the hippodrome as well and remains customary in the capital for a long time: concrete faced with small limestone blocks and reinforced at varying distances by brick bands, each consisting of

The walls of Constantinople are one of the great sights of the Late Antique world. At the same time all these city walls are characteristic of the conservative character of building in the sphere of Constantinople during the fifth century. Not only had the fortification system been

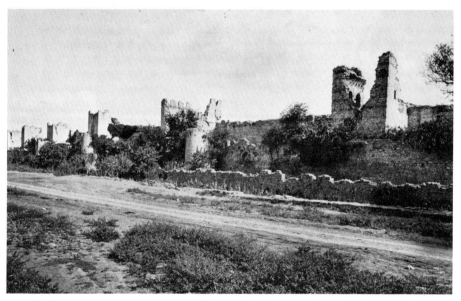

32. Constantinople, city wall, 412/13,
with later repairs

five or more courses of thin bricks – each 3 to 5 cm. ($1\frac{1}{4}$ to 2 in.) high – with mortar beds of equal thickness. The towers are built in the same technique, except for the two which flank the Golden Gate and those which face the Sea of Marmara – all of huge marble blocks. Passages and stairways inside the towers are barrel-vaulted with bricks pitched on their sides; chambers are domed with concentric rings of bricks. In 439, a corresponding wall, though simpler in layout, was built along the Sea of Marmara. The walls of Salonica, about 450, are almost equally impressive and other fortifications around the Aegean, such as those of Nikopolis, represent the type on a smaller scale.[8]

customary for centuries in the Roman Empire; this is naturally so, since military tactics had remained unchanged. Likewise, the technique of construction – mortared rubble levelled by brick bands and faced with stone – had been customary for a long time along the west coast of Asia Minor and apparently had been imported into Constantinople. It is equally important to realize that the decorative vocabulary of public architecture in Constantinople about 400 shows remarkably conservative features, and that it too appears to be rooted in a century-old tradition indigenous to Asia Minor.[9] The capitals from the arch of Theodosius are hardly distinct from classical prototypes and thus exemplify the beginnings

of the classical current which – in more lively form – becomes characteristic of the art of Constantinople in the later fifth century.

JERUSALEM

Buildings surviving in Constantinople from post-Constantinian times are mostly fortifications and palaces of comparatively late date. In Jerusalem, on the other hand, and all over the Holy Land remains have survived of a number of ecclesiastical structures dating from the decades shortly following Constantine's death. The majority were erected over the sites of Christ's life and passion and are therefore martyria, in function identical to those built by Constantine at Bethlehem and on Golgotha. But in contrast to early Constantinian structures, the late- and post-Constantinian martyria of Palestine shun the fusion of a centralized structure with a basilican nave: the centralized structure becomes self-sufficient. In this respect, the martyria of the Holy Land are counterparts of Constantine's Church of the Apostles in Constantinople. Indeed, cross-shaped structures presumably built after the model of the Constantinopolitan church did exist among the martyria of Palestine and the adjoining territories. A plan and short description left by a seventh-century pilgrim, Arculf, exists for one of these structures, built – probably prior to 380 – over the Well of Jacob near Sichem (Shechem) where Christ spoke to the woman of Samaria.[10]

In Palestine, however, cross-shaped martyria were apparently exceptional. As a rule, martyria in the Holy Land were unattached circular structures whose obvious prototype was the rotunda of the Anastasis in Jerusalem.[11] Built of solid ashlar blocks and sheltering the sepulchre whence Christ had risen – hence Anastasis, Resurrection – it faced, at the western end of a shallow three-porticoed courtyard, the apse of Constantine's martyrium-basilica. Possibly

planned from the outset, but apparently not yet completed in 336, it seems to have been in use by 350. Despite frequent remodellings, its original plan has been ascertained in its main lines. A straight façade, pierced by portals, faced the courtyard where rose the Rock of Calvary. Inside, the Anastasis was laid out as a huge rotunda, 33·70 m. (110 ft) in diameter, its centre room enveloped by an ambulatory of irregular shape [33]. In the very middle of the structure – both

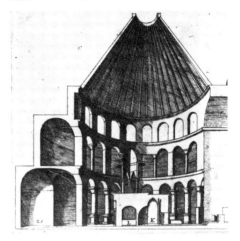

33. Jerusalem, Anastasis Rotunda, as in 1609. Engraving by J. Callot

its focus and its *raison d'être* – rose the cone of Christ's sepulchre below Constantine's baldacchino. The centre room was encircled by twenty supports carrying an arcade, though deprived possibly of two piers where to the east the façade cut in. Ideally, though, the circle of supports was arranged, presumably from the outset, in groups of four. Pairs of piers on the main axis formed a cross; the columns in the diagonals were grouped in triads, symbolizing – in the interpretation of the Fathers – the Twelve Apostles, and the four ends of the world to which they bring the four-fold gospel of the Trinity. The ambulatory, semicircular and with three niches projecting, embraced the western half of

the centre nave, terminating in rectangular spaces near the façade. A gallery above the ambulatory accommodated the faithful unable to find room on the ground floor. Finally, above the clerestory zone rose a dome. It was possibly of timber construction, and – but this is not certain – open in the centre like the roof of the octagon over the Grotto at Bethlehem. The overall design was clumsy, the columns stout and placed on high pedestals, the walls extraordinarily heavy.

The Anastasis Rotunda clearly stands in a tradition of Late Antiquity with strong classical overtones. Whether or not the capitals of the columns and the profiles of their high pedestals were as classical as the old reproductions pretend, the plan is rooted in the tradition of Imperial mausolea and heroa. This is but natural in a structure designed to shelter the sepulchre and to commemorate the resurrection – dare one say the apotheosis – of Christ, the *basileus* of Heaven, the Risen Sun. The huge mausolea-heroa of Imperial Rome come to mind: that of Helena; that of Diocletian at Spalato; and finally, the mausoleum of Constantina, this latter – like the Anastasis – encircled by an inside ambulatory [28]. No doubt the same sources served the architects both of S. Costanza and the Anastasis. Indeed, one wonders whether the self-sufficient circular martyria of the Holy Land, of which the Anastasis Rotunda is first and foremost, should not be interpreted as part of a renascence movement of late- or post-Constantinian times. Against the fusion of basilican and central plan, the free-standing martyria re-establish the tradition of the Imperial mausoleum-heroon.

The Anastasis Rotunda was not the only structure of its kind among the martyria of the Holy Land. Excavations on the Mount of Olives have brought to light a few of the walls of the Imbomon, the sanctuary built in 370 by the Roman lady Pomoenia to commemorate the site from which Christ rose to Heaven.[12] A part

of the circular outer wall has been found – indicating a diameter of roughly 18 m. (60 ft) for the rotunda – together with the remains of an outer colonnade. Inside, the early pilgrims saw another colonnade – that is, an ambulatory – perhaps double-storeyed. The ambulatory enveloped an enclosure, which encircled the rock with the footprints of the ascending Christ. This centre room either had no roof whatever, or its timber roof – possibly conical – terminated in a huge opaion. To the east, a chancel and apse, starting from the centre room, seem to have pierced the ambulatory. In either case, the Imbomon represented a variant on the plan of the Anastasis Rotunda. Nor was it the only variant. A sanctuary much like the Imbomon has been excavated at Beišan-Beth Shean (Scythopolis) in northern Palestine. It was no doubt a martyrium, but the event it commemorated or the relic it sheltered remains unknown.[13] Such centrally planned martyria, whether rotundas or polygons, appear in other variations on the holy sites of Palestine: possibly over the Tomb of the Virgin in the Valley of Josaphat outside Jerusalem;[14] certainly in a church which the Emperor Zeno (474–75, 467–91) dedicated to the Virgin on Mount Garizim (Gerizim) near Sichem – in plan an octagon rather than a circle and sheltering a piece from the Rock of Calvary [118].

Outside the Holy Land 'copies' of the Anastasis and of its filiations were frequent in medieval Europe,[15] but they seem to have been comparatively rare in the Christian world of the fourth and fifth centuries. One example which comes to mind is the church of H. Karpos and Polykarpos in Constantinople. Only the circular substructure survives, but it clearly suggests at ground-level a building composed of a domed centre room and an ambulatory, the latter pierced by chancel and apse. The masonry points to a date near A.D. 400, and the plan as well as a local tradition imply that the church was a comparatively early copy of the Anastasis.[16]

ANTIOCH

Excavations undertaken some years ago have provided for a fairly clear picture of the domestic architecture of Antioch (Antakya). Dozens of houses and villas, mostly of the fifth and sixth centuries, have come to light, following the age-old Greek house plan centred on a peristyle court and lavishly decorated with mosaic pavement.[17] However, few churches have been found; and only one dates from the fourth century, when Antioch was still an Imperial residence: the martyrium of the local martyr St Babylas, whose remains were exhumed during the reign of Julian the Apostate, and whose tomb became a new centre of veneration in the seventies. Built at Kaoussié, just outside the ancient city, and begun probably in 379, his new martyrium was cross-shaped.[18] The centre, square and presumably surmounted by a pyramidal timber roof, incorporated a chancel enclosure which sheltered the altar, the grave of the saint, and the graves of two of his successors on the episcopal throne of Antioch. From this centre section – a kind of towering

baldacchino – extended four arms, lower, aisleless, and timber-roofed [34]. The colourful geometric designs of their mosaic floors contrasted vividly with the plain marble pavement of the centre square. The model was obviously Constantine's Church of the Apostles; in the eyes of the Antioch congregation the relics of St Babylas stood for those of the Disciples and deserved a similar resting place. Even so, some new elements penetrate the structure at Antioch. A baptistery was built against one of the cross arms, and a sacristy against another, thus adapting the martyrium for regular church services. This development, of course, had started under Constantine, the basilica on Golgotha serving both as martyrium and as cathedral of the permanent congregation of Jerusalem, and, like the martyrium of St Babylas, provided with a baptistery. The progressive absorption of the martyrium plan as a regular church type becomes obvious.

Earlier than the martyrium of St Babylas and more important among the churches of Antioch was the Golden Octagon adjoining the Imperial palace on the Orontes island in the

34. Antioch-Kaoussié, St Babylas, begun probably 379. Plan

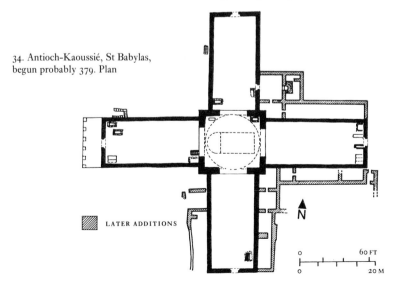

LATER ADDITIONS

N

0 60 FT

0 20 M

centre of the city. Begun by Constantine in 327, it was dedicated – two years after the Council of Nicaea – to Harmony, the divine power that unites Universe, Church, and Empire, and completed in 341 under his son Constantine. No trace has survived of the structure. But its outlines become fairly clear from its name, its summary representation on a floor mosaic found in a villa outside Antioch, its description given by Eusebius, and from the scattered remarks of later writers.[19] Eight-sided, it was preceded by a double-storeyed narthex and surmounted by a gilded roof. Inside, its octagonal centre room carried either a pyramidal roof or, perhaps from the outset, a dome in timber construction. This core was enveloped by colonnaded aisles – Eusebius says *oikoi* – on two levels (that is, an ambulatory and a gallery), and by niches (*exedrae*). The plan may be visualized in two alternative ways; either ambulatory and gallery directly adjoined the centre room, while the niches opened outward from the ambulatory; or the niches billowed from the centre room into the enveloping spaces of ambulatory and gallery. Both solutions are possible. The first corresponds roughly to the plan of the church on Mount Garizim [118]; the second anticipates by two hundred years the plans of H. Sergios and Bakchos in Constantinople and of S. Vitale in Ravenna – a double-shell construction[20] in which a domed central core is enveloped by the ancillary spaces of aisles and galleries [180, 187].

Because of its central plan, the Golden Octagon has been called a martyrium.[21] But no evidence exists that it ever housed an important relic. Nor was it, at the outset, the cathedral of Antioch. An older church in the city held the see of the bishop as late as the end of the fourth century.[22] Rather, the location of the Golden Octagon in or adjoining the palace precinct; the person of its Imperial founder; and its dedication to the divine force uniting Church and Empire, combine to suggest that it was designed as the palace church where the Emperor, God's

counterpart on earth, would attend services. Thus the Octagon at Antioch would indeed be the ancestor of the palatine churches of Justinian and later times, from H. Sergios and Bakchos – Justinian's H. Sophia is but a variant on the type – to Charlemagne's chapel at Aix-la-Chapelle: all octagonal in plan, composed of centre room, ambulatory, and a gallery level.[23] Given the probable identity of function, a resemblance in plan between H. Sergios and Bakchos and the Golden Octagon does not seem improbable.

However, the lines run backward as well as forward – back into the realm of Roman palace architecture. Beginning with the first century, large centrally-planned halls become an increasingly frequent and an increasingly important component in the layout of Late Roman and Early Christian palaces and palace villas. They may be circular, like the one in the smaller palace north of the hippodrome in Constantinople, or like the huge domed rotunda in Diocletian's palace at Spalato. They may be hexagonal, like the hall – later the church of H. Euphemia – in the larger palace north of the hippodrome in Constantinople, or octagonal, as in Nero's Golden House, or even decagonal, like the structure in Rome known as the Minerva Medica. Whether round or polygonal, they may or may not be provided with niches; and these may be hollowed into the thickness of the walls or may billow outward and, indeed, open through arcades into adjoining rooms [30, 186]. Or else such centrally-planned palace rooms were triconchs: the one at Piazza Armerina may stand as an example for many others. No tetraconchs have been found so far in palaces; but it is likely that these too existed. Whatever their shape, however, these centrally-planned palace structures served closely related functions, though under a variety of names. Placed often on the centre axis and at the entrance either of the palace or of its state apartments, they may be *salutatoria*. The rotunda in

Diocletian's palace at Spalato is an example: preceded by a colonnaded 'peristyle' and raised on a podium, its front is surmounted by the arcuated lintel of a *fastigium* – a glorification façade.[24] Inside the room, the Emperor would presumably receive the high court charges; later he would reveal himself below the fastigium to his subjects assembled in the open-air area in front – the *tribunalium*. Elsewhere, such centrally-planned palace rooms were apparently audience-and-throne halls, that is, *basilicae* in contemporary terminology; a '*basilica quae trullus appellatus*' existed in the Great Palace in Constantinople. It has disappeared, but it was obviously domed and presumably of central plan. As early as the second century, the throne room of Septimius Severus with its astrological vault may well have been circular or polygonal in shape.[25] Or again, centrally-planned rooms in palaces, whether triconch, polygonal, or round, served as triclinia: not just dining rooms as the term originally implied, but State banqueting halls, where the Emperor partook of his meal as a God in the ceremony of the *coenatio Jovis*; or they were simply throne-and-audience rooms. The borderline fluctuates, but on the whole the purpose remains the same. Triconch triclinia are found from the second to the sixth century, witness the audience hall in the governor's palace at Qasr Ibn Wardan of 563–4; as late as the ninth century the type is represented by the *triconchos*, known from literary sources in the Imperial Palace at Constantinople.[26] The triclinium in Nero's Golden House was an octagon.[27] Between 310 and 320, the type seems to be represented by the Minerva Medica [186]: surmounted by a dome, its decagonal core billows outward in ten niches, some of them pierced by triple arcades. A podium with heating facilities filled the rear of the centre room, opposite the entrance, and would have been suitable for a banqueting table or a throne. The building may well have been designed as a throne room and State banqueting hall for the winter. Later, two nymphaea were added on the exterior, making the structure comfortable for summer as well.[28] Needless to say, in all such triclinia, salutatoria, and basilicae, religious and secular functions interlocked, as implied in the position of the God-Emperor; in domed rooms in particular the idea of the Dome of Heaven was ever present. In the Chrysotriclinos, the Golden Triclinium, of the Great Palace in Constantinople, the type survives as late as the end of the sixth century. No trace remains of it, but the descriptions leave little doubt regarding its plan: circular, enveloped by eight vaulted niches – perhaps double-storeyed – which opened into adjoining rooms. The centre space was surmounted by sixteen windows placed into the webs of a pumpkin dome. Also, like the Late Roman audience halls, its functions were both religious and secular: it served as audience hall for the Emperor's Majesty and as palace chapel.[29]

True, this double function of the Chrysotriclinos is not documented prior to the tenth century. But the interlocking of the Imperial and the religious sphere goes far back into Late Roman times, pagan and Christian. Thus the transfer of the plan of a circular audience hall to an Imperial palace church is likely enough. If, then, the Golden Octagon at Antioch was indeed a palace church – and this is so far only a hypothesis – its close resemblance to Roman circular audience halls becomes understandable, regardless of which alternative is chosen for reconstructing its plan.

If the Golden Octagon was Constantine's palace church at Antioch, it was the first of its kind. But palace churches in the fourth century were probably more frequent than we imagine. So far none have been definitely ascertained, but the 'suspects' are numerous. Of S. Lorenzo in Milan we shall speak soon. A tetraconch rather than an octagon, it nevertheless shares several features with the church at Antioch: the centripetal plan, the enveloping aisles and

galleries, the neighbourhood of an Imperial palace. But the plans of palace churches may have differed widely. H. Georgios in Salonica is an example.[30] Its core had been built close to, and as part of, the Imperial palace layout about 300, functioning either as a mausoleum or a throne room. Covered by a huge dome 24 m. (80 ft) in diameter, it was an imposing rotunda – built in the same masonry technique which a century later would serve for the walls of Constantinople. Eight barrel-vaulted niches lightened the thickness of its 12-foot walls. About 400 or 450, this rotunda was turned into a church. A chancel and apse were added, an ambulatory was built, all in brick-faced concrete, and the walls of the niches were pierced. A narthex, flanked by staircase turrets and thus probably double-storeyed, projected towards the main road, which led from the triumphal arch of Galerius and, beyond, from the palace grounds. A rich mosaic of saints standing against complex niches and fastigia covers the dome. The plan obviously recalls more closely martyria such as H. Karpos and Polykarpos at Constantinople rather than either the Golden Octagon at Antioch or S. Lorenzo in Milan. But the closeness to the palace and the central plan make it equally plausible that it was to serve as a palace church.[31]

Altogether, in the fourth century, throughout the Eastern capitals of Constantinople, Antioch, and Jerusalem, we are forced to rely mostly on literary evidence and conjecture. We are on firmer ground as we turn to the architecture in the political and religious centres of the West.

MILAN

More clearly than any other centre, Milan conveys an idea of the impact exerted by the new capitals on the formation of a grandiose church architecture since the middle of the fourth century.[32] From 353 the city had frequently been the Imperial residence and, in effect, the capital

of the West. In 373 it became the see of St Ambrose, and, through him, for some decades the spiritual centre of the West as well. Discoveries in recent years have shown that at one time Milan was also one of the great architectural centres of the Christian world. Its importance is demonstrated by five huge churches, three of them standing to this day at nearly their full height – S. Nazaro, S. Simpliciano, S. Giovanni in Conca, S. Tecla, and S. Lorenzo, of which only S. Lorenzo has long been known. Their widely differing plans show the inventiveness of the builders then assembled round the Imperial and episcopal courts at Milan. They have in common monumentality of design, grandeur of volumes, powerful, stark walls, and articulating pilaster strips, blind arcades, and dwarf galleries. They are covered with simple great vaults or timber roofs, and their construction is in solid masonry: high bricks, occasionally laid in herringbone patterns and interspersed with large pebbles, with low beds of white mortar.

S. Lorenzo is a huge quatrefoil structure, of double-shell design [35]: an inner shell, formed by the centre room, is enveloped by an outer shell, that is, the ambulatories and galleries. Remodellings of twelfth- and sixteenth-century date have changed the details but not the basic design as it was laid out probably some time between 352 and 375 – a date suggested by the masonry and the remaining decorative elements.[33] The atrium, facing the street to this day, is preceded by a colonnaded propylaeum: its trabeation, in the centre, curves up into an arch – the old symbol of Imperial power. Four towers rise at the corners of the church [36]. They are tall, but not much higher than the square drum which originally rose over the centre space instead of the present octagon of sixteenth-century date. As complex and as beautiful as this rich silhouette is the interior. A central space, 23·80 m. (78 ft – that is, 80 Roman ft) square and originally c. 27·50 m. (90 ft) high, is

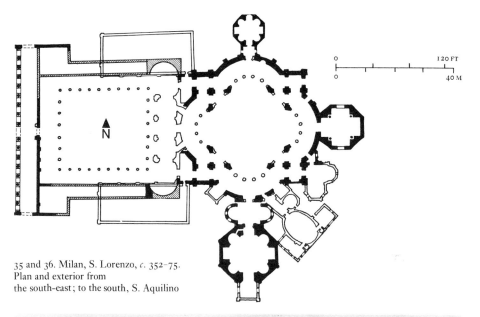

35 and 36. Milan, S. Lorenzo, *c.* 352–75.
Plan and exterior from
the south-east; to the south, S. Aquilino

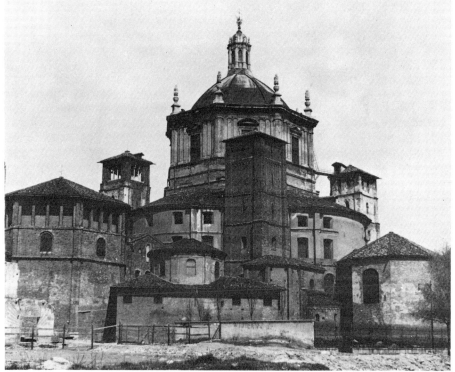

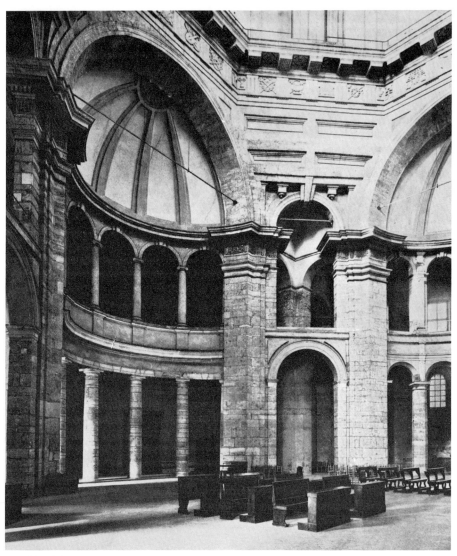

37. Milan, S. Lorenzo, c. 352–75.
Interior facing south-west

marked off at the corners by four L-shaped piers
[37]. Originally covered either by a towering
groin-vault or a dome in timber construction,[34]
this core swings out on its sides in four wide
double-storeyed exedrae – open on both floors,
each in five arches. Their supports, originally
either columns or square piers, in an eleventh-
century remodelling were replaced by or re-

cut into the present octagonal piers. In the sixteenth century, the centre square, its corners bridged by arches, was transformed into an octagon to support the present eight-sided drum and dome. The original tetraconch core – a kind of huge baldacchino – is enveloped by the ancillary zones of aisles and galleries in a double spatial belt, each lit by a row of wide windows. The double-shell construction, the ensuing complexity of the spatial design, and the overlapping views combine with the contrasts of light and shade to create an interplay of superb richness. This splendour was further emphasized by the original decoration: walls faced with marble plaques, wall zones and vaults separated by stucco friezes, window soffits filled with stucco tendrils – all of it contrasting with the starkness of the exterior. Both starkness and lavish interior decoration were taken up in the adjoining much smaller structure of S. Aquilino. Planned at the same time as the huge quatrefoil, it seems to have been an Imperial mausoleum. It is a niched octagon with

its outside walls surmounted by a dwarf gallery resting on slender piers. The interior was covered with marble revetment and mosaics, some well-preserved, and surmounted by a cloister-vault in sheer brickwork. This is a technique of vaulting very different from that previously customary in the West, but it finds its parallels at an early time in the Aegean coast-lands.[35] An Eastern architect may have been at work, brought along either by the court, or by the Arian bishop Auxentius, the presumable founder of the church and a native of Cappadocia. But this does not make S. Lorenzo into an Eastern building. In plan it belongs to the family of double-shell designs which had become common property of thermae and garden and palace buildings all over the Empire from the fourth century, if not before, and which, during that century already, started its migration into church architecture. Within this new church architecture, the specific function of S. Lorenzo remains still in doubt. It lay outside the city walls and thus could hardly have been

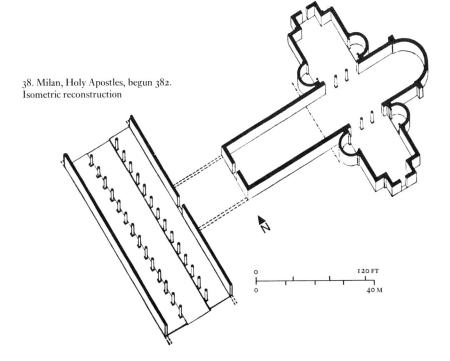

38. Milan, Holy Apostles, begun 382. Isometric reconstruction

N

| 0 | | | 120 FT |
| 0 | | | 40 M |

either the ordinary church of a congregation or the Arian cathedral. No important relic is known ever to have been venerated in the church, and the late dedication to St Lawrence rules out the possibility of its foundation as a martyrium. On the other hand, it lies close to the Imperial palace. Thus it was possibly built under Auxentius as the court church for the Emperors – all Arian until 379 – in otherwise Catholic Milan, and indeed its plan recalls again the possible reconstruction of the Golden Octagon and the palace churches of Justinian's time.

Among the churches of Milan, S. Lorenzo is unique. But links to the other Imperial capitals remain strong in all Milanese architecture of the fourth century. Such links become clear in the Church of the Apostles which St Ambrose laid out in 382.[36] Its walls survive to nearly their full original height, incorporated into the Romanesque S. Nazaro. A huge cross, 200 Roman feet long, is formed by four aisleless arms, each roughly 50 Roman feet wide [38]. The stem of the cross, somewhat longer than the transverse wings, continues unbroken into the head piece. The arms were lower than the nave, and communicated with it through wide arches, each subdivided by a triple arcade on columns. In the centre of the cross rose the altar, the focus of veneration, visible to the faithful who entered either at the ends of the transept wings or at the end of the nave. Relics of the apostles were deposited in a silver casket below the altar presumably by St Ambrose himself. In any case the dedicatory inscription, once in the church, makes it appear that for St Ambrose and his contemporaries the Church of the Apostles in Milan was a copy of Constantine's Apostoleion, intended to hold such relics, and like it – through its cross shape – intertwined with the evocation of the True Cross. Both the dedication and the implied reference of the structure made it a highly desirable burial place, as witness the tombs, one of them the tomb of an Imperial princess,

placed in two niches in each of the cross arms.

The cross plan of St Ambrose's Apostoleion was taken up, with minor variations, from the end of the fourth and throughout the first half of the fifth century in more than one church in North Italy: in a church at Como dedicated to the Princes of the Apostles and buried below the eleventh-century basilica of S. Abbondio; in the large sanctuary of S. Croce at Ravenna, built by Galla Placidia about 425, and – except for her mausoleum off the church – known only from excavations [144]; and in the church of S. Stefano at Verona, about 450.[37] All are cross-shaped with aisleless arms, but at Como and Verona the long head piece has been replaced by a simple apse; the original dedications show that, just as with the rotunda plan of the Anastasis, the cross plan of the Apostoleion was easily transferred from martyria to ordinary churches.

In Milan itself, still at the end of the fourth century, S. Simpliciano took up the cross plan on a huge scale.[38] Perhaps it was the *basilica virginum*, dedicated to all virgin saints by Ambrose's successor Simplicianus. The original structure survives, nearly untouched, like St Ambrose's Church of the Apostles, within a Romanesque remodelling. A cross, the nave is a full 60 m. (197 ft, and 200 Roman ft) long and 22 m. (72 ft – nearly 75 Roman ft) wide. The cross arms project over 50 Roman ft, and a huge apse – recently uncovered – terminated the head piece. The outer walls, built in splendid brickwork, subsist to this day to their full height of 17 m. (56 ft: nearly 60 Roman ft) [39, 40]. A narthex and low side chambers enveloped the nave on three sides. In the upper half, the walls opened in eight windows, each close to 5 m. (16 ft, and 16 Roman ft) high and framed by the upper tier of a double order of large blind arches – an articulating device

widespread from the third century in the Gallic provinces, from Trier to Ravenna. With its simple, spacious interior, its powerful walls, its clear articulation by blind arches and windows, and its beautiful brickwork, S. Simpliciano remains an impressive witness to the grandeur and perfection of building not only in Milan, but in the whole Christian world of the fourth century.

Alongside tetraconch and cross plans, other church types existed in fourth-century Milan. S. Giovanni in Conca, an aisleless church terminated by an apse, survives in the lower portion of its outer walls, to a length of 53 m. (174 ft).[39] The cathedral, apparently built around the middle of the fourth century and in the Middle Ages dedicated to S. Tecla, was first encountered by chance in 1943 under wartime conditions.[40] Re-explored in 1960-2, when the underground station was built on Piazza del Duomo, the outlines of the entire structure

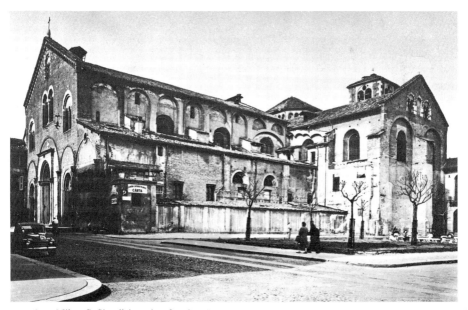

39 and 40. Milan, S. Simpliciano, late fourth century.
Exterior of north transept (*opposite*) and exterior from the south-west (*above*)

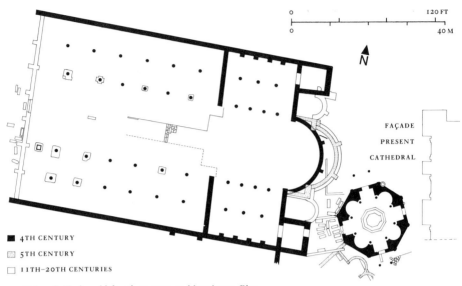

41. Milan, S. Tecla, mid fourth century, and baptistery. Plan

came to light: close to 82 m. long and over 45 m. wide (*c.* 270 by 150 ft) and not much smaller than Constantine's Lateran basilica in Rome; a nave flanked by two aisles on either side, supported by widely spread outer and inner colonnades, presumably arcaded; the nave continued as a chancel to the springing of the apse – as again at the Lateran [41]. Behind the apse rose the eight-sided baptistery, whether contemporary with the cathedral or a couple of decades after; we shall discuss it later. An altar enclosure slightly raised above nave-level filled the area of the chancel and a narrow raised pathway projected nearly the full length of the nave. Two deep wings extended sideways, each divided into two aisles and communicating with the chancel area through a quintuple arcade. Small side chambers projected east from the outer aisles in the wings; but neither in the chancel area nor in the nave did the number of outer and inner supports coincide, again recalling the Lateran. In a remodelling

after 400, a slightly narrower apse preceded by a short bay replaced the original apse. The function of the chancel wings can only be conjectured: presumably they served the rite of the offerings, just like the rooms in the Lateran basilica which projected sideways from the inner aisles flanking the chancel area. The reconstruction of these chancel wings, on the other hand, remains in doubt. They may have been just low, deep wings. Or else the plan may have been analogous to that of the Lateran basilica, a high inner aisle, opening into a low outer shallow wing. Finally, they could have been tripartite transept wings with high arms, though presumably lower than the nave, shut off by arcades from the central area, their end walls strengthened by inside buttresses. Such tripartite transepts, rare in Rome, became frequent in the Aegean coastlands in the fifth and sixth centuries. On the other hand, the chancel enclosure and its long projecting pathway, known already in Constantine's Lateran basilica, disappear

from Rome apparently in the sixth century; in the eastern coastlands, as *bema* and *solea*, they remain customary in the fifth and sixth centuries and far later in Byzantine architecture.[41]

All this throws a sharp light on the place of Milan in Early Christian architecture. Links to Constantine's Lateran basilica are clear. Equally clear is the transposition of such sources into long-standing local construction techniques and stylistic concepts. At the same time, Milan seems to have been the fountain-head of a transept type which was to dominate parts of the Aegean area.

TRIER AND COLOGNE

The Roman Rhineland always maintained strong ties with Milan. Analogies exist in the technique of construction – high bricks with comparatively thin mortar beds; in the use of huge windows; in the articulation of the outer walls by means of pilaster strips and blind arches; and finally, in the design of volumes and masses. The Imperial Basilica at Trier, for example, compares closely in all these respects with S. Simpliciano in Milan, despite nearly a century's interval. Teams of masons and architects seem to have travelled readily from the Imperial capital in North Italy to the capitals in the Rhineland: Trier, Constantine's residence until 312 and sporadically inhabited by his successors until the end of the century, and Cologne, the more important frontier residence used by Julian the Apostate and his successors in their defence of the Empire against the barbarian invasions. But fourth-century Christian architecture in the Rhineland seems to lack the inventiveness and forceful independence of contemporary building in Milan. It clings more strongly to, and indeed revives, Constantinian

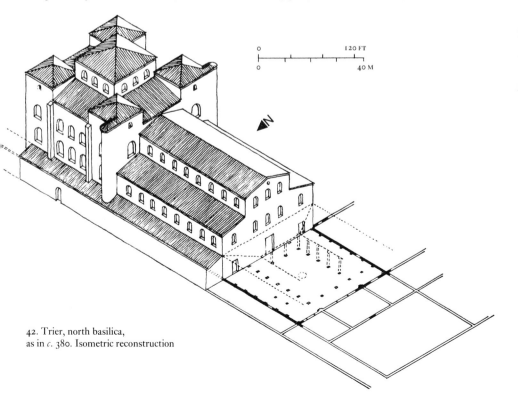

42. Trier, north basilica,
as in *c*. 380. Isometric reconstruction

models. Yet the location of these sources – in Jerusalem and Constantinople – shows up the close ties between the political and religious capitals all through the Empire.

About 380 the Emperor Gratian made Trier his residence, and the twin cathedral, by then nearly fifty years old [15], underwent a thorough rebuilding. The supports in the nave of the north church were strengthened by adding a pier behind each column; these doubled supports were then used to carry galleries, built above the aisles. The old chancel, either then or prior to 353-6, was done away with, and its place was taken by a centrally planned structure. It survives to this day still 25 m. (75 ft) high, incorporated into the Romanesque church: a square, tall block divided into nine bays by arches resting on four monolithic columns and on half-piers projecting from the walls [42]. A large square bay in the middle was enveloped by four rectangular bays on the axes and smaller squares in the four corners. Twenty-four large windows opened in two tiers along three sides of the block, while the fourth side communicated with the nave, aisles, and galleries through huge arches. The roofs of the four corner bays, rising above those of the axial bays and the still higher square drum of the centre bay, recall the nearly contemporary silhouette of S. Lorenzo in Milan. The singular design is certainly rooted in Late Roman architecture. The structure also certainly served as the chancel area, occupied as it was by a raised *bema* – like those at the Lateran and at S. Tecla in Milan – from which a *solea* extended into the nave and terminated near an *ambo* – a pulpit. However, the central plan of the whole structure, its fusion with the basilican nave, and the later addition of galleries to the basilica, recall as well Constantine's martyrium-basilicas on Golgotha and at Bethlehem. Indeed, the new 'chancel' at Trier may well have been a martyrium: a half-submerged circular cavity in its centre, situated below the high drum of the main bay, is encircled by twelve niches corresponding to the number of Apostles. Could it possibly, as a memoria, perhaps surmounted by a canopy, have sheltered a relic of Christ?[42]

The original structure of St Gereon in Cologne, incorporated into the decagonal main room of the Romanesque church, was probably contemporary with Gratian's rebuilding of the cathedral at Trier and probably also a martyrium. But also here, the original dedication is unknown.[43] A 24-m. (80-ft) long oval, its long sides are flanked by four niches – semicircular, vaulted, and jutting outward [43]. An apse to the east and a colonnaded narthex to the west, enlarged by absidioles, complete the plan. Thus ten arched openings, separated by piers attached to the wall, encircle the main room. Paired and

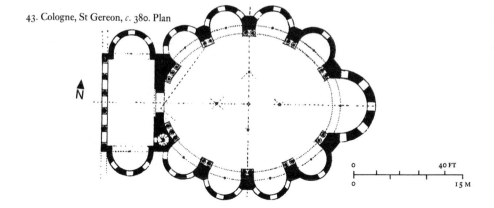

43. Cologne, St Gereon, c. 380. Plan

N

0 40 FT

0 15 M

tripled columns placed in front of the piers carried short pieces of entablature and, above the arches of the niches, the wall of the clerestory (presumably covered with gold mosaic), and the roof of the structure, either an open timber construction or a light cane vault. Imperial mausolea come to mind, such as the one added – in my opinion around 360 – by Constantius to the Apostoleion in Constantinople and designed to shelter the remains of his father, by then displaced from their original resting place in the centre of the church. In any event, the architecture of St Gereon in Cologne recalls that of other Imperial capitals.

ROME

After Constantine's departure in 326, the old capital of the world by-passed for fifty years the problems which occupied church builders in

the ambience of the Imperial court at Antioch, Constantinople, Jerusalem, Milan, and Trier. The papacy and the Roman clergy, instead of developing new types of martyria or palace churches (these latter, in any event, unnecessary in the absence of the emperors), focused their building activity on evolving a church type serviceable for the ordinary needs of the congregations. But of this later. Likewise, they seem to have been indifferent to the classical tradition. This changes in 385, when the new church of St Paul was begun on the Ostian Way as an *ex-voto* of the three reigning emperors.[44] S. Paolo fuori le mura was clearly intended to copy St Peter's on the Vatican Hill. It rose over the shrine of the *doctor gentium*: a mausoleum of perhaps first-century date – either his burial place or a memorial – which had been enclosed under Constantine in a small apse facing east. Oriented inversely, with its entrance to the west,

44. Rome, S. Paolo fuori le mura, begun 385. Interior of nave, as in 1823; engraving by L. Rossini

the new church of 385 was designed to provide a shelter for St Paul as dignified and monumental as the basilica which enshrined St Peter – huge, lavishly built, and providing space for large crowds of pilgrims to attend services and to venerate the tomb, as well as space for burials. The backing given by the Imperial treasury makes it likely that construction was completed by 400 at the latest.

A fire razed the church in 1823, and at present we see but a sore conceit of what the nineteenth century took to be 'Classical Christian Architecture'. But size, proportions, and a few stretches of original wall survive, as do numerous old illustrations and descriptions [44]. Preceded by a colonnaded atrium, the nave – nearly 24 m. (80 ft) or 80 Roman ft wide – extended an impressive 97 m. (319 ft) in length, close to 330 Roman ft. Two aisles flanked the nave on either side, each pair equal to the width of the nave. The shrine of St Paul is located below the altar, close to the triumphal arch which separated transept and nave. (The two columns and the lower archivolt of the triumphal arch were probably added in the fifth century.) A transept, continuous but higher than that of St Peter's, shelters the shrine. Eastward, it terminated in a huge apse, like that of St Peter's. Four rows of arcaded colonnades flanked the nave and separated the aisles; in the nave they supported huge upper walls, and in the aisles low walls. As at St Peter's, the arcaded walls between the aisles were pierced by openings below the roofs. Twenty-one large windows, one above each intercolumniation, instead of the eleven at St Peter's, lit the nave. The apse remained dark, but in the transept arched windows and oculi shed a flood of light on the shrine.

The builders of S. Paolo emulated St Peter's in size and plan, including the rare form of the continuous transept. But they created a variant, not a copy. The transept was nearly as high as the nave, deeper and shorter, with its end walls barely projecting beyond the line of the outer aisles. The reasons for this adjustment are unknown, whether it was the need for more space near the shrine for clergy or pilgrims, or some other cause. The shrine, in any event, rose not on the chord of the apse as at St Peter's, but as close to the nave as possible; also, the altar rose above the shrine. The nave colonnade carried arches instead of an entablature. In contrast to the hodge-podge of architrave pieces, bases, and capitals at St Peter's, those at S. Paolo were originally homogeneous. The shafts were apparently carefully selected from among Roman spoils but the capitals, except for a few spoils, were designed for the building – composite in the nave, Corinthian in the aisles. Both the homogeneous membering and the 'correct' if dry capital types testify to a perfection of execution and a predilection for classical concepts,

45. Rome, S. Maria Maggiore, c. 432–40. Nave elevation as in c. 1480; drawing. *Rome, Vatican Library*

as one would expect them in an Imperial con-
struction of the late fourth century. We do not
know whether the rest of the decoration planned
in 385 would have been closer to the alive classi-
cal vocabulary prevailing elsewhere, say at
Milan, in the ambience of the Imperial court.
True, prior to 1823 the spandrels of the nave
arcades were covered with stucco tendrils and
their soffits overlaid with glass mosaic; stucco
colonnettes, with shafts fluted in clockwise and
counter-clockwise spirals, separated the two
tiers of murals which covered the nave walls
below the window zone. But this entire decora-
tion belongs to the thorough restoration under
Leo I (440-61) – the same restoration which
added the mosaic of the four-and-twenty Elders
and the columns to the triumphal arch and
replaced part of the columns and walls in the
nave.[45]

Indeed, this later decoration of S. Paolo is
representative of a new departure in Roman
church architecture. Its relation to the classical
tradition differs wholly from that which in 385
created the conservatively dry classical capitals
of the church, and, at roughly the same time,
the capitals from the Arch of Theodosius in
Constantinople. The new movement in Rome,
on the contrary, aims at reviving the classical
forms of an era long past. Nor does it limit itself
to the vocabulary, but draws on the entire design
of classical and late classical Roman buildings
of the second, third, and early fourth centuries.
This classical revival comes decisively to the
fore under Sixtus III (432-40) and continues
under his successors to the See of St Peter's
until about 470. The basilica of S. Maria
Maggiore best represents this 'Sixtine Renais-
sance'.[46] The wide nave [46] is flanked by only

46. Rome, S. Maria Maggiore, c. 432-40. Interior of nave

two aisles, all three designed in quiet majestic proportions. Long rows of columns with Ionic capitals carry a 'classical' entablature and lead the eye towards the triumphal arch which continued into the original apse vault. On the nave walls monumental pilasters formed an upper order, each flanked by a double tier of colonnettes with clockwise and counter-clockwise spiral fluting, and carrying a stucco frieze of the purest classical rinceaux design. Pilasters and colonnettes framed the windows as well as the mosaic panels of the nave, the latter each encased in a gabled, colonnaded aedicula [45]. Overall design and details breathe a spirit more retrospective than the live classicism of Constantinople, and reminiscent, more than anything else, of Trajanic art.

But obviously any 'classical' building of the past would equally serve Sixtus III and his

architects, as witness the baptistery at the Lateran. Two remodellings of the sixteenth and seventeenth centuries are easily discounted. Laid out by Constantine as an octagon, undivided inside, well lit by two rows of windows in the outer wall, and presumably covered by a timber roof, it was thoroughly remodelled under Sixtus. Two trabeated orders in the centre – each of eight columns – formed, as it were, an octagonal baldacchino over the font [47]. They were in turn surmounted by the eight large windows of a clerestory, and either a pyramidal timber roof or a light cane dome, possibly a pumpkin dome. Elegant marble panelling revetted the walls, mosaics covered the barrel-vault; also the windows in the clerestory seem to have been framed by stucco profiles. An octagonal and barrel-vaulted ambulatory enveloped this core. Plan and details recall S. Costanza – a century old at the time Sixtus remodelled the baptistery.[47] The same spirit of a renascence persists as late as 468-83, when S.

47. Rome, Lateran Baptistery, c. 315 and c. 432-40. Section; engraving by A. Lafréri

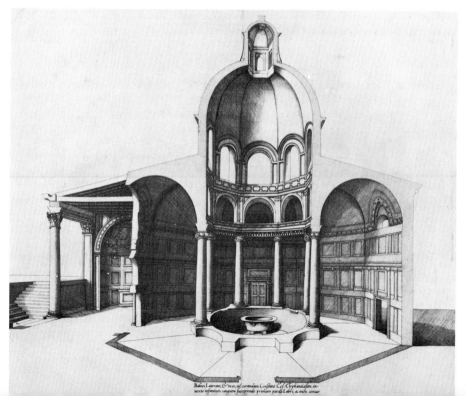

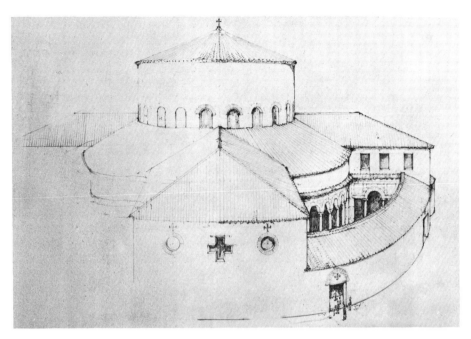

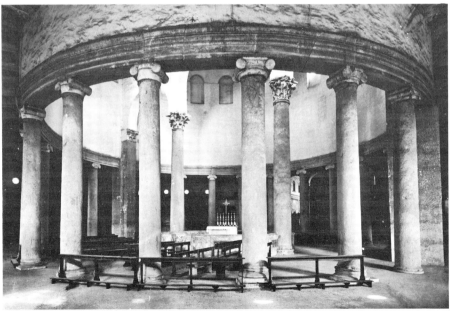

48 and 49. Rome, S. Stefano Rotondo, 468–83. Reconstruction and interior

Stefano Rotondo was built. Comparatively well preserved, it shows to this day its main components. A huge cylindrical nave rests on a trabeated colonnade with Ionic capitals [48, 49]. The high walls of the nave, originally faced with marble plaques below the twenty-two windows of a clerestory, may have carried a dome of light material. This core is enveloped by an ambulatory which opens into groups of five and six colonnaded arcades. These lead, alternatingly, to four deep, tall chapels – laid out crosswise – and presumably to open courtyards containing pools and terminated at the periphery by arcaded porticoes. Remnants of a classical stucco decoration have survived on the archivolts of the first ambulatory and suggest the lavishness of the decoration in general.[48]

Nothing is known of the original function of S. Stefano. But its dedication from the outset to St Stephen, the venerated protomartyr, as well as its circular form suggest that it was a martyrium, perhaps sheltering a relic of the saint. Also, the complex plan with its interpenetration of rotunda and cross shape may have been influenced by the Anastasis, and perhaps collaterally by other martyria in the Holy Land. However, earlier Roman buildings, possibly secular, may equally be among the sources of S. Stefano Rotondo, although none

has come to light so far. Nor has S. Stefano had any descendants, except perhaps for the rotunda of S. Angelo at Perugia.[49]

Altogether, the Sixtine Renaissance throws light on the approach of Christian architects and patrons in Rome to the heritage of classical Antiquity. In plan and vocabulary, monumental classical architecture was traditionally linked to temples, public buildings, and palaces; it threatened Christian architecture through pagan religious connotations, including those of the Emperor cult. Christians in Rome – for the better part of the fourth century – were on the whole indifferent, if not hostile, to classical culture. Thus in contrast to their co-religionaries in the Greek East or in the northern Imperial residences of Milan and Trier, they avoided the classical heritage in their buildings as well. Only with the ultimate defeat of paganism in Rome in 395, and with the concomitant rise of a thoroughly Christian and highly educated aristocracy, could the classical past become acceptable – void of its pagan connotations. Simultaneously, the sack of Rome in 410, the weakening of the Empire in the West, and the increasing alienation from the East compelled the Papacy to absorb and, indeed, to claim both the political and the cultural legacy of Rome.

THE FIFTH CENTURY

CHAPTER 4

INTRODUCTION

The division of the Empire in 395 was envisaged by the Emperor Theodosius as a partnership between East and West.[1] In principle it was to be not much different from the Tetrarchy of Diocletian, but through the force of events it hardened into a schism. From the beginning of the fifth century, the West was ravaged for a hundred and fifty years by successive invasions. As early as 402, its capital had to be transferred from Milan to Ravenna, where it was protected by the fleet in near-by Classe. Rapidly shrinking in political importance, the Western Empire sank into weak dependency on the East. Rome was sacked in 410 by the Visigoths, who afterwards occupied Provence and Spain. Beginning in 429, the Vandals set up their kingdom in North Africa, threatening the Italian islands and the mainland and finally sacking Rome in 455. Central and northern France were lost to the Franks after 460. Italy fell to the Heruleans in 476 and then to the Ostrogoths, who under Theodoric (495-526) set up their strong and peaceful rule from Ravenna.

The East, on the other hand, remained comparatively strong, despite losses on the Danube and Euphrates frontiers. Internal unity was preserved through a well-run administration and protected by strong armed forces, and so the East could maintain itself as the political power of the Empire: the Emperor in Byzan-

tium remained the *Basileus tōn Romaiōn*, the Emperor of all Romans, East and West, and his capital was the capital of the Empire. In fact, though not in law, towards the end of the fifth century, the Western Barbarian kingdoms, now stabilized, considered themselves semi-vassals of Constantinople.

Ecclesiastically the situation was reversed. The East was torn by dogmatic strife over the definition of Christ's nature – whether only divine (monophysitism), or both human and divine (dyophysitism), or some shading of both. Related to this fundamental question was the dogma of the Virgin as God-bearer (*theotokos*), formally accepted in 431 at the Council of Ephesus. As a result of the controversy, dogmatic provinces began to oppose each other. Alexandria was monophysite, Antioch dyophysite, Constantinople held an intermediate position. After the Council of Chalcedon in 450 the division grew sharper. Egypt and Syria, led by Aramaic and Coptic monastic groups from the hinterlands, battled for monophysitism, while hellenistic Constantinople leaned towards dyophysitism. Attempts at reconciliation only resulted in further splintering. As a side effect of the dogmatic battles, the fully developed liturgies of the various provinces parted ways even further. Yet this strife strengthened the role of the Imperial power. Regardless of which

faction was in power, the Church needed the protection of the Empire. A strong Emperor was given a chance to establish himself head of the Church, as finally happened under Justinian (527-65).

The West remained aloof from such theological controversies. Rome increasingly assumed spiritual and administrative authority over the Western Church, from the Balkans to France. Due to the weakening of Imperial power in the West, the Papacy was forced into a political role. Leo I (440-61), continuing the policies of his predecessor, Sixtus III, steadily increased the power of the Papal See. In fact, Rome retained its influence in the West in church matters across the newly created political frontiers and, though threatened, managed to keep a foothold even among the Arian Vandals and Visigoths. The Arian Theodoric treated the Roman Church with the greatest respect. Thus, towards the end of the century, Constantinople and Rome emerged as the two centres of the Church within the Empire. Milan, Alexandria, Antioch, and Jerusalem sank to the rank of important but provincial ecclesiastical capitals, comparable to older local sees such as Carthage or Aquileia.

The architectural history of the fifth century is no less complex. Many monuments are known, but little attempt has been made to present them in a broader perspective. A few general remarks are therefore in order.

Architects and patrons, in the last years of the fourth century, begin to concentrate on problems of church architecture quite foreign to Constantinian thought. The inventiveness and experimentation of the Constantinian age gives way to the establishment of norms, and distinct building types, which had gradually evolved for different liturgical functions, rapidly become standardized. Complementing this development, the three great regions of the Empire formulate differing plans and distinct architectural styles, all diverging in design and decoration.[2] Within each region individual provinces give preference to this or that local variant. Finally, an exchange of architectural concepts develops between provinces. These interlocking developments begin about 380 in the great architectural centres, reaching their peak in the fifth century all over the Empire. And they continue in the provinces far into the sixth century.

Throughout Constantinian and post-Constantinian times, architects, churchmen, and patrons had striven to evolve an architecture appropriate to the needs and demands of the young, powerful Church. By 380 the search for new building types and for a new style comes to an end. The complex plans of Constantinian origin were gradually eliminated. Composite martyria basilicas, huge cross churches and the like fall into disuse. 'Continuous' transepts, such as those of St Peter's and St Paul's in Rome, after 400 find hardly any following for another four centuries. Twin cathedrals, aiseless or aisled halls without apses, altars placed in the middle of the nave, and similar variants survive only in backwater provinces. Instead, clearly distinct building types come to be defined for the ordinary services of the congregation, for the cult of the martyrs, for baptism, for private devotion, for public receptions.[3]

For regular services, standard types of basilicas rise as parish churches in villages and in urban centres. Much simpler than Constantinian designs, they are composed of only a few basic elements: nave, apse, and two aisles. Local custom adds to this basic theme variations, sometimes innovations, more often Constantinian survivals: atria – that is, forecourts – as a rule enclosed by four colonnaded porticoes (*quadriporticus*); nartheces – that is, shallow vestibules – either in front of the church (*exonarthex*) or inside, preceding the nave (*esonarthex*); galleries above the aisles; a supplementary pair of aisles; occasionally, though

rarely, a crypt - a subterranean chamber below or in front of the apse; and, equally rarely, a pair of towers flanking the narthex. Sometimes a cross transept or a tripartite transept intervenes between nave and apse: the former a transept with its wings enveloped by colonnades which continue the colonnades of the aisles; the latter a transept with centre bay and high arms, segregated from each other by arcades.[4] Separate areas are set aside for the auxiliary needs of the Mass and the administration of the congregation. The *prothesis* serves for the preparation of the Eucharist before it is brought to the altar and, as a rule, for its storage after Mass. In the *diaconicon* the deacons receive the offerings, keep the archives, the library, the vestments, and the church treasure. However, local customs determine whether these areas are inside the church, and in that case, in the east bays of the aisles, in the wings of a cross transept or of a tripartite transept; or outside, either in *pastophories*, flanking the main apse, or attached to narthex or atrium. Likewise it depends on local custom whether the Eucharist is kept in the prothesis or in the diaconicon.[5] Similarly, local custom, available materials, and funds determine the choice of nave supports - whether columns or piers or a combination of both - and the shape of the windows - rectangular, round-headed, or circular. Local custom and financial means also decide the choice of a flat, coffered ceiling or an open timber roof. Conventional churches are indistinguishable from parish churches, and cathedrals of large episcopal sees differ from minor churches in size and decor but not in basic plan. They are enriched only by an added baptistery, by a *consignatorium* and further rooms for the rites supplementing baptism, and, at times, by side chapels (*parekklesia*), and a reception hall (*salutatorium*). Orientation becomes the rule. The church axis runs west and east: the apse facing east, the façade west - contrary to Constantinian church plans where the apse faced west, east, or north,

subject to regional custom and local topographical conditions. The manifoldness of Late Constantinian and post-Constantinian martyria also gives way to a few formulas. In the East martyria are generally large, free-standing, and of central plan: either round and enveloped by an ambulatory, thus following the model of the Anastasis Rotunda; or octagonal, with ambulatory and chapels; or cross-shaped, the arms either aisleless or basilican. In the West, from Greece to North Africa and Italy, martyrs' graves more often than not are enclosed in basilicas of standard plan, indistinguishable from parish churches within a town. The relics of a martyr brought inside a city - in Eastern as well as Western provinces - are usually sheltered in a small cross-shaped martyrium attached to a parish church or cathedral. At times - and again this depends on local custom - the diaconicon serves simultaneously as the martyr's chapel. In North Africa the relics often occupy an apse, or a place in the nave opposite the main apse - a counter-apse, as it were, and as a rule added later.[6]

Baptisteries likewise become standardized. In some provinces, e.g. Syria and North Africa, the Constantinian (or pre-Constantinian) square plan continues throughout the fifth century. As a rule, though, the plan is octagonal as it had been at the Lateran. However, the new baptisteries differ from Constantine's: they are often enlarged by niches or enveloped by an ambulatory, and almost always vaulted. The type apparently grew from the tradition of Roman funerary architecture, and this is understandable within the context of Early Christian symbolism: baptism is the death of the old Adam and the resurrection of the new man; eight is the symbolic number of regeneration, salvation, and resurrection, as the world started the eighth day after creation began, and Christ rose from the dead on the eighth day of the Passion. Best known from North Italy and Provence, the octagonal baptistery plan likewise

occurs in Syria, in the Aegean coastlands, including Constantinople, and in Rome.[7]

At the same time, the monastic movement makes its impact felt.[8] Its beginnings in the late third and the early fourth centuries had been anachoretic and individualistic, and the eremitical life continued to play an important part in the East and the West throughout the Middle Ages, and in the Christian East up to our own time. But hermits always were exceptions. For the great majority of monks, the eremitical and hence anarchitectural life gave way by the middle of the fourth century to new rules: either a *lavra* system in which the monks, living in individual hermitages, would gather on feast days at a common centre for services and meals; or a coenobitical system (from *koinos*, meaning common, and *bios*, life) in which the monastic congregation lives together in a compound composed of living quarters (cells), a dining-room (refectory), a kitchen, a guest house, and an oratory or a church. Both systems were developed in the course of the fourth century, the *lavra* in Palestine, the *coenobium* in Egypt and Asia Minor. By the early fifth century, monasteries are found all over the Eastern part of the Empire and regular conventual buildings develop in place of the villas, country houses, or clusters of hovels which had served the first coenobitical congregations. Distinct from episcopal residences and from parish houses containing offices and living quarters for the secular clergy, these conventual buildings vary in plan according to specific monastic custom or local building tradition. Cells, kitchens, guest rooms for pilgrims, refectory, and church may form a cluster of rooms, as in Upper Egypt (Aswân, convent of St Simeon); they may be loosely arranged around an open area, as in northern and eastern Syria and sometimes in Asia Minor; or they may form a tight rectangular block, enveloping an inner courtyard, as in southern Syria; again the various chambers may be attached in a row along the flank of the church, as at Tebessa in North Africa. Different as they are, all these conventual plans become standard within the confines of larger and smaller architectural provinces.

The comparative homogeneity of the church plan in the fifth century does not preclude differences in layout determined by liturgical custom. The ritual of the service determines position and shape of the chancel, absence or presence and placement of pastophories, martyr chapels, and other side rooms. Local ritual likewise dictates the placing of altar, pulpit, clergy seats, and possibly exedrae in the nave, position of entrances on the façade or the flanks of the building, and the separation of nave and aisles, as well as the presence or absence of tripartite or cross transepts. In a leading province, such variations were no doubt determined by custom prevailing in the ecclesiastical capital, be it Constantinople, Milan, Antioch, or Rome, where new liturgical customs would originate and necessitate new planning. Backwater provinces, on the other hand, clung to Constantinian and earlier arrangements: in Africa, chancel and altar rise well forward in the nave; in Istria, a curved free-standing clergy bench is placed behind the altar; in Syria, an exedra occupies the middle of the nave, facing the altar in the apse. However, the dogmatic controversies of the fifth century and the ritual of the service are apparently unconnected. Nor is liturgical planning necessarily linked to architectural design as it develops during the fifth century in the various parts of the Empire.

The variety and inventiveness of Constantinian and post-Constantinian church planning had been evolved within a framework of comparative uniformity in design. Whether in Rome, in Milan, in the Holy Land, in Trier, or in Constantinople, church building seems to have shared in the overall concept of an Imperial *Reichskunst*. Minor provincial centres were nourished by these same ideas, though in cruder form. The reverse is true of the fifth

century. The wide variety of church plans is narrowed down. But norms in architectural and liturgical planning and notably different styles develop within each of three large regions of the Empire. These regional styles come forcefully to the front towards 380, and continue with little change until the sixth century.[9]

One region comprises the Latin-speaking West. Spiritually and to some degree politically the domain of the papacy, this area extended from Italy east to the Adriatic coastland including Dalmatia, west to southern France and Spain, south to North Africa, from western Algeria to Tripolitania. A second style prevails in the coastlands of the Aegean sea where Constantinople was the leading centre, Greek the common language, and the culture hellenistic. Thrace and Macedonia, the southern Balkans, the mainland of Greece, the coasts of Asia Minor and the Greek islands comprise the core of this region. But it also includes the shores of the Black Sea, the big trade centres, mainly on the coasts of Syria, Palestine, Egypt and Cyrenaica, and Greek towns far in mountain or desert regions of the East, where the architecture of the coastland cities penetrated because of the prevailing urban character of hellenistic culture. A third architectural style dominates the inland countries of the Near East, those provinces and borderlands of the Empire where native languages remained in widespread use: Syrian, Aramaic, Coptic, Armenian, and the dialects of Asia Minor. Predominantly rural, these areas preserved their native cultures and continued to resist the impact of hellenized city culture. They touch the sea at the Phoenician coast and extend into the uplands of Palestine, Jordan, and Syria and across the desert to the Euphrates. To the north, beyond the mountain provinces of Cilicia and Pamphylia, they cover the high plateaus of Asia Minor, Cappadocia, and Phrygia; to the south, they reach across the Negev and Sinai peninsulas into the uplands of Egypt; finally, on the borders of the Empire and beyond, they extend into Armenia and Mesopotamia.

Despite their vastness and their geographical diversity, each of these regions remains surprisingly homogeneous in its basic architectural concepts. Space and mass, light and decoration, are handled if not along the same, along similar lines from one end of the region to the other. Frequently such concepts spread from a political and spiritual centre. This seems to have been the case in the Aegean coastlands, where Constantinople with the court, the patriarch's curia, the Imperial Building Office, and the near-by Imperial stone quarries occupied that position. But a style might also form in the village and monastic centres of the hinterland in opposition to the cultural and religious capital of a region. The spiritual hegemony of Antioch or Alexandria, for example, does not guarantee them any architectural leadership in the hinterlands of the Near East.

Neither stylistic concepts nor church plans are tediously uniform throughout each region. Far from being monotonous, they are shot through with ever new variations. Rich and poor buildings stand side by side. Martyria, baptisteries, and parish churches vary in plan among each other. Indeed within one and the same functional category, the variations are numberless. Among parish churches in the Aegean coastlands, basilicas with cross transepts and tripartite transepts stand alongside ordinary basilicas with and without galleries and all become standard types.

The regional styles are determined only in part by the use of the same building materials and techniques. Even where, as is frequently the case, materials and techniques differ in various parts of a major region, the stylistic concepts remain unchanged. In design, the Menas Basilica in Lower Egypt and the church of H. Demetrios in Salonica are close, notwithstanding the use of stone in the former, of mortared rubble and brick bands in the latter

structure. Similarly, the liturgical layout, while linked to the design of the building and the interrelation of its parts, is not necessarily a determining stylistic factor. No doubt, it helps to shape the stylistic development in the Aegean coastlands, where centralizing elements, under the impact of liturgical demands, become increasingly decisive in the church plan. On the other hand, in the Latin West - despite the homogeneity of stylistic concepts - the layout of the chancel, the site of the altar, and the approaches to the church vary vastly from Rome to Milan and Salona. Conversely, liturgical demands, and with them church plans, often cut across regional boundaries. To give one example: tripartite transepts become standard in Corinth and the coastal cities of Epirus, imported in all likelihood from Milan, the metropolitan see for western Greece. But in absorbing the plan from the Latin West, the Greek church-planners retain all the stylistic characteristics of building in the Aegean coastlands.

Nor is there rigid separation in function among the various building types. After 450 and occasionally earlier, church types take on functions different from those originally intended and are assimilated to each other. Because of the increasing inclination to deposit relics in every church, standard basilicas in the West which were originally designed to serve as parish churches are now employed to shelter a martyr's grave and used as covered cemeteries. Conversely, in the Greek East centrally-planned structures, used both for martyria and palace churches, apparently become interchangeable among each other, and indeed interchangeable with parish churches and cathedrals.[10]

The heading of this section, 'The Fifth Century', wants to be taken *cum grano salis*. While the standard types seem to have formed all over the Empire at roughly the same time towards the end of the fourth century, their life span differs in the three great architectural regions. In the Aegean coastlands, the standard types

once formed do not become common property before the middle of the fifth century. Their predominance, except in the border provinces of the Balkans, comes to an end as early as *c.* 530, with the victory of Justinian's architecture. In the Latin West, however, parish churches, cemetery basilicas, and baptisteries had become standardized as early as 420, and remained standard until the early seventh century both in North Africa, where Christian building was cut off by the Arab conquest, beginning in 640, and in Italy until the year 600. Again, in the hinterlands of the Near East, the rule of the native standard types was terminated by the Arab conquest only in Syria. In Asia Minor and Mesopotamia they lived on unchallenged into the ninth century, and in Armenia throughout the Middle Ages.

The standard church plans of the Western provinces as they were developed from the fourth to the early sixth century have been long taken to be the direct source for pre-Carolingian, Carolingian, and Romanesque church building in Western Europe from the eighth to the twelfth century. This belief has become firmly rooted, but it wants to be modified to a considerable degree. In fact, the standard plan of the Latin West, the ordinary basilica with nave, aisles, and apse, falls into disuse - even in its original habitats, Italy and North Africa - towards the end of the fifth and early in the sixth century. Nor does it during the time of its prime and shortly after spread to the christianized countries beyond the Alps. Instead, beginning with the sixth century and increasingly during the seventh and eighth centuries, the West is invaded by church types native to the East, be it the Aegean coastlands or the hinterlands. Basilicas with galleries appear in Rome at this time. Basilicas with three apses occur throughout northern Italy. In France, a small hall-church, barrel-vaulted like the churches at Binbirkilise, is found in the seventh century at Glanfeuil. Apses are flanked by pastophories, as

at St Pierre at Geneva. Small cross churches, their arms either as high as the nave or slightly lower (dwarf transepts), make their appearance from Switzerland to England – possibly an Alpine or Dalmatian type, but closely resembling structures in the highlands of Asia Minor. Occasionally towers, either singly or possibly in pairs – but this wants further investigation – precede the body of the church. Only in the last decades of the eighth and during the first half of the ninth century are these Eastern types again superseded by ordinary simple basilicas or by basilicas with transepts, as had been customary in the Latin West prior to 400: a renascence closely linked to the political concepts of Charlemagne and his papal contemporaries. At the same time, however, this revival merges with the eastern current which had dominated the preceding centuries. Both Late Carolingian and Romanesque architecture continue to draw on this heritage, which fuses into one elements originating in the standard architecture of the fifth century as it developed in the three great regions of the Empire.[11]

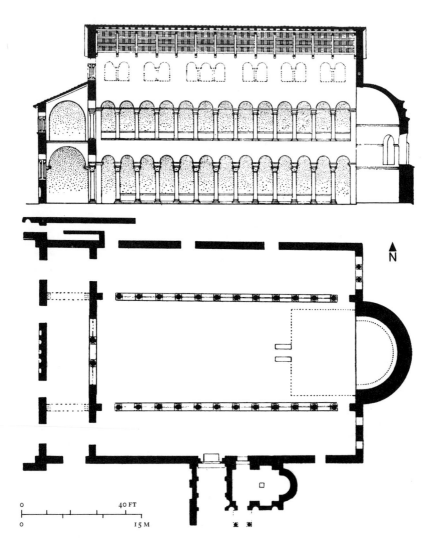

50. Salonica, Church of the Acheiropoietos, *c.* 470. Section and plan

THE AEGEAN COASTLANDS

Stylistically, the architecture of the Aegean coastlands seems to have been closely tied to the Imperial court and concomitantly to Constantinople. However, the genesis of the style and its development up to 450 are hard to visualize. Archaeological evidence of church building in Constantinople prior to 460 has completely disappeared, and it remains scarce up to 530. In the provinces, as well, little has survived of buildings of before 450, owing to the wide building activity of the later fifth and sixth centuries and the havoc wrought on Christian architecture by Arabs, Seljuks, and Turks down to our own days. Yet by the middle of the fifth century, the style of the coastlands presents itself in a maturity and with a wealth of forms in planning and detail that testifies to a long and rich tradition. The abundance and variety of church plans along the Aegean coasts contrast sharply with their comparative uniformity in the Latin West, or in the uplands of the Near East. In the Aegean the 'normal basilica' is merely one of several types, all more complex in design: the basilica of ordinary plan, but with galleries surmounting the aisles; the cross-transept basilica, the wings either enveloped by aisles on two or three sides, or accompanied by only one aisle; the basilica with tripartite transept; the basilica with trefoil sanctuary. Each of these plans prevails in one of the major provinces of the Aegean region. Along with them stand martyria and palace churches of a wide variety of design: cross-shaped martyria, their arms either aisleless or divided into nave and aisles; round martyria enveloped by ambulatories, the centre room timber-roofed, domed, or open to the sky; finally, quatrefoil churches, either palace churches, martyria, or cathedrals.

The architectural style of the Aegean region becomes clear in the church of the Acheiropoietos in Salonica, built about 470.[1] Basically an ordinary basilica with galleries [50], its exterior brick walls look simple enough. But remnants on the façade indicate that an outer narthex (*exonarthex*) was flanked by low towers, which enriched and enlivened the silhouette. Two doors in the rear wall of the outer narthex led to an inner narthex (*esonarthex*), and this in turn opens through a triple arch (*tribelon*) into the nave. Corner bays help to lock the esonarthex to the aisles, and the chain of aisles, corner bays, and esonarthex envelops the nave on three sides: an ancillary zone, it communicates with the nave through colonnaded arcades; but parapets inserted between the columns prevented direct access. Galleries repeat the three-sided movement in the upper zone. Their colonnades accompany those on the ground floor in a similar rhythm, yet differing in scale and decoration. Aisles and galleries are lit by tripartite, sexpartite, and octopartite windows which are subdivided by piers with two half-columns projecting inward and outward respectively – a pier type peculiar to fifth-century architecture in Greece and on the coast of Asia Minor. Whether or not a clerestory rose above the galleries, the nave appeared depressed, delimited on all sides by colonnaded screens, and surrounded by the ancillary zones of esonarthex, aisles, and galleries. Yet the expansive force of the core is remarkable. It moves slowly sideways and upwards into the outer zones across the enclosing hurdles – the high stylobates of the ground-floor colonnades, the parapets which blocked off aisles and galleries from the nave, the curtains which perhaps originally hung in

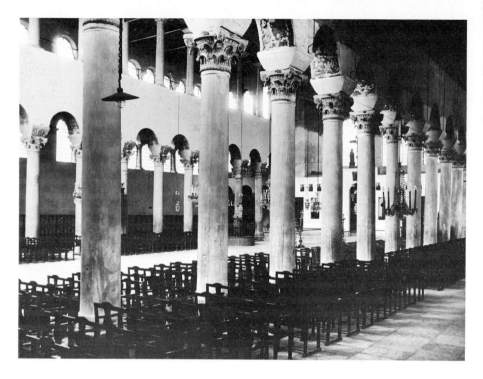

the upper and in the lower arcades; everything remains centred on the nave. The walls in the aisles were covered with marble revetment, simple but impressive. Mosaics covered not only the half-dome of the apse, but also the soffits of both ground-floor and gallery arcades. Large parts of the splendid marble pavement are left in the nave; the aisles apparently were paved in *opus sectile*, with the nave strongly marked off against the aisles, as customary throughout the Aegean coastland. The capitals in the nave are equally splendid [51]. The ground-floor colonnades carry composite capitals of the 'Theodosian' type (a misnomer by now well rooted). Their double rows of acanthus leaves, deeply undercut with the drill, are lacy, finely toothed, and topped by a belt of standing palmettes, the entire design based on the contrast of white marble and dark ground [52]. In

the gallery zone, the blocks of the Ionic impost capitals are covered with leaves and tendrils. Within each colonnade, shafts, capitals, and bases are homogeneous. Details have parted ways with the vocabulary of classical Antiquity, but the classical concept of order pervades the building.

The nave, then, was the focus of the entire design, and this was in keeping with the demands of a liturgy which seems to have assigned nave and chancel to the clergy, aisles and galleries to the congregation. This liturgical division differs from that demanded by the ritual of the Latin West. There (except for North Africa), the clergy, by the time of Constantine, had withdrawn to the apse and the space around the altar; the aisles and in large part the nave as well – certainly since the middle of the fifth century – were given over to the congregation. In the

51 and 52. Salonica, Church of the Acheiropoietos,
c. 470. Interior of nave, south aisle (*opposite*),
and capital of the nave (*above*)

Greek East, on the other hand, by the fifth century the nave belonged mainly to the clergy, whether or not shared intermittently with the congregation, as may have been local custom in Constantinople. The liturgical furniture of the Acheiropoietos, linked to the increasingly hieratic celebration of the Mass, is easily visualized from churches contemporary to it in northern Greece: a semicircular stepped clergy bench (*synthronon*) rising along the curved wall of the apse; a short chancel (*bema*) projecting into the nave to shelter the altar, curtained off and enclosed by parapets; in Greece, high stylobates and parapets between the columns to segregate the nave; and finally, far forward in the nave, the pulpit (*ambo*), linked to the chancel by a raised pathway (*solea*), the latter known from Constantine's Lateran basilica and S. Tecla in Milan.[2] Segregated as it was the

nave thus became a westward elongation of the sanctuary: not as sacred as the chancel proper, where on the altar Christ revealed himself in the flesh, yet sacred enough as the place where Christ revealed himself in the word read and preached from the pulpit, and as the site of the Great and Little Entrances. The emphasis on the nave-chancel axis and on the segregation of nave and enveloping aisles is closely connected with these Entrances: processions, apparently a custom long before they were codified, in which the clergy accompanied first the bishop (later the gospel book) from the esonarthex through the nave to the chancel and in a second procession brought to the altar the elements of the Eucharist, prepared in a side room.[3] The space for the congregation was largely restricted to the aisles. In order to enlarge this area, the aisles were linked by a 'third aisle' along the short end of the nave, the esonarthex. For the same reason, galleries above the aisles (known since Constantine's day) were a welcome addition. Conversely, the nave and the entire body of the church could be kept short. The result was the basilica plan characteristic of the Eastern coastlands in the fifth century: a structure broad and short, its nave with aisles on three sides, the aisles surmounted by galleries. It was a centripetal plan, focused on the nave, where the central action of the liturgical drama took place. Concomitantly, the nave could be fully viewed only by those gathered right there, intent on celebrating the Great Mystery. From the ancillary outer zones, the nave was seen only in fragmented views, blocked by a screen of columns, parapets, and curtains – just as the Mass, the Great Mystery, was meant to be seen but not fully understood by the layfolk.

The Acheiropoietos is representative of the style and the liturgical demands prevailing in large parts of the coastlands. The plan is variable: as a rule an atrium, terminated by an exonarthex, precedes the body of the church; rooms project sideways from the exo-

narthex, one often a baptistery, the other a dia-
conicon where the congregation deposits its
offerings. Liturgical custom may require tran-
septs of varying types; local tradition may de-
mand the suppression of galleries; financial
restrictions may call for a simpler decoration –
but the stylistic principles undergo little change.
In material and technique, on the other hand,
the Aegean lands present a far less unified pic-
ture. To be sure, the interiors are, as a rule,
covered with open timber roofs, the apses are
half-domed, the walls are built of mortared
rubble levelled and held in place by brick bands.
But the facing of these walls differs from pro-
vince to province. At times it is pure brick; in
other places bands of small ashlar stone – from
three to five courses high – alternate with brick
bands from four to nine courses high; elsewhere
the facing may consist of the rough mortared
rubble itself, interspersed with brick bands.[4]

Style, plan, and building technique are easily
characterized in the Aegean coastlands once
they appear fully developed in structures such
as the Acheiropoietos. But it is more difficult to
trace the evolution of church buildings before,
during, or after it reaches that climax. The great
majority of buildings are known only from exca-
vations, and these have not always been carried
through with the necessary care. Documentary
evidence, so plentiful in Rome, exists in the
Aegean region only for a few foundations, mostly
Imperial. Building inscriptions, numerous both
in Italy and Syria, are rare in the Aegean region.
Among the few that exist, some contain a
bishop's name but remain undatable through
the scarcity of bishops' lists. Thus the chrono-
logy of buildings in the Aegean region more
often than not must rest on secondary evidence:
the types of capitals, the design of mosaic pave-
ments, occasionally a change of building tech-
nique. Such evidence is obviously of only limited
validity, and may be contradicted almost any
day by further findings. Moreover, what holds

for Constantinople does not necessarily hold for
the coast of Asia Minor and the near-by islands,
or for the mainland of Greece, or for the coast of
Egypt and Tripolitania. Thus, with all possible
precautions, we shall have to present the archi-
tectural development in the Aegean coastlands
in what appears to be the logical sequence, pro-
ceeding from province to province.

CONSTANTINOPLE AND VICINITY

From the fourth century onwards, the presence
of the Emperor and his court was the determin-
ing factor in the architecture of Constantinople.
The Imperial house, its favourites, and the great
aristocratic families provided commissions and
financial backing. The government-run marble
quarries on the near-by Proconnesian islands in
the Sea of Marmara and the brick kilns furnished
materials, and the continuous building activity
provided experienced teams of masons, self-
perpetuating for centuries. At the same time,
Imperial and aristocratic patronage promoted
an architecture firmly rooted in the Constan-
tinian tradition, and an architectural vocabulary
which retained from classical Antiquity the con-
cept of order, careful workmanship, precious
materials, and elegant design.[5]

The bulk of building activity in Constanti-
nople during the fifth century may well have
been centred on palaces. But we know little
about them, and the situation is not much better
when it comes to church building. Between 404
and 415, the propylaeum of Constantine's Hagia
Sophia was rebuilt after a devastating fire.[6] The
plan – a trabeated colonnade centred on a high
fastigium – remained presumably unchanged.
But the architectural decoration – capitals, en-
tablature, and the frieze on the arcuated lintel of
the fastigium – shows forms quite different from
the conservative ornament that still prevailed in
Constantinople in the last decade of the fourth
century [53, 54]. True, the overall composition

of the Corinthian capitals, of an egg-and-dart frieze, of a lesbian cyma, remains unmistakably classical. But the foliage of the acanthus leaves or of the rinceaux is cut with a new sharpness.

lished since at least the fourth century in the Greek cities along the west coast of Asia Minor – in Pergamon, Ephesus, Miletus. Imported into Constantinople early in the fifth century, this

53 and 54. Constantinople, H. Sophia, propylaeum, 404-15. Trabeation (*above*) and capital (*below*)

The points of the leaves touch and the intervening ground is hollowed and begins to form an independent ornament, composed of geometric forms, triangles, rectangles, and rhomboids. The new style of the architectural decoration was apparently rooted in a tradition firmly estab-

kind of ornament initiates a style of decoration which was to dominate the Imperial capital for a century.

On the other hand, the rebuilding of the propylaeum of the H. Sophia tells us nothing about large-scale architectural concepts or church planning prevailing in fifth-century Constantinople. Only one major church has survived from the century between 415 and 527 when Justinian ascended to the throne. This church, St John, and its adjoining monastery, were founded by the senator Studios (hence St John Studios) in 463.[7] Ruined though it is, the structure is easily visualized: the atrium, enveloped by porticoes and accessible from the front and the sides; the short nave with its columns raised on stylobates and linked by parapets; the aisles with large windows; galleries enveloping the nave on three sides; the façades of the narthex opening outward in a short colonnade; the apse pushing out in a polygon; the rich decoration throughout

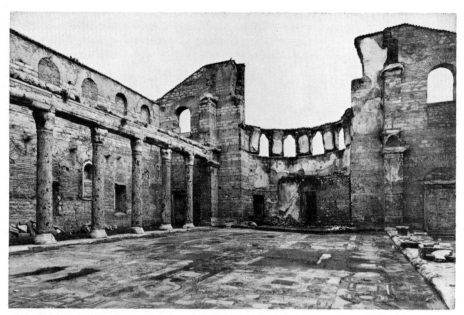

55. Constantinople, St John Studios, founded 463. Interior of nave

[55]. The nave, in all likelihood, had no clerestory and was therefore comparatively dark. Twelve-foot-high columns of precious green marble with 'Theodosian' capitals on the ground floor are surmounted by an entablature which carried shorter, greyish-veined columns in the galleries with elegantly designed Ionic impost capitals. Similarly splendid 'Theodosian' capitals surmount the columns of the narthex [56]. The entablature in nave and narthex bears a deeply undercut acanthus frieze. The walls in the aisles were sheathed with marble plaques, those in the galleries presumably painted, and the apse vault carried a mosaic. Everything speaks of the preservation and strength of a classical tradition nurtured by Constantinian and post-Constantinian sources. The short, almost stumpy proportions, the centripetal design, the galleries, the lavish materials all call to mind the basilica of the Holy Sepulchre. The decoration recalls the Theodosian propylaeum of the first

H. Sophia. Classical as it is in its homogeneity and in its basic forms, however, the decoration is filled with a new life, created largely by the contrasts of dark background and raised design, of light and shade, of organic and inorganic forms. After all, it is only natural that the classical and Constantinian tradition actively continued by the court would determine the architecture of Constantinople throughout the fifth century and beyond. It is equally natural that Constantinople would develop characteristics of its own in church planning and building technique. The Studios church clearly shows these characteristics: an atrium, enveloped by porticoes, its outer wall pierced by wide openings; a semicircular apse faced to the outside by three sides of an octagon; a synthronon rising amphitheatrically along the inner curve of the apse, oversailing a barrel-vaulted corridor; a short bema projecting into the nave, presumably prolonged towards the pulpit by the raised

56. Constantinople, St John Studios, founded 463. Narthex, capitals and entablature, inside

solea; on the chord of the apse, a small, cross-shaped crypt; doors at the ends of the aisles; a slightly raised stylobate, but no parapets between the columns; wide windows, undivided and arched; finally, concrete masonry, faced by pure brick with wide mortar-beds, or by brick interspersed at regular intervals with stone bands in two or three courses – the mortar dressed with horizontal and vertical strokes of the trowel, notwithstanding the contemporary marble revetment.

Basilicas with galleries similar to the Studios church were apparently standard in Constantinople. Remnants survive of only one, the church of St Mary in the Chalkopratiae, near the H. Sophia: a twin of the Studios church except for the presence, adjoining the flank of the atrium, of a central-plan structure, whether baptistery or martyrium. Two others are known from contemporary descriptions: H. Euphemia in Chalcedon (Kadiköy), built

prior to 450; and the church of St Mary in the Blachernai, built under Justin I (518–27) and the last to represent the type in Constantinople.[8] A small martyrium completed the plan of all these churches. Designed to shelter a venerated relic, it was attached to one of the flanks of the atrium in the Chalkopratiae, of an aisle in the Blachernai church, and to the end of one aisle at Chalcedon. At Chalcedon and in the Blachernai, the martyrium was apparently round and double-storeyed, communicating with both the aisles and gallery; in the Chalkopratiae, it was either a single- or double-storeyed octagon – the niched octagonal substructure is the only remnant. Large independent martyria seem to have disappeared from Constantinople with the rotunda of H. Karpos and Polykarpos at the beginning of the fifth century.

The vast majority of church buildings in Constantinople are lost to us. However, building types and architectural decoration closely

linked to what survives at Constantinople crop up during the fifth century all over the Aegean coastlands, from Meriamlik (Meryemlik) and Side (Eski Antalya) to Salonica and Ravenna. Thus it seems logical to suggest that the buildings found on these sites reflect models which existed in Constantinople and are yet to be found.

THE COASTS OF ASIA MINOR

Constantinople was always in close contact with the Greek settlements in Asia Minor, which included the cities along the western and southern coasts, such as Miletus, Ephesus, or Perge; the trade centres inland, such as Sagalassos; and the off-shore islands, from Cyprus to Lesbos. Byzantium – the small town from which grew Constantinople – had been one of these Greek Aegean settlements; and in its architecture, its Imperial successor would naturally draw on concepts and techniques long customary in its sister cities along the eastern shores of the Aegean. The building techniques employed in Constantinople in the late fourth century have their prototype as early as the second and third centuries in Ephesus, Aspendos, Nicaea (Iznik), Salonica – mortared rubble masonry levelled off by broad brick bands; mortared rubble faced with small stone blocks and brick bands; solid masonry of alternating stone and brick bands; finally, vaulting of pure brick rather than cast concrete.[9] Certainly the architectural ornament of the Studios church and, earlier, of the propylaeum of the first H. Sophia is rooted in the building traditions of Asia Minor.

One would expect that, conversely, in the fifth century Constantinopolitan church building would dominate the ecclesiastical architecture of Asia Minor.[10] But this is not so. Only in the late fourth and the very early fifth centuries were prototypes from Constantinople taken up in the coastlands of Asia Minor. And, even at

this early time, it is true only with reservations. The huge Epiphanius basilica at Salamis on Cyprus – only its plan is known – had triple aisles flanking the nave on either side, best explained as a survival of Constantinian planning.[11] The overall broad proportions are also reminiscent of Constantinian churches, such as the Nativity church at Bethlehem and presumably the first H. Sophia in Constantinople. Similarly, the cross-plan structure built after 400 over the tomb of St John at Ephesus (later replaced by Justinian's church) apparently went back, though with modifications, to a Constantinian prototype, the Apostoleion at Constantinople.[12] Four arms, radiating from the shrine of the saint in the centre, were each divided into nave and aisles [57]. While the

57. Ephesus, St John, as in c. 450. Plan (the sixth-century rebuilding in dotted lines)

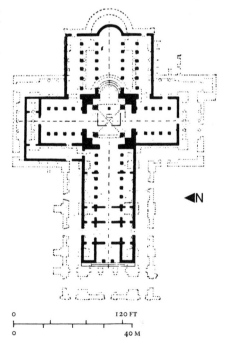

◄N

```
0                    120 FT
|----+----+----|

0                    40 M
```

58. Ephesus, St Mary, c. 400. View facing east

59. Ephesus, St Mary, c. 400 and sixth century. Plan

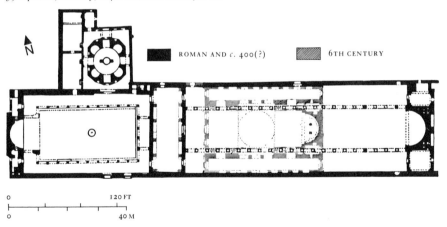

ROMAN AND c. 400(?)　　6TH CENTURY

0　　　　　　120 FT
0　　　　　　40 M

nave arm was slightly longer than the cross arms and apparently preceded by one or two nartheces, the head piece – terminated by an apse and as long as the cross wings – was further enlarged in width by increasing the number of aisles from two to four. Inaccessible to the pilgrims gathered in the three other arms, it was presumably designed for a numerous clergy. But such buildings are exceptional. The rule is a standard basilica plan – as it was adopted c. 400, or even earlier, on a remarkable scale for the large church of St Mary at Ephesus, the cathedral where the Council met in 431 [58, 59]. It was a huge structure, 85 m. (280 ft, nearly 300 Roman ft) long; narthex and atrium added another 58 m. (193 ft). The masonry

was concrete, anchored by large vertical blocks, and faced with alternating bands of brick and small stone. All walls rested on the foundations of a second-century building. The colonnades of the basilica were closely spaced. It is not clear whether they carried an entablature or an arcade, but certainly parapets between the columns closed off the aisles from the nave. The nave terminated in an apse. A baptistery adjoined the flank of the atrium, domed and with eight piers projecting from between alternatingly semicircular and shallow rectangular niches; its walls were faced by brick with wide mortar joints and sheathed by a splendid marble revetment. Impressively simple large crosses mark the marble plaques of the piers, stucco shells the niches. A square outside ambulatory enveloped the baptistery. The entire complex has been dated as early as *c.* 350; judging by the mosaic floors of the narthex, however, a date of *c.* 400 seems more likely.[13]

The plan of the cathedral of Ephesus, then, shares some features, but not all, with the standard basilica plan of Constantinople. It has no galleries. The design is simpler, the proportions lay greater stress on the longitudinal axis. If the church at Ephesus establishes what might be called the standard plan for the coast of Asia Minor, the type is in many respects closer to that of the Greek mainland than to Constantinople. In fact, dozens of churches and baptisteries along the coast and on the islands – ranging from the early fifth far into the sixth century – reflect the plan of Ephesus on a more modest scale, minor deviations notwithstanding. The churches are all basilicas with a nave and two aisles. Nartheces as a rule are tripartite and communicate with the nave and aisles only by doors, as in Constantinople.[14] Apses are at times polygonal on the exterior as in Constantinople.[15] At other times they are semicircular as on the Greek mainland. A church ruin near Mastichari on Cos is an example [60].[16] Mosaic

floors customarily carpet the nave, recalling the propylaeum of the H. Sophia, and (as we shall see later) occasionally bearing the inscription

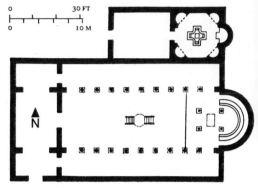

60. Mastichari, basilica, fifth century. Plan

of the donor or local bishop. Galleries were apparently rare, if not unknown, in the coastal towns and on the islands of Asia Minor.[17] Similarly simple are the plans of baptisteries. Frequently they were square, sometimes enveloped by an ambulatory. At other times they were transformed internally by corner niches into octagons, as at Ephesus. Or again, as at Miletus and at St John on Cos, they were round and provided with corner niches, with columns either attached to or standing at a short distance from the walls.[18]

An impressive local school of architecture, somewhat different from that which flourished on the west coast, developed during the fifth and sixth centuries on the south coast of Asia Minor – in Lycia, Pamphylia, Pisidia, and Cilicia, extending north to the Greek towns in the valleys of the Taurus and Antitaurus Mountains.[19] Church plans are related to those found along the west coast, but they are not exactly alike. The simple apse of western Asia Minor gives way to elaborate chancel plans. The apse is flanked by lateral rooms, or it is preceded by a transept of tripartite or of continuous plan –

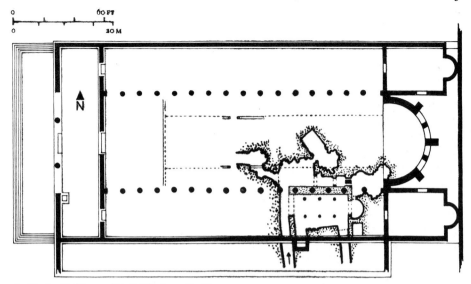

61. Meriamlik (Meryemlik), St Thecla, c. 480. Plan

possibly under the impact of liturgical customs centred in Antioch, the ecclesiastical capital for the southern regions of Asia Minor from the third century. Likewise, building practices and building materials continue local traditions which differ vastly from the techniques customary in the Aegean basin proper, from Ephesus to Constantinople and Corinth. Mortared rubble masonry with brick bands gives way to walls built of heavy stone blocks which convey an impression of stark strength and powerful massiveness. The revival of this building technique, known since Roman times, seems to be linked to neighbouring Syria, and so do some of the chancel plans. A large basilica at Side (Eski Antalya), possibly as early as c. 400, shows the apse flanked by barrel-vaulted rooms which recall the lateral side chambers of Syrian churches. In the cathedral at Korykos (Kiz Kalesi), the last two bays are segregated from the aisles by piers and cross walls, again forming side chambers – this time flanking a forechoir. A basilica of similar plan, dating from the last third of the fifth century, survives at Alahan Manastir. However, the elevation, with

galleries, is closer than other churches in southern Asia Minor to Aegean church types; also the splendid sculptural decoration recalls the Acheiropoietos in Salonica and the Studios church in Constantinople.[20] Finally, in the huge basilica of St Thecla at Meriamlik (Meryemlik) – it measures roughly 78 by 39 m. (256 by 128 ft) and may have been financed by the Emperor Zeno (474-5, 476-91) – an apsed chapel was projected eastward at either side of the semicircular main apse [61]. A straight wall linked the two chapels at their eastern end, leaving an enclosed space behind the apse.[21] In a number of churches in and near Kanlidivane (Kanytilideis), these flanking side rooms become somewhat formless spaces extending on either side and behind the apse in a provincialized version very characteristic of Cilicia.[22]

Impact from neighbouring Syria both in planning and construction technique is only natural. It is more surprising to find church types and decorative forms, well known in Constantinople and Salonica, on the south coast of Asia Minor – forms singularly lacking

in the cities of the west coast, such as Ephesus. At times such imports may have come directly from Constantinople. The splendid Corinthian

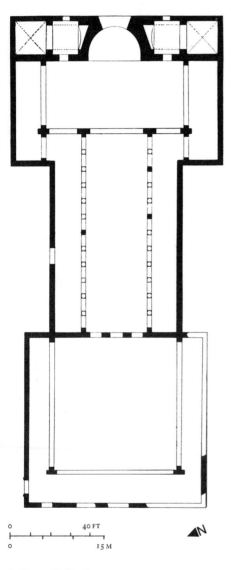

0 40 FT

0 15 M

62. Perge, Basilica A,
fifth or sixth century. Plan

capitals in the Thecla basilica at Meriamlik and its pavements in mosaic and *opus sectile*, all elegant, homogeneous, and of the highest quality, accord with the tradition which assigns the construction to workmen sent from Constantinople by the Emperor Zeno shortly after 476. Traces of marble revetment are still visible in one of the basilicas at Perge. Cross transepts, tripartite transepts, galleries – all elements well known in the great Aegean centres – appear in sizeable church buildings in the small towns along the south coast as well as farther inland. At Perge two churches were provided with 'reduced cross transepts' [62].[23] The plan appears to stand in a tradition which assimilates the plan of Constantine's Church of the Holy Apostles into a basilica: the main stem of the cross is turned into a nave; the head piece is replaced by an apse; finally, the transverse cross arms are enveloped by aisles, either on three sides ('full cross transept') or on two or only one side ('reduced cross transept'). So far, no such cross-transept basilicas have been traced at Constantinople. However, they frequently appear on a large scale and splendidly decorated in buildings and in localities closely linked to the Imperial court: in the last quarter of the fifth century, both in the Menas Basilica in Lower Egypt and in H. Demetrios at Salonica.[24] But it is strange to find the type also in the out-of-the-way towns along the south coast of Asia Minor. It is equally surprising to find in these same places tripartite transepts, well known on the Greek mainland, but as yet unknown on the west coast of Asia Minor. Two examples may suffice. One is found in the basilica *extra muros* at Korykos, combined with a chancel plan recalling the Thecla basilica at Meriamlik: two chapels projecting eastward and joined behind the main apse by a straight wall.[25] The other example, a basilica outside Kanlidivane, presents a tripartite transept incorporated into a basilica with galleries[26] – decidedly a Constantinopolitan or Salonican

type, quite unknown on the west coast [63]. Finally, continuous transepts, possibly derived from cross-transept plans, appear several times

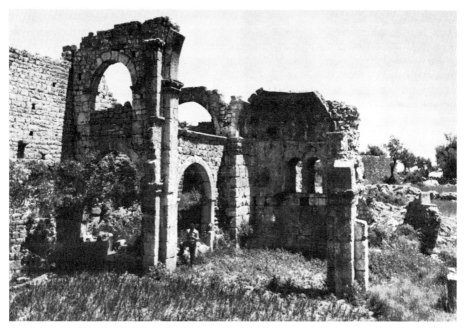

63. Kanlidivane (Kanytilideis), church, sixth century. Choir and apse

in the region: twice in churches at Sagalassos (Ağlasun), and twice in churches at Side.[27] But all the buildings present themselves in a solid, massive design, vastly different from the architecture of the Aegean coastlands. Constantinopolitan and other elements inextricably intermingle with local and Syrian forms in the border territory along the south coast of Asia Minor.

With few exceptions, the available publications have given an all too sketchy picture of the character and the chronology of this architecture. This is particularly regrettable since in the sixth century the south coast of Asia Minor seems to have exerted considerable

impact not only along the coasts of the eastern Mediterranean, but even as far west as Italy. Apses enclosed within rectangular walls which recall the Cilician churches occur on Crete and Lesbos, in southern Palestine, and at Grado on the Adriatic shore. As at Meriamlik, projecting chapels with absidioles flank the main apse of S. Apollinare in Classe.[28]

EGYPT

In Egypt the style of the Aegean coastlands had taken a firm hold by the time the large church of St Menas was built at Abu Mina, in the Mar'yut desert west of Alexandria.[29] A huge basilica was apparently completed in 412, financed by the Emperors Arcadius and Theodosius II. It was remodelled under the Emperor

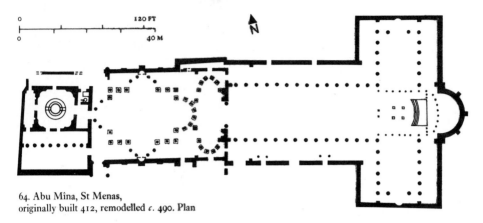

64. Abu Mina, St Menas,
originally built 412, remodelled *c.* 490. Plan

Zeno (474–5, 476–91): nave and aisles remained unchanged; the original continuous transept was enlarged into a cross transept, subdivided by colonnades; a new apse was built and a chancel laid out in front: west of the basilica, and linked to it by a colonnaded, bi-apsidal narthex; a tetraconch was set up over the presumed burial place of St Menas; and attached to it still further west an octagonal baptistery niched, domed, and enveloped by a square ambulatory was built. Only the bottom courses survive, but the layout is clear. From the outset, the entire complex was laid out on a huge scale, with lavish materials, designed to hold large crowds of pilgrims. The main church as completed by *c.* 490 was a cross-transept basilica, *c.* 66·50 m. (218 ft) long from the doors to the apex of the apse and 50 m. (169 ft) wide across the transept [64]. Nave and transept were thus extraordinarily long, while the aisles – compared to the width of the nave – were quite narrow. They continued into the transept, enveloping the wings on three sides with the transverse axis marked by a wider intercolumniation. Chancel, altar, and synthronon occupied the crossing, much as they must have done in Constantine's Apostle Church in Constantinople – presumably the ultimate source of all cross-shaped martyria, and indirectly of all cross-transept basilicas. One

would not wonder, in fact, had the plan of the Menas basilica been sent to Egypt by the Imperial Office of Works, just as a similar plan possibly went to the shrine of St John at Ephesus at the same time, and certainly to Gaza.[30] Zeno was one of the great builders among the Eastern emperors; along with the Menas basilica he financed the construction of the Thecla basilica of Meriamlik, of Qal'at Si'man, and of the church on Mount Garizim, and it seems quite possible that the sumptuous churches built in the last quarter of the fifth century in major Greek sees were in some part due to his support and encouragement. At Abu Mina part of the materials came from Constantinople. So did a number of the details: many of the capitals, whether of imported or local material, are of Aegean design [65]. The columns rise from pedestals, like those of the propylaeum of the early H. Sophia in Constantinople, though alternatingly square and eight-sided. As in Constantinople, the profiles of pedestals and door lintels are highly classical and finely worked. The colonnades in nave and transept, as in the Studios church, were in all likelihood surmounted by architraves and these in turn appear to have carried the colonnades of the galleries. The half-dome of the apse seems to have been covered with a mosaic on gold ground.

65. Capital from the Menas basilica,
fifth century.
Frankfurt, Liebig Haus

quite different from that employed in Constantinople or Ephesus – small ashlar, instead of mortared rubble with brick bands, and very thin walls.

From Alexandria the coastland style spread west and south. To the west, in Cyrenaica, it is manifest in the churches of Apollonia (Marsa Susa). The East Church of Apollonia – of *c.* 400 but possibly rebuilt at roughly the same date as the Menas basilica – retains the position of the chancel in the crossing, as well as the pedestals of the columns [66]. But the aisles are not continued into the transept wings, and (as in many Greek churches) the nave opens through

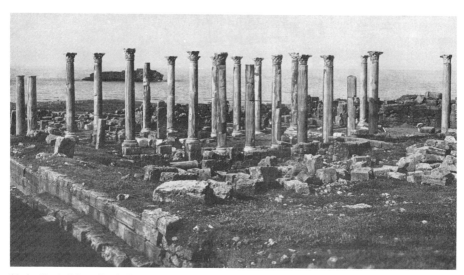

66. Apollonia (Marsa Susa), East Church, *c.* 400,
perhaps rebuilt *c.* 500. Exterior from the south-west

All these are features rooted in a tradition either specifically of Constantinople, or of the Aegean coastlands in general. Such links are not surprising in a famed sanctuary near the large port of Alexandria and favoured by the Imperial court. But it is surprising how clearly the characteristics of the Aegean style come to the fore at Abu Mina despite a building material

a tribelon into the esonarthex. After 500, the 'Central' and the 'Western' church adopt an ordinary standard basilica plan which is much like that prevailing on the west coast of Asia Minor.[31]

On the other hand, during the second third of the fifth century a church type comes to the fore in Middle and Upper Egypt which might

be called an Egyptian variant of Aegean church building: a basilica with galleries, terminated by either a triconch transept or by three apses grouped into a trilobe, the apse walls articulated by columns and niches. In the cathedral at Hermopolis (Ashmunein), presumably dating from 430-40, the nave was enveloped by aisles and galleries on three sides [67]. The colonnades of the aisles continued around the deep

arms of a triconch transept and framed the altar, well in front of the apse.[32] The enveloping movement of aisles and galleries around the nave and into the transept arms recalls the Menas basilica, and the use of trabeated colonnades is reminiscent of the architectural tradition of Constantinople. The triconch plan of the transept arms occurs here for the first time in Egypt. As it appears at Hermopolis, it per-

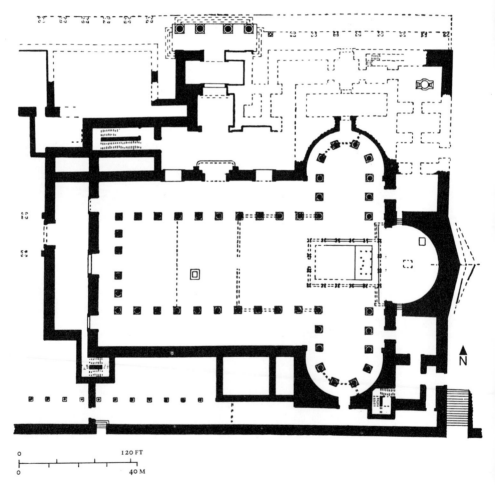

0 120 FT
0 40 M

67. Hermopolis (Ashmunein) Cathedral, 430-40(?). Plan

haps represents a fusion of the cross-transept plan with the trilobe chancel – and the trilobe chancel is a form well established in Egypt by the second quarter of the fifth century. The White Monastery (Deir-el-Abiad) near Sohag far to the south shows the plan fully developed [68]. To this day the structure is extraordinarily impressive.[33] Enclosed by huge walls, slightly sloping and built of beautifully cut large stone blocks, it has the grandeur of an Egyptian temple or, for that matter, of a Roman fortress [69]. Within the tall rectangle of the enclosure, the church is preceded by a narthex and flanked by a long hall on the south side. Both narthex and hall terminate in absidioles supported by free-standing colonnades. Inside the church, trabeated colonnades rose from high pedestals and were surmounted by a second, lower order;

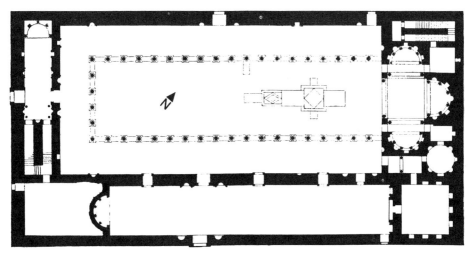

68 and 69. Deir-el-Abiad (White Monastery), c. 440(?).
Plan (above) and
exterior from the south-east (below)

0 40 FT

0 15 M

70. Deir-el-Abiad (White Monastery),
c. 440(?). Nave, aisle, and gallery level facing north

just as at Hermopolis, aisles and galleries en-
veloped the nave on three sides [70]. Profiles
and capitals are crude but clearly reveal their
classical ancestry, and the scanty remnants of
the pavement are composed of splendid white
marble and red granite plaques. The chancel
is laid out along grandiose lines: a shallow bay
with a slightly raised floor terminates the nave;
behind it rose the opening of a triumphal arch
supported by huge columns (they are hidden
within an ungainly eighteenth-century brick
wall). Through the arch one enters the chancel
proper: three half-domed apses extending
north, south, and east from a rectangular centre
bay and forming deep cavities, originally lit,
one supposes, from a clerestory below the
timber roof of the 'crossing' [71].

The layout, then, is clear despite the thorough
remodellings the structure has undergone. The
most recent alteration took place prior to the
eighteenth century, when the trefoil was walled
up to serve as the church by itself; what had
formerly been the nave was filled with the
hovels of monks and fellahin. These huts have
been removed and a few columns rise in the
empty area of the nave, over 7 m. (23 ft) high
and some still carrying Ionic capitals [70]. An-
other alteration, presumably in the eleventh
century, involved the placement of a brick dome
over the centre bay of the triconch. In an earlier
renovation, perhaps in the sixth century, the
apses were possibly rebuilt or redecorated with
columns, capitals, cornices, and gabled niches,
mainly spoils removed from earlier structures
[71].[34] The trefoil plan itself, however, may well
date from about 440 when the great abbot
Shenudi founded the monastery.

Free-standing trefoil memoriae had been
frequent during the third and fourth centuries
on pagan and Christian cemeteries. In post-
Constantinian times the type was carried on by
chapels, as they occur in large numbers in
Tunisia, occasionally in Algeria, and as far away
as Provence and the Veneto. However, thus far
the first known example of a trilobe being de-
signed from the outset to be the apse of a basilica
is the new church laid out in 401/2 by Paulinus
near the grave of St Felix at Nola near Naples.
Shortly after, it would seem, the plan was taken
up in North Italy and in Algeria.[35] Given, then,
the wide spread of the plan in western North
Africa and its dependencies across the seas –
Provence and South Italy – the triconch chancel
plan may have reached Egypt from the West.
It is possible that the trilobe served the very
same function in fifth-century Egypt which
Paulinus had assigned to its component parts
at Nola: the centre bay to hold the altar, and
the conch behind it to shelter the bishop's
throne; the left conch to serve for the prepara-
tion and the guarding of the Eucharist; the

71. Deir-el-Abiad (White Monastery), *c.* 440(?). Triconch; drawing by Freshfield

right conch to be used as a place for meditation and as a library – the latter being a regular function of the diaconicon.[36]

A local building technique and local workmanship, then, serve at Deir-el-Abiad to produce a design which fuses into a whole elements drawn from many foreign parts – elements distinct from those of Upper Egypt and distinct among each other. Constantinople may be one of the sources; certainly the Aegean coastlands are a general source; and presumably western North Africa or southern Italy as well. The church plan and the style which result from this fusion take a firm hold in the architecture of the Nile Valley. The plan of the church of Deir-el-Abiad was taken over by the builders of the Red Monastery, Deir-el-Ahmar. The church is slightly smaller; the conchs of the trefoil chancel are more closely tied together; the number of wall bays in the conchs is reduced from five each to four and three respectively. Capitals, cornices, and niche frames are uniform in style and suggest a possible sixth- rather than a fifth-century date.[37] Indeed, triconch chancels, aisles enveloping the nave on the entrance side, and apses articulated by niches, remain features characteristic of major churches in sixth-century Egypt.[38] But the decoration loses ever more of its classical tenor. A harder, local style of architectural decoration takes over. Alongside the classical and later, classicizing designs imported from across the Aegean, the local 'Coptic' decoration had been powerful in Egypt since at least the third century. But only during the sixth century does it become the dominant note of church decoration in Christian Egypt.[39]

GREECE AND THE BALKANS

Christianity had taken root in the Greek cities as early as the days of St Paul. However, among country folk as well as in educated city circles resistance remained strong even after

Constantine. The closing of the temples by Imperial decree in 395 crushed only the outward signs of paganism. A faint flavour of the old faith lingered among Greek Christians for a long time. No church seems to have risen inside Athens prior to the mid fifth century, and until 529 the University of Athens made a last-ditch stand for the old gods. In the fifth century, however, Christian congregations all over the mainland increased in number, importance, and wealth. Churches of respectable size were built even by country congregations in the mountains and on the sites of the old pagan sanctuaries. Large churches were erected in the cities along the coasts, three, four, and five at a time. Their plans and their decoration mark them as a separate group, though linked to church building both in the eastern Mediterranean – from Constantinople to Egypt – and in North Italy, where Milan remained the leading centre.[40]

This double-headed impact is only natural. Greece was a seafaring country and her cities thrived on commerce. The ports along her east coast had the closest contact with the Imperial capital and with the great and small trading centres along the coast of Asia, from Ephesus to Antioch and Gaza, on the islands of the Aegean Sea, and as far south as Alexandria. Salonica soon grew to be a 'Little Byzantium', a cultural, intellectual, and architectural outpost of Constantinople. Even a minor seaport such as Nea-Anchialos (Thebes) in Thessaly apparently imported its architects and part of its architectural decoration straight from Constantinople. So did a great city such as Corinth; but here the elements from across the Aegean Sea mingled with features drawn, it seems, from Italy. No wonder this either. Like all the western ports of Greece as far north as Epirus, Corinth had close links of trade and navigation with Ravenna and Milan as well as with Constantinople and the Asian coastal centres. These commercial ties were strengthened by ecclesiastical

bonds. As late as the middle of the fifth century the Balkans, including Greece, were claimed by the Roman See as its spiritual domain, and they were in fact subject to the diocese of Milan in the last decades of the fourth century.

The twofold impact from East and West makes itself felt in church building in Greece as early as the end of the fourth and the very beginning of the fifth century. As far east as Epidauros, Eastern and Milanese features were joined in the plan of a church built on the outskirts of the sacred precinct of Aesculapius, just closed down by Imperial decree.[41] The

(200 by 150 ft) – it can never have been very impressive; but it does show the absorption in Greece of many traits from abroad [72]. The transept is divided lengthwise by short column screens into five sections. The bema occupied the centre compartment; the adjoining sections were well adapted to hold the supernumerary clergy; and the outer sections, slightly raised above the inner ones and communicating with the aisles only by doors, lent themselves to the deposition of the offerings. Thus, the plan of the transept recalls S. Tecla in Milan, where about 350 the dwarf wings of the chancel had

72. Epidauros, basilica, c. 400. Plan

style of the pavement mosaics in nave and narthex leaves little doubt regarding their date, about 400. Of the church complex, only the foundations and a few walls have survived, barely a foot above ground and of poor workmanship. In fact, despite its size – 60 by 45 m.

been raised to form a tripartite transept and repartitioned into five sections. Other traits of the plan, however, find their parallels in the architecture of the eastern Mediterranean. The plan of the nave with four aisles is obviously rooted in Constantinian and post-Constantinian

custom. Yet with this tradition, the choice of supports at Epidauros – columns in the inner row, piers in the outer – points to Eastern models, such as the martyrium at the Holy Sepulchre. Decidedly Aegean in planning and style are, finally, the atrium enveloped by chambers – the functions are unknown; the propylaeum in front; the long, closed narthex, with its side rooms pushed outwards; the rectangular baptistery; and the mosaic carpets in atrium, narthex, nave, and outer transept.

At the same time as the quinquepartite transept at Epidauros, or not much later, a transept type of purely Eastern origin makes its appearance in a church just outside the city walls of Athens: the basilica on the Ilissos Island.[42] Datable to about 400 through the pattern of its mosaic floor, and in no case later than 450, its plan is clear: a 'reduced cross transept', its wings enveloped by aisles along the western and the short sides, a dome or pyramidal roof over the centre bay. Obviously the plan, though apparently earlier, finds its closest parallel in the Menas basilica; ultimately it may go back to Constantinople.

Finally, the remnants of a third extraordinary structure dating from the early fifth century rise in the very centre of Athens, inserted into the courtyard of the Library of Hadrian [73].[43] Its quatrefoil plan calls to mind S. Lorenzo in Milan, with its square centre room, its billowing exedrae, its ambulatory and surmounting gallery. The plan is modified only slightly in Athens: the eastward lobe and ambulatory are replaced opposite the entrance by the semicircle of an apse; the columns of the three other lobes rise from stylobates slightly raised above the level of the mosaic floor in the ambulatories; and a huge narthex enclosing a staircase leads into the building. But it is by no means certain that the tetraconch was laid out as a church: it may as well have been a lecture

73. Athens, Tetraconch, Library of Hadrian, c. 400

hall or the audience hall of the provincial governor.

However, all three buildings – the churches at Epidauros and on the Ilissos Island and the quatrefoil in the Library of Hadrian, whatever its original function – stand out as exceptions in the architecture of late-fourth- and early-fifth-century Greece. The normal type, found in dozens of churches from the fourth far into the sixth century, was a simple basilica. Notwithstanding the usually small size and the poor decoration, this standard basilica shares some essential features with the churches along the west coast of Asia Minor. An atrium and exonarthex form the approach. The nave is flanked by two aisles. The colonnades are raised on stylobates and – a feature perhaps proper to Greece – the intercolumniations are closed by parapets. A short chancel projects into the eastern bays of the nave, a synthronon fills the hemicycle of the apse, the ambo stands in the

nave, often off axis. Deviations seem to follow local Greek custom. Contrary to Constantinopolitan habit, the apse tends to be semicircular both inside and out. The colonnades are surmounted not by entablatures, but by arches resting on impost blocks. The esonarthex communicates with the nave through a triple arch, a *tribelon*. Finally, one or two rooms jut out from the end of the narthex, one apparently a diaconicon where the offerings of the congregation were received. Apparently no distinction in planning was made between parish churches and cemetery basilicas. In Greece, it would seem, the two types had become fully assimilated to each other by the early fifth century.

A rural church excavated near Vravron in Attica represents one among many such standard basilicas.[44] The columns had fallen, but some have now been replaced on their stylobates, together with the crudely designed Ionic capitals and impost blocks [74]. Atrium,

74. Vravron, basilica, fifth century. From the north-west

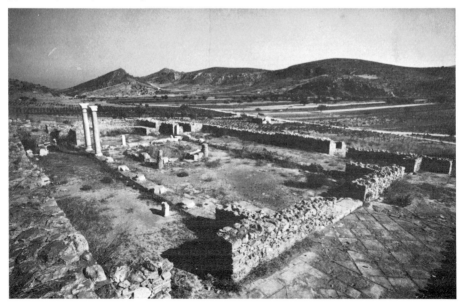

outer narthex, nave, aisles, and chancel are still clearly visible, as well as a small round baptistery adjoining the right flank. Just as typical of the Greek mainland is the masonry: mortared rubble, interspersed with brick bands and strengthened by brick corners, the surface criss-crossed by a network of wavy trowel lines. Also preserved are large remnants of a decoration remarkably rich for a small rural church: the nave is paved with marble slabs; door sills and the base of the chancel screens are of red and white marble; a colourful painted imitation of marble revetment covers the walls of aisles and narthex. Finally, on the walls of the baptistery remain traces of a genuine marble revetment, surmounted by a stucco decoration of twisted colonnettes, cornices, roundels, and peltae. The liturgical arrangements – altar, synthronon, and the footings of the bema enclosure – still exist in a good state of preservation.

Such simple plans remain standard. By the second half of the fifth century, however, they have become overshadowed by the upsurge of a new, lavish church architecture in the major centres. The size of the structures increases, the decoration becomes richer, the plans show greater complexity. Under the impact of Constantinople, basilicas with galleries come to the fore, yet with characteristic differences. The Acheiropoietos in Salonica transposes its prototype – the Studios church – into a looser key with a taller and longer nave, lighter arcades, more complex diagonal vistas. Basilicas with cross transepts become frequent, their enveloping aisles surmounted by galleries. Tripartite-transept plans come into common use; atria, nartheces, annexes become more elaborate; the site is integrated with the design of the building complex. The plans are not new. One recalls the quinquepartite transept plan of Epidauros, the cross transept of the Ilissos basilica, the quatrefoil in the Library of Hadrian – all dating

from about 400 or slightly later.[45] But only towards the end of the fifth century are the stylistic potentials of these plans fully exploited. It is as if the earlier types had been resuscitated on a more complex level. Enriched through the double-zone elevation with galleries, the design no longer seems only a response to liturgical requirements but a sheer enjoyment of a sophisticated architecture. Few buildings of the 'new wave' are dated by inscriptions, but their capitals, friezes, and mosaic and marble pavements leave little doubt that in their great majority they were erected between 470 and 530.

The excavation during recent years of large Christian sites, each with a number of churches, testifies to the wealth of the Greek cities and the lively building activities of the congregations. It also gives visual evidence of the high standards of architectural design, the inventiveness of builders and patrons, and the lasting close links of Greek to Constantinopolitan, Aegean, and Milanese church building. In Nea-Anchialos (Thebes) in Thessaly, four churches have come to light, all sumptuously decorated with finely-worked capitals, chancel screens, floor mosaics, and marble pavements. At Corinth, three huge churches have been explored so far, and remnants of others await excavation. At Nikopolis in Epirus four churches have been found; at Philippi in Thrace likewise four are fully known so far, at Amphipolis at least three. In Salonica two huge churches of the fifth century have survived nearly in their entirety, retaining large parts of their original decoration. All these buildings have in common a complexity of design and a lavishness of decoration, but they differ in plan according to their location. Corinth and Nikopolis on the west coast retain Milanese features; Salonica turns to Constantinople and to Ephesus on the coast of Asia Minor. From Salonica, in turn, church plans spread south, east, and north: to Thessaly, Thrace, southern Yugoslavia, and Bulgaria.

Among the churches excavated at Nea-Anchialos, the largest (Basilica A) - presumably the bishop's church - is close in date and plan to both the Acheiropoietos in Salonica and the Studios basilica in Constantinople. A long eso-narthex, continued by rooms off either end, opened into the nave through the triple arcade of a tribelon and thus enveloped it as a short third aisle - the same plan as found in the Acheiro-poietos [75]. The columns between the nave and

Studios church, the church at Nea-Anchialos was preceded by an atrium, far richer than that at Constantinople. Three colonnaded porticoes surrounded the open centre part, the terminating colonnade to the west curving back in a hemicycle; long apsed rooms flanked the sides - to the north a baptistery, to the south a diaconicon (or prothesis) containing offering tables. The front corners of the atrium were formed by two square rooms; they enclose staircases and have

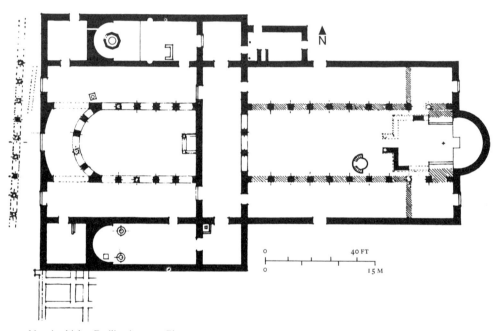

75. Nea-Anchialos, Basilica A, c. 470. Plan

aisles rose from stylobates elevated above the pavement level, and the intercolumniations were closed off by parapets; likewise, parapets crossing the aisles closed off the eastern bays. Arches, not architraves, sprang from the columns and a gallery surmounted each aisle - again all features found in the Acheiropoietos. However, as in the

been tentatively reconstructed as low towers. The capitals, all sumptuous, were subtly chosen with different designs for different parts of the building complex. To the atrium are assigned Corinthian capitals with dry, sharply cut leaves, their points separated by the dark shapes of triangular and rectangular interstices ('leathercut'

76-8. Nea-Anchialos, Basilica A, *c*. 470.
Capitals from the atrium (*top*),
the tribelon (*centre*), and from a window pier (*bottom*)

capitals) [76]. The tribelon capitals are deeply undercut with 'Theodosian' leaves in a lower zone surmounted by the half-figures of lions ('two-zone protomai capitals') [77]. The nave and galleries both have capitals with impost blocks, the former 'Theodosian', the latter, as well as those of the window piers, fused into Ionic impost block capitals [78]. Some of the capitals, of Proconnesian marble, were presumably ordered ready-made from the Imperial quarries on the islands in the Sea of Marmara. Others, of local stone, are yet so close to Constantinopolitan models as to suggest the hand of workers called in from there. No less sumptuous than the capitals were the flagstone pavement of nave and aisles, the marble revetment of the walls, and the liturgical furniture. A fountain (*phiale*) rose in the atrium, surmounted by a canopy with superbly carved foliate friezes. The chancel, projecting far into the nave, was bounded by screens carved with intricate geometric and foliage patterns. Along the sides of the chancel, two straight clergy benches supplemented the high-rising synthronon of the apse; the altar in the bema was under a canopy; the pulpit rose from its circular base outside the chancel in the nave. Following Constantinopolitan custom, doors open from the eastern ends of the aisles. The elegance and refinement of plan and decoration are in no way inferior to the Studios church in the Imperial capital.[46]

The type of the Acheiropoietos in Salonica and of Basilica A at Nea-Anchialos penetrated into southern Yugoslavia and Bulgaria. Like the Greek churches, the bishop's church at Stobi in the Vardar Valley (originally laid out around the middle of the fifth, but rebuilt in the first quarter of the sixth century) was a basilica with galleries, colonnaded arcades closed in by parapets, an atrium, and a narthex. The narthex opened into the body of the church through doors, as in the Studios church, rather than through a tribelon; but as in so many Greek basilicas the area of the narthex was subdivided

by column screens into three bays. Mosaic pavements, wall paintings (both decorative and figural), and presumably a mosaic in the half-dome of the apse completed the picture. Similar church plans of apparently fifth- or sixth-century date, with or without galleries, have been excavated all over the Balkans. Occasionally the standard type was modified. The supports are sometimes piers rather than columns.[47] At Stobi, a crypt extended below apse and chancel,

its semicircular core ringed by a colonnaded corridor. Now and then the outer narthex seems to have been flanked by twin towers, pushed sideways much as in the Acheiropoietos, or else sacristies extend sideways from the ends of the aisles, thus recalling the plan of Constantine's Lateran basilica.[48]

Sumptuous though they are in their best examples, in Salonica or Nea-Anchialos, such basilicas remain comparatively simple in plan.

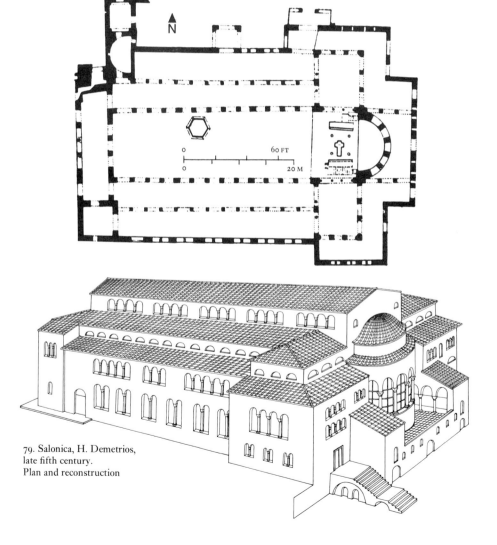

79. Salonica, H. Demetrios,
late fifth century.
Plan and reconstruction

Alongside them, however, basilicas with cross transepts come to the fore as a hallmark of fifth- and early-sixth-century church building in northern Greece and the Balkans. When the plan was first taken up in the Ilissos basilica early in the fifth century, its elevation may have been quite simple. In the last years of the century it appears fully matured in H. Demetrios in Salonica; from there it spread shortly after 500 into Thrace and northern Macedonia, and then on into Bulgaria as far as the coast of the Black Sea.

H. Demetrios in Salonica represents the type of the cross-transept basilica at its best, its most complex, its most lavish.[49] To this day it remains one of the most impressive churches in the Aegean coastlands, more than 55 m. (180 ft) long [79]. The building burnt down in 1917 and was replaced by a replica, incorporating the ruined remains, but both purist and pretentious – the interior whitewashed, the exterior faced with intermingled brick and stone blocks. To distinguish original parts, early rebuildings, and modern additions, is fraught with difficulties.

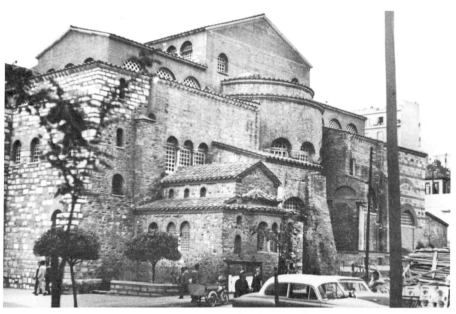

80 and 81. Salonica, H. Demetrios,
late fifth century.
Exterior of apse and transept (*above*)
and interior of nave as in 1960 (*opposite*)

However, the plan, considerable stretches of the outer walls, large numbers of columns and capitals, transept and apse, and finally the tribelon wall at the west end of the nave, splendidly decorated, substantially survive from the original fifth-century structure; until 1917 also the arcade between the two north aisles remained in place. An esonarthex, now flanked by low towers, precedes the body of the structure. Transept wings slightly lower than the nave project side-

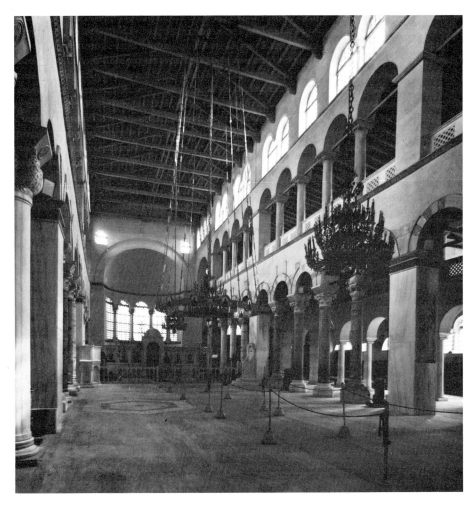

ways in front of the apse [80]. Nave and wings are enveloped by the continuous flow of esonarthex, aisles (doubled along the nave), galleries, and low clerestory windows. The chancel encloses the altar, and was originally linked by a solea to the pulpit far down near the beginning of the nave. The grave of the saint is relegated to a crypt: extending below the south transept wing, it was the spiritual but no longer the architectural focus of the building. In the nave, a sophisticated rhythm of supports, arcades, windows, and a sumptuous decoration reinforce this complex plan [81]: an alternation of pier and column groups gives a sequence of four, five, and four – a rhythm echoed by that of the gallery zone. In the clerestory zone, the rhythm of the windows originally planned remains in doubt. To be sure, the nave was rebuilt after a major catastrophe in the first third of the seventh century [82]. Column shafts, bases,

capitals, and the marble revetment of the arcades are spoils, hastily thrown together. Except, though, for a few fold capitals of clearly sixth-century date – twins of those at H. Sergios and Bakchos – the majority of the capitals appear to have come from the original fifth-century church: Theodosian capitals, double-zone capitals with protomes, eagle capitals, capitals with windblown leaves [83].

The capitals in the gallery zone – copies at present – were originally all Ionic impost capitals. Indeed, the rhythm of piers and columns, too, may have been planned from the outset and have been retained in the rebuilding. The original decoration of the nave is best reflected by its western tribelon wall: *verde antico* columns on Attic bases, Theodosian capitals, marble-sheathed piers and voussoirs, alternatingly red

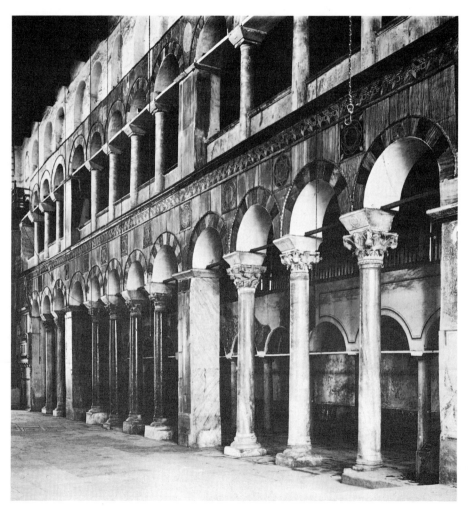

82. Salonica, H. Demetrios, late fifth century. North wall of nave prior to 1917

and green, elegant dwarf pilasters rising from the spandrels. Large parts of the decoration and certainly the plan would still seem to date from the fifth century, including a change already during construction: arcades and walls, projecting eastwards on either side of the apse, suggest that at first, instead of the apse, a rectangular chancel enveloped by an ambulatory was envisaged.

83. Salonica, H. Demetrios, late fifth century. Capital of the nave

The foundation of H. Demetrios has been traditionally assigned to the years 412-13, but all evidence points to a date in the last (or perhaps the third) quarter of the fifth century for the original building - the capitals, the patterns of the marble revetment as preserved in the tribelon wall, the brickwork of the piers with broad mortar joints. The seventh-century rebuilding, in our opinion, did not alter the original design in its essentials.

The impact of H. Demetrios made itself felt throughout northern and eastern Greece and the Balkans. In a cross basilica on Thasos, the aisles not only envelop the transept wings, but continue along the chancel arm much as was planned at first for H. Demetrios. At the same time, the reduced cross-transept plan makes its appearance at Tropaeum on the Black Sea coast, and at Philippi, midway between Salonica and Constantinople - one of the greatest Christian sites in the Aegean and still under excavation [84].[50] Of Basilica A at Philippi only the plan and fragments of the decoration - suggesting a date about 500 or somewhat earlier - have survived, and they give the impression of extra-

84. Philippi, site facing south. Basilica A, c. 500; octagonal church, c. 500; Basilica B, shortly before 540

ordinary splendour. The vast atrium, preceded by a forecourt, was approached from the south by stairs. Its west wall, articulated by niches, formed a monumental fountain. Across the entire east end of the atrium ran a broad flight of stairs ascending to the narthex. Components of the building complex were all laid out on different levels, and the visitor gradually ascended to exonarthex, esonarthex, aisles, and galleries to view the celebration of the Great Mystery which was performed in the central space of nave, transept, and apse, the former two cut off from the

window piers carried splendid capitals. A narthex linked up on either side with a colonnaded street was entered by a sumptuous gabled triple portal. A richly decorated baptistery, a fountain court, a small bath, and other rooms adjoined the church; the bishop's palace, if that it was, extended behind. The type of the church is rooted in the tradition of centrally-planned martyria, such as the church of the Virgin on Mount Garizim (Gerizim) (484) or the martyrium of St George at Izra (Zorah) (515) in Syria. However, by 500 the plan had long migrated from the

85. Philippi, octagonal church,
c. 500. From the north-west

aisles by parapets. At the same time, even more exceptional church types make their appearance at Philippi. Only recently a large and splendid octagonal church has come to light dating perhaps from about 500 or even somewhat later. Columns supported the walls and the roof of the centre room [85]. The encircling ambulatory, likewise octagonal, is supplemented by niches in the four corners and by an apse projecting from the wall of the enclosing square. Huge marble plaques cover the floor of the centre room, the apse, and the intervening bay of the ambulatory, while its other seven sectors are paved with an elegant *opus sectile*. Columns and

realm of martyria into that of ordinary churches and, indeed, the liturgical layout of the Philippi octagon – the bema projecting from the apse and piercing the width of the ambulatory; the ambo near the middle of the centre room – suggests in no way that it served as anything but a parish or bishop's church, despite its extraordinary plan.

Quatrefoil structures with ambulatories are likewise revived around 500 in the eastern Balkans, possibly within the framework of a renascence of building types well known a century earlier but only now fully exploited. The ruin of one such structure, called the 'Red Church', still

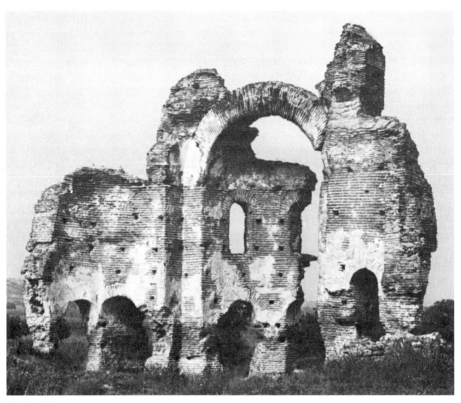

86. Peruštica,
Red Church, early sixth century

towers high on a hill near the village of Peruštica (Peroushtitsa) in Bulgaria, not far from the town of Plovdiv [86].[51] The plan with its out-size narthex and simple apse at the opposite end at first glance recalls the quatrefoil at Athens. But it has been greatly reduced by limiting the ambulatories to the north and south lobes, by replacing the colonnades of the exedrae with heavy piers, and by renouncing the galleries above the ambulatories. The brickwork and the few remnants of capitals and chancel screen suggest a date in the early sixth century. A fully developed quatrefoil church, on the other hand, possibly of the same time or earlier, still stood

with ambulatories and galleries at Adrianople only sixty years ago. But it has since been razed, and only a few photographs and a sketchy plan testify to its grandeur.[52]

Cross-transept and quatrefoil plans were re-vived around 500 apparently in north-eastern Greece and in the eastern Balkans. At the same time, tripartite transepts came to life anew in the architecture of the Greek west coast, from Nikopolis in the north to Corinth in the south. This is not too surprising. A tripartite transept plan had been developed by 350 in Milan and taken up in Rome by 450 – and western Greece maintained close trade links across the Adriatic

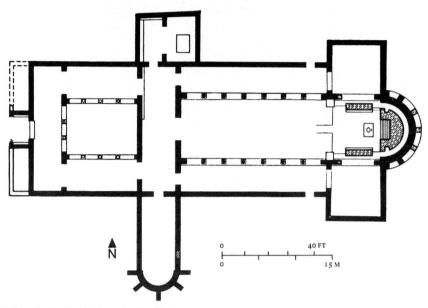

87. Nikopolis, Basilica A (Dumetios Basilica),
sixth century (second quarter). Plan

Sea. Three churches in Nikopolis – dating from roughly the same time (Basilica B, the 'Alkison basilica,' prior to 518, Basilica D, perhaps contemporary, Basilica A, the Dumetios basilica, from the second quarter of the sixth century) – show the layout of such tripartite-transept basilicas.[53] The transept wings, possibly lower than the nave, communicate with the centre bay through either a triple arcade or a single wide arch [87], with the aisles (doubled in Basilica B) through simple or double arches, the latter closed, it seems, by parapets; a diaconicon (or prothesis?), as a rule, is attached or close to the narthex. The churches of these port cities are less monumental than those of either Philippi or Salonica, but they are more precisely outlined. Doors, not column screens, lead from the narthex to the nave and aisles; the apse is raised a few steps above the chancel and buttresses both strengthen and articulate its walls; piers, counter-piers, and arches clearly set off the separate spatial volumes. Even the walls convey an impression of clarity and solidity quite different from the thinner, heavily pierced walls of churches in north-eastern Greece. The thick, solid walls at Nikopolis are built of pure brickwork, with bricks, as at Milan and Ravenna, up to 8 cm. (3 in.) high. Only the rich figured pavement mosaics link Nikopolis to the colourful architecture of the Aegean coastlands.

In the great church of H. Leonidas at Lechaion, the harbour suburb of Corinth, this tripartite-transept plan was transposed into a less rigid and far richer key. The ruin of the basilica was excavated from 1955 to 1965 and is preserved but two feet above ground, but it is still one of the most impressive sights of Early Christian Greece.[54] Forecourt, atrium, and basilica followed one another – totalling 186 m. (610 ft) in length, 600 Byzantine feet. The basilica consisted of nave and aisles, tripartite transept with projecting wings, and a huge half-

domed apse [88]. Two rows of large windows originally pierced the wall of the apse; fragments of their arches and of the spandrels of the apse vault survive. A row of niches along the foot of nating at the foot of the pulpit. The transept wings, set off from the centre by arches, fall into two sections. An inner section, communicating with the aisle through a triple intercolumniation

88 and 89. Corinth-Lechaion, H. Leonidas, 450–60(?) and 518–27. Plan (*above*) and view from the west (*below*)

the apse sheltered thrones for the clergy in lieu of a simple synthronon. Four huge piers and columns in the corners of the centre bay of the transept would have supported a timber-roofed tower or a wooden dome on four arches. The bema below is well preserved; altar site, chancel screens, lateral clergy benches, and solea remain – the solea projecting far into the nave and termi-

closed by parapets, was possibly intended for the offertory, while the narrow outer section, raised one step – but screened off by columns and thus similar to the transept arrangement in the Constantinian St Peter's in Rome – possibly served as a sacristy. Along the nave, high stylobates carried the colonnades and their marble shafts, 0·61 m. (2 ft) in diameter [89].

90–2. Corinth-Lechaion, H. Leonidas.
Pavement (*top*),
nave capital (*centre*),
and Ionic capital (*bottom*),
450–60(?)

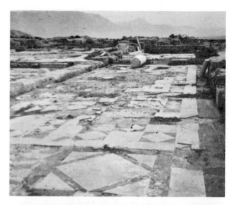

Parapets closed the intercolumniations, pierced only by two entrances near the façade. Galleries may have risen above the aisles, but this is not certain. The esonarthex opened towards the nave in a quintuple arcade while the exonarthex was approached across the atrium – a monumental colonnaded hemicycle which curved behind a fountain and was preceded by an outer forecourt.

Within this grandiose layout every detail was executed with superb workmanship. The walls – mortared rubble with a criss-cross mortar design at the bottom, and pure brickwork higher up – were built with mortar-beds up to 6 cm. ($2\frac{1}{3}$ in.) wide and were covered with fine plaster. The apse vault carried a mosaic; even the outer wall of the apse was painted. The pavement of nave and chancel, still preserved, is composed of huge marble plaques – grey streaked with green, framed by dark grey marble battens, while in the aisles and transept wings plaques of dark and light marble form geometric designs of diamonds and squares [90]; the capitals throughout the basilica point to a fifth-century date [91, 92]. Some are of 'Theodosian' design, others are Ionic impost block capitals with varying foliate design. A date between 450 and 460 seems likely for the start of building; construc-

tion on a building of its size may have gone on for a long time; the atrium and forecourt might well have been completed just prior to the earthquake which ravaged Corinth in 551. Indeed, every detail of the structure is so splendidly preserved as to raise doubts whether the building was used for any length of time.

The Lechaion basilica presents the plan of a basilica with a tripartite transept in an extraordinarily rich and sophisticated language. The sections of the transept, the aisles, and the centre bay are all placed on different levels, and the screens of columns which originally separated them display a variety in rhythm, spacing, and height. Light and shade play over the deep carving of the capitals. The patterns of the pavement slabs in purple and light and dark grey must be visualized against the lively colours of mosaics and wall paintings, of which only scarce remnants survive. All told, the rich and complex architectural concepts of the Lechaion basilica rival the architecture of the other great Aegean centres, whether Constantinople, Salonica, Ephesus, or Philippi. By 500, Christian architecture has reached a peak in Greece – was it due to Imperial support? – and, except for Constantinople, it far outshines the other provinces of the eastern coastlands.

THE INLAND COUNTRIES

The architecture of the Aegean coastlands, both ecclesiastical and domestic, left its traces all over the Near East. Even on the high plateaus inland, fertile throughout antiquity, and across the desert, its impact is felt wherever the Imperial administration took a hand in backing lavish building activities. Its influence is seen even more clearly in the hellenized cities dotting the coast and the caravan routes from Antioch to R'safah on the Mesopotamian border. Yet even in the most hellenized buildings of the inland countries, the architectural designs absorbed from the coastlands were clothed in a vocabulary and built in materials and in a technique alien to the style in which they had originated: a construction in heavy stone blocks encasing a narrow core of rubble masonry; and a solid, somewhat rustic ornament. It becomes clear that in such buildings designs drawn from the Aegean coastlands were constantly vying with, and threatened by, an architecture which was rooted in local tradition.

The native architecture of the Near East drew its strength not from the cities, but from the vast rural areas of the hinterland.[1] Autochthonous in custom and population, speaking Syrian, Aramaic, Cappadocian, or other native dialects, the countryside – beyond a narrow coastal strip – remained relatively impervious to the culture of the Roman-hellenistic cities. Concomitantly, the architecture of these rural areas shows a style distinctly its own. It has been suggested that the style, the plans, and the vocabulary of these country buildings – houses as well as churches – had migrated into the countryside from the great urban centres. True, these rural areas occasionally absorbed architectural forms from Greek cities, such as Antioch or Constantinople. But such outside inspiration seems to have been subsidiary. It is just as likely that the architecture of the hinterland was locally conceived by rural masons active in the market towns, villages, and monastic centres all over the area; numbers of these masons are known by name from building inscriptions.[2]

The strength of the village organization, at least in Syria, and of the monastic movement all over the Near East cannot be overrated. Monophysite monasticism, strongly opposed to hellenization, romanization, and the dogmatic compromises of Constantinople, was nourished from Nisibis (Nusaybin) from the late fourth century and dominated the hinterlands of the East. Even now hundreds of their monasteries are preserved in ruins. Monastic congregations and villagers were jointly responsible for the majority of church buildings, and the borderline between parish and monastic churches is, if traceable, as a rule insignificant.

The usual building material of this inland architecture is the local stone, cut into large blocks [95]; small stones or rubble masonry are used but rarely. These blocks, in Anatolia and Armenia, encase a core of rubble masonry; in Syria they comprise, as a rule in double courses, the full thickness of the wall. The supports are piers, columns, or piers with half-columns attached. Bases, column shafts, and capitals are of local execution, not imported as they often are in the Aegean area, and but rarely pilfered from older buildings as was the rule in Rome. Where wood was available, timber roofing was the rule. Elsewhere, buildings were vaulted – groin-vaulted or domed, as was the custom from the second and third centuries. Occasionally roofing is achieved by huge stone slabs. Vaulting,

however, was the result not of choice but of necessity. Writing about 380, Gregory of Nyssa pointed out to the bishop of Iconium (Konya) 'since in our part of the world we have no timber, we will have to vault the octagonal chapel projected'.[3] To consider vaulting an improvement over timber roofing is a nineteenth-century prejudice and must be discarded in this context.

Building materials and practices support the architectural style of the inlands, but they do not create it. Whether full ashlar or rubble faced with stone blocks, the impression remains unchanged. Interior space is played down: arcade and clerestory zones are poorly articulated, supports heavy and squat, windows small. While the interiors need not always have looked as stark as they do today, their wall paintings and floor or apse mosaics (where, and if, they existed) were quite simple. The exterior of the building, on the other hand, becomes the basis of a design of powerful composite masses, joined together in block units. The units are strongly articulated. Nave and aisles, base zones, walls, and roofs, and the successive storeys of a tower are set off against each other by cornices, eaves lines, and string courses, just as openings, windows, and doors are set off by strong frames.

The profiles of frames and cornices, capitals, and the bases of columns and piers are classical, if crude in design. Yet in contrast to the alive and ever-evolving classical approach of Constantinople, the Aegean coastland, and the hellenized cities of the hinterland, the classical vocabulary of the rural areas remains by and large stationary. Always a foreign element in the Near Eastern hinterland, Roman-hellenistic architecture and its vocabulary are used for centuries in unchanged provincialized form to denote the higher strata of architecture, temples and public buildings. Forms created in the provincial art of Roman Syria in the second and third centuries are retained often into the sixth century. The conservative populations of the uplands cling to the same vocabulary in decorating their sacred buildings, be they dedicated to a local divinity, to a Greek, a Roman, or the Christian god.

Notwithstanding the common stylistic characteristics, a multitude of church types develops in the hinterland of the Near East; timber-roofed basilicas, supported by colonnaded arcades; barrel-vaulted basilicas and barrel-vaulted hall-churches; cross-shaped churches; octagons; aisleless churches, covered by barrel-vaults or by stone slabs placed on transverse arches. Given the vastness of the area and its fragmentation by mountain chains and deserts into isolated districts, it is natural that types and variants in building technique should become standard within their own comparatively small districts – northern and central Syria, the Haûran in southern Syria, Central Lycia, Lycaonia, Cappadocia.

As in the Aegean coastlands, the architecture of the cities in the Near East is known primarily through the fragmentary evidence of excavations. In the hinterland, on the other hand, great numbers of buildings have survived to this day, many almost fully preserved. This is due in part to the depopulation of the countryside from the seventh to the end of the nineteenth century. As a result of re-population, the number of surviving buildings – numbering many hundreds still half a century ago – is rapidly diminishing through popular ignorance and governmental indifference in many, though not all, parts of the Near East. Church architecture in the uplands of Syria and Asia Minor, nevertheless, presents a more complete picture than in most other regions of the Early Christian world. Moreover, many of these buildings bear inscriptions giving the date of construction and at times the names of the founder and the architect. Thus the historical development in a province such as Syria becomes remarkably clear.

The chance preservation of large numbers of buildings in regions abandoned or sparsely settled for centuries has led to a curious situation.

Rediscovered in the formative days of a modern history of architecture – Syria in the 1850s, Asia Minor between 1890 and 1910 – the frequently untouched structures of the hinterland became better known than buildings in large parts of the Latin West and the Aegean coastlands. Moreover, the customary nineteenth-century approach to the history of architecture, still surviving in the twentieth century, was grounded in a concept of technical progress. It worked with vague analogies between building types or details, established on paper without regard to context, scale, quality, concrete design, or historical situation. Hence the heavy, cramped, but as a rule small Syrian churches with their twin-tower façades could be viewed as leading up across a gulf of six hundred years to the huge Romanesque cathedrals of France with their freely organized plans and memberings. This misconception was reinforced by the impact which the first scholarly publication on Syrian building made on French and American architects of the last third of the nineteenth century, such as Labadie and Richardson. During the last fifty years such misjudgements on the architecture of the inlands of the Near East – as to quality, size, and its historical place within the context of both Early Christian and medieval church building – have continued and proliferated. The small cross churches in the highlands of Asia Minor have been interpreted as the fountain-head whence sprang all the decisive elements of medieval church building in Europe. Cappadocia, it is said, gave to Early Christian Palestine, Greece, and Italy, the cross martyrium, the cross transept, and the tripartite transept; to Byzantium, the 'domed basilica'; and to Romanesque France, England, and Germany, the crossing tower, the segregated crossing, the fully developed individual three-bay transept, and the 'square schematism' of the church plan.[4]

Individual features could easily have penetrated without a time lag from the inland countries to the West. The motif of the centre tower could have been carried from Asia Minor to Central Europe and taken root in pre-Carolingian times in the context of small cross churches. Similarly, the twin-tower façade could possibly have penetrated Carolingian Europe from Syria.[5] But by and large, the champions of the Eastern hinterlands as *the* fountain-head of Early Christian, Byzantine, and Western medieval architecture have overshot the mark. Resemblances of plan on paper, regardless of scale, are not historical reality. Gaps of half a millennium between the putative forebear and the offspring are not easily bridged, unless there are unquestionable intermediaries. Nor are links between countries far apart in place and culture – such as Muslim Syria and the Christian West – lightly postulated in the absence of evident means of transmission. Is it, after all, really necessary to speak of dependence and influence wherever a resemblance exists between two styles distant in time and place? Is not a design in solids simply one of the possible architectural concepts which repeats itself in history? We leave the question open and turn to a discussion of the buildings.

SYRIA

Syria had been among the most flourishing provinces of the Roman Empire. Permeated by Roman-hellenistic culture, its great urban centres rose on the coast and along the caravan routes. The hinterland had been one of the rich agricultural reservoirs of the Roman world, producing grain and oil. Nor did its economic or cultural situation change from the fourth into the early seventh century. Only after the conquest of Syria by the Muslims did its rural economy collapse.[6]

The architecture of the cities is closely linked to that of the Aegean coastlands. In culture, nationality, and speech, the upper strata of the urban population were romanized Greeks, and

in their buildings, as well, they naturally leaned towards the plans and the architectural concepts which prevailed all along the shores of the Aegean Sea. Indeed, houses and churches in the large cities of Syria are nearly indistinguishable in plan from those known in Constantinople, Ephesus, and the Greek islands.

From the fourth to the end of the sixth century, the wealthy city houses of Antioch on the Orontes, with peristyle courts and elaborate, colourful mosaic floors, held to a type which had been traditional for nearly half a millennium. The situation holds for church buildings as well. The standard basilicas in the cities were of established Aegean plan: their naves wide, preceded by atria and colonnaded nartheces, their floors carpeted with mosaics, their apses closed outside in three sides of a polygon.[7] At times, basilicas with galleries appear inland even in minor urban centres along the caravan routes. But the type may just as well have been brought to Syria from Constantine's basilica

at the Holy Sepulchre, itself apparently a product of the court architecture of Constantinople.

Little is known about the ecclesiastical buildings in post-Constantinian Antioch. The only major churches known at least from excavations are a basilica at Antioch-Ma'chouka, the cross martyrium at Kaoussié, and a late-fifth-century quatrefoil at Seleucia-Pieria (Samandağ), another suburb.[8] Roughly 36 m. (120 ft) in diameter, the quatrefoil must have been an imposing structure, richly decorated and spacious [93]. In plan it recalls the earlier and somewhat larger church of S. Lorenzo in Milan, with the only difference that a deep chancel or apse projected from its eastern wall. The four exedrae of the inner quatrefoil expanded freely, supported by columns. Marble pavements covered the centre room, mosaics paved the ambulatory. No evidence of galleries was found, and it is quite possible that the ambulatories, like those at Peruštica, were single-storeyed and, like the centre room,

93. Seleucia-Pieria (Samandağ), martyrium(?), late fifth century. Plan

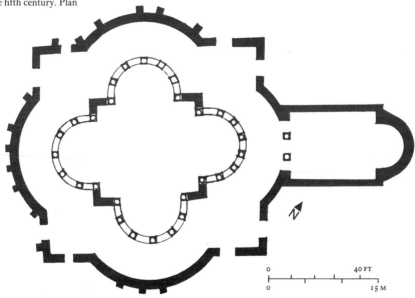

covered with a timber roof. Whether or not the structure was a martyrium is likewise open to conjecture. Clearly, the quatrefoil of Seleucia-Pieria does not represent the style of the inlands of the Near East. Plan and design are based on concepts well established in the Aegean by the end of the fifth century: a double-shell design; spaces freely expanding in contrasting volumes – cubes, half-cylinders, cylinder segments, column screens rather than walls; colourful decoration; complex interior views. Plan and design, however, may be rooted in a Constantinian tradition firmly established at Antioch: the Golden Octagon, whether octaconch or tetraconch. In the sixth century, possibly in a revival, the type took root in the hellenized urban centres: at Apamea (Qalaat el Mudiq) a quatrefoil church has been excavated in the centre of the town; another has survived in large parts incorporated in the mosque el-Halawiya at Aleppo; at Bosra (Bosra Eski Sham), the ruins of the cathedral, dated 512 through an inscription, were well preserved until some fifty years ago; finally, the walls of a quatrefoil church, possibly the cathedral, rise amidst the ruins of R'safah in eastern Syria.[9] Only rarely are central plans transposed into the local dialect of the hinterland, as in the church of St George at Izra (Zorah) (515): an octagon on piers, with ambulatory and corner niches – the whole encased in a square, and crudely built. The egg-shaped dome over the centre room suggests an awkward substitute for the timber dome or pyramid of a centrally-planned structure of Aegean type.[10]

However, both the ecclesiastical and the domestic architecture of the great Syrian cities remain largely unknown. On the other hand, rural Syria is studded with the ruins of churches, monasteries, villas, houses, and stables, and with the remains of entire villages and small towns, all dating from the fourth and earlier, to the end of the sixth century. Three major regions stand out clearly: the north, beyond

Antioch and Aleppo; central Syria, surrounding Apamea and Damascus, and extending east across the desert; and finally the Djebel Haûran around Bosra in the south. While the first two are closely related, the Haûran stands by itself.

Building in the Syrian countryside had little in common with the architecture of the hellenized cities. The plans of the rich houses of Antioch are on the whole as unknown in the villages and small towns of the uplands as are their mosaic decoration and their technique of construction in concrete faced by small stones. In many places, as at Serjilla, entire villages – composed of farm-houses, barns, and stables dating from the fifth century – were reasonably well preserved as late as 1910.[11] Blocky, massive, and with classical, though crude, profiles, capitals, and door frames, their buildings – including thermae and churches – gave impressive testimony of the level of architecture in the north and central Syrian countryside [94]. Houses are laid out as rectangular cubes, two and three storeys high, and divided on each floor into two or more rooms. Walls are built of large blocks of ashlar. Tiers of porticoes, one per floor and supported either by columns or piers, provide access and light through doors which lead to the single rooms; in the hot season they presumably also served as sleeping porches [95]. Windows in the rear walls of the houses or towards the porticoes are rare, and generally of sixth-century date when they do appear. The blocks, as a rule, open on to a courtyard. They are often built in pairs, standing at right angles or facing each other. A tower occasionally surmounts the courtyard gate or rises at one end of the block.

Conventual buildings in the region differ from ordinary domestic architecture mainly in three respects: the individual buildings are internally undivided, as one would expect in monastic dormitories and refectories; the porticoes often envelop the block on three or even on four sides; and, together with the church, the

94. Serjilla, village, fifth century. Plan

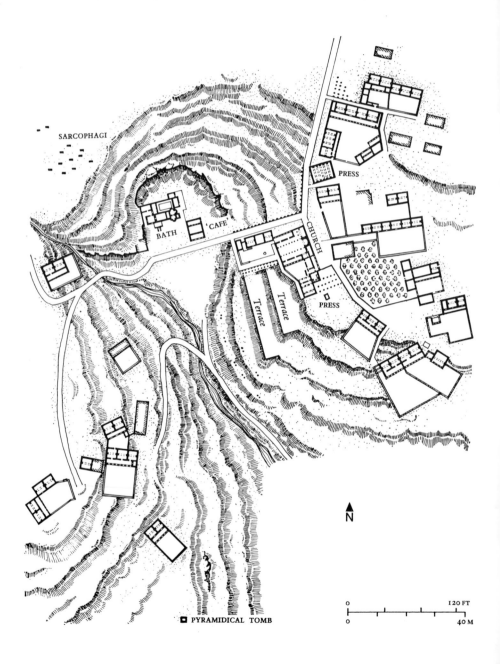

SARCOPHAGI

PRESS

BATH CAFE

CHURCH

PRESS

Terrace

Terrace

N

□ PYRAMIDICAL TOMB

0 120 FT
0 40 M

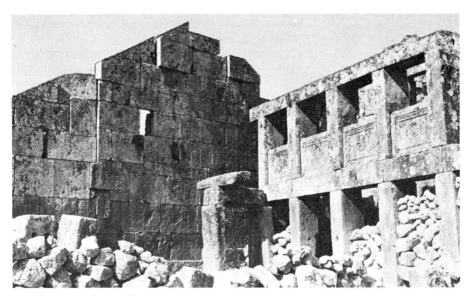

95. Ba'udeh, house façade, fifth century

conventual buildings enclose the four sides of a courtyard.[12]

In the Haûran, to the south, building is even more conservative than in the countryside of central and northern Syria. Little distinguishes church buildings from secular basilicas or even from houses and stables, and nothing sets apart structures of the second or third from those of the fifth or sixth centuries. Construction is based on the principle of a rectangular space covered with stone slabs which rest on a series of transverse diaphragm arches. When over-large, the span was crossed by two or even three parallel rows of arches, the one in the centre full-height, the flanking ones narrower and providing for a double tier of aisles and galleries. Two third-century structures at Tafḥa and El Qanawāt, both presumably secular basilicas, manifest this style. Churches, as a rule, were aisleless; when provided with apses they should probably be assigned a date not before 400.[13] In the course of the fifth century, the uniformity

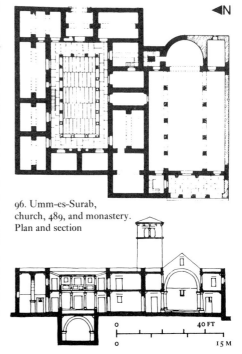

96. Umm-es-Surab, church, 489, and monastery. Plan and section

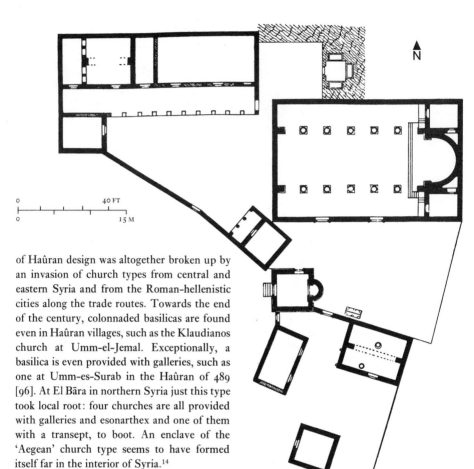

97. Dar Qita, St Paul and Moses, 418. Plan

of Haûran design was altogether broken up by an invasion of church types from central and eastern Syria and from the Roman-hellenistic cities along the trade routes. Towards the end of the century, colonnaded basilicas are found even in Haûran villages, such as the Klaudianos church at Umm-el-Jemal. Exceptionally, a basilica is even provided with galleries, such as one at Umm-es-Surab in the Haûran of 489 [96]. At El Bâra in northern Syria just this type took local root: four churches are all provided with galleries and esonarthex and one of them with a transept, to boot. An enclave of the 'Aegean' church type seems to have formed itself far in the interior of Syria.[14]

In northern, central, and eastern Syria, on the other hand, a wealth of church buildings are known – many dated through inscriptions. Aisleless chapels occur in the north as well as in the Haûran: timber-roofed, small in size, and built at any time from the fourth to the end of the sixth century.[15] They have been interpreted as the aboriginal Syrian church type, but this is by no means certain. It is equally doubtful whether ecclesiastical architecture evolved from domestic building in Syria more directly than elsewhere in the Roman Empire.[16] Nor is there any indication that aisleless chapels antedate

the earliest basilicas in the Syrian uplands, or for that matter, that these latter were carried on from the hellenized urban centres.[17] The basilica appears fully developed in an insignificant village church as early as 372 at Fafertin, and becomes rapidly standard: at Kseidjbe (Hsedjeh) (414), at Kharab Shems, at St Paul and Moses at Dar Qita (418) [97].[18] The plans of such basilicas do not differ fundamentally from those of simple country churches else-

where in the Christian world. The nave is flanked by aisles; the upper walls of the nave rest on arcades; the squat columns are surmounted by crude provincialized Corinthian capitals [98]. However three features distinguish these earliest North Syrian churches: the entrances, two as a rule, are on the south flank of the building; the apse, semicircular both inside and outside, is flanked by two square chambers; finally, the middle of the nave is frequently

the celebrant. Again, the doors on the flank coincide with Syrian upland custom, which precluded a western entrance by separating men and women, the former in front of the exedra, the latter behind.[20] The side chambers, as yet, remain liturgically inexplicable. The traditional term, *pastophories*, may reflect their use as sacristies, but functionally they cannot be established as such prior to the sixth century. On the other hand, tripartite sanctuaries were

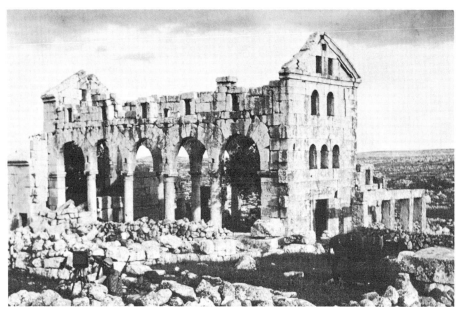

98. Kharab Shems, basilica,
fifth century, as in 1900. From the north-west

occupied by an exedra – a raised rectangular enclosure, its curved end opposing the main apse [113].[19] No doubt, all these features reflect local liturgical custom. The exedra in the nave as it survives in Nestorian churches was reserved, at least in northern and western Syria, for the clergy during the Mass of the Catechumens. The altar site in the apse was approached only during the Mass of the Faithful by the procession of the clergy conducting

customary in Syrian temples still in the third century, and church buildings may have followed such models.[21]

The cramped, austere space of the interiors is as pronounced in these churches as the impressive blockiness of the exterior. Plain profiles set off the eaves lines of the aisles. Windows are simply cut through the thick walls even when their shape, generally rectangular, gives way to a round-headed type. Capitals are Corinthian,

Ionic, or simply cylindrical in shape. In the Corinthian capitals the leaves are heavy and thick and, as a rule, outlined with only the ribs marked; the churches of St Paul and Moses at Dar Qita (418) and at Kseidjbe (414) provide typical examples. In Ionic capitals the volutes are turned into plain disks, set with a cross or a rosette, and placed high against the cylindrical core; the egg-and-dart of the echinus is generally omitted. Only on the door frames does an elegant ornament of Roman-hellenistic origin survive: guilloches, palmette friezes, and laurel patterns seem to be the hallmark of the master builder Markianos Kyris, who designed the churches at Kseidjbe and Dar Qita.[22]

The large number of dated structures makes it possible to trace the development of church building in Syria. After 430 ornamentation disappears from the exteriors. On the other hand, the starkness of the interiors becomes occasionally relieved by some slight decoration. The changes in plan likewise are minor. In central Syria piers instead of columns at times support the nave. The exedra in the middle of the nave now becomes the rule. Perhaps under the influence of urban and Aegean custom, and for no apparent liturgical reason, the main doors are now placed on the façade, while those on the flanks serve as subsidiary entrances. The function of the side chambers flanking the apse, formerly ambiguous, is now clarified. Frequently, though by no means always, one room, as a rule the south one, opens in a wide arch towards the aisle. It functions as a martyr's chapel and frequently shelters a reliquary.[23] The opposite chamber, communicating with the aisles only through a door, would serve as a diaconicon, a sacristy. Frequently a door from one of these rooms leads to the apse as well. In that case, this side chamber – whether diaconicon or martyr's chapel – may have had the additional role of prothesis, the room where, following Eastern rite, the Eucharist was pre-

pared. Occasionally, as at Deir Siman, a second and sometimes a third storey surmount, tower-like, one side chamber.

Baptisteries in the early fifth century were square, apsed rooms attached to the flank of an aisle. The great majority, however, are of sixth-century date – as a rule free-standing, square, and often provided with an apse; none are vaulted. Only one is hexagonal, and only the baptistery at Qal'at Si'man presents the plan known from the Aegean coastlands and the West: an octagon with corner niches, enclosed in a square and enveloped by a low ambulatory [99].[24]

Churches and baptisteries in Syria were rarely isolated in the middle or on the edge of a village or town. As a rule, they were accompanied by domestic structures, living quarters for the secular clergy, for monastic congregations or pilgrims. In planning them, North and East Syria on the one hand, the Haûran in the south on the other, follow different paths just as in their church buildings. In North and East Syria, throughout the fifth century, a number of buildings of the local house type face the area of the courtyard, in front or behind, but most frequently along one of the flanks of the church. In conventual buildings, the individual parts – dormitories, a refectory, kitchen, larder, and a pilgrims' hostel (each preceded or enveloped by corridors and sleeping porches in several storeys) – are as a rule linked by porticoes. Qasr el Benât shows the plan fully developed as early as c. 425; but it continues with little change into the sixth century. At Deir Siman it appears in three convents and a large hostelry at the end of the fifth century. At times the plan is tightened into a continuous rectangle of structures enveloping an inner courtyard; thus at Qal'at Si'man conventual and pilgrims' buildings occupy the south-east quadrant of the huge cross church [100, 101]. The rectangle plan may have reached Qal'at Si'man

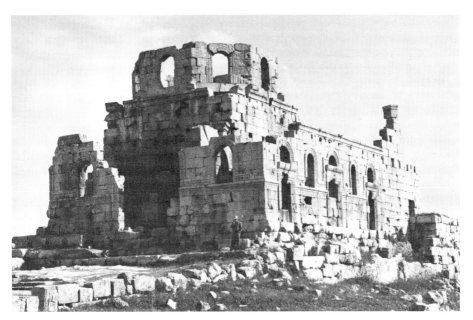

99. Qal'at Si'man, baptistery,
c. 480–90. Exterior, as in 1954

from southern Syria where it had been customary for monasteries from the fourth century, placed, as a rule, along the flank of the church. The monastery of H. Sergios and Bakchos at Umm-es-Surab (489) illustrates the plan [96]. In the Haûran, on occasion, the block of conventual buildings will occupy the site in front of the church so that the inner courtyard simultaneously functions as an atrium. But this plan seems to have been evolved only in the sixth century, under the impact of atrium plans as they were customary in the Aegean coastlands.[25]

In northern and eastern as well as southern Syria by the middle of the fifth century, the plans of churches, baptisteries, and monasteries were definitely established within regional limits. Indeed, planning changes little until the Islamic Conquest, c. 630. But from 480 on, a new classical style and a new vocabulary come to the fore in the great monastic centres. Qal'at Si'man, financed, it appears, by the church builder on the throne, Zeno (474–5, 476–91), is the most grandiose example of this new phase of Syrian church building [100–2].[26] It is a cross martyrium, comparable to the one excavated at Antioch-Kaoussié, or to the fifth-century church of St John at Ephesus. But in execution Qal'at Si'man outstrips everything previously built on Syrian soil. It is of impressive size, 80 and 90 m. (260 and 295 ft) across respectively, designed to house large crowds of pilgrims, and of elaborate design. With its conventual buildings, it covers many acres of ground [100]. The centre part, originally timber-roofed, rose over the pillar on top of which St Simeon Stylites had spent the last part of his life [103, 104]. The four wings, instead of being aisleless, are fully-fledged basilicas: those west and south

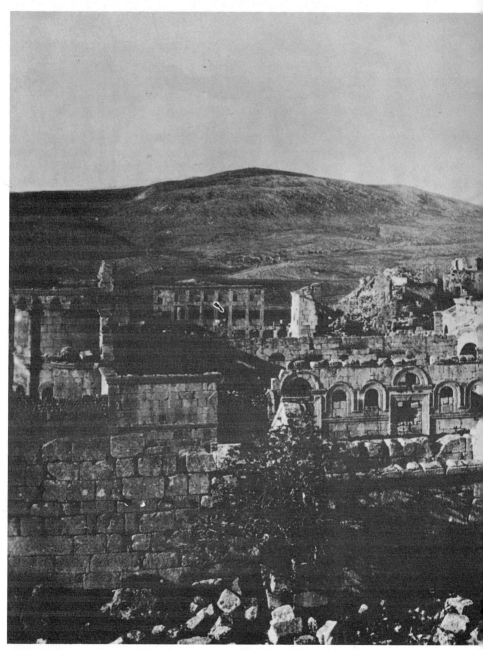

100. Qal'at Si'man, *c.* 480–90. Church and monastery from the north-east, as in 1900

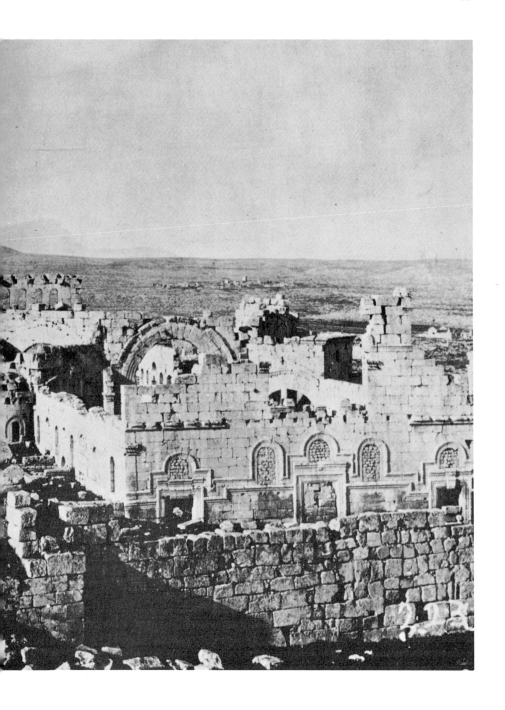

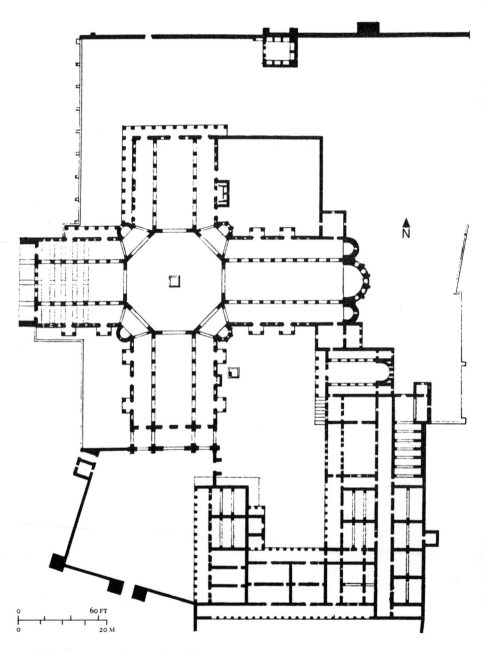

101. Qal'at Si'man, martyrium, *c.* 480-90. Plan

102. Qal'at Si'man, martyrium,
c. 480–90. Isometric reconstruction

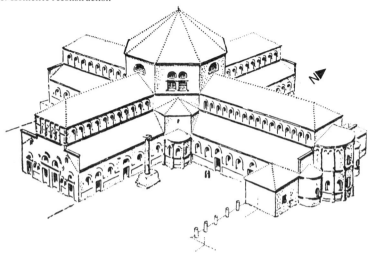

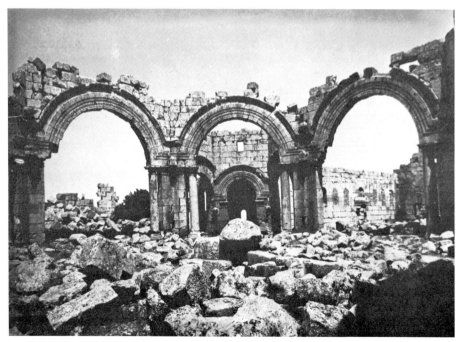

103. Qal'at Si'man, *c.* 480–90. Octagon, looking north-west, as in *c.* 1960

104. Qal'at Si'man,
c. 480-90. Octagon and south wing

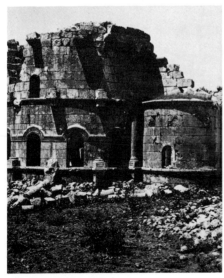

105. Qal'at Si'man, *c.* 480-90.
Exterior of apses, as in *c.* 1960

were preceded by nartheces, while the east wing was terminated by three apses [105, 106]. All parts of the structure are strongly set off against each other. Clearly profiled string courses mark the base zone and rise to frame door jambs and windows. Eaves lines and the arches in the octagon and wings are similarly outlined. The shafts of the columns in the octagon rise from elegant bases and carry capitals covered by windblown acanthus leaves with spiky edges. In the wings the capitals are Corinthian. On the exterior, the main apse was articulated by two tiers of strong engaged columns and a corbel-table frieze – two small arches with scallop fillings to each intercolumniation. On the south façade, fluted pilasters carry the three arches of a triumphal entrance gate [107].

Neither in size nor in plan could the huge martyrium of Qal'at Si'man become the model

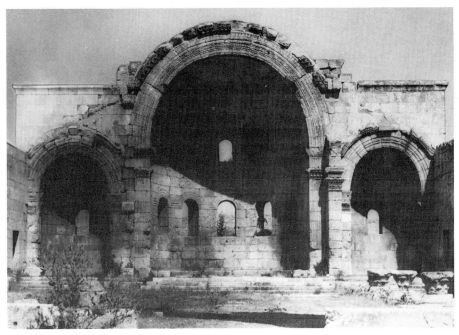

106. Qal'at Si'man, *c*. 480–90. Interior of apses
107. Qal'at Si'man, *c*. 480–90. South façade, as in 1954

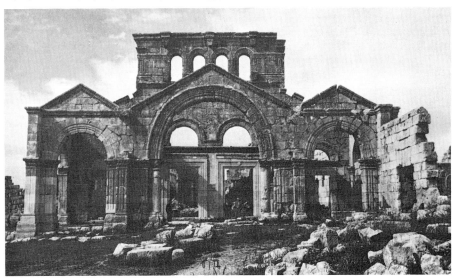

for any number of ordinary monastic or parish churches. In the church built on Mont Admirable to enclose the column of St Simeon Stylites the younger, the plan was taken up on a smaller scale; only the ornament [117] continues the elegant design of the old workshop into the early sixth century. However, it bequeathed to the area a sense of monumentality and a classical vocabulary unrivalled anywhere in fifth-century Christian architecture. For a generation or two these factors determine the design of a group of comparatively large church buildings in northern, central, and eastern Syria, such as Turmanin, Qalb Lozeh, Kerratin, El-Anderin, and Ruwêha (Rueiha). Some of these 'cathedrals', as they have been called, are preserved in ruins, others known only from de Vogüé's drawings. At R'safah-Sergiopolis – one of the major garrisons on the Euphrates frontier and the pilgrimage town of St Sergius – two basilicas rose, one of them apparently the martyrium of the saint.[27] None of the churches in this group

are dated by inscription, but the majority seem to fall between 480 and 520. Turmanin, now destroyed, can hardly be later than 480 since its vocabulary is reflected in dated village churches, such as Basufân (491–2) and the east church at Kalôta (492). Qalb Lozeh, well preserved, seems to date from about 500 [108–10]. Of the two basilicas at R'safah-Sergiopolis, Basilica B was presumably built in the last twenty years of the fifth century; the basilica of St Sergius is later; but it still dates from before 520 [111–14].

Whatever their dates, all these churches are closely related and seem to be designed by one or two workshops active over a thirty- to forty-year period. At Qal'at Si'man, notwithstanding the initiative and support lent by the Imperial court in Constantinople, the cross plan chosen was that customary for martyria in Syria and Palestine from the fourth century. The other cathedrals likewise follow older local customs. Their apses are framed by side chambers; entrances are placed both in the façade and

108 (*right*). Qalb Lozeh, church, *c*. 500. Plan

109 (*opposite, above*). Qalb Lozeh, church, *c*. 500. Exterior from the south-west

110 (*opposite, below*). Qalb Lozeh, church, *c*. 500. Interior of nave

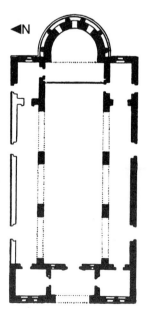

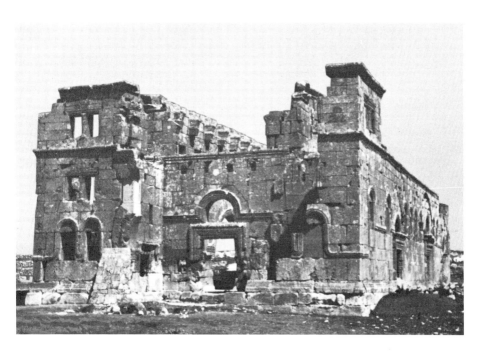

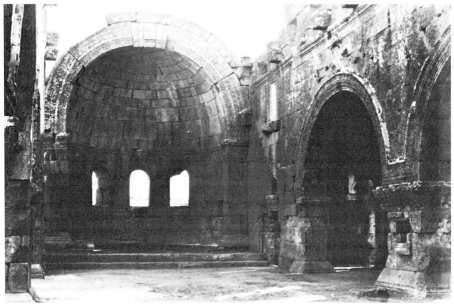

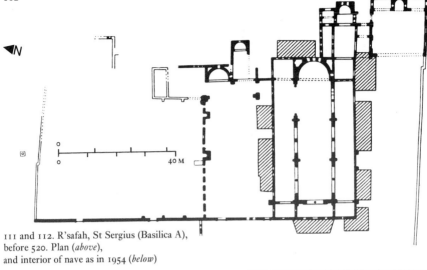

111 and 112. R'safah, St Sergius (Basilica A),
before 520. Plan (*above*),
and interior of nave as in 1954 (*below*)

113. R'safah, St Sergius (Basilica A), before 520. Exedra

114. R'safah, St Sergius (Basilica A), before 520. Room above pastophory

115. R'safah, north gate of town, c. 530. Capital

116. Qal'at Si'man, church, c. 480-90. Capital

117. Mont Admirable (Jebel Seman),
church of St Simeon the Younger, sixth century.
Door jamb

along the two flanks [108, 109]. Supports vary: columns, following North Syrian custom, supported the nave of Turmanin, while those of Qalb Lozeh, of Ruwêha, or of the Sergius Church at R'safah are piers, following central and east Syrian tradition. The vocabulary, as well, is rooted in earlier Syrian church building, but the classical elements grow in number and strength. String courses with rich classical profiles mark the base of the walls and the eaves lines. Half-piers are fluted, piers are topped by foliage capitals. The crude Ionic and Corinthian capitals of the earlier Syrian churches give way to elaborate Corinthian, composite, or wind-blown capitals. Their leaves are sharply cut, with spiky edges separated by deep drill holes [115-17]. Towards the middle of the sixth century, the thorniness of the foliage grows sharper, and the capitals of, for example, Qasr Ibn Wardan look as if they were covered by a thistle growth standing out from a dark ground.[28] But already at Qal'at Si'man all details are of conservatively classical derivation, transposed into harsh forms. Throughout the first half of the sixth century, the silhouette of the buildings grows richer, the treatment of the walls sculptural. Gabled porches on columns projected over the doors along the flanks of the Bizzos church at Ruwêha and of the church at Qalb Lozeh [109]. Towers, slightly lower than the nave, rose on either side of a deep porch at Turmanin, Qalb Lozeh, Ruwêha, and – raised high on a flight of steps – at the Sergius Basilica at R'safah. Jointly, towers and porch form the characteristic Late Syrian twin-tower façade.[29] Even the side chambers of the apse – two-storeyed at Turmanin – were at times surmounted by low towers, or by domed upper chambers. In the Sergius basilica at R'safah the squinches of their domes survive [114]. None of these towers seems to have served any practical or liturgical function. But they convey a feeling of clarity, articulation, and monumentality far greater than is warranted by the

actual dimensions of the structures; indeed, in size these Syrian 'cathedrals', from 35 to 50 m. (115 to 165 ft) in length, are much smaller than even minor parish or cemetery churches in Constantinople, Rome, Corinth, or Ravenna. Likewise, the interior of these 'cathedrals' becomes articulated, and monumentalized, beyond their actual proportions. In fact, in a break with the previous tradition of Syrian architecture, around the turn of the century, the interior becomes an object of architectural awareness. Widely spaced low piers and huge arches convey the impression of a space vaster than reality [110]. At Ruwêha, half-piers rose through the entire height of the wall. In the Sergius Church at R'safah, these half-piers carried an upper order,[30] dividing the interior into distinct spatial units and unifying it in length, width, and height in a monumental design [112]. Even the wide arched openings of the side chambers, functionally inexplicable as either sacristy or prothesis, in the majority of these churches may simply be intended to monumentalize the interior design. Certainly the rows of short columns placed on brackets along the clerestories of Qalb Lozeh, Ruwêha, and R'safah are designed to produce a monumental effect of interlocking space and wall unknown before in Syria. Since such elements for organizing the exterior mass and interior space are comparatively weak at Turmanin, but grow stronger at R'safah and at El-Anderin, one is led to view the group of 'cathedrals' in terms of a stylistic sequence leading from c. 480 to 520 and beyond.

The monumentality of this Late Syrian architecture, the new organization of space and mass, and the rich classical vocabulary are without precedent in the local tradition. Outside forces were apparently at work, and it has been suggested that the new style was first formed at Antioch. This is possible, but it is not borne out by the scanty facts known about church building at Antioch. Hence an alternative hypothesis offers itself. Beginning with the rule

of Zeno (474–5, 476–91), the Imperial administration took a renewed, lively interest in the Eastern provinces. Church buildings financed by the emperors abound from Mount Garizim in Palestine to R'safah on the Euphrates, to Qartamin in the Tur Abdin, and to Qal'at Si'man. To stress the classical heritage was, we recall, a characteristic of Imperial architecture, whether secular or ecclesiastical. Imperial backing might well have led the Syrian builders to take a new look at the antique architecture of their own province, and thus towards a richer, more fully 'classical' vocabulary. Imperial backing would also have led them to absorb elements of a vocabulary customary in the milieu of Constantinople: capitals with wind-blown leaves, though less harsh in design than those at Qal'at Si'man, are known in the fifth century from Salonica, from Nea-Anchialos, from the Balkans, and from Ravenna – all sites within the sphere of influence of the Imperial capital.[31]

Twin-towered façades, too, have been taken to be symbols of rulership, from the Hittite kings to the Byzantine emperors; hence, the Syrian 'cathedral' façades have been linked to Constantinopolitan models.[32] However, it remains to be proven that such twin-towered façades surmounted the gates of the palaces of Constantinople. Proof of Imperial connexions has also been seen in the twin-tower structure, surprisingly Syrian in design, which on the wooden doors of S. Sabina in Rome (c. 430) surmounts, like a canopy, the figures of an angel and of a presumably Imperial personage.[33] In a broader context, though, the question arises whether the new feeling for an articulated interior space in the Syrian 'cathedrals' of the early sixth century may be linked to the movement which at the same time led to the victory of the domed church in Constantinople and the core provinces. Obviously the question cannot be answered, but it is one which to us seems well worth posing.

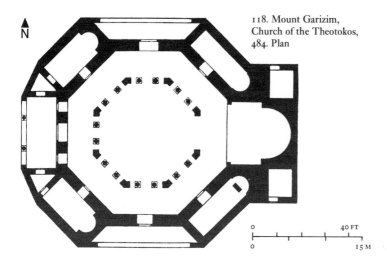

118. Mount Garizim,
Church of the Theotokos,
484. Plan

PALESTINE AND JORDAN

Three currents exert their impact during the fifth and the early sixth centuries on the architecture of Palestine and Jordan: the fourth-century buildings over the holy sites; the architecture of the Aegean coastlands in general, and of the court of Constantinople in particular;

and finally, the monastic and village churches of neighbouring Syria.[34]

The impact of the buildings erected over the holy sites on the later local architectural tradition is surprisingly small. A church on Mount Garizim (Gerizim) is the only one to enrich the formula set by the fourth-century prototypes.[35] Built in 484 by the Emperor Zeno as his offering

119. Mount Garizim, Church of the Theotokos, 484. Capital

120. Mount Garizim, Church of the Theotokos, 484. Wall of ambulatory

of thanks after quelling a Samaritan uprising, the church was dedicated to the Mother of God and further sanctified by a relic from the Rock of Calvary. The octagonal centre room, presumably covered by a wooden dome or a pyramidal timber roof, was enveloped by an ambulatory [118]. Beyond this centre, three shallow entrance porticoes and a deep chancel and apse on the main axes alternated with four chapels in the diagonals, one a baptistery. Eight corner piers and seven pairs of columns supported the centre room; they may have been surmounted by the upper order of a gallery. Imperial backing explains the elegance of the construction, the masonry of carefully hewn ashlar blocks with drafted margins, and the finely worked bases and Corinthian capitals [119, 120]. The plan, extraordinarily rich in its combination of spatial forms and levels, has been linked to Constantine's Golden Octagon at Antioch; but it is more easily explained as a new variant on the type of the martyria erected since Constantine's day in the Holy Land. After all, the late fifth century was fertile in evolving such new variants: S. Stefano Rotondo in Rome at nearly the same time combines in a remarkably similar way a centre room with an ambulatory and an outer ring of alternating spatial units.

The court of Constantinople continued to subsidize church building in the Holy Land throughout the fifth century. Through these Imperial enterprises the architectural concepts of the Aegean coastlands gained a firm hold. At times the impact can be directly traced. At Gaza on the Palestinian coast, a cross church was built in 401 from a plan sent, together with thirty-two columns of Greek green marble, by the Empress Eudokia from Constantinople.[36] The plan, in all probability derived from Constantine's Apostoleion, took root in the Aegean coastlands, as witness the fifth-century church of St John at Ephesus. Another variant of the cross plan appears in 465 in the Church of the Prophets, Apostles, and Martyrs which has been excavated at Gerasa (Jerash), across the Jordan.[37] There the four arms were subdivided into nave and aisles by thirty columns [121]. Similarly in Palestine and Transjordan, some major basilicas reveal the impact of Constantinopolitan and, in general terms, of Aegean architectural concepts. The plan of the church of St Stephen in Jerusalem, built between 437 and

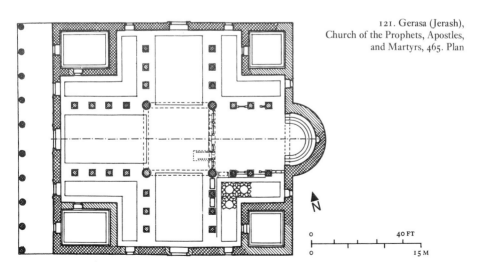

121. Gerasa (Jerash), Church of the Prophets, Apostles, and Martyrs, 465. Plan

N

0 40 FT

0 15 M

460 by the exiled Empress Eudokia, recalls the slightly later Studios church. Like the church in Constantinople, it was a basilica, the aisles possibly surmounted by galleries, the apse polygonal on the exterior, the nave colonnaded and preceded by a colonnaded narthex and an atrium.[38] Aegean elements, such as polygonal apses, aisles enveloping the nave on three sides, rich mosaic floors, and occasionally even galleries, occur in other fifth-century basilicas in Palestine, Jordan, southern Syria: at Evron near Nahariya in Israel, where layers of mosaic pavements and rebuildings, all dated, follow one another from 415 to 492; at Shavei Zion, with a similar sequence of floors, the latest dated 486; at Ramat Rahel, just outside Jerusalem, with enveloping aisles; at Mamshit (Kurnub) in the Negev, where two basilicas rise, of fifth- and sixth-century date, preceded by atria and with rich mosaic pavements; at Madaba in Jordan; in Syria, at Umm-es-Surab about 489; and in Jordan at St Theodore at Gerasa about 494-6. On the site of the Miracle of the Multiplying of the Loaves and Fishes at et-Tabgha (Ein Ha-Shivah) near Lake Tiberias,

a basilica was laid out about 500 with a splendid mosaic floor and with a 'reduced cross transept' [122]. The transept wings are accompanied by aisles along the west wall only, but otherwise the building was much like the many cross-transept basilicas in the Aegean coastlands.[39]

Such Aegean impact seems to have been strongest in Palestine and Jordan during the fifth century. Limited, however, to centres of pilgrimage and trade, it remained an alien element. The masonry technique of large ashlar blocks in Palestine and Jordan was as integral a part of architectural design as in the other inland countries of the Near East. Likewise, in plan and elevation the numberless minor parish and conventual churches in the Holy Land were closely linked to those of neighbouring Syria; the chapel excavated below the transept church of et-Tabgha had its roof supported on diaphragm arches in a technique customary in the Haûran. As a rule, however, country churches in Palestine, as in Syria, were small basilicas supported by arcades on low columns. The apse – flanked by side chambers (after 500 by lateral apses) – was enclosed within a mas-

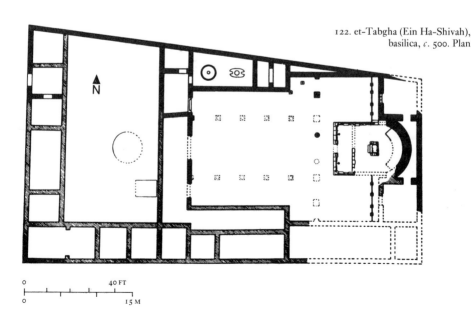

122. et-Tabgha (Ein Ha-Shivah), basilica, c. 500. Plan

o 40 FT

o 15 M

sive straight-sided rear wall, solid or hollowed by hidden recesses.[40] One of three churches preserved to this day at Sbeïta (Shivta) in the Negev, probably of sixth-century date, may stand as an example for many similar buildings known only from remnants [226]. The walls are impressively strong, the windows small. Capitals, bases, and other ornaments are crude variations of the more elegant forms found in the hellenized urban centres of Palestine. The plan occurs occasionally on a larger scale with slight modifications: at Emmaus (Amwas), where the apse projects outward to the east in three sides of a polygon; and at Ras as-Siagha on Mt Nebo, where the fifth-century basilica was preceded by an atrium and a raised narthex, and terminated by an older trefoil, the fourth-century martyrium, recording the site of Moses' death.[41]

Such modifications point to a phenomenon characteristic of Palestine and Jordan – the fusion of concepts rooted in the architecture of both the Aegean coastlands and the inland countries. The nine churches preserved in ruins at Gerasa manifest this fusion.[42] Dated as they are by inscriptions, they show at the same time how the impact of hellenized Aegean church architecture gives way after 500 to a resurgence of inland building. In the cathedral, c. 400, the chancel plan is Syrian, but it is joined to a nave of Aegean type [123]. An atrium precedes the church; the colonnades in the nave are trabeated; the walls of the aisles are sheathed with finely polished stone plaques, and the apse is revetted with marble slabs. Indeed, as late as the sixth century, the church builders of Gerasa and their patrons remained partial to a chancel arrangement of Aegean type and to a lavish interior decoration, with stone-revetted walls, glass mosaics in the apse vaults, and stone mosaic on the floors. But the overall plans are more and more assimilated to those of neighbouring rural Syria. A series of eight churches, dated by inscriptions from 526-7 to 611, shows the common features of the type and the gradual changes it underwent. All are built of heavy ashlar masonry. All are basilicas, except two: the centrally-planned church of the Baptist and the cross church of the Apostles, Prophets, and Martyrs. As in Syria, the supports are

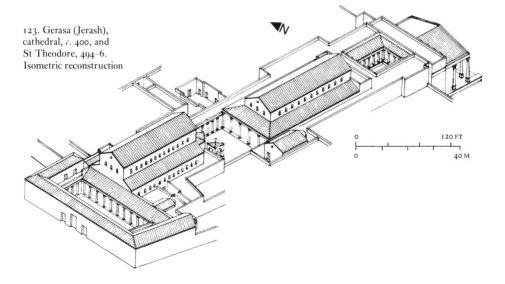

123. Gerasa (Jerash), cathedral, c. 400, and St Theodore, 494-6. Isometric reconstruction

0 120 FT

0 40 M

generally columns, occasionally piers. Geo-
metrical and figural mosaics cover the floor.
Atria disappear in favour of nartheces. In the
second quarter of the sixth century sacristies,
martyria chapels, or baptisteries flanking the
apse give way to lateral apses with forechoirs re-
calling those of Qal'at Si'man. The resemblance
to the Negev churches is close. Finally in the
Genesius church (611), the side rooms are fused
with the forechoir and turned into dwarf tran-
sept wings. The chancels, which at first project
only into the last bays of the nave, later extend
into the aisles as well.

The churches of Gerasa are extraordinarily
impressive – through their size, through their
number, and through their tendency to group
several structures within one precinct. The
cathedral was approached from the rear by a
grand staircase. At the head of the staircase ex-
tended a huge courtyard, and in it a shrine of St
Mary was placed against the rear of the apse.
Between 494 and 496 the church of St Theodore
was set up on a yet higher terrace, in front of
the atrium of the cathedral and on an axis with
the latter. In the group of churches dedicated to
SS. John, Cosmas, and Damian (529–33), the
structures are laid out along a transverse rather
than a longitudinal axis: two small basilicas
flank the centrally-planned church of the Bap-
tist. But fundamentally the principle of group-
ing is the same, and may well be due to the
impact of the building complexes which had
grown on Golgotha since Constantine's times.

THE HIGH PLATEAU OF ASIA MINOR

Sizeable remnants of Christian buildings in the
cities of Asia Minor have survived only on the
sites along the rim of the high plateau. In the
towns of the highlands proper, such as Kayseri,
Ankara, or Konya, barely a few remnants of
large timber-roofed basilicas remain standing.
On the other hand, in rural areas a large num-
ber of church buildings were well preserved

until a generation ago. They represent a variety
of types, but they are small, often not more than
10 m. (30 ft) long or less. But whether large city
churches or small country chapels, with few ex-
ceptions all employed the local stone, either in
large well cut blocks or in slabs, facing a rubble
core; only in later structures are small chunks
used. All were designed in blocky masses recall-
ing the rustic buildings of the Syrian uplands.
All were vaulted throughout, wood being for-
ever unobtainable. Arches were frequently
horseshoe-shaped in plan and elevation. The
decorative vocabulary, as far as it exists, is
crude yet unmistakably of classical derivation,
transmitted either from the coastal cities or
from Syria by way of Cilicia.[43]

Hierapolis (Pamukkale), in Antiquity a size-
able town just beyond the western edge of the
high plateau, had claimed from the first century
to shelter the grave of the Apostle Philip, and
thus occupied a leading position among Chris-
tian congregations in Asia. In the fifth and sixth
centuries it was an important Christian centre,
closely linked to the coastal cities along the
Aegean shore. Three churches remain, and not
too surprisingly, at least one reveals links to the
architecture of the coastlands.[44] An octagonal
structure outside the city walls, it is possibly of
early-fifth-century date and was perhaps the
martyrium of the Apostle Philip [124]. The
centre room, 20·70 m. (68 ft, 70 Roman ft) wide,
and probably timber-domed, was enveloped by
deep niches lit by windows, and by entrance
arms in alternation – all barrel-vaulted and con-
nected by narrow passages and small chapels
hidden inside the piers. All this was enclosed
within a huge square of 60 by 62 m. (197 by
203 ft) of low chambers, perhaps pilgrims'
shelters. Elements of coastland architecture
are manifest throughout: in the brick and stone
bands of the walls, with only the piers utilizing
large blocks; in the vaulting technique in brick;
in the marble revetment and marble pavements;
in the few capitals preserved. All this contrasts

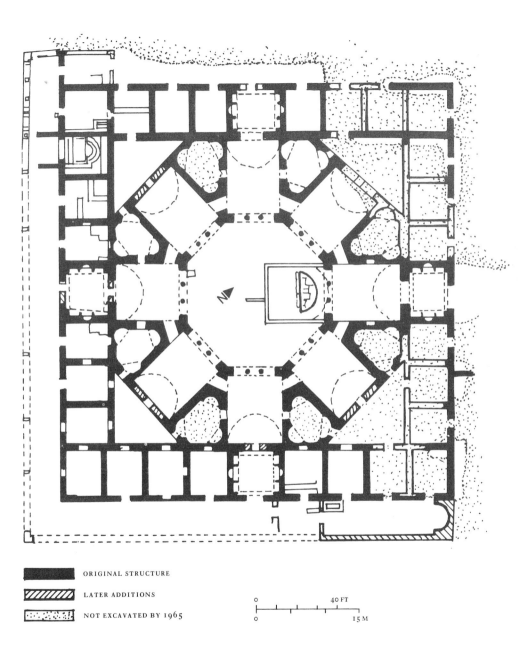

0 40 FT

0 15 M

124. Hierapolis (Pamukkale), martyrium of St Philip(?), early fifth century(?). Plan

with the pure 'inland' design of the other two churches of Hierapolis. One is a huge hall, originally perhaps a bath, flanked by three barrel-vaulted niches on either side. It was transformed into a church about 410 by the addition of three pendentive domes over the nave. The third church is a similarly large hall, its nave flanked by niches, but it dates from as late as 535. In Kayseri, remnants of a large church have survived, possibly a basilica of Syrian type, dating from the early part of the sixth century.[45]

In contrast to Hierapolis's huge city churches, the village churches on the high plateau are tiny. Here two centres of building activity are known. A goodly number of structures had survived until recently in Cappadocia near Kayseri; another cluster of structures – nameless and undated – is located in the mountains of Lycaonia, south-east of Konya, called with Eastern fancy Binbirkilise – the Thousand and One Churches.[46] Not a single building is dated on either site, but a comparison of the architectural vocabulary with that of the neighbouring provinces to the west and south suggests the middle or the second half of the sixth century for the earliest known village churches in Asia Minor. As in Syrian churches between 480 and 550, orders of pilasters articulate the outer walls, string courses with classical profiles arch around windows. Basilicas are built with galleries; capitals are worked with friezes of vertical tongues, and façades may occasionally have had twin towers. All are features characteristic of either Syria or the Aegean coastlands in the late fifth century, and cannot be thought to have penetrated the backwater provinces of Lycaonia and Cappadocia before 550, if that early. Though still recognizable in the seventh century, such decorative elements gradually disappear. But unadorned or adorned in the most modest forms, church buildings in Asia Minor continued unchanged in type and overall design possibly as late as the tenth and eleventh centuries.

Through all this time, the master builders in the uplands seem to have clung to a few basic types. Vaulted basilicas and hall-churches prevail in Lycaonia and western Cappadocia, cross churches in eastern and central Cappadocia. At Binbirkilise, during the sixth and seventh centuries and perhaps earlier, vaulted basilicas seem to have been standard [125–7]. Horseshoe-shaped apses, at times polygonal on the outside, echoed the horseshoe-shaped arches of the arcades. The low piers were widened sideways by half-columns, obviously purloined from the shape of window piers customary along the west coast of Asia Minor. At times side chambers projected sideways off the narthex, recalling fifth-century custom in Greece and along the coast of Asia Minor. Barrel-vaults extended lengthwise over aisles and nave with small windows high up in the upper walls. Occasionally open porches led off sideways from the aisles.

125 (*opposite, above*). Binbirkilise, Church no. 33, *c.* 600. Exterior of apse, as in *c.* 1960

126 (*opposite, below*). Binbirkilise, Church no. 32, *c.* 600. Interior of apse, as in *c.* 1960

127 (*above*). Binbirkilise, Church no. 1, *c.* 600 or later. Interior of nave, as in *c.* 1960

The interior was dark, slightly enlivened by a mosaic floor and perhaps by wall paintings. Only the bare masses of the exterior spoke. The Syrian antecedents of this architecture are clear, as is their transposition into the local language.

This standard plan appears some twenty times at Binbirkilise, varying only in details and size, from as much as 38 m. (125 ft) in length to

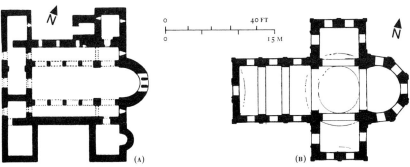

128. (A) Binbirkilise, Church no. 32, *c.* 600. Plan
(B) Tomarza, Panaghia, sixth century. Plan before 1921

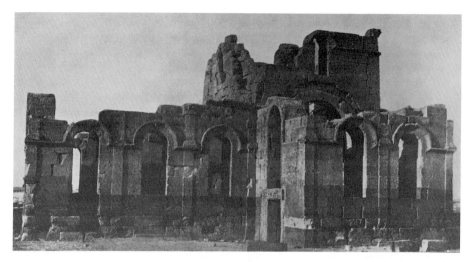

less than 15 m. (50 ft). A major departure from this occurs only in church no. 32: galleries surmount the aisles; towers, if such they were, push outward from the narthex; pastophories project from the aisles near the apse; and the window mullions display tongue ornament [128A]. All this points to fifth- and sixth-century models in the coastlands. Another variant occurs at Eski Andaval, across the south-western border of Cappadocia.[47] Here the nave is not lit by windows of its own and is only slightly higher than the aisles, thus transforming the basilica into a hall-church. The decidedly classical decoration of the apse windows and the exterior polygon of its plan suggest an early date, probably not much after 550.

On the contrary, in central and eastern Cappadocia cross churches were standard. They are

129 (*opposite, above*). Tomarza, Panaghia, sixth century. Exterior before 1921

130 (*opposite, below*). Pesek (Büslük Fesek), church, *c.* 600. Exterior, as in 1954

131 (*below*). Sivrihisar, Kizil Kilise, ninth century(?). Exterior, as in 1954

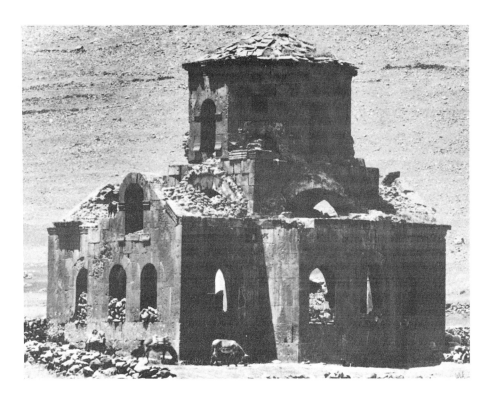

small, never more than 20 and often only 10 m. (65 and 32 ft) long. The wings project strongly, and the apse – horseshoe-shaped inside, polygonal outside – balances the short nave. Nave, apse, and wings are of equal height and barrel-vaulted; four arches segregate the crossing; a tower rose above, sheltering a dome. The plan in Cappadocia became and remained standard for rural parish and monastic churches. Clad in sixth-century ornament, it was well preserved until 1921 in the Panaghia at Tomarza, which was perhaps built as a parish church [128B, 129]. It still survives in the ruins of a monastic church at Pesek (Büslük Fesek), south of Kayseri, where half-piers rise from pedestals at the apse corners and recall Qalb Lozeh, and a doubled order of pilasters marks the façade corners [130]. A simpler, but very powerful

church, possibly as late as the ninth century (?),
rises near Sivrihisar: its octagonal crossing-
tower is placed on squinches, its nave is flanked
to the north by an aisle [131]. The design of
volumes and masses is of a stark, but impressive
beauty.[48]

Cross buildings by 500 were obviously not
new in Christian architecture. On the same
small scale as in Cappadocia, they had been
adapted from Roman mausolea as early as 400
by the builders of Christian martyria, pre-
sumably in Constantinople and certainly in
upper Italy. Indeed, cross-shaped martyr
chapels and tomb chapels are also known in
large numbers in Asia Minor, at and near
Binbirkilise, some on isolated mountains, others
in monastic precincts. However, none antedate
the eighth century and some may be much later.
To be sure, the type may have become accepted
as early as the sixth century in Cappadocia as
well as in Lycaonia. But there is no proof that
the vaulted cross plan was first created in Asia
Minor.

At times an exceptional plan stands out
amidst such standard types, whether basilicas
or cross churches. A small domed octagon at
Binbirkilise, with four arms projecting cross-
wise, is perhaps of sixth- or seventh-century
date, yet it recalls the church described as early
as 380 in the correspondence of Gregory of
Nyssa with the bishop of Konya. At Soasa, near
Aksaray, a larger octagon (now destroyed) rested
on powerful piers enveloped by an ambulatory;
the centre space was domed, the ambulatory
perhaps timber-roofed.[49] A more remarkable
church stood near Küçük Büyüngü (Sari Kilise,

Skupi), until torn down in 1954.[50] The aisleless
nave continued to the springing of the apse,
which was horseshoe-shaped inside and poly-
gonal outside. Attached to the flanks of the nave,
before the apse, were two low chambers which
projected sideways and had prominent portals
facing west. All parts were barrel-vaulted.
Whether porches or sacristies, these chambers
were mere adjuncts to the nave; they formed,
as it were, dwarf transept wings, and the struc-
ture, far from being a cross church, represented
a type of its own. Four orders of pilasters
flanked the nave, and the capitals, though crude,
were foliate. The classical profiles of the cornice
rose over the door lintels and curved over two
superimposed rows of arched windows. The
whole suggests the impact of Syrian buildings
and a date not much after 500.

Taken by itself, this architecture in the up-
lands of Asia Minor - its basilicas, hall-churches,
aisleless structures, octagons, or cross churches
with or without flanking chambers – is but a
backwater offshoot of the greater architecture
of adjoining Syria, Cilicia, and Pamphylia. Yet
it occupies an important place in the history of
Early Christian architecture, not only in the in-
land countries of the Near East, but through-
out the Mediterranean world. It has preserved
in remote mountains and high plains a variety
of church types of the Early Christian East,
which in more accessible regions have been over-
laid by later architectural forms; and between
the seventh and ninth centuries it has contri-
buted plans, techniques, and an architectural
vocabulary towards the formation of an archi-
tecture in Western Europe.

THE LATIN WEST

With the beginning of the fifth century, the Latin West increasingly becomes a sphere of its own, both in its political aspects and in its intellectual, artistic, and religious life. Contacts with the two great regions in the eastern half of the Empire continue, but the West gradually drifts away. After Alaric's Sack of Rome (410), the papacy assumes spiritual and cultural leadership with ever greater decision in the Latin-speaking world: Italy, Dalmatia and the northern Balkans, southern France, Spain, Sicily, and North Africa. And although Rome's political influence on North Africa ceases with the Vandal conquest, this loss is countered towards the end of the century by the expansion of Roman orthodoxy to pagan or Arian territories beyond the Alps in France and southern Germany.

Christian architecture in the West falls into two distinct geographical spheres: to the north, central and northern Italy with her border-countries east and west; to the south, North Africa and her dependencies across the sea – South Italy, Sicily, the Balearic Islands, and the coasts of Spain. In the northern half of the Latin countries, Rome and Milan are the leading architectural centres; Ravenna, beginning c. 425–50, holds a straddling position between the Latin West and Greek East. As early as 385, a standard basilican plan spreads presumably from Rome to Milan, slightly later to Ravenna, Istria, and Dalmatia. At the same time, the octagonal baptistery plan, with a possible origin in either Rome or Milan, becomes standard in Provence, Ravenna, and Dalmatia. In the southern half of the West, on the other hand, Africa takes the lead, but no one city can be identified as a great architectural centre. Nevertheless, standard types develop for basilicas and

baptisteries very different from those customary in central and northern Italy and her borderlands. Yet whatever the divergencies in planning and workmanship, churches from Milan to North Africa differ surprisingly little in style.

Early Christian church building in the Latin West has been comparatively well explored. In Rome, Milan, and Ravenna a significant number of buildings are fully or nearly fully preserved. In addition, widely ranging excavations have brought to light foundation walls and pavements which reveal the characteristic plan and design of churches and baptisteries in cities, villages, and monasteries from Spain to Dalmatia and from southern Algeria to the Alpine regions.[1]

The plan of the standard basilica in the Latin West is simple. The nave was long, generally flanked by aisles, and terminated by a semicircular apse. Whether or not an atrium or a narthex preceded the church depended on local custom, vicinity of streets, and funds available. The supports of the nave were columns, which were either made to order or, together with capitals and bases, were spoils from Roman buildings, as was the custom in Rome. Surmounted by arcades, the columns carried the high upper walls of the nave; these walls were topped by a band of wide windows in the clerestory. As a rule, the number of clerestory windows corresponded to the intercolumniations below. The windows were variously filled: either by stone plaques perforated with numerous holes, or by costly mica, coloured glass, or alabaster panes set in stucco and wood gratings. In every case, the light filtering into the churches was abundant but opaque, not the clear white light which fills them today. Below the clerestory, mosaic panels or, more frequently, less

expensive frescoes covered the walls. As a matter of course, the vault of the apse carried a mosaic fresco. The use of windows in the aisles depended on local custom. All parts of the structure, except for the half-dome of the apse, were covered with open timber roofs, on rare occasions with coffered ceilings, both often gilded. The floors in Rome were paved with flagstones; in Milan they were apparently overlaid with marble; in the eastern parts of North Italy, and in Istria and Dalmatia and in Africa, they are carpeted with mosaics. A chancel enclosed by parapets extended from the apse into the nave; wing walls projected sideways into the aisles, forming a barrier at which the congregation handed its offerings to the clergy. Since until the sixth century sermons were not required in the West, ambos are found neither in Rome nor in North Africa.[2]

Plan and design, then, are both quite plain. Much in contrast to contemporary architectural concepts in the Greek East, the interior was composed of three spatial units clearly designed and neatly separated from each other. In the nave a controlled channelled space moved from the entrances to the apse. It was accompanied by the similar units of the aisles, but the spatial units did not flow into each other. Curtains seem to have closed off the intercolumniations and supported the impression of three parallel but separate space channels. Indeed, contemporaries likened the nave of the fifth-century basilica to a river, flowing slowly along, filled with the broken light filtered through the windows. The walls of nave and aisles neither dissolved into screens, as in the Greek East, nor were they viewed, as in Syria, as massive solids. They want to be seen as surfaces, cardboard-thin and ideally designed to support frescoes or mosaic. The colours of these paintings and mosaics were meant to fuse with the opaque light of the windows, with the tints of the pavement, the gilded timber roofing, the mosaic of the apse vault, the precious furnishings. At night the entire building would shimmer in the flickering light of oil-wicks and candles. Many a contemporary letter and poem speaks of the jewelled golden and silver altars and altar vessels, the gilded roof beams, ceiling coffers, and capitals, the gold mosaics, the shining marble revetments of fifth-century churches in the Latin West.[3]

In contrast to such interior wealth, the exterior of these same churches was utterly plain. The walls and the roofs of nave and aisles nowadays extend in the stark bareness of stone, brick, and tiles, their surfaces broken only by the greyish-white stucco gratings of the windows; whether or not they were, or were intended to be, covered with plaster, remains an open question. Materials and methods of construction vary locally: concrete faced with brick; concrete faced with alternating courses of brick and stone; small stone held in place by stone chains or standing by itself; thin or thick bricks and mortar-beds.

By the last quarter of the fourth century this standard type of basilica was in use in all major centres of the Latin West. Given the plan's uniformity, it may well have spread from a single centre, possibly Rome. Indeed, in Rome, as witness the first structure excavated below the church of S. Marco, it may have been common among parish churches even prior to 350.[4] Certainly this standard plan has determined the picture of Early Christian Rome which we have today.

ROME

Never until the seventeenth century did church building flourish in Rome as it did in the century from 380 to 480.[5] On one hand, there are four huge foundations of the Imperial and Papal courts, designed in the spirit of a classical renascence: S. Paolo fuori le mura, S. Maria Maggiore, the Lateran baptistery, S. Stefano Rotondo. Alongside such monumental structures stand a dozen parish churches in the city,

the suburbs, and on the great estates. Less pretentious and luxurious, they are still impressive by their size, their clear and simple design, their balanced proportions. By sheer number alone they determine the picture of fifth-century Christian Rome as much as the far more ambitious Imperial and papal foundations. S. Sabina is a superb example, well preserved and well restored. But other churches have likewise survived in large portions, hidden below medieval and Baroque remodellings: S. Clemente, S. Sisto Vecchio, S. Pudenziana, S. Anastasia, SS. Giovanni e Paolo, S. Lorenzo in Lucina, S. Vitale, S. Pietro in Vincoli, S. Agata dei Goti. Of still others, such as S. Marcello inside the city walls, S. Stefano on an estate on the Via Latina, and the basilica of Pammachius at Ostia, at least the plans are known, wholly or in part. All, it seems, were designed to replace the obsolete community centres of pre-Constantinian tenor or time. All are standard basilicas, composed of nave, aisles, apse, and atrium. The columns, as a rule, are spoils, the walls built of concrete and faced with pure brickwork, the

bricks likewise looted from older buildings. The width of the mortar-beds and joints progressively changes throughout the century and thus gives a clue for the chronological sequence of the buildings and their parts. More than elsewhere, in Rome such technical data are supported by a wealth of documentary evidence.

S. Clemente not only conveys a good idea of the design of a standard basilica in Rome about 380; it also impressively exemplifies the relationship of these fourth- and fifth-century churches in Rome to earlier buildings on the site, as well as to their later remodellings.[6] The present church, slightly below street level, is a twelfth-century structure, redecorated in the Baroque. The Early Christian church rose from a level more than 4 m. (13 ft) farther down, occupying the site of three earlier buildings [132]. Its apse oversails the ground floor of a second-century house which encloses a mithraeum of third- or early-fourth-century date. Its nave and aisles are inserted into the walls of a third-century structure, possibly used as a Christian community centre; and this in turn

132. Rome, S. Clemente,
c. 380. Isometric reconstruction

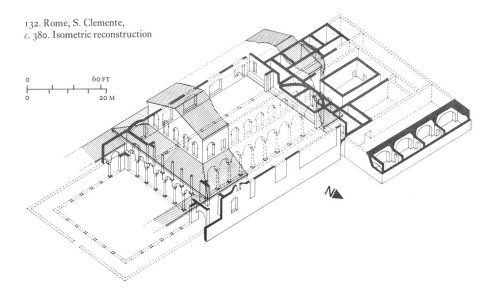

rises on the podium of a public building of first-century date. Yet within this maze the remains of the fourth-century basilica are easily discerned. The columns of the nave, eight on either side, are enclosed into the foundations of the upper church; the arcades, clerestory, and façade are absorbed into the wall of its right aisle. An atrium, in front of the fourth-century church, is buried below the present twelfth-century forecourt. From these remains the first basilica is readily envisaged: the nave was broad, comparatively short, and remarkably low – in metres 15 by 35 by 13·50, in Roman feet 50 by 120 by 45 (50 by 115 by 45 English feet); the

columns were all different in size and material, their wide arcades springing from wedge-shaped impost blocks; the clerestory windows were wide, separated by narrow piers and enveloping the nave on three sides; the atrium included a colonnaded *quadriporticus*; and finally, an open arcade led from the nave into the portico along its façade – the esonarthex, as it were – with the result that the nave was encircled on three sides by the ancillary spaces of aisles and esonarthex. The church plan which prevails during the fifth century in the Aegean coastlands, in the late fourth century seems to have been equally characteristic of Rome.

This standard plan at first glance seems to have been retained unaltered by Roman church builders throughout the fifth century. A more critical look reveals the changes the plan underwent during those hundred years. The proportions of the nave become narrower, longer, and higher: as a rule *c*. 50 by 150 by 60 Roman feet.[7] The number of arcades and windows increases, and their proportions become steeper, while the individual window becomes wider and higher than before. The façades, as late as the first quarter of the fifth century, opened towards the narthex in a series of arcades; the narthex in turn opened in a colonnaded arcade towards the

133 (*opposite*). Rome, SS. Giovanni e Paolo, *c*. 410–20. Façade

134 (*below*). Rome, S. Vitale, 401–17. Reconstruction of façade, narthex, and nave

atrium, and thus functioned both as an exo- and an esonarthex [133, 134]. As a result a double screen of columns intervened between atrium and nave, the first perhaps open, the second certainly hung with curtains, much like the tribelon of a fifth-century church in Greece. In the Roman churches, the faithful were led through these screens into the nave, not barred from it as apparently was Aegean custom. Only after 430, such arcaded façades and 'exo-esonartheces' disappear from Rome and with them the airiness of construction which their openness imparted to the building. Instead the narthex communicated with the nave only through doors. The space of the nave appears to be more compact and the ancillary units of aisles and narthex give way to the parallel flow of nave and aisles towards the apse. The impression of parallel currents of space is further strengthened when, as early as the second decade of the fifth century, the continuous window band breaks into a separate design in the façade, be it a huge five-arched opening, as at S. Vitale and SS. Giovanni e Paolo [133], or a row of oculi, as at S. Pietro in Vincoli.[8]

In this development, S. Sabina on the Aventine represents a high point of Roman church building.[9] Built between 422 and 432, and incorporating remnants of earlier buildings, it typifies in plan and proportion the new Roman standard basilica of the fifth century, quite different from the older variant of the type represented by S. Clemente. At the same time, in elegance of design and lavishness of decoration, S. Sabina partakes of the very beginning of the classical renascence under Sixtus III [135–7]. The twenty-four columns of the nave, of beautiful Proconnesian(?) marble, and their Corinthian capitals and bases are believed to have been taken from a second-century building, but they have been selected with loving care so as to match in every detail. The marble revetment in the spandrels shows in beautiful design chalices

135 and 136. Rome, S. Sabina, 422-32. Interior of nave (*opposite*) and of right-hand aisle and nave (*below*)

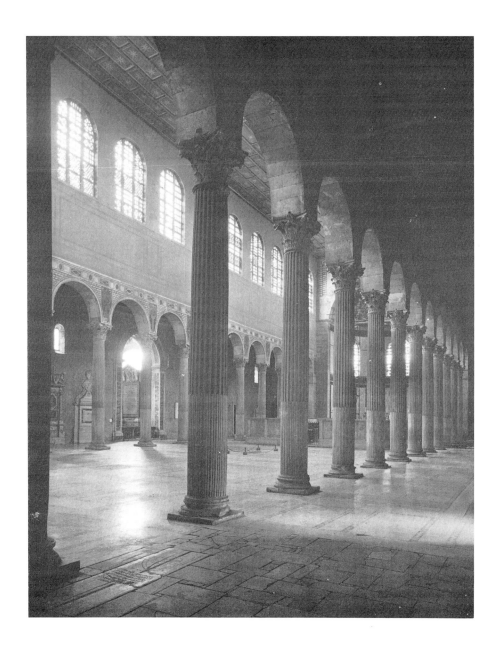

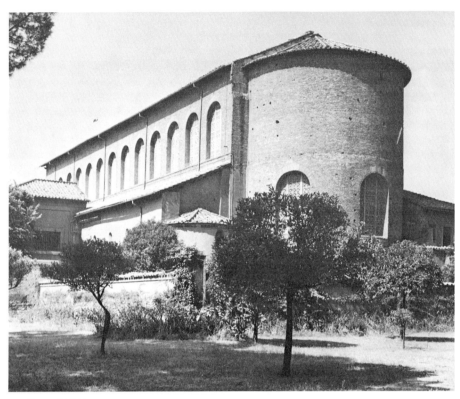

137. Rome, S. Sabina,
422-32. Exterior of apse and clerestory

and patens, the ensigns of Christ. The tendril friezes painted in the aisles are forceful and elegant, and the splendour of the original decoration in the nave is still shown in the monumental mosaic panel across the interior façade with its dedicatory inscription. The lateral walls of the nave apparently carried mosaics above the marble revetment of the spandrels.[10] But all this lavishness is applied to a simple standard plan, albeit of the new variety which comes to the fore in Rome about 420. The nave is extraordinarily high, long, and narrow, its elegant slenderness supported by the narrowness and the length of the flanking aisles, and set off by the lighting. Arcades of thirteen bays on either side of the

nave lead the eye rapidly from the entrance doors to the apse. The arches, closely spaced, swing easily from one tall column to the next. Huge windows, 8 Roman feet wide, 14 feet high, and a bare 4 feet apart, form the clerestory, one above each intercolumniation. Three more windows open in the apse and five in the façade, these latter perhaps replacing an original five-arched window. Together the thirty-four windows bring a flood of light into the nave, presumably filtered through mica panes set into stucco gratings.[11] The aisles, on the other hand, remained windowless and dark, and from nave and aisles only doors communicated with the narthex and the preceding atrium.

None of the other fifth-century parish churches of Rome could apparently vie in elegance with S. Sabina, but at least until the middle of the fifth century they all adhered to the standard plan. Only round the middle of the century was the type modified anew: the windows grew narrower, the distances between them larger, and as a result, the light dimmer. The nave of S. Pietro in Vincoli, as rebuilt apparently *c.* 450, and the small basilica of S. Agata dei Goti, of 462–70, represent this later phase. At the same time outside influences modify church building in Rome: the tripartite transept, included in the remodelling of S. Pietro in Vincoli, recalls that of S. Tecla at Milan, while S. Agata dei Goti corresponds in plan and elevation exactly to the Arian cathedral of Ravenna, S. Spirito, and was laid out in Byzantine instead of Roman feet.[12]

The standard basilicas of the fourth and fifth centuries in Rome are by no means as complex, nor for that matter as subtle and splendid, as those designed at the same time in Constantinople or Salonica. Nor are they as powerful as the churches of Qalb Lozeh or of R'safah in Syria. To western eyes they appear rather ordinary, and the overall picture seems uniform. However, the impression of over-simplification and monotony is hardly fair. We are led to it largely by the strong imprint exerted by the Roman standard type on nearly all medieval church building and even on much later architecture. Revived in the ninth and again in the eleventh and twelfth centuries, the type spread all over Europe and was taken up again in fifteenth-century Italy. The many derivatives have blinded us to some degree to the forceful, simple grandeur of the original design.

NORTHERN ITALY AND SOUTHERN FRANCE

In contrast to Rome, churches of standard plan in northern Italy and southern France are known only through fragmentary excavations.[13] Yet there is sufficient evidence to show that in the old provinces of Gallia Cisalpina and Narbonensis, too, the wealth of earlier church types, as we know it from Milan, was replaced from the late fourth century on by a 'normal' basilica of the type found in Rome. Obviously the new buildings were erected in the traditional techniques of the Po Valley: a concrete masonry faced with high bricks set, as on occasion in Milan, in a herringbone pattern and interspersed with huge pebbles; the vaults composed of brick or of hollow tubes. At times distinguishing features set off the plan of such northern Italian standard basilicas from those in other regions of the Latin West: a rectangular apse, or no apse at all; a martyr's chapel attached to the rear of one of the aisles; the doubling of churches to form a cathedral, a carry-over from Constantinian times.

A huge church, named from the outset after himself, was laid out by St Ambrose about 385 on a Milan cemetery. His burial place was to be located below the altar next to the relics of two local martyrs, appropriately dug up for the consecration in 386. The remnants of this original church have been traced below the present Romanesque S. Ambrogio: a nave and aisles, two colonnades of thirteen or more supports each, the bed of a marble floor, the springings of a stilted semicircular apse, the four columns of a baldacchino over the high altar; the position of the façade, and thus the original length of the nave, remain unknown. The narthex and atrium of the Romanesque structure, unusual in the High Middle Ages, suggest that they too rest on fourth-century foundations and complete the picture of a huge building complex, more than 300 Roman feet long and 100 feet wide, comparable in plan but larger than contemporary standard basilicas in Rome. The plan of S. Ambrogio becomes standard in the fifth century throughout northern Italy, from Vicenza to Verona, Brescia, Pavia, and Turin [138]. Its layout, including the atrium, is closely followed,

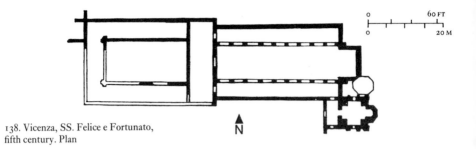

138. Vicenza, SS. Felice e Fortunato,
fifth century. Plan

often presented in the context of a twin cathedral. Local modifications are minor: the apse at SS. Felice e Fortunato in Vicenza is rectangular, at the cathedral in Verona it was semicircular. Pavements in Milan and farther west were marble, in the eastern parts of upper Italy they were mosaic. At Verona, the chancel was raised and prolonged into the nave by a solea, the columns were placed on pedestals. However, major deviations from the standard plan are rare. Occasionally, as for example in the old cathedral at Brescia, one of the two structures of the twin cathedral is a simple rectangular hall; at S. Trinità at Vercelli the basilican nave terminates in a trefoil apse, and once, at Pavia, the basilica is composed of a nave and four aisles.[14]

A main characteristic of the northern Italian standard basilica is the martyr's chapel attached near the end of one aisle: a feature either planned from the outset or pre-existing or, indeed, added slightly later. At S. Ambrogio, the tomb cella of the local martyr Victor, remodelled when the basilica was built and altered a second time about 500, is a small trapezoidal domed room, its apse pierced by two tiers of three windows. More often, however, these chapels are cross-shaped, their arms barrel-vaulted and, like the centre dome, in tube construction. One such structure, presumably a martyrium, is attached to the north arm of the cross church of S. Simpliciano at Milan and may be contemporary with the main structure. The cross martyrium of S.

Prosdocimo at Padua, dating from between 500 and 507 and well restored, projects similarly from the transept of S. Giustina, a huge sixteenth-century building replacing an Early Christian church. A third cross chapel of fifth-century date, S. Teuteria, rose close to the apse of the Church of the Holy Apostles at Verona. Finally, a fourth was added to the right aisle of SS. Felice e Fortunato at Vicenza about 500 [138]. The walls were revetted with marble plaques and the dome decorated with mosaics, of which fragments are preserved on the pendentives.[15]

The position of northern Italy within Christian architecture of the fifth century is not easily determined. The standard basilica plan of northern Italy is so close to those of fourth- and fifth-century Rome that it could very possibly have been imported from there, especially since around and after 400 Milan relinquished its political dominance to Constantinople, its ecclesiastical influence to Rome. On the other hand, the small cross chapels probably find their closest parallels on the coasts of Asia Minor. Documentary evidence prior to 450 locates the chapel of H. Euphemia at the end of the aisle of her basilica at Chalcedon (Kadiköy); and a cruciform martyr's chapel in the same position, though of sixth-century date, has survived at Alakilise (Alaja Jaila) in Lycia.[16] Indeed, northern Italy always had close links with Constantinople and Greece. One need only recall

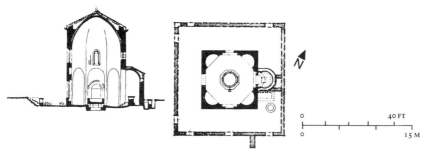

139 and 140. Riva S. Vitale, baptistery, *c.* 500.
Section and plan (*above*) and exterior (*below*)

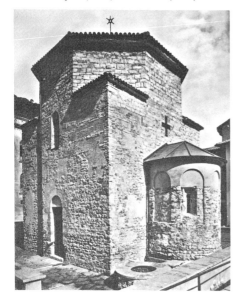

the tripartite transepts of fourth-century Milan and of contemporary and later Greece; or the mosaic floors of Greece, the Balkans, and north-eastern Italy, so different from the marble and flagstone pavements of the standard basilica in Rome. It is still in doubt whether such features were brought to northern Italy from the East, or whether upper Italy and the Aegean coastlands share a common heritage.

On the other hand, a standard type of baptistery may have spread from Milan to northern

Italy and Provence.[17] In the fourth century, baptisteries as a rule had been either square or rectangular rooms, with or without apses, either unvaulted, such as the first baptisteries at Aquileia and Trier, or covered with a flat dome on squinches and attached to the end of the aisles, as at Naples about 400. Conversely, already under Constantine the Lateran baptistery was laid out on an octagon plan, its corners marked by columns; the outer walls of Constantine's structure have possibly survived to this day. The plan was taken up, enriched, when the baptistery of Milan was built behind and either at the same time with the cathedral, about 350, or thirty years later under St Ambrose. In any event, Ambrose provided an inscription alluding to the number symbolism of the building:[18] an octagon, its sides expanding in semicircular niches, its remaining sides forming rectangular niches; a domed centre room; and in the centre, the eight-sided font. In simplified form the plan survives well preserved at Grado, about 450; in elaborate shape, with columns in the corners of the octagon and with a clerestory articulated by arcades, it appears at Fréjus and Albenga. At times the octagonal core expands in niches projecting outward, as at Novara; elsewhere, it is enveloped by ambulatory rooms: square at Aquileia (*c.* 450) and at Riva San Vitale (*c.* 500) [139, 140] on the southern tip of Lake Lugano; octagonal in the Baptistery of the Arians at Ravenna in the late fifth century.[19] However, no

baptistery of the period has preserved its original form and decoration better than that of the Orthodox in Ravenna [141, 142].[20] The bottom parts, now deep in the ground – and with them the octagonal plan and the marble revetment – date from about 400, but this first building was not vaulted. Not until fifty years later, under Bishop Neon, were the dome and the upper part of the outer walls built – the former in tube construction, the latter articulated by pilaster strips. (The terminating corbel-table frieze contrary to former belief seems to date from an early medieval rebuilding.) Likewise, the interior received its decoration partly about 400, partly about 450. In the spandrels of the eight niches mosaic

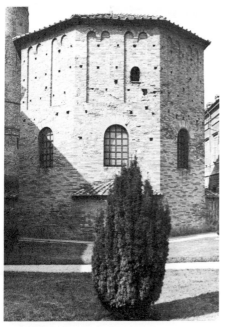

141. Ravenna, Baptistery of the Orthodox, *c*. 400–50. Exterior from the west

tendrils envelop the figures of prophets. In the second zone, tripled stucco arcades, part of the original design, frame windows and stucco aediculas sheltering sixteen minor prophets; they in turn are surmounted by wide arches filled with rich stucco rinceaux, both added about 450. Finally, in the dome, the mosaic, of the same date, represents in three rings empty thrones and altars, apostles, and Christ's Baptism.

Links between northern Italy and the Aegean coastlands are possibly also reflected in the dissemination of the octagonal baptistery plan. About 400, or earlier, it occurs alongside the church of St Mary at Ephesus, some time late in the fifth century near the Menas basilica [59, 64]. But this does not mean that the plan was brought from the Aegean shores or from Constantinople to Milan. In fact, it remains rare in the East. On the other hand, the octagonal baptistery with corner niches is frequent in the sphere of influence of Milan. A more elaborate type develops in the fifth century. The Lateran baptistery, as remodelled by Sixtus III, fused the octagon plan with that of a Roman mausoleum of the type of S. Costanza, with domed centre room, barrel-vaulted colonnaded ambulatory, and narthex with two sideway apses [47]. This fusion need not have taken place first or exclusively in Rome. As early as *c*. 400, octagonal baptisteries with inner colonnade and ambulatory are found in Gallia Narbonensis, for instance at Marseille and Aix-en-Provence.[21] But in the Lateran baptistery it finds its most powerful expression: a monumental blend of Late Roman architectural concepts, of an Ambrosian Christian symbolism, and of the practical requirements of the baptismal ritual.

ISTRIA, EASTERN VENETO, AND CARINTHIA

The Christian congregations on the north shore of the Adriatic, in the Alpine region farther north, and as far east as Hungary and Bosnia, clung to architectural types locally established in the early fourth century or even earlier: box churches, as a rule without apse, the altar site pushed well forward into the nave, a semi-

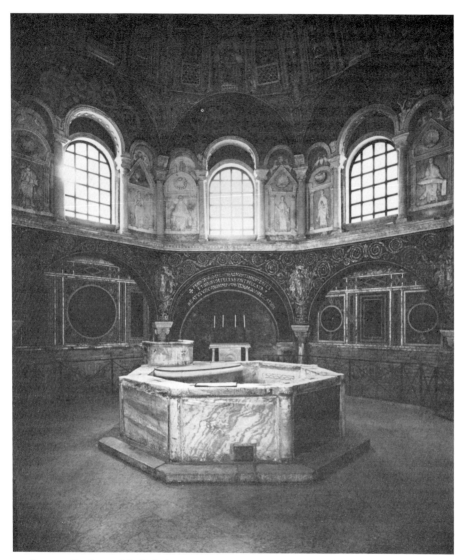

142. Ravenna, Baptistery of the Orthodox,
c. 400–50. Interior

circular clergy bench behind the altar. Often, even in remote places in Carinthia and Hungary, two such simple rectangular halls are coupled into a twin cathedral.[22]

In the fifth century, however, the impact of the standard basilica makes itself felt with increasing force in the larger communities along the sea shore. At Aquileia, either about 350 or

400, a new structure replaced the north hall of the old twin cathedral [9]. Following conservative local custom it lacked an apse, but was provided with a clergy bench. Yet in size the new church can be compared with the new standard basilicas of Rome and Milan; and, like these, it was divided into a wide nave and two comparatively narrow aisles and thus certainly provided with a clerestory.[23] Another feature of the standard type was purloined for the new cathedral at Pula (Pola): a triumphal arch resting on columns and cross piers, together with two minor arches, serves to separate nave and aisles from a clergy section, the latter elevated above the nave level and sheltering the customary clergy bench.[24]

A group of small churches in the Alps and in the mountains that rise from the Istrian plain, share with Istria the motif of the clergy bench. Others enrich the plan by adding an apse and laterally-projecting annexes – forming a cross plan – and by enclosing the nave within corridors. In this form the type is found from Carinthia to the Dalmatian mountains, to Bosnia-Herzegovina, to the Tyrol and to the lakes north of Milan.[25] It may well be derived from the monumental cross churches of Milan and have spread east through the arc of the Alps. From there it was possibly carried in the seventh century to the British Isles, presumably by missionaries.[26] Yet during the fifth century, church building in Istria and Carinthia had little contact with architecture elsewhere in the Christian world.

DALMATIA

The architecture of Salona on the Dalmatian coast, from the fourth to the end of the sixth century, was far from being that of a backwater town. It takes its place alongside the architecture of Rome, Milan, and Ravenna, with a character all its own. In Rome, the comparative uniformity of the standard type and its imper-

viousness to foreign influences are impressive. In Milan, the size of the church buildings, their inventiveness, and the close ties with both Rome and Constantinople are significant. In Salona one is struck by the manifoldness of church plans and by the willingness with which stimuli are absorbed from all over the Mediterranean area. At the same time, Salona so far remains the only sizeable Christian site to come to light along the Dalmatian coast. And even here, nothing more survives of any building than the plan, a few fragments of decorative sculpture, and some mosaic pavements. Over the last eighty years, however, excavations have been exemplarily carried out and carefully published, yielding extraordinarily rich results. They have brought to light numerous mausolea and martyrs' chapels, two baptisteries, and – between parish churches and cemetery basilicas – a dozen churches.[27]

Given the geographical position of Salona, the importance of the port, and the diversified ethnical roots of her population, it is natural that church planners would draw equally on models from the Latin West and from the Greek East, and in both territories on more than one centre.[28] For example, Constantine's basilica at the Lateran with its 'offertory rooms' projecting sideways would seem to be reflected in the *basilica orientalis*. Certainly the thoughts of the Salonitans were on the basilicas of St Peter's or of S. Paolo fuori le mura in Rome when, about 400, the cemetery precinct of Manastirine was remodelled as a basilica with a continuous transept to shelter the grave of the local martyr-bishop. The plan of Salona's twin cathedral, on the other hand, is obviously linked to the tradition of near-by Istria, but it consists of two regular basilicas rather than of two halls. The one to the south, the *basilica episcopalis*, has been dated as early as 350, but this remains uncertain. Whatever its date, the plan with nave, aisles, and narthex, and the proportions are close to fifth-century provincial churches all along the shores

of the eastern Mediterranean. Only the short bay intervening between nave and apse in the *basilica episcopalis* is a distinctive local feature. Except for this short forechoir, the plan is retained unchanged throughout the entire fifth century in the city churches of Salona. The north church of the twin cathedral, the *basilica urbana* (begun before 405; completed by 426), with its mosaic-carpeted floors incorporates into the standard plan a free-standing clergy bench, purloined from neighbouring Istria to the north.[29]

At Salona, earlier than elsewhere, i.e. beginning with the fifth century, the cemetery basilica becomes indistinguishable from such city churches of standard Aegean type. The Anastasius basilica at Salona-Marusinac was a normal basilica like any in Greece, including the mosaic carpets in nave and aisles, the altar directly in front of the apse, the atrium enveloped by porticoes. The buttresses of the apse specifically recall the basilicas at Nikopolis in Epirus, some 500 miles south on the coast, and only the short bay in front of the apse seems derived from the

local *basilica episcopalis*. Were it not for the site of the church outside the town on a cemetery, the fact that the mausoleum of the martyr is enclosed in the atrium, and the presence of private mausolea at the four ends of the aisles, nothing would reveal the cemetery function of the structure. At times the assimilation of cemetery layouts with the plan of the normal city basilica goes even further. A large open-air precinct of regularized plan, adjoining the Anastasius basilica to the north, was laid out in 426 to replace an older, small, apsed martyrium shrine [143]. A courtyard enveloped by porticoes terminated in a group of three mausolea; an apse in the centre and two oblong rooms projecting sideways, a plan which superficially evokes the transept basilica to such a degree that the structure has been termed a 'basilica discoperta', a roofless basilica.[30]

The impact of the Eastern coastlands remained strong in the architecture of Salona even in the sixth century. Probably about 530 the south basilica of the twin cathedral was replaced by a cross structure with four basilican arms, in

143. Salona-Marusinac, Anastasius Basilica, as *c*. 426, Anastasius Mausoleum, *c*. 300, and martyrium precinct, 426. Isometric reconstruction

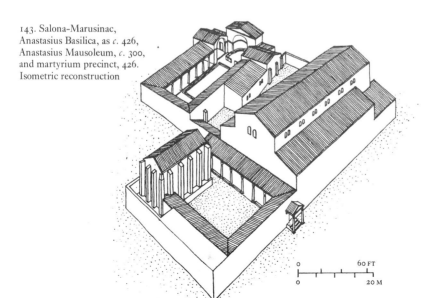

0 60 FT

0 20 M

plan much like the Church of the Apostles at Gerasa, and presumably that of Porphyrius at Gaza.[31] At times the apse of a basilica at Salona is flanked by rectangular rooms with one curved side: the plan known from the islands near the west coast and from the south coast of Asia Minor. Or else, as in the churches of the Negev, the aisles in one of the Salonitan churches terminate in absidioles, which in turn are followed by regular pastophories.[32] But such features intermingle with elements based on the local architectural tradition and on the increasing importance of Ravenna as the cultural centre of the Adriatic coastlands. When the baptistery of the cathedral at Salona was rebuilt towards the end of the fifth century, columns in two tiers were placed against the walls recalling the mausoleum of Diocletian at Spalato. Yet at the same time the sumptuous decoration with gold mosaics, stucco, and wall paintings (only tiny fragments were found) must have been similar to the Baptistery of the Orthodox at Ravenna.[33]

RAVENNA

In contrast to Salona, where only ruins survive, Ravenna to this day glories in a dozen or more church buildings of fifth- and sixth-century date, most of them superbly preserved, with mosaics, stucco decoration, and marble revetments. True, the gradual submersion of the city into the sea has forced successive generations, from the eighth to the end of the sixteenth century, to raise the level of the churches and their arcades and clerestories in complicated building operations which have changed their original proportions. But beneath such remodellings the original structures are easily recognizable. Ravenna presents a splendid example of a locality where Early Christian architecture survives in all its variety in a series of buildings encompassing two centuries: apparently a closed development, were it not for the readiness with which the milieu constantly absorbed foreign concepts

and a foreign vocabulary. This openness is understandable against the background of the geographical location of Ravenna at the border between the Eastern and Western parts of the Empire and of her political position: first, as capital of the Western Emperors, beginning with Honorius, who transferred the Imperial See from Milan, and continuing under his sister Galla Placidia (425–50) and her son Valentinian III (450–5); then, in ever closer contact with Constantinople and the Eastern provinces as the residence of the Ostrogothic conquerors and their highly romanized court – Theodoric (490–526) and his successors; finally, as the See of the Byzantine viceroys after the reconquest of Italy by Justinian's armies. Yet despite all political changes, a local style and a local standard plan

144. Ravenna, S. Croce and mausoleum of Galla Placidia, c. 425. Isometric reconstruction

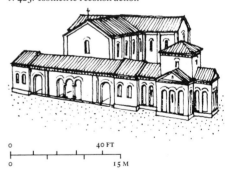

gradually developed, and survived into the seventh and eighth centuries.[34]

Insignificant as it was prior to 402, Ravenna to our knowledge had evolved no autochthonous Christian architecture during the fourth century; its first known church buildings, erected between 402 and 425, draw on the architectural traditions of both Milan, the previous capital, and the Aegean coastlands. Under Galla Placidia, a major church was laid out on a cross plan with aisleless arms, the type common in Milan

up to 400. Of the church proper, only the nave survives under the name of S. Croce, badly mauled and possibly rebuilt in the Middle Ages. But the plan is known [144], including presumably low rooms skirting the flanks of the nave – another Milanese feature – and a long narthex with screened ends – this latter a hallmark of church plans in Greece. To the side of the narthex rises a small structure, the so-called mausoleum of Galla Placidia, added not much after 424 [145, 146]. Dedicated to St Lawrence, it

of white mortar suggests Milanese workmanship. But the refined decoration of the interior is rooted in the art of the Imperial court, whether based at Milan, Constantinople, or Ravenna. Marble revetted the walls from the floor level, originally nearly 5 ft farther down. Mosaics on a blue ground cover the upper zone: four pairs of apostles on the wall of the centre bay, St Lawrence on the rear niche, tangled tendrils on the barrel-vaults of the arms, and the starred Heaven across the dome.

145. Ravenna, Mausoleum of Galla Placidia and S. Croce, c. 425. Exterior

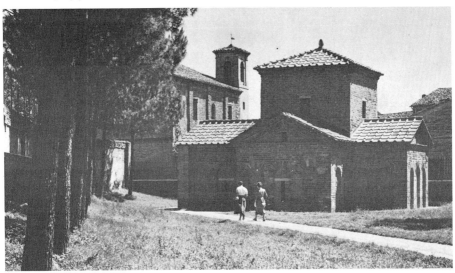

shelters the sarcophagi of Honorius, Galla Placidia, and her husband, and was apparently both Imperial tomb and martyr's chapel. Indeed, like the martyrs' chapels in and near Milan, it is cross-shaped, with a slightly longer nave. Its arms are barrel-vaulted; its centre bay rises high and carries a pendentive dome. Strong blind arcades frame the windows, as at S. Simpliciano; classical cornices set off the pediments over the arms. Like the plan and the exterior design, the masonry with very high bricks and narrow beds

The masonry technique in Ravenna remains Milanese throughout the fifth century. In design, however, from the early fifth century on, the architects of Ravenna break more and more with Milanese church planning and look instead towards contemporary church building in the Aegean coastlands.[35] The basilica of S. Giovanni Evangelista, built between 424 and 434 as an *ex-voto* by Galla Placidia, has undergone several remodellings.[36] Its nave colonnades were raised to the present level and its clerestory newly

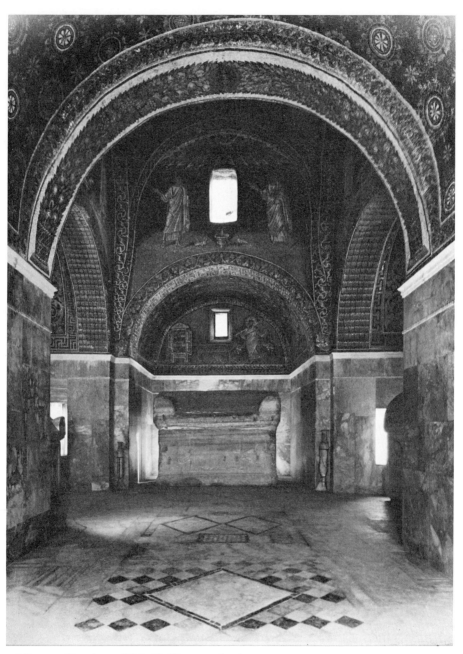

146. Ravenna, Mausoleum of Galla Placidia, *c.* 425. Interior

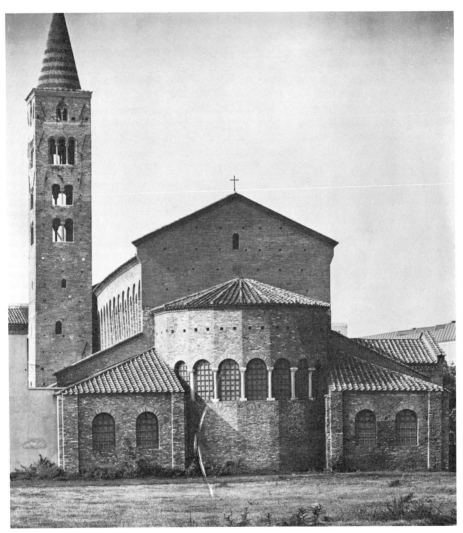

147. Ravenna, S. Giovanni Evangelista,
424–34. Exterior from the south-west

built in the seventh century [147, 148]. It was
thoroughly repaired again in the twelfth century
and finally rebuilt in large part after a bombing
in 1944. However, major portions of the fifth-
century church survive: the outer walls of the

aisles and their windows, the columns and capi-
tals, and finally, the old level, now 2·25 m. (6 ft
6 in.) below the floor. The original basilica con-
sisted of a nave and aisles, cut shorter than the
present ones but with the arcades more widely

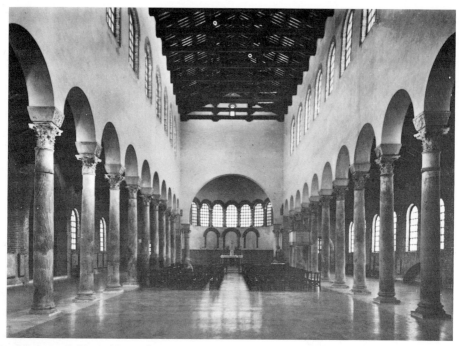

148. Ravenna, S. Giovanni Evangelista,
424–34. Interior

spaced. The aisles are lit by large windows, their walls articulated on the exterior by pilaster strips. Impost blocks in the form of inverted truncated pyramids surmount the capitals, closely recalling contemporary impost blocks in Greece [148]. The narthex was apparently tripartite. Additional rooms jutted out sideways from the narthex, as in so many fifth-century churches in Greece and on the Asian coast, and were possibly surmounted by towers. The apse, too, is of Aegean type, polygonal with three windows. The arcaded opening higher up may well be contemporary. Two free-standing chambers projecting eastward from the aisles may perhaps have been martyrs' chapels, as they resemble the jutting chambers of the Cilician coast rather than the side chambers of Syrian churches [147].

Not until the end of the fifth century, however, does a standard basilica type evolve in Ravenna: in S. Spirito (originally built as the Arian cathedral); in S. Agata, partly rebuilt in the sixth, remodelled in the eighth, twelfth, and fifteenth centuries, but first laid out about 470;[37] and finally in S. Apollinare Nuovo, built by Theodoric in honour of Christ and sixty years later dedicated to St Martin [149].

Were it only for its plan, S. Apollinare Nuovo would seem to be just one more ordinary basilica, with nave and two aisles, an apse, and arcaded colonnades.[38] The earlier standard plans of the Latin West, of Rome, and of Salona come to mind. Also the masonry technique of S. Apollinare Nuovo follows that long established at Milan, while the hollow tube construction of the apse vault had been customary for centuries

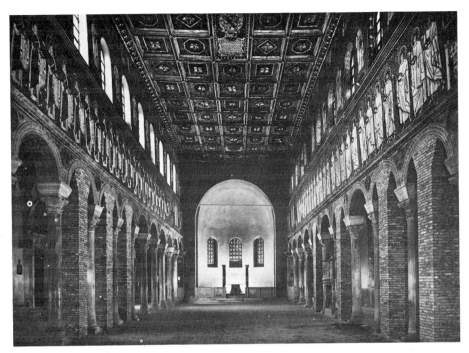

149. Ravenna, S. Apollinare Nuovo, c. 490.
Interior of nave during restoration and (restored) apse

in southern Italy and North Africa. Yet into this Western plan are incorporated countless Eastern features. The exterior polygon of the apse, long at home in Ravenna, is Aegean in origin. The capitals, presumably imported from Constantinople, are exact counterparts of pieces found at Nea-Anchialos about 470 [cf. 76]. Finally, the buttress pilasters of the outer walls are crossed by a brick band arched over the windows which creates a strong pattern of vertical and horizontal elements. Reminiscent of Syrian rather than Aegean churches, this motif hints at the rapidly widening horizon of Ravenna builders in the last decade of the fifth century. Far more than such details, the proportions, the lighting, and the splendid mosaic convey an impression very different from that of a standard basilica in fifth-century Rome. The width of the nave as compared to its length is greater, the span of the arcades is proportionately wider. On the other hand, the height of the nave is conspicuously greater than its width, conveying a sense of an ample space. This impression is intensified by the lighting. While the nave windows are smaller and set farther apart than in Roman basilicas, the aisles are lit by windows as large as those of the nave. The result is an even distribution of light and shadow in both nave and aisles, as customary in the Aegean coastlands. Nothing, however, determines the picture of S. Apollinare Nuovo more strongly than its sumptuous mosaic decoration. In Roman churches by the fifth century and replacing older non-figural patterns, the wall space between arcades and clerestory was given over to individual panels arranged in one or two tiers, each presenting a

historical event from the Bible. St Peter's, S. Paolo fuori le mura, SS. Giovanni e Paolo presented examples of this Roman pattern. Instead, at S. Apollinare, long rows of figures move towards the apse: to the south, male saints advance from Theodoric's *palatium* towards Christ; to the north, female saints step forward from *Classis civitas* towards Mary. Between the upper windows, figures of apostles arrest this eastward movement, while the small topmost panels, containing gospel scenes and decorative shells, counter the height of the nave. The long rows of saints date from after the Byzantine reconquest, about 550; but they only replace original similar processions approaching from the palace and from Classe. Hence, under Theodoric the church would have looked much as today. Throughout, the mosaics balance and correct, as it were, the proportions of the interior. Their smooth expanse and their glitter of whitish-grey, green, blue, and gold, transform the walls into a bodiless tapestry.

Whether or not this concept of a mosaic decoration which envelops the entire building was originally evolved in the sphere of the Imperial courts at Constantinople and Milan during the late fourth century, it had a firm hold in Ravenna from the days of Galla Placidia. Thus S. Apollinare Nuovo represents a new standard type: a Latin Western plan executed in a building technique originating in Milan. Into it are fused elements purloined from the Aegean coastlands and as far away as Syria. The interior is clothed in a shimmer of light and colour, the whole a blend peculiar to Ravenna.

AFRICA

Large numbers of churches have been excavated in Africa: in Algeria, Tunisia, Libya, and western Cyrenaica.[39] Others are preserved across the seas in South Italy, Sicily, and the Balearic Islands. But our ignorance regarding their dates, style, or planning is appalling. It is due in part to obsolete

publications and poor excavation techniques in the past, but also to a widespread propensity for aligning the architectural chronology of Mediterranean Africa with its political history: as a Roman province prior to 427; under the Vandals from 427 until the Byzantine conquest; as a Byzantine province from 534 until the Arab invasion in 647. The fact is, however, that the changing political fate of North Africa apparently exerted little impact on church planning. Nor are the religious heresies of North Africa or the concomitant contrasts of native hinterland and Roman coast reflected in her architecture. Donatist or Arian Vandal structures can be distinguished from orthodox Catholic churches only if demarcated by a distinctive religious inscription.[40] Similarly, churches look basically alike whether built in the larger centres of North Africa, or in any one of the hundreds of small towns. Barely can we start to distinguish church plans in the large administrative provinces of Late Antique North Africa: Mauretania (Western Algeria), Numidia (Eastern Algeria), Byzacene (Tunisia), Tripolitania, Cyrenaica. Carthage, long the political and spiritual centre of the territory, apparently exerted little architectural influence. On the contrary, distinctive regional features such as side chambers flanking the apse, double nave supports, or a colonnade articulating the clerestory, are concentrated in small districts and may well have spread from one or the other of those small town or village bishoprics into which the entire territory was split.

Under the circumstances, any attempt to establish a chronology for North African church architecture must be extremely tentative. Documentary sources are practically non-existent. Rarely does a date inscribed on a pavement, a lintel, or a tomb suggest the period of construction. Regional features may, but need not, be limited to one period. Only the Byzantine occupation of North Africa marks a caesura in church planning, at least in the provinces most strongly

byzantinized: south-eastern Tunisia, Cyrenaica, and the Djebel Aurês.

Two currents seem to flow side by side in North African church planning. The majority of churches that have been found are ordinary basilicas of the type common in the Latin West: a high nave supported by arcaded colonnades, occasionally preceded by a narthex or an atrium, flanked by two low aisles, and terminated by a semicircular apse. Alongside this standard type, however, a distinctly Constantinian plan survives in North Africa in numerous examples. In this group the nave is flanked by four or more aisles, recalling the four-aisle Constantinian basilicas, from the Lateran to Bethlehem and, in Africa itself, Orléansville. Reasons for the expansion into six or eight aisles, as at Tipasa [150], elude us. It is not limited to either cathedrals or martyrs' churches, nor does the number of aisles greatly differ in point either of locale or time. However, Constantinian elements permeate the plan of standard churches as well, and North Africa's place within the history of Christian architecture is best understood when its highly conservative character is kept firmly in mind. Likewise, twin cathedrals occur, recalling those of the early fourth century in Istria and the Rhineland. At times forechurches precede the church proper, basilican in plan and roofed, but cut off by a wall and linked to the main church only by doors. The similar forechurch perhaps intended for catechumens in the Constantinian cathedral at Trier comes to mind, along with the fact that in North Africa in the fourth and fifth centuries reconciled Donatists would take the place of catechumens. Certainly the placement of altar and chancel in the nave is a liturgical fossil of pre-Constantinian and Constantinian times, as witness the cathedral at Aquileia and, in Syria, Eusebius's description of the cathedral at Tyre. Elsewhere in Africa, the opening of the apse is blocked by a triple arcade – a derivative, one suspects, of Constantinian fastigia. Baptisteries as a rule are simple rectangular or square rooms, attached to the rear or flank of an aisle, or occasionally free-standing.

150. Tipasa, basilica, *c*. 450. Air view

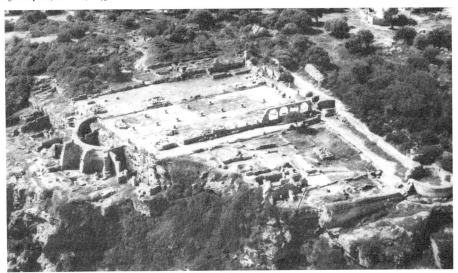

Again, this shape and position of the baptistery are features apparently widespread in the fourth century throughout the Christian world.

Likewise, Constantinian features of a specifically North African kind survive into the fifth and sixth centuries, more often than not linked to the cult of the martyrs. Indeed, at an early period, the cult of the martyrs plays a large role in North African religious thought and hence in church planning. Nevertheless, martyria of central type are unknown, except perhaps for the round building behind the church of Damous El Karita at Carthage [151]. On the other hand,

as late as the fifth century, *areae* or open-air cemeteries were laid out, rectangular or circular and at times enclosed by porticoes, as is an *area* found outside Tipasa. And, as early as the beginning of the fourth century, martyrs' and other relics were deposited in churches, including parish churches inside towns. They would rest either in small vaults below the altar, or in a larger vault, a regular crypt, placed below the altar or below the apse, and often inaccessible. The latter arrangement, found perhaps as early as 324 at Orléansville, survives throughout the fifth century. More frequently, however, the

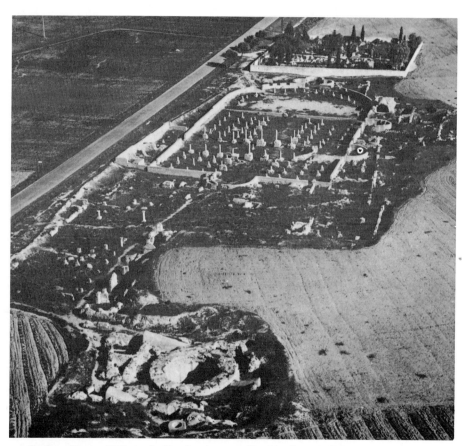

151. Carthage, Damous El Karita, basilica, fourth century(?), with adjacent buildings and (*foreground*) mausoleum

crypt was accessible, but then it served at times as a mere anteroom, whence to view the martyr's grave in a small cella situated behind the apse. Indeed, occasionally the crypt lost all links to the martyr cult and became a baptistery. Elsewhere square or semicircular counter-apses were laid out facing the main apse: in martyrs' churches to shelter the venerated grave, in cities as burial places for very important persons. At Orléansville such a counter-apse was added to the Constantinian (?) church about 400 and re-used in 475 for the tomb of Bishop Reparatus. But counter-apses remain rare; they are not the source for those of medieval churches in Europe.

The building material throughout Christian Africa is invariably the local stone, cut as a rule into small blocks and held in place by vertical stone posts and horizontal chains; as a rule construction is poor. For fortifications and exceptionally for sizeable churches, such as Tebessa, large stone blocks are used. Timber roofing was the rule, except for the stone vaults of apses and baptisteries. The columns supporting the nave and aisles as well as their capitals are also cut mostly of the local stone. Ornament is scarce and, by and large, crudely continues a late classical tradition in carving, stucco, and decorative wall painting. Roman spoils are rarely employed. Plans, more often than not, are carelessly laid out.[41]

A standard basilica is represented in a mosaic from Tabarka, about 400.[42] Representation shifts back and forth between exterior and interior in the discursive manner characteristic of Late Antique and medieval portrayals of architecture [152, 153]. On the right, a flight of steps ascends to the church portal which is closed by a curtain leading into the nave. A triangular gable, pierced by one arched and two round windows, terminates the façade; however,

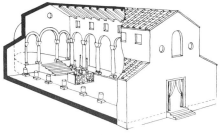

152 (*above*). African basilica; reconstruction of mosaic from Tabarka, *c.* 400

153 (*below*). Mosaic from Tabarka showing a basilica, *c.* 400. *Tunis, Bardo Museum*

these windows may well be intended to be farther down in the wall of the façade proper. Columns support the upper wall of the nave, presumably surmounted by arches; the horizontal which runs above the columns in the mosaic is the bottom line of the outside clerestory and not an architrave, an element rarely, if ever, used in North African churches. Rectangular windows open in the clerestory and are closed with stone slabs pierced by round holes. The roof of the nave is covered by tiles, the floor by a mosaic pavement of bird and floral motifs enclosed in squares. A few steps ascend to the apse and a triple arcade runs across its opening. On the left, the half-dome of the apse is pierced by a huge oculus visible from outside; it has probably slid down in the rendering from its actual place in the rear gable of the nave. Yet the apse does not shelter the altar. With altar cloth, antependium, and three candles, the altar rises in the nave above a funerary vault, a confessio, presumably containing the sarcophagus of a martyr.

In plan and design, then, the standard basilica of Christian North Africa differed little from other basilicas in the Latin West: the space was channelled, the light dimmed by window panes of alabaster or mica. Volumes of aisles, apse, and nave built up in steps. Floor mosaics such as those shown in the Tabarka mosaic recall Aegean or Adriatic rather than Roman Christian architecture. However, the altar placed in the middle of the nave and the triple arcade in front of the apse are hallmarks of African church planning about 400. Examples of the standard type are plentiful from western Algeria to Tripolitania. On a large scale, preceded by a forecourt, it appears at Haïdra in Tunisia about 400, in the church of Melleus [154], presumably the cathedral; the apse is flanked by side chambers, the

154 (above). Haïdra, 'Melleus' church, towards apse, c. 400

155 (opposite). Djemila (Cuicul), basilicas and 'Christian quarter', c. 400–11. Air view

altar and chancel project far into the nave; a second altar and chancel (was it so from the beginning?) occupied the bays near the entrance.[43] At Djemila (Cuicul) in south-eastern Algeria, a basilica of standard type took the place of an older community centre [155].[44] Its nave, two aisles, and colonnades are easy to trace. The floor is carpeted with mosaics of geometric and floral design, framing animals in large octagons. Possibly from the start of construction, or later, a larger basilica was built alongside with floor mosaics of even richer design, four aisles, and paired supports rather than single columns; an inscription names as the founder one bishop Cresconius, mentioned but once, in 411 – hence the church may be earlier or later. Spacious crypts, accessible from the outside through a connecting corridor, extend below the apses of both churches. The baptistery to the west is extraordinarily impressive and exceptional in Christian North Africa through both its size and its monumentality. The core of the structure is round and domed. In its centre, four columns carry a square canopy rising above the font. This core is in turn enveloped by a barrel-vaulted ring corridor, its two walls moulded by niches, pilasters, and a strong cornice. Stucco revetment covers the walls; the columns surmounting the font rise from high pedestals; the column shafts are fluted, the capitals elegant; and a mosaic covers the floor. The whole design breathes the spirit of a classical survival. Thermae, a small basilica, and two open courtyards, all presumably linked to the rites preceding and complementing baptism, are attached to the structure. Indeed, an entire complex of buildings envelops the twin basilicas – a large Christian quarter given over to the administrative functions, living quarters, and utilitarian needs of a large clergy.

156 (*below*). Tebessa, church and monastery, *c.* 390 and sixth century. Plan

157 (*bottom*). Tebessa, basilica, *c.* 390. Propylaeum

158 (*opposite*). Tebessa, basilica, *c.* 390. Nave from east

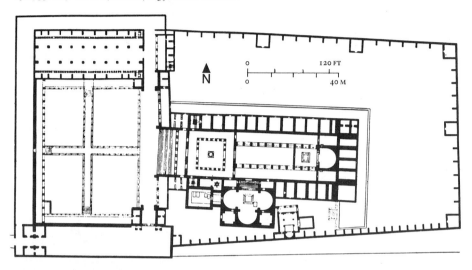

Cresconius's buildings are not the only ones in North Africa to be permeated by the spirit of a still Constantinian classicism. The church complex at Tebessa in its present form dates from about 390 and is strongly imbued with Constantinian concepts.[45] A broad flight of steps ascends from a forecourt (it is of later date) towards a colonnaded propylaeum [156, 157]. From there, three doors lead into the church. All this recalls, if anything, Tyre, or the basilica at the Holy Sepulchre, or the first H. Sophia in Constantinople and its propylaeum. In the nave, the piers – the rear members of the paired supports – carried arches above which appeared the openings of a gallery and presumably of a clerestory. The front columns, all spoils, as are the capitals, were surmounted at gallery level by the projections of a cornice [158]. This cornice in turn supported a second order of columns ascending to the roof beams. Mosaics covered the floors both in the nave and the two aisles.

The sculptured ornament is – an exception in North Africa – remarkably fine. From the right aisle, a broad staircase descended to a trefoil martyrium, built about thirty years before the main church and replacing a yet earlier memoria. A chancel barrier in the last bays of the nave enclosed the altar, and a second 'chancel' was laid out near the entrance. The slightly raised apse is flanked by side chambers, both of which communicate through doors with the aisles as well as the apse.

For the side chambers Tebessa hardly drew on Syrian models. Apparently North African architects had independently developed such side rooms in the fourth century; possibly they derived them from Constantinian models such as the row of side chambers which flanked the chancel of both halls of the twin cathedral at Trier, as well as S. Tecla at Milan [15, 41]. Other features at Tebessa likewise recall Constantinian church building. Galleries, for ex-

ample, marked the basilica of the Holy Sepulchre and probably the first H. Sophia at Constantinople. Occasionally, as in Greece, the aisles are separated from the nave by parapets or high stylobates – at Tebessa as early as the late fourth, elsewhere, for instance at Tigzirt and in the fortress church at Haïdra, as late as the sixth century. An impact from Greece on North Africa is unlikely and one wonders whether the separation of nave and aisles both in Greece and Africa had an early common source – on the other hand, 'counter-chancels' and 'counter-apses' placed opposite the main altar, at the entrance side of the nave, appear to be germane to North Africa. At times laid out from the outset, more frequently installed in the late fifth or the sixth century, the duplication was probably determined by yet unknown demands of the local liturgy.

The largest church in North Africa, at Damous El Karita, a suburb of Carthage, may also belong

among such derivations from the Constantinian past [151]. But like all of Carthage it is poorly explored. What survives are but the outer walls and the pier-like substructures of the columns. Clearly, though the building is exceptional in more than one respect: its size – over 65 m. (215 ft) the length of the basilica, 150 m. (490 ft) the length of the entire complex; its semicircular atrium; its eight aisles; the 'transept' cutting across the centre, its eight piers at the intersection carrying a dome or, more likely, a pyramidal timber roof; the structures which extend behind the basilica – several large halls, one six-aisled and sheltering a font; numerous small mausolea; another hall, composed of nave and aisles; finally, a circular structure, half-subterranean, domed, niched, and colonnaded inside, a mausoleum or martyrium. Smaller mausolea clung to the flanks and the atrium of the church. No doubt, Damous El Karita was a covered cemetery, like the Constantinian ones outside the walls of Rome, and, indeed, its features suggest a date well inside the fourth century.[46]

All such Constantinian features are, as a rule, limited to small districts. Crypts are common only in Algeria. The screening of apses by triple arcades is confined to buildings along and near the coast, from Bénian to Sabratha. Likewise, the doubling of the nave supports seems to be a local phenomenon: from the fourth to the end of the sixth century, paired piers and columns – as in the larger of the basilicas at Djemila – or double columns spread through Numidia, Tunisia, and Tripolitania. The outer row of supports carried the nave arcade as well as, in many cases, a gallery, and always a clerestory. The inner row of supports (towards the nave) supported a second colonnade along that upper wall; the Great Church at Tigzirt, like Tebessa, is an example.[47] This changes only when, in vaulted churches in South Tunisia about 550, arcades and clerestory were placed on the inner supports, and the outer ones carried a vault over the aisles.

Church building in North Africa, then, until the Byzantine conquest in 530, evolves largely in a retrospective clime. Hence, it appears most unlikely that so provincial an architecture should have transmitted to Carolingian Europe such motifs as the counter-apse. A re-invention for different functions is far more plausible. Concomitantly, however, the conservatism of the African provinces may well be responsible for a feature of church planning which is more clearly marked in North Africa than in any other region of the Roman Christian Empire. As pointed out recently, nowhere in North Africa can the church building be viewed as an autonomous structure. On the contrary, it ought to be seen as part of a building complex which comprises the bishop's palace, dwellings for the clergy, dining-rooms for community banquets, often of trefoil plan, libraries, store rooms, bakeries, oil presses, and the like. The 'Christian quarters' unearthed at Djemila and at Bône ('Annoba) – St Augustine's Hippo – are two of many examples [155].[48] They provide a picture of community life in the fifth century far more lively than it can be visualized elsewhere. At the same time, they suggest that conservative North Africa preserved tenaciously the concept of the pre-Constantinian community centre with its fusion of secular-utilitarian and sacred elements in one and the same structure.

SOUTHERN ITALY, SICILY, AND SPAIN

Church architecture in southern Italy, Sicily, the Balearic Islands, and Spain, from the fourth to the end of the sixth century, is perhaps even less known than that of the North African provinces. True, in contrast to the ruins and excavation sites of Christian Africa, a small number of churches and baptisteries have survived in southern Italy, wholly or in large parts. But the number of Christian buildings known in this transmarine zone of African influence is small, and no attempt has been made so far to sift the

material and establish a chronology, even for so outstanding a centre of fourth- and fifth-century Christianity as Naples and Campania.[49] Roughly speaking, in Naples a regional architecture with pre-Constantinian features was apparently overlaid by 400 by large-scale structures with Roman and North African characteristics, as would be natural in the greatest seaport south of Rome with its close African connexions. When Paulinus retired in 394 to his estate at Cimitile-Nola outside Naples, he found, above and near the grave of the martyr Felix, a few modest structures:[50] column screens north and south of the tomb, marking off the martyrium; a small basilica with an apse attached to its eastern end; opposite, a larger western apse, opening in two arched exits towards the adjoining cemetery; finally, two chapels near by, one perhaps remodelled as early as c. 300 from a Roman mausoleum. The whole gives a good idea of the somewhat disorganized layout of a cemetery and pilgrimage centre of a pre-Constantinian kind,

though of fourth-century date. The changes wrought by Paulinus by 401/2 are characteristic of the drive of the new generation towards stricter organization and greater monumentality [159]. The column screens were transformed into a square aedicula-martyrium, enclosed and subdivided by colonnades, their arches covered with mosaics. To the north, a larger colonnaded basilica was added, its façade opening in a triple arcade towards the martyrium, its aisles each flanked by two chapels. The apse formed a trefoil, the right-hand lobe serving as prothesis for the preparation of the Eucharist, the left one as a chapel for meditation. Small trilobe mausolea and martyria are frequent in Early Christian architecture, but trilobe apses attached to a basilican nave occur primarily in Egypt, North Africa, and its transmarine littoral, and it is likely that the architecture of Cimitile-Nola purloined the plan from North Africa.[51] The building technique, on the other hand, is local, an *opus listatum* in small blocks of volcanic stone,

159. Cimitile-Nola, martyrium precinct of St Felix, fourth century and 401/2. Plan

with arches of brick or stone, singly or in alternation. Assembled, it seems, in some hurry, the masonry is not quite as good as that of the older structures.

These building techniques continue apparently unchanged in Campania and in Sicily throughout the fifth and sixth centuries. So do local features of planning, such as arched openings in the curve of an apse. At S. Gennaro extra moenia in Naples, the apse of a single-naved cemetery church of about 400 opens in two arcades towards the near-by catacombs. But the feature was apparently accepted also in

160 (*left*). Naples, S. Giorgio Maggiore, *c.* 400. Apse

161 (*below*). Naples, S. Restituta,
fourth century (last third). Interior of nave

162 (*opposite*). Nocera Inferiore, baptistery of
S. Maria Maggiore, sixth century(?). Interior as in
c. 1770; engraving by F. Morghen

a major parish church such as S. Giorgio Maggiore in Naples, where it served no evident function whatever. A huge structure wholly altered in the Seicento, it apparently had a tripartite transept; to this day, it has preserved its late-fourth- or early-fifth-century apse with a triple arcade on columns opening towards a street or courtyard [160]. In S. Giovanni Maggiore, as late as the sixth century, the apse was even further punctured by two double arcades and one quintuple one.[52]

If open apses are a local feature, other architectural elements in Early Christian Naples point far afield: the impost blocks above the columns in the apse at S. Giorgio Maggiore to the Aegean coastlands, the tripartite transept to Milan. However, North Africa exerts the strongest impact. At Salemi in Sicily a basilica has been found with wide aisles and nave, the floors covered with tomb mosaics. The cathedral at S. Maria di Capua Vetere is a huge structure, its core possibly still of fifth-century date. Very wide in proportion to its length and divided into a nave and four aisles, it recalls North African basilicas. In S. Restituta at Naples the same plan has survived, dating from the last third of the fourth century.[53] The apse with its floor raised high above the nave and its triumphal arch supported by two columns pushed far inward, recalls African churches, such as the one at Sabratha. As late as the fifteenth century, the chancel of S. Restituta rose in the nave, as customary in Christian Africa [161]. The square baptistery placed at the end of the right-hand aisle is also characteristic of North Africa; and while found in Rome, e.g. in Pammachius's basilica at Porto, it may have come there under African influence.[54]

Rome, then, apparently exerted little impact on late-fourth- and fifth-century church building in southern Italy. However, by the end of the sixth century, the impact of Rome came to

be felt alongside that of North Africa in the Christian architecture of Campania. The two currents show perhaps most clearly in the baptistery at Nocera Inferiore, probably dating from the sixth century. The circular plan, the barrel-vaulted ambulatory, the centre dome, the fifteen pairs of enveloping columns, the eight columns placed on the rim of the font – all recall the baptistery at the Lateran [162]; but at the same time a North African parallel comes to mind, the baptistery at Siagu (Ksar Er Zit, near Bir Bou Rekba) in Tunisia. Elsewhere, Roman Christian models come more strongly to the fore. The baptistery at Canosa combines elements purloined from the Lateran baptistery and others taken from S. Stefano Rotondo: a double-apsed narthex precedes the structure; inside, a colonnaded centre room is enveloped by an ambulatory; four arms project outward and are linked by corridors accessible from the ambulatory. A structure of similar plan, though with variations, and much smaller in scale, ad-joins the cathedral of S. Severina near Catanzaro in Calabria: while serving now as a baptistery, the rotunda at S. Severina – built perhaps not before the seventh century – may originally have been a martyr's chapel.[55]

Likewise, two churches in Spain show this balance of architectural power between Rome and North Africa along the northern shores of the Western Mediterranean. A church at S. Pedro de Alcántara (Vega del Mar) between Gibraltar and Málaga on the south coast dates from after 365 and was perhaps originally a parish rather than a cemetery church. It shows the African plan with apse and counter-apse, its opening screened by a triple arcade as on the Tabarka mosaic, and a baptistery to the right of the main apse. On the other hand, at Tarragona on the Catalonian coast, a basilica of a date after 409 has come to light, apparently with continuous transept and thus following the Roman type of a combined martyrium and cemetery church.[56]

EARLY BYZANTINE BUILDING

CHAPTER 8

INTRODUCTION

In 527 Justinian ascended the throne of East Rome to shape for forty years the destinies of the Empire.[1] He was a remarkable man:[2] stocky and ugly; an autocrat deeply conscious of the prerogatives and duties of his exalted position close to God; self-controlled and ascetic in his personal life; unfettered by social mores, as witness his marriage to Theodora – a show girl of extraordinary beauty, courage, and brains; a shrewd diplomat and a first-rate organizer admirably gifted in selecting the best collaborators and in tightening the administrative and legal set-up of the Empire. Profoundly religious, he was permeated by the conviction of his divine mission to re-establish orthodoxy and to guide the Church throughout his dominions and beyond. Very intelligent, but not far-sighted, he was blind to the impossibility of solving religious problems by vacillating political compromises. Unable to stem the progressive exhaustion of the economy, unwilling to form long-range plans for the future to secure the eastern and northern frontiers against Persians and Slavs, Justinian was intent on the immediate present. He occupied himself with grand propaganda schemes to promote his own glory: easy, or seemingly easy conquests; a trade in luxury goods with far-away countries – China, India, Abyssinia; a grandiose building activity largely concentrated in his capital,

directed at both intellectuals and the populace, and providing employment for the masses; a well-planned publicity campaign directed at the intelligentsia throughout the Empire, entrusted to his court historian Procopius, and later to his court poet, Paul the Silentiary.

Procopius has set forth the aims of Justinian's policies: quelling all inner unrest; wresting large parts of the Empire from Barbarian usurpers and expanding the Empire 'to the farthest shores of the ocean'; securing the frontiers; re-establishing religious orthodoxy; re-organizing the law; finally, reviving prosperity. The achievements fall short of these aims, but the direction makes the picture more specific. The bloody repression of the Nike Insurrection of 532 marks the last popular resistance to autocratic rule; the Marcellinus Conspiracy in 556 is the last of the aristocratic uprisings. Related aims underlie Justinian's administrative and religious policies. An autocratic system requires a dependable administrative bureaucracy; and in theory at least, Justinian's Minister of the Interior, John of Cappadocia, succeeded in establishing a reliable and nearly bribe-proof civil service. The universities in Constantinople and Beyrouth, staffed by outstanding faculties, supplied the young men. An autocracy also requires a well-disciplined army; Belisarius and Narses created

it. Autocracy requires a uniform creed. Hence the suppression of the last residues of paganism, the elimination of Arianism, linked as it was to the Ostrogothic usurpation of Italy, and the attempt to bring, under the leadership of Rome, the orthodox of the Greek East, the monophysites of the Semitic provinces, and the dyophysite West to a compromise formula regarding the nature of Christ. The compromise was palatable to none, but its proposal was inevitable in a society in which religion and politics were so closely interwoven that religious divergence struck at the core of absolute Imperial power. Finally, an autocracy requires a uniform code of law, and this was formed by Tribonianus in the early years of Justinian's reign, 529–34: the *Corpus iuris*; it, more than any other of Justinian's achievements, has survived him.

Justinian's code aims at unifying the administration of law and tightening autocratic rule; it strives equally to revive the law of Rome. That most of it was written in Latin and translated into Greek is of limited significance. Greek had never developed a legal terminology. What is significant is that the *Corpus* resurrected a Roman tradition extending from the Twelve Tablets to Theodosius, and thus stressed both the continuity of the Roman State up to the time of Justinian and, by implication, the Western root of the Empire. The revival of Rome and the turn to the West interlock, and the same *Drang nach Westen* underlies to a large degree Justinian's policy of expansion. In the East he aimed at maintaining, even under sacrifices, the *status quo*. A truce with Persia secured an uneasy frontier along the Euphrates. Yet, this appeasement policy freed Justinian's hands for his main goal, the conquest of the West. North Africa was taken over from the Vandals in a short campaign in 533–4; Sicily, Sardinia, and Dalmatia were occupied the year after. Italy was wrested from the Goths in a long-drawn-out and costly war. Finally, in 554 a foothold was gained in the seaports of south-

east Spain – not on, but at least not too far from 'the farthest shores of the ocean'. To be sure, three years after the Emperor's death, Italy was lost again, to the Longobards. Nevertheless, by Justinian's last years, the Mediterranean was a Roman lake. Roman – not Byzantine, for in Justinian's eyes these conquests were re-conquests; the *Basileus tōn Romaiōn*, the Roman Emperor, reasserted his inherited right to provinces illegally occupied by barbarians and, worse, heretics. He waged a crusade against them in the name of both orthodoxy and Rome. He ruled from Byzantium; his funds and manpower were drawn from the Eastern provinces. But the Empire as he viewed it was centred round the Mediterranean. Ravenna was to be a sub-capital, subject to Constantinople yet vying with it in splendour; Rome was to be a spiritual centre, balancing the see of the patriarch in Byzantium. New Rome, Constantinople – 'the daughter more ravishing than the mother' – strove to revive the glory of old Rome. Ideally, though not in reality, Justinian's Empire was the Roman Empire, the Empire of old, with its power shifted to the East.

Building was one of the means by which Justinian's autocracy attempted to impress the peoples both inside and outside the Empire and to unify its territory. Where Constantine had promoted church building by moral and financial support, Justinian was the sole driving force behind the gigantic architectural undertakings, certainly in his capital and possibly throughout his Empire. Thus, Justinian's is an Imperial architecture in a true sense. Only the Emperor could provide the immense funds needed for his building programme, and he was well aware of the programme's significance. After all, he must have been the one to insist that his court historian dedicate an entire volume to this programme, the *Buildings*. And Procopius leaves little doubt that in the Emperor's mind the architectural enterprises ranked with the restitution of religious orthodoxy, the revival of

jurisprudence, the reconquest of the West, the re-establishment of prosperity, and security of the frontiers. Within these propagandistic aims, it was only natural for Justinian's architects to strive towards a style of building, standing in an old tradition, yet newer and bolder than any created earlier.

The time of Justinian marks a turning point in architectural history rivalled by few other periods. The change is noticeable not so much in palace building or in the architectural vocabulary of capitals and decorated friezes as in church planning. Until the beginning of Justinian's reign, the majority of church building, East or West, with but few exceptions, had been based on one building type: the basilica, a timber-roofed hall with or without aisles. Age-old, its plan had been evolved, one recalls, for civil buildings in Italy presumably as early as the third or second century B.C. All changes that developed in later Roman public building, and afterwards in church architecture, were but variations on the old theme. Galleries, apses, multiplied aisles, nartheces, atria, and the like were simply designed to adapt the type to new functions. Similarly, the new vocabulary which gradually evolved – capitals, colonnaded arcades, mosaics on walls, vaults, and pavements – at closer view turn out to be mere adaptations of a basic type to the changing taste of the times and the preferences of the various regions of the Empire, whether in the Latin West, the Aegean coastlands, or the Semitic hinterlands of the Near East.

The situation changes decisively with the sixth century. The West continues to view the basilica as the only appropriate form of church building through the entire Middle Ages and beyond. The vaulting systems of the Romanesque and Gothic centuries and their changing vocabularies leave the principle unaltered. On the other hand, Justinian's architecture in the East breaks with the tradition of the basilica and thus with a tradition going back to early Roman times. Turning to vaulted centrally-planned church buildings, Justinian's architects base themselves on architectural concepts which had been evolved and had certainly matured in the architecture of the Late Empire: in palace halls, in funerary structures, in thermae and garden buildings, ever since at least the third and fourth centuries. From these roots Justinian's builders create a church architecture which is invariably based on a central plan and nearly invariably vaulted, culminating in a central dome. To be sure, centrally-planned churches, roofed or domed in timber or occasionally perhaps groin-vaulted, had been built since the fourth century. But until the second third of the sixth century they were rare and designed only for specific and extraordinary functions: as palace churches or as martyria. About 500 the type becomes slightly more frequent beyond these narrow confines. But only Justinian's architects make the domed brick-vaulted central plan the rule in church building in all the major centres of his Empire, and without regard to special function. Thus they set out on a path radically different from that chosen by the West. The choice of Justinian's architects was destined to determine the character and the development of religious building in the East for a thousand years and more. First Byzantine church builders, later Balkan and Russian architects developed it in ever new variations. So did the builders of Persian, North Indian, and Turkish mosques. The schism between East and West in the realm of architecture, then, starts earlier and it is as deep as, if not deeper than, the religious schism.

Within this broader view, it is of but secondary importance whether the centrally-planned churches of Justinian's time and their immediate forerunners were evolved from martyria, from palace churches, or from both. More important than either – and possibly the truly determinant factor – is, in my opinion, the Christian liturgy as it had developed in the Aegean coastlands. The elaborate celebration of the Mass with the

gradual development of the processional en-
trances had apportioned the nave primarily to
the clergy since the early fifth century, if not
before. The congregation in many parts of the
eastern coastlands seems to have been relegated
for large portions of the service to the ancillary
spaces enveloping the nave, whether aisles, gal-
leries, or esonarthex. Throughout the fifth cen-
tury, this liturgical situation appears to be
reflected through the extension of the chancel
and its solea far into the nave and nearly all over
the Aegean through the use of parapets to close
off the nave and make it, wholly or in part, inac-
cessible from the ancillary spaces. Yet such
adaptation of the basilica plan to local liturgical
needs remained necessarily a solution chosen
for want of a better one. A centrally-planned
building, on the other hand, was ideally suited
to the requirements of a service in which the
performance of the Mass occupied the central
area both liturgically and architecturally. Hence,

it seems to me, Justinian's architects and church-
men – preceded perhaps by a lone maverick two
or three decades before – took up with enthusi-
asm the central plan for their church buildings.
Perhaps without physically closing off by para-
pets the nave from the aisles, they focused the
structure on the area where the action took place.
How right they were from their point of view is
demonstrated to this day by the service as per-
formed in any Greek church: the clergy entirely
filling the nave, the congregation crowded into
whatever there is of the aisles, into the nar-
thex, and into the porticoes along the flanks of
the tiny building.[3]

 With the sixth century, then, the architectural
concepts of Classical Rome, as they had survived
in the Early Christian basilica, finally come to an
end in the Eastern Empire. Their place is taken
by a new architecture, rooted in Late, not in
Classical, Antiquity and developed far beyond.
Byzantine architecture starts with Justinian.

THE HAGIA SOPHIA AND ALLIED BUILDINGS

The foremost task that Justinian set himself and his architects was the building of the Hagia Sophia.[1] The first basilica, completed in 360 and remodelled from 404 to 415, had been burnt to the ground in 532 in the course of a frightful revolt, the Nike Riot. Justinian, after quelling the uprising, decided to build – perhaps as a monument of his victory – a new church on a plan and of a size and lavishness hitherto unheard of. Columns and marbles were brought from all over the Aegean lands and from as far as the Atlantic coast of France. (That these columns were spoils from Rome, Ephesus, and Cyzicus is a later embellishment of the tradition.) The marble workshops of the Proconnesian islands were kept busy furnishing capitals, cornices, and huge pavement plaques. Thousands of labourers were 'gathered from all over the world' to work on the building site, in the brickyards, and in the quarries. The task of organization and logistics, performed by Anthemios, was as phenomenal as that of the Imperial Treasurer. The equivalent of £75,000,000 or $180,000,000 (as per 1972) was spent; and after five years the structure, though without its furnishings, could be consecrated.[2] Correctly or not, tradition has transmitted Justinian's words on the day of consecration: 'Solomon, I have vanquished thee!'

An architecture out of the ordinary requires an architect out of the ordinary. Master builders had long dominated the profession and continued to design and execute the bulk of the building in Justinian's Empire. But, well trained though they were, they were apparently not considered up to the task of supervising the construction of the H. Sophia. Instead, the Emperor chose two men who stood on a different plane both in training and social status: Anthemios of Tralles and Isidorus of Miletus. They were what their contemporaries called *mechanopoioi*, grounded in the theory of statics and kinetics and well versed in mathematics. Such architect-scientists are occasionally, if rarely mentioned in Late Antiquity; but Anthemios and Isidorus appear to have been more scientists than architects. Anthemios was the author of a work on conical sections, an expert in projective geometry, and an inventor who knew the principle of steam power and of the burning mirror. Isidorus taught stereometry and physics at the universities, first of Alexandria, then of Constantinople, and wrote a commentary on an older treatise on vaulting.[3] They were skilled in a theoretical knowledge that could be applied to the practice of either engineering or building, be it a steam engine, a burning mirror, or the complex vaulting system of the H. Sophia. They could organize the work, draw up the plans – including possibly sections and perspective renderings – and train the assistants necessary for executing the building. They were, one would like to think, not architects to start with, but they turned into architects when called upon to devise the plans and statics of a building never before considered viable on a large scale.

As it stands today, the H. Sophia is no longer quite the structure that was dedicated on 27 December 537 [163]. The first dome, quite low and possibly continuing the curve of the pendentives, collapsed in 558. It was replaced by a steeper ribbed dome, completed in 563, and the construction of this new dome carried with it a number of other changes. Its base had been deformed by the thrust of the first dome – which

163 (*above*). Constantinople, H. Sophia,
532-7. From the south-west

164 (*opposite*). Constantinople, H. Sophia,
532-7. Plan

caused the piers and buttresses to tip backward, the east and west arches to expand, and the lateral arches north and south to bend outward. It was regularized by broadening inward the crowns of the arches to the right and left, and partially reconstructing the pendentives. Likewise, the clerestory walls below the lateral arches were rebuilt and the original window pattern – seven, wider than at present, and topped by one single large segmental opening, divided by piers – gave way to the present one; but whether this happened in 558-63 or much later, in 869, is yet undecided. Simultaneously, in any event, the gallery arcades and the wall they supported were shifted back to the perpendicular.[4] Possibly also in the ninth century, the west façade was reinforced with four flying but-

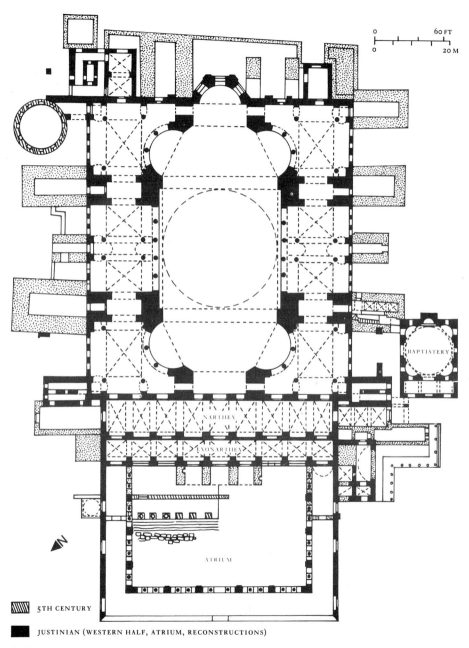

BAPTISTERY

NARTHEX

EXONARTHEX

ATRIUM

N

0 60 FT
0 20 M

5TH CENTURY

JUSTINIAN (WESTERN HALF, ATRIUM, RECONSTRUCTIONS)

LATER ADDITIONS

165 and 166. Constantinople. H. Sophia, 532–7.
Isometric view and
exterior of dome and western half-dome

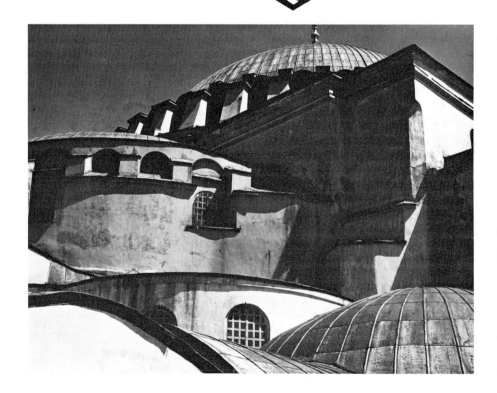

tresses which projected into the atrium.[5] The western portion of the second dome again fell in 989 and was repaired by an Armenian architect, Trdat; and finally the eastern portion collapsed in 1346. More incisive changes were wrought by the Turkish conquerors after 1453: minarets were planted at the four corners, beautiful in themselves but countering the broad curve of the dome; Turkish mausolea were clustered about the flanks of the structure. In the interior, the figural mosaics, all dating from after Justinian, were covered with yellow paint; and four enormous shields, inscribed with verses from the Korān, were hung from the piers flanking apse and entrance. All this has marred, but nothing has destroyed the incredible beauty of the building.

The structural system of the H. Sophia is bold but simple. A huge rectangle was laid out, measuring 71 by 77 m. (230 by 250 ft), equalling roughly 225 by 240 Byzantine feet. Inside it, four huge piers, running north and south, rise at the corners of a square, 100 Byzantine feet on each side [164, 165]. Seventy feet from the ground, four arches swing across, those to the east and west free-standing, those north and south embedded in the side walls of the nave and hardly noticeable inside, but strongly projecting above the roof on the outside [163]. Four pendentives, slightly irregular in shape, link the arches [167]. From the apex of the arches and the four connecting pendentives rises the main dome, a shell scalloped by forty ribs and forty curved webs. It is buttressed on the outside by forty closely-spaced short ribs which frame small windows [166, 168]. The piers to the north and south rise above the roofs of the aisles to abut the lateral thrusts of the east and west arches and, indirectly, of the main dome. Possibly as an afterthought during construction, tower-like excrescences were placed on top of these buttresses to secure them against the thrusts of dome and arches. On the other hand, it is debatable how far the longitudinal

thrusts are countered by the two huge semi-domes which open east and west and which rest on the main piers and on two pairs of subsidiary piers flanking the entrance and chancel bays. True, these semi-domes are too thin to exert much counterthrust, and indeed, their apices have collapsed time and again. Nevertheless, as witness the deformation of the dome base, their strength was sufficient to withstand the thrust of the first, lower dome. On the other hand, the smaller conchs that open on diagonal axes on the bays of the half-domes, inserted between their supporting piers, simply lean their thin shells against the semi-domes without abutting them. Nor is the structure strengthened by the barrel-vaults which project on the centre axis from the huge semi-domes, that to the east ending in the half-dome of the apse, that to the west terminated by the wall of the narthex and its upper gallery.[6]

Hazardous in its statics, this core – composed of piers, arches, domes, half-domes, and conchs – forms the inner core of the double-shell design. A baldacchino, it stands free in space, independent of the enveloping ancillary spatial units. Similarly, aisles, narthex, and galleries remain on the whole unconcerned with the structural workings of the inner nucleus. Their vaults – domical groin-vaults in the lower, pendentive domes in the gallery zone – rest on free-standing columns and piers and are linked to the main piers and walls merely by tiny groin- and barrel-vaults. The construction is both simple and bold, and equally simple and bold are the building methods employed. Only the eight main piers are built of large blocks of ashlar.[7] The walls, through their entire thickness, are built of thin bricks set in mortar-beds up to 7 cm. (2¾ in.) high, interspersed with limestone courses placed apparently at the springing of the vaults [172]. Bricks pitched on their sides, instead of being radially placed, and embedded in thick beds of mortar form extraordinarily thin and light vaults. They fuse with the walls into a

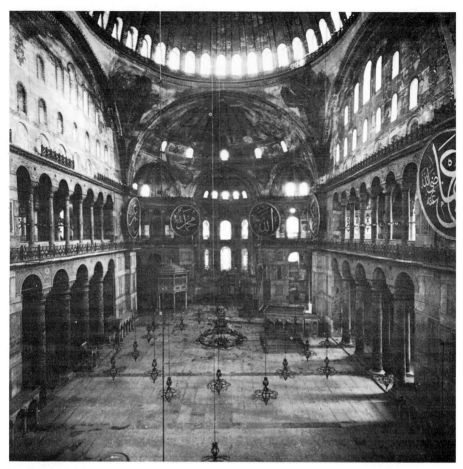

167. Constantinople, H. Sophia, 532-7.
Interior of nave, from the west

nearly homogeneous resilient mass, though not
as resilient or homogeneous as a Roman con-
crete construction.

Defying all laws of statics, shaken by suc-
cessive earthquakes, collapsing at its weak points
and being repaired, the H. Sophia stands by
sheer miracle. Experienced master builders of
537 must have stood aghast at the disregard of
sound building practices by those two non-
professionals to whom the Emperor had en-

trusted his greatest building. True, Anthemios
and Isidorus went to the very limits of what we
call the safety coefficients. Their first project
was apparently bolder still and corrections were
forced on them during construction: openings
towards the nave perforating the main piers
were walled up; arches to buttress the piers
were thrown across aisles and galleries, resting
on half-piers added to the main piers; the main
buttresses surmounting these piers were raised

to provide added weight; and the number of arcades in the gallery zone, planned in five as on the ground floor, was increased to seven, thus diminishing their distances and heights.[8] In building the first, flatter dome, they still went too far and it collapsed within twenty years. Yet at the risk of failure they had to employ hazardous techniques – techniques which were the necessary tools for developing the design they meant to create. Perhaps they could envisage both design and techniques only because they were not professional architects.

The design unfolds itself from the centre of the structure. Standing under the apex of the dome, the visitor begins to grasp the huge space [167]. At first glance amorphous, it gradually falls into shapes and the shapes fall into place. From the vertical centre axis, space expands longitudinally into the huge niches to the east and west. It expands beyond, to the east into the forechoir and its apse, to the west into the entrance bay. From the niches, the space moves into the conchs that open diagonally on either side. It rises vertically into the main dome, gropes along its rim, sinks into the half-dome, widens and moves farther into the quarter spheres of the diagonal conchs. The sequence of spatial shapes develops both centrifugally around a middle axis and longitudinally from the entrance bay to the apse. The huge piers that support the arches of the main square and the subsidiary piers to the east and west are pushed aside into the aisles and galleries. In their place the eye encounters smooth, vertical planes; higher up rise the curved surfaces of arches, pendentives, domes, and half-domes; and between the piers, two orders of arched colonnades open into aisles and galleries. The involved yet simple rhythm of colonnades and window openings forms an accompaniment to the spatial design. Arcades of five bays flank the nave on either side, surmounted by arcades of seven bays in the gallery zone. These in turn were succeeded, it would seem, in the clerestory

zone by seven windows, surmounted in turn by an upper one, with five intercolumniations. In the east and west conchs, three arches on the ground floor support seven in the gallery zone [169]; these are followed by five windows along the rim of the conch vault, and this rhythm is repeated by five more windows at the foot of the western and eastern half-domes. The rhythm of three is again taken up by the three openings which lead into the nave from the west gallery, and by the double row of windows, three to each row, which pierce the wall of the apse.

Clearly articulated by this rhythm of threes, fives, and sevens, and clearly disposed, the spatial units are, nevertheless, not clearly delimited. All expand beyond what seem to be their natural borders. The eye wanders beyond the centre square into aisles and galleries whose shapes cannot be grasped. The gaze of the viewer is drawn beyond the curved arcades in the conchs and into the outer bays; yet the overlapping of these arcades with the windows in the outer walls precludes a ready understanding of the relationship between ancillary and main spaces [169]. Within the inner shell, both the spatial volumes and their sequence are all intelligible. But beyond this core, space remains enigmatic to the beholder who is restricted to the nave. The form and interplay of spatial shapes is first established, then denied. Indeed, none of these spatial shapes are contained by the enveloping solids, be they piers, straight or curved walls, or vaulted surfaces. The term solids – in this architecture at least – is a misnomer. The piers are massive enough if seen from the aisles; but they are not meant to be seen. Their bulk is denied by their marble sheathing. The column shafts are huge, measuring two and a half to three feet in diameter, but the colourful marble counters the feeling of massiveness.

Precious materials, subtly graded, shimmer over the interior. From the dark grey marble plaques of the pavement rise high grey marble

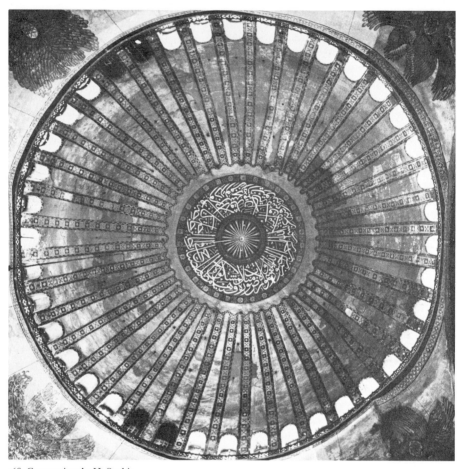

168. Constantinople, H. Sophia,
532–7. Interior of dome

pedestals carrying columns of green marble with large white veins – both on the ground floor and in the gallery arcades. Reddish porphyry columns stand in the conchs that flank apse and entrance. The piers and walls in the nave are covered by marble plaques in three zones: first, green marble slabs flanked by grey-yellowish plaques with purplish veins; above, porphyry slabs enclosed by dark bluish marble with yellow veins; finally, a third tier repeating the first [169]. Slabs have been sliced in two and the sections fitted together so that the veins form a symmetrical pattern along a centre axis. The capitals are all overspun with foliage, their shiny marble leaves and branches standing out against the deep shadows of the ground [173, 185]. A lacework of tendrils overlays the spandrels of the arcades; elsewhere, white mother-of-pearl rinceaux are inlaid into black marble. Silver, gold, and mosaic are joined in this

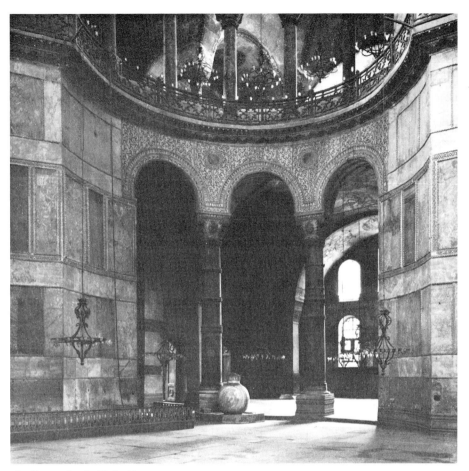

169. Constantinople, H. Sophia, 532–7.
North-west conch

wealth of colours and shades. Silver sheathed both the synthronon, rising in three tiers in the apse, and the column screen of the chancel, the latter projected westward from the arch of the forechoir and continued by the long solea, both protected by parapets. Golden lamps dangled in the intercolumniations; others rose from the trabeation of the chancel screen.[9] Domes and half-domes, vaults, and soffits gleamed with mosaic. A few fragments survive:

golden tendrils on a bluish-green field, purple crosses on a gold or silver ground.[10] Figurative mosaic was apparently missing. The first dome, we know, was covered with plain gold mosaic, while the new dome of 563 carried a huge cross. The windows were filled with glass panes, presumably coloured, like those found at S. Vitale, at Ravenna: deep blue, greenish, dark purplish brown, off-white, yellow, light purple.[11] The light would have risen in gradations from the

darkest zone in the aisles, to the lighter zone of the galleries, and finally into the window zone of the nave. But always subdued, the light remained darkish in tone. At night services, lamps were strung along the rim of the dome, chandeliers hung from its cornice, and candlesticks stood in the arcades of aisles and galleries.[12]

The principle of a design which proceeds by statement and denial acts with equal force throughout the building. It applies to the proportions of the nave, where the soaring height of piers, walls, and domes is countered by the horizontal layers of marble veneers, arcades, window zones, and cornices. It applies equally

to the relationship between principal and subordinate spatial units. At first sight, aisles and galleries seem to be independent spaces. Yet this impression holds only if the aisles and galleries are viewed lengthwise – a view never intended to be seen. On the contrary, they are intended as places whence to view the nave. But seen from the aisles and galleries, the nave remained always half-hidden behind screens of columns; screens, doubled in the centre, where two extra columns carry the vaults of the double bay; or equally confusing, convex in the end bays [170, 171]. Curtains hanging between the columns may have provided a further screen. Hence the nave, from the aisles and galleries, presents itself

170. Constantinople, H. Sophia, 532–7.
View from the south aisle facing north-west

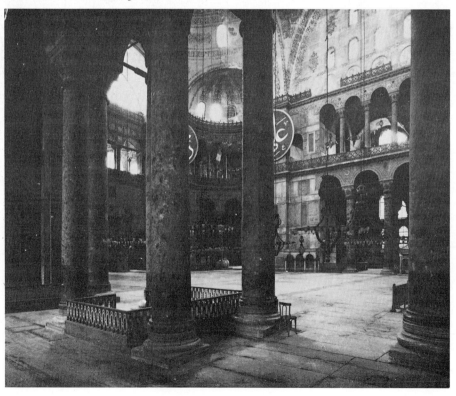

only in fragments. Parts of the main dome, parts of the half-dome, parts of the concave conchs or straight arcades, parts of piers are seen by the beholder, who is never allowed to understand the whole design of the nave, or, indeed, of the building. In short, the beholder relegated to aisles and galleries sees the nave, but is denied its intelligibility. Only those gathered in nave and chancel are permitted to understand the spatial design. Fragmentation of views and of a space which is nevertheless whole, marks the design of the building and its component elements. The first, large windows in the clerestory of the nave were cut across by the lateral arches under the dome; the groin-vaults behind

the curved exedrae are likewise cut by the arched colonnades, and demand a completion never to be attained [171].

Such an interpretation of the H. Sophia in dialectical terms is anything but arbitrary. Procopius proceeds along the same lines in describing the church. The building, so he says, forms part of the city, but at the same time it stands very much by itself. It is exceedingly long, yet extraordinarily wide. It is bulky, yet harmonious. Light seems to flood the interior from the outside, yet it seems generated inside as well. The structure is solid, yet it engenders a feeling of insecurity. The columns perform in a choral dance, the piers are sheer mountain peaks.

171. Constantinople, H. Sophia, 532–7. View from the gallery, south-west bay, facing north-east

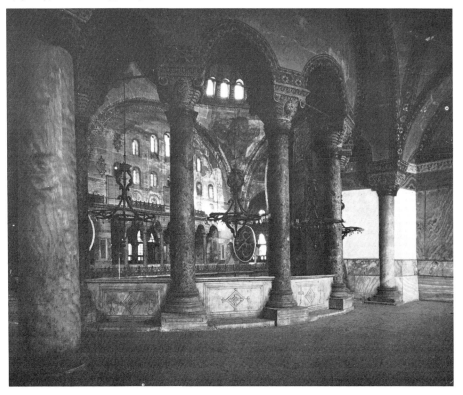

Vaults seem to float, the dome seems suspended from heaven. Vistas change and yet the spatial shapes follow each other in a clear sequence. Statement and denial are at the basis of Procopius's description just as they are at the basis of the architects' design.

To design a shockingly bold interior was, no doubt, the primary concern of Anthemios and Isidorus. Yet the exterior is equally impressive. The volumes are stacked on top of each other and the eye is led subtly towards the forechoir, from there towards the eastern half-dome, and finally up towards the dome [163, 166, 174]. Surrounded by palace buildings to the south and east and by city buildings to the north and west, the Great Church towered above the city and the Sea of Marmara. With this picture still vivid, the visitor entered the atrium to be enclosed by porticoes in which one pier rhythmically alternated with two columns.[13] Finally,

172 (*below*). Constantinople, H. Sophia. Masonry, sixth century (*centre*), tenth century (*left*), and Turkish (*right*)

173 (*opposite*). Constantinople, H. Sophia, 532–7. Twin columns with Ionic impost capitals in the narthex gallery

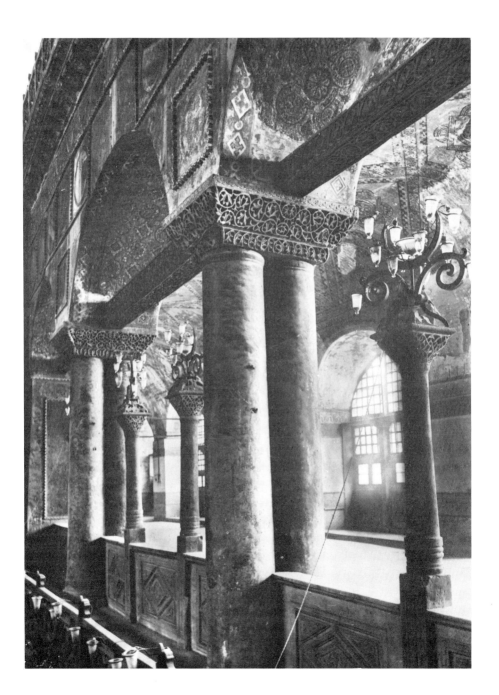

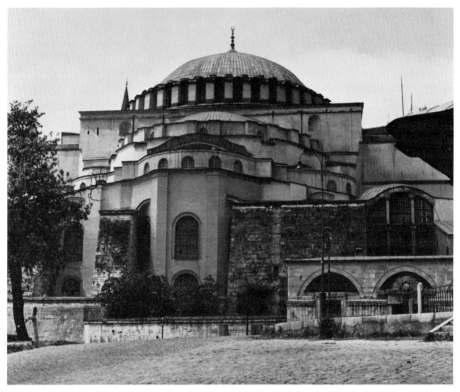

174. Constantinople, H. Sophia,
532–7. Exterior from the east

after passing through the transverse barrier of the long but shallow esonarthex, he entered the church proper through one of five doors, the royal gate in the centre. Only then did he see the nave revealed, focused on its huge dome and half-domes, and only then did he understand as relations in space what had been but half-intelligible from the outside.

However this revelation was reserved for the principal actors on the stage of the nave: the clergy led by the patriarch, and, to a lesser degree perhaps, the Emperor accompanied by his court. The faithful, most of them gathered in aisles and galleries, saw only fragments of the building, just as the solemn celebration of the services was revealed to them only in fragments. The strict segregation of aisles and nave by parapets customary in the Aegean coastlands suggests that the liturgical custom in those provinces kept the faithful out of the nave for the better part of the services, reserving it in principle for the performance of the clergy: the preparation and celebration of the Mass, and the procession of the Lesser Entrance, when the bishop was accompanied to the altar. In Justinian's reign, a second procession – no doubt previously customary but not codified – became a main element in the Mass of Constantinople.[14] This was the Great Entrance, in which the elements of the Eucharist were

brought from the prothesis to the altar accompanied by the clergy emerging from the chancel into the nave, and retiring back into the chancel. In the H. Sophia, both the Lesser and the Great Entrance and the entire celebration of the Mass were, presumably as early as Justinian's time, interwoven with the appearance of the Emperor and his court.[15] The nave, then, was a stage on which the procession moved along a solemn path from the royal gate towards the solea, and along the solea into the bema. Thus it would seem that in principle in Constantinople as well, aisles and galleries were assigned to the faithful, women to one side, men to the other. If at the high points of the celebration or in their aftermath, when the nave was empty, the faithful surged in – there being no parapets in Constantinople – the principle of segregation still remained inviolate. During much of the Mass, indeed, the clergy remained inside the chancel. At stated points in the celebration of the liturgy however, clergy and patriarch re-entered the nave, both with and without their secular counterparts of Emperor and court. The two powers entered the church together during the Lesser Entrance to take their appointed places, the patriarch and clergy in the sanctuary, the Emperor and court in the Imperial enclosure in the south aisle. The clergy emerged for the reading of the scriptures and moved to the ambo, the pulpit, which rose at the entrance to the solea, below the eastern rim of the great dome. On solemn occasions, the patriarch and clergy would proceed a second time to the pulpit to deliver the sermon. The Mass of the Faithful would open with the solemn procession of the Great Entrance, when the patriarch, preceded by the clergy, would proceed from the bema along the solea and into the nave, and return into the chancel to deposit the elements of the Eucharist on the altar – accompanied by the Emperor, the one layman apparently allowed inside the sanctuary.[16] After the sacrifice had been performed, the patriarch would

emerge from the sanctuary a fifth time, to meet the Emperor and exchange with him the Kiss of Peace. Returning to the sanctuary, the patriarch would continue the Mass, emerging one last time towards the end in order to carry the communion to the Emperor. To the faithful, all these appearances of the clergy and the Emperor – epiphanies would be a better term – were but fragments of a celebration which as a whole remained incomprehensible. In sixth-century Byzantium, then, the ceremonial of the Mass fell into two parts: one, removed from profane eyes, took place inside the chancel – in Greek church parlance, the Great Mystery; the other, public and meant to be seen by all, was staged in the nave where clergy and Emperor met to perform their respective roles below the eastern rim of the great dome – the Dome of Heaven.[17]

This ceremonial is closely linked to the exalted place which sixth-century thought assigned on one hand to the clergy, on the other to the Emperor. The clergy – so say the writings of the Pseudo-Areopagite about 500 – reflects the nine celestial hierarchies of the angels; indeed, the hierarch, that is the patriarch, is actually close to the angels. The visible ceremonies he performs with the assistance of the clergy are intended to evoke the image of the invisible world which centres around the divinity. Similarly, the Emperor, one wants to recall, had his assigned place in the celestial hierarchy as mirrored on Earth. Since Constantine's time he had been considered equal to the apostles, and perhaps more than equal. Certainly in the tenth century he acted the part of Christ on solemn occasions – breaking and blessing the bread and raising the cup of wine to his lips after state dinners; swathed in white bands as Christ resurrected and surrounded by twelve apostles on Easter Sunday. Emperor and patriarch were the 'two halves of God'.[18] And if the patriarch reflected the religious aspects of the Godhead, the Emperor mirrored the secular aspects, power and justice. The inter-

action of Emperor and priesthood was essential for establishing and maintaining a Christian Empire, and their meeting under the great dome of the H. Sophia becomes a symbol of the interaction. Both the ecclesiastical and secular hierarchies were permeated by the light of the Divinity which emanated from the centre of heaven and spread to the angels, patriarch, clergy, and Emperor. Thus in the H. Sophia the spatial shapes, the light, and the colours all emanate from the centre dome. The ordinary people in the aisles and galleries remained hidden in the shadows. Only from afar were they allowed to see the light, the colours, and the glory that streamed from the centre, the seat of the Godhead.

Such a symbolic interpretation of an architectural design, in both theological and political terms, was less fantastic to men of the sixth century than it seems today. A hymn written in Syria only fifty years after the building of the H. Sophia describes the cathedral of Edessa (Urfa) in very similar terms.[19] Small though it is, says the poet, it resembles the universe. Its vault expands like the heavens and shines with mosaics as the firmament with stars. Its soaring dome compares with the Heaven of Heavens, where God resides, and its four arches represent the four directions of the world, with their variegated colours like the rainbow. Its piers are like the mountains of the earth; its marble walls shine like the light of the image not man-made, the Godhead; three windows in the apse symbolize the Trinity, the nine steps leading to the chancel represent the nine choirs of the angels. In short, the poet concludes, the building represents heaven and earth, the apostles, the prophets, the martyrs, and, indeed, the Godhead.

The H. Sophia forms a key element within Justinian's architecture, but only a very few other structures are designed along similar lines. In recent years the foundations and hundreds of pieces of architectural sculpture, belonging to an astonishing structure, have come

to light in Constantinople.[20] Identified by a long inscription, in parts preserved on the fragments found, as the church of H. Polyeuktos, it was built in 524-7 next to her palace by Anicia Juliana, the last descendant of the former Imperial House, and a great patroness of the arts. The foundations, a massive platform of solid walls, brick-vaulted corridors, and fill raised the church high above street level, outlining a 52 m. (170 ft) square, two-thirds the size of H. Sophia. Two walls, over 7 m. wide and deep, run the length of the foundation and mark off a nave and aisles, terminated by an apse and flanking side structures of undetermined shape. A small cross-shaped crypt was sunk into the foundation of the apse, continued west by corridors and walls supporting chancel screens, ambo, and solea, the latter possibly extending to the very doors of the nave, the ambo midway between apse and façade. The narthex, reached over a high flight of stairs, was preceded at ground level by an atrium, to the northward restricted by a structure; chapel, baptistery, or part of the palace. The huge lengthwise foundation walls would have carried piers and colonnades both on the ground-floor and gallery level – the latter referred to in the inscription; on the upper level would have fitted in six peacock niches, found in the excavation. Plan and elevation, however, remain conjectural. Vaulting is suggested by the bulk of the foundations, and a plan anticipating that of H. Sophia, with a dome 20 m. (65 ft) in diameter, has been suggested as one alternative. However, a lengthwise plan is more likely: a domed basilica, composed of a barrel-vaulted entrance bay and a domed main bay, and thus related to H. Irene, as built after 532, and possibly to Meriamlik – buildings to be discussed later on.[21] As interesting as the plan is the decoration of the church. The walls were sheathed and the floor paved with precious marble slabs. Capitals, cornices, and furnishings were sumptuously covered with figural, vegetal, and geometric

design, splendidly executed, but widely differing in type. There are niches, each filled by a peacock and bordered by part of the dedicatory inscription, the spandrels covered with vines of a classical type [175]. There are column capitals densely spun over by spiky acanthus with free-standing corner handles; on others, shaped to truncated cones, a fleshy lotus palmette is framed by a broad wicker band. There are pier capitals, the faces marked with palm trees, the corners with thin ivy tendrils, the upper border with a fleshy heart pattern, far removed from any classical tradition. Cornices and impost blocks carry similarly unclassical palmettes, fleshy stylized acanthus, vines, and star flowers. Comparable designs occur on parapet slabs, now dispersed at the Zeyrek (Mollazeyrek) Camii [176], and convincingly this type of ornament has been linked to Sassanian rather than Late Antique or classical sources.

175 (*above*). Constantinople, H. Polyeuktos, 524–7, peacock niche. *Istanbul, Archaeological Museum*

176 (*below*). Constantinople, Zeyrek (Mollazeyrek) Camii, chancel plaque from H. Polyeuktos, 524–7

177. Venice, Piazzetta, pier and capital, from Constantinople, H. Polyeuktos, 524–7

178. Column with inlay, from Constantinople,
H. Euphemia, sixth century.
Istanbul, Archaeological Museum

179. Column with inlay, from Constantinople,
H. Polyeuktos, 524-7
Istanbul, Archaeological Museum

Both types stand side by side in the fragments
of two piers found on the site, the capitals
carrying a sparse, quite unclassical acanthus on
the four faces, the piers covered with rich highly
classical vines. Their exact counterparts in
size and design, but fully preserved, stand on
the Piazzetta in Venice, south of S. Marco [177];
looted from Acre in 1268, they were obviously
brought there from H. Polyeuktos, possibly
from the canopy over the altar. Finally, there
are column shafts inlaid with amethyst and
coloured glass in an intricate pattern. The type,
common in Justinian's Constantinople – splen-

did examples formed the chancel screen set up
when the hexagon hall [30] in one of the palaces
north of the hippodrome became the church of
H. Euphemia – survived into or was possibly
revived in the ninth century [178, 179].

All told, the architectural ornament of H.
Polyeuktos only in part anticipates that of H.
Sophia. The Sassanian elements are an intru-
sion, eliminated by the designers of Justinian's
Great Church. Much closer to this latter, in
plan and details, though not in quality, is the
church of H. Sergios and Bakchos, a simpler
variant on the double-shell compositional sys-

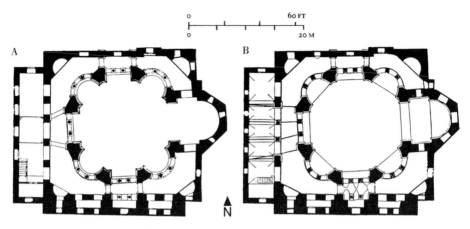

0 60 FT

0 20 M

N

180 (*above*). Constantinople, H. Sergios and Bakchos,
completed prior to 536. Plans (A) of ground floor, (B) of gallery

181 and 182. Constantinople, H. Sergios and Bakchos,
completed prior to 536. Exterior (*below*) and interior (*opposite*)

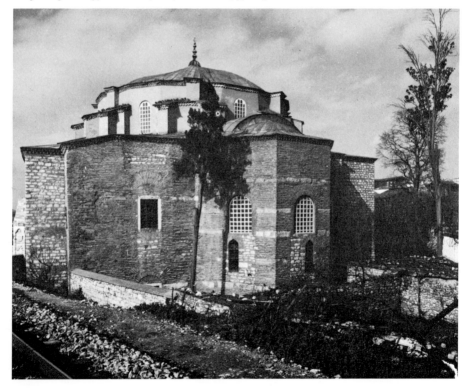

tem. Octagonal in plan, it seems at first glance different from the composite plan of the H. Sophia [180]. But the difference is only apparent, and the H. Sophia contains all the elements of a double-shell octagon: the domed core, the billowing niches, the enveloping aisles and galleries. But these components have been, as it were, broken up and rearranged lengthwise – for the simple reason that the size required for Justinian's Great Church made radial expansion of an octagonal plan impracticable. The octagon of H. Sergios and Bakchos and the plan of the H. Sophia belong to the same family. Also, they are nearly contemporary. H. Sergios and Bakchos, indeed, was begun by Justinian apparently early in his reign and completed prior to 536. The structure was squeezed in on an irregular site between the Hormisdas Palace, Justinian's residence as heir to the throne, and a church of St Peter and St Paul, a basilica with galleries which had been begun before 519. The addition of the church of H.

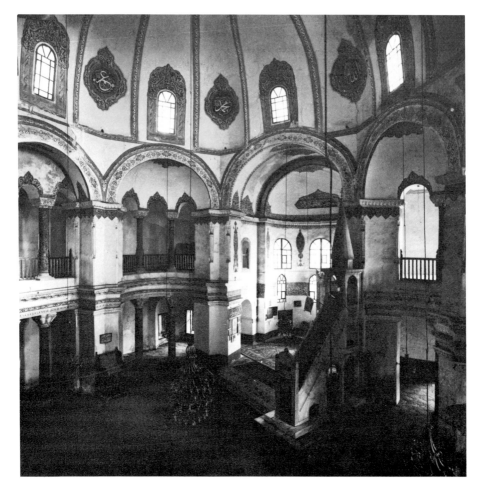

Sergios and Bakchos made of the two churches a double church, a common narthex, atrium, and propylaeum extending in front of both buildings. Moreover, H. Sergios and Bakchos communicated with both the basilica and the palace through open arcades on both floors and thus formed the focus of the entire complex. Incorporated into the south flank of H. Sergios and Bakchos, the north wall of an older structure survives; but whether it be the church of St Peter and Paul or part of the palace, must remain open.[22] Built in the full brick masonry with broad mortar-beds by then customary in Constantinople, and, like the H. Sophia, strengthened with chains of ashlar, the structure is supported by eight piers, which form an octagon placed inside an irregular square [182]. Alternatingly rectangular and semicircular niches link the piers and project into the enveloping ancillary spaces of an ambulatory and upper gallery, both pierced opposite the entrance by a forechoir and apse. Pairs of columns in the curve of the niches carry an architrave on the ground level and triple arcades on the gallery level. Over the centre space rises a sixteen-sided pumpkin dome in which the straight sides, flush with the wall, alternate with scooped segments. The scooped segments rest on the corners of the octagon; the straight sides spring from the centres of its sides and are pierced by windows.

The principle of the architectural design, then, compares with that of the Hagia Sophia. The centre space, at first easily understood, loses its clarity when viewed from the ambulatory and galleries. The space expands into the niches and from the niches out into the ambulatory, but it is bounded by mere screens. Indeed, the intercolumniations in the niches as well as, behind them, the arcades in the outer walls (originally perhaps leading into the neighbouring palace and into the aisles and galleries of St Peter and St Paul) drew the eye from the centre room, through the ambulatory, into

rooms whose relation to the centre room remains unintelligible. Yet, while the principle of planning is subtle, the execution is strangely ambivalent. No attempt has been made to counteract the irregularity of the site, and even the seemingly regular octagon of the piers has sides of different length. The proportions are unpleasantly low, even if the columns on the ground floor were originally placed not only on hexagonal bases (one still shows), but also on pedestals now perhaps buried in the Turkish pavement. Even disregarding the eighteenth-century decoration, the arches of the niches, their triple arcades, the webs of the dome, and the windows seem clumsy. On the other hand, the original ornament of the building is superbly fine and delicate [184]. On the ground floor, the folded capitals are spun all over by tendrils of sharp-toothed acanthus surrounding the monogram of Justinian and crosses – these latter chiselled off by the Turks. The Ionic impost capitals in the galleries are of similar elegance. The soffits of the architrave are coffered and decorated with rosettes, squares, and diamonds. Above, the fine triple architrave of the entablature is surmounted by a bead-and-reel motif, and this in turn followed by an egg-and-dart and tendril design, deeply undercut so that leaves and tendrils stand out sharply against the dark ground. The dedicatory inscription of Justinian and Theodora on the frieze is done in a bold, beautiful lettering, set in white against a greyish ground and topped by the deeply shadowing cornice [184]. The disturbing contrast between this elegant ornament and the subtle planning on the one hand, and the awkward proportions and the clumsy use of the building site on the other is hard to explain. Is it perhaps possible that an excellent plan was handed over to a master mason who was unable to adapt it skilfully to the site, and that, moreover, he was provided with beautiful capitals and entablatures ordered ready-made from the workshops of the Proconnesian quarries?

Variants on the plan were indeed frequent in Justinian's Constantinople; witness St John in the Hebdomon, built shortly before 560 in place of an older church in the Hebdomon Palace, and St Michael in Anaplus. Both are known, from Procopius' description and from a few remains of the Hebdomon church demolished but recently, to have been double-shell domed octagons with seven half-cylindrical niches projecting into an enveloping ambulatory.[23]

The roots of the style which dominates the H. Sophia and H. Sergios and Bakchos have been sought far and wide: in the vaulting techniques of Mesopotamia and in the domed and groin-vaulted structures of Imperial Rome;[24] in the 'de-materialized' wall decoration of Parthian and Sassanian architecture; and in a fusion of all or any of these.[25] Their centralized plans have been traced back to Armenia,[26] or to Rome. The H. Sophia has been explained as a merger of the Basilica of Maxentius with the dome of the Pantheon.[27] Or, its plan has been linked to the tradition of Christian martyria of the fourth and fifth centuries.[28] Its handling of space has been thought to derive from Western-Roman or from Roman-hellenistic concepts of architecture or from principles first evolved in the Roman West, but which had 'long become part of the wider heritage of late classical architecture [and] had incorporated many other elements'.[29] And in opposition to all these attempts at finding origins, the architecture of the H. Sophia has been presented as a break with tradition, as the 'first medieval architectural system'.[30] It has been discussed in terms of its structural problems, its vaulting, abutting, and supports; in terms of its spatial design, its rhythm and decoration; in terms of its function – and depending on these different approaches, different hypotheses have been put forward regarding its origin.

Structure, function, and design are inseparable in the H. Sophia, as they are in any great architecture. But they need not have the same historical origin. The full brick masonry, either strengthened by horizontal stone chains – as at H. Sergios and Bakchos – or chains combined with heavy stone piers – as at the H. Sophia – had been customary since the second and third centuries in the Greek cities along the coasts of Asia Minor, from Aspendos to Miletus, Ephesus, and Pergamon. Also customary was the masonry of mortared rubble – open or faced with small stones, and interspersed with brick bands – of which, e.g., the city walls of Constantinople were built. All three methods of construction had gained a firm foothold in Constantinople and its vicinity by the end of the third and the beginning of the fourth century – a natural development, since Constantinople then became the centre of gravitation for the entire Aegean region. From the fourth to the end of the fifth century these construction techniques were constantly employed in the buildings of the new capital, and by Justinian's time they were the approved practices known to the mason crews of Constantinople.[31]

Similarly, the vaulting techniques employed in the new churches of Justinian's early reign

183. Constantinople, Yerebatan Cistern, fifth century. Vault

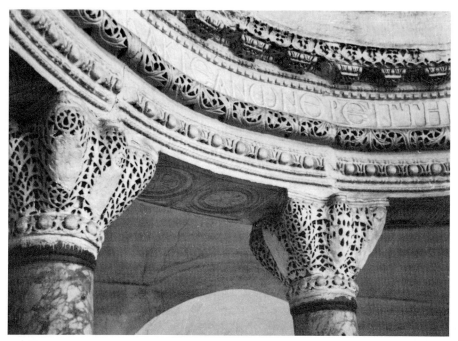

184. Constantinople, H. Sergios and Bakchos,
completed prior to 536. Capitals and entablature

had been brought long before from the coastal
cities of Asia Minor to the metropolitan centres
of the northern Aegean – Constantinople and
Salonica. Groin- and barrel-vaults were con-
structed, not of concrete, but of a single layer of
bricks, slightly pitched, laid across the axis of
the vault, and embedded in very thick mortar
[183]. The result was an extraordinarily light
vault. Whether or not the technique has Meso-
potamian and Egyptian roots, it was at home
in the third century in the Greek cities of Asia
Minor. From there it penetrated into Salonica
around 300, as witness the barrel-vaulted
niches in the rotunda of Galerius, now the
church of H. Georgios. By the early fifth cen-
tury, it was employed in the towers of the city
wall of Constantinople, and remained in use
throughout the century and later. The domes

and half-domes of the H. Sophia and the pump-
kin dome of H. Sergios and Bakchos are in their
construction but an outgrowth of this age-old
practice: thin, light, and built of a single layer of
bricks, pitched on their sides and embedded in
thick mortar. But the transfer of this technique
to domes and half-domes of wide span in Con-
stantinople need not have occurred prior to the
first years of Justinian's reign.

The architectural ornament of H. Sergios and
Bakchos and the capitals and friezes of the H.
Sophia certainly evolved in Constantinople,
or rather, in the marble workshops of the nearby
Proconnesian islands. They are rooted in a
tradition which, shortly after 400, had been
imported into Constantinople from the same
Aegean cities whence had come the techniques
of masonry and vaulting. One recalls how

185. Constantinople, H. Sophia, 532–7.
Composite capital

closely the ornament of the propylaeum which between 404 and 415 was added to the first H. Sophia was still linked to third-century proto-types at Miletus and Ephesus.[32] But this orna-ment was further developed by the stonemasons of Constantinople. By 463 in the Studios church, the undercutting of leaves and tendrils had grown much deeper, the contrast of raised, white foliage and black ground much sharper, and the leaves spikier than ever [53, 54, 56]. Sixty ·years later the ornament has again changed. As among the capitals of H. Polyeuk-tos, the foliage on friezes and capitals at H. Sergios and Bakchos is worked completely *à jour*. More important, the classical propor-tions, still present in the Studios church, have been abandoned: in the relations of architrave, frieze, and cornice of the entablature, and in the ornamental motifs – rope, egg-and-dart, tendril and dentil friezes, and rows of brackets. Corre-spondingly, in the capitals, the traditional Corinthian, composite, or Ionic forms have given way to fold capitals, overspun by twigs with spiky leaves raised high from the black, undercut ground. Even where – as in the H. Sophia – the foliage and volutes of a composite capital remain recognizable in residual form, the leaves have been turned into a dense growth of thorny thistles. As at H. Polyeuktos, possibly under the impact of Sassanian art, the capital itself has been transformed from an organic growth into the geometric shape of a truncated cone, and its decoration continued without a break into that of the impost block, eliminating the difference between support and burden, capital and block [184, 185].[33]

The techniques of masonry and vaulting, and the architectural ornament of Constantinople, are, then, ultimately derived from the same source – the hellenistic cities of the Empire situated along the coasts of Asia Minor. But their development in Constantinople differs. The masonry construction remains conservative. In vaulting, the technique of thin brick vaulting is applied, perhaps first by the architects of Justinian, to forms of vaulting previously executed only in concrete or stone – pendentive domes, domes on pendentives, ribbed domes, pumpkin domes. The ornament, while gradually changing during the fifth century, is finally radically transformed in Justinian's early years.

It is but natural to suspect that plan and general design of Justinian's churches, as epitomized in the H. Sophia, were evolved by Anthemios, Isidorus, and their contemporaries along similar lines, i.e. by radically changing forms long accepted in Constantinopolitan church building. But church building in Constantinople prior to 525 knows no structure remotely comparable to those which now suddenly sprang up. Plan and design of H. Sergios and Bakchos and of the H. Sophia, and the concepts of space, boundaries, light, colour, and rhythm which they embody draw on a multiform tradition in which many threads are interwoven. Different though they are, they have been fused into perfection by the genius of the architects who designed the new structures of Justinian.

Stylistic concepts which by 525 had prevailed for a century or more in Constantinople no doubt play an essential part in this process of fusion. Architects in the northern Aegean coastlands, since the early fifth century, if not before, had been thinking of church buildings in terms of a space which spread sideways, subdivided rather than contained by curtain walls. They had been designing lavish interiors with marble revetted walls, deeply undercut friezes and capitals, and with column shafts of precious colourful marble. By the early sixth century, then, patrons, architects, and the educated public in Constantinople were accustomed to view architecture along lines which, in general terms, also describe a structure such as the H. Sophia. However, such background resemblance is but one constituent element, and all too vague at that. Similarly, the elements of construction, the masonry, and the vaulting practices of Constantinople were but one constituent factor in generating the new structures. The technique of building lighter vaults enabled the architects to think of bolder skeleton constructions, of fewer and thinner supports, and of wider vaulting spans. Like the general concepts of style prevailing, the methods of construction at the disposal of the architects are but part of the background. So are the demands of the liturgy which for centuries had exerted their impact on church planning in the eastern coastlands. As a result of these demands, the traditional basilica plan had been marked by new accents. The nave where Christ revealed Himself in the word and in the flesh, accompanied by the processions of the clergy, was turned into the central element of the design. The dome rose above it, chosen perhaps 'because in the ancient Near East it already had a clear and specific symbolic meaning . . . the canopy of Heaven'.[34] Aisles and esonarthex enveloped the nave on three sides and imparted to the whole design a centripetal note. This was reinforced by the superposition of two ancillary enveloping zones, aisles and galleries, both sheltering the worshippers. Strengthened and codified in the early sixth century, these liturgical demands and iconographic connotations were presumably an essential constituent element in creating the new designs of H. Polyeuktos and H. Sergios and Bakchos. Certainly they were best fulfilled by breaking with the tradition of the basilica and turning instead to a centrally-planned building composed of a free-standing baldacchino and an enveloping

ambulatory, possibly two-storeyed, in short, double-shell designs.

By 525, double-shell designs had been employed in church architecture for nearly two hundred years, beginning with Constantine's Golden Octagon at Antioch. But octagonal double-shell designs, one recalls, remained rare. From the late fourth into the sixth century and sometimes beyond, the majority are tetraconchs, as they rise in all the provinces of the Christian Empire: at Milan in the late fourth century; at Peruštica (Peroushtitsa) in the Balkans in the early sixth century [86] and possibly earlier at Adrianople; in Syria, at Seleucia-Pieria (Samandağ) [93], Apamea (Qalaat el Mudiq), Bosra (Bosra Eski Sham), and Aleppo, shortly before and after 500.[35] The list could easily be enlarged. Near Canosa in southern Italy, the remnants of a tetraconch structure of uncertain date await further exploration. Another one has been dug up near Ohrid in southern Yugoslavia; provided with atrium, narthex, baptistery and diaconicon, it would seem to have been a bishop's cathedral.[36] At R'safah, on the Euphrates frontier, stands the ruin of a quatrefoil, like its Syrian neighbours of early-sixth-century date [221]. As late as the seventh century the type survives in the church which the patriarch Narses III (641-61) built at Zvart'nots in Armenia, adjoining his palace [287].[37] The common features of plan and construction are easily listed: the inner core in tetraconch shape, supported at the corners by four L-shaped piers; the four huge lobes expanding from the core; the enveloping ambulatories and galleries. The covering of the central core remains in doubt, but timber construction seems to have been the rule, either a pyramidal roof or a wooden dome. Variants in plan are insignificant: at Bosra the walls of the ambulatory are circular inside and square outside, instead of repeating the inner tetraconch curve; at Zvart'nots the ambulatory wall, both inside and outside, is circular; at R'safah the eastern and western lobes are elongated, creating a longitudinal axis.

Given the background of stylistic concepts firmly established in the Aegean coastlands, architects and patrons in early-sixth-century Constantinople and throughout the great cities of the region would naturally be attracted by such double-shell designs. They must have been intrigued by the interlocking of spatial volumes, the fragmented views, the change of boundaries into mere screens, the expansion of the core into the lobes of the exedrae and into the envelope of aisles and galleries. Certainly it is not by chance that, in the decades prior to and during the first third of Justinian's reign, tetraconch churches became so frequent in the hellenized cities of Syria and in the Balkans, where Constantinople exerted its strongest influence. Still, compared to H. Sergios and Bakchos or to the H. Sophia, all tetraconch churches are simple in design. A closer look at their liturgical functions leads somewhat further.

It has long been taken for granted that tetraconch churches were without exception martyria.[38] Some probably were: the tetraconch at Seleucia-Pieria may have sheltered apostle relics; and the murals at Peruštica, though apparently a century later than the structure, represent martyrdom scenes. The liturgical functions of the tetraconch churches at Apamea, Adrianople, Aleppo, and Canosa, however, so far remain unknown. On the other hand, the tetraconch at Bosra was certainly the cathedral of the local bishop, as was the one near Ohrid. The one at R'safah has long been termed the martyrium of St Sergius, but recent findings suggest that it too was the cathedral of the city.[39] Likewise the tetraconch at Athens, if indeed it was built as a church (but this is doubtful), was the *Megali Panaghia*, the Great Church of Our Lady, and thus the cathedral [73].[40] Still others were presumably both cathedrals and palace churches, beginning with S. Lorenzo in Milan. Certainly the latest church of the group known

to date, the one at Zvart'nots, was both a reliquary shrine – that is, a martyrium – and the palatine chapel of the patriarch. Likewise, the tetraconch cathedrals at Bosra and R'safah are both so closely linked to the adjoining episcopal palaces that they too must be considered not only cathedrals, but the bishops' palace chapels as well. This throws light also on Justinian's early church buildings. After all, the H. Sophia was both the cathedral of Constantinople and the church of the adjoining Great Palace, and its ceremonial was geared to the participation of the Emperor in the services. H. Sergios and Bakchos was built next to, and communicating with, the palace which Justinian inhabited when heir to the throne. It must have been the palace church, but at the same time it enclosed, like the H. Sophia, relics, and thus also carried the connotation of a martyrium. St John in the Hebdomon, too, rose inside an Imperial palace, this one outside the city. The interplay of functions parallels that found in many a contemporary tetraconch church.

The differences are, of course, obvious. Justinian's churches in Constantinople are not tetraconch structures. H. Sergios and Bakchos rises on an octagonal plan, and the H. Sophia is a variant on the octagon. However, it is likely that octagonal double-shell designs, as well, had their place in church architecture ever since Constantine's Golden Octagon at Antioch. Like the tetraconch, the octagon plan was used occasionally for martyria: about 350, Gregory of Nazianz (Nenezi) built in his native city a martyrium in memory of his father. An octagonal structure, it was enveloped by aisles and galleries like the church at Antioch. A similar structure, dedicated to the Baptist and possibly also a martyrium, rose at Alexandria in Egypt.[41] Neither survives, and nobody can tell whether or not niches billowed into the enveloping spaces of lower and upper ambulatory. On the other hand, there is a good likelihood that this was the case in Constantine's Octagon at

Antioch, which certainly functioned as a palace church and was no doubt well known to Justinian and to his architects. Neither they nor the Emperor, in designing new churches closely linked to the palace at Constantinople, could disregard the model set by the great Constantine at Antioch.

True, the plan of the Golden Octagon – whether or not its niches billowed from the core – remains in doubt. Certainly the structure was timber-roofed, not brick-vaulted, as were Justinian's early churches. But then, one recalls, centrally-planned palace churches – since Constantine's day – were in all likelihood derived from centrally-planned audience halls. Such halls, it will also be recalled, were laid out as triconchs, rotundas, hexagons, octagons and decagons. They were frequently provided with niches, placed either in the thickness of the wall, or expanding from the core into adjoining spaces as in the Minerva Medica in Rome [186]. And they were always vaulted: with regular domes resting on the circular wall, as in the salutatorium at Spalato; with ribbed domes, as in the Minerva Medica; and presumably with pumpkin domes or with domes composed of straight and concave webs in alternation, as they seem to have covered the Chrysotriklinos, the golden audience hall of the Great Palace at Constantinople. With its pumpkin dome and its niches opening into contiguous spaces, the Chrysotriklinos belongs to the same family as H. Sergios and Bakchos and, ultimately, the H. Sophia.[42]

The late date of the Chrysotriklinos, presumably forty-odd years after H. Sergios and Bakchos, does not necessarily mean that its plan was descended from that of Justinian's church. The Chrysotriklinos itself apparently was descended from H. Sergios and Bakchos, but it is one among many examples of vaulted palace halls with complex central plans of sophisticated design – and a late example at that. Nor is it by chance that the niched hexagon hall in the palace north of the Hippodrome at just that

186. Rome, Minerva Medica, *c.* 310,
as in *c.* 1800. Exterior; etching by F. J. B. Kobell.
Munich, Graphische Sammlung

time was transformed into the church of H. Euphemia by simply inserting the requisite liturgical fixtures: synthronos, altar, and chancel barriers, the latter provided with splendid inlaid columns [178]. Given the intertwining of Imperial and religious functions in the Sacred Palace, it seems but natural for Justinian's church builders to have drawn on this living source, palace halls, which continued to flow from the third and fourth to the sixth century, and even later. In doing so, they revitalized the type of the timber-roofed palace church, tetraconch or octaconch, which had come down from the fourth century practically unchanged and thus somewhat obsolescent.

None of this fully circumscribes the framework within which Justinian's early church buildings should be placed. The new stylistic concepts of expanding and interlocking spaces could be achieved to perfection only by applying techniques of construction never before used in such combination and on such a scale. Double-shell churches – whether tetraconchs or octagons – had with few exceptions been covered with timber constructions. Palace halls had been vaulted, but even in the fourth century in Rome they were vaulted in a concrete construction requiring heavy support from walls or piers, as witness the Minerva Medica [186]. We do not know at present whether fifth-

century builders in Constantinople already employed the new techniques of brick vaulting for large spans, as they would be required by an audience hall or church of huge dimensions. In all likelihood this was done only by the architects of Anicia Juliana between 524 and 527 and of Justinian between 527 and 537. Through the use of thin brick shells they adapted to large-scale construction the complex shapes of vaults previously executed only in concrete and over comparatively small spans. The huge stone piers of the H. Sophia, combined with the thin brick curtains of the enclosing walls, allow for the interplay of a solid skeleton and diaphanous screens infinitely more efficient than that of Roman skeleton buildings constructed in their entirety of concrete masonry. The brick vaults are made so thin and light that they exert but a minimum of thrust. They can be shaped on the largest scale into complex forms which continue into the vaulting zone the contraction and expansion and the convex and concave space volumes enclosed by walls and colonnades of the building.

The change in the vaulting techniques throws into relief the relation of Justinian's architecture to the preceding tradition. It rarely breaks radically with the past. Only in its ornamentation does it approach such a break; but even there the principle is rather that of a thorough change in the mutual relationships of traditional forms. More frequently, Justinian's architects translate a form, long used and still much alive, into a different language. The complex vaults of traditional palace building are transposed into the technique of thin brick shells, and are thus made more flexible and capable of covering wider spans. The design of centrally-planned audience halls is transposed from palace architecture into church building, and is thus adapted to the requirements of the sixth-century liturgy of Constantinople. Construction and design, ecclesiastical and Imperial ceremonial interlock. The traditional forms are

a source to be tapped, placed into new contexts, adapted to new demands, transformed, and imbued with new life. Such revitalization of a living tradition is a basic trait of Justinian's architecture as it is of his policies.

Only one building outside Constantinople is close to Justinian's early court churches: S. Vitale in Ravenna.[43] When it was completed in 546-8, it was certainly considered as standing within the ambience of the Imperial court: the mosaics in the chancel – Justinian and Theodora offering gifts – speak for themselves. But we cannot be sure of Imperial backing at the time construction was started, still under Ostrogothic rule. The building was apparently financed by a wealthy local banker, Julianus, and commissioned by Bishop Ecclesius (521-32). However, construction started in earnest possibly only after 540, under Bishop Victor (538-45), whose monogram appears on the capitals of the ground floor. The mosaics in chancel and apse followed in 546-8, and were the only element of the building to be executed under Archbishop Maximian, who stands next to Justinian on the mosaics of the chancel walls.

S. Vitale has often been considered a sister building of H. Sergios and Bakchos. Indeed, the plan is close enough: the octagonal core, vaulted and resting on eight piers and arches; the enveloping superimposed zones of ambulatory and gallery; the seven niches, between the piers of the centre baldacchino, billowing into the enveloping ring; and on the eighth side, the square chancel, and the lower, projecting apse, which breaks through the zone of ambulatory and gallery [187, 189, 192]. Nor is there any doubt that column shafts and capitals were imported from the Proconnesian workshops. One wonders, however, whether the most up-to-date models were provided for the capitals; composite capitals as used throughout the gallery, in Constantinople were long out of date; truncated cones with wicker-framed fleshy lotus palmettes hark back to H. Polyeuktos,

187. Ravenna, S. Vitale, completed 546–8. Interior, facing apse

524-7; and only the dense spiky tendril designs on other truncated cone- or on fold capitals recall the decorative vocabulary of H. Sergios and Bakchos rather than of the H. Sophia. Also, if S. Vitale is a variant on the octagonal double-shell plan which also underlies H. Sergios and Bakchos, it is a very independent variant. It was obviously executed by local workmen and built largely with local materials. The bricks, to be sure, are different from the high bricks previously used in Ravenna and in all of northern Italy. Thin and long, they imitate those of Con-

188. Ravenna, S. Vitale, completed 546-8. Masonry

189. Ravenna, S. Vitale, completed 546-8. Capitals in the chancel

stantinople, and were manufactured locally for all the construction financed by Julianus in Ravenna – S. Apollinare in Classe among others [188]. The vault over the centre baldacchino is built not of pitched bricks, but in the western techniques of hollow tubes inserted into each other.[44] A local western crew, then, was at work. But plan and elevation also differ from H. Sergios and Bakchos. Ambulatory and gallery zones were not vaulted – the present vaults date from the Middle Ages – and as a result greater emphasis is given to the core, the centre baldacchino, and the chancel – the parts of the building where the mosaic decoration, the richly veined marble revetment of the piers, the most elaborate capitals, and the *opus sectile* of the pavement

are concentrated [189-91]. The rhythmical alternation of rectangular and semicircular niches which marks the plan of H. Sergios and Bakchos is abandoned. Instead, the sequence of semicircular niches produces a new unity of design. This impression of unity is furthered by the proportions of the building, which are much steeper than those of H. Sergios and Bakchos, by the placement of arcades in both the upper and lower zones of the niches, and by the slenderness of the surmounting arches. It is further stressed by the flood of light from rows of huge windows in the ambulatory, gallery, and the clerestory zone of the centre room which ties together all the parts of the building. As contrasted with the sister buildings of Con-

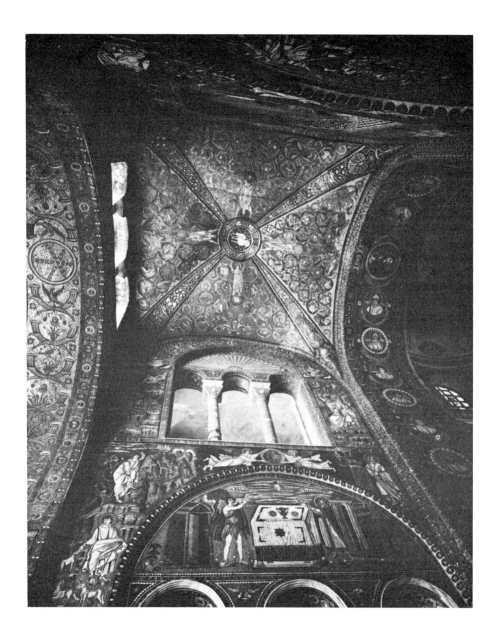

190. Ravenna, S. Vitale, completed 546–8. Vault of chancel

191. Ravenna, S. Vitale, completed 546-8.
Reconstruction of original marble revetment

stantinople, the design seems simplified. But this seeming simplification is counterbalanced both by greater clarity of articulation and greater complexity in the interlocking of volumes and spatial vistas. On the exterior, low circular chapels - each provided with a still lower rectangular absidiole and a higher rectangular turret - flank the polygonal apse [192]. From the apse the eye ascends to the roofs of the gallery, of the chancel, and finally to the roof of the centre room: a graded arrangement of volumes not inferior even to the H. Sophia. Likewise in the interior, unification and complexity interlock. The marble revetment [191], restored on the basis of fragments surviving; the mosaic pavement, reconstructed in two triangular sections of the inner octagon; the mosaic on the walls of the forechoir, on its vault and on that of the apse - all pull the interior together. At the same time, the overlapping of vistas is superb. As the visitor passes through the wide square quadriporticus of the atrium and into the long shallow narthex, he is unaware of the anomalous position of the narthex. Standing off-axis, it touches only a corner of the outer wall of the structure. It communicates with the ambulatory through subordinate triangular spaces, the one to the left leading into the bay opposite the chancel, the other leading into the adjoining bay. Thus the vistas become immensely complex, and the visitor standing behind the convex screens of the niche arcades remains uncertain of his true position with regard to the chancel and altar - eager to clarify it by proceeding to the core of the structure.

The architect of S. Vitale was, I think, a Westerner. But he was intimately acquainted with the new architecture which was being created at that time at the court in Constantinople. He strove to translate into his own terms this new architecture of Justinian. Equal to Anthemios and Isidorus, or nearly their equal, he designed the one truly great building of the West in the sixth century.

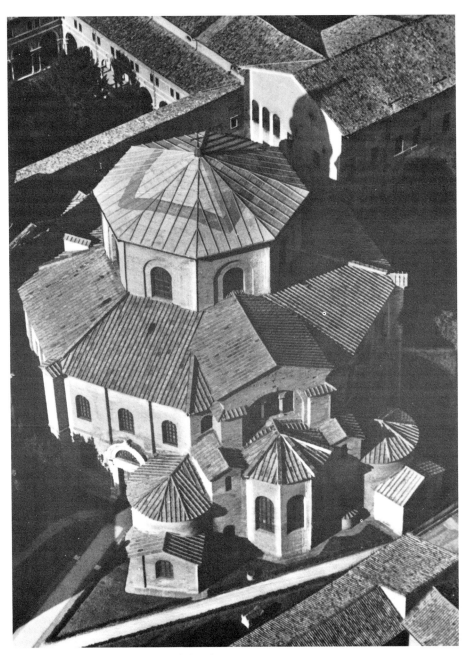

192. Ravenna, S. Vitale, completed 546-8. Exterior

STANDARD BUILDING IN THE AGE OF JUSTINIAN

The bold construction and the sophisticated design of H. Polyeuktos, H. Sergios and Bakchos, and H. Sophia remained confined to Constantinople and to a few years – roughly 524–37. They found no real following and broke off as suddenly as they had started, as would any *tour de force*.[1] By the time the H. Sophia was completed, the style had given way to more sober, less daring, and – as its contemporaries no doubt felt – sounder concepts of construction and design. These concepts were not newly created by the master builders of the sixth century. They are rooted in a tradition which extends back into Roman times, and which had been absorbed into church building long before Justinian's architects had designed their bold and imaginative structures. Indeed, one wonders whether H. Sergios and Bakchos and the H. Sophia should perhaps be viewed as a protest against an ever-broadening current of vaulted church buildings of standard design, sober and sound in plan and construction. In any event, it is not the imaginative architecture of Anthemios and Isidorus that dominates the future. On the contrary, it is the plainer, easily intelligible, and more commonplace concepts and the simpler techniques of construction which underlie the vast majority of sixth-century buildings – even in the capital and the core provinces of the Empire. Easily spread, this standard architecture decisively determines the further course of Byzantine architecture.

The master builders and architects who designed this architecture worked with a few basic elements. From the wealth of Late Roman vaulting – which had remained alive in palace, utilitarian, and funeral architecture – they selected the simple, fundamental types. They shun-

ned such complex forms as pumpkin domes or domes with alternatingly flush and concave sides, and concentrated instead on barrel- and groin-vaults, known from time immemorial, and on pendentive domes (sail-vaults) and domes on pendentives as they had been in frequent use in the utilitarian and funeral architecture of the Aegean coastlands and the Syrian provinces. A thermae building at Gerasa (Jerash) and the 'East Mausoleum' at Side (Eski Antalya) – the former of second-, the latter of early-fourth-century date – are two examples among many.[2] Both in utilitarian buildings and in mausolea, such vaulting forms continued from the fourth into the sixth century and later. Gradually, however, in the course of the fourth and fifth centuries, the technique of construction changed from solid stonework or concrete to thin brick shells reminiscent of the vaults of the H. Sophia. Slender supports become sufficient; and long rows of columns, surmounted by capitals with or without impost blocks, can carry the endless numbers of small groin-vaults and pendentive domes in the cisterns of Constantinople. The Yerebatan Cistern [183] and the cistern near the Studios church, both fifth-century, and the sixth-century Cistern of the Thousand-and-One Columns, the Binbirdirek, are a few of the many examples of this type.[3] Likewise, pendentive domes or domes on pendentives constructed in thin shells of brick easily span large spaces, while resting at the corners on comparatively light supports. Piers hollowed out on the inside, dissolved into a cluster of supports, or, indeed, sheltering inner chambers, replace the now unnecessary solid piers.

All such elements of vaulting are geared to cover a square bay. The sides of the bay may be

closed by walls, solid yet weaker than the corner supports; or they may be open, to continue the main bay in four directions by subsidiary spatial units, groin- or barrel-vaulted. The vaulted square bay is thus easily enlarged into a cross shape by four subordinate barrel-vaulted bays, the whole supported by corner piers.

This cross-shaped compound, as a rule surmounted by a pendentive dome or a dome on pendentives, becomes the basic unit of a standard architecture of the early Byzantine centuries: free-standing and, in that case, enclosed by walls; doubled and tripled; combined into a cruciform cluster; or fused into the plan of a basilica with galleries and transept. Whatever combination is chosen, however, the architects of the new standard buildings insist on sobriety of design, on simple plans, and on easily understandable relationships of the building parts. They shun the expansion of the core by billowing niches or by domes and half-domes flowing into one another. They abstain from double-shell designs and the ensuing interplay of spatial units. They strive towards a clear relation between the spatial units and their boundaries. Walls are solid, and where screens of columns are employed in the openings of a gallery or a huge window, they appear to be used as alien features rather than as integrated elements of an overall design. Mosaics and marble veneers are played down, and throughout the buildings shun the enticing ambiguity of statement and denial, wholeness and fragmentation, on which rests the design of the H. Sophia. When deeply undercut foliage ornament on capitals and friezes is absorbed into this standard architecture, as in Church B at Philippi [213], it stands in sharp contrast to the overall design of the building – a decoration ordered ready-made or done by workmen imported from the Imperial quarries.[4] When on the other hand it is locally made, though, more often than not the architectural ornament also takes on more sober forms.

Sound, but somewhat unimaginative, this standard architecture stands alongside the complex and imaginative buildings of Justinian's early years, and continues long after. Its beginnings, however, go farther back. On a small scale, the cross-shaped basic unit has its antecedents in Roman architecture. Cruciform mausolea, their corner piers either solid or hollowed, abound all over the Empire from the first and second to the end of the sixth century. Their centre bay is, as a rule, surmounted by a groin-vault. But in Syria and the eastern coastlands, from the fourth century on, not infrequently this groin-vault is replaced by a dome on pendentives or by a pendentive dome. The 'East Mausoleum' at Side, the mausoleum of H. Leonidas adjoining the Ilissos basilica at Athens, a mausoleum at Hass and another one at Ruwêha (Rueiha), both in Syria, are a few examples of such domed cross mausolea chosen at random.[5]

By the beginning of the fifth century, this basic element – the domed cross unit – had long penetrated, on a small scale, church architecture all over the Christian world. The mausoleum of Galla Placidia at Ravenna is but one example of many, as are the martyria attached to S. Simpliciano in Milan and to SS. Felice e Fortunato at Vicenza [138, 144, 145].[6] But regular churches of somewhat larger size – fully domed, with side chambers replacing the solid corner piers of earlier small martyrs' chapels – seem also to have existed prior to 500. The earliest surviving examples appear in the Aegean provinces: in Macedonia and on the coast of Asia Minor. Hence it is possible that these standard types originated in the provinces and were transferred to the capital only in the thirties of the sixth century, after the great churches of Justinian's early reign had been built – and failed. But it is equally possible that the early provincial examples which chance has preserved are but derivatives of prototypes in the capital, now lost.

The church of H. David at Salonica shows the cross type fully developed by the last third of the fifth century.[7] The centre bay was surmounted by a dome, of which the pendentives survive to the present day [193]. The cross

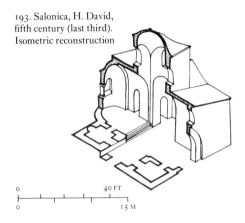

193. Salonica, H. David, fifth century (last third). Isometric reconstruction

wings are comparatively deep and, except for the east arm, accessible through doors. The entrance to the west is slightly recessed. The corner piers have been replaced by small rooms surmounted by pendentive domes, the two rooms to the east terminating in small apsidal niches. No documents record the time of construction, but the splendid mosaics surviving in the apse and on its arch suggest a date shortly before 500. This date is likewise suggested by the few architectural details, such as the poor rubble masonry, with brick voussoirs used only over the double-arcaded window of the apse, and by the one surviving capital over the column of the apse window. The type may well be older. Two churches in the Syrian uplands, one at Shaqra, the other the martyrium of St Elias at Izra (Zorah), both dating from the sixth century, present it in a provincialized version, dome and barrel-vaults replaced by timber roofs. Likewise the type appears in the Byzantine West, witness the church of the Saviour at Rometta near Messina, a

structure of undetermined date.[8] But the plan is that of a domed cross enclosed in a square and resting on the walls of corner chambers. Given the poor construction and the location in the hinterland, these churches may well reflect domed cross buildings of earlier date in one of the great architectural centres. In any event, simple standard buildings of this basic type continue to be built throughout the sixth century. An example near the end of the century was apparently the cathedral of Edessa – a building known only from a poetic and somewhat vague description.[9]

The church of H. David is small. Its centre bay measures but 4·50 m. (15 ft), the entire structure 14·75 m. (49 ft) on each side. The size of the cathedral at Edessa (Urfa) is unknown. But by 530, the standard unit had become the basic element from which monumental architecture – both secular and ecclesiastical – was developed in the capital and all over the Empire. In Constantinople both the main entrance to the Imperial palace – the Chalki – and the porch of the near-by Senate House were evolved from the domed cross unit [194, A and B]. These structures have disappeared, but Procopius's descriptions are clear.[10] In the Chalki a pendentive dome rested on the arches of four barrel-vaults. To the east and west, these arches sprang from piers projecting inward; to the north and south, from the backs of lower, narrow barrel-vaults which linked the sides of the piers to the outer walls [194A]. In the porch of the Senate House, a dome on pendentives was carried right and left by deep barrel-vaults; in front and along the façade of the building proper, it seems to have rested only on arches [194B]. In contrast to the solid walls which enclosed the Chalki, barrel-vaults and arches in the porch of the Senate, which, like the Chalki, was rebuilt after 532, were supported on the exterior by huge columns.

In church building, as well, during Justinian's reign, the domed cross became the

A

194. (A) Constantinople, Chalki gate, 532-6.
Reconstruction
(B) Constantinople, Senate House, porch,
after 532. Reconstruction

B

standard unit on a monumental scale. It lent
itself to easy combinations of large size, and
the number and variety of such combinations
are surprising. Repeated five times and arranged
in a Greek cross pattern, it formed the plan of
Justinian's Church of the Holy Apostles. The
church is known only through a skimpy des-
cription by Procopius, through the reflections
it has had in the provinces – from Ephesus to
Venice – and through representations in late
manuscripts [195].[11] Still, both its building his-
tory and its pattern are clear. Laid out on the
site of Constantine's Apostoleion, it was ap-
parently begun about 536 and dedicated on 28
June 550, the eve of the feast day of the Princes
of the Apostles. Fallen into disrepair, it was re-
modelled after 940, and before 979-89, along
lines slightly different from Justinian's. Dam-
aged again about 1300 and hastily repaired, it
survived until 1469. It then gave way to a
mosque, the Fatih, erected in honour of
Mehmed the Conqueror (el Fatih); and this
first Fatih was in turn replaced by the present,
larger mosque in the third quarter of the
eighteenth century.

From its Constantinian predecessor Jus-
tinian's building took over the cruciform plan,
the entrance arm possibly extending slightly

195. Constantinople, Holy Apostles, *c.* 536–50, as in *c.* 1200. *Paris Bibliothèque Nationale*

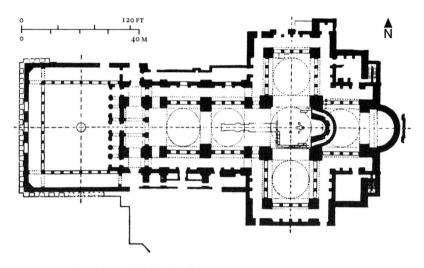

196 (*above*). Ephesus, St John, completed by 565. Plan

197 and 198. Ephesus, St John, completed by 565.
South wall of west bay during rebuilding in 1963
(*below*), and reconstructions of interior (*below right*)
and exterior (*opposite*)

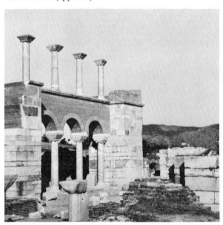

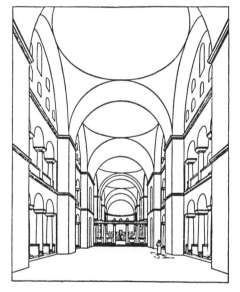

farther than the other three. Five domes rested
on solid piers in the corners of the cross and sur-
mounted the arms and the centre crossing.
Aisles and galleries enfolded each of the four
arms on three sides, and opened towards the
naves in two tiers of colonnades. A cross-shaped

chancel rose below the centre dome, the only
one to be lit by windows. The other domes were
dark and apparently slightly lower, possibly
simply pendentive domes.

In its plan, S. Marco in Venice more or less
follows the pattern of Justinian's Apostoleion,

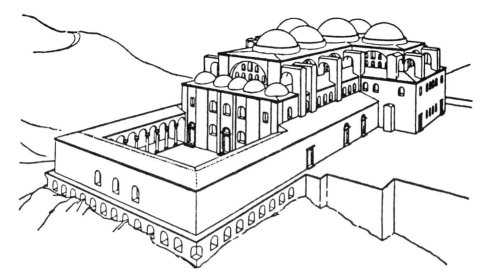

but the design is reflected just as closely in his church of St John at Ephesus [196-8].[12] Prior to Theodora's death in 548 – both her monogram and Justinian's appear on the capitals – the Imperial couple had apparently decided to replace the fifth-century cross structure over the tomb of John the Evangelist by a new vaulted building. Completed by 565, its walls and piers survive to a height of 5 and 6 m. (16 and 20 ft). It was cross-shaped and, moreover, preceded by a narthex and an atrium. Its entrance arm was considerably longer than the other three. Hence, while the crossing, the transept arms, and the chancel were surmounted by one dome each, two domes of oval or slightly elliptical plan covered the bays of the nave. These domes rested on heavy piers built of beautiful blocks of ashlar. Arcades supported by columns inserted between the piers separated nave and aisles, the aisles being carried round the four arms of the building, and segregated from the nave by parapets. Galleries surmounted these lower arcades; smaller column shafts and capitals, found in the excavation, prove their existence. The wall of the nave rose above the galleries, presumably pierced by a series of grouped windows. Barrel-vaults covered aisles and galleries. Not all details of the reconstruction are necessarily correct, but the overall impression is of individual spatial units – aisles, galleries, nave, and the individual bays within the nave – clearly segregated from each other, much in contrast to the principles of the H. Sophia. The plan is simple, plain, sober. The spatial units, rather than emanating from a centre in a fluid movement, stand by themselves. The bays, cut off from each other by the wide barrel-vaults and the strong projecting piers, seem to stand side by side. The domes rise vertically above the transverse spans of the arches further to stress this *staccato* movement. Nor did the nave, seen from aisles or galleries, force itself to be viewed as the essential element of the architectural design. The ornamentation shows a similar change. The Ionic capitals are not just provincialized and poor versions of greater prototypes; even where they are of higher quality, they have become simple and sober, with floral decoration limited to a few elements.[13] As in the design of the building itself, a somewhat unimaginative standard style prevails in every single detail.

The plan of the Holy Apostles and of St John at Ephesus was based on the concept of multiplying the standard element, using short barrel-vaults to expand the square, domed bay into a cross shape. But this solution remains rare. More decisive for the development of Byzantine architecture is the fusion of the standard element, the domed cross, with the transept or the chancel section of a basilican plan. In cross churches and cross-transept basilicas since Constantine's Apostoleion, a timber-roofed tower had, as a rule, risen over the crossing, where normally chancel and altar were located. In the course of the fifth century, this timber-roofed tower was fused into the plan of an ordinary basilica with galleries. Placed over the bay preceding the chancel and the altar, it surmounted the area where the clergy entered into, and emerged from, the sanctuary carrying the elements of the Eucharist and spreading the Word of the Gospel.

This blend occurred as early as the late fifth century in a church at Meriamlik (Meryemlik) on the south coast of Asia Minor.[14] The date is known from contemporary reports, 471–94, and is confirmed by the style of the capitals. The building lies in ruins, but its plan is clear [199]. Preceded by a huge, semicircular forecourt and an outer narthex, the short nave was flanked by barrel-vaulted aisles and galleries. Piers, dividing the nave into two nearly square bays, interrupted the sequence of the short arcades, each of which was formed by only five arches on columns. A short forechoir surmounted by a shallow barrel-vault – hardly deeper than an arch – linked the nave to the semicircular apse. The aisles were also barrel-vaulted – traces of the vault were still visible in 1907[15] – and the general consensus used to be that the nave was likewise vaulted, the first bay being surmounted by a barrel-vault, the second bay in front of the chancel by a stone dome. Thus the church at Meriamlik would have been the first known example of a 'domed basilica'; fifty years later H. Polyeuktos in Constantinople may have been laid out on the same plan. Recently, an alternative reconstruction has been proposed for Meriamlik: the first bay covered by an ordinary timber roof, the second bay by a pyramidal timber construction.[16] The question still awaits a final solution. Certainly, however, basilicas with short naves and tower-like square bays preceding chancel and apse, all timber-roofed, are frequent in south-western Asia Minor. The plan of the east church at Alahan Manastir (Alahan Klissi, Koja Kalessi) is the same as that of Meriamlik, and throughout the building was timber-roofed [200-2]: truss roofs over the

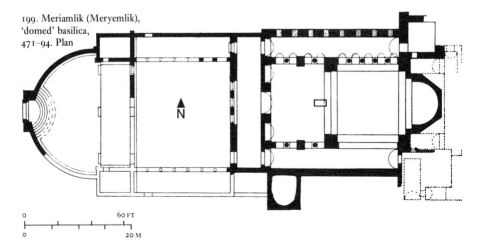

199. Meriamlik (Meryemlik), 'domed' basilica, 471–94. Plan

N

0 60 FT

0 20 M

200–2. Alahan Manastir (Alahan Klissi, Koja Kalessi),
east church, late fifth(?) century.
Plan (*below*), interior of nave facing west (*right*),
and exterior from the south-east (*bottom*)

0 40 FT

0 15 M

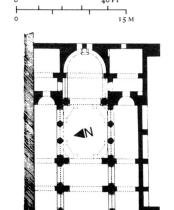

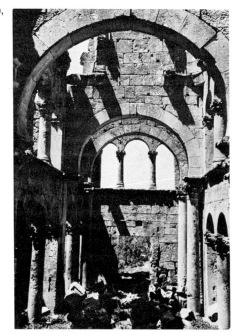

aisles, galleries, the first bay of the nave, and the forechoir; a pyramidal roof over the tower-like final bay of the nave.[17] Rising at the eastern end of a long rock terrace, halfway up the steep cliff, the church is preceded farther west by a sculptured gate and two buildings, one the basilica, previously discussed, the other a baptistery, and all belonging to a monastery. The east church, which still stands to nearly its full height, may thus have been the main church of the monastery, a suggestion supported by its size – roughly 20 by 13·5 m. (65 by 45 ft) interior length and width – as well as its clear volumetric design, its excellent masonry, and the fine workmanship of its capitals. The date of its construction seems no longer in doubt. Inscriptions found on the terrace to the west of the main church suggest a foundation in the late

fifth century; none the less some of the ornament of the church would seem to anticipate a sixth-century date.[18] The ruin of a similar church rises a few miles away at Dağpazari.[19]

It is of course possible that such buildings simply transposed into timber construction a model which was entirely vaulted, with a barrel-vault over the first bay, and a dome over the second bay of the nave – in short a genuine 'domed basilica', to use the accepted term. Such a model may well have existed in Constantinople as early as the third quarter of the fifth century and thus prior to Meriamlik. In all likelihood it existed when, in 524–7, H. Polyeuktos was laid out in the capital. Indeed, it has been suggested that the plan for Meriamlik was designed in Constantinople. Certainly the style and quality of the decoration suggest the activity of a workshop

203. Qasr Ibn Wardan, church, *c.* 564.
South flank

imported from the capital. So far no genuine domed basilica has been found in Constantinople prior to the sixth century. Nevertheless, it is plausible that it did exist and was carried from the capital into the farthest provinces.

The church of Qasr Ibn Wardan occupies the centre of a desert fortress in Eastern Syria together with a palace – this latter dated through an inscription of 564.[20] Rather short, the nave of the church is surmounted in the centre by a dome on squinches; aisles and galleries open on to the centre bay in triple arcades [203-6]. Short barrel-vaults, hardly more than broad arches, continue the domed bay east and west; wall arches carry it on either side. A semicircular apse – flanked by side chambers and embedded with them into the straight rear wall following Syrian custom – terminates the

building. To the west, aisles and galleries are carried along and form an inner narthex and narthex gallery, both opening into the nave through a triple arcade. All this is compact in design, compressed into an area only 13 by 17 m. (43 by 56 ft).

At Qasr Ibn Wardan, then, the plan of the 'domed basilica' has been reduced and condensed – one might term it a 'compact domed basilica'. The nave, comparatively long at Meriamlik, has become a mere fragment. Recalling the H. Sophia, the domed bay has been turned into the focus of the entire design. The short arches east and west take the place of half-domes; aisles and galleries open on to the centre bay; even their continuation into a western narthex and gallery recalls the H. Sophia. Indeed, the decorative and the structural voca-

204. Qasr Ibn Wardan, church,
c. 564. Interior of apse

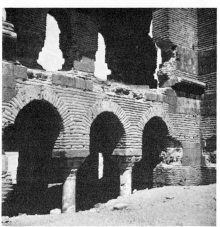

bulary of Qasr Ibn Wardan is permeated with elements imported from Constantinople. The slight pointing of the lateral arches supporting the dome is possibly native; certainly it becomes characteristic of later Syrian building. The undercut, thistle-like foliage of the capitals in the gallery stood blinding white against the deep shadows of the ground.[21] The design recalls the capitals of the H. Sophia and of H. Sergios and Bakchos, but the execution is that customary throughout Syria since Qal'at Si'man [205]. On the other hand, exactly as in the H. Sophia, the windows high up in the centre bay have been turned into fragments cropped across by the lateral arches below the dome. The masonry – rather than being composed of huge blocks of stone as are all other Syrian churches – consists of alternating broad bands of ashlar blocks and bricks, three and eleven per band respectively. The technique is typical of Constantinople from

205–7. Qasr Ibn Wardan, church,
c. 564. North gallery, as in c. 1900 (*top*),
ground-floor level (*above*),
and masonry (*right*)

the fifth century, as is the brickwork, with its very high mortar-beds and long, thin bricks laid in very regular courses [207]. The bricks themselves are of the type used in Justinian's buildings in the capital. Among the very rare bricks in all Syria, they were either made by Constan-

tinopolitan workers or, indeed, brought from Constantinople by sea and camel caravan. It looks as if a plan sent from the Imperial metropolis had been executed partly in imported materials by a crew which mingled local builders and workmen from Byzantium.

Though it recalls in certain details the H. Sophia, the plan of Qasr Ibn Wardan falls in with the standard buildings of Justinian's age. The spatial shapes, rather than expanding, are confined. They do not interpenetrate, but stand side by side. The walls, solid, are strongly stressed as elements of design; the steep proportions support this impression. It is a standard type which appears elsewhere as well: with slightly lengthened east and west arms, for example, in the church which was inserted into the (abandoned) church of St Mary at Ephesus of *c*. 400(?) [59].[22] Indeed, a 'domed basilica' just prior to Justinian is represented in

Constantinople by the recently excavated church of H. Polyeuktos. Another from the very first years of Justinian may have left its traces in the H. Irene in Constantinople.[23] Begun in 532 on the site of the first cathedral of the capital (it had burned down in the Nike Riot), the new church was repaired or rebuilt after another fire in 564, and again remodelled about 740 after an earthquake and all three building phases have survived in the present structure [208–10]. The first building has been reconstructed as a 'domed basilica' with galleries: a narthex, its details unknown; the nave subdivided into two bays – the first, to the west, short and barrel-vaulted, the second surmounted by a dome; a short barrel-vaulted forechoir, and an apse closed on the outside in three sides of a poly-

208. Constantinople, H. Irene,
begun 532. Exterior from the south-west

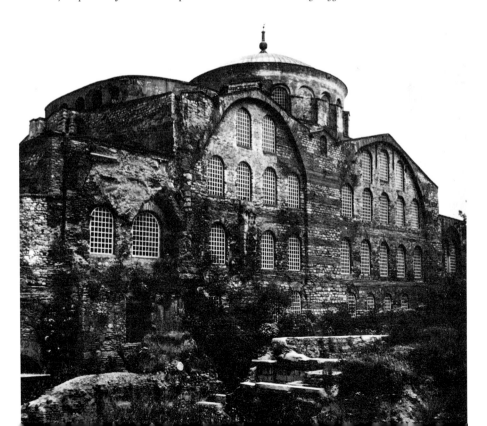

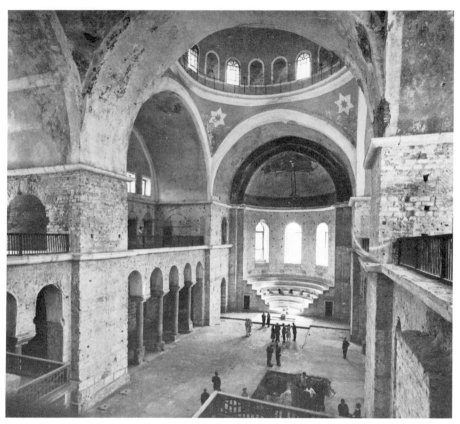

209. Constantinople, H. Irene,
begun 532. Interior facing east

gon. The nave was flanked by aisles and galleries, these latter perhaps surmounted in the domed bay by a 'fragmented window' in the clerestory wall and by the lateral arches supporting the dome. While this reconstruction of the first building of 532, particularly in its upper portions, rests on little evidence, the appearance of the second building, after 564, is clear. At that time the nave was extended west, a new western bay occupying the site of the former narthex; a new narthex and narthex gallery were added westward; and this in turn was preceded by a longish atrium enveloped by arcades on piers. In the eastern part of the church, the galleries along the domed bay opened in a mere trabeated colonnade rather than in arcades. It disappeared in a Turkish remodelling, which also included the rebuilding of the aisle arcades in that bay, but traces of the end piers of the gallery colonnade are clearly visible [209]. Concomitantly, the dome over the gallery bay, instead of being supported by lateral arches embedded in a clerestory wall, must have rested on transverse barrel-vaults extending to the outer walls and oversailing the gallery level.

After 564, then, the church of the H. Irene

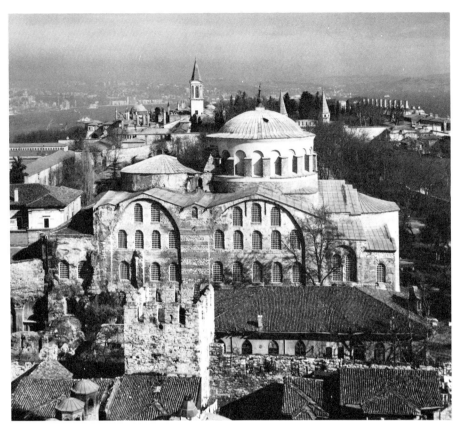

210. Constantinople, H. Irene,
begun 532. Exterior from the south-east

at Constantinople was not just a regular 'domed basilica'. The various standard elements – domed bay, barrel-vaulted nave and chancel, aisles and galleries – had been re-assembled into a new and independent combination. Nor did this second H. Irene of 564 remain isolated in its time. During the last third of the sixth century at Pirdop, not far from Sofia in Bulgaria, an ordinary timber-roofed basilica of fifth-century date, the Stag's Basilica, was thoroughly remodelled. Two strong piers were inserted into each of its colonnades to support the east and west arches of a dome over the east half of the nave. North and south of the dome, transverse barrel-vaults were extended to the outer walls, presumably oversailing the galleries placed over the aisles; the eastern end was rebuilt as a triple sanctuary and upper chambers were superimposed over the pastophories flanking the apse; obviously also, after the remodelling, the aisles and the western half of the nave must have been barrel-vaulted.[24] Everything recalls the H. Irene at Constantinople, as it was in 564.

The number and variety of such combinations in Justinian's architecture is ever surprising. I

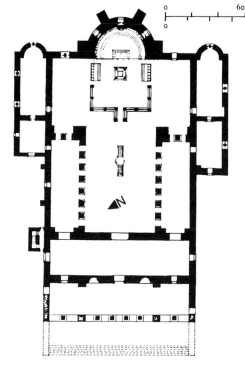

mention one more, known only from the detailed description of a contemporary, Choricius: the church of St Sergius at Gaza, built prior to 536. A short nave, barrel-vaulted and enveloped on three sides by aisles and an esonarthex, led to the domed bay; squinches resting on four pierced corner piers carried the dome; a forechoir and apse extended to the east, short barrel-vaulted arms to the north and south. Galleries were lacking. Thus the plan might have been that of a simple Greek cross, as at H. David in Salonica; with the difference that the domed centre bay and the cross arms were separated by colonnaded arcades forming sheer screens. Surmounted by the huge barrel-vault high up, they produced an effect, one would suppose, much like the trabeated gallery colonnade in the cross arms of the second H. Irene. But it is equally possible that the core of the structure was expanded into cross shape; enveloped by aisles and esonarthex on three sides, it would have anticipated the plan of a cross-domed church.[25] Nor must the decoration of St Sergius be forgotten: the dome and the upper walls of the centre bay carried mosaics which represented in eighteen scenes the life of Christ from the Annunciation to the Resurrection – the first such monumental cycle known, though not preserved.

In the 'domed basilicas' so far discussed the component elements are fairly simple: on the one hand, the basilica with galleries but without transept, on the other, the domed cross unit. The fusion becomes more intriguing where the domed cross is blended into a basilica with deep transept wings. The architect who shortly before 540 built Church B at Philippi in Macedonia based himself on the plan typical of local timber-roofed basilicas: atrium and esonarthex; nave and aisles surmounted by galleries; a transept enclosing a huge chancel; and finally, an apse [84, 211].[26] He superimposed on this plan a system composed of standard vaulting elements; barrel-vaults over the aisles and galleries, a

211-13. Philippi, Basilica B, shortly before 540. Plan (*above*), interior facing west (*opposite, above*), and base, capital, and impost block (*opposite, below*)

ribbed pendentive dome over the crossing, transverse barrel-vaults over the transept wings, a huge groin-vault over the single bay of the nave [212]. No doubt, the plan as transformed by the vaults is based on the standard idea of a dome over the centre bay – that is, the crossing – extended by the barrel-vaults over the transept wings. But to this plan the architect applied concepts of construction and design which seem to refer much more closely to the H. Sophia and H. Sergios and Bakchos than to ordinary standard buildings. As in Constantinople, the piers are built of heavy marble blocks; the filling walls are of solid brick masonry or of mortared rubble with brick bands, and, wherever possible, these walls were dissolved into rows of colonnaded arcades or into huge colonnaded windows. The

decoration, as well, was obviously intended to compete with that of the great churches of Justinian's early years. Marble sheathing covered the walls. The capitals, all overspun by deeply undercut, thorny acanthus leaves [213], were possibly done by the same workers who had carved those of the H. Sophia slightly earlier. Nowhere among surviving buildings has a standard plan been more thoroughly transposed into the language of Justinian's early churches – churches which are, after all, the very opposite of a standard architecture.

The plans of the church at Philippi and that of Justinian's Apostle Church at Constantinople have been blended, it seems, in two churches on the Greek islands, one fully preserved and recently restored, the other an imposing ruin. In the Katapoliani (Hekatontapyliani) on Paros (Our Lady of the Hundred Gates),[27] four barrel-vaulted arms radiate from a domed centre bay. However, nave and chancel are considerably

longer than the transept wings; and barrel-vaulted aisles, galleries, and esonarthex enfold the nave and cross arms on three sides. The cross plan of Holy Apostles has been fused with that of a basilica. A date for Paros not much after 550 is suggested: by the colonnaded arcades of the lower tier and their Ionic impost capitals; by the finely profiled archivolts, the short piers, the impost blocks, and the trabeation of the upper tier; and by the simple, forceful decoration of the parapets as well as by the marble revetment above the arcades, and the carefully bonded marble masonry. The ruin of H. Titos at Gortyna on Crete varies the plan further.[28] Only the nave is enveloped by aisles and galleries [214]. The cross arms, barrel-vaulted like the nave, each terminate in an apse. The chancel is a triconch which communicates with flanking pastophories, each enlarged by an anteroom and apse. The complex chancel plan, no less than the crude Ionic impost capitals, point to the very end of the sixth century.

At Philippi, on Paros, and at Gortyna, the large-scale domed cross unit has incorporated, as it were, the basilican plan. Conversely, towards the end of the sixth century at the outer edge of the Empire, in the cathedral of Sofia, the basilican element decidedly predominates over the barrel-vaulted cross and its dome. Indeed, the dome has been perfectly integrated into the plan of a basilica with nave, aisles, transept, and chancel bay [215, 216]. The triple-storeyed narthex was flanked by tall towers pushed sideways. Flat groin-vaults covered nave, transept wings, and chancel; barrel-vaults covered the aisles. Only the galleries (if indeed they existed) were perhaps timber-roofed. A dome, hidden inside a higher octagonal drum, rose over the crossing, which was segregated between nave, transept wings, and chancel. The nave piers were enlarged by double responds facing nave and aisles; transept and chancel walls were articulated by blind arches. Minor changes excepted, the original structure is perfectly preserved in its major elements; but its date remains in doubt. No documentary evidence exists and the surprisingly 'Romanesque' plan and details have led to datings as late as the eleventh century. However, the building technique – brick with broad mortar bands – points to the ambience of the architecture in the Balkan provinces of Justinian's last years, and if not to the sixth, then

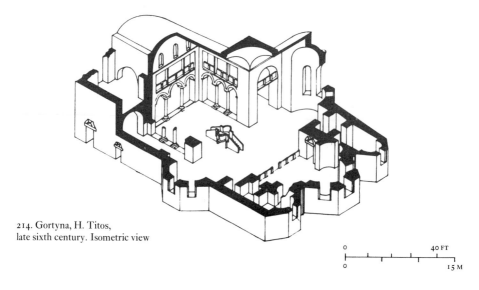

214. Gortyna, H. Titos,
late sixth century. Isometric view

0 40 FT

0 15 M

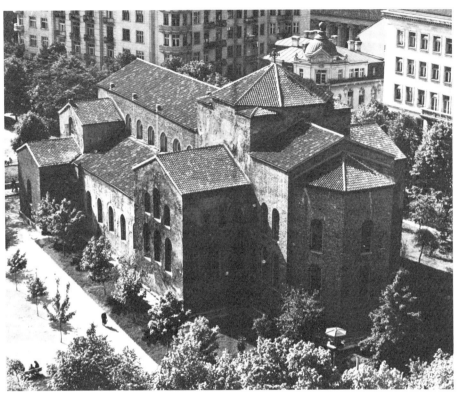

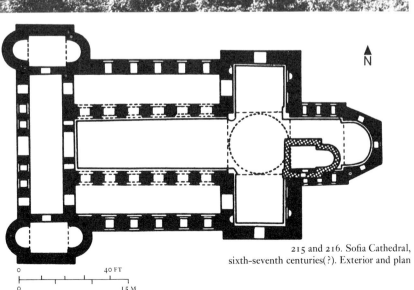

215 and 216. Sofia Cathedral,
sixth–seventh centuries(?). Exterior and plan

not after the early seventh century. The dedication to Holy Wisdom, H. Sophia, establishes a link with Constantinople. Finally, the gradual loss of the Balkans to pagan Slavs and Bulgars from the mid seventh century establishes a *terminus ante quem* for the cathedral of Sofia.[29]

Such fusions of the barrel-vaulted domed cross unit on a large scale with the plan of a transept basilica or of a cross church are far more attractive and intriguing than ordinary domed basilicas, such as the churches at Qasr Ibn Wardan or the H. Irene of 564. But within a history of Byzantine architecture they appear to be freaks, and it is the ordinary domed basilica which exerts a decisive impact on the future course of building in the Byzantine Empire and its satellite countries.

A wealth of church types created by combining standard elements in a variety of permutations is one of the principal characteristics of Justinian's age, taking the term broadly. So far it does not seem possible to state what, if anything, determines the choice of specific types for individual buildings. No geographical pattern emerges, nor can any chronological sequence be traced. Neither does the function of the building clearly determine the choice of the plan. On the other hand, both the variety and the spread of the standard types clarify the position of Anthemios's creation. The H. Sophia, to be sure, in spatial design, in the concept of wall, in the handling of light, and in every detail is fundamentally different from the mass of standard building. It might well be interpreted as a protest by its 'non-professional' architects against a tide rising under the hands of professional builders. If this be true, however, it is a protest which employs the very structural elements – though not the stylistic principles – which had been evolved by the standard builders. Exception that the H. Sophia is, its origins become intelligible and its design possible only against the background of the standard buildings. Conversely, the plan of the H. Sophia exerts its impact occasionally on the later phases of this standard architecture. Different as they are, the two currents of Justinian's architecture interlock.

THE ARCHITECTURE OF THE AGE OF JUSTINIAN

IN THE PROVINCES

The security of the Empire under Justinian and his successors entailed a vast building programme lasting until the turn of the century. Strong-points or small fortified towns were laid out or older ones modernized along the frontiers of old provinces in the East and reconquered provinces in the West, from the borders of Syria into North Africa, Dalmatia, the lower Danube valley, Liguria, and Spain. Interior fortifications were built to protect caravan routes against unruly mountain and desert tribes. Procopius presents an impressive picture of the building programme by listing hundreds of such frontier posts from the Balkans and the Caucasus to the Euphrates and the Lybian desert. Chains of strong-points formed a new kind of *limes* along the vulnerable borders.[1]

Dozens of these frontier posts have survived. Square or rectangular as a rule, they could be as small as 40 m. (130 ft) and as large as 300 m. (1,000 ft) square, such as the citadel of Tebessa; but as a rule, they were rarely larger than 60 by 80 m. (200 by 260 ft). Their exterior walls were from 1 to 3 m. (3 to 10 ft) thick and up to 8 m. (25 ft) high. The corners and the single main gate were protected by projecting towers, square or occasionally round. (Where nature afforded protection, a wall across the neck of a hill or a tower on top of a steep rock might suffice.)[2] Barracks leant against the inner wall. Somewhere within the enclosure there would be a church, often dedicated to the Virgin, the 'guardian of the safety of the cities and of the true faith'.[3] The defence of Throne and Altar coincided, and against the barbarians – both pagans and heretics – the church and its relics afforded as much protection as walls and gates. The remnants of Qasr Ibn Wardan in the

217. Qasr Ibn Wardan,
palace, *c*. 564. Exterior from the south

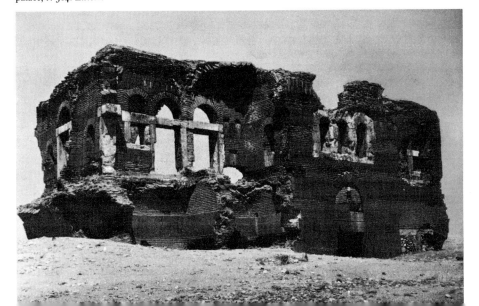

Syrian desert are not typical, but most impressive. On a hillock, enlarged by terraces, rose three buildings: a block of barracks, fortified and provided with store rooms; the church, discussed previously; and the governor's palace [217]. Its four wings formed a square, 50 by 50 m. (165 by 165 ft). The narrow north wing contained the entrance gate, the west wing perhaps the private apartments and offices. The south wing, higher than the rest, was apparently the State Apartment. Surviving to nearly its full height, its centre part shelters a triconch room on either floor; the one on the upper level was presumably the audience hall, where the governor sat enthroned as the Emperor's representative. The date 564, inscribed on the palace, no doubt applies to the entire complex.[4]

But such juxtaposition of a fortified barracks with an unprotected church and palace is anomalous. The norm is a fortified enclosure surrounding church, barracks, and other structures. On Mount Garizim (Gerizim), in the unruly territory of the Samaritans, Justinian surrounded Zeno's church of the Virgin with a wall and towers.[5] On Mt Sinai (Gebel Mûsa), he built a huge fortress – enclosing church, conventual buildings, and barracks – to protect Palestine against the desert nomads. It was apparently dedicated to the Virgin.[6] The fortified walls, extraordinary thick, are fully preserved, including the only entrance, a small postern gate facing west [218]. The conventual buildings as they stand today are of late date. But in their majority they occupy the site of the original structures lining the inside of the walls, both living quarters and common rooms for the monastic congregation and barracks for the protecting garrison. Fortress and monastery

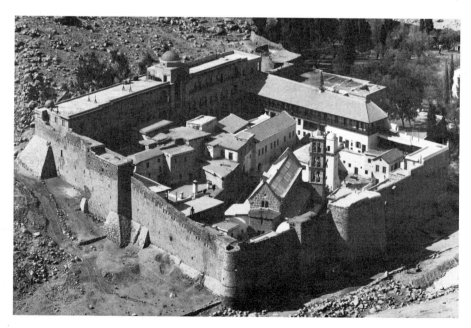

218 (*above*). Mount Sinai (Gebel Mûsa), monastery, founded *c*. 540. Air view

219 (*opposite*). Haïdra, fortress, sixth century. From the north

were joined in a symbiosis strange only to us. Similarly, places such as Avdot (Ab'de) in the Negev were simultaneously monasteries, fortified garrisons, watering places, and caravanserais, whether securing a lonely strategic point or placed protectively as citadels on the outskirts of a town. Both at Haïdra [219] and at Timgad in North Africa such citadels, most impressive, have survived: enclosed by a wall with projecting towers, they shelter barracks, stables, and a good-sized church.[7]

Such fortified posts and garrisoned sanctuaries of the fifth and the sixth centuries apparently provided the model for major monasteries even where no military protection was needed. At Daphni in Greece, an area 97 m. (320 ft) square was enclosed within a huge wall strengthened on the outside by projecting towers; against the inside of the wall were built conventual buildings, cells, and larger rooms – whether dormitories, a refectory, or stables. The church would have stood in the open area much as does the present eleventh-century church. At Tebessa in North Africa, as early as the early fifth century, the church was similarly enclosed by a fortified wall with projecting towers [156].[8] True, since the beginnings of monastic building, whether in Egypt or in northern or southern Syria, it had been customary to enclose the conventual area by a wall. But only from the sixth century was this enclosure fortified and the interior layout regularized and centred on the church. A number of decrees issued by Justinian enjoined strict rules on the monastic congregations regarding their common life and insisted on the building of common dormitories and refectories.[9] In some cases such decrees may have but codified exist-

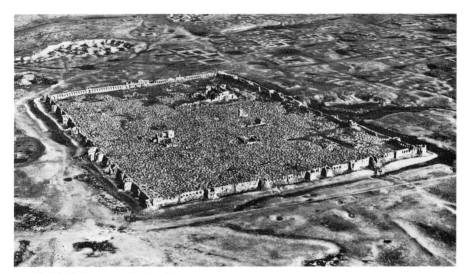

220. R'safah, sixth century. Air view of town

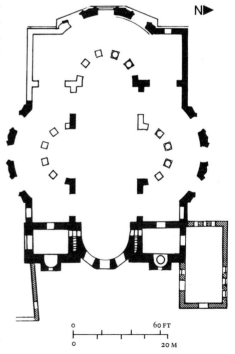

ing custom. But the monasteries built after these regulations laid down a plan which became standard throughout the Empire, and as late as the fifteenth century remained in force at Mistra and on Mount Athos.

At times fortified sanctuaries would be set up as pilgrimage centres on a lavish scale. At R'safah, outside the walls of a small second-century fort, two impressive churches had been built between 480 and 520. Basilica A probably housed relics of St Sergius and was linked to a large ecclesiastical establishment, monastery, or pilgrims' hostel.[10] Under Justinian's building programme, the entire area was enclosed by a huge fortified wall nearly 12 m. (40 ft) high, equipped with square, wedge-shaped, and round towers, and forming a trapezoid roughly 540 by 380 m. (590 by 415 yds) [220]. Two colonnaded streets crossed the interior, baths were erected, 'houses and stores and the other structures which are wont to be the adornments of a city'. A third church was laid out as an elongated tetraconch, built of huge stone blocks in the beautiful technique customary locally

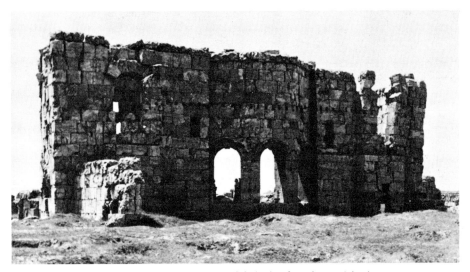

221-3. R'safah, tetraconch, before 553. Plan (*opposite, below*), view from the east (*above*), and interior facing east (*below*)

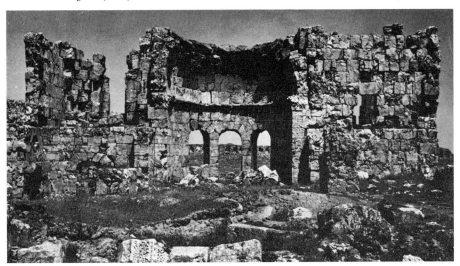

[221-3]. Windows and walls were marked by sparing classical profiles. Nave and ambulatory billowed outward in conchs on three sides, those of the nave opening towards the ambulatory through colonnaded arcades. All these parts were apparently timber-roofed. The fourth side, on the other hand, was occupied by a vaulted chancel, and this is still preserved to its full height. An apse, slightly raised above nave level, encloses a synthronon and a bishop's

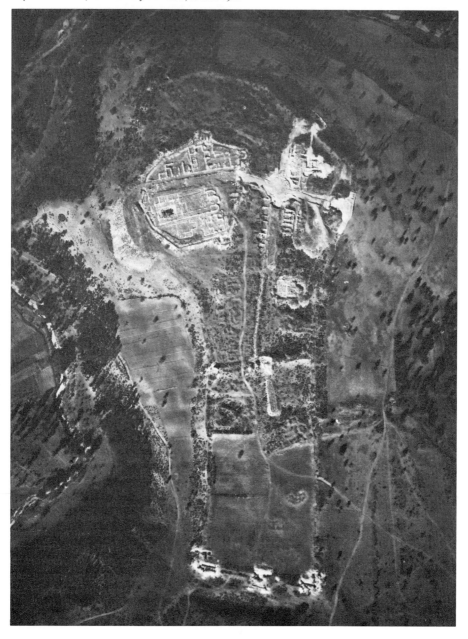

chair. It is flanked on either side by two-storeyed side chambers. The one to the north shelters, on the ground floor, a baptismal font. Both baptistery and cathedra make it likely that this tetraconch church was the cathedral, not a martyrium, as former opinion had it, and an inscription giving a bishop's name suggests a building date prior to 553. A fourth building, outside the city wall, has turned out to be not a church at all, but the audience hall of a local chieftain, the Ghassanid Al-Mundir, who in the third quarter of the sixth century defended the frontier in the Emperor's name [301]. Piers and arches divide the square interior into nine bays: a large centre bay, presumably supporting a timber pyramid; four rectangular bays on the main axes, barrel-vaulted in stone blocks; and four small corner squares, covered with pendentive domes. An apse opposite the entrance probably served as throne niche, and the flanking side chambers illustrate the inter-

play of church building and 'ruler's architecture' in the late sixth century. Of the four gates of the city, the one facing the pacified parts of the Empire to the north was decorated with engaged columns and blind arcades, all richly ornamented. At the same time, Caričin Grad (Justiniana Prima) was laid out as the small fortified capital of a frontier province in the Balkans. A small fortress on the mountain top shelters the cathedral, the baptistery, and apparently the bishop's palace [224]. Spread out on the slope below was the open town with a colonnaded main street, a circular piazza, more churches, and 'lodgings for magistrates, great stoas, fine market places, fountains, streets, baths, and shops' – an elegant layout far in the backwoods.[11]

Fortifications were laid out and built by the army, perhaps with local help. Army crews, as a rule, also built the structures inside the enclosure: barracks, conventual buildings, and

225. El-Anderin Cathedral,
sixth century. Apse facing north-east, as in *c*. 1900

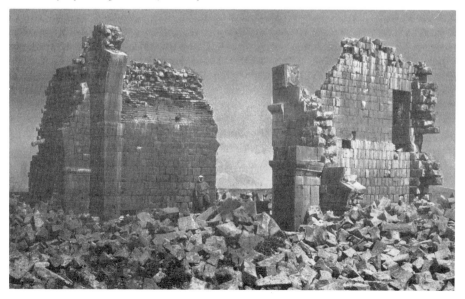

church. A rare exception is Qasr Ibn Wardan, where builders were apparently sent from Constantinople, bringing along perhaps the plans of church and palace. In general, however, both materials and workmen in such frontier posts were drawn from the army, and non-military buildings in the provincial backwaters remained bound to the local tradition. Churches along the Balkan and Carinthian *limes* took up the plan used locally since the early fifth century: an aisleless nave with apse and side chambers, two of the side chambers projecting sideways or parallel to the nave.[12] Similarly, in the Syrian desert, the standard church plan of the area was used unchanged by Justinian's military engineers: a colonnaded basilica, its apse flanked by side chambers. The 'cathedral' at El-Anderin diverged little, either in plan or design, from Qalb Lozeh, despite a time lag of eighty years [225]; the bricks used to face the apse vault recall those at Qasr Ibn Wardan.

Again, churches in the Negev followed the local tradition of enclosing the three apses in a solid mass of masonry, lightened by hidden chambers. This type is remarkably well preserved in three churches at Sbeïta (Shivta), two at Avdot (Ab'de), and two at Mamshit (Kurnub) [226].[13]

The strength of the local tradition was not limited to such outposts in frontier territory. Even in the metropolitan centres of the old provinces, throughout Justinian's reign and after, ecclesiastical and domestic building often developed along lines which had been laid down in the fifth century or earlier. City residences and country houses, in Antioch and its suburbs, laid out in the fifth and sixth centuries follow the old hellenistic and Roman tradition of the eastern provinces in plan and decoration, including the use of splendid mosaic floors. Likewise, in the Syrian uplands, sixth-century houses and villas are indistinguishable from their earlier predecessors.[14]

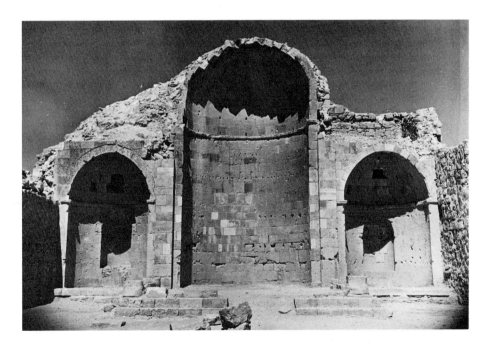

However, not all provincial building under Justinian remains purely local. True, neither the court architecture of the H. Sophia and H. Sergios and Bakchos, nor the plainer domed basilica standard in the sixth century spread much beyond Constantinople and the coastal cities of Asia Minor. S. Vitale, one recalls, transposed the type represented in Constantinople by H. Sergios and Bakchos into Western concepts and techniques. Similarly, a Constantinopolitan model may underlie the plan of the church which replaced Constantine's sanctuary at Bethlehem, apparently between 560 and 603–4 [227].[15] Plan and proportions of atrium, nave, and four aisles were taken over from the fourth-century church with only minor changes. The capitals, in fact, seem to have been so faithfully copied from their Constantinian predecessors as to be hardly distinguishable. Constantine's octagon over the grotto of the Nativity, however, was replaced

by a trefoil transept and chancel. Composed of the strongly marked centre bay, the three arms of transept and chancel, the three attached apses, and the fragmentary aisles in the corners, it provides an intricate spacious design of a type apparently alien in Palestine. Superficially, to be sure, the sixth-century transept at Bethlehem resembles the triconch endings of fifth-century churches in Egypt or the one at Cimitile-Nola; or else it recalls sixth-century churches in Epirus, where apses project from the ends of tripartite and continuous transepts.[16] A closer scrutiny reveals the essential differences. In Egypt, the triconch is but a trefoil apse attached to the forechoir; in Epirus the apses were small, low, and far apart – exerting little impact on the spatial design. On the other hand, at Bethlehem, transept, chancel, and apses are fused into a unified trefoil. It is as if a cross transept of the type of the Menas basilica had been merged with the three apses of a triconch. Possibly

226 (*opposite*). Sbeïta (Shivta), church, sixth century(?). Apses

227 (*below*). Bethlehem, Church of the Nativity, between 560 and 603–4. Plan

0 40 FT

0 15 M

following a similar design, the chancel part of the great church of the Virgin in the Blachernai in Constantinople was apparently remodelled into a trefoil transept under Justinus II (564–76).[17] Whether or not the trefoil transept at Bethlehem drew on the remodelled Blachernai church, it is certain that the design was executed by local workmen in a technique traditional to the highlands of the Near East. The heavy blocks of hewn stone, the hook-shaped joggled voussoirs, and the simplified classical cornices are unmistakable characteristics of this tradition.

However, building in the provinces under Justinian and his successors rarely shows the full impact of the contemporary architecture of the capital, either in plan, building technique, or decoration. The wholesale export at Qasr Ibn Wardan of a metropolitan masons' crew with their building techniques and possibly their material, remains a rare phenomenon. Only the precious marble decoration and furnishings were in many cases provided wholesale from the Imperial quarries in the Proconnessos. A sunken ship has been raised off the coast of Sicily, loaded with columns, bases, capitals, ambo, and chancel screens of Proconnesian marble, apparently the entire furnishings of a church to be delivered ready-made to some place in the North African, Sicilian, or Italian possessions of Justinian's Empire.[18] Similarly at Latrūn in Cyrenaica, two churches, both built after 550, were provided with column shafts and chancel screens of Proconnesian marble and with capitals of the same marble and of Constantinopolitan, if somewhat old-fashioned, design.[19] The materials issued to provincial clients were apparently not the most modern; perhaps they were even remainders. However, as a rule, metropolitan models – if they reached the provinces at all – were executed by local workmen in materials locally available and concomitantly altered in design. The numerous capitals from the ruins at Caričin Grad were obviously drawn from metropolitan

models, brought inland either from Constantinople or from Salonica, perhaps in the pattern book of a migrant journeyman.[20] As in the metropolitan prototypes, the blocks of Ionic impost block capitals are covered with foliage, while a protomai capital shows two rows of acanthus leaves, an abacus, and four rams' heads [228, 229]. But the relation of the elements has been completely and almost perversely changed: the Ionic volutes rise in a sharp angle and invade the impost block; the rams' heads have attached themselves to the abacus instead of to the capital proper; the execution is miser-

228 and 229. Caričin Grad Cathedral and Baptistery, sixth century. Ionic capital (*below*) and composite capital (*bottom*)

ably crude; and the models themselves are obviously types long obsolescent in the leading architectural centres by the second third of the sixth century, when Caričin Grad was built.

Similarly, provincial architects would frequently absorb building types long obsolete in the metropolitan centres of Justinian's Empire. Basilicas with galleries, for example, standard in the Aegean coastlands in the fifth century, went out of fashion in Constantinople and the near-by provinces by 530, but apparently continued in the Balkan provinces. In the ruin of the Old Metropolis at Nessebâr (Mesembria), similar, feigns a gallery. However, the aisles rise high, uninterrupted by a gallery floor, and the upper tier serves only to support the continuous roof of the nave and the high aisles. As it stands, though, it may well have been rebuilt in the tenth century on the old plan, though without the original galleries.[21] Certainly, the shortness of the nave and the lack of a clerestory suggest a Constantinopolitan model of fifth-century date, such as the Studios church. In the Latin West, basilicas with galleries, rare before, spread with the westward movement of Justinian's conquering armies. In North Africa,

230. Nessebâr (Mesembria), Old Metropolis, sixth and tenth centuries(?). Interior facing east

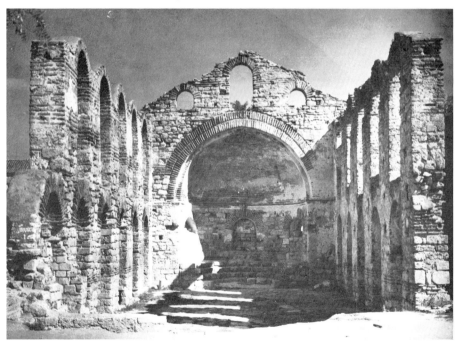

on the Black Sea coast of Bulgaria, clumsy stone and brick piers carry the five low arcades between nave and aisles [230]. An upper tier of arches and piers, built of brick but otherwise where the type had been well established by the end of the fourth century, as witness the great church at Tebessa, it is revived in the sixth century along new lines, small, compact, and

steep; the fortress church at Haïdra is one example [231], a church at Latrūn in Cyrenaica another. A radical innovation in that province, the plan of Latrūn may well have been sent from Constantinople together with the decoration, column shafts, and furnishings of Proconnesian marble. In some cases, galleries were possibly added in the sixth century to older churches, such as Orléansville and S. Salsa at Tipasa.[22] Contemporaneously, basilicas with galleries penetrated into Rome, as witness the east church (now the chancel part) of S. Lorenzo fuori le mura, erected between 579 and 590, and

S. Agnese, 625–38 [232, 233].[23] Both were designed to meet a special situation. In order to alleviate the crowding of the faithful around the tomb of the saint down in the dark catacomb corridors, the hill housing the catacomb was scooped out, and the basilica was sunk into the hill. The galleries were thus level with the crest of the hill, and could hold the overflow of the faithful or make it easy for the aged and lazy to attend Mass and offer prayers from the upper storey. The ground floor, enveloped on three sides by aisles, displayed the tomb in its centre and could be reached by the clergy and the

231. Haïdra, fortress church, apse, sixth century

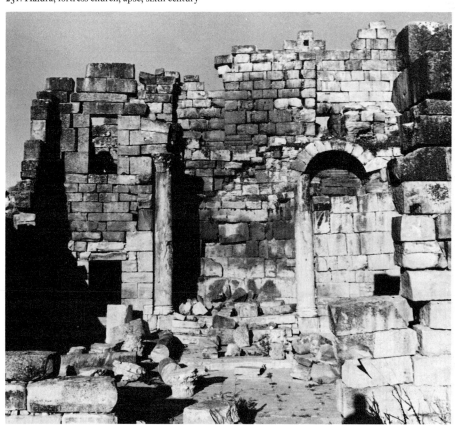

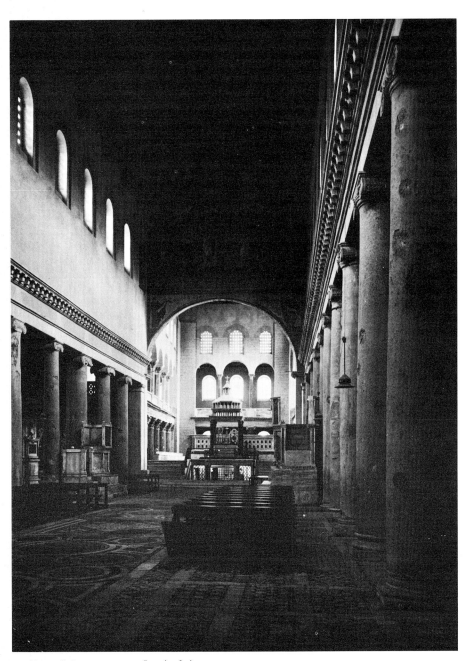

232. Rome, S. Lorenzo, 579–90. Interior facing east

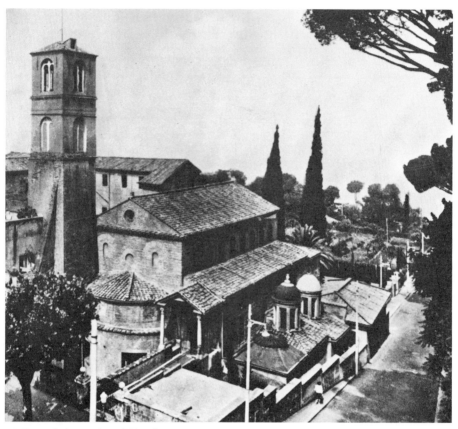

233. Rome, S. Agnese, 625–38. Exterior

faithful – at S. Lorenzo from the side, at S. Agnese by a descending flight of stairs built into the hill.

In all likelihood these galleried basilicas reached Rome not direct from Constantinople, but from the provinces where the type was still alive. Indeed, architectural stimulus frequently came to the border provinces, the vassal states, and the newly conquered Western provinces of the Empire from provinces in the East rather than from the capital. Theodoric's mausoleum, built at Ravenna before or around the time of his death in 526, shows the complexity of the situation.[24] Sombre and impressive, it is built of huge blocks of ashlar [234]. Inside, a cross-shaped vaulted chamber on the ground floor is surmounted by a circular room with a flat dome hewn from a single enormous block. Outside, the lower storey is articulated by ten deep arches resting on strong half-piers. A gallery of short transverse barrel-vaults seems to have enveloped the upper storey, carried by a ring of colonnettes and alternating semicircular and trapezoidal 'arches'. The massive dome, its edge set by twelve pierced spurs, rises above a low, windowless drum. The entire structure recalls

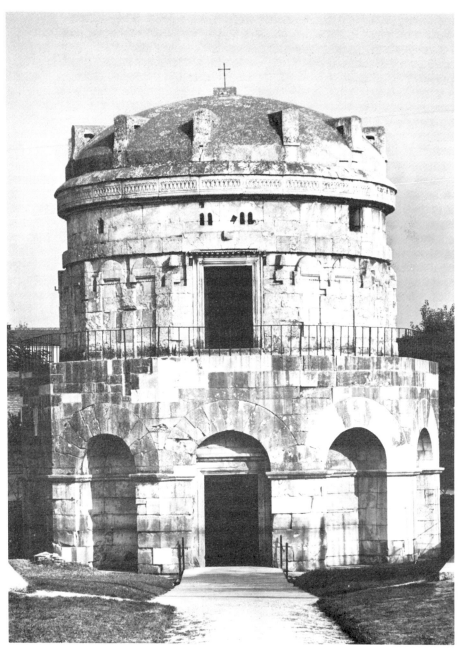

234. Ravenna, Mausoleum of Theodoric, *c.* 526

double-storeyed Imperial mausolea such as the fourth-century tomb of Romulus on the Via Appia. Theodoric, intent on being both chieftain of his Ostrogoths and ruler of Rome, may well have wanted to ally himself with these traditions. But in the Latin West, the tradition of stone building had died out with Diocletian's palace at Spalato. It had remained alive, however, in the Eastern interior, and the joggling of the voussoirs – so evident on Theodoric's tomb – while customary among Roman builders, had survived in the sixth century only in Syria. Hence an Eastern crew may well have been entrusted with the construction of the mausoleum because of their familiarity with building in stone. After all, links between Ravenna and Syrian builders had been manifest as early as the late fifth century at S. Apollinare Nuovo. Moreover, double-storeyed tombs, although surmounted by pyramids rather than circular upper storeys, were common in Syria and Asia Minor as late as the sixth century, with their lower storeys cross-shaped and vaulted much as in Theodoric's mausoleum.[25] The flat dome, on the other hand, with its pierced, projecting spurs (the holes may have served to lift the block in place), recalls, *ante litteram*, as it were, the Hagia Sophia. Only its manufacture from a single stone block may be a residue of the tradition of the stone-covered tomb mounds of Germanic chieftains.

Such fusion of elements widely different in origin is characteristic for provincial architecture in Justinian's Empire. Elements drawn in fragments from Constantinople or some other leading centre, and by that time often obsolete in their native habitat, merge with features purloined from some far-away province and with other elements rooted in a local tradition – and among these latter borrowings, a revival of Roman building types, both pagan and Christian, is not infrequent. In Central Lycia, inland from the south coast of Asia Minor, a basilica at Alakilise (Alaja Jaila), of sixth-century date,

was provided with a double-storeyed narthex, presumably galleries and an apse of Constantinopolitan type; but the spiky floral ornament recalls Syrian prototypes. At Karabel, not far away, ornament, similar, though perhaps later, covers the cornices of a triconch sanctuary, a plan locally widespread.[26] The interplay from many different sources becomes very clear in another province, southern Yugoslavia, where at Caričin Grad as many as eight church buildings have come to light (including a martyrium or baptistery), all of sixth-century date.[27] All differ in plan, but the majority seem to go back to prototypes of earlier date, drawn from Constantinople or Salonica and merged with local elements [224]. As in fifth-century Constantinople and Greece, all are preceded by atria, enclosed by porticoes, and sometimes entered through a propylaeum. The apses are of Constantinopolitan type, the exterior pushing out

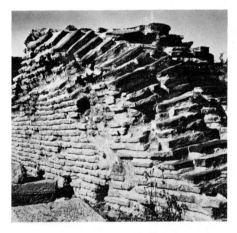

235 (*above*). Caričin Grad, croft church, sixth century. Masonry

236 (*opposite*). (A) Caričin Grad, cathedral and baptistery, sixth century. Plan (B) Caričin Grad, cross church, sixth century. Plan

in three sides of a polygon. All are executed in the brick technique customary in Salonica and in the southern Balkans in the late fifth and the sixth centuries [235]. In major churches, mosaic pavements cover the floor, as in Greece. But the wealth of building types in this provincial town is amazing. Along with models from Constantinople and Salonica, far-away buildings of early date exert their impact as well. Pastophories emerge sideways from the ends of the aisles in the south basilica at Caričin Grad, much as in Constantine's Lateran Basilica in Rome; the *basilica orientalis* at Salona might have transmitted the type to the builders of Caričin Grad. The cathedral of Caričin Grad, inside the fortress, seems at first glance a basilica with atrium, colonnaded aisles, and galleries – the type customary in Constantinople and northern Greece [236A]. The chancel, however, is deep and flanked by pastophories which terminate in absidioles. All this recalls the Thecla basilica at Meriamlik on the Cilician coast in the late fourth century and S. Apollinare in Classe outside Ravenna, a near contemporary of the cathedral at Caričin Grad. Another small church at Caričin Grad was vaulted and cross-shaped, and thus recalls Cappadocian church building [236B]. With far greater likelihood, however, it goes back to Roman mausolea of similar plan, as they were frequent all over the Roman Empire. So does presumably a fourth church building at Caričin Grad, a barrel-vaulted triconch cemetery chapel.[28] For other buildings at Caričin Grad, parallels elsewhere are hard to find. One is a twin chapel with two apses. In the north-east church, the supports are solid walls which carried the three barrel-vaults of nave and aisles; the 'croft' church, a columnar basilica, rests along its entire length on a vaulted crypt. Finally

A

B

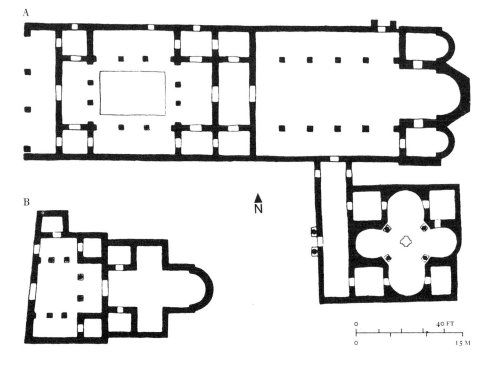

N

0 40 FT

0 15 M

at Konjuh, south of Caričin Grad, the plan of a
sixth-century martyrium has been traced. A
circular nave enveloped by an ambulatory is
terminated by a chancel and flanking pasto-
phories. A tripartite narthex precedes the build-
ing, and the entire plan recalls nothing so much
as the shrine of St Michael at Fal'ul in Syria.[29]
It is not quite certain by what means such plans
were transmitted. But within the narrower con-
fines of a single province plans were apparently
handed from workshop to workshop. Indeed,
it has been demonstrated that the triconch plan
of the cemetery chapel outside Caričin Grad
recurs with exactly the same measurements in
Byzantine feet – though of slightly varying
length – in two other funerary churches near by:
at Kuršumlija and at Klisura. Further, systems
of proportions were likewise transmitted, based
on the root of two and three, and their variants.[30]

However, fragmentary rather than wholesale
borrowing was the typical way for architec-
tural elements to reach the provinces from the
great architectural centres of Justinian's Em-
pire. In Rome, S. Giovanni a Porta Latina,
with forechoir, flanking side rooms, and three-
sided apse recalls the chancels of churches in
Constantinople and along the shores of Asia
Minor.[31] Provincial basilicas, from Asia Minor
to the Balkans and from Tripolitania and
Tunisia to Sicily, were frequently vaulted in
the sixth century, either wholly or in part. But
while vaulting in the deforested uplands of Asia
Minor, at Binbirkilise for instance, was a
necessity forced upon poor village masons, it
was elsewhere apparently a matter of preference.
A basilica at Belovo in Bulgaria carried barrel-
vaults over both nave and aisles; and the solid,
if squat, piers, the arches of arcades and win-
dows, and the brick-faced concrete construc-
tion testify to the highly developed building
techniques of Justinian's time. In a church at
Tolmeita (Ptolemaïs) in Cyrenaica, a similar
plan is executed in the local masonry technique
of ashlar, nave and aisles barrel-vaulted and a

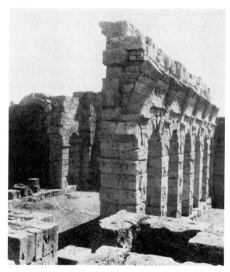

237. Tolmeita (Ptolemaïs), church,
sixth century. Diagonal view from the south-west

pendentive dome covering the side chamber
which flanks the apse on the left [237].[32] More
frequently in a group of churches in Tripoli-
tania and Tunisia, vaulting was limited to the
aisles, while the nave carried a timber roof.
The inner row of a succession of paired columns
supported the clerestory wall; the outer row,
together with a series of piers projecting from
the aisle walls, carried a barrel-vault or a series
of groin-vaults over the aisle. Such vaulting,
exceptional in the West, obviously depends on
the vaulted architecture of Justinian at Con-
stantinople. Certainly the poor village archi-
tecture of the Cappadocian and Lycaonian high-
lands was not the source for the architects of the
powerful basilica at Belovo and of the elegant
churches of Cyrenaica, Tripolitania, and Tu-
nisia. In the same corner of North Africa, apses
were occasionally covered by scalloped half-
domes, reminiscent of the dome of H. Sergios
and Bakchos at Constantinople. Apse walls in
Algeria and Tunisia are at times hollowed out
by a series of niches, as in the churches of the

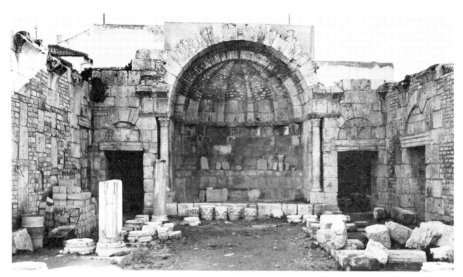

238. Le Kef,
Dar El Kous, facing apse, sixth century

Nile Valley. The church, known as Dar El Kous, at Le Kef carries all the characteristics of the group: paired columns, groin-vaulted aisles, scalloped apse vault [238]. Singly, the features occur time and again in Tunisia: a scalloped apse vault in the citadel church with galleries at Haïdra; groin-vaulted aisles either on piers as at Henchir Rhiria (near Beja), or, more frequently, on paired columns, for instance in the Dermesh (Douimès) Basilica at Carthage, and the Candidus church, in its last, sixth-century phase, at Haïdra. At times, domes were inserted into older basilicas, as possibly at Damous El Karita. Once, in Tripolitania, at Lepcis Magna, a fully vaulted cross church seems to have been laid out, the arms and crossing rising high over the aisles.[33] As a rule, though, such foreign elements are grafted on to buildings which are essentially of traditional local design. Such bastardized types spread from North Africa across the Mediterranean. In Syracuse and surrounding territory, a few small basilicas with barrel-vaulted aisles have sur-

vived much like their North African cousins, though less elegant.[34] Scalloped half-domes appear as far north as Grenoble in France.[35] The use of side chambers to frame the apse is another case in point. The arrangement had long been traditional in North African churches and there is no need to derive it from Syrian prototypes. Only with the Byzantine conquest do the doors open both towards aisles and apse – the arrangement followed in contemporary Syrian churches.

Vaulting and chancel plans, however, are but forlorn fragments of the high-class architecture of Justinian grafted on to provincial buildings. Of greater significance for Early Byzantine provincial church design is the fusion of a plain local plan and an often poor construction with a splendid decoration either directly imported from, or closely linked to, the mosaic and sculpture workshops of Constantinople. The church of the Virgin on Mount Sinai (Gebel Mûsa) presents an example. Remarkably preserved, its nave still carries the original beams, carved in

relief and bearing the dedicatory inscriptions of Justinian, Theodora, and the governor. The mosaic of the Transfiguration in the apse, untouched since Justinian's day, is the superb creation of a workshop brought either from Gaza or some other major centre. But the capitals are of poor local workmanship, the columns squat and crude. The plan remains bound to local tradition except for the towers, which project beyond the narthex on either side, and the placement of the martyrium – the Burning Bush – under the open sky behind the apse.[36]

Apparently the distinction between imported and local materials in the Sinai church followed the lines laid down in Constantine's letter on the Golgotha buildings.[37] In fact, the same contrast between local construction and imported decoration marks the churches built or completed in Ravenna and Istria after the Byzantine reconquest. There, a provincial Byzantine architecture of true grandeur comes into being with a building such as S. Apollinare in Classe, the harbour town of Ravenna, where the high quality of both local and foreign workmanship achieves a superb blend.[38] S. Apollinare was begun between 532 and 536 with the backing of the financier Julianus Argentarius while Ravenna was still under Gothic rule. In 549 the church was consecrated by Maximian, the first archbishop of Ravenna following the Byzantine reconquest. The insertion of a crypt in the ninth century and the concomitant raising of the apse level high above the nave floor

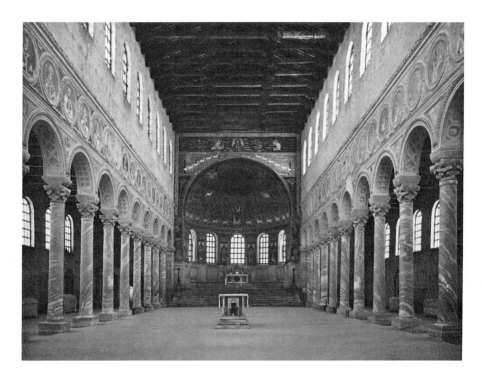

239 and 240. Classe, S. Apollinare, 532/6–49. Interior facing east (*above*) and exterior from the west (*opposite*)

have slightly altered the original plan [239]. The marble revetment of the walls in the aisles, except for small traces, and the sixth-century mosaic floor have been removed. Yet, unimpaired by these losses and by extensive repairs of the clerestory in the eighth century, S. Apollinare in Classe has preserved all the beauty of its original spatial design: the spacious proportions of nave and aisles; the luminous interior flooded with light from fifty-three wide windows in nave and aisles, not counting the five in the apse; the arcades of thirteen bays; the twenty-four column shafts, possibly of Hymettus marble, and certainly imported; the sparing, yet forceful decoration on the pedestals of the columns; the capitals with wind-blown leaves and their impost blocks; finally the

decoration in the apse – marble veneer in the bottom zone and mosaics between the windows, on the piers, and in the half-dome, in part seventh-century and later. The plan continues the building traditions of Ravenna, permeated as it had long been by elements of Aegean origin. In fact, as early as 430 S. Giovanni Evangelista had shown a number of the elements which characterize S. Apollinare in Classe: the narthex and its two low towers projecting sideways; the seven-sided outer polygon of the apse; the projecting side chambers; and the blind arches which frame the windows of nave and aisles on the exterior – ultimately a Milanese feature [240].[39] Only the absidioles of the side chambers at S. Apollinare in Classe recall an Eastern prototype, such as

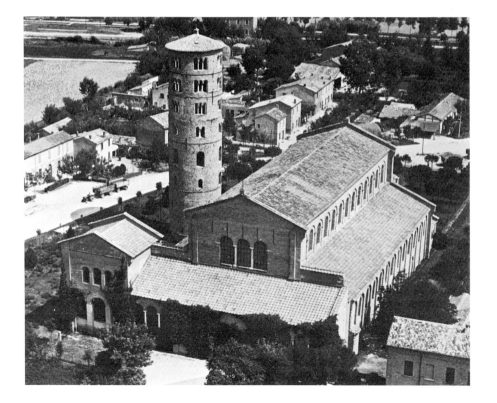

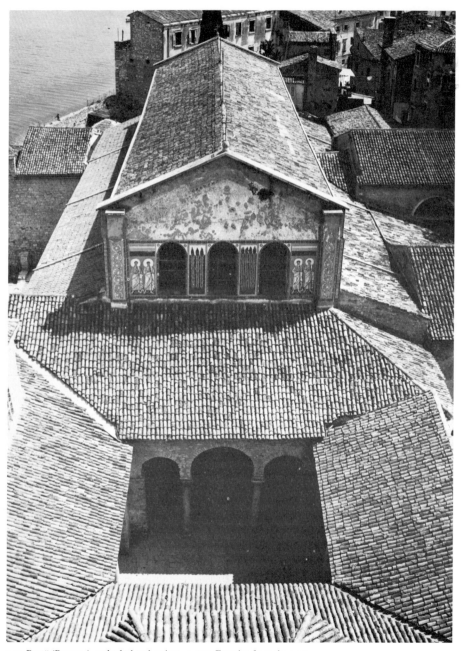

241. Poreč (Parenzo), cathedral and atrium, *c.* 550. Exterior from the west

the Thecla basilica at Meriamlik. On the other hand, the decoration of S. Apollinare, directly or indirectly, came from Constantinople: marble veneers, pedestals, and capitals were furnished by the Imperial workshops in the Proconnesos.

The picture of this architecture of Justinian's circle along the northern shore of the Adriatic is exemplified by a large number of churches. The cathedral of Poreč (Parenzo), built about 550 [241, 242], has preserved not only the complete layout of a major bishop's church, including a tiny atrium, a baptistery opposite the cathedral, a triconch martyr's chapel attached to the north aisle, and the lavish two-storeyed episcopal audience hall north of the atrium, the salutatorium; it has also preserved the Proconnesian marble shafts of the columns in the nave, the stucco decoration of the soffits in the north arcade, the columns of the altar canopy, the chancel plaques of Proconnesian marble, the mosaics between the windows and in the vault of the apse, and even an incrustation of marble and mother-of-pearl below the windows [243]. The capitals – composite, pyramidal or in two zones with protomai – were probably imported from Constantinople. But in the church itself, they were arbitrarily distributed, apparently by local workmen. The masonry of small stones is crude, and the proportions lack the easy flow of the church at Classe. At the same time, a profusion of precious materials is spattered all over the building, even on the outside, where the gables of the façade and above the apse is covered with a glittering mosaic.[40]

Negligence of construction combined with elegance of decoration can be seen to an even greater degree in the cathedral at Grado, built between 571 and 579 to replace a fifth-century structure. But as it rises in the tiny town, the largest of three sizeable churches, it remains an

242. Poreč (Parenzo), cathedral,
baptistery, and salutatorium, c. 550. Plan

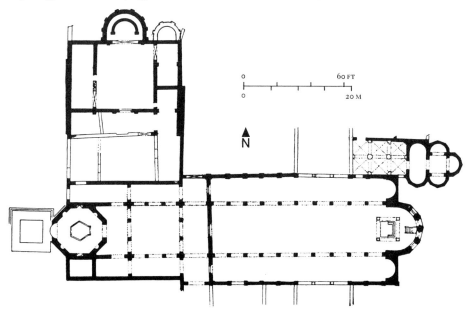

243. Poreč (Parenzo) Cathedral, *c.* 550. Interior of north aisle facing east

244. Grado Cathedral, 571-9. Interior facing east

impressive example of sixth-century 'Adrio-Byzantine' provincial building [244].[41]

These Adriatic cathedrals show the fragmentary use of Eastern architectural elements in Western churches of the sixth century far more clearly than S. Apollinare in Classe. At Poreč, the aisles terminated in absidioles as at Qal'at Si'man, about 480, and at Gerasa in 526/7 and 540. The triconch martyrium, adjoining the cathedral of Poreč, recalls that of Basilica B at R'safah (490-520). Of the cathedral of S. Maria Formosa at Pula (Pola), built by Archbishop Maximian, a cross-shaped martyrium has survived, one of two originally flanking the main building, but these martyria recall the pair of domed pastophories with niches of c. 500 which project at R'safah from the ends of the aisles in both Basilica A and B.[42] At S. Maria delle Grazie at Grado the exterior of the apse is enclosed within a straight wall, as was customary from the fifth century on the Aegean islands and along the south coast of Asia Minor. As early as 450, the double corbel-table frieze which terminates the Baptistery of the Orthodox may well denote Syrian prototypes: the paired small arches springing from, and framed by, pilaster strips are very similar to the tiny half-domes, paired and scalloped, which spring from attached columns and intermediate brackets along the apse of Qal'at Si'man. Similarly, the profiled band which, towards 490, at S. Apollinare Nuovo cuts across the buttresses and curves over the aisle windows, points to links between Ravenna and contemporary Syria.

During the second half of the fifth, during the sixth, and perhaps still in the seventh century, Ravenna and Istria were two of the gates through which Eastern elements penetrated into the early medieval architecture of Western Europe.

CHURCH BUILDING AFTER JUSTINIAN

INTRODUCTION

Justinian's Empire survived barely fifty years after his death.[1] Starting in 568, Italy, except for Ravenna, Rome, and the far south, fell to the Longobards. The Holy Land, Syria, northern Mesopotamia, and large parts of Asia Minor were overrun by the Persians in 614. Reconquered by Heraclius between 622 and 630, these same lands, except for Asia Minor, were lost for good to Islam in 636–8. By 700, the Muslims also held the entire North African coast, including Egypt, which had fallen in 646. In 678, Constantinople itself was besieged by an Arab fleet and saved only by a naval victory won by Constantine IV. The Slavs made inroads in the Balkans and as early as 577–82 ravaged places as far south as Corinth. In 680 the Bulgarians crossed the Danube and established a powerful kingdom throughout the northern Balkans. The far-flung Byzantine Empire, by the second half of the seventh century, had thus been reduced to its Greek-speaking core, focused on Constantinople and the Aegean Sea, and including Asia Minor, the Southern Balkans, Greece, the city of Rome, and a few naval stations along the Adriatic coasts. By 750, even large parts of Greece, though not her coastal settlements, were occupied by Slavic tribes, to be reconquered only in the ninth century. In the East, the vassal states of Armenia formed a temporary buffer against the Islamic onslaught. But naval incursions continued: Cyprus was forced into a state of uneasy neutrality; Crete was lost; Rhodes and the coastal cities of Asia Minor remained threatened throughout the ninth century. For two hundred and fifty years, then, Byzantium was forced on to a precarious defensive. Nor was the domestic situation much better. The financial strain was heavy, and economic problems proved even more difficult to solve than questions of defence. Most of the lands were in the hands of the government, of large monasteries, and of a few aristocratic families. Theological controversies presented still another area of dissension. They grew steadily sharper, and with the third decade of the eighth century culminated in the Iconoclastic Movement. Except for an interlude between 786 and 813, the dispute embroiled clergy, monks, and laymen in a controversy that rent the Empire asunder for more than a hundred and thirty years.[2]

However, despite military, political, and religious strains, church building continued undiminished, though it changed in character under the impact of Iconoclasm. The disappearance of figurative representations from walls and vaults and their replacement by simple crosses is the least of such changes. More relevant in our context are the modifica-

tions in church plans. The growing emphasis on the Great Mystery - the Mass in which the invisible and undepictable God reveals Himself through the action of the priesthood - assigned an increasingly predominant role to the clergy and to their movements about the altar. The space given over to the officiating priests grew larger and became the very focus of the church. Thus, a tendency shown by church planners as early as the days of Justinian continues through the seventh, eighth, and into the ninth century: the domed centre bay, where the Great Mystery of the Mass was performed, becomes the *raison d'être* of the entire building. All attention is drawn to this, the nucleus and the essential element of the structure. Hence it is entirely consistent that the domed bay with short barrel-vaulted cross arms - the standard element of sixth-century church building - should be at the root of church planning after Justinian's time. From this root springs the characteristic church plan of the eighth and ninth centuries - the cross-domed church.

THE CROSS-DOMED CHURCH

Any attempt at clarifying Byzantine church building between 600 and 850 invariably brings to mind the architectural types and concepts of the age of Justinian. At present, however, it is next to impossible to trace a development either from one church type to another, or between types within a single group. Not more than a dozen churches in all have either survived inside the Empire from the 250 years after Justinian or are known satisfactorily from older publications. None are dated through documents or inscriptions, and only two can be given a *terminus ante quem* through such evidence. Worse luck, they are scattered all over the area of the Empire. Thus, the masonry technique, an excellent guide for dating in *one* locale, must be used with a good deal of discrimination. At

the same time, the wide spread of the various types from Macedonia to the southern coast of Asia Minor and to the Euphrates presents another problem – that of determining the priority of the capital or the provinces in originating the cross-domed plan. Rather than attempting rash answers to such questions, it seems preferable for the time being simply to present the material.

Among churches of the centuries after Justinian the ruin of Dere Ağzı, tucked away in the south-west corner of Asia Minor, comes close to Justinian's own architecture.[1] But while Dere Ağzı apparently dates from the mid ninth century, it is no mere provincial throwback [245–8]. Indeed, its plan recalls one of the great churches of Constantinople built in Justinian's last years:

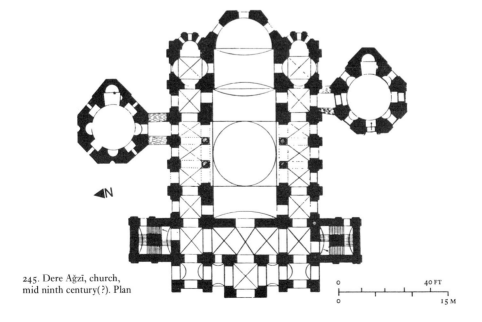

245. Dere Ağzı, church, mid ninth century(?). Plan

0 40 FT

0 15 M

246-8. Dere Ağzı, church, mid ninth century(?).
West end from the south-west (*below*), chancel, north side (*right*), and pendentive (*far right*)

the H. Irene, as remodelled in 564. As at the H. Irene, the aisles are surmounted by galleries, both groin-vaulted; the nave of Dere Ağzı is divided into three, rather than two bays, the first short and barrel-vaulted, the second square and originally surmounted by a pumpkin dome, the third repeating the first. From the domed bay, too, barrel-vaults extend sideways and over-sail the gallery, its centre section protected by a trabeated colonnade. This core is preceded by an esonarthex, again as at the H. Irene, and extended eastward by a chancel. Side chambers flank the chancel on both the ground and gallery level. In contrast to the H. Irene, thus, the chancel appears remarkably long – composed as it seems of two bays preceding the apse and slightly diminishing in width. The esonarthex communicates with the nave not through ar-cades, as in the Constantinopolitan church, but only through a door. Thus at Dere Ağzı the domed centre bay truly forms the focus of the entire plan. In this respect the church recalls, rather than the H. Irene, 'compact domed basilicas' such as Qasr Ibn Wardan. Yet it shares, both with these churches and with Justinian's architecture in general, a feeling for elegant proportions and light, airy design. And this lightness and elegance comes to the fore even more strongly in the two octagonal buildings, possibly martyrs' chapels, which project from either flank. Throughout, the parallels for the plan of Dere Ağzı are found in late-sixth-century architecture and all point to Constantinople as an ultimate source. But none seem to date that early: a church near Vize closely related in plan to Dere Ağzı, though far distant, in Turkish

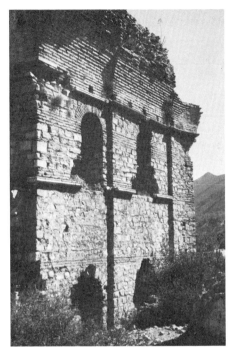

Thrace, has been tentatively dated prior to 902-3.[2] Indeed, also at Dere Ağzı, details such as the pumpkin domes point to a date as late as the ninth century. Hence, a possibly early plan seems to have survived for centuries.

The continued vitality of sixth-century architectural concepts becomes manifest in the modifications imposed by builders of the centuries after Justinian on standard plans of Justinian's own age. The H. Irene itself displays such a variant. In about 740, when the structure was remodelled for the second time, the first bay of the nave, untouched in the rebuilding of 564, was replaced by a domed bay [208-10]. A low drum was built to hide this dome; the dome over the second bay was rebuilt and raised at the same time. The barrel-vault and the true galleries marking the original plan in this bay

were remodelled so as to become nearly identical with the second bay of the nave as designed in 564: barrel-vaulted arms expanded sideways to the outer walls, oversailing a low trabeated column screen at gallery level. The masonry of the new parts utilizes bands of five ashlar courses alternating with an equal number of brick courses, with mortar-beds ranging from 6 to nearly 8 cm. ($2\frac{1}{3}$–3 ins.) in height – a technique of construction possibly characteristic of the eighth and ninth centuries.

The variation of a late-sixth-century design simply by duplication, as achieved in the H. Irene, is not very attractive. It is far less relevant within the overall picture of church building from the seventh to the end of the ninth century than other solutions. Three churches in Asia Minor present variants on Justinian's

standard type exemplified by Qasr Ibn Wardan. They are St Clement at Ankara, wantonly destroyed in 1921, but known from surveys, photographs, and descriptions [249]; St Nicholas at Myra (Demre) on the south coast, badly restored in 1862, but well preserved in its main lines [250, 251]; and perhaps – though this is open to doubt – in atrophied form in the Church of the Archangels at Sige, on the south shore of the Sea of Marmara.[3] All show essentially the same plan. A square domed bay

249. Ankara, St Clement,
ninth century(?). Plan at gallery level

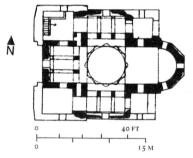

forms the centre of the design; south and north the dome rests on narrow lateral arches, hardly deeper than wall arches, while east and west it is carried by deep barrel-vaults. The east bay, the chancel, is terminated by an apse, polygonal on the exterior. The west bay, equally deep, communicates through a door with an esonarthex. Two tiers of triple arcades, communicating sideways with the centre bay, lead into aisles and galleries. Square rooms on two levels fill the corners of the square and open into the chancel and west bay, through simple apertures. Clearly, both churches are variants on the type of the compact domed basilica as reflected at Qasr Ibn Wardan. However, they modify the prototype in different ways. True, both enlarge the core element – the domed bay – ever so slightly sideways by replacing the wall arches in the pendentive zone by shallow true arches.

However, both at Ankara and Myra, the west arm was filled by a third unit of aisle and gallery, both provided with triple arcades like those to the north and south. Thus to the west the centre dome rested on an arch nearly as shallow as those supporting it north and south. Aisles and galleries became merely ancillary spaces enfolding the dome core on three sides. Differences in size, building technique, and design between Myra and Ankara are nevertheless manifest. At Ankara the structure was small and all details were elegant: the arcades rested on slender rectangular marble piers, the pumpkin dome was subtly designed, the entire structure light and airy. The masonry of the inner domed core was brick, finely pointed, the mortar-beds sloping down and outward; the outer walls were built of alternating bands of brick and ashlar. Piers and capitals were covered with geometric and foliage ornament of metallic sharpness and delicacy; and all this elegance was concentrated in quite a small area, 14 by 20 m. (46 by 66 ft). St Nicholas at Myra is not only larger, 18 by 25 m. (59 by 82 ft), but much heavier, not to say crude. The arcades rest on clumsy brick piers. But the building preserved, still early in this century, some of the original furnishings *in situ* [250]: in the apse, the synthronon for the clergy and the bishop's cathedra; in the chancel, a trabeated canopy on four columns above the altar site; at the entrance to the chancel, the high columns of a *templon*, a trabeated colonnade; finally, in the centre of the nave directly below the dome, an ambo.

Documentary evidence regarding the date of St Nicholas at Myra is meagre. A vague tradition reports a foundation in the sixth century and a rebuilding in 1042. No evidence of this kind exists for St Clement at Ankara. The masonry technique, however, suggests a building date near the middle of the ninth century. Bands of brick and rough stone blocks alternate on the exterior, each composed of four courses; inside piers and arcades, built of thin bricks,

rise from bottom courses of rough blocks. As
at St Clement and in the walls of the citadel at
Ankara, dating from 859, the mortar-beds are
high and slope down and out [252]. The com-
parable method of construction at Dere Ağzı

252. Ankara, city walls, 859

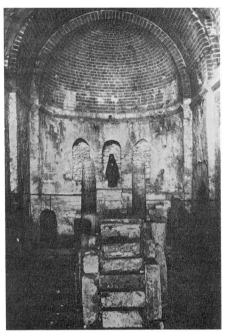

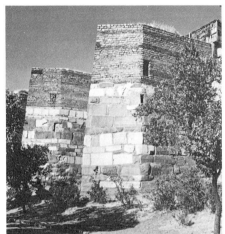

250 and 251. Myra (Demre), St Nicholas, ninth century(?).
Ambo and apse, as in 1906 (*above*), and plan (*below*)

suggests a similar ninth-century date, despite
the occasional substitution of mortared rubble
masonry for ashlar bands. After all, the stylistic
features of Dere Ağzı find their counterparts at
St Clement as well: the elegant, steep pro-
portions, the subtly gored pumpkin domes, the
niched side chambers of the chancel which
form true quatrefoils at Dere Ağzı. The church
at Sige may date from 780, or possibly a century
earlier or later.

Whatever their dates, both St Nicholas at
Myra and St Clement at Ankara preserve or
revive after two or three centuries the sixth-
century plan of the compact domed basilica,
and modify it by deepening ever so slightly the
lateral arches of the domed centre bay. The true
cross-domed church is fundamentally different.

253 and 254. Nicaea (Iznik), Koimesis,
early eighth century(?), rebuilt after 1065.
Section and plan (*right*)
and exterior as in 1906 (*below*)

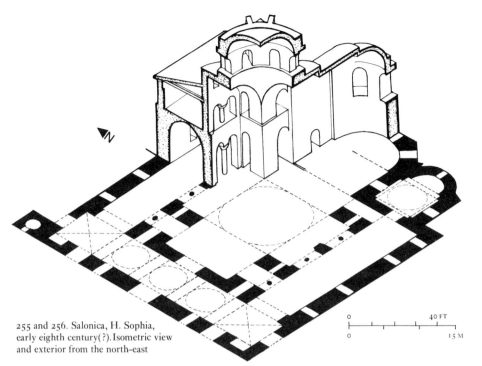

255 and 256. Salonica, H. Sophia,
early eighth century(?). Isometric view
and exterior from the north-east

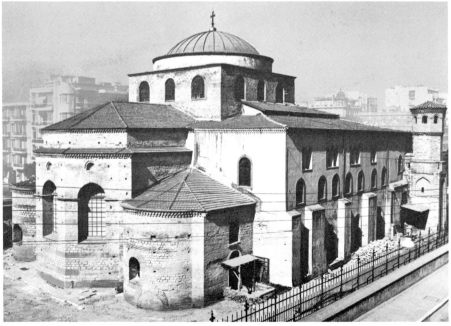

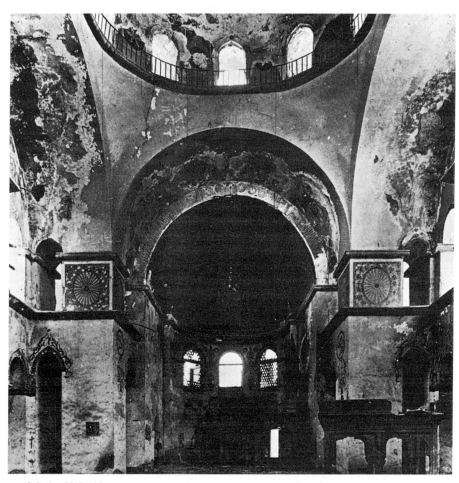

257. Salonica, H. Sophia,
early eighth century(?). Interior facing east, as in 1906

Four strong piers mark the corners of the centre square. Solid or pierced on two levels and sheltering small groin-vaulted bays, the piers carry the barrel-vaults of four cross arms, each clearly marked off and of equal or nearly equal depth. A dome on pendentives rises from the apices of the barrel-vaults and is enclosed in a low drum pierced by only a few windows. The east arm, at times continued by a second short bay, serves as a chancel. Terminated by an apse, it is flanked by side chambers with absidioles. Like the main apse, they form on the outside three sides of a polygon. This cross-shaped, domed nucleus is enveloped north and south by barrel-vaulted aisles and galleries; to the west it leads into an esonarthex, likewise surmounted by a gallery. These ancillary spaces then form a square outer shell, comparable to the outer

shell of Justinian's H. Sophia, though very much simpler, or of Qasr Ibn Wardan. The north and south aisles and the three galleries open in arcades into the adjoining arms of the cross core. Only the esonarthex opposite the chancel is at times closed off by a wall, pierced by but a single door. Aisles and esonarthex on the ground floor as well as the galleries on the upper level inter-communicate, constituting, as it were, a two-storeyed ambulatory. Indeed, the term ambulatory church is occasionally used synonymously with the term cross-domed church. All told, it is a compact and simple plan.

Only a handful of genuine cross-domed churches have survived or are well known from earlier surveys. There is the church of the Koimesis at Nicaea (Iznik) [253, 254]; there is the H. Sophia at Salonica [255-7]; and finally, there remain in Constantinople two cross-domed churches: the Kalenderhane and the Gül Camii, the first perhaps the church of St Mary Kyriotissa [258, 259], the second perhaps St Theodosia.[4] Only the structure in Salonica still stands fully preserved, although thoroughly restored; I use a photograph of the interior taken seventy-odd years ago. The Koimesis church was destroyed in 1920 in an act of vandalism. Only the bottom parts of walls and piers survive, but previous surveys and earlier and later studies have clarified the aspect of the original structure and the extent of subsequent changes; the removal of the galleries above the aisles and the

258. Constantinople, Kalenderhane Camii
(Church of St Mary Kyriotissa?), twelfth century.
Exterior from the south-west, as in 1972

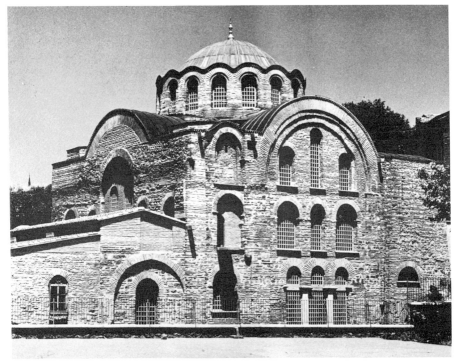

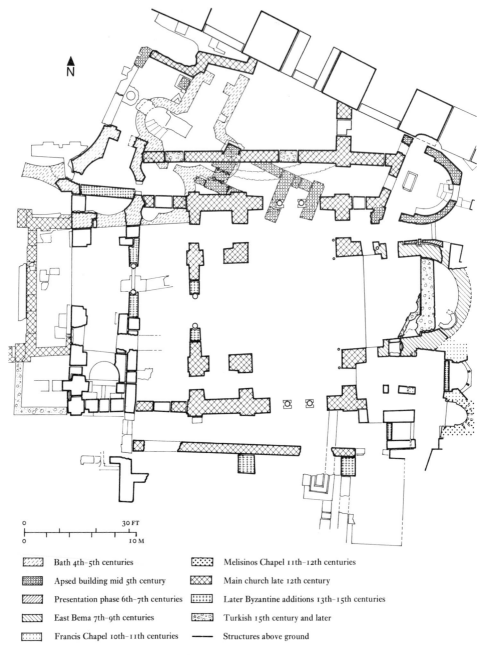

N

0			30 FT	
0			10 M	

	Bath 4th–5th centuries		Melisinos Chapel 11th–12th centuries
	Apsed building mid 5th century		Main church late 12th century
	Presentation phase 6th–7th centuries		Later Byzantine additions 13th–15th centuries
	East Bema 7th–9th centuries		Turkish 15th century and later
	Francis Chapel 10th–11th centuries	——	Structures above ground

259. Constantinople, Kalenderhane Camii
(Church of St Mary Kyriotissa?), twelfth century,
incorporating earlier structures. Plan

addition of an outer narthex some time after 1065. Of the Gül Camii the substructures of the original building have been traced; they suggest that the building retains at least the original plan. Of the Kalenderhane Camii the entire core remains, incorporating both large sections of earlier structures and later Byzantine and Turkish alterations. Differences within this group of buildings are minor. The cross core is fundamentally the same. Only in the Gül Camii are the lateral arms somewhat shallower than those on the longitudinal axis. The side chambers flanking the chancel bay at Salonica and in the Kalenderhane are concealed behind the corner piers. At Nicaea and in the Gül Camii they line up with the north and south aisles and communicate with the chancel bay through longish tunnels east of the corner piers. The corner piers, solid at Nicaea and in the Gül Camii, in the Kalenderhane enclose tiny groin-vaulted bays on the ground level. At Salonica, only the west piers enclose such bays; the east piers are solid, except for a tunnel leading from the aisles to the chancel bay. Finally, at Salonica, aisles and galleries open into the cross arms of the core through two twin arcades, while at Nicaea and perhaps in the Gül Camii, aisles and galleries rested on triple arcades; at the Kalenderhane, the existence of aisles and triple arcades has been ascertained, but galleries, while likely, remain to be proven. However, all these differences seem to be variations on a common theme rather than clues towards tracing a development.

No definite date of construction exists for any of these cross-domed churches. For two, however, a *terminus ante quem* has been established. The mosaic in the apse of the H. Sophia in Salonica, situated below a huge cross, bears an inscription of the donor: Constantine VI, 780–97. The structure, of course, could be considerably older. Indeed, while the bands of brick and ashlar alternate in courses of five, as

in the mid-eighth-century parts of the H. Irene, the bricks at Salonica are much thinner and the mortar-beds much higher – suggesting a date of construction perhaps as early as the first quarter of the eighth century.[5] Certainly the Koimesis church was of no later date than the first quarter of the eighth century and possibly earlier. The mosaics in apse and chancel, dated 843, bear traces of two earlier stages. In one of these, a huge cross previously occupied the place given over to the Virgin in 843. This cross decoration had itself been substituted for a still earlier figurative decoration – the footstool of a representation of the Virgin is still visible – which obviously antedated the Iconoclast Movement. The church, then, must have been built prior to 726.[6] How much earlier is hard to tell, but the very thin bricks and high mortar-beds suggest a date perhaps in the late seventh century. On the other hand, the recessed brickwork both in the substructure and the rising walls of the Gül Camii dates the building between the early eleventh and the late twelfth centuries when that particular technique was customary in Constantinople. (The use of amphorae vaulting in the substructure is a remarkable survival of a much older, Western technique.) Convincingly, too, the core of the Kalenderhane Camii has been assigned a twelfth-century date.[7]

The type of the cross-domed church, then, lives on long beyond the first millennium. In Constantinople, the Atik Mustafa Camii, originally perhaps the church of St Peter and St Mark, modifies the canonical plan.[8] Corner piers and enclosed tiny bays are replaced by spacious barrel-vaulted corner rooms, much like those known from fifth-century buildings such as H. David in Salonica. As late as the eleventh century Russian visitors were so deeply impressed by the cross-domed plan of Constantinopolitan churches as to make it canonical all over Russia, from the Desyatinna (1039)

and the H. Sophia (1037–46) in Kiev to the Preobrašenskij in Černigov (1036); and as far north as Novgorod.[9]

General opinion nowadays derives the plan of the cross-domed church more or less directly from the compact domed basilica of Justinian's late years. However, the longitudinal element inherent in such structures differs fundamentally from the perfectly centralized plan of a cross-domed church. To bridge the gap, churches such as St Clement at Ankara and St Nicholas at Myra have been interpreted as connecting links – compact domed basilicas which utilize slightly broadened lateral arches to carry the centre dome. However, this hypothesis meets with a chronological discrepancy: the cross-domed plan of the Koimesis church at Nicaea dates from before 726 and perhaps from as early as the seventh century, a hundred or a hundred and fifty years before the appearance of the type at St Clement. In fact, the plan of St Clement could well be viewed not as a forerunner, but as a derivative of the cross-domed plan, a 'shrunken cross-domed church' as it were. But neither of such one-track interpretations of history seems plausible. More likely, the plans of Qasr Ibn Wardan, of St Sergius at Gaza, of the Katapoliani (Hekatontapyliani) on Paros, of H. Titos at Gortyna, of St Clement at Ankara, and of Dere Ağzı, are all independent variants of standard types – standard types which had dominated the architecture of Justinian's circle and persisted into the eighth century and far beyond.

The cross-domed plan, it seems to me, belongs to the same lineage. True, the Koimesis church is the first dated example of the type known to us at present. But the plan may have been created much earlier, possibly as early as the sixth century. It could well have existed alongside such variants as the compact domed basilica, with or without encroaching transverse cross arms, or the domed cross church. In fact, the domed cross plan is known from two

churches of early date in far-distant provinces of the Empire. One, now gone, stood at Mayafarquin (Meyyafarikin, Silvan) in northern Mesopotamia, and was presumably built by the Persian king Chosroës II after 591; the date has been questioned, but it seems to be confirmed by the rich late-sixth-century Syrian-looking capitals and carved brackets.[10] The other early survival, incorporated into the ruins of the Cumanin Camii at Antalya (Adalia) on the south coast of Asia Minor, can be assigned a similar date on the evidence of its capitals; the solid stone masonry, too, is comparable [260].[11] To be sure, neither of the two churches was vaulted. The centre room in both carried a pyramidal roof and the other bays were surmounted by sloping timber roofs. But the basic plan is exactly that of the cross-domed churches at Nicaea or Salonica: a centre cross with deep arms, esonarthex, and chancel; enveloping aisles and galleries opening in triple arcades towards the arms of the core; and at Mayafarquin, though not at Antalya, corner piers pierced on both levels.

Two explanations offer themselves regarding the relation of these unvaulted cross-domed churches of late-sixth-century date to the fully vaulted domed structures of the late seventh and eighth centuries, such as Nicaea and Salonica. One explanation is that they are forerunners, created in the provinces in the sixth century and transferred to the capital in the course of the seventh century. There, in Constantinople, the plan would have been vaulted and thus assimilated to Justinian's standard types. In its vaulted form it would then have spread to near-by Nicaea and Salonica. The theory is not implausible. After all, plan and elevation of Antalya and Mayafarquin differ only superficially from the quatrefoil martyria of sixth-century Syria and her borderlands. Like Mayafarquin and Antalya, the Syrian martyria were timber-roofed and focused on a centre bay. This centre bay was axially en-

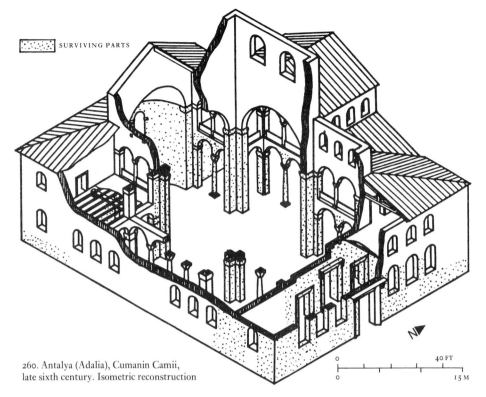

SURVIVING PARTS

260. Antalya (Adalia), Cumanin Camii,
late sixth century. Isometric reconstruction

N

0 40 FT

0 15 M

larged by cross arms, which were provided with rectangular exedrae at Mayafarquin and Antalya, with semicircular exedrae in sixth-century Syrian quatrefoils. In both this core is enveloped by aisles and, sometimes, galleries. Nor is it *a priori* unlikely that a building type from the provinces should have been taken up in Constantinople. From the seventh to the end of the ninth century, the constant need for defending the frontiers gave greater importance to the border provinces and in particular to those provinces from which armies could be drafted. Condottieri from northern Syria and Phrygia ascended to the throne, such as Leo III (717-41) and Michael II (820-9), and brought along their fellow-countrymen, laymen and clergy. Builders from Isauria had been active in Constantinople (and in northern Syria) as early as the latter sixth century.[12] Thus a transfer of

architectural types, or for that matter of architects, from the provinces to the capital is not *a priori* impossible. On the other hand, it is just as possible that buildings such as Mayafarquin and Antalya are but provincial replicas of a fully vaulted and domed prototype, lost to us, which existed prior to 600 at Constantinople. After all, the church of St Sergius at Gaza, which Choricius saw as early as 536, may have represented the type, vaulted and domed, though without galleries.

Regardless of which hypothesis turns out to be correct, it is clear that the cross-domed plan goes back far beyond the late seventh or early eighth centuries, when it was taken up in the Koimesis church at Nicaea; it may well be a creation of Justinian's circle, possibly dating from his last years. However, the plan as it presents itself at Salonica is cast in a style quite

different from that of the sixth century. The masses – walls and piers – are solid and heavy. Openings, whether windows or arcades, are comparatively small. The proportions are wide and easy. The exterior becomes squat, almost awkward: a plain cube, surmounted by a low, square drum which conceals the dome. Only apse and centre bay are lit, and they only dimly because of the smallness of the windows; aisles and galleries, as seen from the nave, remain shadowy, in parts dark. The marble sheathing is sombre in colour; the light greens, greys, and yellows of Justinian's churches are gone. Only the vaults shimmer with the gold ground of the mosaics [257].

Whatever its time and place of origin, however, the cross-domed church was splendidly adapted to the practical demands and the symbolism of the liturgy as they became firmly established during the centuries after Justinian. The architectural and the liturgical plan have been integrated to perfection. Aisles, esonarthex, and galleries envelop the core on three sides as an outer zone from which the faithful participate in the service, visually and spiritually, but passively. Within the core, the naos is domed and central in plan. The chancel bay preceding the apse is deep and barrel-vaulted. And the side chambers – the pastophories – which flank the chancel are domed, fused with chancel and apse into a triple unit, and communicating with aisles and chancel through doors. Plan and placement of all these elements are closely tied to the final codification of the Byzantine liturgy which must have taken place between the late sixth and the early eighth centuries. More specifically, they are tied to the ritual of the two Entrances – the Lesser Entrance, which by the eighth century accompanies the gospel book, rather than the bishop, to the altar; and the Great Entrance, which as of old transfers to the altar the elements of the Eucharist. In particular, the architectural changes are tied to the places assigned

for safekeeping of the gospels and the species of the Eucharist before their actual use in the Mass.

The gradual formation of the triple sanctuary leads into the problem. In Byzantine usage, by the eighth century the gospels are kept in the south room adjoining the chancel – the *diaconicon* – while the north room serves as the *prothesis*, where the species of the Eucharist are kept and prepared before they are brought to the altar during the ceremony of the Great Entrance. However, this was not so from the beginning. In the fourth century, the diaconicon was also the place where the faithful deposited their offerings, and it was situated near the chancel, as presumably in the Lateran basilica and at Epidauros. It is unknown whether or not at that time the species of the Eucharist chosen from among these offerings were prepared in a special ceremony before being brought to the altar; if so, the preparation took place in the diaconicon, which thus would also have served as prothesis. In Syria, from the late fourth century, this room was placed on one side of the apse and thus easily accessible to the faithful, since the entrances of Syrian churches were originally on the flank, not on the façade.[13] The diaconicon, as a rule, had its counterpart in these Syrian churches in a second side chamber, adjoining the apse on the opposite side. But this room was apparently a martyr's chapel sheltering relics. Indeed, while the diaconicon communicated with the aisle and at times the apse through doors, the martyr's chapel opened in an arch.[14] Placement of the two rooms in Syria remained apparently unchanged even after the portals of the church were moved to the façade. In the Aegean coastlands, on the other hand, where the ceremonial preparation of the eucharistic species early may have become part of the liturgy, the diaconicon also served as prothesis. As early as the fifth century, a room serving both purposes was placed near the entrance of the church, accessible to the faithful, but far from

the chancel. It opened either off the narthex or off the atrium. The apsed room projecting south from the narthex in Basilica A at Nikopolis exemplifies the first solution; the apsed room south of the atrium in Basilica A at Nea-Anchialos, the second solution, both in elaborate form.[15] This placement of the diaconicon-prothesis made sense, as long as the faithful actually deposited their gifts there at the beginning of the service. But it also meant that in both the Little and the Great Entrance, the procession of the clergy moved back and forth the entire length of the nave. Nor did the situation change when, apparently in the second third of the sixth century in the Aegean coastlands, the prothesis was separated from the diaconicon and assigned another room adjoining the narthex. By then, however, the custom of the faithful bringing their offerings had long become obsolete, and as a result the position of the corresponding rooms on the entrance side of the church had become an atavism.

It was only natural that – beginning in Justinian's time – churchmen and architects strove to place prothesis and diaconicon closer to the sanctuary, where they could be more easily serviced by the celebrating clergy.[16] S. Vitale in Ravenna seems at first glance an early example of the change; but the side chambers at S. Vitale were primarily martyrs' chapels, whether or not they concurrently served also as pastophories. The side chambers of Syrian churches may have furnished the model. Whatever the beginnings, however, the new placing of the pastophories seems to start in the sixth century. Beginning at that time, prothesis and diaconicon in large parts of the Eastern Empire were ever more closely linked to the chancel. They were made to flank it and thus joined with apse and forechoir in the triple sanctuary which in its final, perfect form characterizes the cross-domed churches as we have come to know them, starting with the early eighth or possibly the late seventh century. In that form the triple

sanctuary becomes a hallmark of Middle and Late Byzantine church planning. However, the first instances known so far appear in churches of basilican plan dating from the middle of the sixth century or shortly after: the cathedral at Caričin Grad; the 'Stag' basilica at Pirdop in its final phase; a church excavated at Sebaste (Selçikler Köyü) in Phrygia; Dağpazarı in Pisidia; possibly S. Apollinare in Classe and the Euphrasius basilica in Poreč (Parenzo), but the function of the apsed side chambers in Classe, of the side apses in Poreč, remains to be clarified. The triple sanctuary, then, was widespread by 600 within the sphere of Byzantium. But Constantinople seems to have shunned it.[17] Its liturgy possibly differed from that in the provinces on this point as it did on the question of separating the nave from the aisles.[18] In any event, though, as a result of the transfer of diaconicon and prothesis, so as to flank apse and forechoir, the Entrances no longer moved along a longitudinal axis through the church, from the door to the sanctuary, as had still been the case in the H. Sophia. Now they proceeded from diaconicon and prothesis – the Little Entrance from the former, the Great Entrance from the latter – to the chancel, moving briefly into the naos in order to exhibit the gospel book and the eucharistic elements to the faithful. Any reminiscences of a lengthwise procession and a longitudinal building were eliminated, and the central plan of the naos was fully integrated with its liturgical function. The congregation is relegated to the aisles, the esonarthex, and the galleries. The cross-domed centre bay, on the other hand, becomes an anteroom to the sanctuary – a stage, as it were, visible to the faithful, but accessible only to the clergy. On this stage, below the dome, Christ reveals Himself to the people in twofold form: as the species of the Eucharist, carried by the celebrant, which appear before their eyes during the Great Entrance and transformed into His body and blood during Communion; and as the Reve-

lation, the Word, pronounced from the ambo in the very centre of the naos.[19]

Concomitantly, the chancel, the site of the altar and the eucharistic sacrifice, became fully integrated into the plan of the cross-domed church. One recalls how, throughout the fifth and often long into the sixth century, its enclosure had projected far into the nave. In Justinian's early years, the plans of the H. Sophia, of H. Sergios and Bakchos, of S. Vitale, change this situation. A deep barrel-vaulted bay is inserted between the apse and the domed centre bay, to shelter, as a forechoir, at least the site of the altar. But the solution is not yet perfect. In the H. Sophia, the chancel still projected from the forechoir into the area of the eastern half-dome, and no prothesis and diaconicon were joined to the sanctuary. At S. Vitale in Ravenna, the integration has gone much further: the pastophories – or rooms much like them – are now integrated with the sanctuary group; and the chancel seems to have extended to the very beginning of the forechoir, but not further. Finally, in the cross-domed churches of the eighth and ninth centuries – but perhaps starting earlier – full integration has been achieved. The forechoir contains the full expanse of the chancel, and it communicates with the pastophories through doors of its own. Thus it has become a solemnly closed precinct, provided with elaborate annexes. The *templon* rises on the very borderline of forechoir and nave and hides, along the architectural boundary, the sanctuary where the ministrant clergy surround the altar. The church of St Nicholas at Myra until the beginning of this century still preserved its original furniture – templon, altar canopy, ambo – and thus illustrates better than words the function of the individual parts of the building.

The interrelations between liturgy and building were not lost on contemporary intellectuals, who interpreted church structures through an elaborate symbolism.[20] As early as 630 Maximus the Confessor presents an interpretation of the church building and of the liturgy it houses. The entire church is an image of the Universe, of the visible world, and of man; within it, the chancel represents man's soul, the altar his spirit, the naos his body. The bishop's Entrance into the church symbolizes Christ's coming into the flesh, his Entrance into the bema Christ's Ascension to Heaven. The Great Entrance stands for Revelation, the Kiss of Peace for the union of the soul with God; indeed, every part of the liturgy has a symbolical spiritual meaning. About 700, Germanos, the patriarch of Constantinople, summed up ideas presumably current for some time and which continued as late as the fourteenth century. The church building to him was the Temple of the Lord: the sacred precinct, the Heaven where God resides, the sacred cave where Christ was buried and whence He rose, the place where the mystical sacrifice is offered. The chancel, in particular, and the altar (the two are used interchangeably) was viewed as the Seat of Mercy. They were the manger of Christ, His tomb, and also the Table of the Last Supper. Equally, they were seen as the Heavenly Altar on which the hosts of Angels offer the eternal sacrifice. The apse was a symbol of the Cross; the seats of the clergy were the raised site and throne where Christ sat among His disciples. They foretell His second coming and the Last Judgement. The columns of the templon revealed the division between the assembly of the people and the Holy of Holies where the clergy gathered; the architrave over these columns symbolized the Cross. The canopy with its four columns stood for the site of the Crucifixion, and also for the four ends of the earth. Finally, the dome represented Heaven.

It is obvious that such interpretations were not applied exclusively to any one part of the church; the same meaning may be represented by several parts of the structure. It is equally

obvious that the interpretations chosen were only in part freshly invented by the theologians of the late eighth century. Many are *topoi*, developed over centuries. Likewise, no doubt, only a small group of laymen was fully conscious of all this sophisticated symbolism. The general ideas, however, permeated to a wider public. In entering the church, the average believer was aware, we may be sure, that he entered Heaven; and he saw, in the procession of the clergy, the angelic host about to offer the sacrifice on the Heavenly altar.

THE BORDERLANDS

Builders and patrons in Justinian's Empire, one recalls, created a new domed architecture – whether staid and standard or boldly experimental – and with it fresh concepts of building. New church plans were evolved; new uses of volume and mass, surface and colour, space and light were achieved. But this architecture of Justinian's circle was limited to a few great centres, and above all to Constantinople. Provincial architecture under Justinian, and for some decades following, absorbs elements of the new vocabulary, torn from context, and fuses them with traditional basilica plans. And even this piecemeal use of elements of Justinian's style is directly related to the impact of the central government: through Imperial donations or through its organs – the army, the civil administration, the Established Church. Much in contrast to such official organs and to the upper class, the popular forces beyond the pale of the Establishment consistently oppose Constantinople's demands for monolithic rule and cling to isolationist folk ways in language, religious custom, and art. This grass-roots reaction is reinforced by clerical, and above all, monastic – monophysite as well as Nestorian – resistance to the central government's religious policy. As a result, the architecture of village churches and monasteries in the borderlands of the Empire is apt to slide back into, or retain for centuries, the ways of a primitive folk architecture, in construction techniques as well as in plan and design. Alternatively, church plans rooted in the higher strata of provincial architecture are transposed into the language of primitivism and carried out in crude methods of construction. It is but natural that such reaction would be strongest where governmental rule was weakest: in remote mountain and desert regions, or along the borders of the Empire. Always slightly in flux, such border populations were never quite integrated within the Empire; nor were the garrisons of *foederati* that protected the borders – Sassanian, Arab, Nubian, Slavic, and Germanic mercenaries, together with kith and kin.

MESOPOTAMIA AND THE TUR ABDIN

Such folk architecture, religious and secular, was widespread in the outer provinces of the Byzantine Empire as well as in territories beyond its borders. It was an architecture carried by native forces, unrelated to political frontiers. The Byzantine Empire was in a nearly continuous state of war with the Sassanian kingdom and later with the Umayyad caliphate which in 636 replaced the Sassanians as rulers of Mesopotamia and Iran. Nevertheless, Nisibis (Nusaybin) on the Byzantine side of the border remained the spiritual centre of vast numbers of both Nestorian and monophysite congregations extending far into Mesopotamia and Persia. Conversely, church plans and techniques of construction seem to have penetrated from the Mesopotamian plain north-west towards Nisibis and the hills of the Tur Abdin on the south slope of the Taurus range. Certainly Mesopotamia and the Byzantine border provinces worked with similar architectural concepts both before and after the fall of these provinces to the Persians, then to the Muslim. Space was cramped, lighting dim, the exterior plain, the interior vaulted. The church plan was determined by local liturgical custom – different in monastic and parish churches – and by local

prototypes in both sacred and secular pre-Christian architecture. Building techniques likewise followed native tradition. In the Mesopotamian plain with its rich clay deposits, brick walling and vaulting were the rule. Northward in the hilly Tur Abdin, stone construction was the norm.

Christianity had early roots in Mesopotamia and in the Tur Abdin. At Edessa (Urfa) by the early third century, Christianity was declared the state religion.[1] Indeed, a church existed there as early as 201, but it remains open to question whether this was a regular church building or a community centre.[2] However, no church buildings of such early date have survived anywhere in Mesopotamia or the

barrel-vault of the nave. Two churches of this type have been excavated at Ctesiphon, one replacing the other [261]. Two other churches were found at Hira, one with transverse side barrel-vaults so deep as to require wall piers as well as free-standing columns. The plan has been linked to royal reception and judiciary halls in Sassanian and Umayyad palaces. If true, this derivation would constitute a neat parallel to the origin of Constantinian church building from the ambience of secular basilicas, both forensic and palatine.[4]

While early church buildings on the Mesopotamian plain are known only from excavations, a comparatively large group of village churches, monastic churches, and martyria still survive in

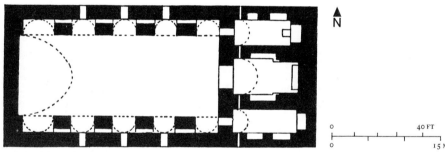

261. Ctesiphon, church, c. 600(?). Plan

Tur Abdin. In general, church building in Mesopotamia is known only from a very few excavations, and none of the buildings can be safely dated. They may have been built at almost any time between the fourth and the ninth century, or later. They are, as a rule, longitudinal halls, terminated by a tripartite sanctuary – a square chancel flanked by corresponding rooms, all three accessible from the nave through narrow doors.[3] Supports, either low columns or piers, project from the side walls into the nave and form a series of niches, covered by short transverse barrel-vaults. From their backs sprang the longitudinal catenary

the Tur Abdin and the adjoining regions, and at least a few are dated by inscriptions and other historical evidence.[5] Situated as the region is between Mesopotamia to the south, Syria to the west, and the Anatolian high plateau to the north, its architecture draws on all three neighbour provinces and adds some features of its own. Some, possibly parish churches, share with the churches of Mesopotamia the longitudinal, barrel-vaulted nave with inward-projecting wall piers. However, a stilted semicircular apse replaces the triple sanctuary. As in neighbouring Anatolia, the walls are built either of blocks or of small stones. Piers, arches, and

262. Qartamin, monastery of Mâr Gabriel
with churches and martyrium, c. 512(?). Plan

occasionally the springings of the vault are of
finely cut blocks. The apex of the vault, on the
other hand, is frequently of brick construction,
the bricks pitched on their sides and often laid
in decorative patterns – both hallmarks of
Mesopotamian building tradition. Occasionally
plans and decoration are taken over from proto-
types on a less provincial level. Martyria as a rule
are square or octagonal [262] and surmounted
by domes or wooden roofs resting on corner
squinches;[6] the plans find their parallel in
Syria, e.g. at R'safah in the martyria attached to
Basilicas A and B. Other churches, possibly
monastic, have a plan of their own invention,
utilizing elements drawn from both Syria and
Mesopotamia. The nave is transverse and
vaulted, preceded by a narthex and terminated
either by an apse flanked by lateral chambers of
Syrian type, or by a Mesopotamian triple
sanctuary [262].[7] Very rarely, the barrel-vault
gives way to two half-domes placed at the ends
of the nave and supporting a dome in the centre,
all three resting on squinches.[8] To such plain
native plans is often applied a splendid orna-
ment, obviously of Syrian derivation: strong
profiles, vine scrolls, festooned Corinthian
capitals, and colonnaded shell niches hollowed
into the wall of the apse. Buildings such as the

martyria of Mâr Yaqub at Nisibis and of el'Adhra at Ḥaḥ or the church of Mâr Azâzaël at Kefr Zeh serve to illustrate this impact [263]. Pilasters and capitals are excellently carved. At Mâr Gabriel at Qartamin a mosaic decorated the chancel, and the tradition is credible that the church was built about 512 with Imperial subsidies. Certainly, the church plans continue unchanged, both in the Tur Abdin itself and in bordering Commagene, into the eighth and ninth centuries.[9] Likewise, the classical vocabulary imported from Syria may well have survived until long after the sixth century. Only gradually does the construction diminish in elegance. The finely cut stonework of the piers and the decorative brick design of the vaults give way to a construction in small, barely hewn stones, until the designs gradually slide back into the realm of a primitive folk architecture. But without much basic change, church building in the Tur Abdin continued along the old lines as late as the twelfth century, and perhaps later.[10]

EGYPT AND NUBIA

Throughout the Empire and its borderlands, folk architecture differs locally in plan, technique, and decoration. Among the Copts in

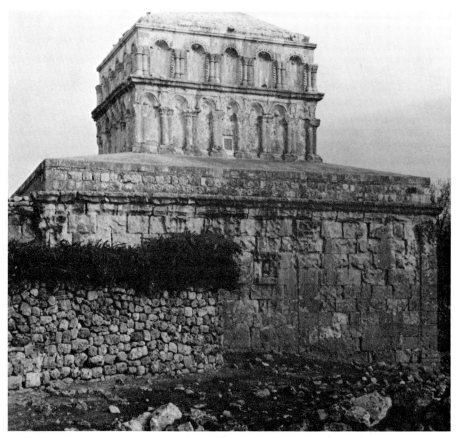

263. Ḥaḥ, martyrium of el'Adhra, sixth century(?); upper part of drum 1907. Exterior

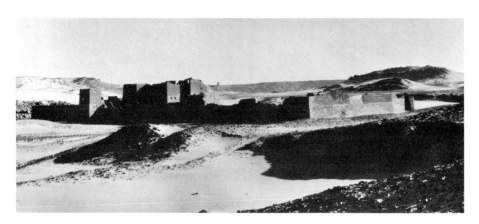

264 (*above*). Aswân, St Simeon, monastery,
fourth-nineteenth centuries. Exterior

265 (*below*). El Khargah, tomb chapel,
fourth century(?). Exterior

Egypt during the fifth and sixth centuries plan
and construction of cemetery buildings and
monasteries are tied to primitive local custom.
(The term Coptic, coined for Christians resi-
dent in Muslim Egypt, is customarily applied
to pre-Muslim Egypt as well.) In the ruins of
Apu Jeremiah at Saqqâra, living quarters, a re-
fectory, courtyards, and three churches – the
major parts dating from the first half of the sixth
century – were chaotically crowded into the area
of the monastery. Rows of cells and storerooms
were huddled together, as in an Egyptian vil-
lage. All were barrel-vaulted, the walls built of
stone at the bottom and of mud bricks higher up.
Only the main church, as originally built in the
sixth century, adhered to a basilican plan of
Aegean type, as adopted in Egypt from at least
the fifth century. An apse and three colonnaded
aisles enveloped the timber-roofed nave.
Column shafts and bases were imported from
the Proconnesian quarries, with capitals ele-
gantly carved by local craftsmen. The abbey of
St Simeon at Aswân to this day shows the same
characteristics as the monastic buildings at Saq-
qâra: mud brick walls, a fortified enclosure,
barrel-vaulted rooms and corridors [264]. At El
Khargah (El Khârga) and at Bawît (Bawiti),

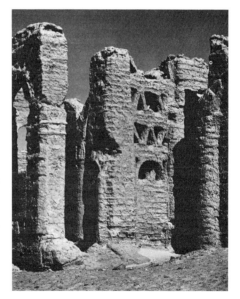

both in the Libyan desert west of Sohag, large
necropolises have survived, composed of many
dozens of free-standing mausolea and funeral
banqueting halls [265]. All are small, built of
mud brick and barrel-vaulted or domed. The
architectural decoration in general points to a

date between 450 and 550; but some may be earlier, given the foundation date, 386-8, of the convent at Bawit.[11] In contrast to the primitive construction and the native design of the buildings, however, their architectural ornament is highly sophisticated and drawn from the vocabulary of the Aegean coastlands [266-8]. Alongside Corinthian capitals of a late-fifth- and early-sixth-century type stand basket capitals overspun by tendrils and thus recalling the capitals of Justinian's time in Constantinople and

266 (*above*). Capital from Bawit, sixth century, *Cairo, Coptic Museum*

267 (*right*). Capital from Hermopolis (Ashmunein), sixth century. *Cairo, Coptic Museum*

268 (*opposite*). Pilaster and demi-column from Bawit, sixth century. *Cairo, Coptic Museum*

Ravenna. A sixth-century date is, then, indicated for most of this ornamentation. But in contrast to their Aegean prototypes, the foliage of the Coptic capitals is cut either lancet-sharp or cardboard-stiff, very different from the true pliable and naturalistic ornament of Justinian's buildings which occasionally penetrates Egypt – probably as an import from Constantinople.[12] Shafts and friezes are covered with geometric and foliate designs. Chevrons, rinceaux, overlapping tongues, stars, and rosettes crowd each other with an abundance characteristic of a popular taste. The late-classical tradition of the Eastern Mediterranean has been absorbed by the Coptic masons and provincialized; it has been applied to the crude architecture which supported it in much the same fragmentary manner that prevailed in other provinces when

Justinian's ornament was applied to local building.

The aversion to Constantinople, shared by the native populations of the border provinces and their monophysite clergy, eventually led to an exchange of architectural ideas among the border populations. The 'Syrian' church plan – an apse, semicircular or square, flanked by lateral chambers – was brought into Egypt by the monastic congregations of the Tur Abdin. Deir Abu Hennes is an early example, probably still of sixth-century date.[13] The isolationist tendencies of the outlying native Christian communities and, concomitantly, the interchange between them, increased in the seventh century with the Muslim conquest of Egypt and the Near East to the south and east of Asia Minor. Independent Christian territories, such as the

Nubian kingdom in Upper Egypt and the Sudan, disappeared behind the Muslim curtain. In either case, the Christian congregations lost the last contact with Byzantium and the Aegean area and their architecture. Isolated, they clung to obsolete church designs in which local traditions intermingled with elements previously absorbed from abroad. Proportions are awkward, details clumsy, the construction poor. From Cairo to the far south, a basilican plan was predominant, with crude round or square piers as supports and with timber roofs. At St Simeon near Aswân, the chancel was formed of three arms of a Greek cross, each surmounted by a half-dome on squinches – obviously a simplified version of the trefoil plan of Deir-el-Abiad. At Deir-es-Suriani (Monastery of the Syrians) in the Natrun Valley, this trefoil chancel plan has been modified by a square domed bay replacing the centre apse. At near-by Amba Bishoï, the cross arm of the trefoil becomes a transverse forechoir. The naves were originally timber-roofed in all these churches; subsequently they were vaulted (and perhaps parts of the chancels later revaulted) with longitudinal or transverse barrel-vaults, or with domes.[14] From such beginnings there springs, it would seem, what might be termed the Coptic standard type: nave and aisles are barrel-vaulted and supported by piers; a forechoir resembling a transept terminates the nave and carries a transverse barrel-vault; the chancel (*haikal*) is composed of three square apses. Developing in the course of the ninth and to the end of the twelfth century, the plan obviously relates to North Mesopotamian types; but it is modified in that all three apses, or at least the centre apse, are domed. By the twelfth century, Deir-Baramus in the Natrun Valley shows the type fully developed.[15] It apparently continues for centuries unchanged, notwithstanding local deviations. But exceptions do occur. The churches of Old Cairo in the eleventh and twelfth centuries – witness Abu Sargeh (St Sergius) – revert to the plan of a

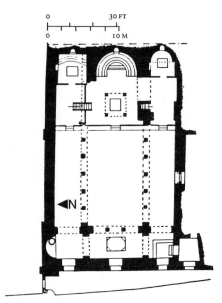

269. Cairo, Abu Sargeh,
twelfth century. Plan

colonnaded basilica with continuous or tri-
partite transept and three apses [269].[16] In
upper Egypt a church plan is developed, very
short, terminating in five and more apses, and
divided into wide rows of domed bays.[17] The
type obviously draws on the customary plan of
mosques – and is no concern of a study of Early
Christian and Byzantine architecture.

Such late Coptic building, however, exerts
no impact on the church architecture of the
Egyptian south and of the Sudan. There the
Christian kingdom of Nubia notwithstanding
occasional invasions held out against the
Muslim and for centuries continued an archi-
tecture ultimately still rooted in the Aegean
tradition of the fifth century. At Qasr Ibrim in
the sixth or seventh century, the nave, on
columns, was flanked by double aisles, the
outer ones on piers and enveloping nave and
inner aisles on three sides, the whole built of

fine ashlar and apparently timber-roofed. The
same high-quality masonry marks the contem-
porary cathedral at Faras. However, the custo-
mary type in Nubia is a basilica with galleries,
barrel-vaulted throughout. But the technique
of construction is native: the materials are stone
in the bottom courses, mud brick in the upper
parts; the supports are broad piers; the arcades
narrow; the gallery openings reduced to the
size of small rectangular windows. Columns, if
used at all, serve only to support the triumphal
arch. Sacristies flank the apse on either side and
a synthronon fills its curve. The last bay of the
nave is occupied by the chancel and set off by
slightly projecting piers. In plan, liturgical ar-
rangement, and design, Aegean, Syrian, and
local elements have been fused and thoroughly
transformed. The interiors are dark; the ex-
teriors form squat, unadorned blocks. Capitals
are of a much debased composite type, un-
related to the elegant Coptic decoration. The
remains of the North Church near Adindân are
one example among many ruins apparently still
preserved. Few are dated precisely. Only for
the cathedral at Faras, the foundation, in 707,
is secured through an inscription; and in the
north church outside the citadel at Faras, a
graffito provides a *terminus ante quem* of 881.
Others can be dated only approximately through
ceramic finds; they were apparently built be-
ginning with the latter sixth century, when
Nubia was christianized, to the eleventh and
twelfth centuries, when it finally fell to the
Muslims. But still prior to that conquest,
Byzantine architecture exerted an ephemeral
impact on Nubia: witness a centrally-planned
church at Serreh (Serra) which translates the
plan of domed cross churches, such as H. David
in Salonica, into the native technique of con-
struction [270].[18]

Both before and after the Muslim Conquest,
then, Christian builders along the southern
fringes of the Empire clung to the outmoded

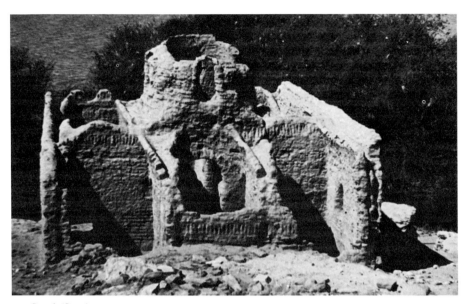

270. Serreh (Serra),
centrally-planned church, tenth century. Exterior

formulas of what might be called 'sub-Byzantine architecture'. The outlook was very different in the independent or semi-autonomous border states along the northern and eastern frontier – the Slavic kingdoms in north-eastern Yugoslavia and Dalmatia; the Bulgarian Empire in the north-eastern and central Balkans; finally, the kingdoms of Armenia extending into north-eastern Asia Minor to the foot of the Caucasus mountains. All these territories develop architectural styles of their own – national *Sonderstile*. Different among each other, these styles are yet at the same time related to, and independent from, Byzantium. In Armenia, and to a lesser degree in the Bulgarian Empire, rulers, churchmen, and architects seem to have striven quite consciously towards rivalling the best, boldest, and most impressive designs of their Byzantine contemporaries. Their buildings might be described as 'para-Byzantine architecture'.

THE BALKANS

Byzantine power in the Balkan provinces lost its grip in the course of the seventh and eighth centuries. The Church and the military and civil administration clung precariously to a few garrisoned cities along the coasts of Dalmatia and Bulgaria, and in the river valleys inland. In the 640s, Slavic Croatian tribes conquered Salona on the Adriatic coast, laid siege to Salonica, and swept as far south as Corinth. Gradually they settled down, with their biggest concentration along the west coast, and were converted to the Church of Rome. Then in 811, the Bulgars, long settled south of the Danube, began pushing south and west to eliminate the last remnants of Byzantine suzerainty in the Balkans. They subjugated the Slavic squatters, except for those on the Dalmatian coast and in Croatia, and formed a new

powerful state.[19] Rapidly spreading, this First Bulgarian Empire was reconquered only in 1018 by the Byzantines, led by Basil II, the Bulgar-Killer. The Bulgar czars – converted to Eastern Christianity in the last third of the ninth century – were perpetually at war with Constantinople both before and after conversion. Yet they were deeply impressed by the culture, wealth, and art of the Byzantine court – more so than the Slavic chieftains along the west coast ever were. The palaces and churches built by the Bulgars, and some of the churches built by the Slavs, are certainly linked to Byzantine concepts of court life and of aulic and ecclesiastic ceremonial. Whether Bulgarian or Slavic, however, building in the Balkans throughout the ninth and tenth centuries has a note of its own. It is quite different from contemporary Byzantine architecture both in style and construction.

Among the Croatian Slavs in Dalmatia, permanent church building seems to have started in the ninth and continued with little change throughout the tenth and eleventh centuries.[20] What has survived is quite unconnected with the Early Christian tradition of Salona, and traces of Byzantine impact are equally scanty. Hall-churches such as Sv. Barbara at Trogir are frequent, but they obviously do not represent a Byzantine type. Even more common are single-naved churches covered with a barrel-vault into which a dome has been inserted: Sv. Luka at Kotor is one of many examples.[21] The dome may, but need not, be a Byzantine element. The barrel-vaulted aisleless nave, on the other hand, recalls a local tradition of Roman mausolea, such as the Anastasius martyrium at Salona. Equally frequent in ninth-century Dalmatia are centrally-planned churches: cross-shaped, trefoil, or frequently round, with six projecting niches, as at Sv. Trojce near Split, and nearly always very small structures. Again, none of these plans are Byzantine. On the contrary, they apparently revive mausolea types as they were scattered all over the Roman world, including presumably Dalmatia. Such mausolea, both Christian and pagan, had exerted a strong impact on the architecture of the western Balkans as early as the sixth century: on the orthodox baptistery at Salona with its double order of columns curtaining the walls; on small trefoil churches of Justinian's time, at Kuršumlija, Klisura, and Caričin Grad; and on round churches with ambulatories, such as Konjuh.[22] It would seem but natural for the builders of the first Croatian centrally-planned churches to fall back either on the same Roman models, or on their sixth-century local descendants. Indeed, like their plans, the construction, the style, and the vocabulary of the Croatian churches point to a Roman tradition. The designs are compact; the masonry has a stoniness due only in part to the use of roughly-hewn chunks of rock; the exterior walls are articulated by pilaster strips or blind arcades. Possibly the long rows of niches hollowed into the outer walls also point to Rome. The back-to-Rome movement, as has been suggested, may be rooted in the opposition of the Roman Catholic Croatians to the attempted encroachment of the Church of Constantinople. A Roman renascence is certainly present in Croatian ninth-century architecture, possibly to some degree sparked by the impact of Lombard architecture across the Adriatic Sea.[23] At the same time, however, Croatian architecture maintains – at least in the function assigned to certain building types – contact with Byzantium.

The church of Sv. Donat at Zadar (Zara), probably of early-ninth-century date, illuminates the situation [271, 272].[24] Circular in plan, its centre room is enveloped by the two tiers of an ambulatory and a gallery, both ring-shaped. Six broad piers and two columns carry the arcade of the ground floor; a second order supports that of the gallery; and three horseshoe apses project from the ambulatory. The ambulatory is barrel-vaulted; the centre room was

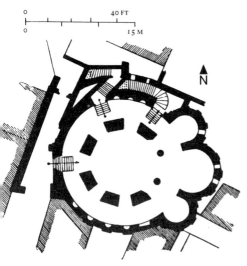

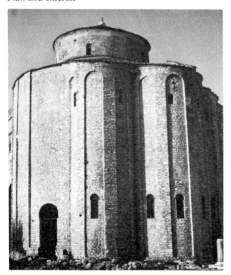

271 and 272. Zadar (Zara), Sv. Donat,
early ninth century(?).
Plan and exterior

originally covered by a dome. On the exterior, blind arches articulate the apses. The gallery was originally linked to some adjoining structure, presumably a palace. The double-storeyed central plan seems to reflect the tradition of palace churches come down from Constantinian times. Sv. Donat is a cousin several times removed of H. Sergios and Bakchos in Constantinople, of S. Vitale in Ravenna, of Charlemagne's palatine chapel at Aix-la-Chapelle, and presumably of palace chapels in Constantinople, now lost. But the impassive solidity of the Dalmatian structure recalls – far more than Byzantine models – Roman buildings or possibly Constantinian churches, such as the Anastasis Rotunda in Jerusalem.

BULGARIA

The situation is different in the eastern Balkans. A specifically local architectural note had come to the fore as early as the late sixth century in the Byzantine provinces in the area of present-day Bulgaria. Even then, dark vaulted hall-churches had begun to vie with the elegant but old-fashioned basilicas of Caričin Grad and with the rare domed churches of metropolitan standard type – such as the 'Stag's Basilica' at Pirdop as remodelled in the late sixth century. Squat, broad piers took the place of marble columns; the arcades became low and narrow. The nave, poorly lit by a few windows in the façade, carried a barrel-vault, and groin-vaults covered the aisles. Such modification of a simple basilican plan through vaulting and heavier supports, parallels similar sixth-century currents in Tunisia, Cyrenaica, and Sicily. However, in the eastern Balkans the type does not remain stationary, and as early as the late sixth century in the cathedral of Sofia, a dome and transept have been fully integrated into the plan of a vaulted basilica with galleries.[25]

The further development – if indeed any building activity continued through the seventh and eighth centuries – came to an end with the Bulgar invasion. The new Bulgarian empire quickly expanded over present-day Bulgaria and southern Yugoslavia. However, little is known

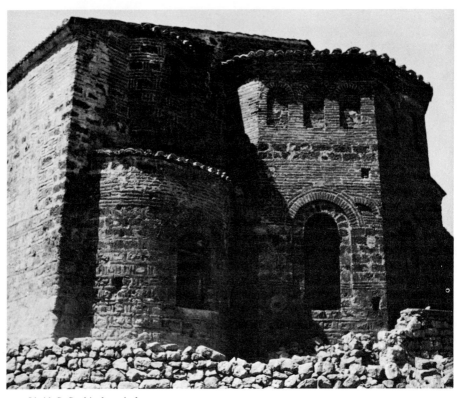

273. Ohrid, St Sophia, late ninth
and eleventh centuries(?). Exterior of apses

about the chronology or the character of architecture in this Greater Bulgaria under the rule of the First Empire. Few, if any, buildings are dated beyond question, and the development is as obscure as the links to other styles – be it architecture previously rooted in the Balkans, contemporary building in Constantinople, or the art of Mesopotamia, Persia, and Armenia. Indeed, what little seemed to be ascertained some forty years ago has recently again come into flux – so much so that a large number of the great palaces and churches excavated in Greater Bulgaria oscillate in date from as late as the ninth, tenth, and eleventh centuries to as early as the sixth. Any attempt at presenting

Bulgarian architecture is therefore quite tentative.[26]

Among the church types of Greater Bulgaria, one appears to be characteristic, new, and unique: a hall-church, supported by heavy piers and low arches, and terminated by three powerful apses. Nave, aisles, transept wings, and chancel bay are barrel-vaulted; a dome surmounts the segregated crossing. The church of St Sophia at Ohrid in southern Yugoslavia seems to have followed this plan when first built in the late ninth century; remodellings, from the eleventh to the fourteenth century, have thoroughly altered its original aspect.[27] Perhaps it was built as the cathedral of the new Bul-

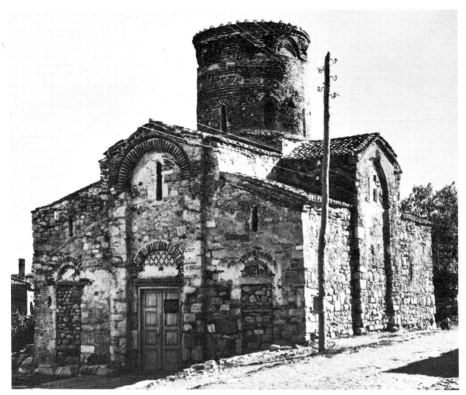

274. Nessebâr (Mesembria), Church of St John
the Baptist, c. 900. Exterior from the south-west

garian patriarchate which was set up at Ohrid
at just that time [273]. Indeed, in its plan and
its heavy style, the first St Sophia at Ohrid does
not stand alone in its time. It finds a counter-
part in the church of St John the Baptist (Sv.
Ivan Kristutel) at Nessebâr (Mesembria) on the
Black Sea coast, a late-ninth- or early-tenth-
rather than an eleventh-century building [274].[28]
It finds an even closer counterpart far to the
south, in Central Greece: the church of the
Panaghia at Skripou[29] [275–7]. Similar in plan
and far better preserved than the original St
Sophia at Ohrid, the Panaghia is dated 873/4 by
an inscription. It is a most impressive building
– 26 m. long and 16 m. wide (85 by 53 ft), not

counting the projecting transept wings – and
thus nearly the exact size of St Sophia at Ohrid.
The design is heavy, solid, and beautifully pro-
portioned. Outside, nave, transept wings, and
chancel are sharply set off against each other and
culminate in the circular drum of the dome. The
aisles, east and west of the crossing, and the
three semicircular apses are subordinate ele-
ments. String courses curve above the windows,
subdividing the outer walls at a level corre-
sponding to the vault springings and reflecting
the perfect integration of the interior space with
the exterior volumes. Inside, aisles and nave
are separated by walls four feet thick, pierced
only by a low, narrow arch on either side. Nave

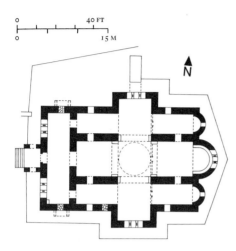

275 and 276. Skripou, Panaghia, 873/4.
Plan (*above*) and view of apses, transept,
and dome from the north-east (*below*)

and transept arms rise steeply to the dark barrel-vaults, encased by the massive walls. Their bleak darkness contrasts beautifully with the bright light in the sharply segregated crossing. All this is built in heavy stone blocks, largely spoils from classical Orchomenos near by.

One has to look far afield in order to establish the place of buildings such as St Sophia at Ohrid and the Panaghia at Skripou in the history of architecture after Justinian. The resemblance to the cathedral of Sofia, with its long nave, aisles, and perhaps its galleries all built of brick, is only skin-deep; and the interval of 250 years is hard to bridge. The contrast to the complex and refined brick architecture of Constantinople, as customary long before the early-tenth-century examples surviving, is apparent as well in the design of spaces and masses. And while building activity in Greece may have been considerable in the latter ninth century, as the Byzantine political position was reconsolidated, the architectural roots of Skripou do not lie in Greek art. True, in the course of the tenth cen-

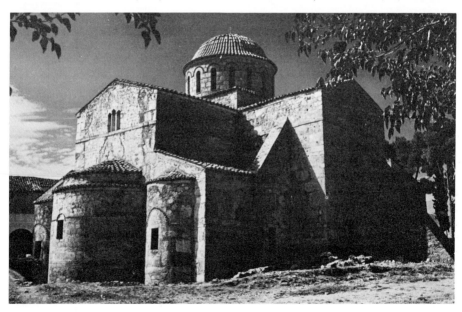

277. Skripou, Panaghia, 873/4. Interior facing east

tury the type of Skripou was taken up in modified form by Greek and Balkan country churches. The walls between aisles and nave are supplanted by heavy piers and low arcades, much as in St Sophia at Ohrid. But in the ninth century Skripou so far seems to be unique or almost unique in Greece. In none of the comparable tenth-century churches is the nave quite that long; and only rarely are the openings towards the aisles quite that low and narrow.[30] Its design in masses and its building technique seem to me best understood in the context of Balkan architecture, as revealed by the fortresses and palaces built for the still pagan Bulgar czars for nearly a century. Such dependence of a ninth-century church in Greece on the contemporary Bulgarian tradition is not impossible. The court of the Bulgar czars and their buildings must have made a deep impression on the neighbouring Byzantine provinces. The immediate frame, then, for churches such as Skripou and St Sophia at Ohrid seems to be the architecture of the Bulgar court. The broader frame leads farther –

to the hinterlands of the Near East and to Armenia.

What survives of Bulgar court buildings is impressive to this day. At Pliska, the walls of a huge palace precinct have been uncovered – including the substructures of throne room and living quarters – presumably dating from 814–31.[31] Within the enclosure of the walls, the buildings are loosely scattered. They are of very large blocks of stone, perfectly hewn with a core of mortared rubble, and apparently designed in clear, solid masses [278, 279]. The throne room may serve as an example. Raised high on a podium, its floor rested on two parallel barrel-vaults in the substructure. The hall itself was presumably aisleless, preceded by a porch and terminated by an apse. On the outside it was probably enveloped by a terrace, either open or covered by a portico.[32] The living quarters of the palace were each laid out as a large rectangular block, divided inside into a main hall – square or rectangular – and rows of flanking rooms. Similar plans prevail in other

278 and 279. Pliska, palace, 814–31. East gate (*above*) and substructure of throne room (*opposite*)

palaces, at Madara and Kalugeritsa, but the splendid masonry technique appears to have rapidly deteriorated.

In layout, the throne room of Pliska obviously vies with the audience halls of the Byzantine emperors at Constantinople as they are known, less from excavations than from contemporary descriptions: an aisleless, apsed hall is found in the palace complex south and downhill from the Sultan Ahmet Mosque; the high position on a podium and the enveloping terrace (*heliakon*) echo the triclinium of the Magnaura.[33] Indeed, the Bulgarian palaces provide a basis for envisaging, at least in plan, the lost palaces of Constantinople – throne rooms as well as possible living quarters. But the builders of the Bulgarian palaces translated the Byzantine models into a building technique of their own, and re-designed them in terms of an architecture composed of clear-cut solids.

Despite the obvious relationship of such palace designs to Byzantium, the origins of the palace architecture of Pliska have been sought far and wide. Their heavy stone work has been attributed to the skill of the Bulgarian conquerors or to craftsmen called in from Byzantium.[34] Neither is plausible: nomads, as the Bulgarians were until the beginning of the ninth century, are not builders, and stone masonry was never in the Byzantine tradition. The plans of the throne rooms and living quarters at Pliska have also been compared to Sassanian palace halls. Undeniably Bulgar buildings, of tenth-century date, often show ornament closely reminiscent of Sassanian art: griffins, winged lions, palm trees, palmetto-and-grape friezes – motifs which, in the Muslim art of Iran and Mesopotamia, survived far into the eleventh and twelfth centuries and beyond; their appearance in sixth-century Constantinople at H. Polyeuktos seems to have remained ephemeral.[35] Indeed it is perfectly possible and even likely that some such decorative motifs migrated directly from Muslim countries to Bulgaria. But it is equally possible that the migration took a detour. In fact, Sassanian

motifs had penetrated the art of Christian Armenia since at least the early seventh century, and this influx continued from the Muslim Caliphate which in 638 succeeded the Sassanian Empire and in 640 subjected part of Armenia. Sassanian ornament could thus just as likely have reached the Balkans from Armenia, and this likelihood is strengthened by the fact that the beautiful masonry of Pliska – with no link whatever to the brick architecture of Mesopotamia – nowhere finds in appearance so close a parallel as in Armenia.[36] Ties to Armenia would explain also the plan and construction of St Sophia at Ohrid and the Panaghia at Skripou. The plan, a domed hall-church, and its design in solid masses have often been linked to Armenian and Georgian building. The stonework too recalls, if loosely, Armenian stone building. Finally, the ornament of Skripou – from the bands curving over the windows to the series of decorative plaques along the apse [280] – shows, intermingled with substantially Byzantine elements, decorative devices of Sassanian origin.[37] Immigrants, either coming across the Black Sea

from Armenia or northern Asia Minor, or long settled in Thrace, could easily have brought to Bulgaria such Sassanian ornamental devices, whence they would have drifted down into Central Greece.[38] Thus both St Sophia at Ohrid and the Panaghia at Skripou seem to represent, c. 870, a style linked to the architecture of the Bulgar court at the time of its conversion to Christianity and permeated by elements of decoration and construction brought from afar. During the following half-century the architecture of Greater Bulgaria takes a new turn. On the one hand it looks more decisively than ever towards contemporary Byzantium – a development we shall discuss later. On the other hand, it models itself on the far distant local past, both the great churches of the sixth century and Roman Late Antique monuments.

From the late ninth to the end of the eleventh century large basilicas were laid out in Greater Bulgaria, some with, others without galleries, and all much like those built in the Balkan provinces of Justinian's days.[39] At times, in fact, doubts have arisen regarding either a sixth- or

280. Skripou, Panaghia, 873/4.
Ornament frieze, apse

ninth-century date for such buildings. The episcopal church at Aboba Pliska, for example, has occasionally been assigned to the sixth century, reversing a contrary dating of 864–86, just after the conversion of the Bulgar czars. Indeed the scale – 99 m. (325 ft) in length – and the main lines of the plan resemble those of any major church of Justinian's time in the Balkan provinces, including atrium, narthex, alternating nave supports, galleries, vaulted chancel, pastophories, and, possibly, six towers [281]. Other features, however, suggest the ninth century: the rooms inserted between aisles and pastophories, presumably dressing rooms (*mitatoria*), as they are known from the Imperial ceremonial at Constantinople;[40] and the construction technique of well-hewn stone blocks, like those at Pliska, albeit alternating with brick bands. Other basilicas in Greater Bulgaria are undoubtedly of ninth-century date and later: H. Achilleos, prior to 1002, on an island in the Prespa Lake, with semicircular apse, flanking pastophories, colonnaded tribelon, and heavy piers, carrying the arcades of nave and galleries;

blocks incorporated into the lower portions of the fourteenth-century church at Staro Nagoričino [393].[41]

It has been suggested that these basilicas represent a renascence of sixth-century prototypes, not a survival, as formerly maintained. Indeed it is hardly plausible that the tradition of building large and lavish basilicas could have weathered nearly three hundred years of unbroken pagan occupation. On the contrary, a late-ninth- and tenth-century renascence of Justinian's style in Greater Bulgaria finds a natural explanation in the desire of the czars, by then fervently Christian, to claim legitimacy and, indeed, succession to the throne of Byzantium. Consistently (much like the Carolingian emperors a century before) they would strive to revive the Imperial architecture best known to them – Justinian's buildings in the Balkans.[42] Similar concepts of a 'renascence' could have been operating when the Round Church at Preslav was laid out [282]. The traditional date in the first third of the tenth century and the identification as the palatine chapel of Czar

281. Aboba Pliska,
basilica, ninth century(?). Plan

N

| 0 | | | 120 FT |
| 0 | | | 40 M |

a basilica, dating possibly from the ninth century still, found below the fourteenth-century Ljeviška church at Prizren in Yugoslavia, and, not far from there, another basilica, erected in 1067–71, parts of its stark outer walls of ashlar

Simeon (893–927) have been recently questioned; however these still seem more convincing than the proposed sixth-century date.[43] Comparatively small, the church complex at Preslav opens with a forecourt, 13·50 by 16·50

m. (44 by 54 ft) [282–4]. Narrow niches billow from its walls, linked on the outside by semi-cylindrical buttresses. Inside, small columns, one foot in diameter, line the walls at a distance of only 50 cm. (20 in.). From this atrium one

Middle Byzantine building, the new style which was just developing at Constantinople at the turn of the tenth century. Indeed, the Round Church at Preslav has numerous elements in common with the first churches built by the Mace-

282. Preslav, Round Church and fortification, early tenth century(?). From the east

entered a narthex – more accurately, a fore-church. Divided by two pairs of columns into a nave and aisles, it was surmounted by an upper floor, no doubt the ruler's gallery, reached by round stair-turrets in the corners. The church proper was circular and domed, with three entrances, apse and chancel, and four niches on either side billowing outward between strong projecting buttresses. Its walls were lined by two tiers of colonnettes, barely $\frac{1}{2}$ m. in diameter, 3 m. high, and only 60 cm. apart (1 ft 6 in. by 10 ft by 2 ft). In the upper tier the octagonal shafts were decorated with variegated inlay. The walls were revetted with glazed tiles painted with floral and geometric motifs. Much of this is rooted in older Byzantine tradition; other elements de-rive from the principles and the vocabulary of

donian Emperors, and with their palaces – elements known either from extant buildings or from literary sources. To begin with, there is its very function, presumably as a palace chapel – that eminently Byzantine architectural type which is referred to time and again in the court ceremonial of the tenth century, and which had probably already served as a model for Charlemagne's chapel at Aix-la-Chapelle. There is the *kyptikon*, the ruler's gallery, above the entrance porch; the colourful decoration of walls and colonnettes; and finally, the small scale of the structure – the rotunda measuring but 10·30 m. (34 ft) across. But these elements stand within the framework of an overall design of a very different tenor. The egg-and-dart, palmette, and half-palmette friezes carved on

the cornices of the church at Preslav are often of a design so classical as to suggest copies from Greek or Roman models rather than the drier and more formal ornament of Middle Byzantine Constantinople; others recall the fleshy patterns of Sassanian decoration [285]. Inlaid columns were customary in Constantinople from the sixth century, as witness those from H. Polyeuktos and H. Euphemia [178, 179]; it is likely that the type continued into Middle Byzantine

283. Preslav, Round Church,
early tenth century(?).
Section (reconstructed) and plan

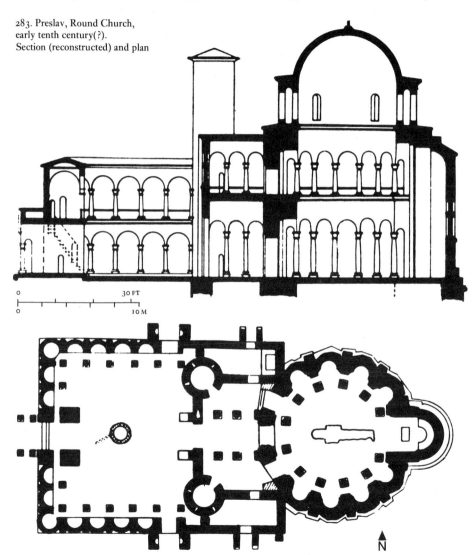

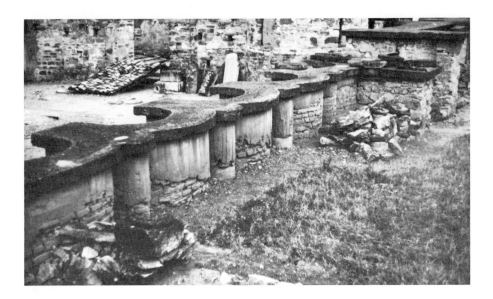

284 (*above*). Preslav, Round Church,
early tenth century(?).
Atrium from the south-west

285 (*below*). Preslav, Round Church,
early tenth century(?). Cornice

times. More important, the circular plan with
billowing niches is so close to Roman mausolea
of the third and fourth centuries that a revival of
such prototypes, Imperial or believed to be Im-
perial, seems most plausible to explain the

Round Church at Preslav. Specifically, the
double tier of columns which curtain the walls
recalls the Mausoleum of Diocletian at Spalato.
It may be premature to speak of a 'Bulgarian
Renaissance' of the tenth century.[44] But a re-
surgence of elements from Rome and Justinian
in tenth-century Greater Bulgaria is highly
likely. Whether or not this resurgence was
sparked by the parallel movement in Dalmatia
during the ninth century is a question un-
answerable at our present state of limited
knowledge.

ARMENIA AND GEORGIA

The kingdom of Armenia was a border state,
divided in 387 into Roman-Byzantine and
Sassanian spheres of influence. From 301 on,
Christianity was the State religion. The eastern
parts of Armenia came under Persian rule in the
fifth century, under Muslim suzerainty in the
seventh. But even then the country remained
semi-autonomous in her policy and emphati-
cally Christian, though opposed to the dogma

and the political claims of the Church of Constantinople. However, relations with the Byzantine Empire remained close, and Armenians rose to high positions in the Imperial administration long before a family of Armenian descent came to occupy the throne of Byzantium – in 867 with Basil I. Armenia herself, split into smaller principalities in the ninth century, survived until the late eleventh century. When at that time she fell to the Seljuks, Armenian nobles emigrated to Cilicia and set up a new kingdom which lasted to the end of the fourteenth century.[45]

To this day Armenia is studded with churches, monasteries, and fortifications – in ruins or well preserved – reaching from the fifth or sixth to the fourteenth century, long after the Seljuk Conquest. A remarkably large number of buildings are dated by dedicatory inscriptions or by contemporary chronicles. In our context we shall focus on the period prior to the eleventh century and on the relation, as I see it, of Armenian to Early Christian and Byzantine architecture.

The beginnings of Armenian church building in the fifth and sixth centuries have long been linked to Syria. However, the ties to the highlands of Asia Minor south and west of the Armenian border, including Cilicia and the hills of northern Mesopotamia in the region of the Tur Abdin, were apparently no less close.[46] In the church at Ereruk, unmistakable features point to Syria, and to a date near to or even before 500: the twin-towered façade, the chambers flanking the apse, the gabled portals along the flanks, the classical profiles framing the windows. But the towers are pushed sideways – an Anatolian rather than a Syrian feature [286A] – and aisles and nave were barrel-vaulted, as in the many small hall-churches still surviving on the high plateau of Asia Minor (and presumably in large churches which have been lost). The beautiful masonry of large stone blocks, facing a narrow core of rubble, is linked to Cappadocian and

286. (A) Ereruk, church, *c.* 500. Plan
(B) Ptghavank', church, *c.* 600. Plan
(C) T'alinn, church, *c.* 662-85. Plan

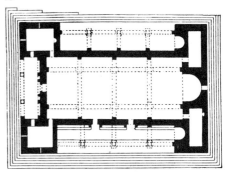

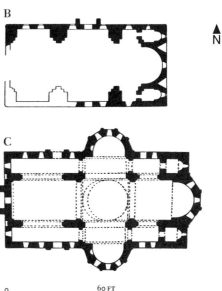

Cilician building techniques, and ultimately goes back to Roman provincial tradition. A group of hall-churches in Armenia, contemporary with or later than Ereruk, shows the Syrian element in decline and the impact from Asia Minor further increasing: at Eghvard (574-

603) – as at Tekor in its first, fifth-century phase – the decorative details, including horseshoe arches, are so close to those of Cappadocian churches as to suggest the activity in Armenia of Cappadocian mason crews.[47]

The seventh century sees a break with this earlier tradition. Hall-churches and barrel-vaulted basilicas give way to a wide variety of centralized longitudinal churches and truly centrally-planned buildings. The impact of Syrian and Cappadocian architecture, however, does not immediately cease. The double-

potamian sources: basket capitals surmounted by Ionic volutes, recalling Mayafarquin; eagle capitals; vine-scroll friezes; classical profiles. The doubled colonnettes which supported the circle of blind arches on the outer wall could equally derive from Mesopotamia.

The late sixth and the seventh centuries are indeed the great centuries of church building in Armenia. Immensely productive in the sheer number of structures, incredibly rich in the variety of central church plans, this architecture is yet hard to define as to its place within

287. Zvart'nots, tetraconch church,
641–61, possibly before 652. View of remains

shell quatrefoil, so frequent in Syria in the sixth century – at Bosra, Apamea, Aleppo, R'safah – was taken up in the palace martyrium built at Zvart'nots, possibly before 652, by the Armenian patriarch Narses III (641–61) [287].[48] The decoration also reveals Syrian as well as North Meso-

the framework of Early Christian and Byzantine building – previous, contemporary, or later. At Tekor, a dome and high cross arms were raised over nave and aisles of the older hall-church. The churches of Ptghavank' (Ptghni) and T'alish (Aroudz) were both laid out from the

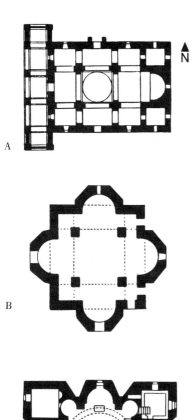

288. (A) Vagharshapat, St Gayané, 630. Plan
(B) Bagaran, church, 621-8 or 624-31(?). Plan
(C) Vagharshapat, St Hrip'simé, 618. Plan

outset with aisleless naves, barrel-vaulted and flanked by three niches with transverse barrel-vaults; the centre bay of the nave was surmounted by a dome on pendentives; the flanking middle niches correspondingly were raised transept-like, thus forming a cross-domed hall with niches [286B].[49] All these buildings and rebuildings have been dated to the last third of the sixth and the early seventh centuries; rightly, it seems, since the cathedral excavated at Dvin, as rebuilt in 608-15 and solidly dated, and the similar church at T'alinn [286C], only vary the plan of the cross-domed hall-church by adding three apses, one each to the ends of the nave and the cross arms.[50] Equally frequent are genuine central plans. There is a group of free-standing cross churches.[51] There are cross-in-square structures, divided into nine bays; the cross arms radiate from a domed and towered centre bay and are raised high above the corner bays. The shape of these latter – squarish as in the Gayané church at Vagharshapat (630), or slightly elongated, as in the cathedral at Mren (629-40) – determine the square or rectangular plan of the entire building [288A]. At Bagaran, dated, though insecurely, 621-8 or 624-31, the corner bays are shrunk to the size of tiny squares, while apses project from the cross arms and transform the structure into a quatrefoil [288B].[52] The church type which more than any other has been called specifically Armenian appears in the seventh century at Avan (after 611?) and at St Hrip'simé at Vagharshapat (618) [288C, 289, 290].[53] An octagonal centre bay is surmounted by a dome. From this core radiate, on the main axes, four cross arms, terminated by apses. In the diagonals appear four steep and narrow cylindrical corner niches. The interior, then, forms a kind of cross-octagon, and the corner niches may well have been designed to abut the diagonal thrusts of the dome. Four sacristies, square or round, are placed behind the niches and fill the spaces between the arms. All this – octagon, cross arms,

289 (*below*). Avan, church, after 611(?). Interior

290 (*opposite*). Vagharshapat, St Hrip'simé, 618. Interior

corner niches, and sacristies – is enclosed within a massive masonry cube, alleviated only by steep triangular slits on the exterior between apses and sacristies. The type continues (or is it revived?) nearly unchanged into the tenth century and beyond when it is found at Aght'amar in Lake Van (915-21) [291, 292].[54] Finally, the cathedral of Zoravar near Eghvard, dated 662-81 and now in ruins, forms an inner octagon with eight niches projecting, but caught in the massive enclosure of an outer octagon.[55]

Building materials throughout are large, well-cut stone blocks facing a narrow core of rubble masonry. The decoration is kept to a minimum: three or four steps at the foot of the walls; flexed arches surmounting, or a band curving above the windows; a row of brackets or a profile marking the eaves lines; 'cube capitals' with semicircular faces, with or without crude foliate or geometric decoration; Ionic capitals transposed into geometric shapes. It is a rustic, though anything but simple architecture, impressive because of its massiveness and its sparseness of detail. But this impressiveness is counter-balanced by the comparatively small size of the structure. The cathedral of Mren, one

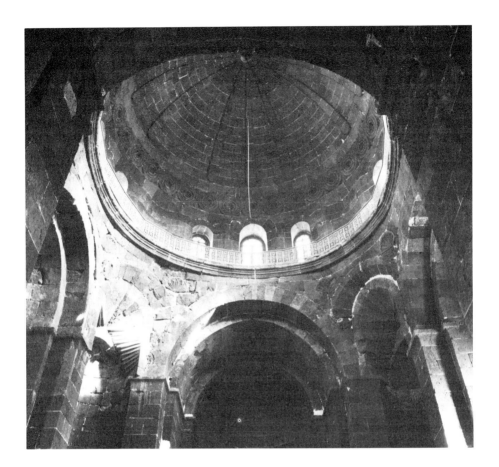

of the largest churches in seventh-century Armenia, measures but 20 by 29 m. (65 by 95 ft). Barely larger than a minor Syrian village church such as St Paul and Moses at Dar Qita, and a good deal smaller than the Syrian 'cathedrals', St Hrip'simé covers an area 17 by 21 m. (56 by 69 ft), comparing in length and width with the cross church of Tomarza in Cappadocia, and covering just about one third the surface of the H. Sophia at Salonica. Armenian church building of the seventh century, then, in material, decoration, and size, continues traditions established in the inlands of the Near East by at least the fifth and sixth centuries, if not indeed since Roman times. Even less complex types among the churches of Armenia still recall the architecture of Cilicia and Cappadocia, in individual features or even as a whole. Apses or forechoirs may be flanked by lateral chambers, apses enclosed in the mass of a straight wall or terminated on the exterior by three or five sides of a polygon. The cross-in-square plan itself of the Gayané church and of the cathedral at Bagaran, at first glance anyway, recalls the audience hall of Al-Mundir at R'safah, of *c*. 560. Free-standing cross chapels

such as Ashtarak in Armenia were common in Cappadocia. To some extent, then, Armenian centrally-planned churches of the seventh century – like their longitudinal predecessors – are embedded in a tradition of church building basic to the inlands of the Near East for two and three hundred years.

On this everybody agrees. But opinions are widely split regarding the further implications of such a consensus: on the one hand, the remote background of the common Near Eastern heritage is in question; on the other, the argument concerns the possible impact of Armenian on Byzantine, or vice versa, of Byzantine on Armenian seventh-century architecture. Based on Strzygowski's theories, a section of scholarly opinion insists that Christian building in the interior of the Near East in general, and Armenian architecture in particular, is rooted in Sassanian and, further back, in Central Asian building traditions. In particular, the technique of dome construction in Armenia is stressed to support such hypotheses. Indeed, Armenian masons used a device unknown to Rome and rare in Byzantium but customary in Parthian and Sassanian buildings in Iran and Mesopotamia: squinches thrown astride the corners to support the dome, always used in conjunction with an octagonal bay and frequently, though not exclusively, when the dome surmounts a square bay. The steep cylindrical corner niches which support such squinches and buttress the dome in a church such as St Hrip'simé have likewise been attributed to Iranian models. Church plans in Armenia are also traced back to Parthian and Sassanian architecture. The cross-in-square plan, for instance, is supposed to be rooted – whether directly or by way of buildings such as the audience hall of Al-Mundir at R'safah – in the design of Iranian Fire Temples.

We need not concern ourselves unduly with the wider claims which have mushroomed from the soil of such hypotheses. That the Iranian domes on squinches derive from wooden houses in North India and Central Asia, or from the tents of Mongol tribesmen, is neither demonstrable nor plausible. Nor is it likely that S. Lorenzo in Milan or the H. Sophia in Constantinople were designed by Armenian architects. All such exaggerations reveal dangers constantly present in this line of thinking: ahistorical reasoning; overstress on technical devices; paper resemblances of plans; and an outlook isolating Eastern, that is Sassanian or Asian, from Western, that is Roman or Byzantine, architecture. Primitive huts are much the same, from the igloo of the Eskimo and the yurte of the Mongolian to the hovel of the Egyptian fellah and the round home of the Etruscan farmer as reflected in the tomb mounds; derivations of complex building types from primitive forms have little validity. Nor is it admissible to postulate the presence in Armenia of building types three or four centuries before their first proven appearance in dated structures. Secondly, technical devices alone are not style-generating, and the design of St Hrip'simé could not have been evolved only from squinches and corner niches. Thirdly, comparison between such buildings as the cross-in-square of Bagaran and of Sassanian Fire Temples, or, for that matter, between these and the audience hall of Al-Mundir, is tempting on paper, but they are quite different in the design of radiating cross arms in the case of the audience hall and of Bagaran, and of enclosing corridors in the instance of the Fire Temples. Lastly, it is unthinkable that Roman and Sassanian architecture should not have influenced each other; or that Armenian centrally-planned churches, when they first appear in the seventh century in highly complex forms, should not have also experienced the impact of the great Byzantine central-plan articulation of the time of Justinian and after.

To me this seems the decisive question. By the seventh century, the architects of Armenia have shifted from longitudinal to central plans,

or else they fuse centralizing elements into longitudinal hall-churches and into aisleless churches with flanking chapels. No preparatory steps can be traced anywhere in Armenia; likewise attempts at tracing a development from longitudinal to central church plans have so far failed. Architectural developments beyond the Armenian borders therefore inevitably come to mind. The fusion of a domed-cross plan with the aisleless and hall-churches of Armenia might well be interpreted as a variant of Justinian's standard cross-type superimposed on the building tradition of the inlands of the Near East; the more so since not infrequently (at T'alinn for example) the dome in these Armenian buildings rests on pendentives, not on squinches. The cross-in-square plan – we will revert to it – had been absorbed, or in fact developed, by Roman architects as early as the second century, and no doubt by the seventh century was common property of the Byzantine provinces in the East. Finally, octagonal buildings with projecting niches enclosed in a massive cube of masonry, as at Zoravar, call to mind Roman mausolea. This type was common, but to date has not been found either on the high plateau of Asia Minor, in Cilicia, or in Armenia. At this point we can only wait patiently for further evidence. The cross-octagon plan with quatrefoil apses and corner sacristies, as it appears at St Hrip'simé, presents an even more complex problem. It has been compared, to be sure, with Roman mausolea plans, but the confrontations remain vague and unsatisfactory.

On the basis of our present knowledge we should much rather view these centrally-planned churches in Armenia as the creation of a local school of architects. After all, central plans in Armenia came to the fore during the last years of the sixth century in innumerable variations, and cross-octagons such as St Hrip'simé are only the most complex among a plethora of central plans. All these churches evolve almost simultaneously and without manifest ancestry on Armenian soil. Obviously they originated within the complex mesh of political, religious, and cultural relationships in which Armenia was involved. The links to neighbouring Georgia are obvious and the question of precedence still under discussion.[56] Technical devices, such as the squinch and the corner niche, very possibly Iranian in origin, certainly played their part in shaping the new centrally-planned churches.[57] Roman mausolea types may have been influential. However, it seems more important to recall that the new central plans gain momentum in Armenia shortly after they had become the only church types truly acceptable to patrons and builders in the Byzantine provinces and in the capital. The cross-in-square plan in Armenia, although in all likelihood linked to Syrian precedents, has been transformed so as to recall – with equal or indeed greater strength – cross-domed churches and their timber-roofed ancestors – or followers, whatever they may be. The tall, powerful corner piers bear little resemblance to the stumpy cross piers of Al-Mundir's audience hall; they call to mind the corner piers of the Cumanin Camii at Antalya and, even more strongly, the powerful corner supports of the H. Sophia in Salonica and the dark, tiny spaces concealed in them. No doubt, Armenian and Byzantine centrally-planned churches differ vastly in their basic concepts. Armenian architects think in terms of cramped space and of solid mass. The interiors are hemmed in; quatrefoils or octagons are prevented from expanding. The basic idea of a structure on a central plan, engendered as it is in my opinion by the development of building of Justinian's age and that following his, conflicts in Armenia with the architectural tradition of the inlands of the Near East from which Armenian architecture had originally sprung. Armenian building thus remains torn between two conflicting concepts: that of the Early Christian Near East, conservative and ever bound to Roman pro-

vincial custom, and that of Justinian's Byzantium, immensely fresh and progressive.

This dichotomy remains inherent throughout the further history of Armenian architecture. The development through the eighth and ninth centuries remains somewhat obscure, but the tenth century experiences what appears to be a renascence of seventh-century building types and concepts. The church of the Horomos Monastery at Goshavank, built in 928-53, and the cathedral of Ani (Kemah) of 989-1001 – it was built by the architect Trdat – both take up the plan of the cathedral of T'alish with only minor differences. The church of the Holy Cross at Aght'amar, built in 915-21, revives after three hundred years the cross octagon plan of St Hrip'simé, with the difference that the exterior mass expresses more clearly the volumes [291, 292]. But the principal changes in all these later buildings concern the vocabu-

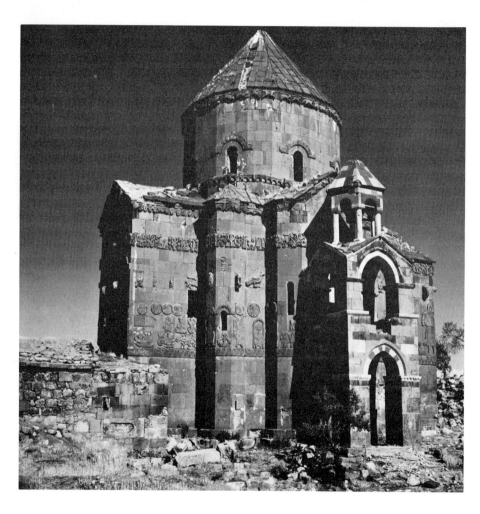

291 and 292. Aght'amar, Holy Cross, 915–21. Exterior from the south-west (*opposite*) and interior facing north (*below*)

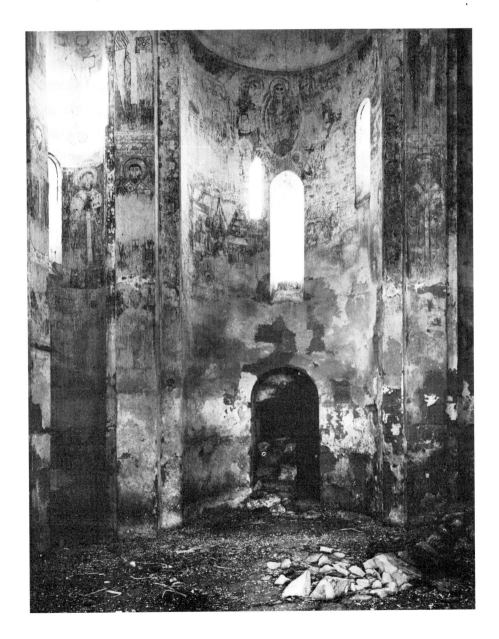

lary. The piers are more complex in design; half-columns take the place of half-piers. The exterior walls are covered with decorative sculpture, as at Aght'amar; or they are articulated, as at the cathedrals of Ani and Marmashen (986–1029), by blind arcades resting on slender colonnettes, single or in pairs.[58] Arches and capitals are covered with a web of geometric or floral ornament. Beginning with the eleventh century, church porches are frequently covered by a system of intersecting cross-arches, recalling Lombard rib-vaults. Despite such innovations in vocabulary, however, the design of space and mass and the relation of solids and volumes remain basically unchanged.

More often than not, Armenian churches of the tenth and eleventh centuries recall the Romanesque cathedrals of Western Europe. As a result, Armenian church building has been given, at least at times, the position of a life-spending source for much of later European and Byzantine architecture. Romanesque builders supposedly received from Armenia the stone technique and the articulation of the wall by blind arcades resting on colonnettes. Gothic builders supposedly acquired the rib-vault by way of Armenia; Byzantine architects, the dome placed on squinches to cover an octagon; and Leonardo and Bramante, the central plans they employed for their churches, including St Peter's in Rome.[59]

Such sweeping claims have rarely been accepted.[60] The comparisons are as a rule ill-defined. St Peter's in Rome and St Hrip'simé at Vagharshapat resemble each other but vaguely, and only on paper. The cross-arches of Armenia are not Lombard rib-vaults. Leonardo was certainly not in Armenia, nor were the Gothic architects of France acquainted with Armenian vaulting. But it would be foolish to deny that Armenian architecture could occasionally have exerted its impact on Western, and, above all, on Byzantine building. It is perhaps of lesser importance that Trdat, the architect of the cathedral of Ani, was called to Constantinople to rebuild the dome of the H. Sophia, badly damaged in 989 by an earthquake. He might have been summoned as a technician. Yet it is undeniable that the plan of Skripou – a hall-church with inserted cross arms and dome, its design in solid masses and confined interior volumes, its sparse decoration, and its technique of heavy stone construction – is as customary in Armenia as it is exceptional in ninth-century Greece. Similarly, in the tenth and eleventh centuries the dome carried by corner squinches above a square bay may well have reached Greece – and, I would add, Constantinople – from Armenia, where it had been well established since the seventh century.[61]

Of all the border countries of the Empire, Armenia is the only one to deal with Byzantine architecture on an equal footing. But the differences between Byzantine and Armenian building – in design, construction, scale, and decoration – cannot be too strongly stressed.

MIDDLE BYZANTINE ARCHITECTURE
FROM THE MACEDONIAN EMPERORS
TO THE LATIN CONQUEST (864–1204)

CHAPTER 15

.

INTRODUCTION

The rule of the Macedonian, Comnene, and the shortlived intervening dynasties, from 867 to 1204, marks a high point on many fronts: in learning, in the arts, in religion and politics. The period has been called the 'Macedonian Renaissance'. But the term Renaissance is ambiguous, because of its primary and almost exclusive implication of a rebirth of Roman-hellenistic antiquity. On the other hand, the new flourishing of Byzantine culture certainly starts before the ascendancy of the Macedonian House, and its effect remains throughout the reigns of the Dukas (1059–81) and the Comnenes (1081–1185), up to the conquest of Constantinople by the Latins in 1204.[1] In the arts, the period has been called the Middle Byzantine Age. This term is not fortunate either. It recalls too closely the Western Middle Ages. Yet we shall use it in this book. It does, after all, isolate as a separate entity art from the ninth to the end of the twelfth century, setting it off against Early Byzantine art, from Justinian to the end of the century of iconoclasm (726–843) on the one hand and on the other Late Byzantine, from the resurgence of the Empire, c. 1250, following the Latin occupation, to the conquest by the Turks in 1453.

The beginnings of the Middle Byzantine Age are clearly marked. Iconoclasm collapsed in 843, and the Church was pacified. The refusal of Photius, the patriarch of Constantinople (858–67 and 877–86), to recognize the supremacy of the Roman See was no definite break with the West; the definite schism between the Churches of Rome and Byzantium was to come only in the second half of the eleventh century.[2] But it established Constantinople – the only patriarchate left outside Islamic domains – as the supreme spiritual authority in the East, and from the time of Photius, the patriarch was considered the spiritual, the Emperor the temporal head of the *oikumene*, the inhabited world, as far as it was ruled from Byzantium.

In temporal affairs the power of the Emperor theoretically was unlimited. In practice, the intrigues of bureaucracy, army, navy, harem, and court led to continuous palace revolts and functioned as a check to Imperial strength. On the other hand, the efficient, continuous administration of the capital and the provinces was guaranteed by a permanent civil and military service: the officers' corps and the higher administrative and diplomatic ranks – drawn

largely from the landed nobility – balanced by a hierarchy of court charges.

Reforms in the administrative and legislative areas stand alongside new activities in the applied sciences, the humanities, and the arts. Under Basil I (867–86) and Leo VI (886–912) the Code of Justinian was reorganized, brought up to date, put into Greek, and thus adapted to contemporary use. The Emperor Theophilus (829–42), possibly stimulated by Arab technique, built a number of complex automata. Presumably at the same time, 'Greek fire' was invented, the dreaded weapon of the Byzantine navy. The university of Constantinople, closed during the iconoclastic centuries, was reopened and successively reorganized, with the primary aim of training an efficient and knowledgeable civil and diplomatic service. Its education was based on a thorough reading of the Greek classics, philosophers, dramatists, poets, historians, rhetoricians, mathematicians, geographers, and medical writers. The reading programme of Photius gives an idea of the astonishing breadth and depth of Byzantine learning, just as his sermons demonstrate the sophistication of Byzantine language and thought. The writings of that encyclopedist on the throne, Constantine VII Porphyrogenetos, not only illustrate the involved court ceremonial of the tenth century; they also show a remarkable political acumen and a thorough acquaintance with foreign countries, especially the Slavic world, acquired by way of diplomatic reports. In causing the Chronicles of Theophanes to be continued, he provides for posterity a thorough account of the Macedonian House and its deeds.[3] Michael Psellos recounts the court intrigues of the mid eleventh century in vivid, classicizing Greek.[4] A popular eleventh-century epic, *Dighenis Akritas*, glorifies the ninth- and tenth-century wars against the Caliphate, and the princess Anna Comnena composed the hundreds of pages of the *Alexiad* in praise of the deeds of her father, Alexius I (1081–1118), in war and peace.[5] All

this rests on the tradition which, since the sixth century, in the cultural centres of the Byzantine Empire and particularly at Constantinople, had blended a classical vocabulary with Christian thought; a tradition which, from the ninth century on, was immensely strengthened in the figurative arts as well as in literature and learning. The illuminated manuscripts, from the Paris Psalter (Bibl. Nat., gr. 139) to the *Menologium* of Basil II (Vat. gr. 1613), speak as clearly as the ivory plaques and caskets and the goldsmiths' and silversmiths' work of the late ninth to the end of the twelfth century.

This high level of culture was evolved and retained regardless of domestic upheavals and the political fortunes of the Empire abroad. The position of Byzantium in the Middle East, the Balkans, and eastern Europe was not primarily determined by the changing fortunes of war. It was not seriously checked by defeats, such as the rise of the Bulgarian Empire and the repeated Russian incursions against Constantinople during the ninth and tenth centuries, and finally in 1071 the catastrophic loss to the Seljuks of Asia Minor except for the Black Sea coast and a few isolated cities along the south coast. Nor was the standing of the Empire impaired by decades of military and palace revolts from 1030 to 1080 or, for that matter, enhanced on the international scene by military successes: counter-offensives in Dalmatia and South Italy under Basil I (867–86) and Nicephoros Phocas (963–9); the temporary reconquest of Syria under Nicephoros Phocas and John I Tzimiskes (969–76); and the reoccupation of the Northern Balkans under Basil II, the Bulgar-Killer (1018). In fact, regardless of the military situation, the position of the Empire both in the East and the West is as firmly established as ever, if not more firmly, during the reigns of the Porphyrogenetos (912–59), of Romanos I Lekapenos (920–44), and finally of the Comnene Emperors Alexius I (1081–1118), John II (1118–43), and Manuel I (1143–80).

For the standing of Byzantium in these centuries rests on very different circumstances: its position at the crossroads of the Western, Islamic, and Slavic worlds; its diplomatic skill coupled with the marriage policy of the Imperial houses; its trade east, north, and west; the expansion of its religious and cultural sphere of influence. Negotiations and payments to its underdeveloped neighbours and trade agreements rather than wars became the principal weapons of the Empire. Commercial relations with the Arab countries, though as a rule illegal, continue. Of greater importance are the trade routes which, from the ninth century, cross Russia to link Byzantium with the Scandinavian countries, and traverse the Balkans to connect with the valley of the Danube and with Central Europe. Simultaneously the young merchant republics of Italy, from Venice to Genoa, Amalfi, and Pisa, establish compounds in Constantinople, and their fleets export to Western Europe goods collected from all over the North and East. In the last third of the ninth century, two missionaries from Salonica, Kyrillos and Methodios, christianize the Serbs, Bulgars, Moravians, and Czechs and thus become the Apostles of the Slavs. Owing to their mission the Balkan peoples, Serbs and Bulgars, submit permanently to the spiritual domination of Constantinople. One hundred years later, the principality of Kiev, its ruler converted to Christianity in 967, is turned from an unruly foe into a close ally of the Empire, both spiritually and politically. Through Kiev, Byzantine influence is carried as far north as Novgorod and Vologda. The Princes of Kiev as well as the Bulgarian Czars – whether at war or peace with Byzantium – take Constantinople as their model both in court ceremonial and in art. In the West, Venice in the tenth century begins increasingly to model her diplomacy on that of Byzantium. By the late tenth and the early eleventh century, Byzantine building types reach Lower Saxony, presumably by way of the Balkan borderlands rather than directly from Constantinople. By the late eleventh century Byzantine mosaicists work at Monte Cassino, Byzantine metalworkers all over southern Italy. In 1063 an architect with a Greek name, Busketos, lays out Pisa Cathedral, and as early as the tenth century the Caliphs of Cordova call mosaic workers from Constantinople to Spain, as the Umayyad Caliphs in the seventh century had called them to Damascus and Jerusalem.[6]

Indeed, despite the Muslim onslaught, the Macedonian emperors maintained close diplomatic relations with the infidel rulers of at least southern Spain. To the Caliphs of Cordova, the Byzantine Emperor was still a major political figure and his capital a cultural centre of the first magnitude. The esteem which the 'barbarians of the West' bestowed on Byzantium is thrown into relief by the marriage negotiations which Otto I eagerly pursued to obtain for his son the Byzantine princess Theophanou – apparently a poor cousin of the Imperial house. The reports of Otto's envoy to Byzantium, Liutprand of Cremona, are filled with ill-concealed admiration of the impressive, if slightly shoddy, glories of the Byzantine capital and court.[7] To pilgrims on their way to the Holy Land, whether Westerners or Russians,[8] Constantinople was *the* Imperial city: Micklegarth or Czarigrad, filled with countless treasures, relics, reliquaries, icons, buildings. To the Byzantines, on the other hand, Bulgars, Russians, Italians, Germans, and French alike were powerful, uncivilized barbarians. Mistrust, well justified, marked the Byzantine attitude towards the Crusaders. Seen as fellow Christians, but dangerous allies and protectors, from 1096 to 1192, they became outright enemies in 1204 when they occupied Constantinople.[9] In Byzantine eyes, one must remember, the Emperor of Byzantium always remained the only true Emperor, the *basileus tōn Rōmaiōn*; his domain, ever smaller and feebler, remained the Roman Empire; his court was the one Imperial court; his capital, the one Imperial capital on earth.

THE NEW BUILDING TYPES

AND THE 'MIDDLE BYZANTINE RENAISSANCE'

With the middle of the ninth century, the church plans of the times immediately after Justinian generally disappear from the architectural centres of the Empire. Their place is taken by new types, widely differing among each other in plan, yet closely related in stylistic concept. The nomenclature of the new types is often confusing, and some explanation is in order. Likewise their origin is far from clear. In their great majority the new Middle Byzantine church types are either freshly invented, or they trans-form older types so radically that they are as good as newly created.[1]

Older plans of the period after Justinian are nevertheless retained or revived, mainly along the borders of the Empire and its sphere of influence in politics and culture. Military architecture remained practically unchanged. When the city walls of Nicaea (Iznik) [293] were rebuilt after an earthquake in 1065, the eleventh-century parts differed from the original Early Byzantine sections only in their masonry tech-

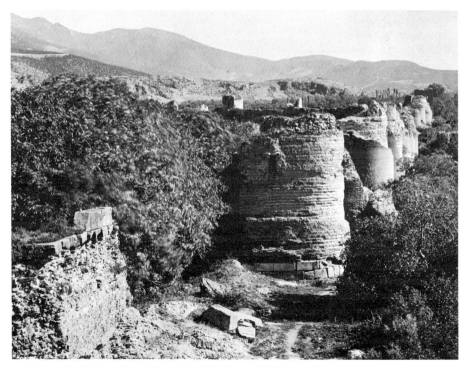

293. Nicaea (Iznik), city wall, south, near Yenişehir Gate, rebuilt after 1065

nique and in very minor details. In church buildings such conservatism is less frequently found. Timber-roofed basilicas provided with galleries had been outmoded for nearly five hundred years in Constantinople and the core provinces of the Empire. From the late ninth to the eleventh century, they stage a comeback at the courts of the 'barbarian princes' in the Balkans and in the West. In Bulgaria, this reversion has been explained as the revival of a plan firmly rooted locally throughout the entire sixth century. The reasons for this 'renascence' remain in doubt. One reason may have been the desire of the newly converted rulers and their ecclesiastical advisers to impress a still pagan population with huge, if simple, church buildings; another may have been the desire to emulate the great rulers of the past, primarily Justinian, himself a native son of the Balkans. At the Ottonian court in Lower Saxony, the church of Gernrode was completed after 971 by adding a nave with galleries above the aisles, a feature previously quite unknown north of the Alps. Attempts have been made to link the appearance of the type with the founder of Gernrode, the Byzantine-born Empress Theophanou.[2] It would have been her influence, the argument goes, which determined a church type similar to those of her native surroundings. Considering the obsolescence of the type in tenth-century Constantinople, the explanation is not very satisfactory, and we wonder whether the advisers of Theophanou did not rather have in mind the churches built at just that time by the flourishing court of the Bulgarian czars. However, basilicas were built or remodelled even in the very heart of the Byzantine Empire when local conditions demanded such obsolete plans. As late as c. 1065, the church of the H. Sophia at Nicaea (Iznik) was rebuilt as a basilica on the foundation walls of an older similar building, presumably of the fifth or sixth century.[3] Other obsolete types are also resuscitated in the eleventh century in the Empire and beyond its borders.

Cross-domed plans, long out of date in Constantinople and the central provinces, were carried by Constantinopolitan masons to the courts of South Russia from the first half of the eleventh century onwards; and after 1070 – beyond the western frontiers of the Empire – Justinian's five-domed church of the Holy Apostles was copied, although transformed, at S. Marco as the palatine church of the Veneto-Byzantine oligarchy.[4] As a rule, then, such revivals of early church types are based on mixed ecclesiastical and political considerations.

Very different in character from reversions to obsolete plans in the sphere of the court are survivals of old-fashioned building types on a popular provincial level, either as a persisting local type or as a borrowing from another remote province. Examples are the small basilicas of north-eastern Greece, southern Yugoslavia, and Bulgaria, barrel-vaulted or timber-roofed, as witness the church of the Anargyroi at Kastoria, H. Theodora at Arta, the Kato Panaghia near by [294].[5] With their steep naves and wide arches, these structures dating from the tenth to the end of the fourteenth century recall nothing so much as the tiny basilicas and hall-churches at Binbirkilise – far distant in time and space. But then small churches, aisleless or basilican, must have been frequent from the fourth to the tenth century, barrel-vaulted in remote deforested mountain regions all over the Christian world.

Likewise, the plans of Late Roman and Early Christian mausolea and martyria apparently survived or were revived in the small trefoil and quatrefoil churches of Middle Byzantine times. Their number is large to this day, both near the capital and in the provinces: in Greece, the Balkan countries, and in Cappadocia. The Kubilidike at Kastoria in northern Greece is one, a church at Heybeliada on Halki in the Sea of Marmara another of many examples [295]. The wide spread of the type in Middle Byzantine times becomes clear when one realizes that the

294 (*below*). Kastoria, Anargyroi, first half
of the eleventh century. From the east

295 (*right*). Kastoria, Kubilidike, first half
of the eleventh century. Exterior from the south-east

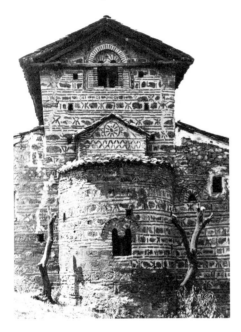

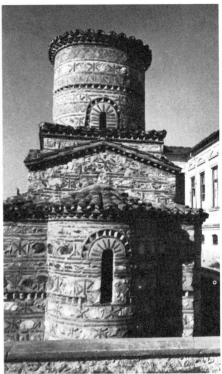

great majority of the structures were apparently either funeral chapels or chapels sheltering an important relic. They were objects of special popular veneration, just like the martyria of Early Christian times, or for that matter, the marabouts of Islamic saints. Their appearance in remote parts of the Empire in Middle Byzantine times may be explained as expressive of popular opposition to the sophisticated court architecture both within and on the outskirts of the Empire, the same popular conservatism which created the small vaulted basilicas of the eleventh century in the Balkans.[6]

Nevertheless, such survivals and revivals of obsolete church plans remain confined either to special circumstances or to local predilection.

The core of Middle Byzantine architecture is formed by building types either newly created or purloined from the outlying borderlands of the Empire and eagerly adopted by Middle Byzantine builders: the atrophied Greek cross plan and its variants; the octagon-domed churches; the related Greek-cross octagon; the ambulatory church; finally, the cross-in-square or quincunx plan.

The atrophied Greek-cross plan consists of but a centre bay with four very shallow arms and one or three apses, the apses at times preceded by short forechoirs. The barrel-vaults over the arms of the cross are hardly more than wide arches, and the dome over the centre bay is pierced by large windows. Groups of windows

are also placed high up in the end walls of the cross arms. The type is represented in Constantinople in the early twelfth century, for example, by the Chora church (Kariye Camii) in its original core. But the plan was in wide use long before. Near Constantinople it presents itself at Ereğli and Yuša Tepesi, both ruins of perhaps ninth- and tenth-century date, and at Sige, possibly in the eighth century. In Bulgaria it appears in a tenth-century church at Vunitsa (Vinitsa).[7] Possibly such atrophied Greek-cross churches were known as early as the eighth century. In any event, the plan seems to have developed from a more elaborate type, either from the Greek-cross churches of Justinian's time with deeper cross arms and corner bays, or from the cross-domed churches of the time immediately after Justinian. The atrophied Greek cross is, after all, but the isolated core of a cross-domed church: domed centre bay, shallow arms and chancel parts. But whatever their origin, the churches built on the atrophied Greek-cross plan do not determine the picture of Middle Byzantine church building. To understand more fully its character and its wealth, one wants to turn to octagon-domed churches, to combined Greek-cross and octagon plans, and to quincunx structures.

The octagon-domed church is laid out on a square plan [296]. Pilasters, cornices, and marble panelling divide the walls into two tiers, each tier comprising three bays: narrow, wide, and narrow. On the third tier, small stilted half-domes – hemispherical squinches – are thrown across the corners to form an octagon, while shallow arches rise in the main axis over the wider bays. Jointly, the bases of the squinches and arches form an octagon of unequal sides, inscribed in the main square. Finally, eight pendentives fill the space between arches and corner squinches, and create a circle from which rises the hemispherical dome, enclosed in a low drum. The type has survived in only a few examples, such as the Nea Moni on Chios and a

296 (*below*). Nea Moni, Chios, Katholikon, 1042–56. Plan

297 (*opposite*). Hosios Lukas, Katholikon, consecrated 1011 or 1022, and Church of the Theotokos, tenth century. Plan

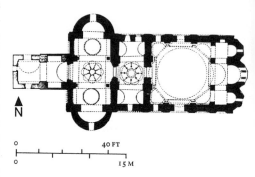

handful of later churches on the same island [318, 319]. But we know that it was brought to Chios from Constantinople.[8] It was thus presumably more widespread in Middle Byzantine times, both in the capital and the provinces, than is indicated by surviving examples.

The Katholikon at Hosios Lukas and the church at Daphni are the best-known and probably the most beautiful representatives of the Greek-cross-octagon plan. The core of the plan is again formed by the octagon-domed square, but the corner squinches are carried by L-shaped piers [297 *bottom*, 298, 344, 345, 347, 351, 352]. This core is then enclosed within a larger rectangle. Four tall cross arms, set between the piers, issue from the centre towards the outer walls of the second rectangle. Each arm is barrel-vaulted, and measures half the width of the centre square; the arm to the east projects in an apse. Between the four cross-arms, the corners

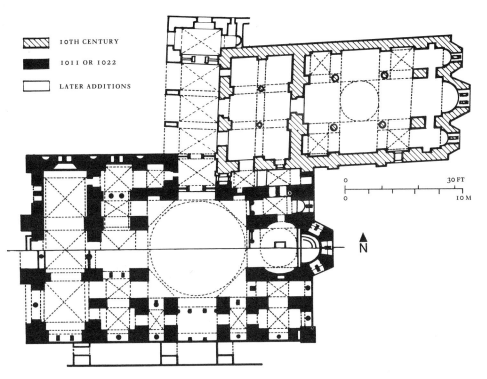

10TH CENTURY

1011 OR 1022

LATER ADDITIONS

30 FT

10 M

N

of the outer rectangle are filled by an ancillary belt of groin-vaulted or domed bays, including prothesis and diaconicon on either side of the chancel arm. As a rule – as at Daphni – this ancillary outer belt is one-storeyed and thus subordinate to the cross arms and the domed centre [351]. But occasionally, as at Hosios Lukas, the outer bays are surmounted by a gallery, closed at the corners but wide open below the encroaching barrel-vaults of the cross arms. In either case the dominant features remain the wide, expanding octagon, the broad dome placed on corner squinches, the subordinate, tall, narrow arms of the cross and their interpenetration with the outer belt. The overall spatial effect is overwhelmingly beautiful in its complex interplay of higher and lower elements, of core and ancillary spaces, of clear, dim, and dark zones of lighting. The Greek-cross-octagon is perhaps the most impressive Middle Byzantine church

plan. It is revived in the thirteenth century, both with and without galleries. But like the octagon-domed plan, it is not widely spread. The surviving examples are confined to the mainland of Greece.[9]

The Greek-cross-octagon plan is but an enlargement of the domed octagon, and the origin of both plans has long been sought in Armenia.[10] Corner squinches used to support a dome were a permanent feature of Armenian church building from at least the seventh century, and they could easily have come to the attention of Middle Byzantine patrons and builders. After all, Armenian architects were active in Constantinople around 1000. But there is no need to focus narrowly on Armenia. By the tenth and eleventh centuries, domes on corner squinches were widespread in Islamic architecture. They could have penetrated into Byzantine construction from Islamic countries as well as from Armenia.

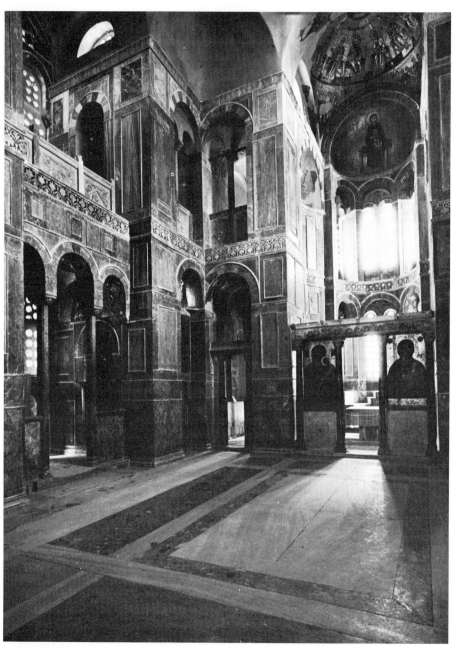

298. Hosios Lukas, Katholikon, consecrated 1011 or 1022. Interior facing north-east

Whatever the origin of the dome on squinches, however, the importance of the question, it seems to me, has been vastly overplayed. Squinches are an element of construction which can be incorporated into almost any kind of architecture. Where the Armenian builders stressed the massive bulk of the structure and cramped the space of the interior, the Byzantine architects played on the expanding space, the pervading light, and the membrane-like enclosing walls. Complex as their plans are, the spatial design of the Middle Byzantine Greek-cross octagons differs most emphatically from the earlier Armenian domed churches. Both the octagon-domed church and the Greek-cross octagon – a domed centre expanding into a cross and interpenetrating with an enveloping belt of subordinate spaces – are, instead, closely linked to the structural principle and the spatial design of cross-domed churches of the time after Justinian and to other designs of the late years of Justinian and the years after him. The principle of allowing the barrel-vaulted arms of a cross design to encroach upon the space of aisles and galleries is exemplified, after all, by churches such as the H. Irene after its remodelling towards the end of the reign of Justinian. The Greek-cross octagon, then, is rooted in a purely Byzantine tradition which has absorbed a borderland element of construction.

The ambulatory church, in plan, recalls the cross-domed churches of Byzantium, known from the late seventh or early eighth centuries, as witness the Koimesis church at Nicaea (Iznik), to its latest twelfth-century examples, such as the Kalenderhane Camii. A domed centre bay is screened off from an enveloping ambulatory by triple arcades inserted between the corner piers. In elevation, though, the differences are marked: the cross arms are reduced to mere wall arches; and the gallery zone, integral to the cross-domed church, is missing. Indeed, one of the earliest examples of an ambulatory church was the Koimesis at Nicaea, as rebuilt shortly after 1065 by removing the galleries and replacing them by clerestory walls. At the same time or shortly later, though, the Fetiyeh Camii in Constantinople was laid out from the outset on the ambulatory plan.[11]

The quincunx or cross-in-square is the most widely spread Middle Byzantine church plan. Small, steep, and enclosed in the outline of a square, its core – the *naos* – is composed of nine elements: a tall centre bay, resting on four supports, either columns or piers; a high, well-lit drum of a dome rising as a rule from pendentives; subordinate to it, four short barrel-vaulted cross arms expanding in the main axes; lower, in the diagonal axes, four corner bays, groin-vaulted, barrel-vaulted or domed [297, *top*, 299, 303, 309, 312, 327A, 328A, 338, and *passim*]. Jointly these corner bays, sometimes surmounted on the exterior by the higher drums

299. Hosios Lukas, Theotokos, tenth century. Interior

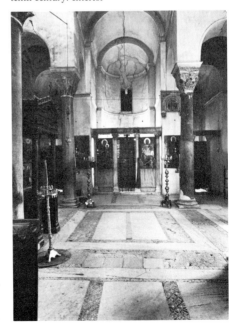

of sham domes, and the taller main dome, form the five spots of a quincunx. At the same time, the term 'cross-in-square' is justified by the way in which the arms of the cross issue from the centre bay and meet the outer square of the structure. Three apses project eastward from the naos. This core is at times enveloped by a narthex, by lateral open porticoes, or by closed side chapels (*parekklesia*). But regardless of such additions or variations, the quincunx or cross-in-square plan becomes the church type almost universally accepted all over the sphere of Byzantine and dependent architecture, from the tenth century to the Fall of Constantinople, and surviving in Russia and the Balkans far beyond.

The origins of the type remain in dispute, both as to its antecedents and the time and place of its first appearance. General consensus lists the Nea, consecrated in 881, as the first known quincunx church in Constantinople. This, though, is less than certain. Granted, none of the many quincunx churches so far known in Greece and the Balkans are earlier. But not far from Constantinople at Tirilye on the southern shore of the Sea of Marmara, a quincunx church has been dated tentatively 780-813. Certainly forerunners do exist outside the capital and the core provinces of the Middle Byzantine Empire. As early as the eighth and throughout the ninth century, the quincunx plan was known in the West: at Germigny-des-Prés on the Loire after 800; at S. Satiro in Milan in 868, and apparently at the same time at S. Miguel at Tarrasa in Spain; finally, as early as the late eighth century at S. Maria delle Cinque Torri at S. Germano near Cassino (778-97) in an unvaulted variant with triple arcades supporting the four walls of the centre bay.[12] Similarly, quincunx churches of the eighth and ninth centuries survive in the outlying provinces of Asia Minor and Thrace. At least one of the quincunx cave churches in the wilderness of Göreme in Cappadocia bears, covered by the frescoes of a cycle of the Passion,

an iconoclast decoration of crosses. It is thus possible that its plan dates from before 843, if not from the eighth century. Another quincunx church stands among the ruins of Side on the south coast of Asia Minor. The final destruction of the city in 886 supplies the church with a *terminus ante quem* – how long before remains open. At Peristerai, in the mountains at the base of Mount Athos, a quincunx plan forms the core of a church built in 870/1 [328B].[13] All these examples – and many more could be listed – raise the question as to whether the type originated in Constantinople long before the Nea and was transmitted to the provinces, or whether at the time the Nea was built, the quincunx plan was imported from the provinces into the capital.

An origin of the quincunx plan either in the Byzantine provinces or beyond the borders of the Empire has been frequently suggested. The plan has been derived from Iranian architecture, either by way of Armenia, or directly from Sassanian Fire Temples.[14] However the resemblances to Iranian building are but superficial. The so-called 'cross arms' of the Fire Temples are part of an ambulatory covered by longitudinal barrel-vaults, and the dates of the Fire Temples are vague. Others have postulated two types of quincunx churches with different origins: one rooted in a hellenistic tradition, the other originating in the highlands of Anatolia.[15] But the sixth-century date claimed for the Anatolian quincunx churches cannot be substantiated. The hypothesis most widely accepted at present derives the quincunx plan from cross-domed churches such as the Koimesis church at Nicaea or the H. Sophia at Salonica: their domed centre bay and barrel-vaulted cross arms would have been taken over, reduced in scale; the vaulted spaces enclosed in the piers would have developed into the corner bays of the quincunx; finally from the enveloping ancillary spaces of the cross-domed plan – the aisles and galleries – would have sprung the outer porticoes and the esonarthex which in the churches

of Constantinople envelop the quincunx.[16] But the hypothesis fails to satisfy. It depends on vague resemblances in plan and disregards essential differences in size and proportion. It is hard to draw any comparison between the slender columns supporting a quincunx and the massive piers of a cross-domed church, between the domed or groin-vaulted open bays of the former and the heavily enclosed corner spaces of the latter. The compactness of the quincunx church has little in common with the expansive design of the older cross-domed structures. The steep, lithe elevation of the first, the squat proportions of the second, are entirely different.

On the other hand, quincunx structures had existed already in the second century in the Roman and Byzantine Near East. As early as A.D. 180, a small building in the Roman camp of Mousmieh (Mismiye) in Syria was divided into the nine bays of a quincunx. Its centre bay, covered either by a cloister-vault or a timber roof, rested on four slender columns [300].[17] It must have been a temple or a praetorium, that is either a religious building, or a secular building imbued with religious connotations. Similar structures are known in the East in later centuries as well. A quincunx building outside the walls of R'safah, with barrel-vaulted arms, groin-vaulted corner bays, and a timber-roofed centre bay, is identified by an inscription as the audience hall of a local chieftain, one Al-Mundir, dating from c. 560 [301].[18] Construction and details leave no doubt that the training of the builders had been in provincial Byzantine conventions. Nonetheless, the links of the Middle Byzantine church type to such early 'quincunxes' are questionable and the further history of the type remains to be established. Armenian seventh-century churches, such as the Gayané at Vagharshapat and the church at Bagaran [288, A and B], bear only a paper resemblance to Al-Mundir's audience hall, and thus cannot be taken to be the missing links between the use of the type in semi-religious secular building and

300. Mousmieh (Mismiye), temple(?), 180. Interior. Drawing, c. 1860

301. R'safah, audience hall of Al-Mundir, c. 560. Interior facing east

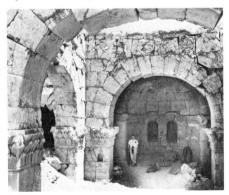

in ecclesiastical architecture. But it seems a plausible hypothesis, though so far unproven, to assume that at some time between the sixth and the ninth centuries the plan of the quincunx audience hall was transferred to ecclesiastical building. The cross-domed plan might well have exerted a collateral impact on the transfer, but the exact time of the transfer, and its place – whether Constantinople, the borderlands, or the

provinces – for the time being must be left open.

Whether quincunx churches, basilicas, octagon-domed structures, tri- and tetraconchs, or Greek-cross octagons, all Middle Byzantine churches are remarkably small. The cross-octagon churches are somewhat larger and their expansive space makes them appear more sizeable. However, even the naos in the cross-octagon church of the Katholikon of Hosios Lukas, not including the narthex, covers an area of only 270 sq. m. (295 sq. yds), just slightly more than twice the adjoining quincunx church of the Theotokos, or the north church in the Fenari Isa Camii in Constantinople, each with an inner area of 115 sq. m. (126 sq. yds) [297, 312]. On the other hand, the area of the Katholikon at Hosios Lukas is not even one third that of the H. Sophia in Salonica, which measures nearly 900 sq. m. (985 sq. yds), not to mention Justinian's churches. Some of the complex factors underlying this predilection for small church buildings should at least be considered.

Monasticism in the East was always of supreme importance within the organization of the Church. The parish and metropolitan organization remained underdeveloped and subordinate to the monastic organization. Frequently parishes and bishoprics were subject to some great monastery; to this day the high Greek clergy is as a rule drawn from among the monastic ranks. This situation, which in the Occident north of the Alps prevailed only to the end of the Carolingian and Ottonian periods, became permanent in the East. It is only natural that within the development of Middle Byzantine church types monastic sanctuaries would take the lead. Such sanctuaries as a rule were designed for small congregations: hermits and monks living under a *lavra* system, in caves or cells scattered at some distance from the church; or monastic congregations residing under a coenobial system in cells adjoining the church, but still comparatively small in number. Indeed, the size of monastic congregations in the Middle

Byzantine Empire, with few exceptions, had shrunk considerably.[19] The cause was not so much the iconodule emigration of the eighth and early ninth centuries, but fiscal pressures of the later ninth and the tenth centuries. At the end of the eighth century monastic congregations still often counted several hundred, but by the eleventh century their membership had dwindled to such a degree that a congregation above eight was considered large. Groups of three and four hermits would use churches such as those at Göreme. The convent of Constantine Lips, one of the largest in Constantinople, sheltered fifty nuns, including both ladies and servant girls. Only rarely did a monastery, such as Hosios Lukas, hold a larger congregation. And even then, such relatively large monasteries cannot begin to be compared with those of medieval Europe, where Cluny by 1100 sheltered over twelve hundred monks. With tiny congregations the rule in the East, small, intimate structures were sufficient, and parish churches followed the lead of the monastic sanctuaries.

Concomitantly, Eastern ritual more and more favoured small architecture. The liturgical development of the service in the East had assigned the naos almost exclusively to the clergy. The lay folk would crowd outside the naos: in lateral porticoes; in the outer and inner narthex; or under the open sky, as is done to this day all through Greece. The naos is Heaven, inaccessible to the laymen during services, and this is brought out in its figurative decoration.[20] The main dome carries the most exalted themes of the heavenly hierarchy: either the Pantokrator in the centre of the dome with the chorus of angels arranged along the lower curve; or at times, the Descent of the Holy Spirit; or else, the Ascension. From this heavenly zone, the themes descend in an ordered hierarchy to subordinate but still exalted subjects. The pendentives and lunettes are occupied by scenes from the life of Christ and his Passion, according to the cycle of the great festivals. Finally, the walls

and barrel-vaults of the aisles carry the figures of the Witnesses, Apostles, Martyrs, Prophets, and Patriarchs. Obviously this symbolism of decoration had to be legibly presented to the clergy and monks assembled in the naos and to such laymen as would enter the naos when services were not in progress. The solution was to concentrate the programme within the smallest possible space.

Lastly, smallness, intimacy, and subtlety are basic stylistic concepts of Middle and Late Byzantine architecture. A wealth of decoration designed to overwhelm the visitor would be crowded into the tiny space of these churches: marble sheathing and precious tapestries on the walls and mosaics or murals in the vaulting zone; icons and reliquaries of gold, enamel, and glass, such as have survived in the treasure of S. Marco in Venice. In centres such as Constantinople and Salonica, these structures were built by the court and the high aristocracy, for monastic congregations often drawn from the sophisticated society of these same circles. Founders, builders, and visitors alike were trained to savour the subtle interlocking of space, its expansion or restriction, the delicate curving of a niche, the membering of a wall by fine mouldings, the carving of a profile or an ornament. This highest level of quality, to be sure, would be found most frequently in the churches of Constantinople, within as well as outside the palace precinct. But it would also be found in the provinces when monasteries and convents were founded by members of the Imperial House, by aristocratic families from Constantinople, or by high civil servants – and ruled by abbots and abbesses sprung from these same social circles. Financial restrictions and the limitations of local master masons frequently resulted in the building of churches reduced in plan and awkward in execution. But we may be sure that, ideally, founders and builders of even such provincial churches strove to compete with the most refined churches of the most aristocratic monasteries, designed and executed on the highest level of subtle sophistication.

From the late ninth to the eleventh and twelfth centuries, then, church building in the capital and throughout the Empire continues to be immensely fertile. New types are established, and a highly developed and sophisticated Middle Byzantine architectural style is evolved. Domestic architecture, on the other hand, apparently remains fettered to age-old traditions, although current evidence allows only a tentative judgement. The dwellings of the poor, presumably hovels, as well as farmhouses are unknown. Nor have any Middle Byzantine houses come to light in Constantinople.[21] Our knowledge of middle-class dwellings is limited to a handful of residences and commercial buildings excavated in a few Greek cities. In Athens, the middle-class city house formed a block, roughly square, with a courtyard in the centre as a source of light and air; rooms enveloped this peristyle on all four sides. A number of twelfth-century houses excavated on the Agora provide examples, and at the same time demonstrate the continuity of the plan in the Aegean area for over fifteen hundred years. These twelfth-century houses are indistinguishable from the fifth-century houses which preceded them on the Agora, or for that matter, from houses in Dura-Europos (Qalat es Sālhīye) of the second century, or from city houses in Delos and Priene dating from the first, second, and third centuries B.C. Likewise the old shopping terrace of Greek and hellenistic ancestry occasionally survives into the twelfth century. Simpler houses have been found at Corinth composed of two or three rectangular rooms, parallel to each other and sometimes partitioned by a pair of supports.[22] Terraces as well as the more elaborate peristyle houses were sometimes provided with upper floors. But the smallness of the rooms and – in the terrace houses – the poor organization of the plan more often than not turned the structures into rabbit warrens.

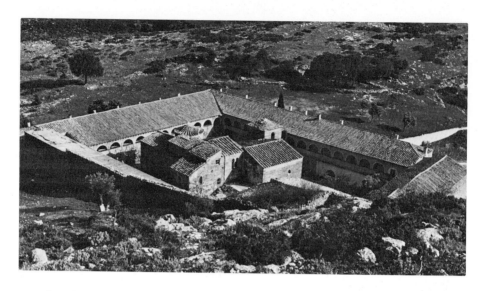

302 and 303. Hosios Meletios, Hymettos, monastery, oldest parts eleventh century. General view and plan

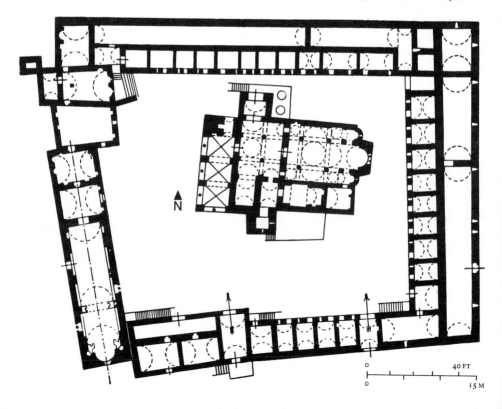

0 40 FT

0 15 M

On the other hand, domestic ecclesiastical architecture – if the term applies – is more monumental in appearance. Numerous examples have come down to us in the form of monasteries in Greece, many well preserved.[23] The monasteries of Hosios Meletios near Megara, of Sagmata in Boeotia, and of the Great Lavra on Mount Athos represent the type to perfection [302–4].[24] A large rectangle or trapezoid, enclosed within a fortified wall, envelops a wide courtyard. The church rises in the centre of the courtyard. The fortified walls are lined with storerooms, stables, and workshops; against this inner row of work rooms, or directly against the wall itself, lean the cells of the monks laid out in long rows and facing the courtyard. At Hosios Meletios they were one-storeyed, but frequently they are built up on two, three, or four floors. If multi-storeyed, the cells have access from long loggias; Kutlumusíu on Mount Athos supplies a well-preserved, if late, example. One side of the rectangle, frequently that opposite the church, is occupied by the refectory (*trapeza*) and the kitchen. The refectory is generally a long hall, aisleless and terminated by an apse: the refectory in the Great Lavra on Mount Athos provides a good example [305]. A long table with benches would run along the centre axis, or else a number of semicircular tables (*sigmata*) would stand along the walls, pushed back into flat rectangular niches. At times the tables are sheltered by low semicircular niches running along the flanks of the hall. Frequently a canopy rises over the well head (*phiale*) in front of the church. Sometimes a bath house and an infirmary (*nosokomion*) stand outside the abbey walls, the latter

304. Mount Athos, Great Lavra,
eleventh century. From the south-west

305. Mount Athos, Great Lavra,
refectory. Interior

a cross-in-square building, its centre bay sur-
mounted by a chimney and thus serving as fire-
place and kitchen for the sick. Throughout the
monastery, all rooms were vaulted – cells, work-
shops, refectory, sick bay, kitchen, and bath.

All this obviously goes back to a tradition
more than half a millenium old by the eleventh
and twelfth centuries. The fortified rectangle
recalls the fifth-century monastery of Daphni or
that of St Catherine on Mount Sinai [218]. The
multi-storeyed rows of cells preceded by open
loggias derive from a Late Antique house type
which is reflected equally in the small town
houses of fourth-, fifth-, and sixth-century Syria
[95].[25] The refectories with niches projecting
from their flanks are obviously linked to Late
Antique banqueting halls; one such hall – the
Dekanneacubita, possibly of sixth-century date
– had apparently survived in the Imperial Palace
in Constantinople.[26] In short, the plan of Middle

Byzantine monasteries in Greece and their de-
tails are largely survivals of Late Antiquity –
pagan as well as Christian – and of Early Byzan-
tine times.

Monasteries are the one aspect of Middle
Byzantine domestic building on which we are
well informed. On the other hand, next to noth-
ing is known about the palaces of the Byzantine
aristocracy, whether in Constantinople or else-
where, during the tenth, eleventh, and twelfth
centuries. Representations in illuminated manu-
scripts of the period, lengthy literary descrip-
tions, and passing hints in contemporary
writings are all of doubtful value.[27] The manu-
scripts show, to be sure, palaces with projecting
wings, sometimes surmounted by towers; bal-
conies resting on columns; façades opened by
double tiers of arcades. But the question always
remains whether such elements are meant to
represent existing structures, or whether they

are conventional symbols handed down to the Byzantine painters by their Late Antique ancestors. On the other hand, it has long been suggested that Middle Byzantine models are reflected in the Venetian palace façades of the eleventh and twelfth centuries. The type is best represented by the Fondaco dei Turchi, built as the palace of the Pesaro family: a shallow *corps de logis*, its rooms open in a double tier of arcaded porticoes flanked by low towers. The type may well derive from Roman country houses, and its appearance in Venice has been explained as a conscious return by Venetian builders to Late Antique buildings still known to them.[28] But it seems much more likely that the type remained in use throughout the centuries both in Constantinople and Venice, not only in rural but in urban architecture as well. Indeed the foundation walls of at least the reception rooms of a palace of just that plan have been recently traced in Constantinople: the palace of Romanos I Lekapenos, built about 920 atop the rotunda – remodelled into a vaulted cistern – of the fifth-century Myrelaion Palace. The case for a Middle Byzantine origin of Venetian palace architecture is strengthened by a second palace type, known in Venice only from the Late Middle Ages onwards. Its plan consists of a long room on the centre axis at right angles to the façade, flanked by smaller rooms on either side. It thus presents a close resemblance, strange as it may seem, to the. princely dwellings found in the tenth-century palaces at Pliska and Preslav in Bulgaria and, as early as the fifth to the seventh centuries, at Dvin in Armenia.[29] If they share, as is likely, a common source, that source can only be Byzantium.

One would expect the Imperial palace in Constantinople to reflect, better than anything else, the architectural style of the Macedonian Age. Certainly building activity in the Great Palace, though it had never ceased entirely, increased anew with the second quarter of the ninth century. Beginning with Theophilos (829–42), and continuing under Basil I (867–86) and Constantine VII Porphyrogenetos (912–59), new parts were added and old ones remodelled and redecorated. No identifiable remains survive. Nevertheless, a general impression can be obtained, I think, of both the layout of the Great Palace in Macedonian times and of the design and decoration of its state apartments. Contemporary descriptions such as the hints contained in Constantine Porphyrogenetos' *Book of Ceremonies* and the short *ekphraseis* scattered in the continuation of Theophanes' *Chronicle* through biographies of the Macedonian House, while tantalizingly obscure on first reading,[30] make sense when viewed against the background of palaces built by the Bulgarian czars and the caliphs of Cordova in the ninth and tenth centuries, by the Norman kings of Sicily in the twelfth, and by the Abencerrages of Granada as late as the fourteenth century. From the *Book of Ceremonies*, the Great Palace at first emerges as a vast maze of reception halls, churches, chapels, porticoes, corridors, courtyards, pools, and staircases – impossible to disentangle. Old parts – some perhaps going as far back as Constantine's first palace on the site, but rebuilt time and again – and additions dating from the fifth on to the end of the ninth century were, it seems, inextricably interwoven. From the hill of the Sarayi behind H. Sophia a loose chain of palaces and palace parts stretched south and west down the slope of the coastline as far as H. Sergios and Bakchos. Near the end, a few remains survive: a peristyle court on a terrace, its floor carrying a splendid mosaic with animals and monsters, hunting and combat scenes, dating in all likelihood from the late sixth century; attached to the courtyard an apsed hall, possibly of the same date, possibly earlier; finally, on the seashore just east of H. Sergios and Bakchos where the Bukoleon harbour was, the so-called 'House of Justinian'. This, grown and rebuilt ever since the fifth century, and in its final phase dating perhaps from as late as the eighth century, had

been enlarged by a grand covered terrace, its marble portals high up opening on a long balcony overlooking the Sea of Marmara.[31] Still, by the middle of the tenth century, when the Porphyrogenetos wrote, the part of the palace in active use had apparently contracted to two sections: the site of Constantine's palace, the Daphne, south-east and south of the H. Sophia, and east of the northern part of the hippodrome; and the closely adjoining slopes towards the seashore. The wings, overlooking the Bukoleon harbour half a mile from the H. Sophia, were probably abandoned. On careful reading, the tangle of structures and courtyards hinted at by the *Book of Ceremonies* unravels itself into several distinct groups of buildings. Directly behind the Chalki Gate (which was remodelled into a towering chapel in 970)[32] appeared an entrance court, enclosed by guard houses, reception rooms, audience halls, and chapels. The state and private apartments of the emperors – with rectangular, octagonal, square, and circular rooms, dressing-rooms, chapels, and dining-rooms – all centred on, it would seem, or adjoined the Chrysotriklinos of Justinus II (565–78). The state banquet hall (the Dekanneacubita) and a reception hall (the Consistorium) were joined by a courtyard. The Magnaura formed another, separate, throne room. Finally, near Basil's new church, the Nea, were located the polo-grounds with stables and warehouses. In short, the impression is not so much of a palace block laid out along an axial system but of a number of pavilions, or building groups, each consisting of several structures and focused on a courtyard or possibly on a domed centre room. Each of these pavilions was more or less self-sufficient and fairly compact, but they all apparently varied considerably in composition, function, and decoration. Yet none were necessarily large. On the contrary, the court ceremonial conveys the impression of fairly small units, laid out at comparatively short distances. The emperors in procession moved from room to room and from pavilion to pavilion, traversing courtyards, changing dress, receiving homage, inspecting guards of honour, venerating icons and crosses – all in the short time available before the services in the H. Sophia. At the same time, the structures, courtyards, and open areas were laid out, it seems, on terraces on the crest and the slope of the hill. They were loosely linked by colonnaded porticoes, by barrel-vaulted corridors on one or two levels, and by staircases. The Magnaura, possibly of Constantinian origin, was still used as the main throne room in Macedonian times. Whether aisleless or basilican, it was terminated by an apse and rose on a terrace (*heliakon*) enclosed by parapets.[33] Elsewhere, balconies projected from upper floors and roof pavilions, either open or glazed in to offer vistas across the city and the sea. A minor reception room, the Triconch of Theophilos (829–42), was laid out on two levels: below, a quatrefoil 'whispering' grotto, where sounds whispered in one corner of the chamber were transmitted aloud to another; above, a trefoil, its main apse resting on four columns, the façade opening in a triple arcade. Both grotto and triconch opened into a hemicycle of colonnades, superimposed on a double level, the lower sheltering an elaborate fountain.[34] All through the palace, gardens enclosed by open halls and enlivened by *jeux d'eau* extended between the pavilions. The convent of the Manganes adjoining the Great Palace (by the mid eleventh century, an Imperial summer palace rather than a monastic establishment) mirrored such landscaping. The church of St George in the centre was surrounded 'on all sides by buildings, some completely, some half surrounded by porticoes . . . then came a second circle of buildings, . . . bigger than the first and lawns full of flowers, some on the circumference, others down the centre. . . . There were fountains . . . gardens, some hanging, others sloping . . . a bath . . . streams of water'.[35] Within the palace, the rooms newly built or redecorated in the ninth and tenth

centuries gleamed with colourful materials. In the Kamilas of Theophilos, six green marble columns supported a ceiling inlaid with gold. Slabs of grey Proconnesian marble paved the floor, variegated marble sheathed the lower parts of the walls, a mosaic depicting harvesters plucking fruit covered the upper wall. In other adjoining rooms the walls opened in colonnades, and the floors were covered with mosaic pavements.[36] In the Kainourgion of Basil I, the main room was apparently laid out as a basilica terminated by an apse. The nave rested on sixteen columns, eight of green marble, six of black onyx carved with vines, two of onyx with spiral flutings. On the walls above the columns and in the apse vault, mosaics represented the deeds of the Emperor. In the adjoining state bedroom, the variegated marble floor centred on a mosaic panel depicting a peacock. The walls were covered with mosaic: floral designs in the lower zone; a floral frieze in the middle zone; finally, a zone devoted to portraits of the Imperial family. A mosaic cross occupied the flat ceiling, and the entire design formed a scheme best explained as a renascence of the iconography of Justinian's time.[37] In the banqueting hall – the Dekanneacubita – Constantine Porphyrogenetos restored and remodelled the ceiling. The building itself presumably dated from the fourth or fifth century. Its name – the Nineteen Couches – reflects its plan. It was long, terminated by an apse, and flanked on either side by nine vaulted niches, each sheltering a dining couch. Constantine VII placed over the nave a coffered ceiling, richly decorated with gilded vines and foliage, '. . . so that whoever saw it was overwhelmed'. The Great Triclinium (Consistorium) of the Lateran in Rome, built by Pope Leo III (795–816) and preserved until 1588, reflected the plan on a smaller scale with only eleven niches. A banqueting hall of the same type with but seven niches has been excavated in Constantinople as part of a sumptuous private palace north of the hippodrome; and a smaller one with but five

niches was built about 450 by Bishop Neon at Ravenna.[38]

The tenor of such descriptions decidedly evokes the image of Late Antique interiors sheathed in marble and mosaic and articulated by columns, pilasters, capitals, and cornices of classical derivation – not so much revivals as survivals of Roman-hellenistic Antiquity, as one would expect in the age of the 'Macedonian Renaissance'. Indeed, such a classical or neoclassical vocabulary may well have remained alive in Constantinople from Late Antiquity. Few traces are left in Constantinople; but it may have left its reflections at Preslav in Bulgaria, where Czar Simeon built his residence in 893. In plan, on the other hand, the ninth- and tenth-century descriptions of the Great Palace in Constantinople call to mind forcefully contemporary and later Arab palaces in southern Spain.[39] In the fourteenth-century parts of the Alhambra, the buildings are grouped in many units, all fairly small. In each unit, higher pavilions and lower wings enclose a courtyard with colonnaded porticoes; domed canopies project from the porticoes into the areas of the courtyard where fountains, pools, and hedges delimit the footpaths. No axial system underlies the overall plan of the palace. The units are linked only by narrow passages or by stairs; levels change; balconies project from upper floors; a belvedere rises from above the roof; loggias open on to the far prospect of the mountains. Most of the reception rooms are domed, and all details are delicate and colourful.[40] The ornament, of course, stands in the tradition of Islamic, specifically Western Islamic, art. But occasionally an element calls to mind parallels in Middle Byzantine art. The marble shafts with black inlays at the Alhambra find their exact counterpart in the Round Church at Preslav, the common source being Byzantium, where such columns were in use as early as the sixth century [178, 179]. The resemblances between Byzantine and Western Islamic art as early as the tenth century become

even clearer in the palace of Medinat-al-Zahra near Cordova. In plan the palace is not quite as loosely laid out as the Alhambra, or presumably the Byzantine palaces of the Macedonian emperors. But like these, it consists of a number of self-contained units, each unit placed on one of the successive terraces of a hill slope, each centred on a courtyard filled with a fountain or a pool. A large reception hall at Medinat-al-Zahra strongly calls to mind those described in the Great Palace at Constantinople: a basilica on columns with splendid capitals; the lower walls of the structure sheathed with marble slabs; the pavement composed of variegated marble; the upper walls presumably covered with mosaics.[41]

Much of this similarity between the plan and decoration of the Great Palace in Constantinople, as gathered from descriptions, and the palaces of southern Spain explains itself as a family resemblance between two cousins, both descended from the palace architecture of Late Antiquity. As early as the late fifth or the early sixth century a country palace on the north shore of the Sea of Marmara scattered over its length of roughly 200 by 150 m. (650 by 500 ft) groups of buildings – square and rectangular rooms, apsed halls, a chapel, and a small bath – all assembled round courtyards and on terraces and but loosely joined to each other.[42] Obviously, then, this palace at Rhegium (Küçükçekmece) establishes a link between Late Roman Imperial villas, such as those at Tivoli and Piazza Armerina, and both the Arab palaces of southern Spain and the lost palaces of Constantinople. At times, however, the links between Middle Byzantine and Western Islamic art are of a more immediate nature. The mosaic decoration and the ornament of the Macedonian palaces are, it seems, directly reflected in the mihrab of the mosque at Cordova. Inside the mihrab niche, the cornices in profile and ornament, as well as the large marble shell in lieu of a dome, are surprisingly classical in flavour. For the decoration of the

façade of the mihrab, the Caliph El-Hakim (961–76) asked for and received from the Emperor Nicephoros Phocas a present of no less than 325 tons of mosaic cubes and the loan of an artist. As they survive to this day, the mosaics – executed in extraordinarily fine cubes – can reasonably be taken to reflect contemporary Byzantine court taste. Ornamentalized plants and palmettes shine in a wealth of colours in ever new combinations: gold on blue, gold on red, green on gold, red on blue, red and green on gold. For Medinat-al-Zahra as well, the emperor allegedly sent the caliph as gifts a sculpted and gilded marble basin, a fountain with figural reliefs, and one hundred and forty columns.[43] More than two centuries later, the castles and summer houses of the Norman kings in Palermo still mirror, whether by direct transmission or by way of the Arab palaces in southern Spain, the ninth- and tenth-century palaces of Constantinople. There are the state rooms of Roger II in the Royal Palace (decorated after his death in 1152) with their marble-clad walls, their lunettes and vaults covered with mosaics in which birds, griffins, and lions are enveloped by interlace work and floral designs. There is the Zisa, a summer house containing five small rooms behind a long vestibule, and opening on to a pool. There is finally the Cuba, a pavilion originally completely surrounded by water. The anteroom of the Cuba was domed; its twelve supporting arches sprang from four columns in a cross-in-square plan. Notwithstanding their stalactite niches and arabesque stucco panels, these Arab and Norman palaces, garden houses, and pools in Cordova, Granada, and Palermo recall the descriptions of the Macedonian palaces at Constantinople.

Links between Byzantium and the Arab world had been close ever since, around 650, the rulers of Islam had established their residences in Damascus and Baghdad. As early as the last quarter of the seventh century, the Dome of the Rock in Jerusalem and the Great Mosque in Damascus

were decorated by mosaicists sent on loan from the Byzantine court. Conversely, Arab sciences – theoretical and applied – certainly exerted their impact on Byzantium in the ninth century, and played no mean part in the furnishings of the Great Palace and in the court ceremonial. At the receptions of ambassadors in the audience hall of the Magnaura, silver chains were hung from columns, golden and silver organs were placed in the intercolumniations. The Emperor was seated on the Throne of Solomon, flanked by bronze lions; before him stood gilded trees in which perched gilded birds. Upon the ambassadors' entry, the bronze lions roared, showed their tongues, and beat the ground with their tails. The birds sang, each its own tune. And while the ambassador performed the *proskynesis*, the enthroned Emperor was raised 'nearly to the ceiling' and then again revealed himself, clad in a different costume.[44] The envoy of the German emperor, Liutprand of Cremona, was duly impressed, as he was meant to be. But it is doubtful that the Cordovan ambassadors were equally baffled. To them *automata* were nothing new, and those in Constantinople, constructed in large part by Theophilos I, were quite possibly built with the help of Arab mechanics.[45] Largely on this evidence, it has been occasionally suggested that the architecture of the ninth-century palaces in Byzantium was also influenced by those of the Umayyad and Abbasid rulers, and that specifically the Triconch of Theophilos in the Great Palace and its whispering grotto followed the model of the triconch throne niches in the reception halls at M'shatta and Ukhaidir.

Nothing precludes *a priori* the possibility either that Islamic architecture could have exerted its impact on palace building in Byzantium, or that both Islamic and Byzantine palace planning are descended directly from the same Late Antique models and therefore resemble each other. Still, neither hypothesis is probable. Early Islamic, that is Umayyad, palaces of the eighth century are quite different from Byzan-

tine palace design of earlier as well as of later date. True, Umayyad and Byzantine palaces both go back to the building traditions of Late Antiquity, but they follow different lines. The designers of the Umayyad palaces take up the plans of Roman *castra* palaces such as that at Spalato. Rigidly laid out along an axial system, the main axis culminates in an audience hall; subordinate quarters line the inside of the square fortified wall.[46] Byzantine palace design, on the other hand, continues the tradition of Roman Imperial villas, such as the Villa of Hadrian at Tivoli and the Imperial villa at Piazza Armerina. Building units more or less self-contained and only loosely linked to each other are scattered over spacious grounds landscaped with gardens, pools, and artificial creeks. This 'pavilion' design, it would seem, had been transferred to urban palaces in Rome as early as the third century A.D. It certainly continued uninterrupted in Byzantium from the fourth to the ninth and tenth centuries via the palaces of the Macedonian emperors and it apparently reached the Islamic courts of Spain, and perhaps of western North Africa and Egypt, in the ninth and tenth centuries. Later, in the twelfth century, it was taken up by the Norman court of Sicily, either directly, or more likely by way of Cordova or Cairo. Clearly this impact of Byzantine palace design of the Macedonian Age does not imply that the classical vocabulary of Islamic buildings in the eighth, ninth, and tenth centuries was in its entirety purloined from Byzantium. The triconch of M'shatta, the shell dome, the egg-and-dart and bead-and-reel cornices of the mihrab of Cordova are part of the Late Antique heritage which Islam shares with Byzantium. But it seems likely, to say the least, that this heritage was strengthened through tenth-century contacts between Islam and the court at Constantinople.

The concept of a Middle Byzantine or 'Macedonian' Renaissance was first coined with an eye to literature and the figurative arts. Illuminated

manuscripts such as the Paris Psalter, ivory caskets, and an occasional stone relief were found to be brimming with scenes, figures, settings, and decorations derived from classical Antiquity both in form and content. Further research has demonstrated that this heritage of hellenism did not spring suddenly into existence. It was found to have grown from a classical tradition which had continued in secular art – and thus not necessarily blended with Christian concepts – throughout the sixth and seventh centuries. Whether or not this tradition had survived, in the non-religious sphere, the iconoclastic century as well is still an open question. Certainly it was immensely strengthened in the Macedonian Age. But the borderline between revival and survival is fluid.[47]

It is even more questionable whether the term Renaissance applies in the realm of Middle Byzantine architecture if understood literally as a conscious revival of an art of the past, in form or content, or in both. Certainly none of the many church types designed and promoted by the Macedonian and Comnene architects in Constantinople and in the core provinces of the Empire drew on models of the Roman-hellenistic past or Late Antiquity, whether pagan or Christian. Nor can they be viewed as reverting to the time of or after Justinian, i.e. pre-iconoclast architectural forms or concepts. Whether domed octagons, Greek-cross-octagons, or atrophied Greek crosses, Middle Byzantine church plans were in their great majority freshly invented in the Macedonian age, invented, that is, within the framework of a tradition of church planning uninterrupted and consistent since the sixth century. Only rarely during pre-iconoclast or iconoclast times was a church plan, such as the quincunx, apparently transferred from the realm of secular or semi-religious buildings of Late Antiquity. Such transfers, always rare, seem to have occurred largely in the provinces or borderlands of the Empire, taken up and refined in Constantinople,

and spread from there anew over the Empire. Only on the outskirts of the Empire are sixth-century building types revived: at S. Marco in Venice, and perhaps in the basilicas with galleries built in the Bulgarian Empire. Even more rarely, if at all, did Middle Byzantine church builders revert to Late Antique building types. By and large Middle Byzantine church planners thought in terms not of old, but of radically new architectural concepts and designs.

Secular architecture of the Middle Byzantine period, on the other hand, was apparently simply Antiquity fossilized. From middle-class urban dwellings to conventual buildings and Imperial palaces, building types of Late Antiquity seem to have survived with little or no change from the fourth and fifth centuries to the time after Justinian and the iconoclast centuries. As in the realm of church building, then – though for different reasons – the term Renaissance is inapplicable to the secular architecture of Middle Byzantine times.

To speak of a Renaissance in Middle Byzantine architecture is most tempting as one looks at its ornament. Granted, our knowledge in that field is woefully limited: chronologically, since ninth- and tenth-century ornament is, with few exceptions, unknown; topographically, since little ornament has survived in Constantinople or in the poorer provinces such as Asia Minor and its dependent islands. In Greece, on the other hand, where the material is plentiful and even partly *in situ*, ornament has not been sufficiently studied to work out a chronology. In addition, the better part of Middle Byzantine ornament known so far dates from the eleventh and twelfth centuries. A fleeting impression of this decoration could be interpreted as a total conscious revival of classical Early Christian ornament or the ornament of Justinian's age. Cornices are composed of tori, cavettoes, and plinths; capitals, lintels, and chancel posts are covered with acanthus leaves, palmettes, half-palmettes, and tendril friezes. But in their great

majority, such elements *all'antica* are derived from, rather than reverting back to, earlier prototypes. They transpose the heavier, fleshy, and more fully developed elements of the fifth and sixth centuries into either soft and doughy, or into spindly, hard, sharply-cut, and often feathery forms and intertwine them with elevated nodules and – perhaps only from the eleventh century – with interlace work. The remnants of the sculptured decoration of the Fenari Isa Camii in Constantinople convey as clear an idea as do the capitals of the Theotokos church at Hosios Lukas and its *templa* or the friezes of the Eski Camii at Constantinople [323, 324, 339, 340]. But as long as we are ignorant of much of the ornament immediately preceding the eleventh century, and as long as we know even less of ornament from the seventh to the end of the tenth century, we cannot say with certainty whether we are dealing with a renascence even in the most classical examples. Only exceptionally a whole group of ornamentation suggests such a conscious renascence, such as the fragments found at Preslav in Bulgaria and the imitations of fifth- and sixth-century capitals in the eleventh-century church of S. Marco in Venice [285, 368]. But such true renascences are few and locally confined.

In a literal sense the term Renaissance, then, does not apply to Middle Byzantine architecture in general. In a broader sense it might be valid: Middle Byzantine architects work with a feeling for articulation of space and mass stronger than that of their eighth- and seventh-, and even than that of their sixth-century predecessors. The spatial units within a structure are more clearly set off and more clearly balanced against each other, be they the nine bays of a quincunx structure, all of different height and shape, or the parts of a Greek-cross octagon. The outer walls of a building are clearly articulated by pilasters and responds, by blind arches, and by string courses formed of bricks and arranged in sawtooth bands. None of this vocabulary is classical. But the feeling for articulation, for contrasts of surface and membering, and for clear relationships calls to mind concepts of classical Antiquity and its architecture. So does the blend of solidity and subtlety which marks the best of the Middle Byzantine buildings: the integration of the plain surfaces of outer walls and variegated marble and mosaic sheathing on the interior, of straight, concave, and convex planes. Finally, the inventiveness, the fertility of production, and the new vigour recall, if one wants to, the Italian Renaissance of the fifteenth century. But these are only analogies, and so – once again – it seems to me that the term Renaissance can only vaguely be applied to the architecture of Middle Byzantine times.[48]

DEVELOPMENT AND REGIONAL STYLES

OF MIDDLE BYZANTINE ARCHITECTURE

It is decidedly possible and not even difficult to characterize Middle Byzantine architecture as a stylistic entity. But the persistence of established architectural types among churches, palaces, and monastic buildings for over three hundred years makes the chronological presentation of Middle Byzantine architecture troublesome. External evidence for dating the monuments is scarce. Rarely will an inscription identify building or founder by name. Even then, remodelled or indeed rebuilt from the ground, the structure may bear an inscription bodily transferred or copied from its predecessor. Documentary evidence, if and when available, is equally confusing for the same reasons. Difficulties increase when, as in Constantinople and Salonica, churches are known only by the Turkish names they acquired at the time of their transformation into mosques; identification, then, depends at times on topographical indications, at times on information gleaned from local Greeks by sixteenth- and seventeenth-century travellers – one or two centuries after the buildings fell to the Muslims. In either case, the result is little more than guesswork.[1] Thus, the historian of Middle and Late Byzantine architecture must glean clues from the few reliably dated buildings by which to date the mass of undated structures. Such clues, to be sure, are provided by details of plan and design; the presence or absence of lateral porticoes or *parekklesia*, side chapels; the shape and construction of windows; the details of domes and drums; the hollowing of outer and inner walls by niches; the ornament of friezes, capitals, and wall surfaces. Equally revealing obviously are the features of the masonry. The alternating bands of brick and ashlar which prevail in Constantinople from at least the fourth century continue throughout the tenth century, and the number of courses in each band often helps to establish a date.[2] The pure brickwork used more frequently by Middle Byzantine builders in Constantinople and Salonica can be dated by the number of bricks and mortar-beds per Byzantine foot, by the height of the mortar between the brick courses, or by the tooling of the mortar – grooved or slanting, either inward or outward; the tenth-century repairs on the H. Sophia in Constantinople offer a good example [172]. From the early eleventh or possibly the late tenth to the late twelfth century, Constantinople and her sphere of influence – including South Russia and southern Serbia – is marked by the 'recessed brick' technique:

306. Constantinople, Zeyrek Camii,
twelfth century. Recessed brickwork

307. Antigoni (Burgas, Sea of Marmara), ruin, eleventh or twelfth century. Recessed brickwork

alternating brick courses, regardless of whether the masonry is faced with pure brick or with alternating bands of brick and ashlar, are recessed from the wall plane and covered over by mortar [306, 307]. As a result, the mortar-beds, appear to have a thickness two to three times that of the brick courses.[3] At the same period in Greece, an equally characteristic, though different technique prevailed: the *cloisonné*. Small stone blocks were framed by horizontally and vertically placed bricks [335, 336]. The horizontal bricks were laid in single or double courses, rarely more; the vertical bricks formed either single or double courses, or geometric, christological, or 'cufic' designs. Occasionally a reticulate design was imitated. The profiling of the cornices may provide further clues, as does the shaping of dog-tooth friezes, single or double, and their location in the building: along the eaves line, as window frames, or as string courses. In some cases the chronology of such tell-tale marks has been established: a superb job has been done, for instance, regarding the architecture of the eleventh and twelfth centuries on the mainland of Greece.[4] Elsewhere – and this includes Constantinople –

research lags far behind, and scholarly opinion concerning the date of an individual building or a group of buildings often fluctuates from one to three hundred years, much as it did a century ago with regard to Romanesque architecture.

In any event, however, a chronology of Middle Byzantine architecture, based on clues of masonry technique, decoration, or even planning, is valid as a rule only for one region or for one workshop. Indeed, once established, such elements are easily transformed into permanent features of a regional school. It is therefore not too difficult to distinguish between the various provinces of Middle Byzantine architecture: Constantinople; Salonica and vicinity; Central and Southern Greece; Serbia; South Russia; Central Asia Minor. It is even comparatively easy to differentiate between subordinate regions such as Attica, the Argolis, Epirus. But the historian has a hard time to trace in a more than tentative manner the development within the regional schools. And it seems at the moment nearly impossible to present a development of the whole of Middle Byzantine architecture during its life span of over three hundred years.

CONSTANTINOPLE

Middle Byzantine architecture in Constantinople apparently entered the scene in the last quarter of the ninth century with two churches, both built by Basil I within the Great Palace. One was the Nea, the New Church, completed in 880, and the other the sanctuary of St Mary at the Pharos, consecrated probably in 864. Both are gone, but contemporary and slightly later descriptions convey a sketchy idea of their plans as well as a glimpse of their decoration and furnishings.[5] The Nea rose on a terrace, and was supported by a substructure. The five-domed naos was built on the quincunx plan and preceded by an atrium, its open area set with two fountains, its walls revetted with marble plaques. Two porticoes – long, colonnaded, and

barrel-vaulted – ran along the flanks of the church and extended beyond to enclose a long courtyard which reached to the polo-ground of the palace.[6] Inside, the naos was sheathed with marble and decorated with mosaics. A templon on columns, surmounted by arcaded colonnettes, screened the raised chancel from the nave. Over the altar rose a canopy; a synthronon followed the curve of the apse. A pattern of red and white marble slabs formed the pavement, and silk hangings enriched the decoration. Finally, openings in the floor communicated with the substructure, whence aromatic smoke would rise upon the entrance of the Emperor into the naos.[7] The Pharos church resembled the Nea in its rich decoration. Of its plan, only one feature is known: the centre dome was of the pumpkin type and covered with mosaics – in the centre, the Pantokrator; in the sections, angels.

Much admired by Byzantine and foreign visitors alike, the Nea was bound to exert a steady influence on the architecture of the capital, of near-by Salonica, and on the neighbourhoods of both cities. In Constantinople, half a dozen churches seem to reflect the Nea. All are closely linked in plan, style, and details, and all date roughly from between 900 and 1200. But few can be identified beyond question with churches known from documents, and thus dated externally. None the less, internal and external evidence assigns at least two to the first half of the tenth century. Both in ruins and recently restored, they can be identified: the north structure of the Fenari Isa as the church of the monastery of Constantine Lips; the Bodrum Camii as that of the Myrelaion.

Both are small and steep, and both are quincunx churches. The Bodrum Camii is raised on a terrace [308-11].[8] The supporting

308. Constantinople, Bodrum Camii (Myrelaion church),
c. 920, as in 1938. From the south

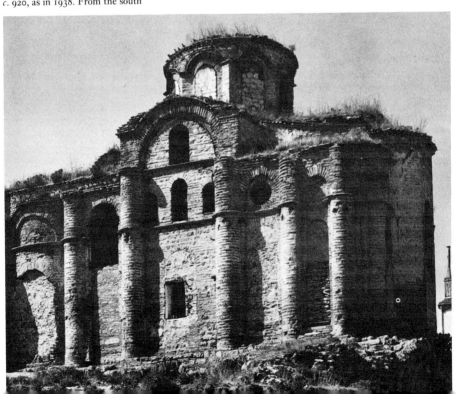

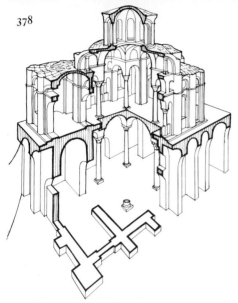

309. Constantinople, Bodrum Camii
(Myrelaion Church), *c.* 920.
Reconstructed perspective section
and plans of substructure and upper church

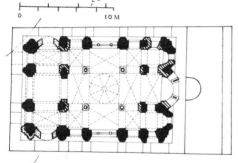

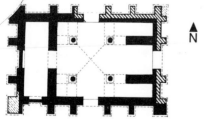

ORIGINAL CONSTRUCTION PRESERVED

ORIGINAL CONSTRUCTION MISSING BUT ATTESTED TO

ORIGINAL CONSTRUCTION HYPOTHETICAL

310. Constantinople, Bodrum Camii,
c. 920. Interior of dome

structure, also of quincunx plan, is low, some-
what heavy, possibly just a basement shed, and
built in a pattern of alternating bands: four
brick courses followed by five courses of
roughly hewn stones. For the upper church the
builders shifted to pure brick. Over the centre
bay rises a pumpkin dome; over the corner bays,
groin-vaults. The cross arms are covered by
barrel-vaults with interpenetrations so deep as
to approximate oblong groin-vaults. The apses,
all three polygonal on the outside, project
strongly. Low walls rise over those on the sides
and hide their half-domes. The main dome is
set on a circular drum supported by eight
triangular buttresses. Blind arches frame the
windows of the drum, but are held down by a
horizontal dog-tooth cornice slightly higher up.
The main bay of the narthex and the forechoirs
of the lateral apses are covered by pendentive
domes; a groin-vaulted exonarthex originally
ran along the façade. The flanks of the naos –
set with strong, yet elegant half-cylindrical

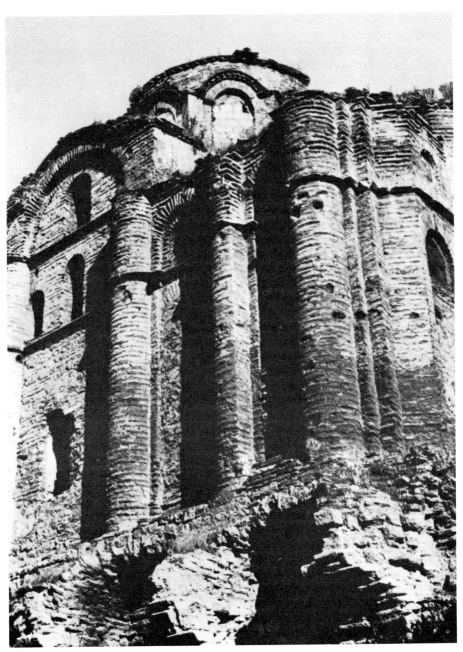

311. Constantinople, Bodrum Camii, *c.* 920, as in 1960. Exterior from the south-east

buttresses – were pierced all over by openings [309, 311]: huge semicircular windows, presumably subdivided by mullions high up in the cross arms; oculi or large round-headed windows further down in the corner bays; three smaller windows in the cross arms; finally at ground level, arches in the corner bays, the lateral forechoir, and in the end walls of the esonarthex, and a triple arch in the cross arms. An uncovered ambulatory, quite narrow, ran along both flanks and behind the apses, supported by the projecting terrace of the substructure. Within, shallow niches billow into the side walls of lateral forechoirs and esonarthex. The concave webs of the main dome curve subtly [310]. Traces of marble revetment on the walls, of mosaic in the vaulting zone, survive all over the interior. Simple cornices, sharply profiled, mark off the lower wall and window zones on the exterior. Dog-tooth friezes mark all eaves lines.

Three parts at present compose the ruin of the Fenari Isa Camii: along the entire front and extending south, an exonarthex and a parekklesion probably of early-fourteenth-century date; in the middle and slightly earlier, the Paleologue South Church; finally, the original Middle Byzantine North Church [312-14, 325].[9] This original core is close to the Bodrum Camii in plan, style, and details; it also complements its missing parts: three bases remain of the four columns that carried the centre bay; a wealth of original ornament has survived on shafts, bases, and capitals of the window mullions and on the cornice of the centre dome, not counting the fifth-century pilaster capitals in second use; and marble sheathing can be traced not only inside, but on the outer walls as well. As in the Bodrum Camii, in the Fenari Isa too, the esonarthex terminates in shallow niches at either end; the apse and its barrel-vaulted forechoir are flanked by small lateral bays and tiny but tall absidioles, serving as pastophories, prothesis, and diaconicon; the cross

arms of the naos open in steep triple windows, their arches stilted, surmounted by large semicircular windows, each tripartite. But throughout, plan and elevation in the Fenari Isa are richer than in the Bodrum Camii. Longish chapels, *parekklesia*, flanked the chancel – the one to the right now incorporated into the north aisle of the later South Church. Combined with the three steep apses of the naos, the lower apses of the parekklesia formed an impressive fivefold group of polygonal half-cylinders; terminating the original church, they opened alternatingly in rich triple and plain single windows. A stair-tower south of the narthex ascended to a narthex gallery which at vault level opens in a triple arcade into the west arm of the naos. Four tiny chapels, their walls hollowed by shallow niches, rise over the four corners of the structure, domed and originally surmounted by drums high above roof level. Those to the west are placed over the end bays of the narthex gallery, those to the east above the pastophories, sheltered eastward by parapet walls and reached presumably by outside catwalks. Shallow niches billow from the forechoirs of the lateral absidioles, and their triple accord is further strengthened by shaping the absidioles into tiny trefoils. As in the Bodrum Camii, the walls inside were sheathed with marble plaques, the vaulting zones covered with mosaic; ornamented glazed tiles supported the colouristic effect. Also the walling of the Fenari Isa is similar to that of the Bodrum Camii. Alternating bands of brick and roughly hewn stone, as they appear in the substructure of the Bodrum, form the walls of the Fenari Isa below the vaulting zone; the pure brickwork of the upper church of the Bodrum is duplicated by that found in the apses of the Fenari Isa [313].

The Bodrum Camii has been identified, since the sixteenth century, with the funerary church of Romanos I Lekapenos (920-44) and has been dated convincingly prior to 922. In the Fenari Isa, an inscription on the cornice between win-

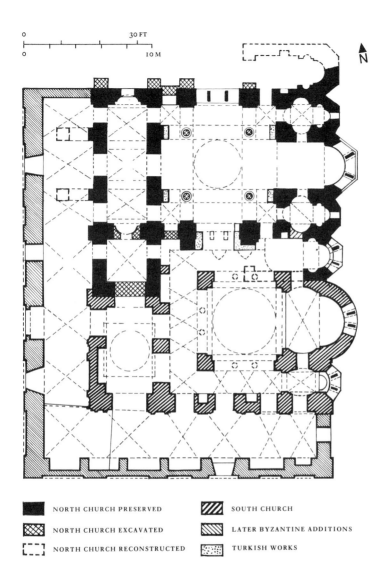

NORTH CHURCH PRESERVED

NORTH CHURCH EXCAVATED

NORTH CHURCH RECONSTRUCTED

SOUTH CHURCH

LATER BYZANTINE ADDITIONS

TURKISH WORKS

312. Constantinople, Fenari Isa Camii. Plan

dow and attic zones of the apses gives the name of the founder – Constantine: he is Constantine Lips, killed in action in 917 as admiral of the fleet, and the Fenari Isa is the church of the monastery he dedicated in 907 to the Mother of God. Construction techniques, indeed, favour a tenth-century date for both churches. The inward-downward slant of the broad mortar-beds in the brickwork of both not only coincides with the technique used in the tenth-century portions of the H. Sophia; together with the alternating bands of brick and roughly hewn

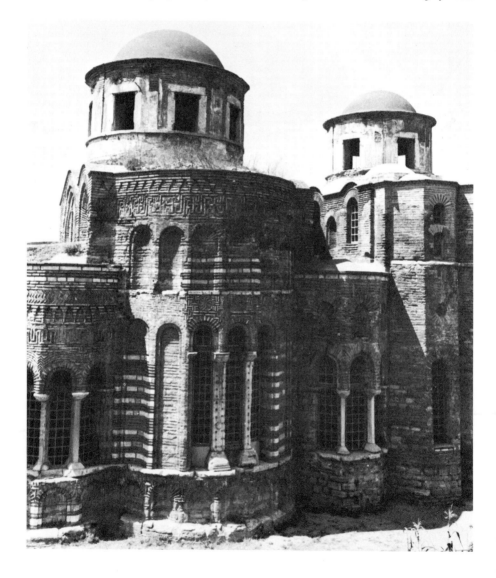

stone both in the Fenari Isa and the lower church of the Bodrum Camii, it still recalls ninth-century structures such as the ruin at Dere Ağzi. On the other hand, the 'recessed brickwork', that tell-tale eleventh- and twelfth-century device, is yet unknown.

Both the Fenari Isa and the Bodrum Camii are thus representative of an early phase of Middle Byzantine church building in Constantinople. The structures are small. The naos measures but 10·50 by 8·80 m. (34 by 29 ft) in the Bodrum Camii; in the Fenari Isa it measures

313 (*opposite*). Constantinople, Fenari Isa Camii (Church of Constantine Lips), South Church, founded 1282/1304, and North Church, dedicated 907. From the south-east

314 (*above*). Constantinople, Fenari Isa Camii, North Church, dedicated 907. Interior facing east

13 by 9·50 m. (43 by 31 ft), and 21 by 16 m. (69 by 53 ft) including all appendices – narthex, porticoes, and apses. The centre and the corner bays are extraordinarily steep; the space billows into shallow niches. All parts are tiny – corner bays, lateral forechoir, and apses, whether simple or triconch – and all communicate with each other through steep arches or through doors pierced into niches. The detailing is firm and simple, but subtle and varied – cornices are strong, niches and absidioles curve subtly, windows vary from oculi to single, double, or triple apertures. Smooth exterior walls are enlivened only by broad niches in the attic zone. The centre drum and blind drums over the corner bays enliven the outer silhouette. Almost all interior decoration is gone, but traces of a marble revetment have survived on the walls of

the Fenari Isa, and traces of mosaic are still visible on the vaults of the Bodrum Camii.

Once established, the style continues in Constantinople, unchanged in many respects, throughout the eleventh century. As in the Fenari Isa, in the Eski Imaret Camii, the church of Christ Pantepoptes, founded after 1081 and prior to 1087 [315], the narthex gallery opens into vaulted chambers placed above the western corner bays of the naos and originally surmounted by blind outer drums like those presumably planned in the Fenari Isa.[10] As in the Bodrum Camii the drum of the main dome is strongly articulated, though by colonnettes rather than by triangular buttresses; dog-tooth friezes arched over the windows, originally, it seems, forming the eaves line in a striking rippling effect. The cross arms opened in

315 and 316. Constantinople, Eski Imaret Camii, founded between 1081 and 1087.
Exterior from the south-east (*above*) and detail of brickwork (*opposite*)

triple arcades, their arches steeply stilted. Above, three windows were grouped, close together, yet separate, instead of the tripartite large semicircular window customary in Macedonian times. Whether or not the triple arcade was sheltered by a short flanking portico remains in doubt. Early Macedonian elements thus are blended with new features. 'Recessed brickwork' comes into use. The detailing grows richer, but the delicate subtlety of tenth-century design decreases. The contrast between clear profiles and plain wall surfaces, between half-cylindrical buttresses and wall openings, is lost. Instead, the outer walls are set with pilasters, backed up by two or three responds, with niches and blind arches. The clear segregation of window and attic zones on the outer walls of the apses has been abandoned; instead, the

facets of the apse polygon are each articulated by a wall arch; the outer arches are blind, those in the centre frame a triple window. This lower zone of arches and windows is surmounted by a tier of low, broad niches in the attic zone. The elegant pumpkin dome of the Bodrum Camii gives way to a shallow bowled dome with heavy ribs. Niches disappear from the inner side walls of forechoirs. Wall and vaulting zones are no longer marked off by firm, simple cornices, but by running friezes: palmettes, heart shapes, or tendrils, carved precisely but without harshness. Bricks form meander patterns on the flanks of the building, weaving patterns under blind arches, zigzag ornaments in the niche heads [316]. *Cloisonné* masonry, so characteristic for Middle Byzantine building in Greece, but unknown elsewhere in Constantinople,

appears in the outer walls of the exonarthex and suggests as does the rippling eaves line of the drum – if it originally existed – that by the end of the eleventh century Greek custom exerted an impact on Constantinople.

Like the Eski Imaret, the Kilise Camii, presumably the church of St Theodore, represents the style of Comnene quincunx churches in Constantinople: 'recessed' brick masonry, with slanting mortar-beds; blind arches, triple window, and surmounting niches in the apse; brick ornament, including a meander; triple arcades in the cross arms, possibly an opening rather than a window, surmounted originally by semicircular tripartite windows. A date about 1100 or slightly later seems likely [317].[11]

The Nea Moni on Chios shows this same blend of earlier and later features applied to a domed-octagon plan – a plan possibly of Early Macedonian origin, though so far unknown in Constantinopolitan architecture of the tenth century [296].[12] Founded by Constantine IX

Monomachos, the church was built and decorated between 1042 and 1056 under the direction of 'the Imperial *surintendant des bâtiments*, sent from Constantinople together with a master builder and other artists in charge of the subordinate work', presumably masons and mosaic workers. Jointly, patron, architect, and craftsmen created one of the most beautiful structures of pure Constantinopolitan design and execution. An outer narthex, crowned by three domes and terminated right and left by an absidiole, leads into the esonarthex. From there, the naos opens, only 7.80 m. (26 ft – 25 Byzantine ft) square. The tripartite articulation of its walls was effected in the ground-floor zone originally by pairs of projecting octagonal colonnettes, surmounted in the second zone by strong, yet elegant, half-piers [318, 319]. This counterplay was taken up by the intervening niches: rectangular niches below, both in the centre and in the corners, followed in the second tier by deep semicircular niches in the corners, and

317. Constantinople, Kilise Camii, *c.* 1100. Exterior from the south; drawing by Texier, *c.* 1835

318 and 319. Nea Moni, Chios, 1042–56. Interior facing north-west (*above*) and interior facing south (*below*)

delicate shallow, curved niches in the middle. In the third zone, elliptical dome segments in the middle alternate with high stilted half-domes in the corners to form the octagonal base for pendentives, drum, and dome. This complex and eminently refined spatial design is supported by an equally subtle decoration. Marble slabs – also an Imperial gift – sheath the walls, framed by marble cornices *à billettes*. Quarter-domes, half-domes, and pendentives are covered with mosaics which rank among the best in Middle Byzantine design and workmanship; a similar decoration presumably covered the main dome as well. The floor was surfaced by interlaced *opus alexandrinum*. Viewed as a whole, the decoration conveys an idea of what the churches and palaces of Constantinople looked like before they fell into ruin. But all this wealth and subtleness in the Nea Moni is encased in a comparatively simple and not too delicate shell. The outer walls, built in 'recessed' brick technique, are articulated by recessed blind arches. Two tiers of niches articulate the main apse: those below, steep and flanking a triple window; the upper ones squat and deep, much like those found on the apses of the Eski Imaret and the Kilise Camii.

Other church plans, whether newly invented, derived from models long obsolete, surviving or revived, come forcefully to the fore in Constantinople between 1050 and 1150. Both the Gül Camii and the Kalenderhane, the former around 1100, the latter half a century later, continue or revive the type of the cross-domed church, obsolete since the eighth century. Only details – the steep niches of the apses and the 'recessed' brickwork – reveal the true date of the Gül Camii; that of the Kalenderhane is given away only by finds made during excavations.[13] The ambulatory plan, too, originates in that century. It seems to derive from the cross-domed type by omitting the gallery level. The first instance, indeed, so far known appears to have been the Koimesis church in Nicaea (Iznik) as re-

modelled after an earthquake in 1065 [253]. The galleries, formerly surmounting the aisles, were removed and their place taken by clerestory walls each with three windows, one full-sized and round-topped in the middle, those on either side halved and closed by a half-arch: a grouping as telling for the time of construction as the 'recessed' brickwork employed or the articulation of the narthex façade.[14] At roughly the same time, as witness the Kariye Camii, churches are apt to be simplified in plan and shrunk. A single bay is topped by a dome, but provided with a full-scale chancel – forechoir, main apse, flanking apsed pastophories – wider than the nave. The interior, remarkably steep, is sheathed all over with marble plaques and mosaics: a jewel, designed to impress the visitor by sophisticated preciousness. Outside, the structure is simpler: the dome articulated by colonnettes and blind arches, the apse by a triple tier of niches, the higher main tier grouped around a triple window [400]. Plan and elegance of design spread to the countryside near Constantinople: one example survives at Kurşunlu on the south coast of the Sea of Marmara. In the Toklu Dede Mescidi in Constantinople – its Byzantine name yet unknown – a nave, aisleless and barrel-vaulted, is pierced by a centre dome; the end bay, as the chancel, billows out in a trefoil plan, with shallow niches sideways and a terminating apse. The details, pilasters and responds on the flanks, outside niches on the apse suggest an eleventh-century date. Tetraconchs, too, come to the fore in these same decades, their interior walls hollowed out by larger and smaller niches: a small sanctuary, the Panaghia Kamariotissa, at Heybeliada (Heybeli), on one of the islands in the Sea of Marmara, is the first example of the type known, near the capital and hence probably Constantinopolitan; in a complex form, moreover, in which tetraconch and Greek-cross octagon interpenetrate, and built in recessed brickwork.[15] The counterplay of subtle interior effects with a

320. Constantinople, Zeyrek Camii, twelfth century. Exterior from the south-west; drawing by Texier, c. 1835

321. Constantinople, Zeyrek Camii, South Church, 1118–24. Exterior of apses

322. Constantinople, Gül Camii, c. 1100(?). Exterior of apses

comparatively plain exterior shows even in a timber-roofed basilica such as the H. Sophia at Nicaea (Iznik), built shortly after 1065. Prior to a Turkish remodelling, two triple arcades on columns, separated and linked by an extraordinarily long pier, carried the clerestory wall with its five windows – a complex overlapping rhythm enveloped by the plainest outer wall.[16]

The end phase of Middle Byzantine architecture in Constantinople differs from the eleventh-century phase only by richer, if less subtle decorative effects. The arcades of an apse window, always tripled, or the openings of a narthex gallery grow increasingly slender, their supports thinner. The number of ribs in a dome increases. The dome over the naos finds its

counterpart in a smaller dome, rising from the upper floor of the narthex. A chapel may be crowned by two domes, placed lengthwise over its aisleless nave. Apses often push out in seven, rather than five facets. The niches surmounting the window zone on the exterior apse wall become higher and deeper than in the eleventh century. Similarly, the niches which flank the triple apse window grow tall and steep. All this is exemplified in the three structures incorporated into the Zeyrek (Mollazeyrek) Camii [320]: the large south church [321], built by the Empress Irene between 1118 and 1124 and dedicated to Christ Pantokrator; the north church, dating but shortly after 1124; finally, the chapel in the middle, completed by 1136 as the Imperial

mausoleum – *heroon* is the term used in the deed of foundation. Of the splendid decoration of the south church the pavement survives little damaged: an *opus sectile* design of coloured marbles, laid out in five-spot guilloche patterns enveloping roundels, with human and animal figures inlaid. Fragments of the marble revetment remain on the chancel walls. Finally, bits of stained glass show that the windows were filled with panes showing figures of saints.[17] At times, the articulation of the apses is further heightened by a third tier of niches, added at the bottom below the steep niches of the window zone, and a cornice – composed of a dogtooth frieze and pendant triangles – runs below

the eaves line. Such detailing is found in the lateral apses of the Gül Camii [322], and, though without the terminating frieze, in the main apse of the Kariye Camii [400]. At the same time, the ornament of these Late Middle Byzantine churches appears to have changed its character. Indeed, ornament of the Comnene and the Late Macedonian types in Constantinople seems quite different from earlier architectural decoration. A number of capitals and a base from the Fenari Isa Camii exemplify the earlier style of ornament [323–5]: leaves of foliage are scooped, and rounded at the tips; the lines of the half-wheel design on the base are wavy, the eagle on the capital is lively; the whole

323 (*below*). Constantinople, Fenari Isa Camii, North Church, dedicated 907. Capital of window in main apse

324 (*right*). Constantinople, Fenari Isa Camii, South Church. Capital of a window from the North Church, dedicated 907, re-used

325 (*below right*). Constantinople, Fenari Isa Camii, North Church, dedicated 907. Capital in the window of the north arm

design is imaginative and rich. By the eleventh century, on the other hand, the ornament turns harder. The capitals of the Nea Moni on Chios carried on their faces an interlaced cross pattern with sharp corners. On the cornices in the north church of the Zeyrek Camii group, the palmettes have hardened, their leaves turned spiky. In the Eski Imaret Camii of *c.* 1080 the fluid forms of a Lesbian cyma have congealed into cold heart-and-arrow shapes. The clear-cut half-palmettes on a window capital in the small church of St John in Trullo end in sharply

326. Constantinople, St John in Trullo, twelfth century. Window capital

pointed leaves [326]. But so little ornament survives in Constantinople that any statement regarding the late eleventh or indeed the twelfth century is hazardous in the extreme.

NORTHERN GREECE AND THE BALKANS

Nowhere is Middle Byzantine architecture more closely linked to Constantinople than in northern Greece and the Balkan countries: in Macedonia, comprising the border provinces of Greece and Yugoslavia, and in Thrace, meaning present-day Bulgaria, European Turkey, and northern Greece east of Salonica.[18]

Before 1018

Despite continued wars, throughout the ninth century the buildings of the Bulgar czars - witness the throne hall at Pliska - had vied in plan and size, though not in style, with those of the emperors at Constantinople. With the early tenth century, the situation changed. A structure such as the Round Church at Preslav revived the plan of Roman mausolea, but fused into it features drawn from the contemporary architecture of Byzantium.[19] However, the full impact of Middle Byzantine building is felt more directly in the many dozens of parish and monastery churches founded by Czars Simeon (893-927) and Peter (927-69) around their two residences: at Preslav, where alone some thirty-odd churches and monasteries have so far been excavated - all built before the destruction of the town in 971; and at Ohrid. The ruins of churches around Preslav, in particular, seem to mirror to perfection the contemporary architecture of Constantinople. Indeed, alongside church plans known from Constantinople appear building types and schemes of decoration no longer preserved among her churches and palaces, but presumably once extant in the Byzantine capital as well as in its outposts.

The great majority of these churches were quincunx structures, much like those built by the Macedonian House in the capital. True, the methods of construction differ. The building material in Bulgaria is, with few exceptions, roughly hewn blocks of rubble; the supports are piers or columns, the shafts of the columns either crude, stumpy monoliths or a rough pile of low drums. But Constantinopolitan reminiscences abound in plan and detail. Sometimes the outer walls are set with half-cylindrical buttresses, recalling the Bodrum Camii. At times the apses are polygonal on the outside and preceded by clearly marked forechoirs [327A]. Occasionally the narthex is surmounted by an upper gallery. Also as in Constantinople, the flanks of the naos

often open in triple windows (or are they arcades?) towards the outside.[20] The ornament may be crudely executed, but on the capitals Ionic volutes and impost blocks are unmistakable. At times, indeed, the decoration is planned – though not carried out – along extraordinarily refined lines. Pavements are laid out in large colourful panels; hexagonal brick tiles are sometimes framed by bits of white stone and green marble; white stone octagons with four concave sides appear set between pieces of green and red stone; or again,

red, white, and green materials form a zigzag pattern and are framed by a band of red-brick tiles inset with white disks.

A few churches excavated around Preslav and Ohrid, however, seem to have departed from the commonplace quincunx plan. At Vunitsa (Vinitsa), about 950, the naos was formed by a domed square.[21] Only four odd metres (13 ft) long and wide, it would seem to anticipate on a small scale the plan of the early-twelfth-century church incorporated into the Kariye Camii at Constantinople, and it may stand as an example

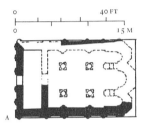
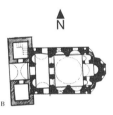
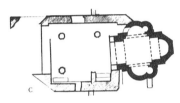

327. (A) Preslav, Bial Briag, Church 2, early tenth century. Plan
(B) Vunitsa (Vinitsa), church, *c.* 950. Plan
(C) Ohrid, Sv. Panteleimon, early tenth century. Plan
(D) (*below*) Patleina, church, 907(?). Plan

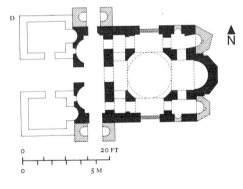

RISING WALLS ⎫
FOUNDATIONS ⎬ ORIGINAL STRUCTURE
 ⎭
BLOCKED

of earlier buildings of this type no longer preserved in the capital [327B]. But at Vunitsa the type presents itself in the true language of the tenth century. Shallow niches on either side enlarge the interior square; tiny lateral absidioles project eastward, carved into the springing of the main forechoir. Outside, small niches are hollowed into the mass of the walls. Similarly, the complex tiny trefoil chapels, widespread in Macedonia and as far south as Central Greece, seem to be rooted in Constantinople. Simple trefoil chapels of Late Antique derivation were of course common from Early Christian times to the end of the sixth century, and indeed a number of small trefoil churches of Justinian's time have been found in the Balkans.[22] But the triconch appears in far more complex form in Middle Byzantine times in a number of tiny trefoil and quatrefoil chapels of complex design of the late ninth and tenth century in Macedonia, Greece, and Constantinople, as witness the one at Heybeliada. Literary sources, too, refer to triconch structures, whether audience halls or

chapels in the palace precinct.[23] At Ohrid, for instance, the church of Sv. Panteleimon (it is known only from excavations) was composed of a domed square, a forechoir and apse, and two semicircular niches, billowing out on either side and shooting forth tiny absidioles [327C].[24] Far to the south, on Mount Varasova opposite Patras, the ruin of another trefoil church has survived: the lateral conchs are enclosed in outside polygons; domed chapels flank the short stem of the triconch; and throughout, niches are hollowed into the inner walls.[25]

Likewise, complex variants on the standard quincunx plan are frequent among tenth-century churches around Preslav, variants which in all likelihood again reflect prototypes lost at Constantinople. Such Constantinopolitan impact becomes evident in the plan of the church excavated at Patleina near Preslav and dating perhaps from 907 [327D].[26] The forechoirs of the lateral apses were separated from the naos; the walls were set with niches; the three apses terminated on the exterior as polygons. The flanks of the naos were pierced, and deep niches hollowed the walls of the narthex. Most of these features find their counterparts in tenth-century churches in Constantinople, such as the Bodrum Camii or the Fenari Isa. But the spatial design at Patleina was more subtle. Not only was the eastward pair of supports omitted from the quincunx plan, but the corners of both the apse and the corresponding western piers of the naos curve inward. Thus the dome rising from these curved corners must have interpenetrated with the barrel-vaults of the four cross-arms and transformed them into mere spatial fragments. All this was condensed into the tiny space of a naos only 5 m. (16 ft) wide and 3·40 m. (11 ft) deep. The preciousness of this jewel-box design was further enhanced by the decoration of glazed tiles which spread over floor and walls like a colourful, shiny sheet. Sassanian prototypes have been invoked for this decoration. However, glazed tiles were also known in Con-

stantinople; and while not all the ornamental motifs painted on the Patleina tiles can be matched by what little has survived at Constantinople, the designs built from palmettes, S-shaped leaves, and wheel-shaped blossoms placed symmetrically around a central stem find their counterparts in the mosaics designed and executed by Byzantine artists at Cordova.[27] Thus at Patleina as well, it was presumably Byzantine designs that inspired the painters of the tiles. Whether imported or locally produced, tile revetting must have appealed to the architects at Preslav as an acceptable substitute for the unobtainable marble veneer and mosaic decoration prevalent in Middle Byzantine Constantinople.

Comparable in its smallness, complexity, and crudeness of execution – though of slightly earlier date – is a remarkable church south of the Bulgarian border. Situated at Peristerai, in the mountains east of Salonica, it was built in 870/1 by a Salonican disciple of St Methodios [328A].[28] Executed in rough rubble and reduced to 15 m. (50 ft) in either direction, the core of the plan yet forms a Greek cross with five domes, recalling, on a small scale, Justinian's Church of the Apostles [328B]. But this basic plan undergoes further complications: each arm has been transformed into a triconch by the addition of three steep billowing niches. Four columns placed in the corners turn the centre bay into a cross-in-square, with corner bays but 60 cm. (2 ft) wide and deep. All this calls to mind the complexity of Early Middle Byzantine architecture at a time when it had hardly begun at Constantinople.

Structures such as Peristerai or the churches of the Bulgarian court found at Preslav and Ohrid combine a frequently crude technique with the most elaborate spatial designs. Alongside them, however, stand churches of an extremely simple type. They are tiny hall-churches or basilicas, their three naves barrel-vaulted, carried by only one or two pairs of supports. Frequently they have been linked to similar

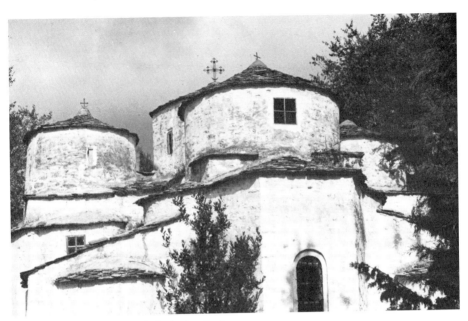

328 (A) and (B). Peristerai, church, 870/1. Exterior from the east (*above*) and section and plan (*below*)

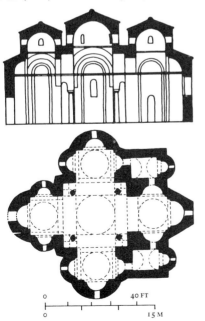

0
40 FT

0
15 M

churches in Asia Minor, but this is doubtful: it is probably more correct to view them as the product of a folk architecture free from, and possibly opposed to, the influence of the Imperial, Royal, and Patriarchal courts at Preslav, Ohrid, and Constantinople.[29] Indeed, in the majority they date from the period after 976, when Byzantine influence in Bulgaria had much weakened. Their appearance could well be explained within the framework of a reaction directed both against the Byzantines and against the Byzantine-permeated Bulgarian court of the Preslav era. From excavations at and near Pliska, a number of such churches are known from the time of the new Czar Samuel (976–1014), when Pliska was again the capital of Bulgaria. In many cases only plans are known, making it impossible to tell how many were hall-churches, how many basilicas. Hall-churches, no doubt, did occur.[30] On the other hand, the numerous small churches with nave and aisles surviving

329. Veljusa, church, 1080,
with later additions. Plan

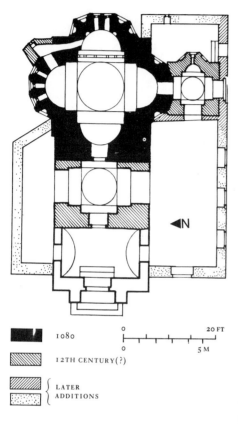

◀N

■ 1080

▨ 12TH CENTURY(?)

▨ ▧ } LATER
ADDITIONS

0 20 FT
├──┼──┼──┤
0 5 M

at Kastoria in southern Macedonia are all ba-
silicas. Although heavily restored, they present
a good picture of the type.[31] The naves are ex-
traordinarily high, the clerestory windows small,
the supports either stumpy columns or squat
piers prolonged by pilasters to carry the soffits
of the arcades. Nave and aisles are barrel-
vaulted, the aisles at times surmounted by gal-
leries. A narthex, triple-naved or provided with
a gallery, precedes the naos. The overall plan,
then, is exactly like that of the hall-churches and

basilicas to the north, in Bulgaria. Occasionally
there appears amidst these small-size basilicas
an equally tiny triconch chapel surmounted by
the over-tall drum of its dome, witness the
church of the Kubilidike [295]. But the masonry
technique of the churches at Kastoria and their
variegated ornament points southward, to
Greece. Whether it is the church of the Anar-
gyroi, of the Taxiarches, or that of H. Stephanos,
the walls are built in the colourful *cloisonné*
masonry shot through with cufic motifs which
date the Greek churches – and hence presum-
ably those of Kastoria as well – to the end of the
tenth and the first half of the eleventh century.[32]
Both this date and the fusion of Bulgarian plans
and Greek masonry techniques coincide with
the historical situation of Kastoria, a border
town, wrested from Bulgaria in 1018 by Basil II,
the Bulgar-Killer, and re-united with the Byzan-
tine Empire. Through its geographical position,
it became a well-to-do trading centre on the way
from Salonica to Ohrid. To this day, the dozens of
small churches – unsophisticated, colourful, and
all vaulted basilicas or aisleless churches except
for the trefoil of the Kubilidike – make Kastoria
a site where Middle Byzantine architecture can
be studied in abundance.

1018-1185

The victory of Basil II radically changed the
political map of the Balkan peninsula. Of the
Bulgarian Empire, only the part north of the
Haemon range and east of the Struma river
survived as a Byzantine vassal state, lasting until
1184, when an independent, if weak, second
Bulgarian kingdom established itself. South of
the mountains, Thrace returned to Byzantine
rule. Likewise, Byzantium re-established herself
in northern Macedonia, meaning present-day
northernmost Greece and southern Yugoslavia.
The Morava and Vardar valleys, from Kastoria
and Ohrid to Skopje and Niš, remained in-
disputably Byzantine until the latter part of the
twelfth century. The administrative and eco-

nomic leadership of this entire vast region came to rest with Salonica, the seaport for the Central Balkans. Spiritually as well, Salonica became the true centre for the entire territory, although as early as 1020 an 'autocephalous' patriarchate was established at Ohrid as a sub-centre for the Central Balkans within and beyond the frontiers of the Empire. At about the same time, the monastic communities on Holy Mount Athos made their impact felt all through the Balkans. Architecturally the situation is less clear. The close links which always existed between Salonica and Constantinople, separated by only two days' sailing time, make it likely that prior to the mid eleventh century Salonican architecture also had strong ties to Constantinople. But this assumption cannot be proved, as no

church building has survived in Salonica from the three hundred odd years intervening between the construction of the H. Sophia and the first half of the eleventh century. Certainly the reconquest in 1018 of the vast hinterland of the Balkans gave rise to the revival of building activity in Salonica. The first witness of this new activity is the Panaghia Chalkeon, dedicated in 1028 to the Mother of God.[33] This first Middle Byzantine church surviving in Salonica remains remarkably impressive, despite its small size and notwithstanding all too thorough restorations undergone in 1934 [330]. A structure of uniform build, it is in plan a quincunx on columns, preceded by a double-storeyed esonarthex. The building material is pure brick, and the outer walls are heavily accentuated by

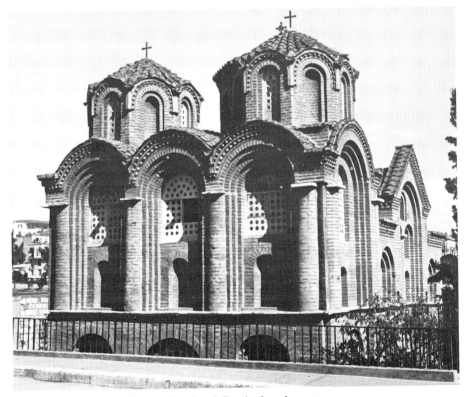

330. Salonica, Panaghia Chalkeon, dedicated 1028. Exterior from the west

pilasters, responds, and half-cylindrical buttresses. The capitals, all uniform, bear on their four faces a guilloche design comparable to that on the capitals of the nearly contemporary Nea Moni on Chios. While capitals and building technique relate to contemporary practices in Constantinople, the simple handling of the interior with straight walls recalls churches in Central Greece rather than in Constantinople.[34] However, neither Greek nor Constantinopolitan custom fully determines plan and design of the Panaghia Chalkeon. On the contrary, it evolves a style characteristic, it seems, of Salonica and her territory. The walls, instead of opening in arcaded large windows as in Constantinople, are pierced by small windows, following Greek custom; but unlike Greek custom, the windows are framed by larger and smaller niches with doubly and triply recessed jambs. The façade likewise is powerfully accentuated: three huge arches spring from half-columns and pull together the upper and lower windows of the narthex gallery. Finally, the drums of three domes sprout high from above the roofs. Taken by itself, this is not a new motif: outer drums, though hidden behind parapet walls, rose over the four corners of the Fenari Isa Camii, and possibly – but this is sheer hypothesis – rose above the corner bays of the Nea. By the late eleventh century, two drums rise from the western corner bays of the Eski Imaret; four low drums rise undisguised from the corner bays of some Greek and South Italian churches [364]; and in the Pantokrator church, the south church of the Zeyrek Camii complex (1118–24), a single dome rises from the narthex gallery.[35] But in the Panaghia Chalkeon the motif takes on added significance. The drums rise higher, they are strongly accentuated, and they are placed not over the five bays of the naos, but over its centre and over the two outer bays of the narthex gallery. Throughout, the silhouette is immensely lively. Triangular gables over the arms of the quincunx contrast with semi-circular arches rising from the end bays of the narthex. The tall centre dome is set with two rows of windows and is terminated by a straight eaves line; while on the two narthex domes, slightly lower, a row of alternating windows and niches is crowned by the rippling effect of an arched eaves line. On the outer walls, the surfaces, recesses, niches, windows, pilasters, responds, and half-columns are played off against each other in a contrast of surfaces, masses, and depth, in oppositions of light and shade.

Next to nothing is known at present about church building in Salonica for the century following the dedication of the Panaghia Chalkeon. On Mount Athos, perhaps as early as the last third of the tenth century and thus prior to the Panaghia Chalkeon, a local church type had been evolved in the main church, the Katholikon, of the Lavra Monastery [331].[36] Notwithstanding later remodellings, the core of the structure is well preserved: a cross-in-square, enlarged into a triconch by apses added to the cross arms, the dome supported by clumsy piers, the outside austere. Two chapels, parekklesia on a quincunx plan, flank the deep narthex. All these elements, triconch plan, parekklesia, deep narthex (liti), become the hallmark of monastic churches all through northern Greece and the Balkans. The source on which the church of the Great Lavra drew, on the other hand, remains in doubt. The plain polygonal apses of the triple chancel call to mind tenth-century Constantinopolitan churches, such as the Bodrum Camii. The overall grimness of the design may be due both to the austerity of the founder and to his place of origin. In Trebizond (Trabzon), whence he came to the wilderness of Mount Athos, the few early churches surviving wholly or in fragments are designed with similarly heavy forms and with a comparable disdain for detail as early as the ninth century.[37]

However, the churches and monasteries on Mount Athos always stand somewhat apart. Within the Balkans proper, Salonica and Con-

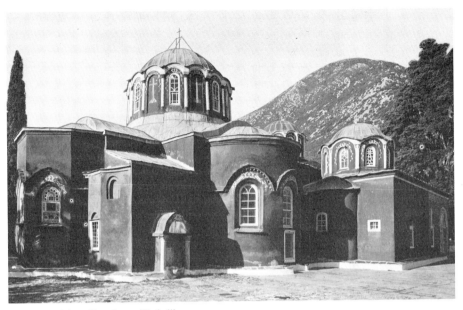

331. Mount Athos, Great Lavra, Katholikon,
tenth century, last third(?). From the north-east

stantinople seem to remain the two main springs
– singly or combined – on which patrons and
architects drew for techniques of construction,
plan, and decorative vocabulary. Personal ties
more than anything else may have dictated the
preference for one or the other source. At
Veljusa in the Struma valley, a Greek bishop,
Manuel, in 1080 built his funeral chapel, follow-
ing, if not a Constantinopolitan model, Con-
stantinopolitan custom. The original structure
– enveloped by a later (?) domed narthex and
side chapels – is well preserved [329]. It is a
small domed quatrefoil, built of pure brick.
The four foils, semicircular inside, project on
the exterior as seven-sided polygons. Their
three centre facets are pierced by a row of
windows, each framed by a steep blind arch;
the four remaining facets are hollowed by
two tiers of niches which continue the line
of the windows on either side. The whole recalls
contemporary churches of Constantinople, such

as the Zeyrek Camii, or the Nea Moni on Chios,
or the quatrefoil on Heybeliada in the Sea of
Marmara; so do details, such as the herringbone
patterns which decorate the half-domes of the
niches in the upper tier of the main apse. Quite
possibly Bishop Manuel employed a crew of
Constantinopolitan workmen; for decoration
and furnishings of the church also recall what
little has survived in the contemporary churches
of the Imperial city. A pavement in *opus vermi-
culatum* covers the floor in an involved, elegant
guilloche pattern, and a templon with finely-
carved lintel and capitals closes off the entrance
to the main apse. The murals which covered all
the walls complete the picture of a lavish
decoration.[38]

Few such pure Constantinopolitan buildings
are known in the Balkans so far. One, a variant
on the quincunx plan, still rises at Ferai (Vira;
Feredjik) near Alexandroupolis on the coast of
Thrace. Dated 1152, its foundation by the

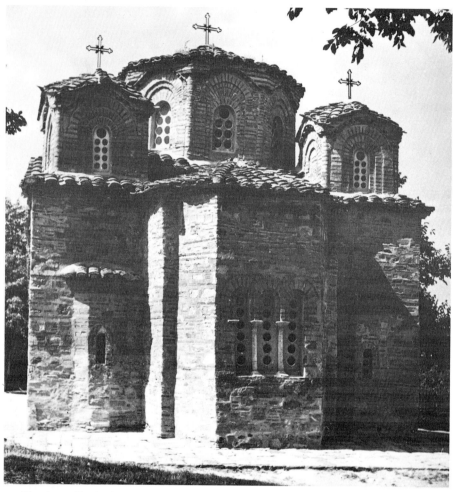

332. Nerezi, near Skopje, church,
c. 1164. Exterior of apses

Emperor Isaac Comnenos explains the Constantinopolitan features of design: the five drums rising from the centre and corner bays; their pumpkin webs; the 'recessed' brickwork alternating with stone bands; the high-shouldered window groups in the cross arms; the tier of niches surmounting the apse windows and their brick ornament; the colonnettes and pilaster articulation of the drums; and the elegant palmette decoration on cornices and capitals – a remarkably lavish layout for a monastic church in the provinces. More frequently, in the second half of the twelfth century in Macedonia and Thrace, Salonican and Constantinopolitan elements blend with each other; and grafted on to the blend are new

features of a developing Balkan architecture. Nerezi near Skopje, in or shortly before 1164, offers yet another variant on the quincunx formula [332]. An exonarthex preceded the naos, open on the sides. The corner bays are cut off by walls from the naos: those to the east as forechoirs of the main apses, those to the west as separate chapels, accessible only from the narthex. Small drums rise from the domed corner bays in what may be the original Constantinopolitan five-spot design rather than the three-spot variant of the Panaghia Chalkeon. But at Nerezi these subordinate drums are turned into square tower-like aediculae, their gabled roofs contrasting sharply with the octagon of the centre drum - originally terminated by a rippled eaves line. Much as at the Panaghia Chalkeon, this contrast of shapes is enhanced by a counter-play of wall surfaces, projecting colonnettes, responds, and windows, set into doubly recessed niches, though built in *cloisonné* masonry rather than brick.[39]

The political changes in the Balkans in the last third of the twelfth century also altered its architectural picture. The Serbian mountain tribes, settled west of the Moravian valley and never conquered by the Empire, banded together in the kingdom of Rascia, and under Stephan Nemanja (1168–97) pushed eastward into the valley towards Niš and Skopje. Their geographical position in the western mountains and their close bonds to the tribes settled along the Dalmatian littoral make it appear natural for their architecture to show close affinities to building concepts long prevalent on the Dalmatian coast and across the Adriatic Sea. A Western Romanesque vocabulary of pilasters, corbel-table friezes, and recessed portals and a masonry technique of large ashlar blocks – both drawn ultimately from Apulia and Lombardy – are applied more often than not to the church type traditional in Dalmatia: an aisleless nave, its barrel-vault pierced half-way down by a dome. It is equally natural that such

Romanesque features would be blended with elements drawn from Middle Byzantine church architecture: the ribbing of a dome, the colonnettes and arches of a drum. The Church of the Virgin at Studenica, founded by Stephan Nemanja after 1183, represents this current at its best [391]. Given its fundamentally Romanesque style, however, this 'West Serbian' or Rascian group is not our concern.[40]

Conversely, it is equally natural that in the eastern parts of the Serbian kingdom recently wrested from the Byzantine Empire or close to her frontiers, Byzantine building traditions – in the form customary at Constantinople – would remain as strong as ever, though for a short time only. The ruin of St Nicholas near

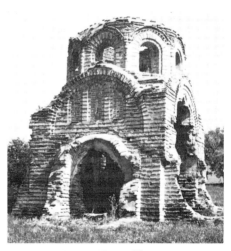

333. St Nicholas, near Kuršumlija,
founded 1168. Exterior

Kuršumlija, founded by Stephan Nemanja in 1168, is a splendid example [333]. The 'recessed' brickwork, that hallmark of Constantinople, leaves no doubt as to the origins of the builders. Possibly under the direction of a Constantinopolitan architect, this crew from the Imperial capital thoroughly re-interpreted the Dalmato-Rascian plan which was presumably stipulated

by the royal founder. The barrel-vaulted bays of the nave east and west of the dome were shrunk to the size of broad arches. Conversely, the centre bay, surmounted by the dome, grew in proportion. Its four supporting walls rise high, each pierced by a high-shouldered triple window of unmistakably Constantinopolitan design. Higher up rises the drum of the dome. Eight-sided and pierced by eight large windows, it has been turned into the dominant element of the entire design. A shallow esonarthex preceded a triple chancel opened from the main bay: a plan recalling the Kariye Camii, yet even more sophisticated. With its alternating deep red brick courses and its broad white mortar bands, the structure presents itself as an eminently Constantinopolitan building – *in partibus infidelium*, as it were.[41]

St Nicholas at Kuršumlija and the conventual church at Nerezi reflect two contemporary versions of Middle Byzantine architecture in the Central Balkans. Behind them stand the variants of the style, as represented by the two architectural capitals of the North Aegean coast in the age of the Macedonian and Comnene emperors: Constantinople and Salonica. This is where the last phase of Byzantine architecture in the Balkans has its starting point. But Middle and Late Byzantine building in the Balkan countries after the tenth century always retains a more than slightly provincial flavour. To see Byzantine architecture of the eleventh and twelfth centuries outside Constantinople at its best, one must turn to Greece.

GREECE

Middle Byzantine church building on the Greek mainland, exclusive of Salonica and Macedonia, stands apart from the architecture of Constantinople under the Macedonian and Comnene emperors. The differences have at times been exaggerated, but they are present in the techniques of construction, in the decoration, in detailing, and, to a lesser degree, in the plan and overall design. Where the builders of Constantinople generally face their walls with pure brick, Greek builders from the late tenth century at least use a *cloisonné* facing. Quite unknown in Greece is the system of half-columns, pilasters, responds, blind arches, and niches which articulates the outer walls of churches in Constantinople and Salonica. In place of strong relief and the play of light and shade, the wall surface in Greece is determined by texture and colour. Dog-tooth friezes are used by the school of Constantinople only on drums; in Greece these same friezes serve to frame windows, to articulate the wall horizontally, or to enliven the surface – places where the masons of Constantinople would have employed projecting cornices. Straight horizontal lines set off unified walls; gables are triangular, not curved as so often in Constantinople. The drums of domes in Greece are circular or octagonal; they rarely aspire to the twelve- or fourteen-sided shapes which prevail in Constantinople from the eleventh century on. From the late tenth century, however, semicircular arches often resting on colonnettes frame the windows of the drum and form the characteristic rippling eaves line – a motif which does not reach Constantinople before the end of the century, and even then differs from the Greek version in the use of segmental blind arches. H. Sotir in Athens presents one of many examples [334].[42]

Plans also differ. The triple arcaded window openings in cross arms customary in the quincunx churches of Constantinople remain unknown in Middle Byzantine church building in Greece. Lateral forechoirs and absidioles open wide into each other and into the eastern corner bays of the naos, whereas in Constantinople they communicate through narrow openings, sometimes simply through doors. More often than not, the Greek Middle Byzantine

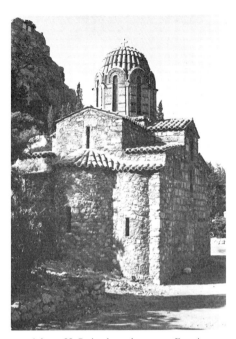

334. Athens, H. Sotir, eleventh century. Exterior

designers fuse outright the lateral forechoirs with the eastern corner bays.

A firm chronology based on a few dated structures and involving a meticulous analysis of the characteristics of masonry, ornament, and window shapes has been established for a majority of Middle Byzantine churches in Greece.[43] Colouristic ornamental effects in the exterior walling start early, possibly around or before the middle of the tenth century, when chequerboard reticulate designs make their appearance in provincial churches. The patterns of the *cloisonné* walling, in particular, change in a highly characteristic way from the late tenth to the end of the twelfth century [335, 336]. Irregular to start with, the *cloisonné* was apparently fully developed by the end of that century. It was either composed of single or double horizontal brick courses, or of brick pat-

terns, geometric or imitating Greek and cufic characters, inserted vertically between the ashlar blocks. Occasionally, these cufic patterns develop into continuous friezes which, in turn, by 1070 are composed of terracotta panels inscribed with cufic characters in *champlevé* technique [336]. From the middle of the century, however, if not earlier, these elaborate designs are more and more replaced by simple patterns: single bricks are inserted vertically between the ashlar blocks; dentil courses, used in overabundance in the earliest buildings, are employed with increasing economy; by 1080 rows of large stone crosses take the place of the irregular stone masonry used earlier along the base of the outer walls [352]. After the middle of the century, too, meander friezes of bricks and friezes composed of cut brick come into use; local schools in the Argolis and elsewhere further develop this feature in the second third of the twelfth century [356, 357]. Other features undergo equally characteristic changes. Coupled and tripled arcaded windows gradually give way to grouped windows, with one large arch surmounting the arcades; possibly a Constantinopolitan detail, known in Greece since the early part of the century but rarely used, this feature begins to prevail about 1080. Simultaneously, the tympanum of the window arch, originally often filled with a cufic design, presents a pattern of bricks laid at right angles in horizontal and vertical courses. These patterns become curvilinear in the first half of the twelfth century, and glazed bowls – an occasional addition since 1040 – become a customary feature in the design of window tympana. Concomitantly, high-shouldered triple windows, as known from Constantinople, become frequent in the design of gables: a single, double, or triple window flanked by lower semicircular arches, either blind or open. Finally, from about 1150, arches, tympana, and jambs of windows are dressed in stone instead of

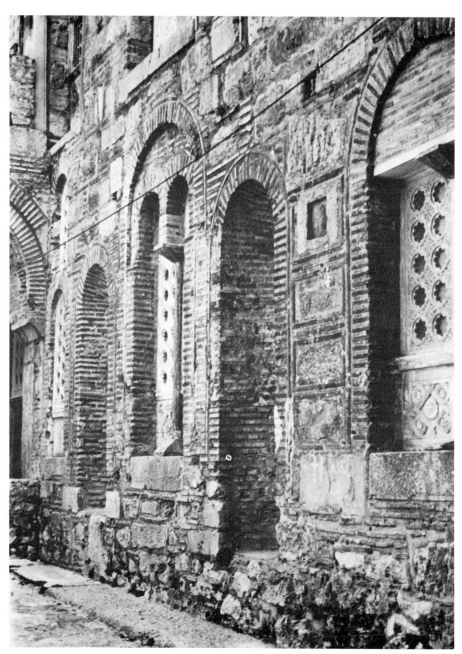

335. Hosios Lukas, Katholikon, consecrated 1011 or 1022. North flank, *cloisonné* and brickwork

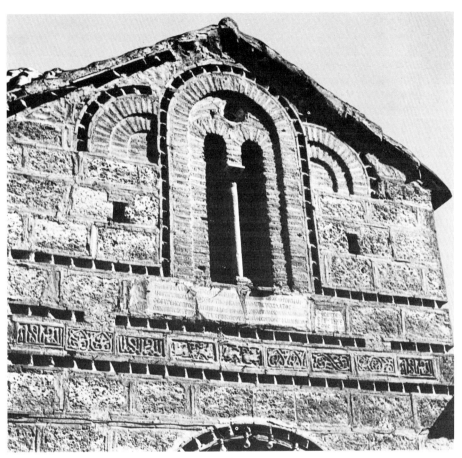

336. Athens, H. Theodoroi, *c.* 1060–70.
West façade, *cloisonné* and cufic frieze

brick. Such tell-tale features, then, establish a chronological sequence for the majority of Greek churches in the centres of building activity.

Few churches seem to have survived in Greece from the early tenth century, when Middle Byzantine architecture was first flourishing in Constantinople. What little has remained is crude: small barrel-vaulted chapels, aisleless or occasionally small basilicas on piers; or quin-cunx structures resting on four piers, the three apses rounded outside: a hallmark, it seems, of early church design in Greece, though possibly often as a provincial survival.[44] But in the latter part of the tenth century, the situation changes, starting from a few major centres. At Hosios Lukas, the church of the Theotokos-Panaghia – the smaller one, to the north – presents the quincunx type clad in a new, rich vocabulary.[45] Constantinopolitan impact apparently makes

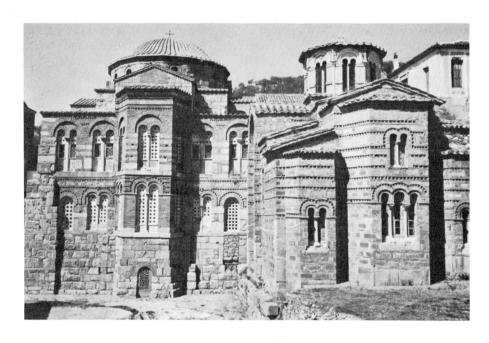

337 (*above*). Hosios Lukas, Theotokos,
tenth century,
and Katholikon, consecrated 1011 or 1022

338–40. Hosios Lukas, Theotokos,
tenth century.
Vaults (*right*) and capitals (*opposite*)

itself felt: the apses, outside, project in three sides of a polygon [337]; their windows are bipartite and tripartite, divided by slight mullions; and the four inside supports are slender columns. But plan and design retain a character of their own with features destined to shape for a long time Middle Byzantine building in Greece. The inner outlines remain simple. The walls clearly delimit the interior; windows are few and narrow. Forechoirs and narthex lack the elegant shallow niches billowing into the walls, forming trefoils and quatrefoils. Cornices sharply mark the springings of the barrel-vaults in the cross arms and the centre drum; decorative ribs underscore the groins of the vaults in the corner bays [338]; templa formed by trabeated pairs of columns shut off the forechoirs from the naos. The decoration, too, on the inside, is precise and somewhat dry. Typical are a frieze of standing leaves on the sharp and hard cornices; two Corinthian capitals with

long, feathery hard leaves – the *flos* replaced by globules with a cross [339, 340]; and two capitals spun all over with flat foliage, interspersed with diamond shapes and recalling – we shall revert to it – Islamic design. Hard foliage fused with rosettes, diamonds, crosses, and hearts pressed into tight patterns covers the architraves of the templa. On the contrary, the outside is sheathed in the richest, most colourful design. The walling is done in a lively *cloisonné*, the ashlar blocks of different sizes and shapes, framed by double and triple horizontal courses and single vertical bricks, the mortar – where original – rust red. Cufic inserts, including continuous friezes, enliven the design; so do the multiple shadow-bands of dog-tooth friezes – as much as nine bands on the main apse. Forceful verticals join with these horizontals in an upright skeleton grid. A strong arch frames the cross arm. Colonnettes project at the corners of the eight-sided drum [341]: strongly profiled

341. Hosios Lukas, Theotokos, tenth century.
Exterior of drum

arches, slightly horseshoe-shaped, curve above, to form originally a rippling eaves line; marble panels with deeply cut interlace design frame the windows, the ground originally inlaid. The impact of Islamic art could not be clearer; but it remains a matter of discussion how this impact reached Greece – through textiles, manuscripts, workmen – and why it reached Greece in particular.[46]

Though more complex in plan, the church of the Apostles on the Agora in Athens employs a vocabulary much like that of the Theotokos-Panaghia in Hosios Lukas and is probably close in date [342, 343].[47] Here, the quincunx has been fused with an eight-leaved rose formed by four major apses on the main axes and four absidioles on the diagonals. Low and high, square,

rectangular and curved spaces interlock and merge. The interior decoration is gone. But on the outside, the combination of strong polygonal shapes bound together by multiple dogtooth friezes and the red and greyish-white *cloisonné* walling with cufic inserts conveys an impression of both strength and colouristic variety. At the corners of the drum, slender colonnettes are sunk into grooves; above, arches rise high and interpenetrate with the eaves line of the roof – the 'rippling dome' of Middle Byzantine Greece.

Neither the Theotokos-Panaghia nor the church of the Holy Apostles achieves the sophistication and the superb quality of the Katholikon at Hosios Lukas [297, 298, 344-6]. Designed a generation later or less, and consecrated pre-

342 and 343. Athens, Holy Apostles, *c.* 1000(?).
From the south (*above*) and plan (*below*)

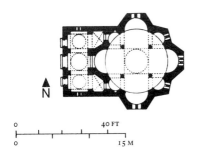

sumably in 1011 or 1022, it combines a complex
spatial design, subtle lighting and colourful
handling of wall surfaces. Laid out as a Greek-
cross octagon, the centre bay freely expands up-
ward under its ribbed dome; the steep and nar-
row cross arms pierce through an enfolding
belt of aisles and galleries; the aisles are en-
closed save for narrow entrances; the galleries
open like cages. Wide and narrow, high and low,
closed and open volumes thus interpenetrate on
different levels [298, 344]. Double and triple
windows face the west arm; double windows
standing at right angles open at each of the four
corners of the centre bay. At ground level, solid
walls, set with tall, flattened round-headed
niches, close off the corners of the centre square.
In contrast, the gap rent by the lateral cross

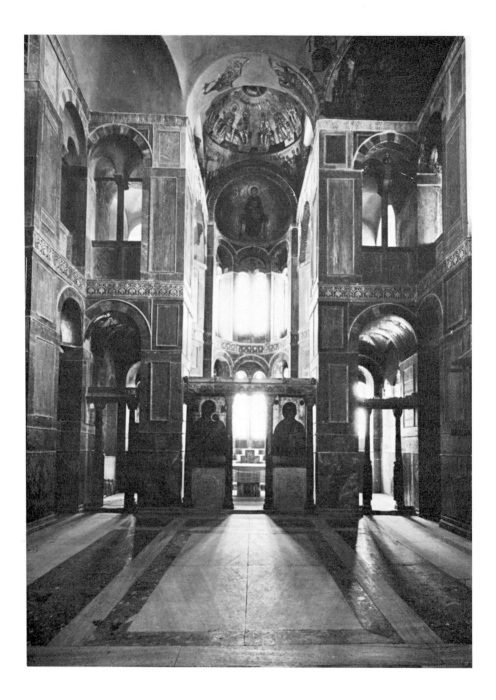

arms is bridged on the ground floor by a slender triple arcade, on the upper level by the wide platform of an open gallery [345]. High up, the barrel-vault oversails at right angles both platform and supporting arcade. Unexpected views across the core of the naos meet the visitor who either submerges into or emerges from the caves of fragmented aisles and galleries. Alternating in clear and dim zones, light plays over the mosaics in the dome, the corner squinches, the apse, and on the vaults of the cross arms. In darkish shades, it glides over the marble sheathing which covers wall surfaces, piers, and spandrels in a sophisticated design of light and

dark grey, purple and olive slabs, framed by cornices à *billettes*, and set off at gallery level by a frieze of standing leaves, white against a blue-black ground and remarkably free in design [346]. If the Greek-cross octagon, indeed, harks back to the cross-domed type, the re-interpretation in terms of Middle Byzantine architectural concepts is striking: all massiveness has been eliminated; the spatial volumes, rather than being separated, interlock; the lighting, plainly defined in the H. Sophia at Salonica, has become highly sophisticated; solidity has given way to elegance and squatness to lithe slenderness.

The outer shell is simple in outline: a cube, topped by a low octagonal drum and the curve of a squat dome [337, 347]. Projecting east is a single polygonal apse. Yet this shell opens like a wire screen. Single windows pierce the drum, double and triple windows are broken through

344–6. Hosios Lukas, Katholikon,
consecrated 1011 or 1022.
Interior facing east (*opposite*),
interior of apse and templon (*below*),
and detail of decoration (*right*)

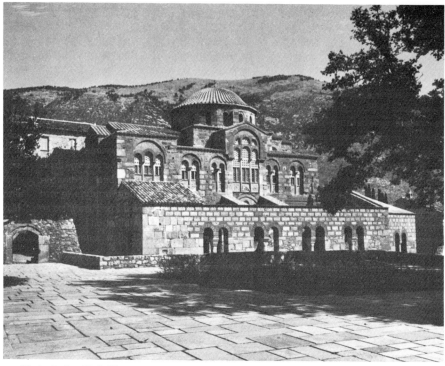

347. Hosios Lukas, Katholikon,
consecrated 1011 or 1022, and trapeza. From the south

the flanks. A tall, triple aperture opens at the ends of the cross arms, subdivided below by colonnettes and surmounted by the group of a high-shouldered triple window. Arches resting on broad half-piers anchor the windows to the wall. The walling is an irregular pre-*cloisonné*: brick is used for window piers and spandrels, and it is interspersed here and there in patches between the stone blocks of the base. Only at the top of the walls is there a genuine *cloisonné*, though often framed by two courses rather than a single course of bricks. The deep-shadow bands of dog-tooth friezes in the lower spandrel zone of the main apse break up the grey and red tapestry of the walling.

Given the dates of these buildings, the latter part of the tenth and the early decades of the eleventh centuries, the new Middle Byzantine church design in Greece lags nearly a century behind the first of the Middle Byzantine churches surviving in Constantinople. The precious design and costliness of the decoration make it plausible that Imperial support played a part in engendering the flowering of the new style. But such support, if given, did not impose Constantinopolitan solutions on the Greek builders. The plan of the Greek-cross octagon, while not surviving in the capital, might yet have come from there. But in their vocabulary the Greek builders from the outset searched for

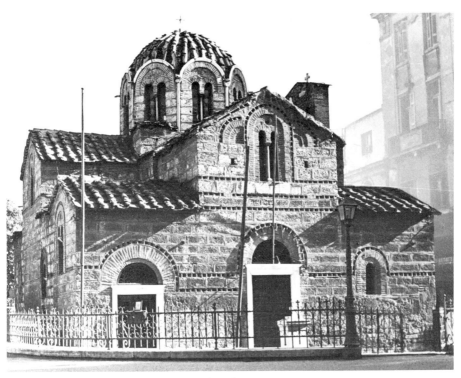

348. Athens, H. Theodoroi, *c.* 1060–70. Exterior from the west

349. Athens, Kapnikarea, *c.* 1060–70. Exterior from the west

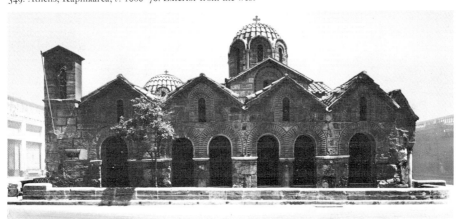

their own solutions: lively colours, stronger accents of light and shade, rippling effects, sculptural forms.

This early style, however, seems to have lasted but a short time. The complexity of the spatial design, as seen in the Katholikon of Hosios Lukas and the Apostle church in Athens, finds no following. The colourful texture of the walling, to be sure, lives on for some decades: the churches of Kastoria, shortly after 1018, offer an example. Yet the classical phase of Middle Byzantine architecture in Greece – from the last third of the eleventh to the early twelfth century – is marked by greater sobriety. As late as 1060/70 the use of multiple dog-tooth bands and the cufic *champlevé* frieze across the façade of the H. Theodoroi in Athens recall

350. Athens, Kapnikarea,
c. 1060–70. Capital and impost block

earlier custom, as do an occasional ornamental *cloisonné* and the multi-gabled roof line of narthex and parekklesion on the, presumably contemporary, Kapnikarea [348, 349].[48] The window capitals show a heart-shaped foliage ornament, still reminiscent of that on the templa of the Theotokos at Hosios Lukas [350]. By and large, however, the texture of the walling grows quieter, the exteriors simpler, the interior spaces ever more precisely marked off. At times, the design reaches a climax in an uncomplicated, beautiful, and subtle equilibrium. By the time the monastic church at Daphni was built, *c.* 1080, the masses of apses, corner bays, cross arms, dome base, and drum are as superbly balanced against each other as the wall surfaces, tile roofs, and window openings [351–3].[49] Cufic or geometrical inserts in the *cloisonné* walling are less frequent, and single bricks alone frame the stone blocks, both vertically and horizontally. The stone masonry along the base of the walls has been arranged into a series of large crosses. Indeed, in its layout as well, the cross octagon at Daphni takes on aspects very different from those of the Katholikon of Hosios Lukas. The belt of spaces enfolding the centre bay and the cross arms is but one-storeyed. There are no galleries, and the aisles are broken up into four chapels, groin-vaulted and but dimly lit. On the other hand, the centre room appears steeper: the squinches sit high up, the entrances into the aisle fragment, and the flat corner niches are extraordinarily tall, the proportions remarkably simple and beautiful. Where the design of the Katholikon at Hosios Lukas was based on the sophisticated counterplay of spatial units overlapping and interlocking, of graded shades of light and dark and of variegated colours, sixty years later an impressive simplicity and balance reigns at Daphni.

Similar changes affect the plan and design of quincunx churches all over the country. The composite plan survives well into the twelfth century. The main church of Hosios Meletios –

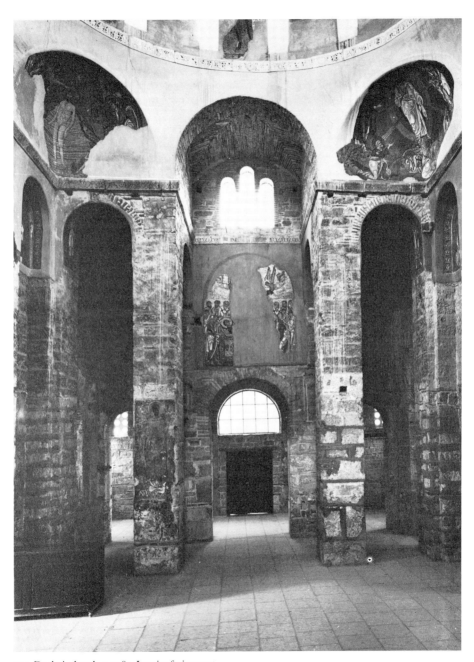

351. Daphni, church, *c*. 1080. Interior facing west

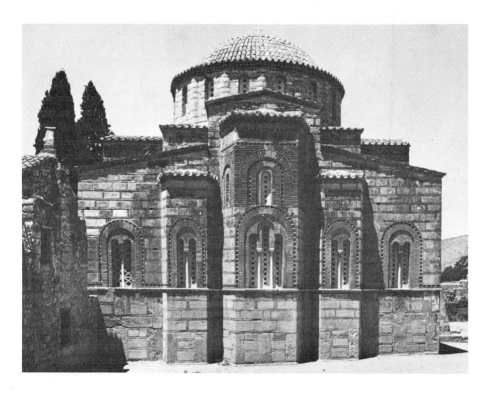

352 and 353. Daphni, church, *c.* 1080.
Exterior of apses (*above*) and window (*right*)

on the Kitheron in northern Attica, built before 1100 – provides a good example, remarkable also for the rich ornament of its door lintels, templa, and capitals [302]. But the tendency from the late eleventh century onwards is towards the fusion of forechoirs and eastern corner bays of the naos into one space. This is achieved in three variants. Either corner bays and forechoirs are fused into one barrel-vaulted rectangular bay [354A]; or they are contracted into a square bay and covered by a groin- or barrel-vault [354B]. In either case, the naos with its four columns and three projecting apses remains intact. At times, however, the fusion goes still farther: the two eastward columns of the naos are lost and the piers of the forechoirs

Theodoros at Vamvaka (Vamvakou) on the Mani peninsula are well-preserved country churches of the third type. The last two are dated, the first about 1080, the second, through an inscription, 1075.[50] These few stand for hundreds of similar churches in towns, monasteries, and villages all over Greece. All are quite small. The interior surface in the Theotokos at Hosios Lukas, covering as much as 122 sq. m. (400 sq. ft), is often reduced to as little as 70 or even 45 sq. m. (230 or 150 sq. ft), with the centre bay measuring but 2·70 and even 1·70 m. (9 ft and 5 ft 6 in.) along the side. The interiors are extraordinarily steep: the vaults of the cross arms and the pendentives of the dome spring from a level twice and nearly three times as high

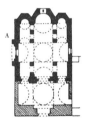
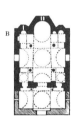
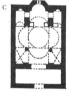

354. (A) Kaisariani, Hymettos, church, late eleventh century. Plan
(B) St John the Theologian, Hymettos, c. 1120. Plan
(C) Ligourio, H. Yoannis, c. 1080. Plan

function simultaneously as the eastern supports of the centre bay [354C]. At the same time, in many churches the apses are shrunk to small niches embedded in the thickness of the wall, or they are entirely omitted. The church at Kaisariani on the Hymettos near Athens exemplifies the first type in the late eleventh century. The second type is represented by the near-by church of St John the Theologian, of c. 1120, and by St George near Kitta, on the Mani peninsula far south in the Peloponnesus, of c. 1150. H. Sotir at Amphissa in Locris, H. Yoannis at Ligourio in the Argolis, and H.

as the centre square is wide. The dome rises to a height three and four times that modulus. Special local features are frequent, as in the churches on the Mani peninsula where the nave vault of the naos projects into the narthex. Walling, as a rule, forms a simple *cloisonné* pattern, the base set with stone crosses. Vaults were cast over centering; at Ligourio the imprints and even one board of the centering are well preserved [355]. Domes with rippling eaves are still frequent, but surprisingly often they give way to a drum with a straight eaves line which holds down the blind arches framing the windows.[51]

Ornament also takes on new shapes. Cufic motifs and Islamic interlace panels, so prominent in the latter tenth and the early eleventh centuries, by 1070 have become less conspicuous

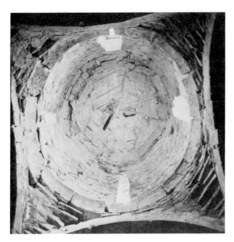

355. Ligourio, H. Yoannis, *c.* 1080. Interior of dome

356 (*below*). Merbaka, church,
mid twelfth century(?). Exterior

357 (*opposite*). Amphissa, H. Sotir,
twelfth century. Detail

in the overall picture. Geometric forms and foliage fused and tightly compressed, as already in the templa of the Theotokos, remain in use as late as the first quarter of the twelfth century. But the geometric elements are increasingly eliminated in favour of tendril friezes with tre-foil shoots. These too are tight at first, but gradually the tendrils loosen, the ground appears, and animals are inserted between the winding scrolls. By the third quarter of the twelfth century, the development is complete.[52]

At least one local school of masons, however, as early as the second third of the twelfth century renounced the sober and austere wall patterns which had come to the fore in the latter eleventh century. Four churches in the Argolis, not far from Nauplion, represent a new playful and rich design: three are quincunx churches, at Chonika, Merbaka [356], and H. Moni; the fourth is a charming small Greek-cross chapel at Plataniti.[53] The quincunx rests on four

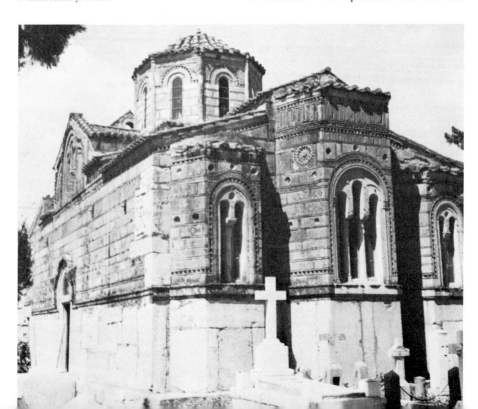

columns; the corner bays carry pendentive domes or groin-vaults and are small in comparison to the centre bay (in a ratio of roughly one to four). Shallow niches enlarge the chancel sideways and shelter the passages – long, dark, and barrel-vaulted – which lead to the lateral forechoirs. The esonarthex is closed off from the naos except for narrow doors. Three apses project clearly on the exterior. The upper sections of the cross arms rise only slightly over the roof of the corner bays; the drums are simple, articulated only by projecting corner colonnettes and by blind arches framing the windows. Only the H. Moni is dated, by an inscription of 1149. The church at Chonika has been assigned to the first, Merbaka to the last quarter of the twelfth or the early thirteenth century. But the measurements in all three are so nearly the same that one would like to attribute them to one workshop, active near the middle of the twelfth century. Details of walling and ornament are

likewise almost identical: the simple *cloisonné* walling sparsely interspersed with dog-tooth friezes; the brick meander friezes; the triple windows in the gables of the cross arms, flanked by high-shouldered blind half-arches and filled with a brick decoration at right angles; and for the spandrels of the windows, a fan-shaped brick design. But brick ornament of this type is found beyond the borders of the Argolis as well; H. Sotir near Amphissa, not far from Delphi, shows it already early in the twelfth century [357]. Frequently ceramic bowls inserted into the walls add colour to the masonry. *Cloisonné* and linear elements combine to form a splendid if somewhat playful design, characteristic, it would seem, of the last phase of Middle Byzantine architecture in Greece – a design carried over into the early stages of Late Byzantine building.

ASIA MINOR

From the outset, Middle Byzantine architecture in Asia Minor stands somewhat apart. It lacks the subtlety of Constantinople and the slightly overdone elegance of Salonica and Bulgaria, and it is far less experimental and free than Greece. Caught in provincial custom, its masons work with the traditional building material, ashlar blocks, and prefer the locally customary pier to the foreign column. For a long time, they cling to old-fashioned plans. But once Middle Byzantine taste caught the fancy of patrons and monastic congregations – local or immigrants from the capital – Constantinopolitan elements blended easily with native forms. The fusion presumably took place in the course of the tenth and eleventh centuries.

The loss to the Seljuks of nearly all of eastern and southern Asia Minor and temporarily as far north as Nicaea (Iznik) after 1071 seriously affected church building in the larger urban centres. In the countryside, Christian congrega-

tions and monasteries survived, and church building continued for some time. A number of factors, in fact, strengthened the hand of the Christian groups: the establishment of an Armenian kingdom (Lesser Armenia) in Cilicia after 1071; the passage of the Crusaders in 1097-8, 1147-8, and 1196-9; and the Byzantine re-occupation of northern and western Asia Minor by 1118 and of the southern coastline, including Lesser Armenia, from 1137 to 1176.

Vaulted chapels without aisles, cross-shaped churches, and hall-churches with nave and flanking aisles are known from the sixth and seventh centuries all through the interior of Asia Minor [128–31].[54] Unchanged, these same types apparently continued to the beginning of and into the Middle Byzantine period. Neither the masonry of well-squared large stones facing a rubble core nor the vaulting technique differ

from those of the earlier buildings. Naves were covered by barrel-vaults, domes placed on squinches. Profiling and ornament likewise for centuries remained the same, and since few inscriptions have been reported, there is little evidence – external or internal – for dating the buildings. But at least three churches at Trebizond (Trabzon), on the northern coast of Asia Minor, are dated.[55] St Anne was built in 884/5 as a tiny basilica with barrel-vaulted nave and aisles; the two arches on either side of the nave rest on a single column, a spoil. The Nakip Camii, probably slightly later, was a hall-church, barrel-vaulted and terminated by three apses. The Chrysocephalos was laid out, in the tenth or eleventh century, apparently as a large hall-church, 30 m. (100 ft) long, with galleries above the aisles. The overall plan; the barrel-vaults, longitudinal over the nave, while transverse over

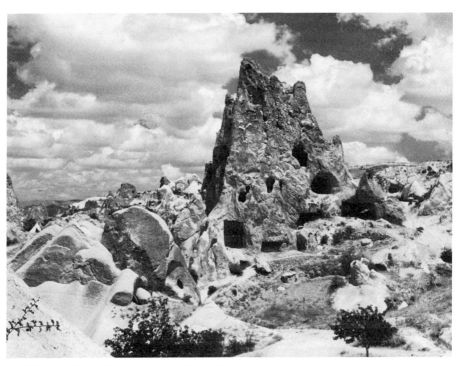

358. Göreme, rock chapels, eighth–twelfth(?) centuries

the aisles; and finally, the shape of the main apse, horseshoe-shaped within, polygonal without, closely link the Chrysocephalos, like the other churches, to the architectural customs that had prevailed for centuries in the interior of Asia Minor.

Needless to say, traditional plans of the ninth, tenth, and eleventh centuries were also employed in the strange cliff chapels which, from the eighth and ninth centuries, had been hollowed out by monastic congregations from the fantastic rock cones in the wild 'moonscapes' of Cappadocia [358]. Large numbers are preserved in an excellent state in the valleys of Soğanli (Soğandere), Göreme, and Menendiz Suyu (Peristrema), all south-west of Kayseri.[56] Floors, walls, piers, columns, and vaults are hewn from the living rock, as are furnishings: altar, benches, chancel screens, and, once, a fully-fledged iconostasis. In their majority, the cliff chapels are tiny, some only 2 by 4 m. (6½ by 13 ft) and rarely over 7 m. (25 ft) long or wide. All are terminated by horseshoe apses. Often they are aisleless. But double-naved churches do occur – one of the chapels is even a fully developed hall-church, its nave and aisles separated by colonnades. At times a barrel-vaulted quadriporticus, its centre open to the sky, precedes the chapel. In the Tokali Kilise, the largest of the rock churches at Göreme, a square porch leads into the nave, which in turn is laid out on a transverse axis, and terminated by the five arches of an iconostasis and by three apses [359]. One is reminded of the transverse churches of the Tur Abdin.[57] The whole is most impressive, both in decoration and size – the nave alone measures 9 m. in width and nearly 6 m. in depth (30 by 20 ft).

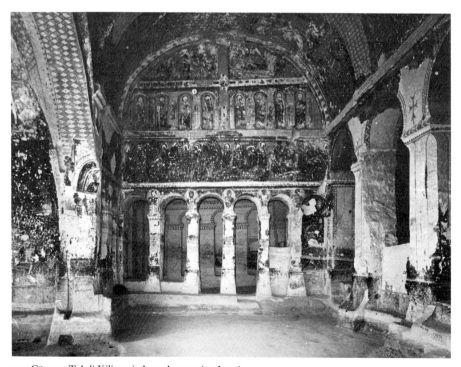

359. Göreme, Tokali Kilise, ninth-tenth centuries. Interior

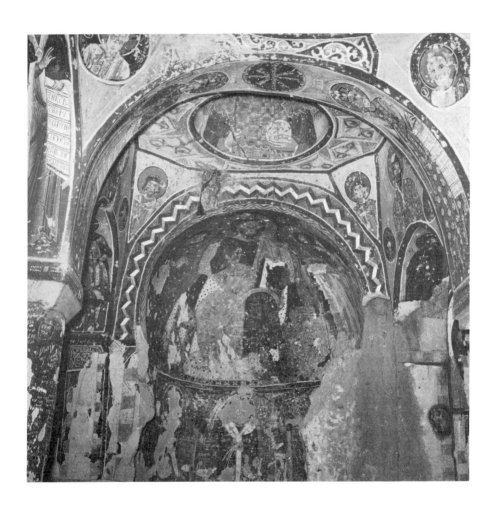

360. Göreme, Elmali Kilise, tenth-twelfth centuries(?). Interior of apse and domes

In the great majority of the rock churches, walls and vaults are covered with extensive fresco cycles of an obviously Middle Byzantine character. A few of the cycles are dated by inscriptions ranging from the early tenth to the third quarter of the eleventh century. At times these paintings may have been executed shortly after the chapels had been hewn from the rock. Frequently, however, an older layer of frescoes appears below the Middle Byzantine murals, and this older layer often appears to be aniconic. While it is true that monastic congregations in the Cappadocian mountains could very likely have clung to the tenets of iconoclasm beyond its official end in 843, a good case can be made for a ninth- or eighth-century date for at least some of the rock churches. Indeed, a group of six, based on the style of their mural decoration, has been assigned to the iconoclastic decades 726-87. On the other hand, given the tolerant religious policies of the Muslim conquerors, the monastic congregations in the Cappadocian wilderness may well have continued their building activity through the twelfth century.[58]

But not all rock churches cling to obsolete plans. Middle Byzantine taste also makes itself felt in their planning, and quincunx plans are frequent [360]. The majority of the churches in this group may date from the eleventh or even the twelfth century. But at least one, because of the style of its murals, has been dated into the second half of the ninth century. Such a dating would be prior to, or contemporaneous with, the building of the Nea in Constantinople. Yet the plans of the quincunx churches in Göreme differ from those in Constantinople: all nine bays are equal in size, and not only the corner bays, but in at least one case the cross arms as well are surmounted by domes – this latter a variation impossible in a real building, but easy in a cave. At the same time, the playful transposition suggests a date before the quincunx type was hardened and codified in Constantinople during the eleventh century.[59]

Indeed, during the eleventh and possibly as early as the tenth century, Constantinople and her quincunx churches must have exerted a strong impact on the builders of Asia Minor. Few Middle Byzantine churches above ground have survived in the interior, but among those extant Constantinopolitan elements are para-

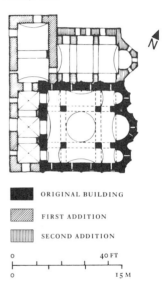

361. Çanlikilise, Hassan Dağ, eleventh century. Plan

ORIGINAL BUILDING

FIRST ADDITION

SECOND ADDITION

mount. In the Çanlikilise (Tchânliklisse) at the foot of the Hassan Dağ south-west of Kayseri [361, 362], the walling of alternating bands of well-cut ashlar and brick recalls the technique well known in Constantinople from the ninth to the eleventh century, and possibly later.[60] The brickwork with extraordinarily broad mortar joints either imitates or is executed in the recessed brick technique of eleventh- and early-twelfth-century Constantinople. Other features equally point to the capital: the slender proportions of interior, drum, and apses, the latter with their polygonal exterior and semi-circular interior curves. Blind arches, twice

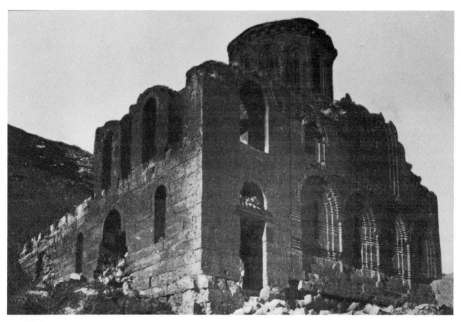

362.Çanlikilise, Hassan Dağ,
eleventh century. Exterior from the south-west

recessed, frame the windows of the apse, the tall drum, and the south flank, as well as outlining the upper cross arms. Blind niches form an upper tier high on the apse wall; the blind arches spring from elegant colonnettes. The fan design of bricks in the spandrels is better known from Greek buildings, but it may well have originated in Constantinople. In short, the design of the Çanlikilise – on the wild Hassan Dağ – stems from Constantinople and was executed by a crew in which at least some members must have been trained in the capital. Closely related is the ruin of another church, Üçayak near Kirşehir, 90 miles north-west of Kayseri: a twin chapel, formed by two atrophied Greek-cross buildings opened towards each other and originally with a common narthex, but each provided with its own apse; the two domes, formerly on high drums, each with

twelve windows; the apses polygonal outside and articulated by probably three tiers of shallow niches; the flanks opened in arcades and windows, both triple; the outer walls articulated by blind arches, three and four times stepped back; the masonry brick throughout, with broad mortar-beds, whether in genuine or imitated 'recessed' technique. Design and details closely recall the Kariye Camii or the Eski Imaret and suggest a date perhaps just prior to 1071 and Constantinopolitan building practice. Elsewhere regional building tradition perseveres. The small-stone masonry follows native custom; supports are invariably piers; the plans are limited to a naos and a triple sanctuary; apses retain their semicircular exterior in compliance with centuries-old local custom; nartheces, lateral porticoes, and parekklesia are unknown. But the impact of Constantinople is unmis-

363. Lindos, Rhodes, H. Yoannis,
c. 1100. Exterior from the south-east

takable. The plans are cross-in-square, the chancels are set off from the east corner bays. Windows are framed by twice-recessed blind arches or by niches; upper tiers of niches encircle drums and apses. Graceful pilasters and recessed arches articulate the outer walls, and mouldings are remarkably elegant.[61]

Middle Byzantine building found its way from southern Asia Minor to the islands of the southern Aegean Sea, at times unadulterated, at other times merged with elements brought from the Greek mainland. The blend is represented on Rhodes by a number of churches,[62] but nowhere more attractively than in the ruins of H. Yoannis high up on the Acropolis of Lindos – a superb site among the Greek ruins [363]. Its cross-in-square plan clearly shows both the impact of Asia Minor and the collateral influence of the Greek mainland: the esonarthex has been fused with the naos as in the churches of the Mani peninsula in the Peloponnesus, and as so often in Greece, the chancel parts have been fused with the east bays of the nave. But the masonry of small ashlar, the exclusive use of barrel-vaults in the corner bays, and the recessed double frames enclosing narrow window slits link the structure to Asia Minor and suggest a date in the late eleventh or early twelfth century. On Crete, structures such as a ruin near Milopotamo and a well-preserved church at H. Myron show the same mixture of elements: stone construction, coupled with brick for the vaulting zone; a quincunx plan resting on piers, rarely on columns; domes or barrel-vaults over the corner bays; finally, blind arches, singly or doubly recessed, to articulate the outer walls. The links to church building on the mainland of Greece are weak; links to Constantinople

hardly exist.[63] On Cyprus, close as it lies to the south coast, the impact of the mainland of Asia Minor is even more strongly felt.[64] Alongside the customary Middle Byzantine church types such as quincunx buildings, domed-octagon plans, and small Greek-cross structures, a cross plan with an elongated west arm makes its appearance – probably descended directly from Cappadocian and Lycaonian cross churches of the sixth to eighth centuries. Quincunx churches are almost without exception supported by heavy piers, not by columns. The masonry of remarkably well-cut stone blocks hardly ever includes any brickwork. Everything suggests the architecture of a provincial island which more and more isolates itself against Constantinople and the core of the Byzantine Empire. This is not surprising, given the political history of Cyprus: ruled by Byzantium until 648, it maintained from then until 965 an uneasy state of neutrality, bound by treaties to both Constantinople and the Arab rulers of Syria; recovered by Byzantium, it fell prey in 1192 to Western powers – Crusader kings, and later the Republic of Venice. Nor is it surprising that at least one church plan characteristic of Cyprus has its counterpart in Apulia and Sicily: a nave covered along its main axis by three domes in succession, and flanked by barrel-vaulted aisles, which in turn are pierced by cross arms.[65] Whatever the relationship, the sea lanes of the Middle Byzantine Empire seem to have formed a link between its eastern and western Mediterranean outposts.

THE WESTERN OUTPOSTS

Middle Byzantine architecture established itself in the West in two outposts, each of a distinct character. In Venice and her vicinity, Middle Byzantine building is represented by a small number of churches and palaces. Monumental in design and lavish in execution, they are on the one hand apparently linked to the art of Constantinople and some major centres in Greece, and on the other, to the styles of Romanesque Europe. In southern Italy and Sicily a comparatively large number of Middle Byzantine churches has survived. But all are small and insignificant within the overall picture of Byzantine architecture of the eleventh to twelfth centuries. Their execution is poor and their decoration, save for the mosaics of the Martorana in Palermo, negligible. Finally, in plan they are related not to Constantinople, but to the more retarded provinces of the Aegean basin.

The ties of the Italian peninsula with the Byzantine world from the late sixth to the end of the eighth century, while weaker than under Justinian's rule, had never been completely broken. Byzantine officials sat in Ravenna and Naples; the policy of the papacy in Rome was oriented towards Byzantium. In other areas of religious activity, however – in hagiology, liturgy, and church architecture – it is not so much Byzantium that exerts its impact as what has been vaguely called 'the East': more precisely, a conglomeration of diverse influences, stemming from different provinces in the Eastern hinterlands and the Aegean coastlands, which penetrate the West from the sixth century on. Accumulated over the centuries, blended with each other and with Western features, these often heterogeneous elements remain active in the West as a common heritage. Eastern saints were absorbed by Western martyrologies, Eastern relics were being acquired, Eastern elements were filtering into Western liturgies. In church architecture – in Ravenna, Rome, and North Italy – galleries, alternating supports, pastophories, triple apses, polygonal apse shapes, and impost blocks are gradually fused with Western church plans. However, this Eastern heritage had spent itself by the end of the eighth century. It was replaced by a revival of Western Early Christian traditions, first under Carolingian impact, later by the awakening of the High

Middle Ages and their Romanesque art. True, quincunx churches sporadically made their appearance at an early moment in the West as in other borderlands of the Empire – in Italy at Milan, near Cassino, and perhaps elsewhere.[66] But in the overall framework of the West and of Italy, the East both as a heritage and as a living force had lost its significance.

Locally, in southern Italy the picture changed again in the late tenth century. In about 970 Apulia and Calabria were reconquered by the Byzantine forces, and for the next hundred years a Byzantine governor, the *katapan*, resided at Bari. At the same time, if not earlier, small congregations of Basilian monks established themselves in the countryside. The Eastern tradition of painting they carried along with them is important enough. But the cave churches in which these murals were executed are, architecturally, without significance. Other churches of Byzantine type do, of course, exist in the territory, at Otranto, Stilo [364], Rossano; their dates of construction, however, are unknown.[67]

364. Stilo, Cattolica,
eleventh century(?). Exterior

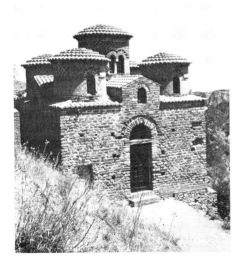

They may have been built either while the district was under Byzantine rule, or somewhat later. Indeed, Byzantine architectural types certainly survived beyond the Norman Conquest of the territory in 1071. But regardless of their actual dates, Byzantine structures in southern Italy are highly provincial, as one would expect in an outlying province, virtually an overseas colony, of the Empire. The materials used are invariably local stone, rarely brick; construction is crude. Plans were drawn from other provinces of the Byzantine world, distant but accessible over the seas. No doubt the buildings have their charm. But they have attracted attention for reasons external to either quality or historical importance: by virtue of the scenery, the appealing quality of folk art, and their exceptional position as building types otherwise unknown in the West. Within the overall picture of Middle Byzantine church building the churches of Calabria and Apulia are no more significant than those of any outlying mountain province in Greece. Their significance lies only in the evidence they furnish of the links between one distant province and another along the sea lanes of the Empire. The funerary chapel of Count Bohemund at Canosa – it dates from 1111, forty years after the collapse of Byzantine rule – is a quincunx structure sliced in half to adjust it to the adjoining cathedral; given the smallness of the corner bays, it may possibly be inspired by Salonican models. Basilicas with three domes rising over the longitudinal axis of the nave, found as late as the thirteenth century in the cathedral at Molfetta, find their closest parallel in Cypriote churches.[68] Similarly, the planimetric scheme of S. Marco at Rossano and the Cattolica at Stilo, both in Calabria, has been linked to distant Crete and indeed even further east to the quincunxes in the caves of Cappadocia. Nine bays, all of equal or nearly equal size, form the cross-in-square, thus forcing the centre bay into a disproportionate narrowness and steepness. The lack of balance and pro-

portion may well be due, both in Calabria and Cappadocia, to sheer awkwardness on the part of the local builders. Wherever the plan had originated, however, it seems to have come to Calabria by way of the Peloponnesus; there it could have absorbed a number of features which at Stilo strongly recall churches in the small harbour cities of the Greek peninsula. Sawtooth friezes articulate the wall surfaces as in the Koimesis at Tegea; as in the Pantanassa at Monemvasia, five drums rise from the roof. The use of bricks at Stilo, exceptional in South Italy, likewise suggests ties with Greece. The broad chequer bands which encircle the drums of the domes have their source in the decorative walling of churches as early as the tenth century in the Peloponnesus. This may well be when the Cattolica at Stilo, too, was built; S. Marco at Rossano, being more awkward in every respect, may be a later follower.[69] The fusion of quincunx and trefoil which characterizes the churches of Mount Athos also appears, with little change, at Castro in Apulia. In short, the small, awkward village churches of South Italy seem to have drawn, whether directly or indirectly, on quite a few provinces of Middle Byzantine architecture. There is little doubt that the builders were rustics, but one wonders whether they came from the Calabrian countryside or were migrant masons from the East. On the other hand, a large structure of decidedly Western plan, the Roccelletta of Squillace near Catanzaro, in the last third of the eleventh century or possibly after 1100, uses a vocabulary of decidedly Comnene and Constantinopolitan character, including triple-recessed niches in double tiers on the apse and similar blind arches along the flanks of its aisleless nave.[70]

Sicily occupies a very different place in the scheme of Middle Byzantine architecture.[71] Its links to the Christian East, tight in the past, had been severed by the Arab occupation in 827. The Norman Conquest of 1091, based as it was on Campania, Calabria, and Apulia, naturally established ties with these ex-Byzantine provinces, and through them with the Byzantine Empire. But these ties grew strong only in the second and the last third of the twelfth century, when the Norman court reached the highest level of contemporary aulic refinement. At that time the Norman kings and the Comnene Emperors were in constant contact. Byzantine mosaic workers were called to Palermo, perhaps from Greece and certainly from Constantinople, and their art was blended with the traditions of church planning drawn from Rome, Montecassino, and France, and the traditions of palace architecture and decoration drawn from the countries of the Islamic West. Within this wonderful and fantastic blend, Byzantine church plans are rare, unassuming, and related to provincial architecture in Greece rather than to Constantinople. What little has survived on Sicily or on the near-by islands – S. Costanzo on Capri is the northernmost outpost[72] – are quincunx structures. The supports are four columns; the apses are semicircular inside and out; the corner bays carry domical groin-vaults. The lone centre drum is extraordinarily high, and placed sometimes on Byzantine pendentives, sometimes on Islamic squinches. But the architectural design never transgresses a level of decent mediocrity.

One would expect the Martorana in Palermo to be an exception [365].[73] Dedicated in 1143 by Admiral George of Antioch to the Theotokos, and placed under the charge of the Greek clergy, it carries to this day its splendid mosaics. The dedicatory inscriptions in Greek and Arabic leave no doubt as to the love and care the founder bestowed on the structure and its decoration. But the splendour of the mosaics and the pride of its inscriptions only bring out more strongly the contrast to the architecture; for the proportions are anything but elegant, and columns and capitals are spoils of different size. True, the tower – built slightly later than the church, in front of what may have been an

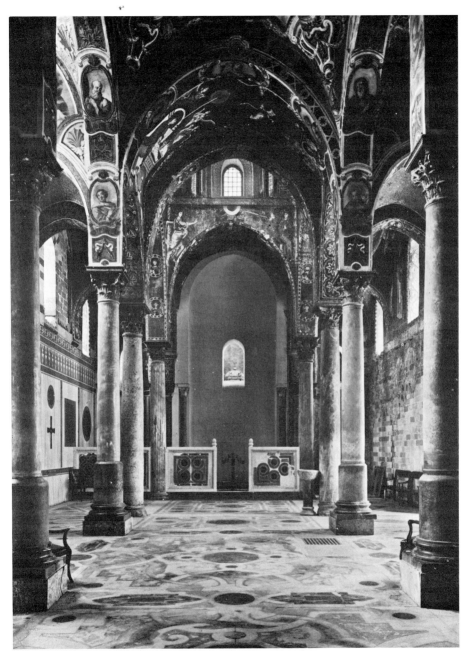

365. Palermo, Martorana, dedicated 1143. Interior facing east

atrium – is extraordinarily beautiful and was much admired by contemporary travellers. But it is of French, not of Byzantine design, an early derivative of the cathedral of Laon.

The dichotomy between the high quality of the decoration and the mediocrity of the architecture finds its explanation within the framework of an approach to Western and Byzantine art characteristic of the city states and courts of South Italy since the late eleventh century. Trading with the Levant, the merchant cities of Amalfi and Salerno had established close ties with Constantinople in business, politics, and art. The great lords of Norman South Italy, from the abbot of Montecassino to the king at Palermo, followed suit. From Byzantium they imported what they considered superior to Western art: bronze doors, mosaic workers, enamel work. But they insisted on building their fortresses and their churches along Western lines, probably because they rightly thought the first to be stronger, the latter more monumental, spacious, and better adapted to Roman liturgy than their Byzantine counterparts. Hence the churches at Montecassino, Salerno, Ravello, Bari, or Monreale were laid out according to, or modifying, Western custom: Roman Early Christian basilicas, Norman and Lombard Romanesque churches with galleries, basilicas with segregated crossings surmounted by a dome and drum. Only the extraordinary height of the drum recalls the tall drums of Byzantine quincunx churches. But the buildings themselves remain Western.[74] Even the cathedral at Pisa, begun in 1063 by an architect with the Greek name Busketos as a huge cross-transept basilica with galleries and doubled aisles, is fundamentally Western, notwithstanding possible collateral influences from the East.

In Venice the situation differs radically from that prevailing in southern Italy and Sicily in the tenth, eleventh, and twelfth centuries. The settlements in the Venetian lagoon had long slipped from active Byzantine rule. But the growing merchant republic maintained close diplomatic and mercantile ties with the Byzantine Empire. Venetian businessmen were well established in the ports of Central Greece and the Peloponnesus, and nowhere were they more powerful than in Constantinople. Finally in 1204, by engineering the Fourth Crusade, the Republic of Venice, with the aid of her feudal allies, could take over capital and Empire. No wonder, then, that the art of Venice until the eleventh and twelfth centuries – notwithstanding an ever-growing penetration of Western Romanesque elements – remained closely linked to the Middle Byzantine art of Byzantium.

Building activity in Venice may have been extensive as early as the ninth and tenth centuries. But nothing has survived save for the foundations of the first church of S. Marco, which we shall soon discuss. The picture of Venetian architecture becomes clear only with the eleventh and twelfth centuries. At that point the penetration of Western elements into Venetian building is obvious. The building material employed is the high brick with thin mortarbeds customary in North Italy from antiquity to the twelfth century among Milanese, Ravennatic, Longobard, Carolingian, and Romanesque builders. In planning, Western liturgical demands are taken into consideration. The decoration in many of its features has been assimilated to Western custom. But it is equally obvious that Venetian building of the eleventh and twelfth centuries, in its basic plans, its spatial designs, and in a wealth of details, is tied far more closely to Middle Byzantine building in Constantinople and in the great architectural centres of Greece than to building in the West.

S. Fosca on the island of Torcello is a typical Greek-cross octagon; the dome has collapsed, but two squinches superimposed in each corner and the first rings of the dome have survived.[75] In plan it gives way to Western liturgical tradition by substituting short open aisles for the

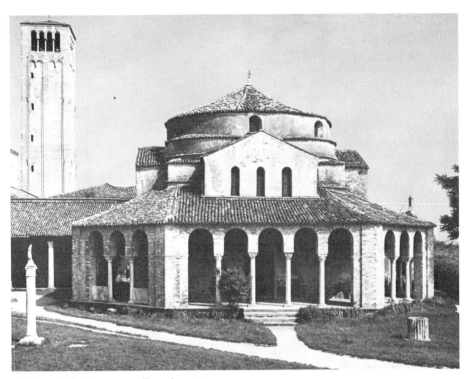

366. Torcello, S. Fosca, *c.* 1000. From the west

closed-off forechoirs of the Byzantine rite [366]. (The eight-sided outer portico is quite possibly of later date.) Otherwise the plan might just as well have been designed in Greece; the Panaghia Lykodimou in Athens and the cathedral at Christianou, both of the eleventh century, offer parallels. For that matter, the architect of S. Fosca might have drawn on Constantinople, though no Greek-cross octagon survives at present in the Byzantine capital. In fact the decorative details of the apse are those customary in eleventh- and twelfth-century Constantinople: two tiers of niches, as in the Kilise Camii; paired colonnettes, recalling the Nea Moni on Chios; a terminating frieze of pendant triangles and saw-tooth bands, as on the lateral apses of the Gül Camii. All these elements, to be sure, are

rendered less subtly than in Constantinople. They have been provincialized and translated, as it were, into the Venetian dialect. But this Venetian dialect of the late eleventh and twelfth centuries is essentially a variant of Middle Byzantine, not of Western Romanesque architecture.

The ties of Venice to both Byzantium and the West become most obvious at S. Marco, the main church of Venice as well as the palatine chapel of her doge.[76] But the network of relationships is more involved than usual. The plan of S. Marco draws not on a Middle Byzantine, but on a sixth-century Byzantine model – a sixth-century prototype, that is, which was apparently remodelled in the tenth century. And this remodelled prototype was transposed at St Mark's

into the Middle Byzantine dialect of Venice and crossed with a number of purely Western elements.

Remnants of a first church of St Mark's, built as early as 830, apparently survive in the foundation walls of the main piers and perhaps the bottom courses of some of the outer walls of the present structure. These remnants suggest that already the first building was cross-shaped, of approximately the same size as the present church, and thus presumably laid out as a copy of Justinian's Apostoleion; this regardless of whether the Venetian church was timber-roofed or whether (as has often been rashly assumed) it, like its Constantinopolitan model, was surmounted by five domes, one over each arm and one over the crossing. The reasons for this link to Constantinople are obvious. Venice, as protectress of the patriarchate of Grado, had just abducted the relics of the Evangelist St Mark – according to the legend the apostle of the Upper Adria, and the founder of both the patriarchal sees of Aquileia and Grado, as well as of the see of Alexandria in Egypt – from their resting place in Alexandria. The abduction reveals the Venetian ambition to raise the see of Grado, now under their control, above that of Aquileia, which in turn had long been eager to supplant the see of Alexandria, to all practical purposes long-extinct.[77] Equally at issue may have been competition with the patriarchate of Constantinople, supposedly founded by St Andrew. Thus, in 830, to honour the apostle of the Adria finally returned to their shores, the Venetians built a church cross-shaped like Justinian's church of the Holy Apostles in Constantinople – the shrine which sheltered, among other relics, those of St Andrew. Indeed, Justinian's church also remained the model when the Venetians, starting perhaps in 1063, replaced this first cross church by the present structure. By the late eleventh century, however, the church of the Holy Apostles was no longer quite Justinian's original building. The five low domes of Jus-

tinian's structure – only the centre dome having been provided with windows – had been replaced by domes raised on high drums with large windows which shed light into the arms as well as the centre bay. This remodelled Apostoleion is the structure reflected in the eleventh-century church of S. Marco.[78]

Construction of this new church of St Mark proceeded speedily. Walls and piers may have been completed by 1071, and in 1073 a first consecration took place. On the other hand, the decoration dragged on, and additions were made for centuries. The colonnades inside date from the late eleventh and early twelfth centuries, the marble revetment of piers and inside walls largely from the twelfth, and the mosaics from the twelfth and thirteenth centuries. After 1204, the narthex – originally limited to the façade – was continued along the flanks of the nave so as to envelop the western arm. The domes were given the tall and steep outer shells in timber construction and slightly bell-shaped, and surmounted – at first only the one in the centre – by open lanterns with bulbous and ribbed cupolas. Construction and design, and with them the characteristic silhouette of S. Marco, are rooted in Islamic architecture, be it the Dome of the Rock in Jerusalem or the bulbous, ribbed domes of Fatimid eleventh-century mausolea in Cairo. Also after 1204 and possibly not before the second quarter of the century, the outer walls of the narthex were sheathed in the panoply that to this day greets the visitor who approaches from the Piazza: deep portal niches, mosaics, dense rows of columns in two tiers, marble slabs, parapets, and sculptures as they appear as early as the third quarter of the thirteenth century in a mosaic above the left-hand narthex door [367].[79] Much of the decoration was looted from Constantinople, together with the four bronze horses placed above the centre portal, and the best pieces of the Treasury. The fifteenth century added the florid Gothic gables above the

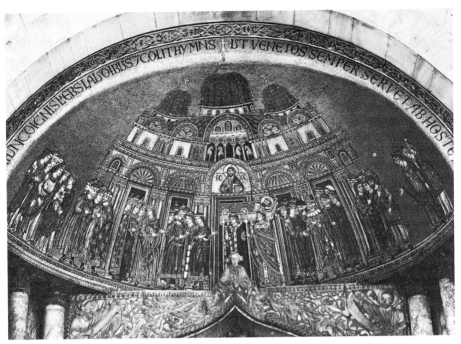

367. Venice, S. Marco, begun 1063(?). Mosaic on the
Porta di S. Alipio, showing church as after 1204

façade, the seventeenth the large mosaics in its
upper part. These additions have carried with
them elements of their own, all Western in
character: Italian Baroque, International
Gothic, twelfth- and thirteenth-century Lom-
bard. But none have altered the original
character of the building, its perfect integration
of elements of Justinian's age and Middle By-
zantine elements.

With the plan of Justinian's Apostle church,
S. Marco was bound to absorb sixth-century
concepts of space and mass [368, 369]. The
volumes of the five bays are huge. Surmounted
by the hemispheres of the domes, they are
emphatically segregated by broad arches. As in
the H. Sophia and at S. Vitale, the masses of
piers and walls are sheathed in a marble revet-
ment, the slabs forming a pattern and the veins

of adjoining slabs often counter-matching.
Their designs are less subtle, their materials less
precious. Yet in the handling of space and
masses and in the use of a marble covering, S.
Marco breathes much of the spirit of Justinian's
art.

All the same, S. Marco is permeated by new
concepts, both Middle Byzantine and Western
Romanesque. As in the Apostoleion after its
remodelling, at S. Marco the five domes rise
on high drums. Light evenly fills the upper
zones; nave, aisles, and chancel remain dim,
almost dark. As in the Apostle church, the gal-
leries in Venice also originally spanned the full
depth of the aisles to the outer walls. But de-
parting from Justinian's design, at S. Marco
the galleries were not screened by colonnades;
on the contrary, the lateral barrel-vaults sup-

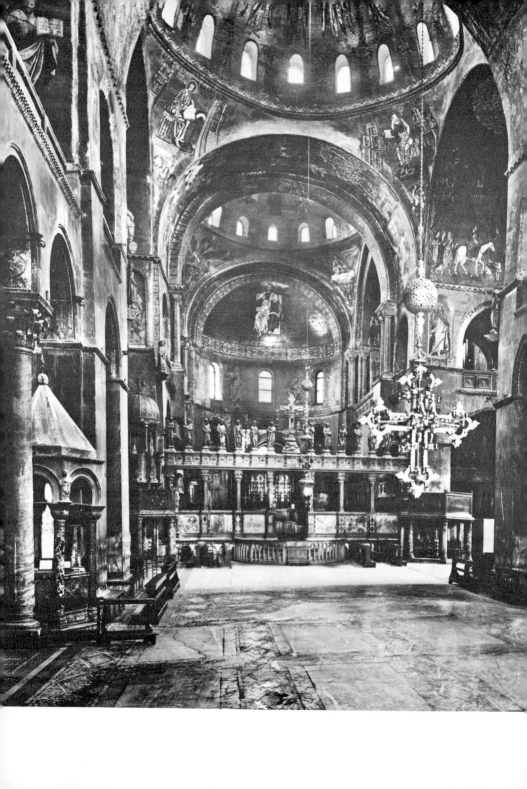

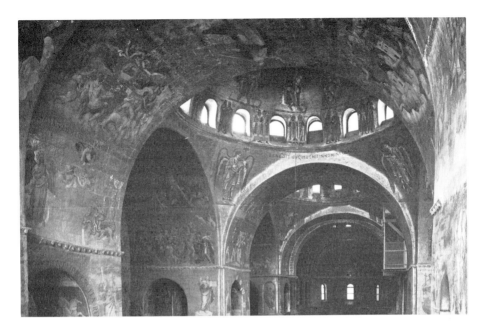

368-70. Venice, S. Marco, begun 1063(?).
Interior of nave (*opposite*),
interior of cupolas (*top*),
and decorative details of gallery (*above*)

porting each of the five domed bays extended across the aisles, much as in the late-sixth-century rebuilding of the H. Irene in Constantinople and at Dere Ağzı in the ninth century. At

S. Marco this syncopation of spatial units was reinforced when, in the twelfth century, the full galleries were replaced by mere catwalks on top of the lower colonnades [368]. These latter thus became screens engulfed by the sideward expansion of the nave bays, much in the spirit of eleventh-century church design in Constantinople. Details also find their parallel in Macedonian and Comnene architecture in Constantinople and in the major churches of contemporary Greece: the palmette frieze above the arcades; the cornices on top of the parapets in niello technique – black foliage on white ground [370]; the cubic capitals in the crypt, their sides set with a projecting knotted nodule; the delicate marble profiles along the bases of the main piers. Where not sheathed in marble, the walls along the façades are articulated into delicate planes by doubled and tripled blind arches, by friezes with saw-tooth patterns, foliage, and rows of pendant triangles. The same decoration still covers the façades behind their

later marble sheathing. The bricks in the niche-heads are laid out in a wicker pattern. Parallels in contemporary Byzantium come easily to mind.[80]

Perhaps one may go further. The solid masses and clearly outlined spaces of St Mark's, forced upon the builders by the model of Justinian's church, coincide with the predilection for well-defined volumes and balanced forms so evident in Middle Byzantine structures of the late eleventh century in Greece, as at Daphni, for example. In any event, within the framework of Middle Byzantine architecture, Venice is one of the centres of a genuine renascence of the art of Justinian and before. The evidence of the plan is confirmed by the capitals. A large number, if not all, in the colonnades of the interior and elsewhere are eleventh-century copies from models of Justinian's age and slightly earlier, done so carefully that only the harsher details distinguish them from fifth- and sixth-century capitals, Corinthian or two-zone capitals with projecting figures of rams.[81] The ecclesiastical and political reasons underlying the choice of a specific Byzantine plan are fused with the sheer aesthetic enjoyment of the forms of Justinian's churches and similar early forms.

Nonetheless, S. Marco was not built by craftsmen or with materials shipped from the East. The high bricks are those used in North Italy since Roman times. Even the piers are built of bricks, facing a core of rubble masonry so poor as to create very serious problems of maintenance, and much poorer than in any genuine Byzantine construction. Contrary to Byzantine and following Western technique, the bricks of the domes are laid in concentric, not radial courses. The harsh and precise workmanship of the capitals likewise reveals Lombard, not Byzantine hands, as do the bases of the columns (the shafts are no doubt spoils), and the profiles of the revetment base along the inner walls. The plan itself seems to have been adjusted to the Western predilection for basilican patterns: the nave is pulled slightly lengthwise; a deep barrel-vault continues the nave westward; to the east, the chancel and apse are raised above nave level, supported by a huge hall crypt; along the chancel, the lateral forechoirs open towards the transept in wide arches as in any Romanesque church.

Such blending of Byzantine and Western features is only natural in Venice, the western-most cultural stronghold of the Eastern Empire and at the same time a powerful member of both the European and Near Eastern political and economic communities from the eleventh into the thirteenth century. However, Western elements evidently penetrated much farther into the Byzantine Empire and reached, if not its provinces, at least its capital. The details of Constantinopolitan churches from the Pante-poptes church (Eski Imaret) and the Kilise Camii to the churches of the Zeyrek Camii often suggest the possibility of an impact of Romanesque architecture on the later phases of Middle Byzantine building. In particular, they recall the architecture of the so-called *premier art roman* in Lombardy. Rows of niches in the attic zone of apses, right below the eaves lines, had been a hallmark of Lombard churches since the ninth century, such as S. Pietro at Agliate and S. Ambrogio in Milan. Blind arches frame the windows and articulate the walls of apses in dozens of Lombard churches from the ninth to the end of the eleventh century. Finally, dog-tooth friezes are a common decorative element in Lombard brick construction. Such features might easily have reached eleventh-century Constantinople either directly or by way of Venice. It is too early to go beyond a mere suggestion of this possibility. But it is certainly worthwhile considering the idea that Byzantine architects were not entirely ignorant of, or disinterested in, the development of Western architecture.

THE END OF BYZANTINE ARCHITECTURE

CHAPTER 18

INTRODUCTION

If historical dates are taken literally, the By-
zantine Empire came to an end on 29 May 1453,
with the death in action of Constantine XI
Paleologos and the victorious entry into Con-
stantinople of Sultan Mehmed. In reality the
beginning of the end had started long before,
and the last two hundred and fifty years of By-
zantine history are but a drawn-out last phase.
When the end starts is disputable. Does it be-
gin in 1204 when the Latins – the Franks – oc-
cupied Constantinople; in 1390 when the
Empire became a Turkish vassal state – limited
to the capital, its immediate vicinity, and a small
slice of the Peloponnesus around Mistra; or at
some time in between? In political history, cer-
tainly, 1204 seems a good starting point for the
Byzantine epilogue. On the other hand, the
Latin Conquest lasted but fifty-odd years in the
capital, and a shorter time in the few provinces
where the Frankish barons had established
themselves. Further, despite the fall of Con-
stantinople, Byzantine grandees kept large
strongholds in the provinces. In Asia Minor –
except for the tiny north-western slice under
Latin occupation and the south-eastern third
(long under Seljuk occupation) – the Empire of
Nicaea was established by the Laskaris and
Vatatzes families. At the same time in Epirus,
the dynasty of the Angeloi founded an indepen-
dent despotate with Arta as its capital. From

there the dynasty reconquered Macedonia and
Thrace from the Franks and in 1224 usurped
the Imperial title at Ohrid – only to be defeated
first by the Bulgarians, then by the Vatatzes of
Nicaea and the Paleologues who became gover-
nors of Salonica. In Trebizond, finally, the
family of the Comnenes founded a third state
and precariously managed to hold on until 1461.
But in 1204 the Empire had lost its capital, for
so many centuries a symbol to the East and
West. It had lost the islands, the important
Greek ports, and the trade routes to the Vene-
tians. And it had been split into a number of
dwarf states, both Byzantine and Latin, all
fighting one another and none able to live. The
reconquest of Constantinople by Michael VIII
Paleologos in 1261 and the subsequent sub-
mission into vassalage of Epirus and the entire
Peloponnesus only just stemmed the tide.[1]
Granted that until 1340 the Empire still held
on to Thrace, Macedonia, Thessaly, Epirus,
the Peloponnesus, and half of Asia Minor, yet
it played only a minor part in Mediterranean
and Balkan politics. To the north, powerful
neighbours had grown up since the late twelfth
century: Serbia since 1168, Bulgaria's Second
Empire since 1184. Both grew more threaten-
ing in the late thirteenth and the fourteenth
century: Bulgaria under the rule of Czar Ivan
Asen II (1218-41) and a century later under Ivan

Alexander (1331-71); Serbia under her kings Milutin (1282-1321) and Dušan (1331-55). To the south the Seljuks pressed ever harder. The final breakup came during the years 1340-50. Asia Minor was wrested from the Empire by the Turks; the Central Balkans, including Macedonia, Epirus, and Thessaly, were conquered by the Serbs under Dušan, and Thrace by the Bulgarians – both only to be lost to the Turks in 1388-9. What little was left of the Empire – Mistra, Constantinople, and Salonica – to all practical intents went into vassalage to the Turks. The fall of Salonica in 1430, of Constantinople in 1453, of Mistra in 1460, and of Trebizond in 1461, have symbolic more than practical significance.

As a political entity, then, Byzantium died a slow death, dragged out over nearly two hundred and fifty years. As a cultural power it survived with remarkable vigour both in the territories left to Byzantine rule – Nicaea, reconquered Constantinople, Epirus, Salonica, and Mistra – and beyond the ever-shrinking frontiers of the Empire. This is but natural. In the Byzantine territories the newly established dynasties – the Angeloi, the Laskaris, and from 1260, the Paleologues – needed outward signs of their rule: court poetry, palaces, tomb chapels, churches, mural decoration, and icons. Yet Byzantine writing, painting, and church building remain equally strong in lands long lost politically: in the Balkan countries and in the provinces and islands under Latin and Venetian rule. Again this is natural. For many centuries Byzantine culture had been carried by the Church as much as, or more than, by the court and its nobles. The church, one recalls, had been firmly rooted in the Slavic countries since before the twelfth century. And through the Church, Byzantine art and architecture dominated the Balkans and Russia for nearly two hundred and fifty years or more before the physical end of the Empire. Yugoslavia and Bulgaria, and Russia to a degree, remained cultural satellites of the Byzantine world. Indeed, even after the fall of the Empire, Byzantine culture lives on with considerable strength in and through the Church, under the comparatively mild rule of the Turks. The survival of flourishing monasteries on Mount Athos is but the most striking of many examples that come easily to mind.

LATE BYZANTINE ARCHITECTURE

The after-life of Byzantine culture in the Ottoman Empire is limited in the realm of art largely to painting. Architecture dwindles into insignificant repetitiousness, and is thus no longer within the scope of this volume. But Byzantine art from 1200 to 1450 does concern us, and it is relevant that at this late stage the term Byzantine needs to be understood in terms far broader than the political confines of the Empire – in terms not only of the Paleologues and their predecessors, but also of the reigns of Milutin and Dušan and their families in Serbia, and of the rule of Ivan Asen II and of Ivan Alexander in Bulgaria.

Byzantine art, then, is remarkably active during the last two centuries before the fall of Constantinople. It is also remarkably far spread, from the Danube to the Peloponnesus and Constantinople, and from there to Trebizond and Crete. Nor is there any doubt that the Paleologue Age created an exciting, expressive, and monumental new style in mural painting and manuscript illumination.[1] But in architecture the situation is somewhat different. To be sure, Byzantine builders – taking the term Byzantine in a broad sense – both continue and create new variants on traditional church plans. They play with virtuosity on and enrich the stylistic concepts of Middle Byzantine architecture. New liturgical needs, come to the fore since early Middle Byzantine times and grown ever stronger, forced changes on Paleologue patrons and builders. Separate spaces were needed outside the naos for burial of benefactors, for funeral monuments, and for the commemoration of saints and members of the monastic community: spaces in the narthex which, acquiring greater importance, was lengthened and deepened or doubled or supplemented by a second and third corridor along the flanks of the church. Or else chapels, parekklesia, were attached to the bema, the chancel part, or to the narthex.[2] The Fenari Isa in Constantinople and the Great Lavra on Mount Athos present early examples, the former of the first, the latter of the second solution. Growing ever more frequent and richer, by the thirteenth and fourteenth centuries such parekklesia might be laid out as miniature quincunx churches of traditional type, provided with double-storeyed, twin-domed nartheces; or as aisleless naves, their barrel-vaults interrupted and surmounted by high domes – a Middle Byzantine type, as witness the Imperial mausoleum in the Pantokrator, the Zeyrek Camii group, prior to 1136. Often, the spaces set aside to serve as parekklesia would be absorbed into the narthex or the narthex gallery of the main church and marked by domes – doubled or singly rising from the roof of the narthex gallery: again a Middle Byzantine feature, first known from the Panaghia Chalkeon in Salonica. Also, nartheces and parekklesia were fused into an envelope embracing on three sides the naos: as a rule opening into it by mere doors; but occasionally absorbed inside and forming a belt of aisle-like, galleried spaces. In consequence of such changes in function and plan, the church, itself often of older date, in Paleologue times rarely is viewed as a self-contained unit. Rather, it is but the core around which are grouped the appended structures, differing among each other in size and shape but, as a rule, all surmounted by domes and richly decorated. Grouping, varying, and multiplying the volumes and surfaces of the envelope

of subordinate, attached elements, all on minia-
ture scale, Paleologue architects create the
vision of Late Byzantine church building. They
stress the diversified, exciting silhouette of
grouped domes and wavy roof lines. They ac-
centuate the vertical axes: drums, domes, apses,
and interior spaces grow narrower and steeper.
They tend to fuse, regionally anyhow, basilican
and central plans. They enrich the decorative
patterns, both inside and outside. They strive
for new colouristic and ornamental effects on
the outer walls, through ever more complicated
brick patterns, through combining brick, white
and red stone, and glazed tiles into variegated
designs, through alternating in the masonry
brick and stone bands. Inside, they blend
mosaic, painting, sculptural decoration, and
interior space into a unit. At times – particularly
in Constantinople and Salonica during the first
decades of the fourteenth century – their
designs are developed with remarkable subtlety
and with a delicacy rarely achieved before. On
this everyone agrees. But excepting Constanti-
nople and Salonica in the early fourteenth cen-
tury, the architectural production seems to us
rich, varied, often interesting – but not always
of high quality. This opinion contrasts strongly
with that of many of the great nineteenth-
century scholars who, as late as the twenties
and thirties of this century, dealt with Late
Byzantine architecture always lovingly, and
with high praise either explicit or implied.[3] In
the Balkan countries national pride may oc-
casionally have contributed towards excessive
enthusiasm. But this is less important than the
'visual habits' of late-nineteenth-century his-
torians. Their generation was naturally fasci-
nated by an architecture which is colourful,
richly silhouetted, and complicated – qualities
which underlie a good deal of late-nineteenth-
century architecture as well, and which attracted
other historians of their generation towards the
Late Romanesque architecture of Germany.
Obviously these qualities have less meaning to

a generation which grew up with Le Corbusier
and the Bauhaus or their followers active since
the middle of this century. Quite possibly be-
cause of the visual habits thus engendered, we
now underrate the quality of Late Byzantine
architectural design. But it does seem that Late
Byzantine building is rarely original. Planning
and design have their roots in the tradition of
Middle Byzantine times, often as far back as
the early tenth century; parekklesia, narthex
galleries surmounted by twin domes, rippled
eaves lines, brick patterns, church plans. Nor
does it seem that the overall level of Byzantine
building between 1200 and 1450 – certainly
outside Constantinople – is always of the
highest. The decoration is overplayed and the
constituent forms are of an undeniable same-
ness. Regional differences and provincial idio-
syncrasies are more strongly marked than ever
before. The buildings are at times overladen
and crude; at other times they are virtuoso.
And never is Late Byzantine architecture
monumental and never is it great. So it is to us
no more than an epilogue, a terminating
chapter, albeit often attractive and at times
exciting.

EARLY PALEOLOGUE ARCHITECTURE

The characteristics of Late Byzantine building
first present themselves in the last third of the
thirteenth century and appear nearly simul-
taneously at far distant points of the various
Byzantine principalities: in Epirus, Macedonia,
Thessaly; in the Peloponnesus; in Asia Minor;
in Constantinople. A first phase is clearly
marked off; we shall call it Early Paleologue,
although it starts before the reconquest of
Constantinople. This first phase makes way
about 1310 for a High Paleologue phase, which
in turn fades out, in different places at different
times but always during the century between
1340 and 1440. This first phase bears remark-
ably similar characteristics everywhere, both in

planning and decoration. For the most part, church planning continues traditions uninterrupted since the days of the Macedonians and Comnenes: quincunx plans, triconch and tetraconch chapels, and the like – the former sometimes replacing with a high transverse barrel-vault the dome customary over the centre bay. Small tetraconchs of the type widespread in the tenth, eleventh, and twelfth centuries near Constantinople, as on Heybeliada in the Sea of Marmara, in the southern Balkans, and in Greece may have survived into Paleologue times: witness St Mary Mugliotissa in Constantinople.[4] At other times, and apparently limited locally, central plans are blended with basilican naves; an impact that perhaps stems less from Western influence than from the small vaulted basilicas customary in Bulgaria, Epirus, Macedonia, and Thrace ever since at least the tenth century. As early as 1232 or shortly after in the Panaghia at Bryoni near Arta, a fusion has been effected between a domed quincunx sanctuary and a barrel-vaulted nave and aisles. Similarly in the Kato Panaghia just outside Arta, a quincunx is joined to a barrel-vaulted basilican nave with the difference, however, that a transverse barrel-vault, taller than the longitudinal vaults of the nave, is substituted for the domed bay of the quincunx. In the Porta Panaghia in Thessaly, both centre bay and cross arms are pulled together by one single transverse barrel-vault, high up.[5] Aisleless chapels are widespread, either as small monastery or village churches or as funerary chapels. As monastery churches and clearly of old lineage, they become frequent, it seems, in Late Byzantine Constantinople as well as in the provincial and allied centres: terminated by single or tripled apses; barrel-vaulted and domed, as in the Church of the Archangels in the latter thirteenth century at Nessebâr; plain and timber-roofed or simply barrel-vaulted as in the region of Ohrid and all over Greece and the Balkans; occasionally enriched, as the small church of H. Basilios at Arta [385],

by no less than four parekklesia, two on either flank separated by a barrel-vaulted passage.[6] As funeral chapels, often double-storeyed – the lower floor serving as crypt – they appear early in Bulgaria and, possibly quite a bit later, in Constantinople. The Asen church at Stanimaka (Assenovgrad) [398A], dating from the late twelfth or the early thirteenth century, offers an example; barrel-vaulted and, on the upper floor, supporting a dome as well and terminating in apses both on the chapel and on the crypt level.[7]

As a rule, though, in the major centres and when funds were available, the demand was for larger – always relatively – and more sophisticated buildings. In the South Church of the Fenari Isa Camii in Constantinople [312], the plan of an ambulatory church, as known from the eleventh century on, was taken up at the turn of the thirteenth century; whether the type had survived or was revived, remains open.[8] Occasionally, however, late-thirteenth-century builders and patrons seem to have taken up plans fallen into disuse after the eleventh century or earlier still. Thus the Greek-cross octagon last seen at Daphni was revived all over the various Byzantine principalities: in the Parigoritissa at Arta, in 1282-9 [371-4]; in H. Sophia at Monemvasia, after 1287; in H. Theodoroi at Mistra (Mystra), 1290-6 [384].[9] Shortly after 1300 in the Aphentiko church of the Brontocheion at Mistra the plan of a basilica with galleries was fused with that of a cross church with open galleries bridging the transept arms [377, 378], so as to call to mind churches of eighth- and ninth-century date. In brief, it seems not impossible that Byzantine and possibly Western contemporary conceits were fused with the concept of a revival of Early Byzantine architecture. The idea of a renascence of church plans fallen into oblivion centuries before seems a natural phenomenon in the spurt of enthusiasm accompanying the resurgence of a Byzantine Empire in the last third of the thirteenth cen-

tury. It finds its close parallel in painting in the revival of Early Macedonian models in the last decades of the thirteenth century.[10]

Such 'renascence' plans, to be sure, are rarely copies after the earlier prototypes. Both at Monemvasia and at Arta the Greek-cross octagon is enclosed within a solid cube more bulky and inarticulate than that of Daphni [352, 374]. The interior at Arta, on the contrary, is far more complex, if somewhat crude, in design.[11] A triple order of colonnettes, standing at right angles, rises from projecting brackets and supports the squinches of the dome; a device which recalls the Nea Moni on Chios rather than the Katholikon at Hosios Lukas. At the same time, at Arta the cross arms are narrower and shallower than at either Hosios Lukas or Daphni. Far more important is the addition, as an afterthought during construction, of parekklesia, surmounted by galleries, and their fusion with the narthex and its gallery and the relation of this three-sided envelope to to the naos. While on the ground floor parekklesia and naos remain separate units, accessible from each other and from the naos only through arched doorways, on the gallery level they open freely into the centre space. Correspondingly, the vaulting marks chapels and narthex on the ground floor as separate entities, each focused on a domed bay in the middle; on the contrary, on the upper level, three domes are placed over the narthex, two more over the end bays of the side galleries all surmounted by drums, the one in the middle of the façade lit by an open lantern [371-4]. Nonetheless, the Parigoritissa never crosses the threshold of provincial heaviness, and this provincial element prevails more strongly yet in the smaller churches in Epirus.

Arta, throughout the Latin occupation and until the end of the thirteenth century capital of a powerful independent state, the despotate of Epirus, was a natural centre to develop a new regional style in its buildings. It seems equally

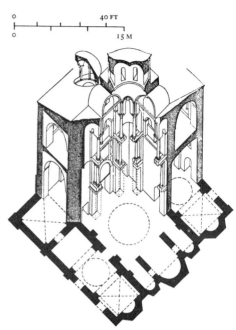

371 and 372. Arta, Parigoritissa, 1282-9. Isometric view and interior facing north

373. Arta, Parigoritissa, 1282-9. Interior facing east

natural that new solutions, though different in planning, would be evolved regionally in at least some of the capitals of the other Byzantine states, surviving through the Latin occupation of Constantinople or set up afterwards in territory wrested from the Latins. To be sure, neither at Salonica, occupied early by the despots of Epirus and afterwards by the emperors of Nicaea, nor at Nicaea itself does there seem to have been much building activity during the thirteenth century. But at Trebizond (Trabzon), where a semi-independent Empire survived until 1461, building activity went on; and Mistra, wrested from the Franks in 1262 and ruled, first from Constantinople, then from 1348 until 1460 as the suzerain despotate of Morea, was from the end of the thirteenth century a flourishing centre. In Trebizond, the church of H. Sophia, dating from some time between 1238

and 1263, presents a local variation on the quincunx plan, with elongated western corner bays and deep projecting porches north, south and west – all opening in triple arcades [375, 376]. The local traditions of the highlands of Asia Minor, reinforced possibly by Armenian or Georgian influence, are felt in the heavy stone construction, in the almost basilican stretching of the nave, the profile of the windows, the sculptural decoration outside, the spareness of detail inside. Only the pendentives and the drum, built in brick, betray, at least in technique, Byzantine tradition.[12] Things were different at Mistra. Starting with the Byzantine reconquest, a town, to a large extent newly built grew on the steep hill sloping down from the older castle; a town complete with city walls, large tracts added to the palace in the castle, houses along narrow streets but widely scattered, and num-

374 (*opposite*). Arta, Parigoritissa, 1282-9. From the north-west

375 and 376. Trebizond (Trabzon), H. Sophia, between 1238 and 1263. Exterior from the south and plan

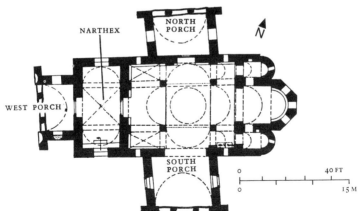

bers of churches, dating from the end of the thirteenth to the fifteenth century. Thoroughly, though at times perhaps too thoroughly restored, Mistra thus provides an idea of what an important if not too populous Paleologue capital looked like.[13] At the beginning (of houses, palaces, and of High and Late Paleologue churches we shall speak later) stand three

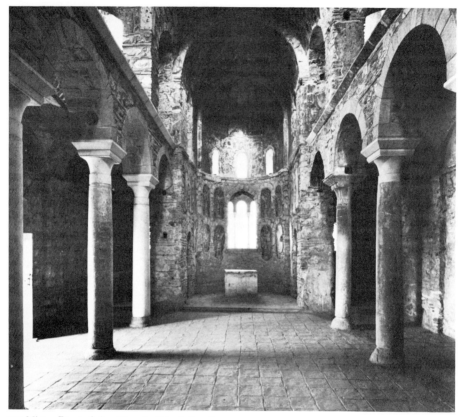

377. Mistra, Brontocheion, Church of the Aphentiko,
1310-22. Interior of nave facing east

churches: the Metropolis, the cathedral founded
in 1291-2; and the two churches of the Bronto-
cheion convent, one dedicated to the H. Theo-
doroi and built in 1290-6, the other to the Virgin
Hodegetria, built between 1310 and 1322 and
known as the Aphentiko. The Metropolis, in the
beginning, was apparently laid out as a simple
basilica, remodelled perhaps only in the fifteenth
century. In the H. Theodoroi, the Greek-cross
octagon was taken up, as a few years earlier in
the H. Sophia at Monemvasia – in its simplest
form, one-storeyed, without the galleries and
the belt of parekklesia and narthex of the Pari-

goritissa at Arta: a survival or revival of the type
as first known from the Panaghia Lykodimou in
Athens and from Daphni, c. 1080. In the
Aphentiko [377, 378], on the other hand, and
possibly as an afterthought during construction,
a new building type was created. Instead of a
cross-in-square, possibly first planned, the
structure was thoroughly changed: preceded by
a double-storeyed narthex, the ground floor was
divided into nave and aisles like a basilica. The
aisles were given vaults, to carry a gallery floor –
laid out as a quincunx supported by piers: domed
over the centre bay in the nave; barrel-vaulted

the rest of the nave, west and east; the cross arms, too, barrel-vaulted and oversailing the galleries; the four remaining corner bays in the gallery domed and surmounted outside by

The churches of Mistra, from the outset, are far more subtle in planning and design than the Parigoritissa at Arta. In their subtleness – sometimes provincial, but subtle nonetheless –

378. Mistra, Brontocheion, Church of the Aphentiko, 1310–22. From the east

drums. The type locally took firm roots and has become known as the Mistra type. If anything, it recalls the H. Irene in Constantinople, as it presented itself before the second dome replaced the barrel-vault over the nave in 740 – continuous colonnaded arcades below, galleries, centre dome, and cross arms oversailing the gallery; or other churches of post-Justinian times, such as Dere Ağzı. Though on the smallest scale – it measures inside but 11 by 8·50 m. (36 by 28 ft) – the architect of the Aphentiko seems to have reverted to a grand type of the great past of Byzantium.

they are close to Early Paleologue church building in Constantinople; but planning in Constantinople took again different lines. The South Church of the Fenari Isa Camii, founded between 1282 and 1304 by Theodora, widow of the emperor Michael VIII Paleologos, and dedicated to John the Baptist, was laid out on an ambulatory plan.[14] The traces of the steep stilted arches which screened the centre bay from the ambulatory are as clearly visible as those of the high-shouldered triple window above [312, 379]. The type, then, continues or revives earlier models, such as the Koimesis

379. Constantinople, Fenari Isa Camii, South Church, founded 1282/1304.
Interior of south wall of nave

church in Nicaea (Iznik), as rebuilt after 1065 and the presumably somewhat later core of the Fetiyeh Camii, the Pammakaristos church. As already in this latter, the scale in the Paleologue church of St John in the Fenari Isa complex is small; its surface is hardly larger than the tenth-century quincunx church adjoining it to the north. Moreover the core of the structure is limited to a simple domed square bay. The faithful were confined to the tall, narrow, and moreover dark bays of the ambulatory, and at the same time pressed against the triple arcades which separate ambulatory and centre bay. They were unable to view the centre bay at a distance and therefore unable to take in its expanse. Close as they stood, they saw only a tiny fragment of the domed core, and, unless they pushed

into the nave, only a fragment of the processions of the clergy as they passed behind the screening colonnades. Rather, the new element in planning Paleologue churches was the auxiliary spaces which on three sides envelop the core, naos, bema, and ambulatory: in the South Church of the Fenari Isa, to the west the esonarthex, lengthened to extend in front of the old North Church as well; to the north, the tenth-century North Church, whose southern parekklesion was incorporated into the left-hand ambulatory of the Paleologue South Church; finally to the south a parekklesion, added presumably after 1300 to the new structure; all built in a masonry of alternating brick and stone bands, characteristic for Late Byzantine Constantinople [312, 313, 380, 381]. Such belts of appended spaces, around 1300 became a hallmark of Paleologue church planning in Constantinople: witness the Pammakaristos church, the Fetiyeh Camii, where prior to 1294 at least the corridor to the north and the small domed chapel at its east end may have been laid out; and the Kariye Camii, where the doubled narthex and both long parekklesia, north and south, were built in one campaign, 1315-20.[15] Paleologue churches - one thinks also of the Parigoritissa at Arta – thus grew into intricate complexes of structures: full of surprises for the visitor who passes from one part to the next, always confronted with unexpected views and unexpected spatial forms, but nevertheless complexes lacking in integration. Nor was the interior decoration of the new church in the Fenari Isa complex better integrated. To be sure, only a few elements survive: the dowel holes of a marble revetment on the upper walls of the centre bay [379]; a palmette and cross frieze along the cornice of the dome; in the south apse, the capitals and shafts of two window piers covered with palmette designs. But the decorative motifs are nearly indistinguishable from Middle Byzantine ornament; indeed, the frieze on the cornice of the dome so closely resembles

380. Constantinople, Fenari Isa Camii, South Church, founded 1282/1304, main apse; foreground, south apse of North Church, dedicated 907

381. Constantinople, Fenari Isa Camii, South Church, founded 1282/1304. Exterior of apse

the corresponding one in the North Church that one wonders whether it is a copy or possibly composed of Middle Byzantine spoils, and the same doubts arise regarding the window piers. Only the treatment of the wall surfaces on the Paleologue parts of the Fenari Isa Camii reveals the character of late-thirteenth-century decoration in Constantinople. The main and the south apse (the north apse was taken over from the south parekklesion of the tenth-century North Church) are covered all over with the rich panoply of late-thirteenth-century Byzantine decoration [381]. On the seven-faceted main apse three tiers are superimposed: blind niches in a sequence of low, steep, and medium high; and inserted in the centre of the tier of steep niches, a triple group of windows. Between the

tiers, inside the niches and in the spandrels, the brickwork forms arch and hook patterns, meander friezes, pendant triangles, sun-wheel, swastika, zigzag, and fan designs. Between these designs appear alternating bands of snow white and deep red, one course of ashlar and from two to five courses of brick: a new colourism is announced. It becomes after 1300 the hallmark of Late Byzantine building in Constantinople.

Indeed, all such types of Late Byzantine architecture, whether in Constantinople, Arta, or Mistra and whether traditional, newly invented, or revived and remodelled, were clad with an exterior decoration which continues, enriched and more playful, the last phases of Middle Byzantine building. At Sv. Kliment at Ohrid, in 1294/5 (originally dedicated to St

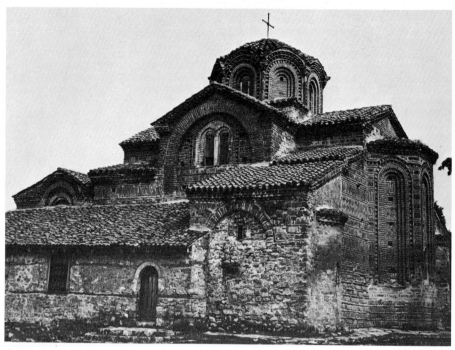

382 and 383. Ohrid, Sv. Kliment, 1294/5. Exterior from the south-east (*above*) and detail of exterior of apse wall (*below*)

Mary Peribleptos), the colonnettes of the drum project from triply recessed window frames [382, 383]. Saw-tooth friezes are doubled and tripled all along the edges, double and single brick courses alternate in the *cloisonné* walling. The brickwork forms meander friezes and chequerboard and *cloisonné* bands all along the walls. Steep, deeply recessed niches articulate the three sides of the apse, and the panels of the niches are patterned with chequerboards of dark and light diamond shapes, with hollow rhomboids enclosed between the arms of a cross and with bands in herringbone designs.[16] Similar effects were achieved contemporaneously at Mistra and Arta: in the H. Theodoroi at Mistra by deep niches in drum and main apse, by herringbone patterns and by multiple saw-tooth bands [384]. On the outer walls of the

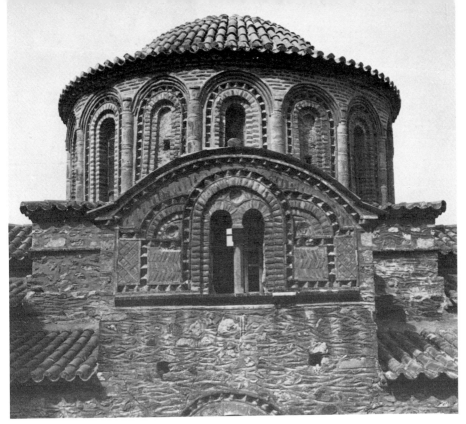

384. Mistra, H. Theodoroi,
1290–6. Exterior of south arm and dome

Parigoritissa at Arta, chequerboard diamond strips were used to mark off the *cloisonné* walling, and an open tempietto, playfully contrasting with the five other drums, rises above the centre of the narthex gallery [374]. The Parigoritissa also shows more clearly than any other church the penetration of Byzantine building by a Western vocabulary: crocket capitals, pairs of intertwined columns, archivolts covered with the figures of prophets, monsters serving as brackets – strangely contrasting with the high quality of the mosaics and murals, clumsily executed and all retarded derivatives of Late Romanesque rather than Gothic design [372, 373]. The same intermingling of Western elements – long outmoded in their natural habitat – with genuine Byzantine forms dominates the architectural vocabulary in the smaller churches of Epirus, often in far richer combinations. In these smaller churches, the exterior decoration also reaches a much greater richness: chequerboard patterns in three and four shades; saw-tooth bands; fan patterns of bricks in the window spandrels; wavy lines, meanders, and broken hook friezes – all of this patterned or cut from bricks. H. Basilios and H. Theodora, both at Arta, H. Nikolaos at Rhodia, and the monastery church of the Kato Panaghia are examples [385]. But none of the small churches in Epirus achieves either subtlety or real grandeur.[17]

The rich brick ornament and the varied decorative vocabulary of the late thirteenth century make their appearance at almost the same time in far distant places of the Late Byzantine world – in Mistra, Arta, Ohrid, Constantinople. Their origin, on the other hand, is

385. Arta, H. Basilios, thirteenth century(?). Detail of exterior

not clear. No doubt the beginnings go far back. Fan designs occur in Constantinople from the early tenth century, meander and wicker patterns in the course of the eleventh both in Greece and Constantinople. But such features remain isolated and comparatively simple. In all their richness, brick patterns come to the fore by the middle of the twelfth century, when local workshops in Greece decorated the outer walls of churches with the whole gamut of designs, meander and fan patterns, saw-tooth

friezes, wavy lines, and others all laid out in brick [356, 357]. In all likelihood the decorative wave was widespread; as early as 1232 or 1238 it covers the walls of a small church, the Panaghia, at Bryoni near Niochoraki in Epirus. It apparently survived until the thirteenth century in the outlying principalities on the western edge of the Byzantine world, in Epirus, in north-western Thessaly, in western Macedonia. In its fullness, it reached Constantinople and Salonica not before the last decade of the thirteenth century.[18]

HIGH PALEOLOGUE ARCHITECTURE

By that time, however, a new High Paleologue style had evolved all through the Byzantine world and that of her cultural satellites. The comparatively uniform vocabulary which Late Byzantine architecture had developed in the late thirteenth century, by 1300 gives way to numerous regional, national, provincial, and workshop variations. A western and northern group of High Paleologue buildings, in Salonica, Macedonia, and central and northern Yugoslavia, however, is easily marked off from an eastern group, centred in Constantinople and Bulgaria; and nothing is easier than to distinguish fourteenth-century hallmarks of Serbian, Bulgarian, Constantinopolitan, and Salonican building. On the other hand, though they differ on questions of planning, exterior design, and decorative vocabulary, the builders of the High Paleologue period work with common architectural concepts. They make a radical break with the patterns of Early Paleologue architecture, either still Middle Byzantine in planning and style or reviving yet older models, as it dominated the last third of the thirteenth century.

At Mistra, church planning remained virtually untouched by the new current. The blend of longitudinal and central plan elements, as created first in the Aphentiko, was taken up at least twice: in the Pantanassa, consecrated in 1428; and in the remodelling, at an undetermined time, but possibly in the fifteenth century, of the Metropolis. Or else the cross-in-square plan is favoured, as witness the churches of H. Sophia, of the Virgin Peribleptos, and of the Evangelistria. All date presumably from the late fourteenth century, and all show the traditional plan in a characteristic variant: the western corner bays are lengthened and inject a longitudinal element into the central plan. The vocabulary changes more visibly, presumably under the impact of ideas carried

over from South Italy. Single towers recalling the *campanili* of South Italy and Sicily rise alongside the body of the church. In the Pantanassa a colonnaded open porch runs along the north flank, and five domes, with the exception of the one in the centre, are hidden below a continuous roof – contrary to Byzantine, but corresponding to Western custom [386]. Likewise construction and decoration are permeated by devices known from Salerno, Ravello, and Palermo: ribs of rectangular section in the domes; triple windows under pointed arches;

386. Mistra, Pantanassa, consecrated 1428.
Section, and plan of ground floor

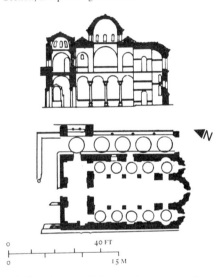

o ⊢─────────────── 40 FT
o ⊢─────────────── 15 M

blind arches carried on colonnettes and surmounted by fan-like feathery leaves; a row of festoons crowned by fleur-de-lis.

SALONICA AND SERBIA

Such mingling of foreign and Byzantine elements recalls the similar blend that pervades the Parigoritissa at Arta about 1285. But it is as exceptional in High Paleologue as it was in Early Paleologue architecture. A purely Byzan-

tine High Paleologue style forms itself within the core of the Byzantine world around 1300, and continues through the fourteenth, and in some regions into the fifteenth century or even beyond. An upsurge of building activity in Salonica starts off this last phase of Late Byzantine architecture in Macedonia, southern and central Yugoslavia, and all over the western Balkans. The church of H. Katherini at first glance seems hardly remarkable [387]. Its date of construction remains undetermined, but plan and design suggest the last years of the

struction techniques of Middle Byzantine Greece. But the dome over the centre bay, the barrel-vaults of the cross arms, and the semicircle of the apse rise more steeply than ever before in any Middle Byzantine church. This steepness is enhanced by the narthex which encloses the core on three sides as a broad, low envelope in pure brick. Divided into two tiers by a strong cornice, it is articulated by blind niches, windows, and open arcades – the latter doubled, tripled, or composed of one high and one low opening. Four drums placed at the

387. Salonica, H. Katherini,
late thirteenth century(?). From the south-east

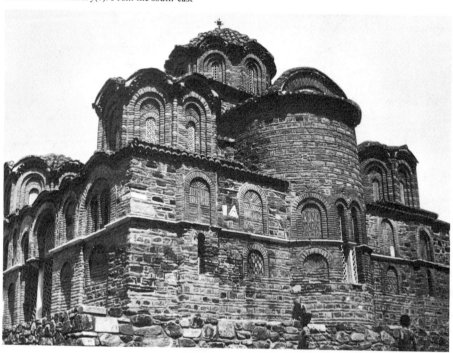

thirteenth century. A quincunx with tiny corner bays, its core does not essentially differ in plan from the eleventh-century Panaghia Chalkeon. Similarly its walling, a simple *cloisonné* in the chancel part, continues the con-

corners of the narthex counter the single drum over the centre bay of the core structure. Comparatively low and set apart from the centre drum, they make for a disparate rather than a unified silhouette – very different from even the

boldest Middle Byzantine design. The niches along the eastern flank, on the apse, and along the sides of the narthex are covered with a brick decoration of lozenges, triangles, crosses, and basket weaves which recalls nothing as much as the decoration of Sv. Kliment at Ohrid (1295) [382, 383]. On the other hand, the brickwork in the colonnettes of the drums, as on the centre dome, is interspersed at regular intervals with white stones, reminiscent of the red and white decoration of the Paleologue Fenari Isa Camii at Constantinople, built in the last third of the

thirteenth century. It seems reasonable, then, to assign the H. Katherini also to the years 1280-1300. At roughly the same time in the church of the Chilandari monastery on Mount Athos, built by the Serbian king Milutin in 1303 as a cross-in-square triconch of the traditional Athos type, drums were placed over the corner bays of its deep monastic narthex. Links to Salonica certainly existed, but their direction so far remains unclear.[19]

The H. Katherini marks only the beginning of the new High Paleologue style in Salonica.

388. Salonica, Holy Apostles,
1310-14. Plan sketch

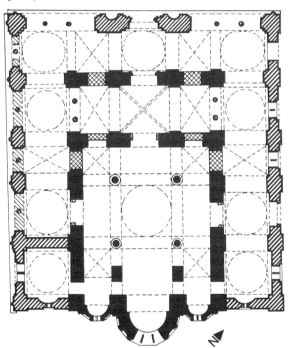

0 20 FT

0 5 M

▬▬▬ PHASE I ⎫
⧄⧄⧄ PHASE II ⎬ BYZANTINE (14TH CENTURY)
▨▨▨ PHASE III ⎭
▒▒▒ PORTIONS REMOVED (BY THE TURKS?)

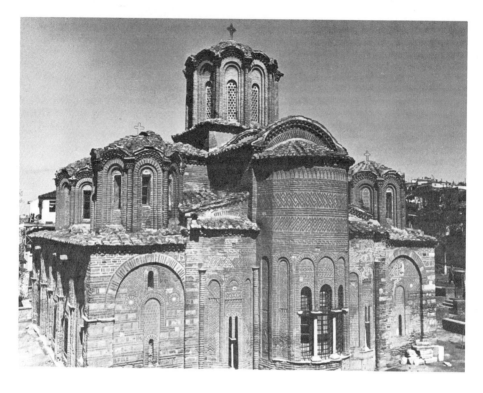

In the church of the Holy Apostles – its narthex is dated 1310-14, and presumably the entire structure was built at that time – the three-sided envelope of the narthex is lower than at H. Katherini [388-90]. But in contrast, its four corner drums are steeper and set even farther apart from the centre drum and its square base. The interior proportions of width and height of the centre bay have risen to 1:5 as against 1:3·9 at the Panaghia Chalkeon. While the flanks of the narthex to the north are marked off by simple blind arches, its front on either side of the portal, and originally its south flank as well, open in arcades [390]. In triple groups, they are arranged along the façade in an intricate rhythm: the two outer arcades are coupled under a wide blind arch, while the third inner intercolumniation is surmounted by a steep,

narrow stilted arch. Along the south flank, the narthex opened in four twin arcades.

The opening of the façade in arcades, the new proportions, the new rhythm, and the new silhouette are blended with a new and richer texture of wall surface. Main dome, vaulting zones and walls inside disappear under the tapestries of splendid mosaics and frescoes presumably executed by a workshop from Constantinople, possibly the one responsible for the decoration of the parekklesion of the Kariye Camii. Similarly the outer walls are hidden under a decoration of brick ornament. Bands of large, tightly-interwoven double zigzags, hook patterns, cross-stitch designs, and pendant triangles form a textile covering over the wall and in the niches of the apses, denying them the last trace of massiveness. On the façade of the

389 and 390. Salonica, Holy Apostles, 1310-14. From the east (*opposite*) and from the north-west (*below*)

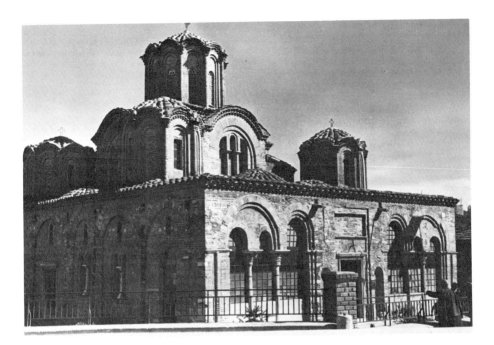

narthex, weave patterns and hexagon stars fill the spandrels of the arches. In the voussoirs, these monochrome patterns give way to a colourful alternation of white stones with groups of three and four red bricks. Neither the monochrome brick decoration nor the two-tone patterns were apparently invented at Salonica. Both were customary as early as the twelfth century in northern Macedonia and southern Thrace, on either side of the Yugoslav-Bulgarian border.[20] At Sv. Kliment at Ohrid, one recalls, the brick decoration occurs fully developed by 1295, while at the same time at Arta the walls of small and large churches are sheathed with two-tone patterns. But Salonica seems to be the place where throughout the whole fourteenth century such decoration is fused with both the new proportions and the

new silhouette into ever new designs. H. Elias, dating perhaps from 1360-85, is a triconch monastic church, like Chilandari with domed drums placed over the end bays of a deep open-arched narthex. But inside, the corner bays of the cross-in-square have been shrunk, enlarging the size of the main dome and leaving the supporting columns squeezed against the walls. Outside, domed chapels are pushed into the four corners of the structure. The main dome, larger than usual, rises from among and above a wealth of arched roof lines, domed drums, apses, and high roofed barrel-vaults; all spun over with brick patterns - meanders, pendant triangles, basket weaves - and interspersed with whole stone bands. Even more strongly is the vertical element stressed in the little church of H. Sotir where a single bay, enlarged by small

apses into a tiny triconch, is crowned by a tall domed drum.

Certainly, Salonica is the centre from which, after 1300, the new style fans out in all directions. Southward it appears to reach as far as the Meteorite monasteries huddled on top of their rocky crags in north-western Thessaly. The buildings of the Great Meteora – erected between 1356 and 1388, except for the sixteenth-century church – convey a good impression of the structures comprising a Late Byzantine monastery: the longish refectory (the *trapeza*)

the new style shows its imprint in some of the later churches in Epirus. But the northward expansion from Salonica into what is now southern and central Yugoslavia is by far the most important.[22]

In Serbia, throughout the thirteenth century, the old West Serbian (Rascian) formula of an aisleless, barrel-vaulted, and domed nave had been elaborated to include both Byzantine and Western Romanesque elements: short cross arms and Byzantine domes on pendentives; corbel-table friezes, pilaster strips, and tendril-

391. Studenica, Church of the Virgin, after 1183. Exterior

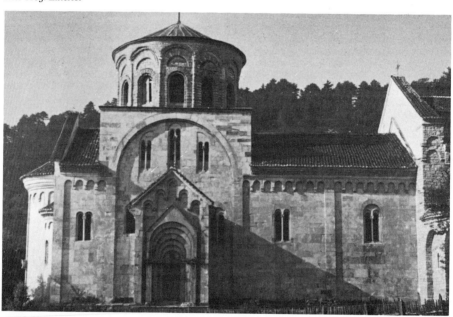

with its projecting apse; the square kitchen with its domed chimney; the infirmary, square and divided into nine bays – eight groin-vaulted, the ninth in the centre resting on four columns and opening in a domed chimney. Arches and vaults are formed throughout by alternating bands of red brick and white stone.[21] Westward,

covered window jambs of North Italian derivation; frequently, a tall tower rising from the narthex. The Church of the Virgin in the monastery at Studenica, as early as the late twelfth century, presents an example [391].[23] By the early fourteenth century, however, this Rascian mountain architecture gives way in the valleys to

a fully Byzantine architecture. Clearly this would happen in territory still under Byzantine occupation. To the old church of St Sophia at Ohrid in 1313–17 an exonarthex was added, surmounted by a gallery and flanked by low towers, the upper floors domed and serving perhaps as parekklesia. Seen from the outside only a few features are new: arcades in a bottom and a top tier, separated by a row of flat blind niches; rich textile brick ornament in the niches; drums surmounting the corner bays, widely separated from the older centre drum, no longer extant, of

the transept [392].[24] But it is in the central regions of Serbia and under the rule of the Serbian kings Milutin (1282–1321) and Dušan (1331–55), eager to compete also as builders of churches with Byzantine emperors present and past, that the Salonican formula bears its ripest fruit. The point of contact may well have been Chilandari, the Serbian monastery on Mount Athos, where in 1303 Milutin's architects seem to have encountered the new concepts of Paleologue building, as rooted by then in Salonica. A few years later, in 1307–9, the church of the

392. Ohrid, St Sophia,
narthex, 1313–17

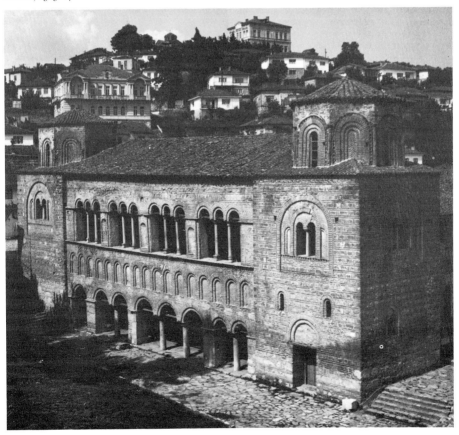

Mother of God of Ljeviška in Prizren, a ba-
silica of eleventh-century date, already once
rebuilt in the thirteenth century, was entirely
remodelled under the auspices of Milutin.[25] The
outer walls and the piers and upper walls of the
nave were preserved. But the aisles were vaulted;
a narthex was added, surmounted by a single
tall tower; and the wide old nave was sub-
divided by eight piers, placed so as to add two
more inner aisles and to divide the remaining
nave into a series of square bays. The barrel-
vaulting of the nave is interrupted by two
domes: one over the centre bay, the other over
the chancel. A tall drum encloses the centre

dome; four tiny domes surmounted by steep,
slender drums rise over the western and eastern
ends of the inner aisles, far distant from the
main dome; and the outer walls throughout
this upper zone are enlivened by white and red
bands of brick and stone, *cloisonné*, embroidery
patterns, cufic lettering, meanders, and scallops,
all laid in brick, and by the dense layering of
bricks in the voussoirs of the triple-recessed
window embrasures. The same decoration of
the wall surfaces appears in 1307 at Sv. Nikita
at Čučer near Skopje.[26] Obviously plan and sil-
houette of the 'elongated quincunx' in the
Ljeviška church were determined by the under-

393. Staro Nagoričino,
1067–71 and 1313. From the south-west

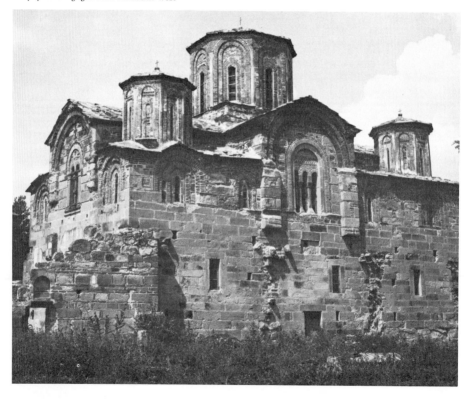

lying plan of the old basilica. But they tally with the principles of the new High Paleologue style, as it presents itself in the Holy Apostles at Salonica. The elongated quincunx remains a basic element of fourteenth-century architecture in central and southern Yugoslavia. It reappears in a new variant at Staro Nagoričino where, in 1313, Milutin's architects solved for a second time – and in a way very similar to the Ljeviška church – the problem of remodelling an older basilica. The outer walls of smooth stone blocks were preserved up to the window zone [393, 394A]. Beginning with the window level, the walling is of the fourteenth century, a *cloisonné* enriched by brick ornament in the spandrels of the windows and in the blind, flat niches on the drums. In the interior, a dome and drum, placed over the centre bay, rise high above the barrel-vaults of the short nave (in function and appearance an esonarthex), the deep chancel, and the transverse arms. The aisles are barrel- and groin-vaulted, but at both ends of each aisle a slender, tall drum shoots up from the roof zone far from the centre drum and hardly visible inside, over the esonarthex and the pastophories.[27] At Gračanica, where no old basilica had survived, a plan was adopted nevertheless, before 1321, very similar to that of the Ljeviška church at Prizren: an elongated quincunx at the core, its chancel deepened and domed; and an ancillary envelope of spaces along three sides of that core – esonarthex, aisles pierced by secondary cross arms, pastophories – the four end bays marked by domes and tall drums. The link to the three-sided nartheces of H. Katherini and H. Apostoloi at Salonica is convincing.[28] But the proportions have been pushed far beyond anything ever adopted before [394B, 395, 396]. The dome of the centre bay rises to a height more than six times its width, the domes of the corner bays rise to nearly eight times their width. The slim drums seem to be driven higher and higher by the

394. (A) Staro Nagoričino, church, 1067–71 and 1313. Plan
(B) Gračanica, church, before 1321. Plan
(C) Kruševac, church, *c.* 1380. Plan
(D) Ravanica, church, 1375–7. Plan

A

B

C

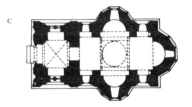

D

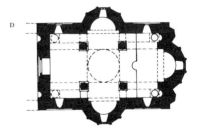

semicircular or pointed gables of the corner bays, drum bases, chancel, esonarthex, nave, and transverse arms which, recessed against each other, rise ever higher towards the centre of the structure. Nowhere else has Late Byzantine architecture achieved a more richly fantastic exterior design than in this, the latest of Milutin's churches.

The walling of these early-fourteenth-century Serbian churches is either a simple *cloisonné*, or brick, often pure, but at times richly patterned. With the middle of the fourteenth century, yet richer and more colourful patterns spread all over the country. But the plans turn, it seems, to greater simplicity. Ordinary quincunx plans, certainly in Macedonia, but in Central Serbia as well, take the place of the elongated, often enveloped quincunx. Corner domes and drums – those hallmarks of Salonican and Serbian builders in the early part of the fourteenth century – while occasionally still in use, are no longer a must. Instead a second dome is often placed over the narthex, possibly linked both to Salonican custom and to the building traditions

395 and 396. Gračanica, church, before 1321.
From the south-east (*below*) and apses (*opposite*)

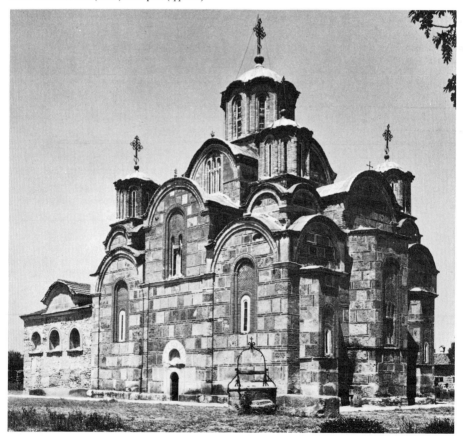

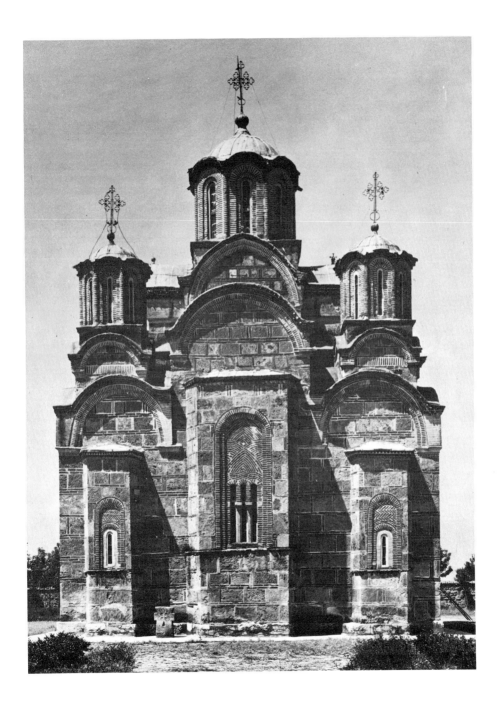

of western Serbia, where a tower frequently rises over the narthex.[29] But whatever the plan, the decoration of Serbian churches in the second half of the fourteenth century grows ever richer and more colourful. Bulgarian churches since the thirteenth century, if not earlier, had been clad in colouristic textures; Constantinopolitan buildings of the early fourteenth century had taken up the idea and the vocabulary of such red and white surface decoration; and models in both Bulgaria and Constantinople apparently exerted a powerful impact on Serbian builders. The second narthex added between 1372 and 1389 to the early-fourteenth-century church at Chilandari shows this over-abundant decoration at its peak: alternating brick and stone bands neatly cut and pointed; window tympana covered with cross-stitch patterns, chequer-boards, and fleur-de-lis friezes; arches overlaid with interlace work; capitals spread with eagle and floral designs.[30]

Richly decorated and often attractive, though never great or inventive, quincunx churches of one or the other type continued to be built in southern and central Yugoslavia until its conquest by the Turks. In the northern parts, independent until 1459, an autonomous architectural school had formed as early as the last third of the fourteenth century in the Morava valley. Dependent on the church type customary on Mount Athos, it adopted a triconch plan, developed round either an atrophied Greek-cross or a quincunx core. But little changes either in the spatial design, the silhouette, or the red and white texture of the walls with alternating brick and stone bands – three bands of bricks to one stone – and with chequer-board patterns. Not infrequently, these traditional designs are enriched by sculptured ornament framing the windows, by twisted colonnettes, and by pointed tracery windows – these latter forms obviously drawn from Western Late Romanesque and Gothic models. Tiny, elegant, and almost riotously colourful, as at

Ravanica (1375–7) [394D, 397], at Kruševac (c. 1380) [394C], at Kalenić (1407–13), and Rudenica (1402–27), these Morava churches are attractive. But within the history of Byzantine architecture properly speaking, they are of purely local interest. Their plan and decoration are reflected, it seems, only in Rumania, where, towards the end of the fourteenth century, the church at Cozia is of pure Morava type – triconch plan, blind arcades, red and white striping. Such wall texture had penetrated into Rumania at least a generation before, when the church at Curtea de Argeş was laid out as a quincunx on piers, like so many churches of much simpler design in Serbia or, for that matter, Bulgaria. To us, the territory of Rumania in the century between 1350 and 1450 seems to have been on the edge of the Byzantine world. Indeed, Byzantine seems to have been even then in competition with Gothic building. Such competition grows stronger when in the second half of the fifteenth and during the sixteenth century, Renaissance intermingle with Gothic and Neo-Romanesque forms. This mixed vocabulary is applied to buildings laid out on plans still sprung from Late Byzantine antecedents in the Morava valley, albeit shot through with elements imported from Russia. The resulting cross-breed style has no place within the history of Byzantine building.[31]

BULGARIA AND CONSTANTINOPLE

In Bulgaria and Constantinople, High Paleologue architecture develops along lines quite different in plan and vocabulary from the style prevailing in Salonica and the western Balkans. In Bulgaria, the quincunx churches so widespread at the time of her First Empire never gained full ascendancy after her Second Empire was established in the late twelfth century.[32] The quincunx plan seems to have taken root only late and only sporadically. The churches of St Peter and Paul at Turnovo in south-

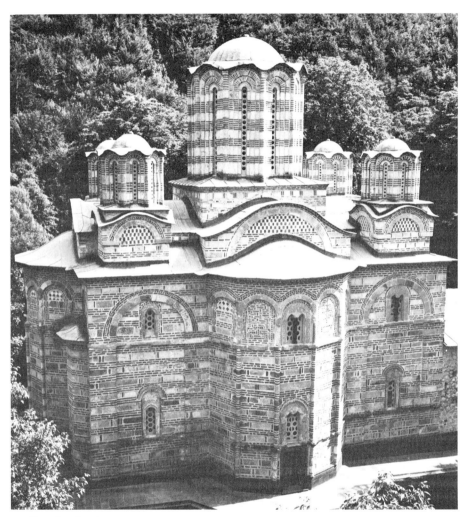

397. Ravanica, church, 1375-7.
Exterior from the north

western Bulgaria and those of the Pantokrator
and of St John Aleiturgitos at Nessebâr
(Mesembria) on the Black Sea coast are out-
standing examples [398C, 399]. Both date pre-
sumably from the second quarter of the four-
teenth century; but while the barrel-vaulted

corner bays at Turnovo recall provincial quin-
cunx churches in Greece, the doubling of domes
in the eastern corner bays of the church of St
John Aleiturgitos – the secondary domes far re-
moved from the centre dome – possibly suggests
Serbian models, such as Gračanica. This is not

398. (A) Stanimaka (Assenovgrad), Asen Church,
late twelfth or early thirteenth century. Plan
(B) Nessebâr (Mesembria), Church of the Archangels,
fourteenth century (second third). Plan
(C) Nessebâr (Mesembria), St John Aleiturgitos,
fourteenth century (second quarter). Plan

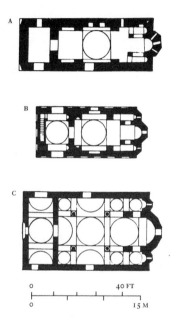

surprising, given the dynasty ruling since 1330
in Bulgaria with its close links to its Serbian
royal relatives.

But quincunx churches, otherwise predomi-
nant throughout Middle and Late Byzantine
architecture, are not the only church type in
Bulgaria. Equally frequent and perhaps more
interesting is another type: an aisleless hall, its
barrel-vault interrupted in the middle by a
dome raised high on a drum, while a second
drum, only slightly lower, surmounts the nar-
thex. The type comes to the fore as early as
1186, in Sv. Dimitri at Turnovo.[33] In the late
twelfth or early thirteenth century, it is used,
fully developed, to form the upper floor of
double-storeyed funerary chapels, such as the
church at Stanimaka (Assenovgrad) [398A],

built either by Asen I (1187–96) or by Ivan
Asen II (1218–41).[34] Finally, and again single-
storeyed, it reaches a climax at Nessebâr, in the
churches of the Archangels [398B], of the
Paraskevi, of Sv. Todor – all dating presumably
from the second third of the fourteenth cen-
tury.[35] The origin of the type remains to be
clarified. The dome rising from the narthex has
its source possibly in Serbian custom. The
aisleless, barrel-vaulted, and domed plan of
the nave came certainly from Constantinople,
where it had been customary since at least the
eleventh century. The double-storeyed plan of
the Asen church, on the other hand, poses some-
what of a problem. The first instance known so
far in Constantinople, the Boğdan Sarayi, is
later than the Asen church: but earlier
Constantinopolitan examples may have been
lost. It has also been suggested that the double-
storeyed plan represents a revival of Roman
mausolea types; or that it reached Bulgaria
from Armenia.[36] Whatever its origin, it is
characterized in Bulgaria by a somewhat in-
organic design. Nave and narthex form a simple,
longish, and low block on which are planted the
domes, unconnected with the carrying ground
floor except for the decoration. And this de-
coration is antitectonic to the highest degree as
well. St John Aleiturgitos at Nessebâr is a
splendid, if late example [399]. Blind arcades
encircle the lower block, rising from pilasters
and responds, and both the arches and their
supports expand and contract as space permits.
Wide on the flanks, they become narrow on the
main apse, and narrower still on the minor
apses. A corbel-table frieze runs along the
eaves line. But blind arches, corbel-table frieze,
and, indeed, the entire structure are hidden
under a profusion of polychrome decoration.
Broad bands of white, well-carved stone blocks,
one to three courses high, alternate with bands
of brick in four courses. Red brick and white
mortar strips alternate in the voussoirs of the
arches. Panels of chequerboard, interwoven

brick, zigzag, and cross-stitch patterns – all in contrasts of red and white – run as a frieze along the apses. Small pieces of brick embedded into a wide mortar-bed curve as a pointillé design

vocabulary from the workshops in the Imperial capital. But the beginnings of this polychrome decoration do not lie in Paleologue Constantinople. They reach farther back, to Justinianic

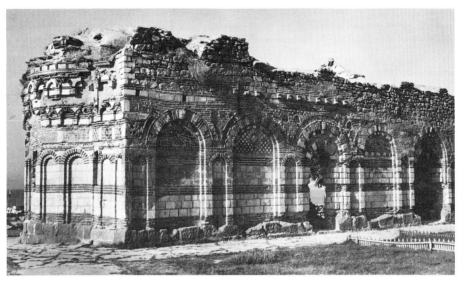

399. Nessebâr (Mesembria), St John Aleiturgitos, fourteenth century (second quarter). Exterior

over the blind arches. Finally, irregularities in the bricks or the pointing of the mortar were corrected with paint by the craftsmen.

Taken by themselves, the individual motifs used in this decoration stand in the tradition represented in the early fourteenth century for instance by the narthex façade of the Holy Apostles at Salonica. But, fully developed as it appears at St John Aleiturgitos, the decoration as a whole has been translated from pure or nearly pure brick designs into a highly colourful language. Such colouristic patterns characterize – as we shall see – early-fourteenth-century buildings at Constantinople which antedate the majority of the churches at Nessebâr. No doubt the builders of Czar Ivan Alexander (1331-71) in Nessebâr drew their decorative

and earlier architecture both in Constantinople and in the eastern and western provinces and successor states of the Empire, and beyond that possibly to Roman provincial building techniques. Alternating bands of brick and neatly hewn stone mark, one recalls, the city walls of Constantinople and numberless buildings throughout the Byzantine Empire from the fifth to the ninth and still the twelfth century, both in the capital and in the more remote provinces: the Studios church in Constantinople; the church of Constantine Lips in the Fenari Isa complex; the Kalenderhane Camii; the Çanlikilise on the Hassan Dağ [55, 314, 258, 362]. In Bulgaria, this type of masonry was equally known. Alternating red and white voussoirs appear around 1000 at the church of

St John the Baptist at Nessebâr; and alternating brick and stone bands, though crudely hewn, are used in the eleventh and twelfth centuries at Bačkovo and at Sv. Dimitri at Turnovo (1186). The red and white patterns which decorate the walls of the fourteenth-century churches at Nessebâr likewise go far back. At Stanimaka, at the end of the twelfth or in the first half of the thirteenth century, 'reticulate' panels in red and white stone fill the spandrels of the blind arches along the flank of the church. Nor are such motifs confined to Bulgarian building. Chequered bands in the thirteenth century decorate the churches of Arta; but earlier still, they occur in Sicily, at the church of St Peter and St Paul at Forza d'Agro, built for Basilian monks in the twelfth century; at Stilo in Calabria, possibly in the tenth century; and certainly that early in a number of churches on the Peloponnesus. Similarly, a chequered band encircles the campanile of S. Apollinare in Classe near Ravenna – at that time still on the fringe of the sphere of Byzantine influence. But chequered and similar patterns and alternating voussoirs in red and white stone were widespread in the Carolingian and Ottonian Empires as well, from the Lorsch gatehouse to the church of St Généroux and to Bernward's church of St Michael at Hildesheim. Indeed, the tradition in the West has been traced back to Late Roman structures in Gaul and in the Rhineland. Hence it has been suggested that this polychrome wall decoration infiltrated Byzantine architecture from the West and penetrated first Epirus, later Bulgaria; a suggestion countered by the thesis that, on the contrary, vocabulary and technique were carried from the Byzantine sphere to the West. To us it seems equally possible that a Late Roman polychrome masonry technique, surviving in the West as well as in the Byzantine provinces, was reawakened in the East in Paleologue times.[37]

Whatever the origin of this and similar patterning motifs, the use of polychrome walling seems to have been transplanted to Constantinople in the early fourteenth century from provincial Bulgarian architecture. Refined and remodelled in Constantinople – with elegantly cut stone bands and finely pointed white mortar-beds – this polychrome treatment possibly found its way back to Bulgaria, and in the second third of the century spread over the churches of Nessebâr.

Such links between Constantinopolitan and provincial architecture throw into strong relief the changed position of Constantinople and her court in the fourteenth century. In Middle Byzantine as in Justinian's times, the Imperial court in Constantinople was still a dominant centre. The provinces led a life of their own, but time and again the court sent builders and plans where an extraordinary building was to be laid out and decorated. On the other hand, the provinces only rarely, if ever, exerted their impact on the architecture of the capital. This changed in High Paleologue times. The impact of Constantinople on other centres by no means ceased. In Salonica, even in Ohrid, and certainly in Nessebâr, Constantinopolitan elements are evident. But just as frequently, provincial elements seem to have been absorbed into the architecture of the capital. Examples are easily listed: the twin-domed narthex gallery penetrates from Salonica into Constantinople, witness the parekklesion of the Fetiyeh Camii; also, there is, from the last years of the thirteenth century onward, the widespread use in Constantinople of polychrome walling. Still, Constantinople stands out with an approach to architecture much its own. Where Bulgarian builders think anti-structurally, in terms of colourful surfaces, the architects of Constantinople, as a rule, subordinate the polychrome decoration to strictly structural concepts. Where Salonican and Serbian churches rise to exaggerated heights, Constantinopolitan structures keep to reasonable proportions. Where the provincial schools cling to one building type,

Constantinopolitan builders and patrons work easily with a variety of plans. And whatever is done in Constantinople is done with subtlety, gradation, refinement, and, as a rule, with superb workmanship. Four structures in Constantinople represent this last flowering of a Byzantine architecture in the capital: the exonarthex and parekklesion of the Kariye Camii;

the parekklesion of the Fetiyeh Camii; the narthex of the Kilise Camii; and finally, the Tekfur Sarayi.

At the Kariye Camii, the twelfth-century structure was remodelled and redecorated in the very first years of the fourteenth century by the Grand Logothete Theodore Metochites.[38] A mosaic in the parekklesion bears the date

400. Constantinople, Kariye Camii,
eleventh, twelfth, and early fourteenth centuries.
From the south-east

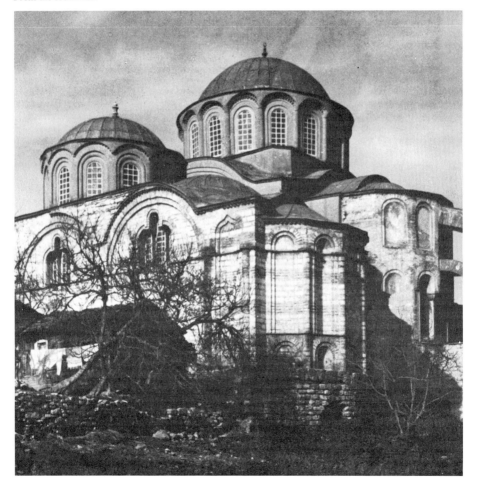

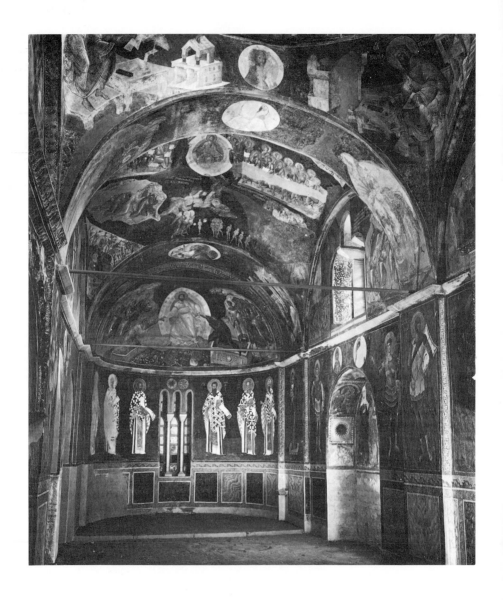

401. Constantinople, Kariye Camii, parekklesion, *c.* 1303–*c.* 1320. Interior looking east

1303, and work was terminated prior to 1321. A new dome – its drum survives – was placed over the centre bay of the main church; both exonarthex and esonarthex were newly laid out; and – continuing the exonarthex along the south flank of the church – a parekklesion was added [400, 401]. Turning the corner from the western main wing of the exonarthex are two square bays, covered by two low pendentive domes and forming an anteroom. Entered through the triple arcade of a small-scale

interior serves as a frame for the mosaics and paintings that cover wall and vaulting zones in such profusion and beauty as to overshadow the architectural design. But the subtle interplay of high and low spatial volumes, the gracefully falling and rising vaults, the elegant relationship of anteroom to chapel, and the gradual concentration of light towards the centre bay, are masterpieces of refinement and architectural jewellery work. On the outer walls, the red and white striping is subordinated to structural ac-

402. Constantinople, Fetiyeh Camii, parekklesion, c. 1315. From the south-west

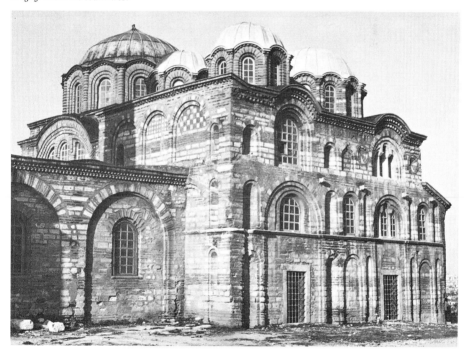

tribelon, the nave is composed of three units: first a deep barrel-vaulted arch; then the main bay, surmounted by a ribbed well-lit pumpkin dome; after that a second bay, which carries a pendentive dome similar to those in the anteroom, but slightly higher; finally the apse. This

cents: on the apse, responds, half-columns, and two tiers of niches – low and high; along the flank, pilaster strips, and recessed blind arches surmounting high-shouldered triple windows; at the corner, a flat niche closed by a depressed ogee arch.

The parekklesion of the Fetiyeh Camii, the Church of St Mary Pammakaristos, develops the new style along different lines.[39] Built either shortly before or shortly after 1315, it is a small quincunx with tiny corner bays and a tall drum – its height being four and a half times its width, steeper than in Middle Byzantine Constantinople but less immoderate than in contemporary Serbia [402]. A narthex precedes this small naos, double-storeyed and with a pair of domes rising from its upper gallery – the motif known from Salonica and the Balkan countries. Everything is designed with elegance on the smallest possible scale. On the south flank, three tiers of blind arches and windows grouped in triads prevail over the alternating

403. Constantinople, Kilise Camii, narthex, c. 1320

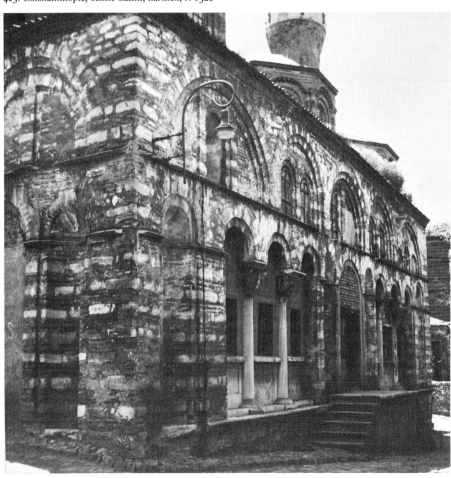

textile bands of red and white – one to five courses of bricks and one to four of neat ashlar blocks. A succession of low niches, steep niches, and a frieze of pendant triangles, marked off by horizontal string courses, articulate the three absidioles. On the façade of the narthex gallery, panels of polychrome chequerboard and grille patterns are anchored in place by blind arches with red and white voussoirs. On the main block, the eaves line curves up over the transverse and longitudinal barrel-vaults, and marks off on the exterior the inside volumes. Rising above these curves, the three drums are tied into the design by their own rippled eaves lines; against the background of the older dome of the main church, they form a picturesque group.

No other contemporary church building in Constantinople reaches the level of the parekklesia adjoining the Kariye and the Fetiyeh Camii: neither the parekklesion along the south flank of the Fenari Isa Camii, with its simple blind arches and niched pilasters; nor the Boğdan Sarayi; nor, for that matter, the envelope of structures added, probably at that time, to the Kilise Camii [403]: the exonarthex to the west; to the south, a colonnaded and arcaded portico, linking up with a possibly older parekklesion next to the original bema; to the north a corridor, perhaps likewise a parekklesion.[40] In all of them, the blocks of the ashlar bands are less neatly cut, the brick bands less precisely coursed, and the mortar-beds less finely pointed. In the narthex of the Kilise Camii, the three domes rise inorganically from above the roof. Yet the structure does reveal some characteristics of High Paleologue architecture in Constantinople more clearly than the superior design of the parekklesion along the Fetiyeh Camii. The façade opens in arcades much like the exonartheces of H. Katherini and the Church of the Apostles at Salonica and of St Sophia at Ohrid; but the rhythm is more com-

plex. On the bottom level are steep niches at the corners, followed by open triple arcades; the portal in the centre is coupled with steep niches in a triad. On the upper floor, incongruous with the rhythm of the ground floor, are five semicircular blind arches framing windows. Inside, the succession of high pumpkin domes at the corners, low pendentive domes in the next bays, and a higher ribbed dome in the centre aims at a sharper focusing of the spatial volumes towards the middle. Reminiscences of Justinian's architecture are scattered all over the structure, whether or not in a conscious spirit of renascence: the open, colonnaded south portico – it is known from nineteenth-century drawings – with door frames inserted between the columns, like the narthex of the Studios church or the sea façade of the Bukoleon Palace; another such frame between column shafts, linking the narthex to the north corridor; and fifth- and sixth-century capitals and chancel slabs used as decorative elements. The date of the structures is undetermined, but one would like to place them after, rather than before, the parekklesia of the Kariye and the Fetiyeh Camii.

Equally undated is the Tekfur Sarayi, the only surviving Imperial palace building in Constantinople [404-6]. Based on top of the city walls and projecting beyond towards the open country, it was long attributed to the reign of Constantine VII Porphyrogenetos (912-59).[41] Indeed, the short side of its ground floor is supposedly earlier than the adjoining fortification – a twelfth-century repair of the city walls. Whether or not this is correct, it affects neither the plan of the building nor its decoration and its supports. The dating of all these elements to the first third of the fourteenth century is given, in my opinion, by the textile walling and its incorporation into a strong structural skeleton: the red and white

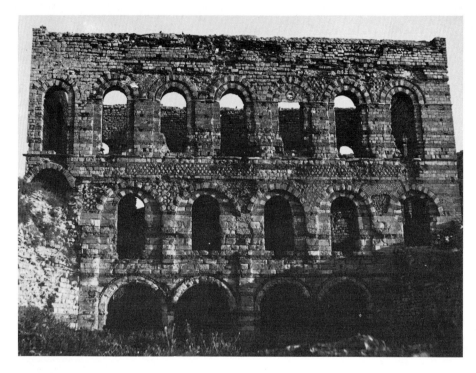

bands with finely cut ashlar blocks; the alternating voussoirs of blind arches and windows; the diamond, hexagon-cross, and chequerboard patterns in polychrome treatment – all fitted into spandrels, frieze bands, and archivolt stripes. No doubt the designer of this façade was close to the architect of the parekklesion of the Fetiyeh Camii and left in the Tekfur Sarayi a splendid example of the last stage in Late Byzantine architectural design.

But the plan of the Tekfur Sarayi is essentially not Byzantine. A solid block, it rises in three storeys. The ground floor, with groin-vaults, rests on two rows of columns. The two upper floors are undivided and were covered by flat ceilings [406]. On the main façade, two double openings on the ground floor are followed by a row of windows on each of the upper floors. Two low wings project forward from the main façade and carried terraces at the second-floor level. All this recalls the *palas* of a Romanesque or Gothic castle in France or Germany more closely than the Late Antique tradition of Early and Middle Byzantine palace building. Indeed, Western palace architecture had penetrated the Byzantine world since the thirteenth-century inroads made by the Western conquerors. At Mistra (Mystra), the oldest palace wing on the castle height was just such a rectangular multi-storeyed block, vaulted on the ground floor. Given its narrowness, no dividing supports were needed. Whether begun prior to 1260 by the Frankish Villehardouin or after the Byzantine reconquest in 1262, it is Western in every respect. So are the two later wings, one built in the late fourteenth, the other in the first half of the fifteenth century. The fourteenth-century wing is two-storeyed, the

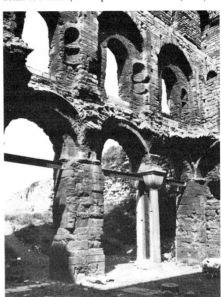

404-6. Constantinople, Tekfur Sarayi, early fourteenth century. North-west façade (*opposite*), detail of north-west façade (*left*), and detail of interior, lower part towards north (*below*)

fifteenth-century wing three-storeyed; the top floor was a long hall, lit by windows and, higher up, oculi, presumably the throne room. Likewise, smaller palaces scattered through Mistra and ordinary, if substantial houses follow a type well known in the West: the ground floor vaulted and, as a rule, dark; the upper floor occupied by a long, well-lit room, occasionally preceded by a terrace. The palaces of Frangopoulos and of Laskaris and a number of bourgeois houses offer examples.[42] The Western palace type, then, was willingly absorbed by the Paleologue courts. As early as the late thirteenth century, an Imperial palace at Nymphaion (Nymphaeum; Kemalpaşa) near Izmir was laid out as a solid rectangular block, supported by two groin-vaulted naves and a row of supports on the ground floor.[43] In the Tekfur Sarayi, this Western palace type has been clad in the decoration of Late Byzantine architecture.

The situation is symptomatic for the end phase of Byzantine architecture. The building itself is of relatively minor interest to the architect. It may be, as in palace building, a Western type virtually unchanged. In ecclesiastical architecture, the basic structure is any of a number of traditional church types, long repeated in ever new, but fundamentally minor variants: quincunx churches, cross-octagons, domed and barrel-vaulted chapels. The proportions change; open nartheces and parekklesia are added. But the basic plan remains. All interest is centred on the decoration, both inside and out. In contrast to the figurative arts, architecture is comparatively sterile. The interest of patrons and the talent of artists had turned to painting.[44]

LIST OF PRINCIPAL ABBREVIATIONS

A.J.A.	*American Journal of Archaeology*
A.M.	*Athenische Mitteilungen (Mitteilungen des Deutschen Archäologischen Instituts, Athenische Abteilung)*
Antioch	G. W. Elderkin (ed.), *Antioch on-the-Orontes*. 4 vols. Princeton, 1934–52
Archeion	*Archeion tōn Byzantinōn Mnimeiōn tis Hellados* (all papers written by A. K. Orlandos)
B.A.C.	*Bullettino di Archeologia Cristiana*
B.d.A.	*Bollettino d'Arte*
Bonn Corpus	*Corpus Scriptorum Historiae Byzantinae*. Bonn, 1828–97
B.S.A.	*British School at Athens, Annual*
B.S.A.F.	*Bulletin Société Antiquaires de France*
Bull. Arch.	*Bulletin Archéologique du Comité des Travaux Historiques*
Bull. Byz. Inst.	*Bulletin of the Byzantine Institute* (vols 1 and 2 only)
Bull. Com.	*Bullettino della Commissione Archeologica Comunale di Roma*
Butler, *Architecture*	H. C. Butler, *Architecture and Other Arts*. New York, 1923
Butler, *Churches*	H. C. Butler, ed. E. Baldwin Smith, *Early Churches in Syria*. Princeton, 1929
B.Z.	*Byzantinische Zeitschrift*
C.A.	*Cahiers Archéologiques*
C.A.C.	*Congresso di Archeologia Cristiana* (Atti, Actes; preceded in Roman numerals by the number of the Congress, and followed by the place and year)
C.C.R.	*Corsi di cultura ravennate e bizantina*
C.E.B.	*Congrès International des Études Byzantines* (preceded in Roman numerals by the number of the Congress, and followed by the place and year)
Corpus	R. Krautheimer and others, *Corpus Basilicarum Christianarum Romae*. Vatican City, 1939 ff.
C.R.A.I.	*Comptes-rendus de l'Académie des Inscriptions et Belles-Lettres*
C.S.E.L.	*Corpus Scriptorum Ecclesiasticorum Latinorum*. Vienna, 1866 ff.
Deichmann, *Studien*	F. Deichmann, *Studien zur Architektur Konstantinopels (Deutsche Beiträge zur Altertumswissenschaft)*. Baden-Baden, 1956
Deltion	*Archaiologikon Deltion*
Diehl, *Manuel*	C. Diehl, *Manuel d'art byzantin*. 2 vols, 2nd ed. Paris, 1925
D.O.P.	*Dumbarton Oaks Papers*
Dyggve, *Salonitan Christianity*	E. Dyggve, *History of Salonitan Christianity*. Oslo and Cambridge, Mass., 1951
Ebersolt, *Monuments*	J. Ebersolt, *Monuments d'architecture byzantine*. Paris, 1934
Ebersolt and Thiers, *Églises*	J. Ebersolt and A. Thiers, *Les Églises de Constantinople*. Paris, 1913
Ephimeris	*Ephimeris Archaiologiki*
Forschungen in Salona	W. Gerber, R. Egger, and E. Dyggve, *Forschungen in Salona*. 3 vols. Vienna, 1917–39
Gauckler, *Basiliques*	P. Gauckler, *Basiliques chrétiennes de Tunisie*. Paris, 1913
G.N.M.S.	*Godišnik Naroden Muzei Sofia (Annuaire du Musée Nationale de Sofia)*
Gsell, *Monuments*	S. Gsell, *Les monuments antiques de l'Algérie*. Paris, 1901
Grabar, *Martyrium*	A. Grabar, *Martyrium*. 2 vols. Paris, 1943–6
I.B.A.I.	*Izvestija na B'lgarskija Arheologičesk Institut*
Ist. M.	*Istanbuler Mitteilungen* (Deutsches Archäologisches Institut, Abteilung Istanbul)

I.R.A.I.K.	*Izveztia Russko Archeologisko Instituts na Konstantinople*
Janin, *Églises*	R. Janin, *La géographie ecclésiastique de l'empire byzantin, première partie, Le siège de Constantinople et le patriarcat oecuménique, tome III, Les églises et les monastères.* Paris, 1953
J.A.C.	*Jahrbuch für Antike und Christentum*
J.D.A.I.	*Jahrbuch des deutschen archäologischen Instituts*
J.D.A.I., A.A.	*Jahrbuch des deutschen archäologischen Instituts, Archäologischer Anzeiger*
J.H.S.	*Journal of Hellenic Studies*
J.Ö.A.I.	*Jahreshefte des österreichischen archäologischen Instituts*
J.S.A.H.	*Journal of the American Society of Architectural Historians*
Kautzsch, *Kapitellstudien*	R. Kautzsch, *Kapitellstudien (Studien zur spätantiken Kunstgeschichte).* Berlin and Leipzig, 1936
Krautheimer, *Studies*	R. Krautheimer, *Studies in Early Christian Medieval and Renaissance Art.* New York–London, 1969
Lassus, *Sanctuaires*	J. Lassus, *Sanctuaires chrétiens de Syrie.* Paris, 1947
L.C.L.	*Loeb Classical Library*
L.P.	L. Duchesne, *Le Liber Pontificalis.* Paris, 1881–92
Mavrodinov (1959)	N. Mavrodinov, *Staroblgarskoto Isskustvo.* Sofia, 1959
M.K.	*Mitteilungen des Deutschen Archäologischen Instituts, Abteilung Kairo*
N.B.A.C.	*Nuovo Bulletino di Archeologia Cristiana*
Orlandos, *Basiliki*	A. Orlandos, *Hi Basiliki xylostegos tis mesogeiakis lekanis.* Athens, 1950–9
P.B.S.R.	*Papers of the British School at Rome*
P.E.	*Publications of the Princeton University Archaeological Expeditions to Syria*
P.E.F.Q. St.	*Palestine Exploration Fund, Quarterly Statement*
P.G.	J. P. Migne, *Patrologia Graeca.* Paris, 1857 ff.
P.L.	J. P. Migne, *Patrologia Latina.* Paris, 1842 ff.
Q.D.A.P.	*Quarterly of the Department of Antiquities in Palstine*
R.A.C.	*Rivista di Archeologia Cristiana*
Ramsay and Bell, *Churches*	Sir W. M. Ramsay and G. L. Bell, *The Thousand and One Churches.* London, 1909
Recherches à Salone	E. Dyggve (ed.), *Recherches à Salone*, I (trans. E. Philipot). Copenhagen, 1928 ff.
Rev. Arch.	*Revue Archéologique*
Richter, *Schriftquellen*	J. P. Richter, *Quellen der byzantinischen Kunstgeschichte (Quellenschriften für Kunstgeschichte und Kunsttechnik des Mittelalters und der Renaissance, n.s. VIII).* Vienna, 1897
R.i.P.	*Razkopki i Prousevanija*
R.K.W.	*Repertorium für Kunstwissenschaft*
R.L.A.C.	Th. Klauser (ed.), *Reallexikon für Antike und Christentum.* Stuttgart, 1950–62
R.L.B.K.	*Reallexikon zur Byzantinischen Kunst*
R.M.	*Römische Mitteilungen (Mitteilungen des deutschen archäologischen Instituts, Römische Abteilung)*
Rott, *Denkmäler*	H. Rott, *Kleinasiatische Denkmäler . . . (Studien über christliche Denkmäler,* N.F. V, VI). Leipzig, 1908
R.Qu.Schr.	*Römische Quartalschrift*
Schneider, *Byzanz*	A. M. Schneider, *Byzanz, Vorarbeiten zur Topographie und Archäologie der Stadt (Istanbuler Forschungen,* VIII). Berlin, 1936
Sotiriou, *Basilikai*	G. Sotiriou, *Hai Christianikai Thibai kai hai palaiochristianikai Basilikai tis Hellados.* Athens, 1931 *(Ephemeris, 1929–30)*
Tchalenko, *Villages*	G. Tchalenko, *Villages antiques de la Syrie du Nord (Institut Français d'Archéologie de Beyrouth, Bibliothèque Archéologique et Historique,* I). Paris, 1953–8
Van Millingen, *Churches*	A. van Millingen and others, *Byzantine Churches in Constantinople, Their History and Architecture.* London, 1912

Verzone (1942)	P. Verzone, *L'architettura religiosa dell'alto medio evo nell'Italia settentrionale.* Milan, 1942
Wulff, *Handbuch*	O. Wulff, *Altchristliche und byzantinische Kunst (Handbuch der Kunstwissenschaft).* Potsdam-Wildpark, 1918
Zb.R.	*Zbornik Radova, Institut d'Études Byzantines,* Belgrade
Z.D.P.V.	*Zeitschrift des deutschen Palästina-Vereins*

NOTES

Bold figures indicate page reference.

PART ONE:
CHRISTIAN BUILDING
PRIOR TO CONSTANTINE

CHAPTER I

23. 1. The early establishment of Christian congregations in Mesopotamia, Iran, and elsewhere beyond the pale of the Empire, while important for the development of Eastern Christianity, had no impact on the rise and spread of a Christian architecture.
2. Pliny the Younger, *Letters*, x, 96 (*L.C.L.*, 11, 400 ff.); A. von Harnack, *The Expansion of Christianity* (New York and London, 1904) (*Die Mission und Ausbreitung des Christentums*, Leipzig, 1924).
24. 3. Clement of Rome, 1 Corinthians 13:8; 19:4. The service in an Eastern congregation around A.D. 100 is reflected in the Didache, chapters 9 ff. (*Ante-Nicene Fathers*, ed. P. Schaff, New York, 1889, 1); a concise survey of the situation is given by J. A. Jungmann, *Missarum Solemnia*, 1 (Freiburg, 1952) (English transl., *The Mass of the Roman Rite*, New York, 1951), 7 f., and G. Dix, *The Shape of the Liturgy* (London, 1945), 78 ff.
4. Acts of the Apostles, 13:15, 17; 17:2 ff.; 18:4, 19, 26; 19:8.
5. Acts of the Apostles, 16:13; 17:7; 19:9.
6. Acts of the Apostles, 2:46.
7. Acts of the Apostles, 1:17; 20:8; and *passim*.
8. Tertullian, *Adversus Valentinianos*, cap. 3 (*P.L.*, 11, 580): '... columbae ... domus simplex in editis semper et ad lucem'. For other testimony, see also J.-R. Laurin in *Analecta Gregoriana 70, ser. facultatis Historiae ecclesiasticae, sectio A* (n. 3) (Rome, 1954), 39 ff.
9. Acts of the Apostles, 20:5–10.
10. H. C. Butler, *Architecture*, section A, *Southern Syria*; section B, *Northern Syria* (*Publications of the Princeton ... Expeditions...*) (Leyden, 1919–), *passim*; Tchalenko, *Villages, passim*; A. Boëthius in *Die Antike*, XI (1941), 110 ff.; L. Crema, *L'architettura romana*, *Enciclopedia classica*, sezione III, vol. 12,

tomo I (Turin, 1959), *passim*; A. Boëthius and J. B. Ward-Perkins, *Etruscan and Roman Architecture* (*Pelican History of Art*) (Harmondsworth, 1970), 118 ff.
11. Th. Klauser, in *Pisciculi... Franz Joseph Doelger ... dargeboten* (Münster, 1939), 157 ff.
25. 12. Harnack, *op. cit., passim*.
13. Cyprian, *De Lapsis*, cap. 6, in J. Martin (ed.), *Florilegium Patristicum*, XXI (Bonn, 1930), 14: 'Episcopi plurimi divina procuratione contempta procuratores regum saecularium facti sunt.' The passage is not beyond doubt, since some manuscripts read *rerum* for *regum* (*P.L.*, IV, 484). But Tertullian's statement (*Apologeticum*, cap. 37; *P.L.*, I, 525) is in essence the same.
14. H. Grégoire, *Les persécutions dans l'empire romain* (*Académie Royale de Belgique, Classe des Lettres...*, XLVI, 1) (Brussels, 1951); J. Moreau, *Die Christenverfolgung im römischen Reich* (Berlin, 1961). H. Mattingly, *Christianity in the Roman Empire* (University of Otago, 1955), gives a concise picture of the situation.
15. Eusebius, *Ecclesiastical History*, VII, xiii, 1 (*L.C.L.*, 11, 168 f.), gives the text of the Imperial rescript.
26. 16. G. Krüger, *Die Rechtsstellung der vorkonstantinischen Kirchen* (Stuttgart, 1935); G. Bovini, *La proprietà ecclesiastica ... in età preconstantiniana* (Milan, 1949). The Edict of Milan as quoted by Lactantius, *De mortibus persecutorum*, cap. 48 (*P.L.*, VII, 267) returns to the Christians both the 'houses where they are used to meet and others belonging to their corporation' (*ad jus corporis eorum*), that is, to their Churches, not to individuals. Eusebius, *Ecclesiastical History*, x, v, ii, has mistranslated the passage.
17. Jungmann, *op. cit., passim*; also B. Steuart, *The Development of Christian Worship* (London, 1953).
18. The arrangement and furniture of the assembly rooms in the early centuries can be gathered from scattered references in the early Fathers and from Church orders such as the Syrian *Didascalia*, chapter 12 (ed. H. Conolly, Oxford, 1929, 120).

19. For the seating of the congregation, see H. Selhorst, *Die Platzanordnung im Gläubigenraum der altchristlichen Kirche* (Münster, 1931).
20. Tertullian, *De Poenitentibus*, cap. 7 (*P.L.*, I, 1352).
21. L. Duchesne (transl. M. L. McClure), *Christian Worship* (London, 1949), 334, quoting Tertullian, *De Baptismo* (*P.L.*, I, 1308 ff.), and Hippolytus, *In Danielem*, v, 17 (*P.G.*, x, 654); A. Stenzel, *Die Taufe* (Innsbruck, 1958); E. C. Whitaker, *Documents of the Baptismal Liturgy* (London, 1960). See also above, Note 11.
22. J. P. Kirsch, *Die römischen Titelkirchen im Altertum* (Bonn, 1918), *passim*; L. Voelkl, *R.A.C.*, XXIX (1953), 49 ff., and XXX (1954), 99 ff.; more cautiously, Th. Klauser, *J.A.C.*, XI/XII (1968/9), 221 f., though I cannot accept his thesis that community centres in the old sense no longer existed in the fourth century.
23. Minucius Felix, *Octavius*, chap. XXXII (*P.L.*, III, 353): 'delubra non habemus, aras non habemus'.
24. Older theories had it that the early Christians congregated in the atrium, the partly-covered central room of the Italic house; in the peristyle, the garden court of the hellenistic or hellenized Italic house; in the *basilicae privatae*, large reception rooms in the palaces of the wealthy; or in the *oikoi*, the lavish dining-rooms of such palaces. None of these suggestions holds. The atrium house had become obsolete by the middle of the first century, perhaps surviving in small country towns such as Pompeii, but not in the large cities where Christian congregations were forming; even when in fashion, it was limited to Italy, where Christianity was weakest. Furthermore the open roof of the atrium house and the pool in the centre would make it unsuitable for any gathering. The alleged resemblance of its plan, with the *alae* on either side, to that of an Early Christian transept basilica fails with the realization that the transept was always exceptional in Christian basilicas. *Oikoi*, peristyle courts, and audience halls – while hellenistic features and thus common from the first century onwards around the Mediterranean – were limited to the houses of the very rich. Hence, they were not available to the early congregations. Moreover, both garden courts and audience halls would have been utterly unsuitable for the ritual meals of the believers.
25. The definitive publication, C. H. Kraeling, *The Christian Building* (*The Excavations at Dura Europos . . . Final Report*, VIII, 2) (New Haven, 1967), with older bibliography, suggests the dates here accepted, the former thesis being that the house was remodelled for Christian use in 231/2 – a minimal difference anyhow.

28. 26. M. Mirabella Roberti, in *Studi aquileiesi offerti a Giovanni Brusin* (Padua, 1953), 209 ff., discusses the possible existence of a similar community house at Aquileia, preceding the double cathedral of the early fourth century.
27. See the anti-Donatist documents, collected in Migne, (*P.L.*, VIII, 673 ff., as *Monumenta Vetera ad Donatistarum historiam pertinentia*, esp. col. 231); better, K. Ziwsa (ed.), *C.S.E.L.*, XXVI (Vienna, 1893), esp. 186.
28. C. H. Kraeling, *The Synagogue* (*The Excavations at Dura Europos . . . Final Report*, VIII, 1) (New Haven, 1956).
29. 29. See above, Note 10.
30. Kirsch, *op. cit.*, *passim*; R. Vieillard, *Recherches sur les origines de la Rome chrétienne* (Mâcon, 1942). K. Gamber, *Domus Ecclesiae* (Regensburg, 1968), should be used with caution; see the review by Th. Klauser, *J.A.C.*, XI/XII (1968/9), 215 ff.
31. *Corpus*, I, 267 ff.; A. Prandi, *Il complesso monumentale della basilica . . . dei SS. Giovanni e Paolo* (Vatican City, 1953), dates the church building prior to 400.
32. E. Junyent, *Il titolo di San Clemente* (Rome, 1932); *Corpus*, I, 117 ff.; A. Petrignani, *La basilica di S. Pudenziana* (Vatican City, 1934); *Corpus*, III, 277 ff.
33. The bibliography on catacombs is vast. For Rome, the basic work, G. B. de Rossi, *Roma sotterranea* (Rome, 1857), is to be supplemented by O. Marucchi, *Le catacombe romane* (Rome, 1933), and by numerous papers published in *B.A.C.*, *N.B.A.C.*, and *R.A.C.* H. Achelis, *Die Katakomben von Neapel* (Leipzig, 1936), and J. Führer, *Forschungen zur Sicilia sotterranea* (Munich, 1897), are still standard works, the latter to be supplemented by the studies of G. and S. Agnello, *R.A.C.*, *passim*; see index, *ibid.*, XLI (1965 [1968]). The North African catacombs remain to be explored.
34. *Areae* are best known from North Africa; see, e.g., P.-A. Février, *C.C.R.* (1970), 191 ff., and N. Duval, *ibid.*, 119 ff., esp. 127 ff., both with previous bibliography. An *area* near the catacomb of Praetextatus in Rome, surrounded by mausolea, has been studied by H. Winfeld-Hansen, *Institutum Romanum Norvegiae, Acta*, IV (1969), 61 ff.
Mausolea incorporated into medieval churches have survived, for instance, at Poitiers, Saint-Maximin, and elsewhere; see J. Hubert, *L'art pré-roman* (Paris, 1938), 53 ff.
35. At Cirte (modern Constantine) in North Africa, a bishop was elected 'in casa maiore in area martyrum' (*P.L.*, VIII, col. 739; see also Gsell, *Monuments*, II,

192, 397). At Tipasa, a portico with mensae has been found, adjoining the tomb basilica of one bishop Alexander of *c.* 400 (L. Leschi, *Bull. Arch.*, XL, 1938, 422 ff.; Duval, *op. cit.*). Another funerary building of fourth-century date has been uncovered in a Christian cemetery situated below the church of St Severin at Cologne. But neither the reconstruction nor the date of this first building, nor of the structures succeeding it – supposedly in the late fourth and the fifth century, as proposed by F. Fremersdorff in *Neue Ausgrabungen in Deutschland* (Berlin, 1958), 329 ff. – are beyond question.

36. A. Grabar, *Martyrium* (Paris, 1948), is basic for the problems involved. See also the summary given by Grabar in *Archaeology*, 11 (1949), 95 ff.

33. 37. The remnants found below St Peter's, including the large pagan necropolis, the aedicula of the apostle, the foundation walls of Constantine's basilica, and small portions of its rising walls and its colonnades have been published *in extenso* in *Esplorazioni sotto la confessione di San Pietro in Vaticano . . . 1940-1949; relazione a cura di B.M. Apollonj-Ghetti, A. Ferrua, S.J., E. Josi, E. Kirschbaum, S.J. . . .* (Vatican City, 1951). J. C. M. Toynbee and J. B. Ward Perkins, *The Shrine of Saint Peter* (London and New York, 1956), and E. Kirschbaum, *The Tombs of St Peter and Paul* (New York, 1959), present excellent summaries and clarify the situation further. The reconstruction of the aedicula as suggested by Toynbee and Ward Perkins seems preferable to that proposed in *Esplorazioni*.

34. 38. Kirschbaum, *op. cit.*, 119 ff., and Th. Klauser, *Die römische Petrustradition* (Cologne-Opladen, 1956), *passim*, represent different points of view.

39. De Rossi, *op. cit.*, 1, 72 f.; 11, 253 ff.; Marucchi, *op. cit.*, 185 ff.

35. 40. Kirschbaum, *op. cit.*, and Klauser, *op. cit.* See also: P. Styger, *Römische Märtyrergrüfte* (Berlin, 1935); A. Prandi, *La memoria apostolorum in catacumbas* (Vatican City, 1936); F. Tolotti, *La memoria degli apostoli* (Vatican City, 1953); *Corpus*, IV, 114 ff.

41. Th. Kempf, *V C.A.C. . . . Aix-en-Provence . . . 1954*, 61 ff., with bibliography.

42. The exploration of Salona since 1920 has been directed primarily by E. Dyggve and R. Egger, and published in *Forschungen in Salona*, I-III (Vienna, 1914-39), and *Recherches à Salone*, I, II (Copenhagen, 1920-). A great deal of the findings, however, was published only in summary form by E. Dyggve, *History of Salonitan Christianity* (Oslo, 1951). Regarding early *memoriae*, see *ibid.*, 71 ff.

36. 43. Dyggve and Egger, *Forschungen in Salona*, III (Vienna, 1939), especially 95 ff., 116 ff.

44. *Ibid.*, 80 ff., 107 ff.; for Pécs, see E. Dyggve, in *IV C.A.C. . . . Rome . . . 1938*, I, 395 f., and F. Gerke,

in *Neue Beiträge zur Kunst des 1. Jahrtausends*, I (*Forschungen zur Kunstgeschichte und Archäologie*, I) (Baden-Baden, 1952), 115 ff.; for Alberca, H. Schlunk, *Cronica del III Congresso Arqueologico del Sudeste Español* (1947), 335 ff., and *J.D.A.I., A.A.*, LXIX (1954), 451 ff. The dependence of this type on Sassanian architecture, as suggested by Dyggve, is hardly tenable.

45. Best known are the cellae trichorae of S. Sotere and S. Sisto above the Callisto catacomb; see De Rossi, *op. cit.*, 11, 4 f.; 111, 29 f. The dates of construction and the original dedications of the various buildings await further clarification.

46. A cross-shaped mausoleum, known as the chapel of SS. Tiburtius, Valerianus, and Maximus, rises over the catacomb of SS. Marcellino e Pietro, but the martyr's grave here seems to have been in the catacomb (*Corpus*, 11, 191 ff.). Regarding the niched rotunda and other mausolea at the Praetextatus catacomb, see Winfeld-Hansen, *op. cit.* (Note 34 above).

37. 47. J. Keil and H. Hörmann (ed.), *Forschungen in Ephesos*, V, 3 (Vienna, 1951), 224 ff.; also J. B. Ward Perkins, *P.B.S.R.*, XVII (1949), 32, 40.

48. Kirsch, *op. cit.*, *passim*.

38. 49. Eusebius, *Ecclesiastical History*, VII, XXX, 9 (*L.C.L.*, 11, 219).

50. Lactantius, *De mortibus persecutorum*, cap. 12 (*P.L.*, VII, 213 f.). Likewise, the church building at Edessa, damaged and rebuilt in 201, was presumably a *domus ecclesiae*, not, as frequently maintained, an independent church building. The same probably holds true for the 'churches of spacious dimensions' which were erected after 260, as reported by Eusebius, *Ecclesiastical History*, VIII, i, 5 (*L.C.L.*, 11, 253).

51. Porphyry, *Adversus Christianos*, fragment 76, ed. A. von Harnack, *Abhandlungen Berliner Akademie der Wissenschaften, Phil. Hist. Klasse* (1916), no. 1, 98.

52. *Corpus*, 1, 144 ff. B. M. Apollonj-Ghetti, *S. Crisogono* (*Chiese illustrate*, XCII) (1966), believes that the first remains belong to third-century buildings of unknown design and function which were prolonged and provided with apse and side chambers *c.* 450.

53. See below, Chapter 2, Note 32; *Corpus*, IV, 99 ff.

PART TWO: THE FOURTH CENTURY

CHAPTER 2

39. 1. Writings on Constantine are numberless. His position regarding Christianity and the Church is best traced through A. Piganiol, *L'empereur Constantin* (Paris, 1928); N. H. Baynes, *Constantine the Great and the Christian Church* (London, 1929); A. Alföldi, *The*

Conversion of Constantine (Oxford, 1948); and H. Dörries, *Konstantin der Grosse* (Stuttgart, 1958). Primary sources are Constantine's letters and decrees (paraphrased, interpreted, and at times over-interpreted by H. Dörries, *Das Selbstzeugnis Kaiser Konstantins*, Göttingen, 1954) and Eusebius's *Life of Constantine* (*P.G.*, XX, 905 ff.; transl., ed. P. Schaff and H. Wace, *A Select Library of Nicene and post-Nicene Fathers*, second series, I, New York–Oxford–London, 1890, 473 ff.; and Eusebius's *Gesammelte Werke*, ed. I. A. Heikel, I, Berlin, 1898).

40. 2. Insignia and ceremonial of high officialdom need not all have become episcopal prerogatives at the same time. Th. Klauser, *Der Ursprung der bischöflichen Insignien und Ehrenrechte* (Krefeld, 1948), leaves in doubt whether candles, book, and fan preceded the bishop from the fourth or only from the seventh century. According to J. A. Jungmann, *Missarum Solemnia*, I (Freiburg, 1952), 51, note 21, on the other hand, both candles and the proskynesis were episcopal prerogatives from the fourth century.

3. While Christ was visually represented as *basileus* first during the last third of the fourth century (J. Kollwitz, *Oströmische Plastik*, Berlin, 1941, 145 ff.), in literature and presumably in popular opinion His equation with the Emperor goes back to the time of Constantine, if not before. See K. M. Setton, *Christian Attitude Towards the Emperor* (New York, 1941), 18 ff.; K. Wessel, *J.D.A.I., A.A.*, LXIX (1953), 118 ff.; P. Beskow, *Rex Gloriae* (Stockholm, 1962), *passim*.

41. 4. Much remains to be clarified regarding the precise forms of the liturgy in the fourth century in the various parts of the Empire. The present state of the question is summarized by Jungmann, *op. cit.*

5. F. W. Deichmann, *J.D.A.I.*, LIV (1939), 105 ff.

6. Numberless theories, beginning in the fifteenth century, have been propounded regarding the origin of the Christian basilica. The building type has been variously derived from the secular forum basilica; the palace basilica; religious pagan basilicas; synagogues; funerary pagan basilicas; the Italic atrium house; the peristyle of the hellenistic house; the plan of Imperial palaces; hellenistic heroa; the layout of Roman Imperial fora; or from the colonnaded streets of Roman cities. Or else it has been evolved entirely from the requirements of the Christian liturgy, or from a combination of some or of all these factors. Summaries of the principal hypotheses have been presented in recent times in *R.L.A.C.*, I, 1249 ff.; by C. Delvoye, in *Annuaire de l'Institut de Philologie et d'Histoire Orientales et Slaves*, XIV (1957), 180 ff., and *idem*, in *C.C.R.* (1959), I, 49 ff.; by a discussion group, *Kunstchronik*, IV (1951), 97 ff.; N. Duval, in *L'Information de l'Histoire de l'Art*, VII (1962), I ff. Leaving

aside the more questionable theories, it would seem that the problem can be placed in the right perspective only by focusing not on one feature, such as the transept (an exceptional element in any event), but on plan and function in their entirety, and by thinking in terms of the creation of a new variant within the framework of a traditional genus (Krautheimer, *D.O.P.*, XXI, 1967, 115 ff.) rather than in terms of the derivation of the Christian basilica from any Roman prototype, be it religious or secular, private or public (Deichmann, *B.Z.*, LIX, 1966, 334 ff., esp. 359).

42. 7. R. Schultze, *Basilika* (Berlin, 1928); more recently, E. Langlotz, *R.L.A.C.*, I, 1225 ff.; L. Crema, *L'architettura romana*, Enciclopedia classica, sezione III, vol. 12, tomo I (Turin, 1959), *passim*; and Boëthius and Ward-Perkins, *op. cit.* (Chapter 1, Note 10), *passim*. Regarding the covering of the nave, see F. W. Deichmann, *Felix Ravenna*, LXXV (1957), 63 ff.

8. B. Pace, *I mosaici di Piazza Armerina* (Rome, 1955); W. Reusch, *Trierer Zeitschrift*, XVIII (1949), 198 ff.; P.-A. Février, *C.A.*, XIV (1964), I ff., esp. 12 ff.; R. Günter, *Wand, Fenster und Licht in der Trierer Palastaula und in spätantiken Bauten* (Herford, 1968).

9. The *Thesaurus Linguae Latinae* (Leipzig, 1900 ff.), II, 1761 ff., under 'basilica', gives examples of the usage of the term with and without explanatory epithets.

10. Vitruvius, *De Architectura*, V, 1; see also R. Krautheimer, *D.O.P.* (*op. cit.*).

11. S. Pudenziana in Rome encloses the core of such a thermae basilica of second-century date; see A. Petrignani, *La basilica di S. Pudenziana . . .* (Vatican City, 1934), and *Corpus*, III, 227 ff.

12. Pagan religious basilicas known from excavations in Rome, apart from that of the 'Tree Bearers of the Great Mother and Attys' (Basilica Hilariana; see E. Nash, *Pictorial Dictionary of Ancient Rome*, London, 1961–2, I, 169 ff., with older bibliography), are the neo-Pythagorean subterranean basilica at Porta Maggiore (*ibid.*, 183) and the Basilica Crepereia known from an inscription. Synagogues of basilican plan have been discussed by H. Kohl and C. Watzinger, *Antike Synagogen in Galiläa* (Leipzig, 1916); by E. L. Sukenik, *Ancient Synagogues in Palestine and Greece* (London, 1934); and by S. J. Saller, *A Revised Catalogue of the Ancient Synagogues of the Holy Land* (Jerusalem, 1969). Their dates, whether third or fifth century, are under discussion. For funerary basilicas, see Ch. G. Picard, *Civitas Mactaritana* (Paris, 1957), 96 ff.; W. Seston and Ch. Perrat, *Annales de Bordeaux (Revue des Études Anciennes)*, XLIX (1947), 139 ff.; and S. Bettini, in *Studi aquileiesi offerti a Giovanni Brusin* (Padua, 1953), 307 ff.

13. J. B. Ward Perkins, *P.B.S.R.*, IX (1954), 69 ff.

43. 14. *Itinerarium Burdigalense*, in P. Geyer, *Itinera Hierosolymitana* (*C.S.E.L.*, XXXVIII) (Vienna, 1889), 1 ff., and especially 23; Eusebius, *Life of Constantine* (*op. cit.*), 11, 51, and 111, 26. The terms used in Constantinian times for Christian cult buildings have been examined by L. Voelkl, *R.A.C.*, XXIX (1953), 49 ff., 187 ff., and XXX (1954), 99 ff., and, with special regard to North African usage, by F. J. Dölger, *J.A.C.*, VI (1950), 174 ff.

15. For the main lines of Constantine's building policy, see L. Voelkl, *Die Kirchenstiftungen des Kaisers Konstantin* (Cologne-Opladen, 1964); Krautheimer, *VII C.A.C. . . . 1965*, 237 ff.; G. T. Armstrong, *Church History*, XXXVI (1967), 1 ff. Regarding Constantine's part in creating the Christian basilica and the style of his church building, Krautheimer, *D.O.P.*, XXI (1967), 115 ff.

44. 16. K. Lanckoroński and G. Niemann, *Der Dom von Aquileia* (Vienna, 1906); C. Cecchelli, *La Basilica di Aquileia* (Bologna, 1933); G. Brusin, *Aquileia e Grado* (Aquileia, 1956). More recently the buildings have been re-studied by M. Mirabella Roberti, in *Studi in onore di . . . Calderini e . . . Paribeni* (Milan, 1957), III, 863 ff., and in *Studi aquileiesi offerti a Giovanni Brusin* (*op. cit.*), 209 ff.; by H. Kaehler, *Die spätantiken Bauten unter dem Dom von Aquileia* (Saarbrücken, 1957); and by S. Corbett in *R.A.C.*, XXXII (1956), 99 ff. Regarding the placing of altar and cathedra, see M. Mirabella Roberti, *R.A.C.*, XXVI (1950), 180 ff.; regarding the ceilings (with painted coffers), Deichmann, *loc. cit.* (Note 7 above).

45. 17. Examples are found along the Istrian coast at Pula (Pola), Poreč (Parenzo), Nesactium, Trieste, and Brioni, and in Carinthia at Hemmaberg and Hoischhügel. See R. Egger, *Frühchristliche Kirchenbauten im südlichen Norikum* (*J.Ö.A.I., Sonderhefte*, IX) (Vienna, 1916), with bibliography; B. Molajoli, *La basilica eufrasiana di Parenzo* (Padua, 1943); and G. C. Menis, *La basilica paleocristiana nelle diocesi settentrionali della metropoli d'Aquileia* (Vatican City, 1958). For the problem of twin cathedrals in general, see Krautheimer, *Studies*, 161 ff., esp. 176 ff., with bibliography.

18. Gsell, *Monuments*, II, 236 ff. The remnants are no longer visible, except for the mosaics, transferred to the modern church; G. Vidal, *Un témoin d'une date célèbre* (Algiers, n.d., *c.* 1940). The floor mosaic, according to Février and Duval (*VIII C.A.C. . . . Barcelona . . . 1969*, 24), dates from the late fourth century, and the inscription giving the date 324 would thus be the copy of an earlier one. It must remain undecided whether this latter refers to the church excavated in 1840 or to a lost predecessor. Until proven to

the contrary, I consider the former likely. J. Christern, *VII C.A.C. . . . Trier . . . 1956*, 407 ff., is in doubt whether the church had galleries; if so, he considers them original rather than added (see also Deichmann, *B.Z.*, LXV, 1972, 104). Since the *corpus delicti* is gone, the decision remains suspended; in any event, the evidence for galleries at Orléansville is scanty.

19. Eusebius, *Ecclesiastical History*, X, iv, 44 ff. (*L.C.L.*, II, 424 ff.); M. H. Shepherd, Jr, *Yearbook of Liturgical Studies* (1965), 73 ff.

20. The term for the Christian atrium derives from the Greek *aithrion* (an area under the open sky) rather than from the Latin *atrium*, the smoke-blackened main room of the Italic house.

46. 21. S. Corbett, *R.A.C.*, XXXII (1956), 99 ff., and Kaehler, *op. cit.* The function of the three halls is still under debate, although general consensus seems to incline towards viewing the south as the church proper. But it is still doubtful whether or not the transverse hall and the north hall, or one of the two, served for the withdrawal of the catechumens and others excluded from the Mass of the Faithful.

22. H. Sedlmayr, 'Spätantike Wandsysteme', *Bayerische Akademie der Wissenschaften, Philosophisch-Historische Klasse, Sitzungsberichte* (1958), Heft 7.

23. P. Lauer, *Le palais de Latran* (Paris, 1911). Regarding the excavations undertaken in 1934-8 and 1956-7, see E. Josi, *R.A.C.*, XI (1934), 335 ff.; J. B. Ward Perkins, *P.B.S.R.*, XXII (1954), 286 ff.; E. Josi, R. Krautheimer, and S. Corbett, *R.A.C.*, XXXIII (1957), 79 ff., and XXXIV (1958), 59 ff. For an attempt at reconstruction, see R. Krautheimer and S. Corbett, *R.A.C.*, XLIII (1967 [1968]), 125 ff., for the medieval alterations, R. Malmstrom, *ibid.*, 155 ff.

Regarding the chancel arrangement in Rome and the pathway leading to it (*solea*) - the one at the Lateran yet unpublished - see, in general, T. Mathews, *R.A.C.*, XXXVIII (1962, but published 1965), 73 ff.

49. 24. *L.P.*, I, 171; M. Teasdale Smith, *R.A.C.*, XLVI (1970), 149 ff.

25. *L.P.*, I, *ibid.*

26. The findings at Trier have been published by the excavator, Th. Kempf, from 1947 onward, most recently in *Neue Ausgrabungen in Deutschland* (Berlin, 1958), 368 ff.; *Germania*, XLII (1964), 126 ff.; *Frühchristliche Zeugnisse im Einzugsgebiet von Rhein und Mosel*, ed. Th. Kempf and W. Reusch (Trier, 1965), 209 ff.; *Das Münster*, XXI (1968), 1 ff. The preliminary character of the successive reports has led to occasional inconsistencies in the interpretation of the finds and the accompanying plans. For the mid- and late-fourth-century changes in Constantine's twin cathedral, see below, p. 90.

51. 27. Next to nothing is known of the cathedral in Constantine's new capital, Constantinople. It may have been a double church, a common precinct enclosing both an older sanctuary, dedicated to Holy Peace (Hagia Irene), and a new building farther south dedicated to Holy Wisdom (Hagia Sophia), presumably endowed by Constantine in his will but not completed until 360. This first H. Sophia burned down in 404. Rebuilt to an unknown extent and rededicated in 415, it was provided with a new propylaeum (see below, pp. 108-9; A. M. Schneider, *Die Grabung im Westhof d. Sophienkirche* . . . , *Istanbuler Forschungen*, XII, Berlin, 1941) of which the remnants were excavated in 1935. This church was finally replaced in 532-7 by Justinian's great church. Scanty contemporary references and a few fragments of foundation walls excavated below the pavement and the atrium of Justinian's church suggest that Constantine's church was a basilica provided with galleries and preceded by a propylaeum and atrium. Schneider, *B.Z.*, XXXVI (1936), 85, assigned the rear wall of the propylaeum to the first H. Sophia, a hypothesis later withdrawn by him (*Grabung*, 6 f., and note). But the fifth-century date assigned to the brick stamps found in the rear wall seems quite uncertain; with J. B. Ward Perkins (in D. Talbot Rice (ed.), *The Great Palace of the Byzantine Emperors, Second Report*, Edinburgh, 1958, 64), I still think it possible that the wall belongs to Constantine's atrium rather than to Theodosius II's rebuilding.

28. *Corpus*, I, 165 ff. I no longer distinguish two phases of rebuilding, dating from 350 and 400 respectively; instead, I see only one remodelling dating from between Helena's visit to the Holy Land in 325/6 and her death probably late in 329. The proposed reconstruction with longitudinal arcades linking the transverse arches into a square (F. W. Deichmann, *Frühchristliche Kirchen in Rom*, Basel, 1948, 31) founders on the lack of longitudinal counterthrust in the direction of the apse.

52. 29. *L.P.*, I, 181, and *Corpus*, II, 6, 115 f.

30. *Forschungen in Salona*, II (Vienna, 1926), 12 ff.; E. Dyggve, *History of Salonitan Christianity* (Oslo, 1951), 76 f. and figure IV, 12.

31. At Salona two such halls adjoining an open area have been excavated under the Anastasius basilica (*Forschungen in Salona*, III, Vienna, 1939, 6 ff.). Others have been found, e.g., in Vicenza, on the site of the later cemetery church of SS. Felice and Fortunato (Verzone, 1942, 39); at St Alban in Mainz (E. Neeb, *Mainzer Zeitschrift*, IV (1909), 34 ff.); and below the medieval cathedral of Xanten.

53. 32. The problem of the *coemeteria subteglata* has been taken up only in comparatively recent years. The one *ad catacumbas*, now the church of S. Sebastiano on the Via Appia, has been known in its original state since 1915 (P. Styger, *R.Qu.Schr.*, XXIX, 1915, 73 ff.; recently *Corpus*, IV, 99 ff., proposing a new reconstruction for the building as first laid out), but was looked upon as an isolated and unexplained phenomenon until further examples were found (see F. Tolotti, *La memoria degli apostoli*, Vatican City, 1953, *passim*): the covered cemetery at S. Agnese, first identified in 1946 by F. W. Deichmann, *R.A.C.*, XXII (1946), 1 ff. and further investigated by N. Perotti, *Palladio*, N.S. VI (1956), 80 ff.; the coemeterium of SS. Marcellino e Pietro at Tor Pignattara excavated in 1955 by F. W. Deichmann and A. v. Tschira (*J.D.A.I.*, LXXII, 1957, 44 ff.); the one at S. Lorenzo on the Via Tiburtina traced by R. Krautheimer and W. Frankl in 1957 (*Corpus*, II, 93 ff.). Another building of the type, yet unidentified, has come to light in the grounds of the Villa dei Gordiani on the Via Prenestina (G. Gatti, *Capitolium*, XXXV, June 1960, 3 ff.). The monuments known by 1958 were discussed in the light of fourth-century funerary custom and martyr cult by R. Krautheimer, *C.A.*, XI (1960), 15 ff.; also *idem, Studies*, 35 ff.

F.W. Deichmann, *R.M.*, LXXVII (1970), 144 ff., questions my interpretation of the structures under discussion as primarily covered cemeteries and funerary halls rather than regular churches. But he disregards my main arguments: covering of the floor by graves instead of pavement; lack of clergy of their own; no regular services; and location of the venerated tomb, as a rule, outside.

54. 33. *Recherches à Salone*, I (Copenhagen, 1920), 176 ff., and E. Dyggve, *Salonitan Christianity* (*op. cit.*), 77 ff. and figure IV, 26.

55. 34. Gsell, *Monuments*, II, 333, and L. Leschi, *Bull. Arch.* (1932), 422 ff.; N. Duval, *C.C.R.* (1970), 119 ff., esp. 127 ff.; P.-A. Février, *ibid.*, 191 ff.

35. The foundations and the bottom courses of apse, transept, and some of the westernmost portions of nave and aisles of St Peter's, as well as some fragments of columns, were uncovered in many years of excavations, thirty years ago. Published in *Esplorazioni* (see above, Chapter 1, Note 37), these remnants form the basis of any reconstruction, supplemented by old descriptions and by the numerous drawings and prints recording the building prior to its demolition between 1505 and 1612. Outstanding among these are the plan Uffizi *dis. arch.* 20, probably by Bramante (H. von Geymüller, *Die ursprünglichen Entwürfe für Sanct Peter*, Paris, 1875, plate 9); the detailed survey

of the column shafts by Baldassare Peruzzi (A. Bartoli, *Monumenti antichi nei disegni degli Uffizi*, Florence, 1914 ff., plate 164); the *vedute* of the church, particularly those by Marten van Heemskerck (H. Egger, *Römische Veduten*, I, 1911 (1931), plates 17 ff., and H. Egger and C. Hülsen, *Die römischen Skizzenbücher des Marten van Heemskerck*, Berlin, 1916, *passim*); finally, the minute description by Alfarano and his less reliable plan (M. Cerrati, ed., *Tiberii Alpharani De Basilicae Vaticanae . . . structura, Studi e Testi*, XXVI, Rome, 1914).

A reconstruction based on these and other elements has been worked out by Alfred Frazer in an unpublished Master's thesis, *A Graphic Reconstruction of Old St Peter's* (New York University, 1957). It wants revising on a number of points in the light of new suggestions made by Jongkees (*Studies on Old St Peter's*, Groningen, 1966), Bannister (*J.S.A.H.*, XXXVII, 1968, 3 ff.), Christern (*R.Qu.Schr.*, LXII, 1967, 133 ff., and LXIV, 1969, 1 ff.), and by Mr Frazer's and my own joint findings. The revisions have been incorporated into the reconstruction here presented [21, 22]. The entire question is taken up in *Corpus*, V (in preparation by myself and A. K. Frazer).

36. The years 319-22 are suggested as a *terminus post* by the temporary closing until 350 of a pagan sanctuary near by (Josi, *Rend. Pont. Accad.*, XXV/XXVI, 1949-51, 4 ff., and Guarducci, *ibid.*, XXXIX, 1967, 142 ff.); 324 is suggested as a *terminus ad quem* by the presence among Constantine's donations to the church of large numbers of estates in the eastern provinces, estates which became available to him only after his conquest of the East in 324 (Piganiol, *op. cit.*, 112 ff.). On the other hand, a donation made still by Helena, thus prior to 329, suggests previous completion of construction. Concomitantly an Imperial decree referring to the violation of graves prior to 333 may be linked to the destruction of the old necropolis. But contrary to W. Seston, *C.A.*, II (1947), 153 ff., who first linked the decree to St Peter's, and Kirschbaum, *op. cit.*, 151 ff., it constitutes, in my opinion, a *terminus ante*, not *post*, for the construction of the church and, possibly, for completion of the atrium.

The completion of the atrium prior to 396 and possibly by 333 is confirmed by a letter of Paulinus of Nola (*P.L.*, LXI, col. 213 ff.). The date of the nave murals in the pontificate of Leo I, 440-61, is suggested by the resemblance of the surviving copies to those reflecting the murals (likewise lost) from S. Paolo fuori le mura: the latter were plausibly assigned to Leo's pontificate by J. Garber, *Wirkungen der frühchristlichen Gemäldezyklen der alten Peters- und Pauls-Basiliken in Rom* (Berlin-Vienna, 1918), 27 f.

The numerous later remodellings affected decoration and furnishings rather than plan or structure of Constantine's church. The structural changes appear to have been limited to the raising of the north exedra to the height of the transept; the addition of a *cavetto* terminating the façade under Gregory IX (1227-41), who provided a new façade mosaic; the alteration of five round-headed into pointed windows in the apse, possibly under Innocent III (1198-1216), who donated the apse mosaic; and the insertion of Gothic tracery in the windows of nave and façade, perhaps also in the thirteenth, but more likely in the fifteenth century, when Nicholas V began extensive repairs on the old structure. The fourth-century façade and its mosaic are shown in an eleventh-century Farfa Codex, now at Eton College.

57. 37. See Paulinus of Nola as quoted above, Note 36.

38. R. Krautheimer, *Art Bulletin*, XXXI (1949), 211 ff. K. J. Conant, in reconstructing Constantine's St Peter's, proposed to keep the outer ends lower than the main part of the transept (*A Brief Commentary on Early Medieval Church Architecture*, Baltimore, 1942, plate 111), a suggestion now convincingly proven by Christern (see above, Note 35). Also Christern's further proposal to keep also the centre section of the transept lower than the nave has been confirmed, see *Corpus*, V, in preparation. Christern has also corrected the measurements of St Peter's as given in the first edition of the present volume, p. 35, lines 2 and 3, and I apologize for my mistake.

S. Alexander has rightly questioned whether Constantine's atrium of St Peter's, like that at Tyre, was already enveloped by a quadriporticus; indeed, the lateral porticoes were built shortly before 500.

39. J. C. M. Toynbee and J. B. Ward Perkins, *The Shrine of St Peter* (London, 1956), 200 ff. and figure 20.

58. 40. Regarding the main functions of the transept at St Peter's, see *ibid.*, 207 ff., and G. Forsyth, in *Late Classical and Medieval Studies in honor of Albert Mathias Friend, Jr* (Princeton, 1955), 56 ff.; regarding the differing types of transepts in Early Christian times, see Krautheimer, *Studies*, 59 ff., esp. 67 ff. The complexity of the problem has not always been fully understood; see F. W. Deichmann, *Ravenna*, I (Berlin, 1969), 58.

60. 41. R. Krautheimer, *Art Bulletin*, XXIV (1942), 1 ff. Exceptions to the rule are S. Paolo fuori le mura in Rome (see below, p. 91); perhaps S. Eusebio at Vercelli (P. Verzone, *L'architettura romanica nel . . . Vercellese*, Vercelli, 1939, 84 ff.); and the basilica of Manastirine at Salona, as remodelled and dedicated to St Peter about 400 (R. Egger, *Forschungen in Salona*, II, Vienna, 1926, 18 ff. and E. Dyggve,

Salonitan Christianity, op. cit., 79 and figure IV, 30).

42. J. W. Crowfoot, *Early Churches in Palestine* (London, 1941), *passim*, with bibliography; for the buildings in Jerusalem see also L. H. Vincent and F. M. Abel, *Jérusalem nouvelle*, II, 1 and 2 (Paris, 1925). A. Ovadiah, *Corpus of the Byzantine Churches in the Holy Land* (Bonn, 1970), sums up – not always impeccably – findings and older bibliography (henceforth quoted as Ovadiah, *Corpus*).

43. E. Mader, *Mambre* (Freiburg, 1957), interprets with a good deal of fancy the extraordinarily solid foundation walls found.

44. Regarding the Pilgrim of Bordeaux, see P. Geyer, *Itinera Hierosolymitana* (*C.S.E.L.*, XXXVIII) (Vienna, 1898). R. W. Hamilton, *Q.D.A.P.*, III (1934), 1 ff., E. T. Richmond, *ibid.*, V (1936), 75 ff., and W. Harvey, *Archaeologia*, LXXXVII (1937), 7 ff., report on the excavation of Constantine's church. B. Bagatti, *Gli antichi edifici sacri di Betlemme* (Jerusalem, 1952), has raised doubts regarding *inter alia* the existence of an opening into the grotto from the octagon; closed, it would have supported, in his view, the altar. The archaeological evidence, including traces of a canopy over the opening – appropriate in Constantinian eyes for a memoria rather than an altar – militates in favour of the traditional reconstruction. K. J. Conant's reconstruction proposal is found in his *Brief Commentary* (*op. cit.*, see above, Note 38), F. W. Deichmann's in *Die Religion in Geschichte und Gegenwart*, ed. K. Galling (Tübingen, 1959), III, figure 20, figure 3 (both with opaion in the roof of the octagon). For the date of the mosaic pavements, see L. H. Vincent, *Revue Biblique*, XLV (1936), 544 ff., and XLVI (1937), 93 ff. (late fourth century), and E. Kitzinger, in *Kyriakon, Festschrift Quasten* (Münster, 1970), II, 639 ff. (first half of the fifth century). The bi-partition of the steps at the end of the nave, half ascending to the octagon, half descending to the grotto, proposed by Bagatti, *op. cit.*, 47 ff., has been confirmed by Kitzinger, *op. cit.*, with reference also to the flanking pavement panels, one inscribed ICHTHYS.

62. 45. The standard work, Vincent and Abel, *Jérusalem nouvelle* (*op. cit.*), II, 1, gives an accurate survey of the remains known before 1920 and a full compilation of the documents referring to Constantine's building. This survey must now be supplemented by the new evidence presented for the Anastasis Rotunda by Fr. V. Corbo (see below, Chapter 3, Note 11) and by the results of excavations under way at the Constantinian basilica.

A preliminary summary of the fouth-century remains on Golgotha, as far as known by 1969 (Anastasis Rotunda, courtyard, atrium of Constantine's martyrium, and the rear wall of its apse) is presented by V. Corbo, *Liber Annuus*, XIX (1969), 65 ff. Mr T. Iconomopoulos, the architect in charge of restoring the Anastasis Rotunda and of supervising the excavation of the apse, has given a brief report on the find of the apse and of a colonnade behind it, skirting the eastern side of the Anastasis courtyard, in *La Terra Santa*, XLVII (1971), 107 ff. I am greatly indebted to Mr Iconomopoulos for providing me with a copy of the issue and with photographs of the finds and to Professor A. K. Orlandos, who kindly established the connexion. Constantine's rescript, dated 325/6 (the first edition of the present volume, p. 39, erroneously gave 328), and the description of the structures as in 336 are given by Eusebius, *Life of Constantine*, III, 26 ff. (*P.G.*, 1399 ff.); the names of the architects, Eustathios from Constantinople, and Zenobius, apparently a Syrian, are given by Prosper of Aquitaine (*P.L.*, LI, 576) and Theophanes (*Chronographia*, ed. De Boor, Leipzig, 1883, 33). The documentary evidence has been interpreted with great clarity by E. K. H. Wistrand, *Konstantins Kirche am Heiligen Grab . . .* (*Göteborgs Högskolas Arsskrift*, LVIII, 1952, 1). Attempts at graphic reconstructions of Constantine's buildings, based on Eusebius's description, are legion: Vincent and Abel, *op. cit.*; C. Schmaltz, *Mater Ecclesiarum* (Strasbourg, 1918); E. Dyggve, *Gravkirken i Jerusalem* (Copenhagen, 1941); K. J. Conant, *Speculum*, XXXI (1956), 1 ff.; Orlandos, *Basiliki*, 33; my own proposal in the first edition of the present volume (Figures 16 and 17); and many others. All are mistaken, as witness the recent finds both in the Anastasis Rotunda and at the martyrium. In particular, placing at the end of the basilica the hemisphairion as a three-quarter rotunda becomes impossible. Whatever the final reconstruction is, it will be different from those proposed on the basis of the literary sources alone.

63. 46. Dyggve, *op. cit.*, in Note 45.

66. 47. Regarding the mausoleum of S. Costanza, consult H. Stern, *D.O.P.*, XII (1958), 157 ff., with older bibliography; regarding that of St Helena, F. W. Deichmann, *J.D.A.I.*, LXXII (1959), 44 ff. The two mausolea adjoining St Peter's, both rotundas with eight niches and nearly equal in size, were destroyed in the sixteenth and eighteenth centuries respectively. The one attached to the south transept and later dedicated to St Petronilla was used about 400 for burials of the Honorian dynasty. The other mausoleum, known as S. Maria della Febbre, or S. Andrea, was apparently of early-third-century date (F. Castagnoli, *Rendiconti Pont. Accad. Romana*, XXXII, 1959-60, 97 ff.).

67. 48. The letter addressed to the bishops assembled at Mambre is quoted by Eusebius, *Life of Constantine*, II, 51 ff. (*P.G.*, XX, 1112 ff.); for the passage from

Constantine's address to the Council of Nicaea, see Gelasius Cyzicenus, *Ecclesiastical History*, II, 7, 13 (*P.G.*, LXXXV, 1232).

68. 49. H. Stern, as quoted above, Note 47.

50. Sedlmayr, 'Spätantike Wandsysteme', as quoted above, Note 22, has recently attempted a stylistic interpretation of Constantinian church building along similar lines, though within the framework of an all too rigid *Systematik*; see now also F. W. Deichmann, *B.Z.*, LIX (1966), 334 ff.

CHAPTER 3

72. 1. The classical spirit prevailing at the court in the fourth century has been set forth by A. Alföldi, *A Conflict of Ideas in the Late Fourth Century* (Oxford, 1952), and by J. Bidez, *Julien l'Apostat* (Paris, 1930).

2. R. Krautheimer, in *De Artibus Opuscula XL, Essays in Honor of Erwin Panofsky* (New York, 1961), 191 ff.

3. For the first church of the H. Sophia, see above, Chapter 2, Note 27.

4. Eusebius, *Life of Constantine*, IV, 58 ff. (*P.G.*, XX, 1209 f.). The attribution of the building to Constantius rather than to Constantine, as proposed by G. Downey, *D.O.P.*, VI (1951), 53 ff., is to me unconvincing; see Krautheimer, *Mullus* (*J.A.C., Erg. Bd.*, I, 1964), 224 ff. Equally unconvincing seems to me the reconstruction of Constantine's church either as an ordinary basilica (A. Heisenberg, *Grabeskirche und Apostelkirche*, Leipzig, 1908, II, 97 ff; still F. W. Deichmann, *B.Z.*, LV, 1972, 105) or as a basilica with colonnaded cross transept (H. Christ, *R.A.C.*, XII, 1935, 306 ff.). The texts of Eusebius and of Gregory of Nazianz (*P.G.*, XXXVII, 1258) as well as the filiations of the Apostoleion down to Justinian's structure strongly suggest the plausibility of a Greek-cross plan with arms of equal or nearly equal length for Constantine's church. For the (later) mausoleum, see R. Egger, *J.Ö.A.I.*, XVI (1913), 212 ff., and suggestively C. Nordenfalk, *Gazette des Beaux-Arts*, LXII (1963), 17 ff.

73. 5. R. Krautheimer, *Journal of the Warburg and Courtauld Institutes*, V (1942), 1 ff.

6. See below, *passim*. It has been questioned whether the Apostoleion in Constantinople was really the fountain-head of all churches on a cross plan or with cross transept (Deichmann, *loc. cit.*; Ph. Verdier, *A.J.A.*, LXXIII, 1969, 255 ff., esp. 256). As to the latter category, I have modified the all-too-general statement in the first edition of the present volume; as to the former, I stick to my guns.

75. 7. For the palaces at the hippodrome, see now

R. Naumann and H. Belting, *Die Euphemia Kirche . . . in Istanbul . . .* (Berlin, 1966); R. Naumann, *Ist. M.*, XV (1965), 135 ff.; R. Krautheimer, in *Tortulae* (*R. Qu. Schr., Suppl.* 30) (Rome-Freiburg, 1966), 195 ff., the latter two regarding the banqueting hall and related ones in Constantinople and Rome. For the Myrelaion palace, see R. Naumann, *Ist. M.*, XVI (1966), 199 ff., for the triumphal arch of Theodosius, R. Duyuran, *Istanbul Arkeoloji Müzeleri Yilliği*, VIII (1958), 25 ff., revising the former identification as tetrapylon. The botanical prototype of the 'tear drop' columns has been established by L. Koswig, *Ist. M.*, XVIII (1968), 259 ff.

76. 8. For the cisterns of Constantinople, see P. Forchheimer and J. Strzygowski, *Byzantinische Wasserbehälter in Konstantinopel* (Vienna, 1893), supplemented by A. M. Schneider, *Byzanz* (Berlin, 1938), *passim*, R. Janin, *Constantinople Byzantin* (Paris, 1964), 201 ff., and the yearly reports of N. Firatli, *Istanbul Arkeoloji Müzeleri Yilliği* (the Fildami cistern, *ibid.*, XV/XVI, 1969, 192). For the city walls see F. Krischen, *Die Landmauer von Konstantinopel*, I (*Denkmäler antiker Architektur, Archaeologisches Instituts des Deutschen Reiches*) (Berlin, 1938); B. Meyer-Plath and A. M. Schneider, *ibid.*, II (*Denkmäler . . .*, VIII) (Berlin, 1943); also R. Janin, *op. cit.*, 265 ff. For the walls of Salonica, O. Tafrali, *Topographie de Thessalonique* (Paris, 1913), 30 ff., and for a revised dating, 448–50, H. Koethe, *J.D.A.I.*, XLVIII (1933), 197 ff., M. Vickers, *Istanbul Arkeoloji Müzeleri Yilliği*, XV/XVI (1969), 313 ff., and G. Gounaris, *Makedonika*, XI (1971), 312 ff.; for those at Plovdiv, L. Botoucharova, *Latomus*, XLIX (1960), 183 ff.

9. F. W. Deichmann, *Studien zur Architektur Konstantinopels* (Baden-Baden, 1956), 56 ff.

77. 10. For Arculf's report and sketch-plan see Adamnanus, *De locis sanctis libri tres*, in P. Geyer, *Itinera Hierosolymitana* (*C.S.E.L.*, XXXVIII) (Vienna, 1898), 219 ff., esp. 270 ff.; H.-M. Schenke's proposal, *Z.D.P.V.*, LXXXI (1968), 159 ff., to view the arms as basilical wants more solid proof.

11. Much remains unclear in the Anastasis, beginning with the date of construction. Perhaps the structure was not yet built, or at least not yet completed, in 336, when Eusebius last visited Jerusalem. On the other hand, the sermons of Cyril of Jerusalem, *c.* 350, seem to have been delivered inside the building, and towards the end of the fourth century, Aetheria-Egeria reports seeing the rotunda (*Aetheriae peregrinatio*, Geyer, *op. cit.*, 71 ff.). Hence the Constantinian date proposed by Vincent and Abel, *op. cit.*, is possibly too early, while the sixth-century date suggested by Dyggve (*op. cit.*, in Chapter 2, Note 45), is certainly too late. Wistrand (see Chapter 2, Note 45) arrives

correctly perhaps at a date between 340 and 350.

A major rebuilding took place about 1045, financed by the Byzantine emperor Constantine IX Monomachos. The chevet extending eastward, and thus cutting off the façade of the rotunda, dates from the Crusaders' times, the early twelfth century. Finally, in 1811, the original supports were enclosed in heavy piers (they are now in part being removed) and the present dome was built.

Recent investigations by V. Corbo (summed up by him in *Liber Annuus*, XIX, 1969, 15 ff., with reference to his earlier publications) have clarified plan, design, and later rebuildings of the fourth-century structure, replacing earlier surveys (L.-H. Vincent and F.-M. Abel, *Jérusalem Nouvelle*, Paris, 1925, II, 1, *passim*; W. Harvey, *Church of the Holy Sepulchre*, London, 1935) and the reconstructions based thereon, including my own (first edition of the present volume, p. 50 and note 11; I apologize incidentally for the oversight, p. 50, line 10, where it reads 'diameter' instead of 'radius'). The plan, with centre nave and enveloping ambulatory, the latter terminated near the façade by rectangular spaces, survives as originally laid out; so do large parts of the outer walls at ground-floor and gallery level, the three apses off the ambulatory, and small parts of the façade. The three pairs of piers in the main axes have been found as well as a number of the ground-floor columns, though in fragmentary condition, enclosed in the clumsy piers built in 1811. The reconstruction of the plan, then, is certain, and I depart from Fr. Corbo's proposal only where the centre room adjoins the façade: the two eastward piers may have been missing, though not necessarily so, but certainly there were groups of three, rather than two, columns in that part of the building as well. A preliminary reconstruction proposal, perhaps overly elaborate, has been made by Fr. Ch. Coüasnon, *VII C.A.C. . . . Trier . . . 1965*, 447 ff. and plates ccxv-ccxxii.

The rebuilding at present under way, while unsatisfactory aesthetically, nonetheless is based in its main lines on such data as reliably provided by the finds and supplemented by descriptions and depictions supplied by visitors from the seventh to the eighteenth centuries, such as B. Amico, *Piante et imagini di Terra Santa* (Rome, 1609), reprinted with an English translation of the original text as *Plans of the Holy Land* (Jerusalem, 1953), and E. Horn, *Ichnographiae Terrae Sanctae* (1725-44), ed. H. Golubovich (Rome, 1902), and with English translation, ed. E. Hoade (Jerusalem, 1962). Thus the clumsy proportions of the column shafts, their material – pink stone – and their high dadoes with profiles and large crosses are ascertained for the original structure. The form of the fourth-century capitals is less certain, notwith-standing Horn's drawing (*op. cit.*, 69). Also, piers and columns from the outset must have carried arches, rather than an architrave; otherwise they would not reach the fourth-century level of the gallery.

The original design of the upper parts of the rotunda, on the other hand, is less certain. Eleventh-century masonry survives in the outer walls of the gallery and in the upper parts of the façade – the latter, incidentally, in recessed brickwork (see below, p. 375 f., and glossary). Thus the arcades of the gallery and their alternating supports may well date from that rebuilding. For the covering of the centre room we depend entirely on early pilgrims' reports and depictions such as those on the sixth- and seventh-century Monza ampullae and the seventh-century casket from the Sancta Sanctorum, now in the Vatican Museum (A. Grabar, *Les ampoules de Terre Sainte*, Paris, 1959; C. R. Morey, in *Festschrift Paul Clemen*, Bonn, 1926, 150 ff.); always keeping in mind early medieval habits of viewing a building (R. Krautheimer, *Warburg Journal*, as above, Note 5) and the possibility of later remodellings. Thus, the conical roof shown on all except the earliest views probably dates from 1048. Prior to that, the centre room was apparently surmounted by a dome, as shown on the Monza ampullae and on the Sancta Sanctorum casket. The dome may well have been wooden. The clerestory also existed in the seventh century, as witness these same depictions.

78. 12. Recent excavations (V. Corbo, *Ricerche archeologiche al Monte degli Ulivi*, Jerusalem, 1965, 93 ff.) have made obsolete the reconstruction proposed by Vincent and Abel, *op. cit.*, II, 1. Their compilation of the sources remains, of course, valid; see also Geyer, *op. cit.*, 246 ff. Reconstruction and dating of the finds still leave room for questions.

13. G. M. Fitzgerald, *Beth Shan Excavations* (*Publications, Palestine Section, Museum, University of Pennsylvania*, III) (Philadelphia, 1931), 18 ff. The ruins have meanwhile disappeared. An octagon church, composed of a (roofed?) centre room, ambulatory, and porches rose in the fifth century at Capernaum (Kefar-Nahum; Tell Hum) over what is believed to be the house of St Peter; see V. Corbo, *The House of St Peter at Capharnaum* (Jerusalem, 1969).

14. Vincent and Abel, *op. cit.*, II, 2, 805 ff., and R. Krautheimer, in *Arte del . . . primo millenio* (Turin, 1954), 26; but both reconstructions are hypothetical.

15. Krautheimer, *Warburg Journal* (*loc. cit.*, in Note 5), 1 ff.

16. Schneider, *Byzanz*, 1 ff., has published both the remnants of the church and a tentative reconstruction and has suggested the possible links to the Anastasis Rotunda.

79. 17. *Antioch on the Orontes*, I-IV, *passim* (quoted as

Antioch, I, II, etc.); see also G. Downey, *A History of Antioch* (Princeton, 1961).

18. *Antioch*, II, 5 ff.; Downey, *op. cit.*, 358.

80. 19. The principal sources for our knowledge of the octagon are: Eusebius, *Life of Constantine*, III, 50, and *Triakontaetirikos*, IX, 15; Malalas, *Chronographia* (*Bonn Corpus*, 318, 325, 429 f.); Evagrius, *Ecclesiastical History*, VI, 8 (*P.G.*, LXXXVI, 2, 2853 ff.); finally, the floor mosaic at Yakto (*Antioch*, I, 114 f.).

20. The first solution has been proposed by A. Birnbaum, *R.K.W.*, XXXVI (1913), 181 ff., the second by Wayne Dynes, *Marsyas*, XI (1964), 1 ff.; W. E. Kleinbauer, in his forthcoming book, *The Aisled Tetraconch*, proposes to view the structure as a tetraconch, recalling S. Lorenzo in Milan (see below, p. 82 and Chapter 3, Note 33). The term double-shell construction was formulated by W. MacDonald, *Early Christian and Byzantine Architecture* (New York, 1962).

21. A. Grabar, *Martyrium* (Paris, 1948), I, 214 ff.

22. W. Eltester, *Zeitschrift für neutestamentliche Wissenschaft*, XXXVI (1937), 251 ff.

23. Function, names, and symbolism of reception rooms – both centrally planned and others – in Imperial Roman palaces and their link to the cult of the Emperor have been frequently discussed during the last decades, in the first place by K. Lehmann-Hartleben, *Art Bulletin*, XXVII (1945), 1 ff.; by A. Boëthius, *B.S.A.*, XLVI (1951), 25 ff.; by H. P. L'Orange, *Symbolae Osloensés*, XXVII (1952), 114 ff., and in *Studi . . . Calderini e . . . Parimbeni*, III (Milan, 1956), 593 ff.; and by E. Baldwin Smith, *The Dome* (Princeton, 1950), and *Architectural Symbolism* (Princeton, 1956). The problem of centrally-planned palace churches and of both centrally-planned and triconch reception rooms in Roman palaces has been discussed with brilliance by I. Lavin, *Art Bulletin*, XLIV (1962), 1 ff.

81. 24. E. Dyggve, *Ravennatum Palatium Sacrum* (*Kgl. Danske Videnskabernes Selskab Archaeologisk Kunsthistoriske Meddedelser*, III, 2) (Copenhagen, 1941). While Dyggve was apt to over-interpret the symbolism of architectural elements or to misinterpret their function (the 'peristyle', e.g., as a 'basilica discoperta'; see below, Chapter 7, Note 30), I feel he was right in viewing the fastigium at Spalato as a glorification façade and assigning to both peristyle and rotunda ceremonial functions.

The discovery at Spalato of a flight of stairs descending from below the centre of podium and fastigium to the basement level has kindled doubts as to the function of peristyle, podium, and fastigium and their link, if any, to Imperial ceremonial. Both the rotunda and the huge hall behind have been explained as simple thoroughfares leading to the Imperial apartments, including an audience hall in one of the wings. Indeed, it is suggested that Diocletian, in retirement at Spalato, was no longer surrounded by Imperial ceremonial (N. Duval, *Bull. Antiqu. de France*, 1961, 76 ff., and *idem*, *Urbs*, 1961/2, 67 ff.; G. Francovich, *Il Palazzo di Teodorico*, Rome, 1971, only restates Duval's theses, though translated from the latter's scholarly and cautious argumentation into his very own bilious language). All told, though, I am not persuaded by Duval's conclusions, the more so since he himself admits the representative character of the focal grouping at Spalato. Nor can the glorifying meaning of the fastigium be denied as easily as is done by Francovich, *op. cit.*

The interpretation of architecture, Late Antique, Early Christian, or Medieval, in terms of symbolism and iconographic meaning has often overshot the mark, as witness Dyggve, *op. cit.*, E. Baldwin Smith, *Architectural Symbolism* (Princeton, 1956), and *idem*, *The Dome* (Princeton, 1950). However, the negative stance taken *a limine* by the critics (J. Christern, *Ist. M.*, XIII, XIV, 1963-4, 108 ff.; Francovich, *op. cit.*, *passim*) against any attempt at interpretation seems to me barren. Buildings in antiquity, as today, did use after all a vocabulary expressive of their function and their place in a social or religious hierarchy. To deny this means closing one's eyes to an element integral to any architecture.

25. Dio Cassius, *Roman History*, LXXVI (*L.C.L.*, IX), 60. Lehmann-Hartleben, in quoting the passage (*Art Bulletin*, as quoted above, Note 23), interpreted it as referring to a full dome rather than to the half-dome of an apse, obviously an equally valid explanation.

26. Lavin, *loc. cit.*

27. See, aside from the bibliography quoted in Note 23, A. Boëthius, *Nero's Golden House* (Ann Arbor, 1960).

28. Professors Deichmann and Stettler have promised for many years a full-scale publication of the Minerva Medica. At this point, see M. Stettler, *Jahrbuch des Römisch-Germanischen Zentralmuseums Mainz*, IV (1957), 123 ff., and A. Boëthius and J. B. Ward-Perkins, *Etruscan and Roman Architecture (Pelican History of Art)* (Harmondsworth, 1970), 508 ff. For previous bibliography, see E. Nash, *Pictorial Dictionary of Ancient Rome*, II (London, 1962), 127 ff.

29. The main sources for the Chrysotriclinos are Constantinus Porphyrogenetos, *De caeremoniis*, II, 15 (*Bonn Corpus*, II, 560, 586) and other passages as excerpted in Richter, *Schriftquellen*, 315 ff. See also J. Ebersolt, *Le grand palais de Constantinople* (Paris,

1910), 77 ff., and H. Fichtenau, *Mitteilungen des Instituts für Österreichische Geschichtsforschung*, LIX (1951), 1 ff.

82. 30. The definitive study prepared by the late E. Dyggve, together with H. P. L'Orange and H. Torp, awaits publication. At present, see E. Dyggve, in *Studia orientalia Johanni Pedersen* (Copenhagen, 1953), 59 ff.; idem, in *Acta Congressus Madvigiani Hafniae, MDMLIV* (sic) (Copenhagen, 1958), 353 ff.; and Boëthius and Ward-Perkins, *op. cit.*, 522 ff.

31. See Dyggve, *op. cit.* (1958), as quoted above. The date of the rebuilding and the mosaic decoration, *c.* 450 rather than 400, is suggested by M. Vickers, *Istanbul Arkeoloji Müzeleri Yilliği*, XV/XVI (1969), 313 ff., and *P.B.S.R.*, XXXVIII (1970), 183 ff., and accepted by W. E. Kleinbauer, *C.A.*, XXII (1972), 55 ff., and idem, *Viator*, III (1972), 27 ff.; however G. Gounaris, *Makedonika*, XI (1971), 311 ff., sustains the older thesis.

32. New surveys of extant and discoveries of previously unknown buildings during the decades 1950–70 permit us to gauge for the first time the importance of Milan as a prime centre of fourth- and fifth-century architecture. See the summary presentations by Verzone (1942) and A. de Capitani d'Arzago, *Architettura dei secoli quarto e quinto in Alta Italia* (Milan, *c.* 1948); more recently G. Traversari, *Architettura paleocristiana milanese* (Milan, 1964), the monographs listed in the subsequent Notes, and S. Ruffolo, *Riv. Ist. Naz. d'Archeologia e Storia dell'Arte*, XVII (1970), 5 ff.

33. A. Calderini, G. Chierici, and C. Cecchelli, *La basilica di S. Lorenzo Maggiore in Milano* (Milan, 1951), maintain a late-fourth-century date. The dates previously suggested, such as A. de Capitani d'Arzago in *VI C.E.B. . . . Paris . . . 1948*, II, 80: 390-408, Verzone (1942): mid fifth century, or yet later ones, can safely be dismissed; see also W. E. Kleinbauer, *Arte Lombarda*, XIII (1968), 1 ff., and D. Kinney, *J.S.A.H.*, XXXIV (1972), 92 ff., the latter convincingly suggesting a date between 352 and 375. The remnants of an atrium were discovered some years ago by M. Mirabella Roberti (*Studi . . . Carlo Castiglioni*, Milan, 1957, 473 ff.). J. B. Ward Perkins (*The Italian Element in Late Roman and Medieval Architecture, Annual Italian Lecture of the British Academy*, 1947) presents a clear and brilliant analysis of the style and construction of S. Lorenzo. The volume by Calderini, Chierici, and Cecchelli, while basic as a survey, requires cautious reading and makes evident the need of further study. See W. E. Kleinbauer, *The Aisled Tetraconch* (manuscript made available to me through the author's kindness).

84. 34. Verzone (1942), 82 f., was in doubt whether

to visualize the vault of the centre room as a brick dome or as a groin-vault. Ward Perkins and Calderini - Chierici - Cecchelli decided in favour of the latter. A timber dome or pyramid roof seems to me equally possible.

85. 35. Deichmann, *Studien* (*op. cit.*), 36. Regarding the function of S. Aquilino as a mausoleum rather than a baptistery, and its date, contemporary with S. Lorenzo, see D. Kinney, *Marsyas*, XV (1970-1), 13 ff.

86. 36. The documentary evidence for the Ambrosian church, including the lost inscriptions, is best found in A. K. Porter, *Lombard Architecture* (New Haven, 1915 ff.), II, 632 ff., to whom the fourth-century nucleus still contained within the Romanesque building was, of course, unknown. The original structure has been uncovered under the direction of Don E. Villa, who has published his findings in a number of papers, e.g. *Arte del primo millenio* (Turin, 1954), 77 ff. Plan, function, and symbolism of the church have been discussed by S. Lewis, *Art Bull.*, LI (1969), 205 ff., and idem, *J.S.A.H.*, XXVIII (1969), 83 ff. It remains in doubt whether the head piece of the church was originally provided with an apse or terminated in a straight wall. The archaeological evidence to me seems to favour the latter solution (see also Traversari, *op. cit.*, Note 32, 100 ff.), while Lewis, *J.S.A.H. (op. cit.)*, 89, considers the apse an original part of the structure. Likewise, the plan of the western portion of the nave and particularly the form of entrance and forecourt (?) are still in doubt.

37. For the North Italian cross-plan churches, see F. Tolotti in *Miscellanea Giulio Belvederi* (Vatican City, 1954-5), 369 ff.; for Como, specifically, Verzone, *Arte del primo millenio*, as in previous note, 28 ff.; for S. Croce in Ravenna, idem (1942), 9 f., and G. Bovini, *Felix Ravenna*, LX (1952), 44 ff.; for S. Stefano in Verona, Verzone (1942), 20 ff.

87. 38. The discovery of the fourth-century nucleus enclosed within the twelfth-century structure of S. Simpliciano is due to Edoardo Arslan, who has published his successive findings in *R.A.C.*, XXIII-XXIV (1947-8), 397 ff.; *Archivio Storico Lombardo*, N.S. X (1947), 5 ff.; *VII C.E.B. . . . Paris . . . 1952*, 15 ff.; *B.d.A.* (1958), 199 ff.; *Arte Lombarda* (1961), 149 ff. See also P. Verzone, *Arte del primo millenio*, 28 ff., and Traversari, *op. cit.* (as in Note 32), 111 ff. The walls recently found in front of the façade and along either flank at a distance of 7 m. from the body of the nave (Arslan, *Arte Lombarda, loc. cit.*) suggest either enveloping side chambers or corridors. Comparable rooms seem to have existed at S. Croce in Ravenna and at St Peter and Paul at Como. See also M. Mirabella Roberti, *VIII C.A.C. . . . Barcelona . . . 1969*, 127 ff.

39. L. Crema, in *Frühmittelalterliche Kunst in den Alpenländern* (Olten and Lausanne, 1954), 77 ff.; Traversari, *op. cit.*, 139 ff.

40. The discovery and subsequent first excavation of S. Tecla was due to the devoted energy of the late De Capitani d'Arzago. The results were published posthumously: A. de Capitani d'Arzago, *La chiesa maggiore di Milano* (Milan, 1952). The results of the re-excavation, directed by M. Mirabella Roberti, and the reconstruction of the plan, were published by him first in *Arte Lombarda*, VIII (1963), 77 ff., and more recently, with some revisions of his original proposals, in *Atti del Congresso sul Duomo di Milano*, I (Milan, 1969), 31 ff. The eastern parts of the church and the baptistery are accessible below the steps of the fourteenth-century cathedral.

89. 41. In the light of the 1960-2 excavations, the section on S. Tecla (first edition of the present volume, 58 ff.) has been thoroughly revised: the first structure *c*. 350 instead of third quarter of the century; the re-modelling, *c*. 400 instead of 450; the wings divided from the outset into two colonnaded aisles; their possible reconstruction from the first as tripartite transept wings. Likewise, the existence at the Lateran of a pathway leading to the chancel and the survival of this chancel type in Rome until at least the sixth century (for this latter, see T. Mathews, *R.A.C.*, XXXVIII, 1962 [1964], 73 ff.) required revising the relation of S. Tecla to the Eastern coastlands. Clearly, too, the tripartite transept of S. Pietro in Vincoli in Rome (*Corpus*, III, 178 ff., esp. 224 f.) is later than that of S. Tecla. Only the latter could thus be the fountain-head of the Greek representatives of the type; for this problem, see also Krautheimer, *Studies*, 59 ff., esp. the postscript, p. 67.

90. 42. Kempf, as quoted above, Chapter 2, Note 26. From the latest reports (*Germania*, XLII, 1964, 126 ff.; *Das Münster*, XXI, 1968, 1 ff.) it would seem that Gratian's rebuilding was preceded by two earlier remodellings of the earliest chancel of 326: a long basilical chancel which already enclosed the circular memoria and a structure much like Gratian's including the huge monolithic columns. For both a date prior to 353-6 is suggested by Th. Kempf. It seems best, though, to await the final publication.

43. For the findings at St Gereon in Cologne and the reconstruction of the fourth-century church, see A. von Gerkan, in *Spätantike und Byzanz* (*Neue Beiträge zur Kunstgeschichte des 1. Jahrtausends*, I, *Forschungen zur Kunstgeschichte und christlichen Archäologie*, I) (Baden-Baden, 1952), 91 ff.; and Stettler, as quoted above, Note 28.

91. 44. The archaeological and documentary evidence for the late-fourth-century basilica of S. Paolo and its mid-fifth-century repair is found in N. M. Nicolai, *La basilica di S. Paolo* (Rome, 1815); P. Belloni, *La basilica ostiense* (Rome, 1854); and particularly S. Pesarini, *Studi Romani*, I (1913), 386 ff., and *Dissertazioni Pontificia Accademia di Archeologia*, XIII (1918), 195 ff. F. W. Deichmann, *R.M.*, LIV (1939), 99 ff., presents a study on the capitals surviving from the fourth-century basilica. Of the Constantinian church, only a small piece of the foundation wall of the apse has been found. Otherwise the plan as suggested by Belloni and often reprinted is sheer fantasy. Nevertheless, G. Belvederi, *R.A.C.*, XXII (1946), 103 ff., has attempted, not too successfully, to reconstruct the aspect of the Constantinian building. The evidence for the second-century mausoleum below the high altar and the grave of St Paul has been newly sifted by E. Kirschbaum, *The Tombs of Saint Peter and Paul* (New York, 1960), 170 ff. But only an excavation - an unlikely project - could clarify the situation.

93. 45. Pesarini, *op. cit.*, 1918; also L. M. Martínez-Fazio, *La Segunda Basilica de San Pablo Extramuros* (Rome, 1972).

The murals in the nave were repainted about 1300 by Cavallini; see J. Garber, *Wirkungen der frühchristlichen Gemäldezyklen der alten Peters- und Pauls-Basiliken in Rom* (Berlin-Vienna, 1918), 27 f.

46. R. Krautheimer, in *Opuscula XL*, *op. cit.*, and, with postscript, in Krautheimer, *Studies*, 181 ff.; for the building of S. Maria Maggiore and its date, see *Corpus*, III, I, with bibliography; for the finds underneath, F. Magi, *Il Calendario dipinto sotto S. Maria Maggiore* (*Memorie Pont. Accad.*, XI) (Vatican City, 1972).

The building can be dated neither in the second century (J. P. Richter and A. C. Taylor, *The Golden Age of Classical Christian Art*, London, 1904), nor in the fourth, as proposed by P. Künzle, *R.Qu.Schr.*, LVI (1961), 1 ff., 129 ff. Technique of construction, style, and documentation preclude any date much before 432-40, the pontificate of Sixtus III, whose inscriptions mark the mosaic decoration as well, granted even that the foundation walls may have been laid as early as 420. Later changes in the structure are easily determined: the transept and the present apse were added in 1290; the aisle vaults and the coffered ceiling of the nave were inserted in 1460 and 1500 respectively. The number of windows was halved and the mosaics deprived of their original framing aediculas and flanking stucco colonnettes; the present capitals and bases date from 1734, but the original capitals were also Ionic; finally, the chapels, façade, and apse decoration

which encase the original structure date from the fifteenth to the eighteenth century.

94. 47. G. B. Giovenale, *Il Battistero Lateranense* (Rome, 1930), wants revising in the light of recent investigations and excavations, supervised by Professor F. Magi and, it is hoped, soon to be published. The octagonal outer wall as well as the huge font appear to date back (as I see it) to Constantine; the marble revetment applied to that wall and known from old drawings, and the blocking of some of the original lower windows, may date from the late years of Constantine or slightly after. Sixtus III (432–40) erected the colonnaded inner octagon surmounted by the upper order and clerestory; the lower columns apparently had been procured by Constantine for the angles of the outer octagon wall, but never used.

96. 48. *Corpus*, IV, 199 ff., with reference to bibliography, reconstruction proposals, and tentative explanations of the unusual plan. Of the two suggestions for envisaging the original structure, either with inner corridors and outer narrow courtyards linking the chapels (Krautheimer, *R.A.C.*, XII, 1935, 51 ff.; revised with postscript, *idem, Studies*, 69 ff.), or with inner open-air areas and outer porticoes, the latter has turned out to be correct in the light of still unpublished findings by Professor Ceschi; regarding the suggestion of a domed covering in light material for the centre room see F. W. Deichmann, *Miscellanea Giulio Belvederi* (Rome, 1955), 437 ff.; for the possible links to the Anastasis Rotunda, see Krautheimer, *loc. cit.*

49. For S. Angelo see D. Viviani, *B.d.A.*, V (1911), 28 ff., P. Verzone, in *Arte del primo millenio* (*op. cit.*), 28 ff., and G. De Angelis d'Ossat in *C.C.R.* (1966), 105 ff.

PART THREE:
THE FIFTH CENTURY

CHAPTER 4

97. 1. For the political and ecclesiastical history of the East, see G. Ostrogorsky, *History of the Byzantine State* (Oxford, 1956), *passim*. For the West, and in particular for the position of the papacy, I rely largely on E. Caspar, *Geschichte des Papsttums* (Tübingen, 1930 ff.).

98. 2. F. W. Deichmann, *Versuch einer Darstellung der Grundrisstypen des Kirchenbaues . . .*, diss. Halle-Wittenberg (Würzburg, 1937). For the architecture of the Greek East, we have the standard works of Sotiriou, *Basilikai*, and Orlandos, *Basiliki*. No comparable summary treatment exists for the other

regions of the Empire, except for individual provinces, such as Syria; see below, Chapter 6, Note 1.

3. For problems and types of martyria, see always the standard work, A. Grabar, *Martyrium* (Paris, 1948); for baptisteries, see the collection of plans (with short bibliographies) presented by A. Katchatrian, *Les baptistères paléochrétiens* (Paris, 1962). No satisfactory summary deals in general terms with the impact of the liturgy on the planning of ordinary churches in the fifth century – an extraordinarily difficult subject, as evident from its superficial treatment in C. Liesenberg, *Der Einfluss der Liturgie auf die frühchristliche Basilika* (Neustadt a.d. Haardt, 1928). Recent attempts to link liturgy and church building have been more successful by limiting the problem to clearly defined territories and periods: to Syria, see A. M. Schneider, *Göttinger Nachrichten* (1949), no. 3; to Rome, from the fourth to the early eighth centuries, see T. Mathews, *R.A.C.*, XXXVIII (1962, but published in 1965), 73 ff.; to Aquileia, G. Cuscito, *Aquileia Nostra*, XXXVIII (1967), 87 ff.; to Constantinople in the fifth and early sixth centuries, *idem, The Early Churches of Constantinople* (Pennyslvania University Park, and London, 1971) (henceforth, Mathews, *Churches*).

99. 4. For an attempt at differentiating the three principal transept types – 'continuous' transept, tripartite transept, and cross transept – and at determining their function, see Krautheimer, *Studies*, 59 ff., esp. 67 f.

For the rarity of 'continuous' transepts in the Latin West, see also above, Chapter 2, Note 41.

5. The changing functions of prothesis and diaconicon are discussed by Lassus, *Sanctuaires*, 194 ff., and by G. Bandmann, *Kunstgeschichtliche Studien für Hans Kauffmann* (Berlin, 1956), 19 ff.; those of the atrium and its parts by D. Pallas, *Epitiris*, XX (1955), 265 ff., especially 279 ff.

6. The orientation of Early Christian churches has been much discussed, but no common ground has been found so far. See, however, E. Weigand, *Festschrift Sebastian Merkle* (Düsseldorf, 1922), 370 ff., and E. Peterson, *Ephemerides liturgicae*, LIX (1945), 52 ff. Regarding the North African 'counter-apses' and 'counter-chancels', their dates and functions (these latter still doubtful), see N. Duval, *C.C.R.* (1970), 119 ff.; *idem, C.R.A.I.* (1969), 409 ff., esp. 419 ff.; and *idem, Sbeitla et les églises africaines à deux absides*, I, *Les églises de Sbeitla* (Paris, 1971).

100. 7. Katchatrian, *op. cit.*, for the various types of baptisteries; E. Dyggve, *V.C.A.C. . . . Ravenna*, 189 ff., for the function of the rooms attached to baptisteries; Krautheimer, *Studies*, 115 ff., for the links between baptisteries and mausolea.

8. No satisfactory publication sums up the problems and the various types of monastery building in Early Christian times. A. K. Orlandos, *Monastiriaki Architektoniki* (Athens, 1926; 2nd ed., 1958), an excellent survey, is focused on Middle Byzantine monastic architecture.

101. 9. Deichmann, *op. cit.*, as above, Note 2; Mathews, *Churches, passim.*

102. 10. Grabar, *op. cit., passim.*

103. 11. Krautheimer, *Studies*, 203 ff., with bibliography and postscript.

CHAPTER 5

105. 1. The standard works on the architecture of the Greek East are quoted above, Chapter 4, Note 2. For northern Greece and southern Yugoslavia, the catalogue part of R. F. Hoddinot, *Early Byzantine Churches in Macedonia and Southern Serbia* (London, 1963) (henceforth quoted as Hoddinot, *Churches*) provides a useful summary of the findings originally often published in Greek or Serbo-Croatian. For the church of the Acheiropoietos (formerly known as H. Paraskevi, prior to 1911 as Eski Djuma), see in addition: J. Ebersolt, H. Saladin, and M. Le Tourneau, *Les églises de Salonique* (Paris, 1916); S. Pelikanides, *Palaiochristianika Mnimeia tis Thessalonikis* (Salonica, 1949); and A. Xyngopoulos, *Makedonika*, 11 (1941–52), 472 ff. Orlandos, *Basiliki*, 121, figure 159, reconstructs the nave with a clerestory.

107. 2. Despite the excellent surveys of Gregory Dix (*The Shape of the Liturgy*, London, 1945) and J. M. Hanssens (*De missa rituum orientalium, Institutiones liturgicae de ritibus orientalibus*, 11, 111, appendix, Rome, 1930 ff.), the development of the liturgical ritual in the eastern coastlands is far from clear. The situation in Constantinople has been recently clarified by Mathews, *Churches.* In any event, it seems certain that the Lesser Entrance was originally the ceremonial entrance of the bishop into the church, and common to the entire Christian world. Not until the eighth century was it apparently assimilated into the procession of the gospel (Hanssens, *op. cit.*, 11, 10 ff.). Likewise, it seems certain that as early as 400 the Eucharistic elements were ceremonially (though silently) placed on the altar by the clergy (Dix, *op. cit.*, 118 ff., 282 ff.). While no procession is specifically mentioned, it is nevertheless clear that this transfer of the species to the altar anticipates the Great Entrance. Since the species were kept in the diaconicon, and since in the Aegean coastlands – and in Rome as well, although not in Syria – this room was apparently located off the atrium or off the narthex, during the transfer the

clergy must have passed through the entire length of the nave.

3. Chancel arrangement, altar, canopy, solea, and pulpit as employed in the Greek East in Early Christian times are discussed by Sotiriou, *Basilikai*, and Orlandos, *Basiliki, passim*, and for Constantinople, Mathews, *Churches, passim.*

108. 4. Orlandos, *Basiliki*, 235 ff., gives a summary of the building materials used in the Greek East. See also below, Note 9.

5. Standard works for the churches of Constantinople are, among older publications, Ebersolt and Thiers, *Églises*; Van Millingen, *Churches*; Schneider, *Byzanz*; Janin, *Églises*; and, recently, Mathews, *Churches*. W. Holz, *Byzanz Konstantinopel Istanbul* (Munich-Berlin, 1971) is a handy guide through the monuments; see, however, the review by H. Schäfer, *Architectura*, 11 (1971), 197 ff.

6. Schneider, and Ward Perkins, as quoted above, Chapter 2, Note 27.

109. 7. Van Millingen, *Churches*, 35 ff.; Ebersolt and Thiers, *Églises*, 3 ff.; Janin, *Églises*, 444 ff.; Schneider, *Byzanz*, 76 f.; Mathews, *Churches*, 19 ff. The extant remnants indicate the main lines of the original building. They are supplemented by a number of Texier's drawings in the Library of the R.I.B.A. in London (Sir Banister Fletcher Collection, Texier volumes, *Constantinople*, 1) and by the limited results of an excavation undertaken sixty-odd years ago (*Izvestija Russko Arkeol. Inst. K.*, XIV (1909), 36; XV (1911), 250; XVI (1912), 1 f.). Mathews, *loc. cit.*, presents reconstructions of atrium and bema and suggests that the galleries were entered over outside stairs flanking the narthex.

111. 8. Janin, *Églises*, 246 ff., sums up the historical data for the church of St Mary in the Chalkopratiae. The remnants, described briefly by Ebersolt and Thiers (*Églises*, 256) and Schneider (*Byzanz*, 56), have been explored by W. Kleiss (*Ist. M.*, XV, 1965, 149 ff.; *ibid.*, XVI, 1966, 217 ff.; *VII C.A.C. . . . Trier . . . 1965*, 587 ff.) and discussed by Mathews, *Churches*, 28 ff. Recalling the Studios church in nearly all respects except the octagonal niched structure on the north side (the interpretation as a baptistery seems to me still unlikely), it probably dates from the same time. Of the homonymous church in the Blachernai, only descriptions have survived, from Procopius (*Buildings*, 1, iii, 21) to the fifteenth century (Ruiz González de Clavijo, *Historia del Gran Tamerlan*, 1402, ed. F. López Estrada, *Embajada a Tamorlán*, Madrid, 1943; G. Mercati, *Memorie Pont. Accad. Rom.*, 1, 1923, 23 ff.; Richter, *Schriftquellen*, 164 ff.); see also J. Ebersolt (ed. A. Grabar), *Constantinople* (Paris, 1951); Schneider, *Byzanz*, 54 ff.; Janin, *Églises*,

169 ff. Our knowledge of H. Euphemia at Chalcedon is based only on Evagrius, *Ecclesiastical History*, 11, 3 (*P.G.*, LXXXVIII, 2, 2492 ff.). A small basilica of fifth-century date in the area of the Ottoman Imperial palace, Topkapi Sarayi, is known but from meagre excavation reports (Mathews, *Churches*, 33 ff.); remains of another, possibly early basilica (with tripartite transept?) have been reported from Eregli on the south coast of the Black Sea (S. Eyice, *C.C.R.*, 1971, 318 f.).

112. 9. The masonry techniques of fifth-century Constantinople and their antecedents have been studied with similar results by F. W. Deichmann, *Studien zur Architektur Konstantinopels* (Baden-Baden, 1956), 19 ff., and J. B. Ward Perkins, *Great Palace* (as quoted above, Chapter 2, Note 27), 52 ff.

10. Orlandos, *Basiliki*, *passim*, and numerous papers in *Praktika*, *Ergon*, *Archeion*, and *V C.A.C. . . . Aix-en-Provence . . . 1954*, *passim*.

11. For the revised plan of the Epiphanius basilica, see A. H. S. Megaw, *J.H.S.*, LXXV (1956), 29 ff., and *idem*, XI *C.E.B. . . . Munich . . . 1958*, *Akten* (1960), 345 ff.

12. J. Keil and H. Hörmann (*Forschungen in Ephesos*, IV, 3, ed. Österreichisches Archäologisches Institut, Vienna, 1951, 200 ff.) have attempted, successfully in the main, to present a reconstruction of the fifth-century church of St John.

114. 13. *Forschungen in Ephesos*, IV, 1 (Vienna, 1932), 5, 27 ff.; F. Fasolo, *Palladio*, n.s. VI (1956), 1 ff. Keil, the editor of *Forschungen*, IV, 1, gives no reasons for suggesting a date as early as 350 for the remodelling of the second-century structure into a church. Nor is there any proof for the dedication of this church to the Virgin prior to 431. About 500, a domed church took the place of the earlier nave (*Forschungen*, *op. cit.*, 51 ff.). The chancel part of the early church was occupied in the seventh or eighth century by a small basilica on piers (*ibid.*, 63 ff.). Fasolo, *op. cit.*, attempts to replace this hypothesis of an abrupt sequence by proposing a slow succession of construction phases.

14. Examples are Mastichari (Cos) (*Ergon*, 1955, 98), Didyma (T. Wiegand, ed. H. Knackfuss, *Didyma*, I, Berlin, 1941, 29 ff.), Curium on Cyprus (A. H. S. Megaw, XI *C.E.B. . . . Munich . . . 1958*, *Akten*, 1961, 345 ff.).

15. For example, at Eressos on Lesbos, *c.* 431 (A. K. Orlandos, *Deltion*, XIII, 1929, 29 ff.); at the Heraeon basilica on Samos (A. M. Schneider, *J.D.A.I.*, *A.A.*, 1927, 399 ff.); at Arnithi on Rhodes (A. K. Orlandos, *V C.A.C. . . . Aix-en-Provence . . . 1954*, 115); and finally, at Curium, as quoted in previous note.

16. Examples, apart from Mastichari, are found, e.g., at Gülbahçe near Izmir (known through G. Weber,

B.Z., X, 1901, 568 ff.) and at Chalinados on Lesbos (A. K. Orlandos, *Archeion*, III, 1937, 115 ff.).

17. Wiegand (*op cit.*, as above, Note 14, 29 ff.) has suggested a reconstruction with galleries for the church which at Didyma was inserted in the Temple of Apollo after 392. But the piers with double half-columns on which this reconstruction is based were probably window piers; see above, p. 105.

18. A. K. Orlandos, *V C.A.C. . . . Aix-en-Provence . . . 1954*, 199 ff., reports on the baptisteries found in the Dodecanese: the one at Mastichari, and six others on Cos, five on Rhodes, e.g. at Arnithi (see also above, Note 15), and numerous others. Wiegand has published the baptistery at Miletus (*Sitzungsberichte der Preussischen Akademie der Wissenschaften, Phil.-hist. Klasse*, 1904, 87 f.), Weber the one at Gülbahçe (see above, Note 16). Cf. also A. Katchatrian, *Les baptistères paléochrétiens* (Paris, 1962), *passim*.

19. The church ruins of Cilicia and Isauria were explored first by G. M. L. Bell and published in a series of papers in *Rev. Arch.* (1906), I and II. She was followed by S. Guyer (*B.Z.*, XXXIII, 1933, 78 ff., 313 ff.; also *Grundlagen mittelalterlicher europäischer Baukunst*, Einsiedeln, 1950, *passim*), who with E. Herzfeld published *Meriamlik und Korykos* (*Monumenta Asiae Minoris Antiqua*, II) (Manchester, 1930), and by Keil (J. Keil and A. Wilhelm, *Denkmäler aus dem Rauhen Kilikien, Monumenta . . .*, III, Manchester, 1931). More recent reports are due to G. Forsyth (*D.O.P.*, XI, 1957, 223 ff., and *De Artibus Opuscula XL in honor of Erwin Panofsky*, New York, 1961, 117 ff.), to M. Gough, *Anatolian Studies*, II (1952), 85 ff.; IV (1954), 49 ff.; VII (1957), 153 ff.; to E. Rosenbaum, G. Huber, S. Onurkan, *A Survey of Coastal Cities in Western Cilicia* (Ankara, 1967); and to O. Feld, *Ist. M.*, XIII/XIV (1963/4), 82 ff., and *R. Qu. Schr.*, LX (1965), 131 ff.

115. 20. The few hints published so far on the ruins of Side (S. Eyice, X *C.E.B. . . . Constantinople . . . 1955*, 130 ff.) only whet the appetite. On the cathedral of Korykos see, aside from Bell, *Rev. Arch.* (1906), II, 7 ff., Herzfeld and Guyer, *op. cit.*, 94 ff., and with revisions, G. Forsyth, *D.O.P.*, XI (1957), 223 ff. The date given in the pavement mosaic has been read as 429-30 (Herzfeld and Guyer, *op. cit.*, 108), 533 (A. M. Schneider, as quoted by Kautzsch, *Kapitellstudien*, 93), and 629-30 (G. Downey, as quoted by Forsyth, *op. cit.*, 137, note 32). Some basilicas in Crete represent the same type: two near Chersonesos, see *Ergon* (1955), 109 f.; *ibid.* (1956), 118 f.; *ibid.* (1959), 120 f., and one at Kera, *ibid.* (1956), 119; a third at Panormos is provided with a tripartite transept, *Praktika* (1945-8), 112 ff., a type possibly imported from Epirus (see below, pp. 137-8). M. Gough, after cleaning, excavat-

ing, and exploring the ruins of Alahan Manastir, has published the results in successive reports in *Anatolian Studies*, from XII (1962) through XXII (1972), and summed them up in *Bulletin, Metropolitan Museum of Art* (1968), 455 ff. P. Verzone, *Alahan Monastir* (Turin, 1954), published prior to cleaning, is outdated. Gough's date for the basilica, mid fifth century, seems somewhat early.

21. On Meriamlik, see Herzfeld and Guyer, *op. cit.*, 4 ff.; Kautzsch, *Kapitellstudien*, 88, on the basis of the capitals, favours a date around 480.

22. G. M. L. Bell, *Rev. Arch.* (1906), I, 306 ff., and G. Forsyth, *De Artibus Opuscula XL*, as quoted above, Note 19.

116. 23. H. Rott, *Kleinasiatische Denkmäler* (Leipzig, 1908), 46 ff., still offers the only plans and illustration published so far.

24. See below, pp. 117-19 and 132-5.

25. Herzfeld and Guyer, *op. cit.*, 110 f.; Kautzsch, *Kapitellstudien*, 89; G. Forsyth, *D.O.P.*, XI (1957), 223 ff.

26. Forsyth, as quoted above, Note 19. For the numerous other ruins extant at Kanlidivane, see G. M. L. Bell, *Rev. Arch.* (1906), I, 404 ff.

117. 27. The church ruins of Sagalassos are still known only through the publication in Rott, *op. cit.*, 14 ff., those at Side through Eyice, *op. cit.*

28. See below, p. 291.

29. C. M. Kaufmann, *Die Menasstadt* (Leipzig, 1910), has to be revised. An excavation campaign directed successively by H. Schläger (*M.K.*, XIX, 1963, 114 ff.; *ibid.*, XX, 1965, 122 ff.), M. Müller-Wiener (*ibid.*, XX, 1965, 126 ff.; *ibid.*, XXI, 1966, 171 ff.; *ibid.*, XXII, 1967, 206 ff.) and P. Grossmann (*ibid.*, XXVI, 1970, 55 ff.) has clarified the phases of construction, the layout of the buildings, and their dates – the main phase dating from the reign of the Emperor Zeno (476-91), not as formerly believed 412. H. Schläger, in *Christentum am Nil*, ed. K. Wessel (Recklinghausen, 1964), 158 ff., provides a summary.

118. 30. See below, p. 167.

119. 31. J. B. Ward Perkins, *Bull. Soc. d'Archéol. Copte*, XI (1943), 123 ff.; R. Goodchild, *Kyrene und Apollonia* (Zürich, 1971), 183, 187 f.

120. 32. A. Wace, A. H. S. Megaw, T. C. Skeat, S. Shenouda, *Hermopolis Magna, Ashmunein* (Alexandria, 1959).

121. 33. V. de Bock, *Matériaux pour servir à l'archéologie chrétienne de l'Égypte* (St Petersburg, 1901); Somers Clarke, *Christian Antiquities in the Nile Valley* (Oxford, 1912); U. Monneret de Villard, *Les couvents de Sohag* (Milan, 1925); E. Kitzinger, *Archaeologia*, LXXXVII (1938), 181 ff.; H. G. Evers and R. Romero, in *Christentum am Nil* (as Note 29), 175 ff., with new

surveys of the White and Red Convent. The proposal to reconstruct the naves as unroofed *basilicae discopertae* seems to me as untenable as the one to derive the plan from that of Egyptian temples.

122. 34. Kitzinger, *op. cit.*, 191, note 4.

35. For the church complex at the grave of St Felix at Cimitile (Nola), see below, pp. 207-8, and Paulinus's descriptions in his letters (*Paulinus' Churches at Nola*, ed. R. C. Goldschmidt, Amsterdam, 1941).

124. 36. Paulinus as quoted in previous Note.

37. See above, Notes 33 and 34.

38. A glance at Somers Clarke, *op. cit.*, or Monneret de Villard, *op. cit.*, will provide numerous examples, such as the churches at Denderah, Erment (Armant), Deir Abu Hennes, or Deir Bagarah. However, both the chronology of Christian architecture in Egypt and the successive construction phases of individual buildings require further study; see also P. Grossmann, *M.K.*, XXIV/XXV (1969), 144 ff., and *R.L.B.K.*, I, 61 ff.

39. Kitzinger, *op. cit.*; see also below, pp. 321-3.

40. Both Sotiriou, *Basilikai*, and Orlandos, *Basiliki*, present good surveys of the monuments of Early Christian Greece known at this point, supplemented by the numerous papers published in *Ephemeris, Deltion, Praktika, Epitiris*, and *Archeion*. The brief reports annually published in *Ergon* keep the reader informed about new finds. A general history of Early Christian architecture in Greece is still wanting, despite the brilliant beginning made by E. Kitzinger, *D.O.P.*, III (1946), 134 ff., to establish a chronology of the churches based on the development of their floor mosaics. The absence of churches inside Athens prior to 450 has been demonstrated by J. Travlos, *Poleodomiki Exelixis tōn Athinōn* (Athens, 1960), 135 ff. Regarding the ecclesiastical links to Rome and Milan, see E. Caspar, *Geschichte des Papsttums* (Tübingen, 1930), I, 309 f.

125. 41. Sotiriou, *Basilikai*, 198 ff., Orlandos, *Basiliki*, *passim*, both with bibliography.

126. 42. The original aspect of the Ilissos basilica is unclear as its date. G. Sotiriou, *Ephemeris* (1919), 1 ff., assumed a date about 400 and envisaged a dome over the crossing. M. Chatzidakis, *C.A.*, V (1951), 61 ff., and following him, Orlandos, *Basiliki*, 186, incline towards reconstructing a pyramidal roof over the crossing, and towards a date *c.* 500. Our own dating, about 400 and not after 450, has been kindly confirmed by Mr Kitzinger, based on the style of the mosaics.

43. M. Sisson, *P.B.S.R.*, XI (1929), 50 ff., has published an architectural survey of the tetraconch, but history and function remain in doubt. J. Travlos, *Praktika* (1950), 41 ff., saw it as a lecture hall; but,

notwithstanding his stress on the absence of churches inside the city before 450, he identified it as a church in *Poleodomiki Exelixis tōn Athinōn* (see Note 40), 139. The inscription placed in 401-2 on the entrance by the sophist Plutarch in honour of the Governor Herculios does not suggest an ecclesiastical function for the building complex; see E. Weigand, *B.Z.*, XXXIII (1933), 151 f., and, with new good reasons, A. Frantz, *VII C.A.C. . . . Trier . . . 1965*, 527 ff.

127. 44. E. Stikas, *Praktika* (1951), 53 ff.; (1952), 73 ff.; (1954), 14 f.

128. 45. A tripartite-transept plan occurs at the same time at Daphnousion; Sotiriou, *Basilikai*, 207 ff., with bibliography.

130. 46. Sotiriou, *Basilikai*, 15 ff.; see also Kautzsch, *Kapitellstudien, passim*. The gradual shift in the Greek churches of the diaconicon from the entrance side to the flank and finally near the apse has been discussed by A. K. Orlandos, *Deltion Christianikis Archaiologikis Hetairias*, ser. IV, 4 (1964), 353 ff.

131. 47. For the cathedral at Stobi, see R. Egger, *J.Ö.A.I.*, XXIV (1929), 42 ff.; E. Kitzinger, *D.O.P.*, III (1946), 81 ff.; Hoddinot, *Churches*, 161 ff. Based on a study of the capitals, I. Nikolajević-Stojković, *La décoration architecturale sculptée de l'époque bas-romaine en Macédoine, en Serbie, et au Monténégro* (Belgrade, 1957) (in Serbian with French résumé) had already suggested a mid-fifth-century date. Recent studies (D. Bošković, *Charistirion eis A.K. Orlandon*, IV, Athens, 1965, 484 ff.) and excavations in progress (J. Wiseman and D. Mano-Zissi, *A.J.A.*, LXXV, 1971, 395 ff.) have confirmed the existence of two churches superimposed and dating from the mid fifth and sixth centuries respectively. Other colonnaded basilicas in Stobi are the so-called synagogue - apparently a late-fourth- or early-fifth-century church and not a synagogue (Kitzinger, *op. cit.*, 129 ff.; Hoddinot, *Churches*, 179 ff.; Wiseman and Mano-Zissi, *op. cit.*, with the present earlier, if provisional date); a basilica with a quatrefoil baptistery attached (Hoddinot, *op. cit.*, 168 ff.); and a cemetery basilica (*ibid.*, 167 f.; Wiseman and Mano-Zissi, *op. cit.*). Other churches of the type are numerous in Bulgaria and Rumania. They abound in Tropaeum (near Custantza, Rumania), Odessos (Varna), Hisar Bania (Hisarja, Hisar - Momina Banja), and elsewhere on the Black Sea coast (V. Ivanova, *I.B.A.I.*, x, 1935-6, 2, 211 ff., and XI, 1937, 214 ff.; E. Condurachi, *Ephemeris Daco-Romana*, IX, 1940, 34 ff.; and Académie bulgare, Institut d'Archéologie, *Serdica*, Sofia, 1964). Those in Yugoslavia are collected in A. Deroko, *Architecture in Medieval Serbia* (Belgrade, 1953), and Hoddinot, *Churches, passim*. The supports

frequently are piers; we list Suvodol, Radolište, and Prokuplje (Hoddinot, *op. cit., passim*).

48. Towers were possibly found at Bukhovo, see V. Ivanova, *V C.E.B. . . . Sofia . . . 1936 = I.B.A.I.*, x (1936), 253 ff.; lateral sacristies at Deli Dyška, *idem*, *R.i.P.* (1949), 65 ff.

132. 49. The basic monograph, G. and M. Sotiriou, *Hi basiliki tou Hagiou Dimitriou tis Thessalonikis* (Athens, 1952), presents the findings and surveys made during the rebuilding in the 1930s and 40s. The authors correctly distinguish the original parts of the structure from those rebuilt in the seventh century. In my opinion, though, they somewhat overestimate the extent of that rebuilding. In particular, I cannot agree either with their attribution of the alternation of supports in the nave arcade to the seventh century or with their contention that the original nave arcade was composed only of columns. Indeed, unless the columns were all shifted in the seventh-century reconstruction, the rhythm of piers and columns must go back to the fifth-century plan.

As the date of construction, the Sotirious propose, p. 246 f., the decade 460-70 instead of 412-13, as previously accepted. (In the first edition of the present volume, p. 328, note 49, I had misread their dating.) This coincides with the dating of the surviving capitals by Kautzsch, *Kapitellstudien*, 72 ff., and E. Kitzinger, *D.O.P.*, III (1946), 63. Recently, R. S. Cormack, *B.S.A.*, LXIV (1969), 17 ff., arrives at a date near the end of the fifth century, while W. E. Kleinbauer, *Byzantion*, XL (1970), 36 ff., proposes the third quarter or even the mid fifth century. None of this precludes, though, that the late-fifth-century church was preceded by an earlier one, possibly the one founded by the governor Leontios in 412-13. Might not the apse excavated below the end of the present nave be a remnant of that church, rather than of a Roman structure, as suggested by the Sotirious?

The rebuilding as it stands differs from the reconstruction proposed by the Sotirious and on which our isometric view, illustration 79, is based.

135. 50. P. Lemerle, *Philippes et la Macédoine orientale* (Paris, 1945), with its careful surveys of Basilicas A and B (see below, pp. 266-7; also Hoddinot, *Churches*, 169 ff., 188 ff.) is supplemented by S. Pelikanides, *Ephemeris* (1955), 114 ff. (cemetery basilica, late fourth century; also Hoddinot, *Churches*, 99 ff.) and by successive reports on the octagon church published from 1958 to 1969 in *Praktika* and *Ergon*. In 1963, below the marble floor of the octagon, an older church with a splendid mosaic pavement was discovered, possibly a basilica (its atrium was incorporated in the complex of the octagon); coins found on the pavement

suggest a date after, though not too long after, 408 (*Ergon*, 1963, 57). The octagon and its related structures, thus, might date either from the late fifth or early sixth century. For Thasos see A. K. Orlandos, *Archeion*, VII (1951), 1 ff., who assigns to the same group of cross churches the original timber-roofed church of the Katapoliani (Hekatontapyliani) on Paros (*VI C.A.C. . . . Ravenna . . . 1962*, 159 ff.; *Epitiris Hetairias Kykladikōn Meletōn*, V, 1965, 19 ff.), preceding the present sixth-century structure on the same plan; for Tropaeum, Ivanova, as quoted above, Note 47.

137. 51. A. Frolow, *Bull. Byz. Inst.*, I (1946), 14 ff.; J. D. Panaiatova, *Chervenata crkva pri Peruštica* (Sofia, 1956).

52. A. Choisy, *L'art de bâtir chez les Byzantins* (Paris, 1883), 131 f.; N. Mavrodinov, *VI C.E.B. . . . Paris . . . 1948*, 11, 286 ff. At Ohrid another tetraconch has recently come to light, presumably of late-fifth-century date; see G. Babić, *Zb. R.*, XIII (1971), 263 ff., D. Koćo, *Annuaire Faculté de Philosophie Skopje* (1967), 257 ff.

138. 53. Sotiriou, *Basilikai*, sums up the findings in Basilicas A and B with reference to the original excavation reports, while E. Kitzinger, *D.O.P.*, VI (1951), 83 ff., arrives at the dating we accept for Basilicas B and A, based on the chronology of the mosaics. Two more basilicas have been found meanwhile; see *Ergon* (1956), (1959), (1961), (1962); and D. Pallas, in *R.A.C.*, XXXV (1959), 197 ff.

54. Preliminary reports have been published successively by the excavator, D. Pallas, in *Ergon* from 1956 to 1961, in *Praktika* from 1956 to 1965; *Ergon* (1961), 141 ff., gives a final plan of the complex of buildings including the baptistery and a tetraconch martyrium (?), and the date 450-60 for the church, 518-27 for the atrium - correctly I think, instead of the sixth-century date previously assigned to the entire complex.

CHAPTER 6

143. 1. The inland architecture of the Near East is comparatively well known. Syria in particular has been extensively treated in numerous publications: C. J. M. de Vogüé, *La Syrie centrale* (Paris, 1865 f.); H. C. Butler, *Architecture and other arts, Part II of the Publications of an American Archeological Expedition to Syria, 1899-1900* (New York, 1903); *idem, Publications of the Princeton Archeological Expeditions to Syria in 1904-05 and 1909, Part II, Architecture, sections A and B* (Leyden, 1910 ff.); *idem* (ed. E. Baldwin Smith), *Early Churches in Syria* (Princeton, 1929); J. Lassus,

Sanctuaires chrétiens de Syrie (Paris, 1947). An admirably broad picture of secular and ecclesiastical building in the economic and cultural context of northern Syria is provided by Tchalenko, *Villages*. The monuments of Asia Minor have been published by J. Strzygowski, *Kleinasien* (Leipzig, 1904); H. Rott, *Kleinasiatische Denkmäler* (Leipzig, 1908); W. M. Ramsay and G. L. Bell, *The Thousand and One Churches* (London, 1909); and S. Guyer, *Grundlagen mittelalterlicher abendländischer Baukunst* (Einsiedeln-Zürich-Cologne, [1950]). All are out of date, and both Strzygowski's and Guyer's are loaded in favour of pet theories; but even they, not to mention the splendid factual reports of Rott and Bell, provide material since lost. For more up-to-date information, see numerous papers in *Anatolian Studies*, *B.Z.*, and elsewhere to be quoted below. For Palestine, see J. W. Crowfoot, *Early Churches in Palestine* (London, 1941), numerous papers in *Q.D.A.P.*, *P.E.F.Q.St.*, *Z.D.P.V.*, *Oriens Christianus*, *Israel Exploration Journal*, and the summaries in Ovadiah, *Corpus* (see above, Chapter 2, Note 42).

For a view opposite to my own regarding the place of the inlands of the Near East within the overall framework of Early Christian architecture, see F. W. Deichmann, *B.Z.*, LXV (1972), 102 ff., but also my reply, *ibid.*, 441 ff., and his answer, *ibid.*, 448 ff.

2. Lassus, *Sanctuaires*, 262 ff.; and Tchalenko, *Villages, passim*, for the village organization in general, and for a list of village masons.

144. 3. The letter is published, for instance, in *P.G.*, XLVI, 1093 ff.; for its interpretation, see Strzygowski, *op. cit.*, 71 ff., and A. Birnbaum, *R.K.W.*, XXXVI (1913), 181 ff.

145. 4. Strzygowski, *op. cit., passim*; Guyer, *op. cit.* (Note 1).

5. Guyer, *op. cit., passim*, and *idem*, *Zeitschrift für Schweizerische Archäologie und Kunstgeschichte*, VII (1945), 73 ff., with regard to cross churches. H. Schaefer, *Art Bulletin*, XXVII (1945), 85 ff. has discussed the possibilities of the origins of the Romanesque twin-tower façade. The entire question has been brilliantly posed by E. Weigand, *B.Z.*, XXVII (1927), 149 ff., in a critique of its superficial treatment by H. W. Beyer, *Der syrische Kirchenbau* (Berlin, 1925).

6. Tchalenko, *Villages*, I, 55 ff.

146. 7. For the houses, villas, and their mosaic floors, see *Antioch*, I, II, and III, *passim*.

8. *Antioch*, III, 35 ff. For Antioch-Ma'chouka see Lassus, *Sanctuaires*, 229 f. and plate XLI, 2. Other basilicas are found at Ba'albek (Th. Wiegand, *Baalbek*, II, Berlin-Leipzig, 1923, 130 ff.) and Palmyra (Lassus, *op. cit.*, 168).

147. 9. For the tetraconch at Apamea, see F. Mayence, *Bulletin des Musées Royaux de Bruxelles*, VII (1935), 2 ff.; for Aleppo, S. Guyer, *Bulletin de l'Institut Français d'Archéologie Orientale*, XI (1915), 217 ff., and M. Écochard, *Syria*, XXVII (1950), 270 ff.; for Bosra, J. W. Crowfoot, *P.E.F.Q.St.* (1936), 7 ff., and *British School of Archaeology in Jerusalem, Suppl., Paper 4* (1937), replacing the erroneous reconstruction in Butler, *Early Churches*, 124 ff.; for the overall problem, W. E. Kleinbauer, *The Aisled Tetraconch* (forthcoming).

Whether or not the huge church of the Virgin at Amida (Diyarbekr; G. L. Bell in M. van Berchem and J. Strzygowski, *Amida*, Heidelberg, 1910, 192 ff.) was a tetraconch, with circular ambulatory, so far remains as uncertain as its date.

10. Butler, *Churches*, 124 ff., and Lassus, *Sanctuaires*, 138, 142.

11. Tchalenko, *Villages*, 21 ff., 383 ff.; Butler, *Architecture, passim*, and *P.E., passim*; also A. M. Schneider, *Göttinger Nachrichten* (1949), no. 3, 57 f. Entire villages with similar characteristics survive in ruins, e.g. at Qirqbīze and Behyo; see Tchalenko, *Villages*, 339 ff., and plates C ff.

149. 12. Butler, *Churches*, 49 f. (Kseidjbe-Ksedjbeh, Dar Qita); 85 ff. (Umm-il-Kutten, Umm-es-Surab, Id-Deir, Qasr el Benât); 93 ff. (Deir Termānin, Qal'at Si'man, Deir Siman); Lassus, *Sanctuaires*, 264 ff.; and Tchalenko, *Villages, passim*.

13. S. Corbett, *P.B.S.R.*, XXV (1957), 39 ff.

150. 14. Butler, *Churches*, 47, on Umm-es-Surab; Tchalenko, *Villages*, 32, note 1 and plate XII, the only source for El Bāra; Lassus, *Sanctuaires*, 67 f., goes perhaps too far in assuming that in a great number of churches galleries were projected but not executed.

15. For example, in the double church at Umm-el-Jemal, at Brād, Banaqfur, Kfêr (Djebel el A'la), and frequently elsewhere (Butler, *Churches*, 74 ff.).

16. Lassus, *Sanctuaires*, 25 ff.; Tchalenko, *Villages*, 17 f.

17. Lassus, *Sanctuaires*, 95 f. and *passim*.

18. Butler, *Churches*, 33 f. (Fafertin); 49 f. (Kseidjbe-Ksedjbeh); 32 f. (Kharab Shems); 50 ff. (Dar Qita). See also Lassus, *Sanctuaires, passim*.

151. 19. The exedrae of the Syrian churches were first discussed by A. M. Schneider, *Göttinger Nachrichten* (1949), no. 31, 59 ff., and at greater length by J. Lassus and G. Tchalenko, *C.A.*, V (1951), 75 ff.; see also Lassus, *Sanctuaires*, 207 ff.; Tchalenko, *Villages, passim*; and, cautioning as to possible differences in the liturgical function of the bema among northern, eastern, and western Syria, R. Taft, *Orientalia Christiana Periodica*, XXXIV (1968), 326 ff., with older bibliography.

20. Schneider, *op. cit.*; Lassus, *Sanctuaires*, 186 ff.; Taft, *op. cit.* R. Bernheimer, *A.J.A.*, XLIII (1939), 647 ff., and H. Glück, *Der Breit- und Langhausbau in Syrien* (*Zeitschrift für Geschichte der Architektur, Beiheft*, XIV) (Heidelberg, 1916), link the lateral entrances of Syrian churches to transverse temple plans customary a thousand years before in the Ancient Near East – a far-fetched hypothesis.

21. The complex question of the changing function and place of the pastophories – that is, prothesis and diaconicon – in Syria has been explored by Lassus, *Sanctuaires*, 162 ff., 194 ff., and by Bandmann, as quoted above, Chapter 4, Note 5. The link with the tripartite sanctuaries of Syrian temples was first pointed out by H. C. Butler, in *Studien zur Kunst des Ostens* [for] *Joseph Strzygowski* (Vienna and Hellerau, 1923), 9 ff.

152. 22. Butler, *Churches*, 49 ff.; Lassus, *Sanctuaires, passim*, in particular, 290 ff.; Schneider, as quoted above, Note 11; Tchalenko, *Villages, passim*.

23. Lassus, *Sanctuaires*, 162 ff., assigns this role to the south room, but points out the frequency of exceptions, in my count, nearly half.

24. Butler, *Churches*, 151 ff., 207 ff.; Lassus, *Sanctuaires*, 217 ff., and *passim*; A. Katchatrian, *Les baptistères paléochrétiens* (Paris, 1962), *passim*; J. Emminghaus, in *Tortulae* (*R. Qu. Schr., Suppl.* 30) (Rome-Freiburg, 1966), 82 ff.

153. 25. See above, Note 12, and, in particular, Tchalenko, *Villages*, 159 ff., 208 ff., 235 f.

26. De Vogüé, *Syrie centrale*, 141 ff. and plates 139 ff.; Butler, *Churches*, 97 ff.; Lassus, *Sanctuaires*, 129 ff.; and Tchalenko, *Villages*, 223 ff., with detailed description, convincing dating, roughly 476 to 491, and the evidence pointing to Zeno's having initiated and supported construction. While De Vogüé, Butler, and still S. Guyer, *J.D.A.I.*, XLIX (1934), 90 ff., assumed the central octagon to have been an open-air area, D. Krencker (*J.D.A.I.*, XLIX, 1934, 62 ff., and *Forschungen und Fortschritte*, XV, 1939, 32) envisaged it with a wooden dome; Lassus, *Sanctuaires*, 135, assumes that a dome was planned, but not executed. Tchalenko, *op. cit.*, 268 ff., proposes a double-shell plan, the centre room higher and resting on an interior ring of supports; but so far no traces of such inner supports have been found. K. J. Conant, *A Brief Commentary on Early Medieval Church Architecture* (Baltimore, 1942), plate II, reconstructs a pyramidal roof spanning the width of the octagon – to my mind still a plausible solution. Whatever the covering, it collapsed in 528, turning the octagon into an open courtyard: an arrangement copied on smaller scale in the sanctuary of Simeon Stylites the Younger on Mont Admirable around 551; see W. Djoubadze, *Ist.*

M., XV (1965), 218 ff. Major repairs, including the construction of a fortress at Qal'at Si'man, were undertaken in 965 and 979, the latter by Basil II after the reconquest of the region from the Moslems (Tchalenko, *Villages*, 242 and note 4). The plan of the church as given by De Vogüé is incorrect in that it disregards the deviation of the east arm from the perpendicular (see Lassus, *Sanctuaires,* figure 46, and Deichmann, *B.Z.*, LXV, 1972, 112). Nonetheless, we reproduce it as our illustration 101, since it is the only plan to show the church not isolated but within the overall complex.

160. 27. For Mont Admirable, see Lassus, *Sanctuaires*, 133 ff.; for the 'cathedral' group, see Butler, *Churches*, 130 (Turmanin, entirely destroyed as early as 1900); 71 ff. (Qalb Lozeh); 158 (Kerratin); 158 ff. (El-Anderin, now completely destroyed); 147 ff. (Ruwêha). See also Lassus, *Sanctuaires*, and Tchalenko, *Villages, passim*. The 'cathedral' - better, Church A - at R'safah, first published by H. Spanner and S. Guyer, *Rusafah* (Berlin, 1926), has been newly explored and surveyed in the course of the excavation of the entire city begun by the late J. Kollwitz; see his preliminary reports, in *Neue Deutsche Ausgrabungen im Mittelmeergebiet und im Vorderen Orient* (1959), 45 ff.; *J.D.A.I., A.A.* (1957), 88 ff.; *ibid.* (1963), 328 ff. Tchalenko, *Villages*, 349, note 5, dates Qalb Lozeh prior to Qal'at Si'man.

164. 28. See below, p. 262.

29. Tchalenko, *Villages*, 31 ff., points out that twin-tower façades occur only in what appear to be pilgrimage churches, suggesting that the essential features are not the towers, but the loggia in between where relics may have been exhibited. For towers flanking the apse, *ibid.*, 31, note 5. See also above, Chapter 6, Note 5.

165. 30. The double arches below the nave arcades are apparently a later insertion; their date remains undetermined, but is probably not much later than the completion of the original building. The reconstruction of diaphragm arches across the nave, as proposed by Butler, *Churches*, 162 and accepted by myself in the first edition of the present volume, p. 115, is erroneous.

31. S. Pelikanides (*Makedonika*, 11, 1951-2, 167 ff.), following Kautzsch, *Kapitellstudien*, 140 ff., has made an attempt at listing the capitals with wind-blown foliage and at tracing their origin to the second and third century. But their place of origin - whether the coastal cities of Asia Minor, Syria, or, as Kautzsch suggests, Constantinople and Salonica - remains in doubt.

32. E. Baldwin Smith, *Architectural Symbolism* (Princeton, 1956).

33. E. Kantorowicz, *Art Bulletin*, XXVI (1944), 207 ff., especially 221 ff.

166. 34. Apart from the bibliography quoted above, Note 1, for Palestine, see L. H. Vincent and F. M. Abel, *Jérusalem nouvelle*, 11, 1-4 (Paris, 1925 ff.), 19 ff.; A. M. Schneider, *Antiquity*, XII (1938), 172 ff.; R. W. Hamilton, *P.E.F.Q.St.*, LXXIV (1952), 83 ff.; and the reports on new finds published regularly by the *Revue Biblique, Liber Annuus, Z.D.P.V.*, and *Israel Exploration Journal*.

35. A. M. Schneider, *Z.D.P.V.*, LXVIII (1944-51), 211 ff.; Ovadiah, *Corpus*, 140 ff.

167. 36. The church is described by Mark the Deacon, *Life of Porphyry of Gaza*, chapter 75, transl. G. F. Hill (Oxford, 1913), 85 ff.

37. J. W. Crowfoot, in C. H. Kraeling (ed.), *Gerasa* (New Haven, 1938), 256 ff.; Ovadiah, *Corpus*, 77 f.

168. 38. Vincent and Abel, *op. cit.*, 11, 745 ff.

39. Evron, see M. Avi-Yonah, *Israel Exploration Journal*, 11 (1952), 143, and Ovadiah, *Corpus*, 67 ff.; Shavei Zion, M. W. Prausnitz, *Excavations at Shavei Zion* (Rome, 1967); Ramat Rahel, P. Testini in P. Aharoni, *Excavations at Ramat Rahel . . . 1959 and 1960* (Rome, 1962), 73 ff., and, with final plan, *idem, Excavations . . . 1961 and 1962* (Rome, 1964), 101 ff.; Mamshit (Kurnub), newly cleared and systematically excavated since 1966, A. Negev, *Raggi*, VII (1969), 67 ff.; Madaba, U. Lux, *Z.D.P.V.*, LXXXIII (1967), 165 ff.; Umm-es-Surab, Butler, *Churches*, 47; St Theodore, *Gerasa, op. cit.*, 219 ff.; et-Tabgha, A. M. Schneider, *Die Brotvermehrungskirche . . .* (Paderborn, 1934). The date suggested by Schneider, in the middle or second half of the fourth century, must be discarded. Schneider himself (*Oriens Christianus*, XXXIV, 1937, 59 ff.) found below the transept basilica an earlier chapel. The find of a coin of 395-408, in its foundation, provides for this chapel a *terminus ad* or *post quem* and this, together with the transept plan and the style of the mosaics, assigns the basilica a date in the late fifth or, better, the early sixth century (V. Corbo, *Liber Annuus*, XX, 1970, 370 ff.).

169. 40. E. Mader, *Altchristliche Basiliken . . . in Süd-judäa* (Paderborn, 1918); A. M. Schneider, *Z.D.P.V.*, LXI (1938), 96 ff.; Ovadiah, *Corpus, passim*.

41. For Sbeïta, see C. L. Woolley and T. E. Lawrence, *The Wilderness of Zin* (London, 1936), 97 ff. and Crowfoot, *Early Churches*, 70 f.; for Emmaus, L. H. Vincent and F. M. Abel, *Emmaus* (Paris, 1932) (with the erroneous dating 'third century'); for Ras as-Siagha, S. Saller, *The Memorial of Moses on Mount Nebo* (Jerusalem, 1941).

42. *Gerasa* (*op. cit.*), 171 ff. St Peter and Paul at Gerasa and the North Church at Sbeïta (Shivta) are nearly identical in plan and size.

170. 43. For bibliography, see above, Note 1.

44. P. Verzone, *C.C.R.* (1965), 613 ff., with reference to the preliminary reports on his survey and clearing of the site.

172. 45. F. W. Deichmann, *J.D.A.I.*, *A.A.*, LIII (1938), col. 205 ff.

46. Rott, *Denkmäler, passim*; Guyer, *Grundlagen* (as quoted above, Note 1); Ramsay and Bell, *Churches, passim*; R. Lienhardt, *J.S.A.H.*, XXIV (1965), 300 ff. Of the forty-odd structures still seen by Ramsay and Bell but a few survive; see S. Eyice, *Karadağ ve Karaman* (Istanbul, 1971). J. Kollwitz, in *Tardo antico e alto medioevo ... 1967 (Accad. Lincei, Problemi*, CV) (Rome, 1968), 315 ff., questions the existence of twin-tower façades at Binbirkilise. M. Restlé, *R.L.B.K.*, I, 690 ff., views the churches in the lower city (Madenşehir), such as nos. 1 and 15, as built from the fifth to the early eighth and restored from the ninth to the eleventh centuries, those in the upper city (Değile), such as no. 32, as built in the eighth and ninth centuries. A thorough study is badly called for.

174. 47. Rott, *Denkmäler*, 102 ff.; N. and M. Thierry, *Nouvelles églises rupestres de Cappadoce* (Paris, 1963), 29 f.

176. 48. Rott, *Denkmäler*, 180 ff. (Tomarza); 188 ff. (Büslük Fesek); 276 ff. (Sivrihisar; also Ramsay and Bell, *Churches*, 441 ff., and Thierry, *op. cit.*, 25 f.).

49. For the octagon at Binbirkilise, see Ramsay and Bell, *Churches*, 99 ff., and J. Friedenthal, *Das kreuzförmige Oktogon* (Berlin, 1907); for Soasa, Rott, *op. cit.*, 249 ff.

50. Rott, *Denkmäler*, 192 ff. (identifying the locality as Skupi; J. Lafontaine-Dosogne, *Byzantion*, XXXIII, 1963, 139, calls it Sari Kilise). *Enciclopedia italiana* (vol. VIII, plate 209) has, to my knowledge, the only extant photograph of the flank of the church.

CHAPTER 7

177. 1. Discussion of Christian building in the Latin West has suffered in the past from an over-emphasis on Rome. The discovery of new sites, in Istria, Dalmatia, Milan, and Upper Italy in particular, has helped to correct this perspective.

178. 2. Thomas F. Mathews, *R.A.C.*, XXXVIII (1962 [1964]), 73 ff.

3. The lists of Imperial, papal, and other gifts presented to churches, particularly those inserted into the *Liber Pontificalis*, refer time and again to lighting fixtures, and beginning with the fifth century, to sets of curtains, evidently intended for the intercolumniations of the nave. See *L.P.*, CXLVII and *passim*; Pru-

dentius, *Peristephanon*, XII, V, 31 ff.; Sidonius Apollinaris, II, ep. 10 (*P.L.*, LVIII, 486 ff.); Jerome, *Letters*, ep. 52 (*L.C.L.*, 214); Venantius Fortunatus, *Poems* (*P.L.*, LXXXVIII, *passim*); and numerous inscriptions (E. Diehl, *Inscriptiones Christianae Veteres Latinae*, Berlin, 1925 ff., 1756 ff.), provide some of the evidence.

4. Of the church of S. Marco in Rome, built in 336 as a parish church, only a few foundation walls and a splendid marble pavement have been found. They are sufficient to suggest the plan of a colonnaded basilica, its altar rising in the nave in front of a low platform, possibly intended for the clergy. It is uncertain whether the nave was terminated by an apse or a straight wall. See *Corpus*, II, 216 f.

5. F. W. Deichmann, *Frühchristliche Kirchen in Rom* (Basel, 1948); *Corpus, passim*; also, numerous monographs in the series *Le chiese di Roma illustrate*, published by the Istituto di Studi Romani in Rome.

179. 6. *Corpus*, I, 118 ff.; E. Junyent, *Il titolo di San Clemente* (Rome, 1932), and C. Cecchelli, *San Clemente (Chiese illustrate*, XXIV-XXV, 1930). In the sixth century, a chancel composed of marble screens with a long solea and an altar canopy was set up in the fourth-century church; the former are re-used in the upper twelfth-century church, while the columns and capitals of the altar canopy now stand on the staircase leading into the lower church. Deichmann, *R.M.*, LVIII (1943), 153, suggests a seventh-century remodelling; I see no evidence.

181. 7. The figures obviously fluctuate, but there seems to be a constant progression, as is evident from the following list (*Corpus, passim*):

	length	width	height
S. Clemente	35.00*	15.00	13.50
S. Vitale	45.00	14.43	13.45
SS. Giovanni e Paolo	c. 41.00	13.40	19.00
S. Sabina	48.00	13.50	19.00
S. Lorenzo in Lucina	43.84	13.25	+14.50
S. Agata dei Goti	22.60	9.80	13.00

* All figures are in metres.

8. Open-arcaded façades are known as early as *c.* 310 at S. Sebastiano (*Corpus*, IV, 99 ff., esp. 124) and were common shortly before and after 400: at S. Clemente; S. Pudenziana (*Corpus*, III, 277 ff.); S. Vitale (*Corpus*, IV, 313 ff.); SS. Giovanni e Paolo (A. Prandi, *Il complesso monumentale della basilica celimontana dei SS. Giovanni e Paolo*, Vatican City, 1953); S. Pietro in Vincoli, first church (*Corpus*, III, 178 ff., esp. 216 ff.). The open façade of S. Maria Maggiore (Prandi, in *Atti I° Congres. Naz. Archeol. Crist.*) remains in doubt (*Corpus*, III, 46). Façades with doors are ascertained for S. Sabina, S. Lorenzo in Lucina, S. Stefano in Via

Latina, the second church of S. Pietro in Vincoli, S. Agata dei Goti, all dating from the second third of the fifth century.
9. *Corpus*, IV, 72 ff.

184. 10. *Corpus*, IV, 96.

11. Muñoz, *Il restauro della basilica di Santa Sabina* (Rome, 1938), 31 ff., believed the original stucco gratings of the windows to be of ninth-century date.

185. 12. S. Pietro in Vincoli: transept of second church, *c.* 450 (*Corpus*, III, 209 ff., 325 f., 228 ff.); the first church, *c.* 400, may have had projecting 'aisle-transepts' recalling those at the Lateran (*ibid.*, 224 f.). S. Agata dei Goti (A. Muñoz, C. Cecchelli, and C. C. F. Hülsen, *S. Agata dei Goti*, Rome, 1924; *Corpus*, I, 2 ff.; G. de Angelis d'Ossat, *Studi Ravennati*, Ravenna, 1962, 22 ff.).

13. The surveys of the material then known in northern Italy as first collected by Verzone (1942) and De Capitani d'Arzago (1948) (both as quoted above, Chapter 3, Note 32) are supplemented by the more recent publications of Traversari (as quoted *ibid.*), Mirabella Roberti, Villa, Crema, and Tamara-Forlati referred to in the following Notes. The monuments in southern France have been briefly summarized, with the older bibliography, by Jean Hubert, *L'art pré-Roman* (Paris, 1938).

186. 14. For S. Ambrogio and the other buildings mentioned, see Verzone (1942) and De Capitani d'Arzago (1948); F. Forlati, 'La basilica dei SS. Felice e Fortunato', *Palladio*, N.S. VII (1943), 67 ff.; B. Tamara-Forlati, 'La basilica paleocristiana di Verona', *Rend. Pont. Accad.*, XXX/XXXI (1959), 117 ff.; *idem* and others, *Il duomo di Vicenza* (Vicenza, 1956). For bibliography on the numerous twin cathedrals in upper Italy see Krautheimer, *Studies*, 161 ff. and postscript, the latter replying to the critique of A. de Capitani d'Arzago, in *Munera . . . Antonio Giussan* (1943), 188; J. Hubert, *Primo Congresso Internazionale di Studi Longobardi* (Spoleto, 1952), 167 ff.; G. Panazza, *Atti 4⁰ Congresso Internazionale . . . sull'Alto Medioevo . . . 1967* (Spoleto, 1969), 479 ff.; D. Bullough, *P.B.S.R.*, XXXIV (1966), 82 ff.

15. Martyrs' chapels in upper Italy have never been discussed as a type. For individual buildings see Verzone (1942), *passim*, and Arslan, as quoted above, Chapter 3, Note 38. For S. Prosdocimo, see P. L. Zovatto, *R.A.C.*, XXXIV (1958), 137 ff.

16. For H. Euphemia at Chalcedon, see above, Chapter 5, Note 8; for Alaja Jaila, Rott, *Denkmäler*, 318 ff., and R. M. Harrison, *Anatolian Studies*, XII (1963), 126 ff.

187. 17. F. Reggiori, *Dieci battisteri lombardi* (Rome, 1935), 435; Verzone (1942), and De Capitani d'Arzago (1948), *passim*; for the spread of the type, G. de Angelis

d'Ossat, *Arte Lombarda*, XIV (1969), 1 ff.; for baptisteries in Provence, see Hubert, *op. cit.*, *passim*; for the Lateran baptistery, see above, Chapter 3, Note 47.

18. Mirabella Roberti, as quoted above, Chapter 3, Note 40. Because St Ambrose composed the verses inscribed in the baptistery, the structure, too, has been generally considered his. I think it more likely that it was built together with the cathedral, about 350, and only decorated by him. On number symbolism, see above, Chapter 4.

19. Grado and Aquileia: G. Brusin and P. L. Zovatto, *Monumenti di Aquileia e Grado* (Padua, 1957), 174 ff., 399 ff.; Fréjus: J. Formigé in *Villes épiscopales de Provence* (Paris, 1954), 29 ff.; Aix: P.-A. Février, *ibid.*, 13 ff.; Albenga: C. Casalone, *Arte Lombarda*, VIII (1963), 103 ff.; Novara: U. Chierici, *Il battistero del duomo di Novara* (Novara, 1967); Riva S. Vitale: S. Steinmann-Brodtbeck, *Zeitschrift für Schweizer-ische Archäeologie und Kuntsgeschichte*, III (1941), 193 ff.; Arian baptistery, Ravenna: still, G. Gerola, in *Zur Kunst des Ostens* [for] J. Strzygowski (Vienna-Hellerau, 1923), 112 ff.; M. Mazzotti, *Felix Ravenna*, CI (1970), 115 ff., stressing the steep proportions of the original structure; and briefly, F. W. Deichmann, *Ravenna*, I (Wiesbaden, 1969), 209 ff.; T. Bruno, *Felix Ravenna*, LXXXVIII (1963), 5 ff.

188. 20. S. Kostof, *The Orthodox Baptistery in Ravenna* (New Haven and London, 1965), and the remarks of Deichmann, *B.Z.*, LXI (1968), 105 ff., and Krautheimer, *Archaeology*, XX (1967), 233 ff.

21. A. Khatchatrian, *Les baptistères paléochrétiens* (Paris, 1962), 63, 105.

189. 22. R. Egger, as quoted above, Chapter 2, Note 17; for Kekkut, N. Lajos, in *III C.A.C. . . . Ravenna . . . 1932*, 294 f.

190. 23. Brusin, as quoted above, Chapter 2, Note 16; A. Gnirs, *J.Ö.A.I.*, XIX-XX (1919), 165 ff.; B. Molajoli, *La basilica eufrasiana di Parenzo* (Padua, 1943). For the 'post-Theodorian' north basilica at Aquileia and its date, see M. Mirabella Roberti, in *Studi in onore di A. Calderini e R. Paribeni*, III (Milan, 1956), 863 ff., and S. Tavano, *VIII C.A.C. . . . Barcelona . . . 1969*, 517 ff. The date of the enlargement (whether about 350 or 400) is still under discussion. For the enlargement of the south basilica, after 452, see L. Bertacchi, *Aquileia Nostra*, XLII (1971), 15 ff.

24. The finds at Pula have been published by D. Frey, *Jahrbuch der K.K. Zentralkommission*, VIII (1914), 11 ff.

25. Examples are found in Carinthia at Teurnia (St Peter am Holz); at Duel near Feistritz; on the Hoischhügel, and elsewhere (Menis, *op. cit.*, *passim*); in the Tyrol at Lavant, R. Egger, in *Frühmittelalter-liche Kunst in den Alpenländern* (Olten and Lausanne,

1954), 17 ff.; in upper Italy in the church of St Peter and Paul, excavated below the eleventh-century church of S. Abbondio at Como (C. Boïto, *Architettura del Medio Evo in Italia*, Milan, 1880, 14 ff.); in Dalmatia and Bosnia-Herzegovina at Mokro Polje, Majdan, Breza (near Sarajevo) (I. Nikolajević, *Zb. R.*, X, 1967, 87 ff., 97 ff.).

26. Examples are found, e.g., at Reculver, at St Pancras and St Augustine at Canterbury, and elsewhere (A. W. Clapham, *English Romanesque Architecture before the Conquest*, Oxford, 1930, *passim*). A group of early medieval churches north of Lake Como, provided with two parallel apses, may be a late derivative of such small double churches; W. Suber, *Zeitschrift für Schweizerische Archäologie und Kunstgeschichte*, XXI (1961), 152 ff.

27. At this point, four of the church complexes have been fully published: the cathedral (*Forschungen in Salona*, I, Vienna, 1914); Manastirine (*idem*, II); Marusinac (*idem*, III); Kapljuč (*Recherches à Salone*, I, Copenhagen, 1920).

28. E. Dyggve, *History of Salonitan Christianity* (Oslo, 1951), *passim*, and E. Condurachi, *V.C.E.B.... Rome ... 1936*, II, 78 ff., have both stressed and overstressed the impact of Eastern church types on Salona. Syrians were apparently numerous in the congregation of Salona prior to and around 300; but indications of Syrian or Eastern impact on its architecture are few, unless the buttresses of the Anastasius mausoleum are counted as such (Dyggve, *Salonitan Christianity*, 8, 81 f.)

191. 29. Of the *basilica orientalis*, so far only a small-scale plan has been published by Dyggve (*op. cit.*, figure III, 12), who dates the structure to the fourth century; his proposed reconstruction of a cross transept does not seem to me to be borne out by the foundation walls, the only element ascertained. The twin cathedral has been published in *Forschungen in Salona*, I. The reconstruction of its north building, the *basilica urbana*, as a basilica with nave, four aisles, and galleries as proposed by Gerber, *ibid.*, has been rightly refuted by his co-author Egger, *op. cit.*

30. *Forschungen in Salona*, III (Vienna, 1939), 95, and Dyggve, *op. cit.*, 78 and figure IV, 23–5. The term 'basilica discoperta' is misleading. The late date of the structure at Marusinac militates against the hypothesis that it influenced the origins of Christian church building as suggested by Dyggve. The resemblance to Constantinian transept basilicas is based on a superficial similarity in plan; if anything, the Marusinac precinct derives from such transept basilicas. See also R. M. Milesović, *J.Ö.A.I.*, XLI (1954), Beiblatt, 128 ff.

192. 31. *Forschungen in Salona*, I, 91 ff.; Dyggve, *op. cit.*, figure 11 b, 13.

32. The first type is represented by the basilica in the south cemetery, Dyggve, *op. cit.*, IV, 28, the second by the *basilica orientalis*, *ibid.*, III, 13.

33. For the baptistery of the cathedral, see Dyggve, *V C.A.C.... Aix-en-Provence ... 1954*, 189 ff.

34. C. Ricci, *Guida di Ravenna* (1876), frequently reprinted with revisions, and *idem*, *Tavole storiche dei mosaici di Ravenna* (Rome, 1930), are standard works, as is the periodical *Felix Ravenna* (1910-). Of Deichmann's huge publication (see above, Note 19) only plates and text have appeared, the former 1953, the latter 1969 and regrettably thin as to both the architectural monuments and their history; the supporting catalogue or commentary is still missing. G. de Angelis d'Ossat, *Studi Ravennati* (Ravenna, 1962), makes an (unconvincing) attempt at tracing the development of the basilicas at Ravenna based on their changing proportions. The bibliographical references are conveniently collected by G. Bovini, *Saggio di bibliografia su Ravenna antica* (Bologna, 1968).

193. 35. Excavations are under way at S. Croce to clarify further the plan and history of the church. At this point, see G. Bovini, *Felix Ravenna*, LX (1952), 44 ff. The cathedral of Ravenna, built prior to 425 and remodelled in the twelfth century, was demolished in 1748. Old engravings and descriptions (G. L. Amadesi, *La metropolitana di Ravenna*, Bologna, 1748) furnish the basis for a summary reconstruction (G. M. Zafagnani, *Felix Ravenna*, XCI, 1965, 5 ff., and XCII, 1965, 69 ff.; see also Deichmann, *Ravenna*, I, 128 f.). The nave was flanked by four aisles, the apse was enclosed in an exterior polygon. The colonnades, each with fourteen columns, carried arcades; the walls of the nave were decorated with stucco figures. The altar, enclosed in a chancel, occupied the centre of the nave. Many of these features – the four aisles, the position of the altar – appear to be residuals of Constantinian church planning, and the dedication of the cathedral to the Resurrection (Anastasis) carries an additional Constantinian overtone. On the other hand, the capitals with animal half-figures now in the Museo Arcivescovile – if indeed they come from the cathedral – would suggest a rebuilding of the nave c. 500.

36. Ricci, *Tavole*, fasc. VIII, 43 ff.; L. Scevola, *Felix Ravenna*, LXXXVII (1964), 5 ff.; P. Grossmann, *R.M.*, LXXI (1964), 166 ff.; Deichmann, *Ravenna*, I, 152 ff. De Angelis d'Ossat, *op. cit.*, 14 ff., considers both the present plan, without narthex, and the clerestory to be of fifth-century date.

196. 37. For S. Spirito and S. Agata, see M. Mazzotti, *Felix Ravenna*, XXIV (1957), 25 ff.; *idem*, *C.C.R.*,

(1967), 233 ff.; Deichmann, *Ravenna*, I, 207 f.; De Angelis d'Ossat, *op. cit.*, 22 ff.

38. G. Bovini, *Sant'Apollinare Nuovo* (Milan, 1961), presents a good, if brief treatment of the building and its decoration. See also De Angelis d'Ossat, as quoted above, Note 34, and, particularly, Deichmann, *Ravenna*, I, 171 ff. The apse, demolished in a sixteenth-century remodelling, was rebuilt in 1950 on the old foundation (G. Bovini, *Felix Ravenna*, LIV, 1950, 14 ff.). The arcades in the sixteenth century were raised from their original level, 1·20 m. below the present floor, without damage to the mosaic decoration of the upper walls (*ibid.*, LVII, 1951, 5 ff.). Of Theodoric's mosaic decoration large parts survive: the groups of Christ and the Virgin near the apse; the palace and cityscape near the façade, save the king and his suite within the palace arcades and before the walls of Classe; the prophets between the windows; and the christological scenes above. Only the rows of saints date from after the Byzantine conquest, when also the figures of Theodoric and his court were obliterated. However, these processions merely replace earlier similar representations. The hollow tube construction of the original apse vault and the history of the technique have been discussed by G. Bovini, *Felix Ravenna*, XXX (1960), 78 ff., and by De Angelis d'Ossat, as quoted, Note 34.

198. 39. For Algeria and Tunisia, Gsell, *Monuments*, II, and Gauckler, *Basiliques*, while antiquated, remain standard, supplemented by numerous papers in *Mélanges École Française, Bulletin Archéologique, C.R.A.I.*, and *Bulletin Société Antiquaires de France* (quoted as *B.S.A.F.*). Reports on new discoveries have appeared in the successive volumes of *C.A.C.*, as have tentative summaries on the character and history of African church building; outstanding among them are J. Lassus, *VI C.A.C. . . . Ravenna . . . 1962*, 581 ff., and P.-A. Février and N. Duval, *VIII C.A.C. . . . Barcelona . . . 1969*, 5 ff.; P.-A. Février, *ibid.*, 299 ff.; and J. Lassus, *ibid.*, 104 ff., a brilliant presentation of the known facts and the open questions. Quite recently N. Duval, *Mél. Éc. Franç., Antiquité*, LXXXIV (1972), 1071 ff., has summed up the material with a critical eye. Re-exploration of some major sites and a consequent re-evaluation of individual problems in the development has started, e.g.: N. Duval, *Sbeïtla et les églises africaines à deux absides*, I, II (Paris, 1971, 1973); *idem, C.R.A.I.* (1968), 221 ff. (1969), 409 ff. (1971), 136 ff. (all on Haïdra); *idem, B.S.A.F.* (1969), 207 ff. (Bulla Regia, now Hammam Deradji); *idem, C.C.R.* (1970), 119 ff. (counter-apses); M. Fendri, *Basiliques de la Skhira* (Paris, 1961); P.-A. Février, *Fouilles de Sétif* (Paris, 1965); *idem, C.A., XIV* (1964), 1 ff. (on Djemila, Sétif, and Late Antique

urban development in North Africa). The social, economic, and religious picture of Christian North Africa has been beautifully presented by both W. H. C. Frend, *The Donatist Church* (Oxford, 1952), and, with different emphasis, by Février, *op. cit., C.A.*, XIV (1964), and *C.C.R.* (1970).

For the Christian antiquities of Tripolitania, see J. B. Ward Perkins, *Archaeologia*, XCV (1953), 1 ff.; *idem, VIII C.A.C. . . . Barcelona . . . 1969*, 219 ff.

40. The architectural remains, both Donatist and Catholic, of the interior are published by A. Berthier, *Les vestiges du christianisme . . . dans la Numidie centrale* (Algiers, 1942).

201. 41. For the general characteristics, see Lassus, as quoted, Note 39; for the ornamentation, see L. Leschi, *IV C.A.C. . . . Rome . . . 1938*, I, 145 ff.

42. The Tabarka mosaic (now at the Bardo Museum at Tunis) and its depiction of a basilica have been previously interpreted by R. Krautheimer (*Warburg Journal*, V, 1942, 1 ff.), J. B. Ward Perkins (as quoted, Note 39), and P. Lampl (*Marsyas*, IX, 1960–1, 6 ff.). Our illustration 152 is a revised version of Ward Perkins's drawing, figure 29.

203. 43. For the Melleus church (Basilica I) at Haïdra, see Duval, *op. cit., C.R.A.I.* (1968 and 1969). Other examples of the standard type are selected at random: in western Algeria, Bénian (Ala Miliaria), prior to 439 (Gsell, *Monuments*, II, 175 ff.); Castiglione (*ibid.*, 187 ff.); in eastern Algeria, Announa, sixth-century (*ibid.*, 165 ff.); Henchir-el-Ateuch, *c.* 380–450 (*ibid.*, 170 ff.); Kherbet Guidra, prior to 444 (*ibid.*, 205 ff.); Sétif, *c.* 375 (P.-A. Février, as above); in Tunisia, Es Skhira, fourth-century (M. Fendri, as above) – the latter two sites with two basilicas each; in Tripolitania, two churches (1 and 3) at Sabratha; in central Numidia, a church (1) at Kherbet bou Addoufen (Kherbet bou Hadef) with its apse raised above nave level and a long chancel enclosing the altar in the nave.

44. Y. Allais, *Djémila* (Algiers, n.d.); E. F. Albertini, *III C.A.C. . . . Ravenna . . . 1932*, 411 ff.; L. Leschi, *IV C.A.C. . . . Rome . . . 1938*, I, 1940, 161 ff. Lassus, *VI C.A.C. . . . Ravenna . . . 1962*, 591 ff., in agreement with P.-A. Février, suggests that the two basilicas at Djemila are contemporary, not following each other as previous opinion had it – a thesis so far not generally accepted; see N. Duval and P.-A. Février, *VIII C.A.C. . . . Barcelona . . . 1969*, 24 f.

204. 45. A. Ballu, *Le monastère byzantin de Tébessa* (Paris, 1897), and Gsell, *Monuments*, II, *passim* are outdated. New studies, one by P.-A. Février, another by J. Christern, are in preparation; both authors, in preliminary publications (Février, *C.C.R.*, 1970, 164; Christern, *ibid.*, 103 ff.), agree on an early-fifth-century date.

Side chambers, occasionally projected sideways into longish rectangles, are common in North Africa, but their functions remain unknown. Galleries, likewise, were common, the first perhaps being those at Orléansville (see above, Chapter 2, Note 18), though perhaps not as frequent in the fourth and early fifth centuries (Djemila, South Church; Tipasa, Great Basilica), as proposed by Christern, *op. cit.*, 407 ff.
206. 46. The churches of Carthage, including the huge complex of buildings at Damous El Karita, while excavated nearly a century ago, still await scholarly publication. So far only a most sketchy survey has appeared from the pen of J. Vaultrin, *Revue Africaine*, LXXIII (1932), 188 ff., and LXXIV (1933), 118 ff.

47. Gsell, *Monuments*, II, 247 ff.

48. The 'Christian quarter' and the church of Bône ('Annoba; Hippo) have come to light through the efforts of Admiral E. Marec (*Monuments chrétiens d'Hippone*, Paris, 1958). In particular, see J. Lassus, *VI C.A.C. . . . Ravenna . . . 1962*, 581 ff., and P.-A. Février, *op. cit., C.A.* (1964), both of which brilliantly demonstrate the need for viewing North African churches as part and parcel of such 'Christian quarters'.

207. 49. A. Venditti, *Architettura bizantina nell'Italia meridionale*, I (Naples, 1967), has collected the material and the pertinent bibliography.

50. The letters and poems of Paulinus describing the buildings at Nola-Cimitile are found in *P.L.*, LXI, *passim*, and with English translation and commentary, in R. C. Goldschmidt, *Paulinus' Churches at Nola* (Amsterdam, 1940). G. Chierici has reported on his excavations in more or less final form in *Ambrosiana* (Milan, 1942), 315 ff., and *Atti III° Congresso di Studi sull'Alto Medioevo . . . 1956* (Spoleto, 1959), 125 ff.; see also Venditti, *op. cit.*, 530 ff.

51. Trefoil apses are found, e.g., at the White and Red Monasteries; at Kherbet bou Addoufen (Kherbet bou Hadef) in Numidia; at San Pere at Tarrasa on the Catalonian coast. None are as early as Paulinus's church, but given their frequency in the territory, their origin in North African church building is likely.
209. 52. See Venditti, *op. cit.*, 476 ff., and more specifically for S. Gennaro, E. Lavagnino, *B.d.A.*, ser. 2, VIII (1928/9), 145 ff., and IX (1929/30), 337 ff.; for S. Giorgio Maggiore, G. B. de Rossi, *B.A.C.*, ser. 3, V (1880), 144 ff.; B. Capasso, *Commissione municipale per la conservazione dei monumenti* (1881); for S. Giovanni Maggiore, G. B. de Rossi, *B.A.C., ibid.*, 161 ff., and *B.A.C.*, ser. 3, I (1876), 157.

53. Like many of the early churches of Naples, S. Restituta awaits a satisfactory examination. At this point, see still A. Sorrentino, *B.d.A.*, III (1909), 217 ff.;

for Salemi, see B. Pace, *Memorie della R. Accademia dei Lincei*, ser. 5, XV (1917), fasc. 6, 469 ff.

54. The basilica of Pammachius at Porto has been published in *B.A.C.*, IV (1866), 37 ff., based on a report of Lanciani's. But only the apse and the adjoining baptistery were then excavated. The reconstruction of the building with nave, aisles, atrium, and side rooms, as given there, and repeated frequently, has no basis in fact.

210. 55. Nocera: M. Stettler, *R.A.C.*, XVII (1940), 83 ff., and Venditti, *op. cit.*, 550 ff.; Siagu (Ksar Er Zit, near Bir Bou Rekba): Gauckler, *Basiliques*, 17; Canosa: R. Moreno Cassano, *Vetera Christianorum*, V (1968), 163 ff.; S. Severina: P. Lojacono, *B.d.A.*, XXVIII (1934-5), 174 ff.

56. For the churches at Vega del Mar and Tarragona, see E. Junyent, *III C.A.C. . . . Ravenna . . . 1932*, 258 ff., with older bibliography; H. Schlunk, *Archivio Español Arqueologico*, LX (1945), 177 ff.; P. de Palol, *Arqueologia cristiana de la España Romana* (Madrid, 1967), 51 ff., 71 ff.

PART FOUR:
EARLY BYZANTINE BUILDING

CHAPTER 8

211. 1. From among the many excellent books dealing with Byzantine history and civilization I would list: G. Ostrogorsky, *History of the Byzantine State* (Oxford, 1956); N. H. Baynes and H. Moss, *Byzantium* (Oxford, 1948; I quote from the paperback edition, Oxford and New York, 1961); L. Bréhier, *La civilisation byzantine* (Paris, 1950), with extraordinarily rich bibliography; and R. Guerdan, *Vie, grandeur et misères de Byzance* (Paris, 1954), transl. Hartley, *Byzantium*, paperback ed. (New York, 1962).

2. The best source on Justinian is still Procopius in his various works (*L.C.L.*, I–VI, ed. H. B. Dewing, and VII, ed. G. Downey). For a summary of his personality, see W. G. Holmes, *The Age of Justinian and Theodora* (London, 1905 ff.); C. Diehl, *Justinien et la civilisation byzantine* (Paris, 1901); Ostrogorsky, *op. cit.*, 57 ff.

214. 3. Mathews, *Churches* (as quoted above, Chapter 4, Note 3), has investigated with a critical eye the relation of architecture and liturgy, as reflected in the churches of Constantinople prior to and in the reign of Justinian. His findings and cautionings have led me to modify, at least in part, the views on Justinian's period, expressed in the first edition of this book. The closing off by parapets of the nave, for instance, would

seem to have not been customary in fifth- and early-sixth-century Constantinople, notwithstanding its use in centres as close to Constantinople and as important as Salonica, Philippi, and Ephesus.

CHAPTER 9

215. 1. As much as thirty years ago the (incomplete) bibliography on the H. Sophia filled seven pages in E. H. Swift, *Hagia Sophia* (New York, 1940), despite its shortcomings (A. Keck, *Art Bulletin*, XXIII, 1941, 231 ff.) still the standard work in English. Outstanding among earlier publications are G. Fossati, *Aya Sofia* (London, 1852); W. Salzenberg, *Altchristliche Baudenkmäler von Constantinopel* (Berlin, 1877); W. R. Lethaby and H. Swainson, *The Church of Sancta Sophia* (London, 1894); E. M. Antoniades, *Ekphrasis tis Hagias Sōphias* (Athens, 1907 ff.); G. A. Andreades, *Kunstwissenschaftliche Forschungen*, I (1931), 33 ff.; H. Sedlmayr, *ibid.*, II (1933), 25 ff., and *B.Z.*, XXXV (1935), 38 ff., and the critique by E. Weigand, *I.B.A.I.*, X (1935), 145 ff. Good summaries with excellent illustrations are A. M. Schneider, *Die Sophienkirche in Konstantinopel* (Berlin, 1939), and H. Kähler, *Hagia Sophia* (New York and Washington, 1967). The structural problems have been and still are under discussion: see W. Emerson and R. Van Nice, *A.J.A.*, XLVII (1943), 403 ff., *A.J.A.*, LIV (1950), 28 ff., and *Archaeology*, LV (1951), 94 ff., 162 ff.; R. Van Nice, *J.S.A.H.*, VII (1948), 5 ff.; K. J. Conant, *A.J.A.*, XLIII (1939), 589 ff., and *Bull. Byz. Inst.*, I (1946), 71 ff.; W. MacDonald, *Perspecta*, LV (1957), 20 ff.; Van Nice, *Architectural Forum* (1963), 131 ff.; R. J. Mainstone, *Transactions Newcomen Society*, XXVIII (1965/6), 23 ff.; *idem*, *Architectural History*, XII (1969), 39 ff.; and *D.O.P.*, XXIII/XXIV (1969/70), 353 ff. Of Mr Van Nice's magnum opus, *Saint Sophia in Istanbul: An Architectural Survey*, instalment one (1966) has appeared.

The principal sources regarding both construction and rebuilding under Justinian are Procopius, *The Buildings*, I, i, 22 ff. (*L.C.L.*, VII), and Paulus Silentiarius (*Bonn Corpus*, XXXII, and *P.G.*, LXXXVI, 2119 ff., excerpts translated in Lethaby and Swainson, *op. cit.*, 38 ff.). Supplementary source material (in German translation) in Richter, *Schriftquellen*, 12 ff.; see also Janin, *Églises*, 471 ff.

2. G. Downey, *Art Bulletin*, XXXII (1950), 262 ff.

3. G. Downey, *Byzantion*, XVIII (1946-8), 99 ff.; G. L. Huxley, *Anthemius of Tralles* (Cambridge, Mass., 1959).

216. 4. The best sources for the rebuilding of 558-63 are Agathias, *History*, V, 9 (*Bonn Corpus*, I, 1828, 295)

and John Malalas, *Chronographia* (*ibid.*, XV, 489 and 495). For their interpretation in the light of the structural evidence, see Conant (1939 and 1946) and Mainstone (1965-6 and 1969/70) (both as quoted above, Note 1). While P. A. Underwood and E. J. W. Hawkins, *D.O.P.*, XV (1961), 187 and, in particular, 212 ff., assigned the present clerestory walls to the rebuilding of 558-63, Mainstone with good reasons pleads for the ninth century.

219. 5. In listing these repairs, Swift, *op. cit.*, erroneously attributes the buttresses to the thirteenth, Antoniades (*op. cit.*, I, 141) to the fourteenth century. A. M. Schneider (as quoted above, Note 1) makes a ninth-century date seem plausible.

6. In addition to Conant, MacDonald, Van Nice, and Mainstone as quoted above, Note 1, see J. B. Ward Perkins, *The Listener* (1956), 746 ff. The forces and counter-forces active in the structure still need further clarification, despite the careful study given them so far by Conant and by Emerson and Van Nice, as quoted above, Note 1.

7. The brick construction techniques used in the H. Sophia and their previous history have been analysed by J. B. Ward Perkins, in D. Talbot Rice (ed.), *The Great Palace of the Byzantine Emperors, Second Report* (Edinburgh, 1958), 71 ff., W. MacDonald (see also *idem*, *J.S.A.H.*, XVII, 1958, 2 ff.), and W. Emerson and R. Van Nice, *A.J.A.*, XLVII (1943), 403 ff. Van Nice, *Archaeology*, IV (1951), 101, has also pointed out that – contrary to Procopius (*Buildings*, I, i, 53) – the blocks of the main piers rest on hairline-thin beds of mortar instead of being fastened to each other, as Procopius thought, by metal sheets; a lead sheet is inserted only at the springing of some of the minor vaults (correction of my interpretation in the first edition of the present volume, p. 337, Note 8 end, kindly communicated by Mr Robert Van Nice).

221. 8. In reconstructing the first project W. Kleiss, *Ist. M.*, XV (1965), 168 ff., goes much too far. But some of his observations are correct; see also Mainstone (1969), 47 (as quoted above, Note 1).

223. 9. For chancel and solea see Paul the Silentiary, *P.G.*, LXXXVI, 2119 ff. (transl. Lethaby and Swainson, *op. cit.*, 46 ff.), G. Xydis, *Art Bulletin*, XXIX (1947), 1 ff., and Mathews, *Churches*, 96 ff. As to the marble revetment of the piers, my notes differ slightly from those of Antoniades (as quoted above, Note 1), 11, 20. I retain the latter since Antoniades probably saw the marbles cleaned.

10. Underwood, *loc. cit.*, esp. 210 ff., and *idem*, *D.O.P.*, XIV (1959), 209.

11. For Ravenna, see C. Cecchelli, *Felix Ravenna*, N.S. XXXV (1930), 1 ff.

224. 12. See above, Note 9.

226. 13. Schneider, *op. cit.*, 22 ff., plates 8 f.
228. 14. See above, p. 107, and Chapter 5, Note 2. Mathews, *Churches*, 117 ff., esp. 121, counters my former assumption of the congregation's being entirely excluded from the nave and I have correspondingly modified my text. Indeed, the passages supporting his thesis clearly speak of the faithful at times entering the nave. Procopius, on the other hand (*Buildings*, I, i, 55 ff., as translated by Mathews, 131), with equal clarity assigns them to the aisles and galleries of the H. Sophia; Maximus Confessor, while specifically excluding them from the chancel, remains unspecific about the nave; and the occasions when the faithful are expressly mentioned as being in the nave are always moments of unusual excitement: the Lesser Entrance at the dedication of the H. Sophia in 563; sermons by John Chrysostomus; political trouble at the Reading of Commemorations.
229. 15. The main source for the Imperial ceremonial is of course Constantine Porphyrogenetos, *Book of Ceremonies* (*P.G.*, CXII; *Bonn Corpus*, IX–X; better (Book I only), *Le livre des cérémonies*, ed. A. Vogt, Paris, 1935, *passim*), which is the basis for J. Ebersolt, *Ste Sophie de Constantinople d'après les cérémonies* (Paris, 1910), as well as for my own description – *faute de mieux* and despite my misgivings regarding the use of a tenth-century source for a sixth-century situation; but, then, both religious and court ceremonial are conservative in the extreme.
16. Mathews, *Churches*, 162 ff., points out that, contrary to former belief, the celebration of the Eucharist was not hidden from profane eyes by curtains either in the chancel screen or around the altar. Regarding the Imperial pew: *ibid.*, 96, 133 ff. The entrance of the Emperor into the sanctuary and his role there have given rise to much discussion. O. von Simson, *Sacred Fortress* (Chicago, 1948), 30, and Dj. Stričević, *Felix Ravenna*, LXXX (1959), 5 ff., maintain that the Emperor actually participated in the offertory procession of the Great Entrance. On the contrary, A. Grabar, *ibid.*, LXXXI (1959), 63 ff., is of the opinion that the Emperor entered the sanctuary only later, during Mass, to deposit a special gift on the altar. Certainly this holds true for the tenth century, when Constantine Porphyrogenetos compiled his *Book of Ceremonies*; but the lack of earlier documentation makes it difficult to judge the custom prevailing in the sixth century.
17. K. Lehmann, *Art Bulletin*, XXVII (1945), 1 ff.; J. B. Ward Perkins, *Proceedings British Academy*, LI (1965), 175 ff. Main sources are Dionysius the Areopagite, *The Ecclesiastical Hierarchy* (*P.G.*, 111, 119 ff.), and *The Celestial Hierarchy* (*ibid.*, 369 ff.), *passim* (both in English translation, John Parker, London, 1894).

18. The intermeshing of Imperial and ecclesiastical ceremonial in the H. Sophia has been frequently observed, e.g. Andreades, *op. cit.*, 58 ff. Regarding the role of the Emperor imitating Christ, see R. Guerdan, as quoted in Chapter 8, Note 1, 17 ff.
230. 19. A. Dupont-Sommer, *C.A.*, 11 (1947), 29 ff., and A. Grabar, *ibid.*, 41 ff.
20. C. Mango and I. Ševčenko, *D.O.P.*, XV (1961), 243 ff.; R. M. Harrison and N. Firatli, *ibid.*, XIX (1965), 230 ff.; *idem*, *ibid.*, XX (1966), 223 ff.; also XXI (1967), 273 ff., and XXII (1968), 195 ff., all reporting on the excavation. Mr Harrison's tentative suggestion (*VII C.A.C.... Trier... 1965*, 545 ff.) of a reconstruction of H. Polyeuktos on a central plan has been superseded (*D.O.P.*, XXI, 1967, 276) by his proposal to view it as a 'domed basilica' with short barrel-vaulted nave and centre dome, like H. Irene prior to 740, or – this less likely – as an ordinary basilica. In *VIII C.A.C. ... Barcelona ... 1969*, 325 f., Mr Harrison comments briefly on the (partly) Sassanian character of the ornament. His final report is in preparation. See also Mathews, *Churches*, 52 ff.
21. See below, p. 263 f.
236. 22. Van Millingen, *Churches*, 62 ff.; Ebersolt and Thiers, *Églises*, 21 ff.; Janin, *Églises*, 466 ff.; P. A. Underwood, *C.A.*, 111 (1948), 64 ff.; Mathews, *Churches*, 42 ff. P. Sanpaolesi, *Rivista dell'Istituto Nazionale d'Archeologia e Storia dell'Arte*, N.S. X (1961), 116 ff., presents a survey and structural analysis of the church correcting the older ones; he suggests that the upper portions of the dome (the lower parts are of brick, pitched on their sides) consist perhaps of some light material, cane or a mixture of straw, lime, and mortar on a wooden frame. This is possible, but so far unprovable. See also the critical remarks of O. Feld, *Ist. M.*, XVIII (1968), 264 ff. The attribution of the design to Anthemios of Tralles (H. Sedlmayr, *Kunstwissenschaftliche Forschungen*, II, 1933, 46 ff.; Sanpaolesi, *op. cit.*, note 29) rests on no historical evidence. For St Peter and Paul, see Procopius, *Buildings*, I, iv, 1 ff. (*L.C.L.*, VII, 42 ff.), and a request by Justinian, supported by the papal legates to Constantinople, dated 519, asking for *brandea* of St Peter, St Paul, and St Lawrence for the church (*Epistolae imperatorum pontificum . . .*, ed. O. Günther, *C.S.E.L.*, XXXV, Vienna, 1895, 644 f., 679 f.). Mathews, *loc. cit.*, convincingly argues for the location of the old church south of H. Sergios and Bakchos; see also, for the location of the Hormisdas Palace at some distance from the seashore, R. Guilland, *Études sur la topographie de Constantinople byzantine*, I (Berlin and Amsterdam, 1969), 294 ff.
C. Mango, *Jahrbuch der österreichischen Byzantinistik*, XXI (1972), 189 ff., *Festschrift Otto Demus*, views H. Sergios and Bakchos, based on a monophysite

account, as built shortly before 536, primarily by Theodora, for the use of monophysite refugee monks camping in the Hormisdas Palace. I still consider it a palace church because of: Procopius' statement to that effect (*Buildings*, I, iv, 7 f.); the church's lavish construction, unlikely in a refugee context; its link by double-storeyed arcades, to St Peter and Paul on one, to other tall structures, presumably of the palace, on the opposite flank; the refugees' account's reference to services held in one of the palace halls rather than in a church; and the refugees' arrival in large numbers probably not before the start of serious persecution in 537. The question of central plan palace churches cannot be dismissed as lightly as Mr Mango attempts.

237. 23. R. Demangel, *Contributions à la topographie de l'Hebdomon* (Paris, 1945); Mathews, *op. cit.*, 55 ff.; Procopius, *Buildings*, I, viii, 6 (St Michael in Anaplus).

24. Both J. B. Ward Perkins (*The Listener*, 1956, 701 ff., 746 ff., and *Great Palace*, *op. cit.*, especially 90 ff.) and F. W. Deichmann (*Studien zur Architektur Konstantinopels*, Baden-Baden, 1956, 38 ff.) stress the origin in Asia Minor of the vaulting techniques of Constantinople under Justinian. Following the thesis set forth by G. T. Rivoira (*L'architettura romana*, Milan, 1921) and G. Giovannoni (e.g. *V.C.E.B. . . . Rome . . . 1938*, II, 133 ff.), G. de Angelis d'Ossat (*Romanità delle cupole romane*, Rome, 1946), S. Bettini (*L'architettura di San Marco*, Padua, 1946), and still L. Crema (*L'architettura romana*, *Enciclopedia classica*, sezione III, vol. 12, tomo I, Turin, 1956, 575) have seen the vaulting system of the H. Sophia as part and parcel of Western Roman vaulting techniques. In contrast, J. B. Ward Perkins, *Great Palace* (*op. cit.*), 91 ff., and *Proceedings British Academy*, LI (1965), 175 ff., stresses the impact of Mesopotamian techniques on Late Roman building in the Aegean area and through it on Byzantine Constantinople.

25. Andreades, *op. cit.*, *passim* and especially 85, views the design of the H. Sophia as fusing into one and further developing what he chooses to call the 'humanistic vaulted space of Rome, the Hellenistic peristyle space, the oriental cave space and the Persian principle of dematerialization'.

26. J. Strzygowski, *Origins of Christian Church Art*, transl. O. M. Dalton (Oxford, 1923), 46 ff. ('In conception the church is purely Armenian') and *passim*. The best, since balanced, interpretation of the role of the East in the formation of Byzantine domed architecture is given by J. B. Ward Perkins, as quoted above, Note 17.

27. W. R. Zaloziecky, *Die Sophienkirche in Konstantinopel . . .* (Rome, 1936); Swift, *op. cit.*, 47 ff. Zaloziecky, *passim*, interprets the plan of the H. Sophia as fundamentally a composite of elements all

traceable back to Roman bath and palace architecture. Rivoira's interpretation (*op. cit.*) of the H. Sophia as deriving from a fusion of the Basilica of Maxentius with the dome of the Pantheon has left its traces still in Andreades, *op. cit.*

28. A. Grabar, *Martyrium* (Paris, 1948), *passim*.

29. Like the Italian scholars, quoted above, Note 24, Zaloziecky was foremost in claiming a purely Western-Roman design for the H. Sophia. Swift inclined towards a Roman-hellenistic derivation; while J. B. Ward Perkins (*The Italian Element in Late Roman and Early Medieval Architecture*, Annual Italian Lecture of the British Academy 1947, Proceedings British Academy, XXXIII, 1947, *passim*), very correctly in my opinion, sees its sources in the tradition of the Roman West, but long fused – with other, still unknown, elements – into the art of Late Antiquity spread all over the Empire. (The quotation incorporated in my text is from p. 21 of Ward Perkins's lecture.)

30. Sedlmayr, *op. cit.* (Note 1); and the critique of Weigand, listed *ibid.*

31. Ward Perkins, *Great Palace*, and Deichmann, *Studien*, as above, Note 24; also Sanpaolesi, as quoted above, Note 22.

239. 32. See above, Chapter 3, and Deichmann, *op. cit.*, *passim*.

33. Deichmann, *op. cit.*, 72 ff.; Harrison (as above, Note 20), *VIII C.A.C. . . . Barcelona . . . 1969*.

240. 34. J. B. Ward Perkins, *Proceedings British Academy*, LI (1965), 198 ff.

241. 35. See above, Chapter 3, Notes 20 ff., Chapter 5, Notes 51 f., and Chapter 6, Notes 9 f.

36. N.T., *Palladio*, II (1938), 149 f., on Canosa. On Ohrid, see G. Babić, as quoted above, Chapter 5, Note 52.

37. See below, pp. 241–2, 340.

38. Grabar, *op. cit.*, *passim*.

39. J. Kollwitz, in *Neue Deutsche Ausgrabungen im Mittelmeergebiet . . .* (Berlin, 1959), 46 ff., in particular, 69.

40. See above, Chapter 5, Note 43.

242. 41. *Funebris Oratio in Patrem*, cap. 39 (*P.G.*, XXXV, 1037; see also, *Funeral Orations*, in L. Schopp (ed.), transl. L. P. McCauley, *The Fathers of the Church*, New York, 1953, 153 f.). A. Birnbaum, *R.K.W.*, XXXVI (1913), 181 ff., has analysed both Gregory's text and the *scholia* which refer to octagonal churches of St John at Alexandria and of the Virgin at Tyre.

42. See above, Chapter 3, p. 80 and Note 23.

244. 43. Outstanding among the publications on S. Vitale are G. Gerola, *Felix Ravenna*, X (1913), 427 ff.; *idem*, XI (1913), 459 ff.; *idem*, XXI (1916), 879 ff.; R. Bartoccini, *ibid.*, XXXVIII (1931), 77 ff.,

and XLI (1932), 133 ff.; finally F. W. Deichmann, *ibid.*, LX (1952), 5, ff.; *idem*, in *Arte del primo millenio* (Turin, 1953), 111 ff.; and again, *idem*, *Ravenna*, I, 226 ff. It remains a point of contention whether or not S. Vitale was intended as a palace church - in view of its plan and decoration, a tempting hypothesis defended by G. de Angelis d'Ossat, *Studi Ravennati* (Ravenna, 1962), 59 ff., and combated by Deichmann (Deichmann's counter-arguments will be offered in his forthcoming volume, 11). The question is obviously linked to that of Julianus's position - whether he was just a wealthy banker or also the head of a fifth column in still-Gothic Ravenna - as well as to the significance of the Imperial portraits in the chancel - whether they merely indicate Imperial financial contributions or have a deeper significance.

246. 44. See Deichmann, *Arte del primo millenio* (*op. cit.*), and *Ravenna*, I, 54, on the brickwork. On the hollow tube vault, see *ibid.*, 54 f.; De Angelis d'Ossat, *op. cit.*, 135 ff.; and G. Bovini, *Felix Ravenna*, LXXXI (1960), 78 ff.

CHAPTER 10

251. 1. J. B. Ward Perkins, *The Listener* (1956), 748.
2. See for Gerasa, A. Boëthius and J. B. Ward Perkins, *Etruscan and Roman Architecture (Pelican History of Art)* (Harmondsworth, 1970), 438 ff.; for Side, Arid Müfid Mansel, *J.D.A.I., A.A.*, LXXIV (1959), 364 ff., and figure 3.
3. Forchheimer and Strzygowski, as quoted above, Chapter 3, Note 8; Schneider, *Byzanz* (Berlin, 1938), *passim*.
252. 4. See below, p. 267.
5. The mausoleum of Leonidas, probably of fourth-century date, is well preserved, incorporated into the Ilissos basilica at Athens, in the corner between the aisle and north transept; see above, Chapter 5, p. 126 and Note 42. For the East Mausoleum at Side, see above, Note 2. The sixth-century mausoleum at Hass and a similar one at Ruwêha are illustrated in Butler, *Architecture*, 246 f. S. Guyer, *Grundlagen mittelalter-licher europäischer Baukunst* (Einsiedeln, 1950), 30 ff., adds other examples of tombs and martyria of this type.
6. See above, pp. 192-3, 87, 186.
253. 7. A. Xyngopoulos, *Deltion*, XII (1929), 142 ff.; E. Kitzinger, *XI C.E.B.... Munich ... 1959*, Berichte, 24. Both authors suggest a date shortly before 500, for the building as well as for the mosaics. But dates as early as 450 and as late as 535-40 have likewise been suggested.

8. Lassus, *Sanctuaires*, 147 f.; St Elias at Izra (Ezra') is dated 542 through an inscription. For Rometta, see G. Agnello, *L'architettura bizantina in Sicilia* (Florence, 1952), 305, and P. Lojacono, *I monumenti bizantini della Sicilia* (Florence, 1951), 61 f., and figure 83 ff.; the building is of unknown date, but very possibly of the sixth century.
9. See above, Chapter 9, p. 230 and Note 19.
10. Procopius, *Buildings*, I, x, 8 ff.; for the Chalki see also C. Mango, *The Brazen House* (*Kgl. Danske Vidensk. Selskab, Arkaeologisk-kunsthistoriske Meddelelser*, 4, 4) (Copenhagen, 1959), 30 ff.
254. 11. The principal sources for visualizing Justinian's Holy Apostles are Procopius, *Buildings*, I, iv, 9 ff. (also his comparison with St John at Ephesus, *ibid.*, v, i, 4 ff.), and the poem of Constantine the Rhodian (*Revue des Études Grecques*, IX, 1896, 32 ff.) *c.* 940; see also Janin, *Églises*, 46 ff. Reconstructions have been frequently attempted, for instance by A. Heisenberg, *Grabeskirche und Apostelkirche* (Leipzig, 1908), 11, *passim*, and S. Bettini, *L'architettura di San Marco* (Padua, 1946), 53 ff. However both the description by Nicholas Mesarites (trans. G. Downey, *Transactions American Philosophical Society*, N.S. XLVII, 1957, 855 ff.) and the depictions of the church (see below, Chapter 17, Note 78) refer to the church after a remodelling between 940 and 979-89.
257. 12. Procopius, *Buildings*, V, i, 4 ff. *Forschungen in Ephesos*, IV, 3, 19 ff. presents a careful survey of the remnants and, 157 ff., a tentative, if somewhat fanciful, reconstruction. One side of the westernmost bay was rebuilt in 1963. Regarding S. Marco in Venice and the Church of the Holy Apostles, see below, pp. 431-6 and Chapter 17, Note 78.
13. Kautzsch, *Kapitellstudien*, 177 f., and figures 566 a-f *versus* 567 a-e.
258. 14. E. Herzfeld and S. Guyer, *Meriamlik and Korykos* (Manchester, 1932), 46 ff.; G. Forsyth, *D.O.P.*, XI (1957), 227 ff.
15. Herzfeld and Guyer, *op. cit.*, figure 64.
16. Herzfeld and Guyer, *op. cit.*, 70 ff., envisage the building as vaulted throughout as first proposed by them, *J.D.A.I., A.A.*, XXIV (1909), 433 ff. I no longer favour the proposal. The reconstruction with pyramidal timber roof, first suggested by Forsyth, *op. cit.*, has been accepted by Gough, *Anatolian Studies*, XXII (1972), 202 f. J. Kramer, *B.Z.*, LVII (1963), has traced the remains of an attached baptistery.
260. 17. A. C. Headlam, *Ecclesiastical Sites in Isauria*, The Society for the Promotion of Hellenic Studies, Supplementary Papers, 1 (London, 1893), 9 ff.; M. Gough, *Anatolian Studies*, V (1955), 115 ff., *ibid.*, XIV (1964), 185 ff., and XXII (1972), 199 ff.; see also above,

Chapter 5, Note 20, and G. Forsyth, *D.O.P.*, XI (1957), 223 ff., esp. 228 ff.

18. Gough, while formerly inclining towards a date shortly after 450, has meanwhile settled on the last quarter of the century, during the reign of the Emperor Zeno (*Anatolian Studies*, XXII, 1972, 199 ff.). Indeed, the date proposed by Forsyth, *op. cit.*, and Kautzsch, *Kapitellstudien*, 96 and 221, about 550 or 560, is certainly too late. A sixth-century date, though preferably early in the century, might be possible as accepted in the first edition of the present volume, 179, based on both the eagle capitals on the ground floor (E. Kitzinger, *D.O.P.*, I, 1946, 1 ff.: second half of the fifth century; F. W. Deichmann, *Charistirion eis A. K. Orlandon*, I, Athens, 1965, 136 ff.: fifth and sixth century; also J. Kramer, *Skulpturen mit Adlerfiguren . . .*, Ph.D. thesis, Munich, 1968, 76, 93 f., and O. Feld, *B.Z.*, LXI, 1968, 205) and the basket capitals carrying the colonnettes of the squinches; however, I now incline towards Gough's recent dating.

19. Headlam, *op. cit.*, 20 f., who knew Dağpazari by the name of Kestel, interpreted the remnants as those of a basilica on piers. Forsyth, *op. cit.*, and Gough, *Anatolian Studies*, XXII (1972), 199 ff., re-interpret the plan along the lines of Alahan Manastir.

261. 20. Butler, *Early Churches*, 191; Lassus, *Sanctuaires*, 146 f.; see also below, Chapter 11, Note 4.

262. 21. The galleries have collapsed since the time of Butler's visit and the capitals seem to have disappeared.

263. 22. *Forschungen in Ephesos*, IV, 1, 51 ff.

23. W. S. George, *The Church of St Eirene* (London, 1913); Van Millingen, *Churches*, 84 ff.; Ebersolt and Thiers, *Églises*, 57 ff.; Janin, *Églises*, 108 ff.; Mathews, *Churches*, 77 ff.; and, for the atrium of 564, P. Grossmann, *Ist. M.*, XV (1965), 186 ff. A study by Mr Peschlow is in preparation. The interpretation of the building history proposed by H. Buchwald, *The Church of the Archangels at Sige* (Vienna, 1968), note 251, seems to me erroneous.

265. 24. P. Mutafjiev, *I.B.A.I.*, V (1915), 50 ff.; V. Ivanova, *G.N.M. Sofia*, IV (1922-5), 429 ff., with French résumé. Professor Dj. Stričević was kind enough to communicate to me his convincing observations on the remodelling of the church at Pirdop; see also *idem*, *XII C.E.B. . . . Ohrid*, *Actes*, 169 and note 18.

266. 25. R. W. Hamilton, *P.E.F.Q.St.* (1930), 178 ff., quotes in translation the description of the church as given by Choricius, after 536, when building and decoration were complete; see also Pauly-Wissowa, *R.E.*, III, 2424 ff. The first reconstruction proposed is Hamilton's; the second was suggested by some of my students in a seminar discussion.

26. P. Lemerle, *Philippes et la Macédoine orientale* (Paris, 1945), 415 ff.

267. 27. H. H. Jewell and F. W. Hasluck, *Our Lady of the Hundred Gates in Paros* (London, 1920). The capitals are discussed by Kautzsch, *Kapitellstudien*, 188. See also above, Chapter 5, Note 50.

268. 28. T. Fyfe, *Architectural Review*, XXII (1907), 60 ff.; A. K. Orlandos, *Epitiris* (1926), 301 ff.; G. Gerola, *Monumenti veneti nell'isola di Creta* (1908), II, 29.

270. 29. Mavrodinov (1959), 30 f., and St. Boyadjiev, in *Studia in honorem Acad. D. Dečev, Acad. Bulgare des Sciences* (1958), 611 ff., and Dj. Stričević, *XII C.E.B. . . . Ohrid, 1961, Rapports*, 176, correctly maintain a sixth-century date for the church, contrary to the medieval dates proposed by A. Protič, *Sofijskata crkva sv. Sofija* (Sofia, 1912), and Filow, same title, 1913.

CHAPTER 11

271. 1. Procopius, *Buildings*, *passim*.

2. Examples are too numerous to list, but smaller and larger fortresses and forts abound from North Africa (Gsell, *Monuments*, II, 366 ff.; P.-A. Février, *C.C.R.*, 1970, 147 ff.) to Syria (Butler, *P.E.*, *Southern Syria*, 70 f., 80 ff., 145 ff., 340 ff.; *Northern Syria*, 102), Jordan (R. E. Brünnow and A. von Domaszewski, *Die Provincia Arabia*, Strassburg, 1904, II, 433 ff.), the Yugoslav Danube (*Srpska Akademija Nauka, Anciennes Cultures du Djerdap*, ed. L. Trifunović, Belgrade, 1969, 88 ff.), and Carinthia (R. Egger, *J.Ö.A.I.*, XXV, 1929, 189 ff.). In many cases, Justinian's engineers seem to have remodelled fortified posts originally built by Trajan and Diocletian as *limes* defences, e.g. Koser-al-Hallabât in Syria (Butler, *P.E.*, *Southern Syria*, 70 f.) and Veliki Gradac on the Danube. Among fortified places in North Africa, some turn out to antedate the Byzantine re-conquest by a century and more, such as Henchir Faraoun (P.-A. Février, *C.C.R.*, 1970, 166 ff.).

3. Procopius, *Buildings*, e.g. II, i, 3 ff.; III, iv, 12; V, vii, 7; V, viii, 5, etc. Regarding the Virgin as defender of the cities, also *ibid.*, I, iii, 9; VI, ii, 20.

272. 4. See above, p. 261, and Butler, *P.E.*, *Northern Syria*, 34 ff., 40 ff.

5. See above, pp. 166-7 (also Chapter 6, Note 35), and Procopius, *op. cit.*, V, vii, 16 f.

6. Procopius, *Buildings*, V, viii, 4 ff. Church and convent on Mt Sinai are still under study by a joint expedition, led by Professors Weitzmann and Forsyth; I am greatly indebted to my friend Forsyth for the information and the photographs he has kindly supplied. The dilemma remains as to whether the church was dedicated to the Virgin, as suggested by Procopius,

or to the Transfiguration, as intimated by the apse mosaic.

273. 7. Avdot: see C. L. Woolley and T. E. Lawrence, *The Wilderness of Zin* (London, 1936), 86 ff.; Ovadiah, *Corpus*, 23 ff. Haïdra: the old publications (Gauckler, *Basiliques*, plate XIV, and S. Gsell, *II C.A.C.* . . . *Rome . . . 1900*, 225 ff.) are being replaced by N. Duval, *C.R.A.I.* (1968), 221 ff., and *ibid.* (1971), 136 ff.
8. G. Millet, *Le monastère de Daphni* (Paris, 1899), 4 ff. (the dating, *ibid.*, 16, is of the vaguest). The fortified wall of the church at Tebessa, formerly assigned to the fifth (Gsell, *Monuments*, 287 f.) or sixth century (Ch. Diehl, *Nouvelles Archives des Missions scientifiques*, IV, 1893, 331), is now thought to be contemporary with the church or but shortly later (J. Christern, *C.C.R.*, 1970, 103 ff.).
9. A. K. Orlandos, *Monastiriaki Architektoniki* (Athens, 1958; 1st ed. 1927), 28, quoting Justinian, *Novellae*, 5, 3; 123, 36; 133, introduction.
274. 10. Procopius, *Buildings*, II, ix, 3 ff. The Sergius Basilica – that is, Basilica A – has been surveyed by Spanner and Guyer and, with corrections, by Kollwitz, as quoted above Chapter 6, Note 27; Basilica B and the tetraconch are discussed by Kollwitz, *op. cit.*, and W. Wirth, in *Tortulae* (*R. Qu. Schr.*, Suppl. 30), 326 ff. The building outside the walls (Butler, *Churches*, 170, as 'Central Church') was the audience hall of Al-Mundir (J. Sauvaget, *Byzantion*, XIV, 1939, 115 ff.). For the data regarding Al-Mundir's reign and fall (in 581) and his subsequent exile to Sicily, see P. Goubert, *VI C.E.B.* . . . *Paris . . . 1948*, I, 103 ff.
277. 11. Procopius, *Buildings*, IV, i, 19 ff. See also V. R. Petković, *C.A.*, III (1948), 40 ff.; A. Grabar, *ibid.*, 49 ff.; moreover the successive excavation reports in *Starinar*. The Arheološki Institut, *Caričin Grad 1912-1962* (Belgrade, 1962), has published the bibliography up to then, to be complemented by Đ. Mano-Zisi, *Starinar*, XV-XVI (1964-5), 50 ff.; *ibid.*, XIX (1968), 111 ff. Also, on the urban layout, Đ. Bošković, *ibid.*, XV-XVI (1964-5), 47 ff., and N. Petrović, *ibid.*, 61 ff.
278. 12. Majdan, Mokro Polje, and Lovrečina (I. Nikolajevič, *Zb. R.*, X, 1967, 87 ff.) in the Dalmatian mountains, Breza in Bosnia (*idem, ibid.*, 95 ff.), Duel near Feistritz and St Peter im Holz (Teurnia) in Carinthia (G. C. Menis, *La basilica paleocristiana nelle diocesi settentrionali della metropoli d'Aquileia*, Vatican City, 1958, 105 ff., 136 ff.).
13. Butler, *Churches*, and Lassus, *Sanctuaires, passim*; regarding El-Anderin, Butler, 158 ff.; for Avdot, above, Note 7; for Sbeïta (Shivta), Ovadiah, *Corpus*, 166 ff.; for Mamshit (Kurnub), see above, Chapter 6, Note 39.

14. *Antioch*, I, *passim*; II, 59 ff.; III, 1 ff.; see also Butler, *Architecture*, 251 ff.; Tchalenko, *Villages*, *passim*.
279. 15. W. Harvey and others, *The Church of the Nativity at Bethlehem* (Oxford, 1910); B. Bagatti, *Gli edifici antichi di Betlemme* (Jerusalem, 1952). The date of construction is in doubt; while Procopius' silence suggests a *terminus post c.* 560 (unless one assigns the trefoil church a date before Justinian's reign), a poem datable 603-4 (Bagatti, *op. cit.*, 12; Harvey, *op. cit.*, 57, gives the date 635) provides a *terminus ante*. M. Restlé, *R.L.B.K.*, I, 599 ff. suggests a fifth-century date – unconvincingly to me, given the fifth-century date of the mosaics in the first, Constantinian church and the resemblance of the ornament on the wooden architraves in the present structure to Ummayad work.
16. E.g. at Dodona and at Paramythia; Sotiriou, *Basilikai*, 203 ff.
280. 17. Janin, *Églises*, 169 ff., in particular 175 f., quotes two epigrams 'in the apses [arches?] of the Blachernae' from the *Anthologia Palatina*; see also Richter, *Schriftquellen*, 164 ff.
18. G. Agnello, *Byzantion*, XXXIII (1963), 1 ff.
19. Information on the excavation of these two churches, undertaken in 1962, was kindly supplied by Mr Widrig. For Proconnesian pieces found in the West Church at Apollonia, see W. Widrig and R. Goodchild, *P.B.S.R.*, XXXVIII (1960), 70 ff., especially 73. For summaries, also R. Goodchild, *C.C.R.* (1966), 205 ff., 225 ff.
20. I. Nikolajević-Stojković, *La décoration architecturale sculptée . . . en Macédoine, en Serbie et au Monténégro* (Belgrade, 1957) (in Serbian, with French summary).
281. 21. Recent finds (*Bulletin de correspondance hellénique*, LXXXIV, 1960-1, 254 ff.; St. Bojadžiev, *Byzantino-Bulgarica*, I (1962), 361 ff.) suggest for the Old Metropolis, instead of the formerly adopted tenth-century date (A. Rašenov, *Églises de Mesembria*, Sofia, 1932, 2 ff.), a sixth-century origin, and a later rebuilding on the old plan, but with changed elevation.
282. 22. J. Christern, *VII C.A.C.* . . . *Trier . . . 1965*, 407 ff.; N. Duval, *C.R.A.I.* (1971), 136 ff. (Haïdra); and recently J. Christern, *Bulletin d'archéologie algérienne*, III (1968), 193 ff. (Tipasa, S. Salsa). See also above, Chapter 2, Note 18.
23. *Corpus*, I, 14 ff. (S. Agnese); II, 1 ff. (east church of S. Lorenzo).
284. 24. R. Heidenreich and H. Johannes, *Das Grabmal Theoderichs zu Ravenna* (Wiesbaden, 1971), bring a detailed survey together with a new proposal for a graphic reconstruction. In my opinion, however, the

reconstruction with upper gallery, as suggested by G. de Angelis d'Ossat, *Studi Ravennati* (Ravenna, 1962), 91 ff., still remains slightly more convincing. Earlier interpretations, often based on racial theories (A. Haupt, *Das Grabmal Theoderichs des Grossen* . . ., Leipzig, 1913), or on unchecked architectural fantasy (C. Cecchelli, *Felix Ravenna*, LXXII, 1956, 5ff.), have been dealt with by E. Dyggve (*Studi in onore di . . . Calderini e . . . Paribeni*, III, 765 ff., and *Kung Theoderik og den nordiske runddysse*, Copenhagen, 1957), and by K. Wessel, in *Das Altertum*, IV (1958), 229 ff. A collateral relationship of the monolithic dome to megalithic tomb covers seems to me nonetheless possible.

286. 25. E. Dyggve, *op. cit.*; A. Grabar, *Martyrium* (Paris, 1916), 140 ff., 204 ff.; for further examples, S. Guyer, *Grundlagen mittelalterlicher europäischer Baukunst* (Einsiedeln, 1950), plate 1.

26. R. M. Harrison, *Anatolian Studies*, XIII (1963), 117 ff.; also Rott, *Denkmäler*, 318 ff. Alongside Alakilise, apparently rebuilt in 812, basilicas abound in the region, their apses either semicircular or polygonal outside (Harrison, *op. cit.*). No explanation can so far be given for the frequent occurrence of trefoil sanctuaries (*ibid.*).

27. See above, Note 11, and Đ. Mano-Zisi, *Starinar*, XVII (1966), 163 ff.; P. Spremo-Petrović, *ibid.*, IX-X (1958-9), 169 ff.; Dj. Stričević, *XII C.E.B.* . . . *Ohrid, Rapports*, VII, *passim*; and Hoddinot, *Churches*, 204 ff.

287. 28. Đ. Mano-Zisi, *Starinar*, III-IV (1952-3), 156 ff.; Dj. Stričević, *XII C.E.B.* . . . *Ohrid, 1961, Actes*, 224 ff. The reconstruction of a dome over the nave of the cathedral (V. R. Petković, *C.A.*, III, 1948, 40 ff.) is erroneous.

288. 29. S. Radojčeč, *Zb.R.*, I (1952), 148 ff.; Hoddinot, *Churches*, 220 ff.; for Fal'ul, see Butler, *Churches*, 164 ff.

30. Dj. Stričević, *Zb.R.*, I (1952), 179 ff. (with French summary); *idem, X C.E.B.* . . . *Istanbul* . . . *1955* 171 ff.; N. Petrović, *Starinar*, VII-VIII (1956-7), 165 ff.

31. *Corpus*, I, 304 ff., and, with slightly later date, W. and R. Schumacher, *Kölner Domblatt* (1957), 22 ff.

32. Belovo: A. Frolov, *Bulletin Byz. Inst.*, I (1946), 43 ff.; Tolmeita: C. H. Kraeling, *Ptolemais, City of the Libyan Pentapolis* (Chicago, 1962), 97 ff.

289. 33. N. Duval, *C.R.A.I.* (1971), 160 ff.; *idem, ibid.*, 136 ff.; *idem, ibid.* (1969), 419 ff.; *idem, Sbeitla et les églises africaines à deux absides*, I (Paris, 1971), 63 ff.; Gauckler, *Basiliques*, plates I, XV, XXXII, XXXVIII; J. B. Ward Perkins and R. G. Goodchild, *Archaeologia*, XCV (1953), 24 ff., 70.

34. For example, S. Pietro at Syracuse, S. Foca near Priola Gargallo, a ruin near Palagonia, and, with triconch sanctuary, S. Pietro ad Bajas, Syracuse (G. Agnello, *L'architettura bizantina in Sicilia*, Florence, 1952, 81 ff., 89 ff., 93, 295; G. Libertini, *Atti I° Congresso Nazionale di Archeologia Cristiana*, 1952, 201 ff., erroneously maintained that the arcades of the nave marked the outer limits of these churches).

35. St Laurent at Grenoble; the late-eighth- or ninth-century date suggested by J. Hubert, *Arte del primo millenio* (Turin, 1953), 327 ff., and M. Viellard-Troiekouroff, in *Karl der Grosse*, III, ed. W. Braunfels (Düsseldorf, 1965), 359 f., has not been generally accepted.

290. 36. See above, Note 6. High quality though it is, the apse mosaic is no longer attributed to a Constantinopolitan workshop. For the towers, one might compare, e.g., the Acheiropoietos in Salonica (above, p. 105). The site of the martyrium, the Burning Bush, originally under the open sky behind the apse, was apparently replaced only later by the present chapel. Comparable to the insertion of a precious apse mosaic into the crude basilica on Mt Sinai, a church at Sabratha (Church 2) is provided with a splendid floor mosaic, obviously laid by a workshop brought into Tripolitania from overseas, although the church itself is traditional in plan and crude in execution (Ward Perkins and Goodchild, as above, Note 33, 12 ff.).

37. See above, Chapter 2, Note 45.

38. M. Mazzotti, *La basilica di Sant'Apollinare in Classe* (Vatican City, 1954); Deichmann, *Ravenna*, I, 257 ff.

291. 39. See also above, pp. 193-5.

293. 40. B. Molajoli, *La basilica eufrasiana di Parenzo* (Padua, 1943), with bibliography; M. Prelog, *Poreč* (Belgrade, 1957), 93 ff.; A. Šonje, *Felix Ravenna*, XLIV (1967), 51 ff. (on the stuccoes).

295. 41. G. Brusin, *Aquileia e Grado* (Padua, 1956); M. Mirabella Roberti, *Grado* (Grado, 1956).

42. Verzone (1942), 56 ff., and previous note.

PART FIVE:
CHURCH BUILDING AFTER JUSTINIAN

CHAPTER 12

297. 1. G. Ostrogorsky, *History of the Byzantine State* (Oxford, 1956), 72 ff.

2. *Ibid.*, 119 ff., and, for the relation of iconoclasm and art, A. Grabar, *L'iconoclasme byzantin* (Paris, 1957), and E. Kitzinger, *D.O.P.*, VIII (1957), 83 ff.

CHAPTER 13

299. 1. Rott, *Denkmäler*, 299 ff. A new study is under way; see the preliminary reports, J. Morganstern, *D.O.P.*, XXII (1968), 217 ff., and *idem* and R. Stone, *ibid.*, XXIII/XXIV (1969-70), 383 ff.; for the probable date, *ibid.*, 393. I am indebted to Mr Morganstern and Mr Martin Harrison for a set of splendid photographs.

301. 2. C. Mango, *Zb. R.*, XI (1968), 9 ff.; F. Dirimtekin, *Aya Sofia Müzeleri Yılliği*, III (1961), 47 ff.; and S. Eyice, *C.C.R.* (1971), 293 ff., who suggests a fourteenth-century date.

302. 3. H. Buchwald, *The Church of the Archangels at Sige* (Vienna, 1968), 36 ff., has taken up anew the question of type, origin, and development of the cross-domed church. He rightly points to the limitations of our present knowledge regarding the individual buildings of the group, but nonetheless suggests (p. 61) a development which I consider over-rigid; as witness the dates, contrary to his, now secured for the Gül and Kalenderhane Camii. I vastly prefer my own concept of often contemporary variants. Nor can I agree on applying his term 'cross-domed basilica' (*op. cit.*, 47 and note 213) to both St Clement at Ankara and the Koimesis at Nicaea; I consider it essential to distinguish between a 'true cross-domed church' with cross arms of equal depth, as at the Koimesis, and a 'compact domed basilica' with barely developed lateral arches, as at St Clement. Indeed, both the terms 'cross-domed basilica' (Koimesis) and 'cross-domed basilica with inscribed aisles' (Dere Ağzi, *op. cit.*, 52) seem to me inappropriate and a bit clumsy.

St Clement at Ankara was surveyed before its destruction by G. de Jerphanion, *Mélanges de l'Université Saint-Joseph à Beyrouth*, XIII (1928), 113 ff. St Nicholas at Myra, badly rebuilt, in particular in its upper portions, in 1862, was last published by Rott, *Denkmäler*, 324. Since then large parts of the furnishings have gone and new repairs, inside and out, have obscured the picture. Altogether the situation is far from clear, in particular with regard to the structures south of the main church. A study, under way some years ago, has not yet led to published results. Meanwhile, Mr Morganstern has kindly provided me with photographs and notes.

C. F. M. Texier's surveys of St Clement at Ankara and St Nicholas at Myra (*Description de l'Asie mineure*, Paris, 1839-49, I, plate 71; III, plate 222) are unreliable. The sixth-century date proposed for St Clement by Jerphanion is untenable.

As to Sige, the reconstruction as a cross-domed church, proposed by Buchwald, *op. cit.*, seems to me far from secured, given the lack of information regarding shape and, indeed, existence of enveloping

spaces; most certainly, the church had no galleries, an element integral, it seems to me, to the basic type.

307. 4. For the Koimesis church see: O. Wulff, *Die Koimesiskirche in Nicaea* (Strassburg, 1903); T. Schmit, *Die Koimesiskirche von Nikaia* (Berlin and Leipzig, 1927), based on a survey made in 1912; P. A. Underwood, *D.O.P.*, XIII (1959), 235 ff., regarding the pre-iconoclast first state of the apse mosaic; E. Kitzinger, *XI C.E.B. . . . Munich . . . 1958*, *Berichte*, 1 ff. regarding the import of this observation for dating the architecture; and C. Mango, *D.O.P.*, XIII (1959), 245 ff., pointing out (250 f.) the elimination, after 1065, of the galleries and the rebuilding of the lateral tympana and the narthex. (U. Peschlow, *Ist. M.*, XXII, 1972, 145 ff., doubts the original existence of galleries and correctly denies the use of recessed brick.) For H. Sophia at Salonica, see: H. Saladin and M. Le Tourneau, *Les monuments chrétiens de Salonique* (Paris, 1918), plates 35-49; M. Kalligas, *Die Hagia Sophia von Thessalonike* (Würzburg, 1935); *idem*, *Praktika*, 1936 to 1944; S. Pelikanides, *IX C.E.B. . . . Salonica . . . 1953*, 398 ff., proposing a single-storeyed domed narthex and low towers (further proof will be required). Buchwald, *op. cit.*, 43, suggests a building date 780-7 - too late, in my opinion.

Previous surveys of the Kalenderhane Camii and suggestions regarding its date and original dedication (Van Millingen, *Churches*, 183 ff., as Mary Diaconissa; N. Brunov, *B.Z.*, XXXII, 1932, 54 ff.; J. Kollwitz, *R. Qu. Schr.*, XLII, 1934, 233 ff., as Akataleptos and ninth-century, followed by Schneider, *Byzanz*, 51, and Janin, *Églises*, 518 ff.) can be discarded in the light of the study of the present structure and preceding buildings undertaken by C. L. Striker and Y. D. Kuban (final publication in preparation); at present see the preliminary reports, *D.O.P.*, XXI (1967), 267 ff.; *ibid.*, XXII (1968), 185 ff.; and *ibid.*, XXV (1971), 251 ff.

For the Gül Camii (Ebersolt and Thiers, *Églises*, 113 ff.; Van Millingen, *Churches*, 164; Janin, *Églises*, 150 ff.; N. Brunov, *B.Z.*, XXX (1929/30), 554 ff.) see now H. Schäfer, *Die Gül Camii in Istanbul*, *Ist. M.*, Beiheft VII (Tübingen, 1973), establishing a date about 1100.

A number of other structures in Constantinople were formerly listed as cross-domed churches of the period extending from the late sixth to the early ninth centuries; the Koča Mustafa Pasha Camii (presumably St Andrew in Krisei); the core of the Chora Church (Kariye Camii); the core of the Pammakaristos (Fetiyeh Camii) (Van Millingen, *Churches*, 106 ff., 288 ff., 138 ff.; Janin, *Églises*, 32 ff., 217 ff., 545 ff.). However, the Kariye Camii has nothing whatever to do with the cross-domed plan and is moreover of

eleventh- or twelfth-century date; P. A. Underwood, *The Kariye Djami* (London, 1967). The Koča Mustafa Pasha Camii, formerly identified with St Andrew in Krisei and dated into the sixth century (Van Millingen, *Churches*, 106 ff.; Kautzsch, *Kapitellstudien*, 179 f.), appears to be a thirteenth-century version of the cross-domed plan; see S. Eyice, *IX C.E.B. . . . Salonica . . . 1953*, 184 ff.; *idem, Son Devir Bizans Mimârisi* (Istanbul, 1963; with German summary), 5 ff.

309. 5. Kalligas, *op. cit.*; the sixth-century capitals, which to previous students had suggested an earlier date, are spoils (Kautzsch, *Kapitellstudien*, 141 ff., 185 f.).

6. Underwood and Kitzinger, as above, Note 4.

7. See above, Note 4, for both the Gül and the Kalenderhane Camii. Regarding the recessed brick technique at the Gül Camii, see Schäfer, as quoted there, and below, pp. 375–6 and Chapter 17, Note 3.

8. Van Millingen, *Churches*, 191 ff.; Schneider, *Byzanz*, 53; Janin, *Églises*, 416. The date of construction has been placed in the ninth, tenth, and eleventh centuries, but it may be later still.

310. 9. G. H. Hamilton, *Art and Architecture of Russia (Pelican History of Art)* (London, 1957), *passim*.

10. G. M. L. Bell, *Churches and Monasteries of the Tur Abdin (Zeitschrift für Geschichte der Architektur, Beiheft*, IX) (Heidelberg, 1913), 88 ff.; Kautzsch, *Kapitellstudien*, 222. The structure no longer stands, see *ibid*. Miss Bell's assumption, accepted by Leroy, *op. cit.*, 480, that the church was vaulted seems to me erroneous, as witness her photographs of aisles and galleries. Only the apse and its flanking chambers carried vaults: nave and ancillary spaces were in all likelihood timber-roofed (or, the former, timber-domed). The date 591 is questioned by C. Foss in Buchwald, *op. cit.*, note 219; but the ornamentation can hardly be later.

11. M. Ballance, *P.B.S.R.* (1955), 99 ff., revising Rott, *Denkmäler*, 32 ff., and suggesting with Kautzsch, *Kapitellstudien*, 183, a date 'not much later than the time of Justinian' for the capitals.

311. 12. C. Mango, in *Polychronion, Festschrift Franz Dölger* (Heidelberg, 1966), 358 ff.

312. 13. The history of Byzantine liturgy requires further elucidation. At this point, see G. Dix, *The Shape of the Liturgy* (London, 1947), 443 ff.; J. M. Hanssens, *Institutiones liturgicae rituum orientalium* (Rome, 1930 ff.), II, III, *passim*; Mathews, *Churches, passim*.

14. See above, Chapter 6, Note 23; and regarding the placing of the entrances in Syria, Chapter 6, Note 20.

313. 15. For other examples see Orlandos, *Basiliki*, 130 ff.

16. The older view linked the triple sanctuary to the alleged introduction of the *trisagion* in 567 (E. H. Freshfield, *Archaeologia*, XLV, 1877–80, 57 ff.); but neither the date nor the link can be sustained. Present opinion on the question of prothesis and diaconicon is best summarized by Lassus, *Sanctuaires*, 162 ff.; G. Bandmann, *Kunstgeschichtliche Studien für Hans Kaufmann* (Berlin, 1956), 19 ff.; Dj. Stričević, *Starinar*, IX–X (1958–9), 59 ff.; A. K. Orlandos, *Deltion Christianikis Archaiologikis Hetairias*, Ser. 4, IV (1964), 353 ff.; and Mathews, *Churches, passim*.

17. For the examples quoted, see above, *passim*; also Stričević, *op. cit.*, and (for Sebaste) N. Firatli, *C.A.*, XIX (1969), 151 ff. Within the context, H. David at Salonica (above, p. 253 and Chapter 10, Note 7) presents a problem: side chambers (with niches) flank the chancel bay, but they open only into the cross arms, not into the chancel as well; hence their function remains unclear, as does that of the chambers at S. Apollinare in Classe.

Mathews, *op. cit.*, stresses the absence of triple sanctuaries from Constantinopolitan church planning prior to Middle Byzantine times, and points out (*op. cit.*, 84, 94) that the bays flanking the chancel in both H. Irene and H. Sophia were simply entrance bays. The corresponding areas at H. Polyeuktos (*ibid.*, 55) could have sheltered staircases; but the problem wants further study.

18. See above, pp. 228–9 and Chapter 9, Note 14.

314. 19. For the following, see, despite their vagueness, O. Wulff, *B.Z.*, XXX (1929–30), 531 ff., and P. A. Michaelis, *An Aesthetic Approach to Byzantine Art* (London, 1955).

20. The symbolism of the church building is summed up with admirable clarity by O. Demus, *Middle Byzantine Churches and their Decoration* (London, 1948), 14 ff. The main sources are: Maximus Confessor, *Mystagogia*, *P.G.*, XCI, 660 ff. (also Urs Balthasar, *Kosmische Liturgie*, Freiburg, 1946, esp. 246 f.); Germanos, *Ecclesiastical History*, *P.G.*, XCVIII, 383 ff.; Simeon of Salonica, *Peri tou Agiou Naou*, *P.G.*, CLV, 305 ff., esp. 387 ff.

CHAPTER 14

318. 1. A. von Harnack, *Mission*, English ed. (1908), II, 142 ff.

2. The Syriac text of the chronicle, as translated by L. Hallier, *Über die edessenische Chronik (Texte und Untersuchungen*, IX, 1892, 1), 86, 'the sanctuary of the Christian congregation' is ambiguous. See also A. von Harnack, *op. cit.*, II, 86; J.-R. Laurin, in *Analecta*

Gregoriana, LXX (Rome, 1954); E. Kirsten, *J.A.C.*, VI (1950), 144 ff., esp. 161 f.

3. D. Talbot Rice, *Antiquity*, VI (1932), 276 ff.; U. Monneret de Villard, *Le chiese della Mesopotamia* (*Orientalia Christiana Analecta*, CXXVIII) (Rome, 1940); O. Reuther, *Ausgrabungen der Deutschen Ktesiphon-Gesellschaft, 1928-1929* (Berlin, n.d.).

4. Monneret de Villard, *op. cit.*, 51 ff.; Rice, *op. cit.*, *passim*.

5. G. M. L. Bell, *Churches and Monasteries of the Tur Abdin* (London, 1913), *passim*; S. Guyer, *R.K.W.*, XXXV (1912), 481 ff.; Monneret de Villard, *op. cit.*, 45 ff.; J. Leroy, *C.R.A.I.* (1967), 324 ff., (1968), 478 ff. A large number of the churches, according to information kindly supplied by my late friend Johannes Kollwitz and confirmed by Leroy, *op. cit.* (1968), are well preserved.

319. 6. The type is well represented by Mâr Yaqub at Nisibis (Bell, *op. cit.*, 96 ff.). The date 359 frequently assigned to the church (e.g. Monneret de Villard, *op. cit.*, 87) can refer neither to the decoration, which is of sixth-century date (Kautzsch, *Kapitellstudien*, 222 f.), nor to the construction, which coincides with fifth- and sixth-century Syrian building.

7. Mâr Ibrahim at Midyat; Mâr Yaqub at Šalāḥ (Bell, *op. cit.*, 68 ff.).

8. El'Adhra, Ḥaḥ (Bell, *op. cit.*, 82 ff.). The drum of the church (our illustration 263) was raised in 1907 adding a second arcade; see Bell, *op. cit.*, 82, and Leroy, *op. cit.*, 484.

320. 9. Guyer, *op. cit.*, published the ruin of a church at Surg Hagop in Commagene, but closely related to Tur Abdin architecture and dated through an inscription between 818 and 845, where the transverse nave was enveloped by projecting arched niches carrying a gallery. Based on the classical vocabulary of this late church, he suggested dates ranging from the seventh to the ninth century for the majority of the Tur Abdin churches, as well, including Mâr Yaqub at Šalāḥ, el 'Adhra at Ḥaḥ, and even Mâr Gabriel at Qartamin. Leroy, *op. cit.* (1968), too, proposes for Deir Za'faran the traditional foundation date, 792, for el 'Adhra at Ḥaḥ, a date in the late seventh/early eighth century. Late dates for many of the Tur Abdin churches seem indeed quite plausible, and Monneret de Villard, *op. cit.*, *passim*, gives yet later examples, such as the twelfth- or thirteenth-century church of Mâr Augēn (*ibid.*, 79). Still, for the ornamentation of Qartamin, Deir Za'faran, and Ḥaḥ, a date after the sixth century is hard to accept and one must await Leroy's final publication and reasoning.

10. Except for a few new photographs and plans so far published by Leroy, *op. cit.* (1968), the excellent illustrations in Bell, *op. cit.*, are still the best source.

322. 11. J. E. Quibell, *Excavations at Saqqarah* (Cairo, 1909), IV, 1 ff.; U. Monneret de Villard, *Il monastero di San Simeone presso Aswân* (Milan, 1927); A. Fakhry, *The Necropolis of El-Bagawat* (Cairo, 1951); finally, on Bawit, *Mémoires de l'Institut Français d' Archéologie du Caire*, XII, XIII, XXXIX, LIX; H. Torp, *Byzantion*, XXV-XXVII (1955-7), 513 ff.; *idem*, *Mélanges École Française*, LXXVI (1964), 137 ff., and LXXVII (1965), 153 ff.

12. E. Kitzinger, *Archaeologia*, LXXXVII (1938), 181 ff.

323. 13. For this and other examples, see Somers Clarke, *Christian Antiquities in the Nile Valley* (Oxford, 1912), *passim*; U. Monneret de Villard, *Les couvents près de Sohag* (Milan, 1926), *passim*.

14. Clarke, *op. cit.*, 95 ff.; Monneret de Villard, as above, Note 11; H. G. Evelyn-White, *The Monasteries of the Wadi'n Natrun*, III (*Egyptian Expedition Publications*, VIII) (New York, 1928); more recently, in summary form, W. Müller-Wiener, in *Koptische Kunst*, exhibition catalogue (Essen, 1963), 131 ff. In few of the structures has research as yet succeeded in definitely distinguishing original and added parts or in dating either securely; but it is possible that the original structure at Aswân dates from the late tenth or eleventh centuries. The church at Deir-es-Suriani has been convincingly assigned to the ninth century, its vaulting to about 1200. The original plan of Amba Bishoï dates from 830-49, the vaulting from 1330.

15. Evelyn-White, *op. cit.*, 131 ff. (Amba Bishoï). 227 ff. (Deir Baramus).

324. 16. St Sergius (Abu Sargeh), St Barbara (Barbarah), Al Muallakah; see U. Monneret de Villard, *IV C.A.C. ... Rome ... 1938*, 291 ff., and *idem*, *La chiesa di Santa Barbara al Vecchio Cairo* (Florence, 1922).

17. Clarke, *op. cit.*, *passim*.

18. G. S. Mileham, *Churches in Lower Nubia* (Philadelphia, 1910), 37 ff. (Adindân-Addendan with illustration); 27 ff. (Faras, churches outside citadel); 41 f. (Serreh). More recently, W. Y. Adams, *Journal Amer. Research Center in Egypt*, IV (1965), 87 ff. (attempt to trace development, 500-1400); W. H. C. Frend, *VII C.A.C. ... Trier ... 1965*, 530 ff. (Qasr Ibrim); K. Michalowski, *Faras* (Leiden, 1966: Faras Cathedral, 707, replacing an older church); *idem*, in *Kunst und Geschichte Nubiens*, ed. E. Dinckler (Recklinghausen, 1970), 11 ff. (Faras, south church in citadel, 'not later than 600'); T. Säve-Söderbergh, *ibid.*, 219 ff. (Serreh, south church, 600-850; Sahâba, prior to 850).

326. 19. S. Runciman, *The First Bulgarian Empire* (Oxford, 1934).

20. E. Dyggve, *History of Salonitan Christianity* (Oslo, 1951), 125 ff.; L. Karaman, in *L'art chez les Slaves*, 11 (Paris, 1932), 332 ff.

21. Another example is Sv. Petar at Omiš; see F. Bulič, in *Studien zur Kunst des Ostens* [for] *Joseph Strzygowski* (Vienna and Hellerau, 1923), 136 ff.

22. See above, pp. 287-8, and Chapter 11, Notes 29, 30.

23. U. Monneret de Villard, *L'architettura romanica in Dalmazia* (Milan, 1910).

24. R. von Eitelberger, *Jahrbuch der K.K. Central-Kommission*, V (1861), 160 ff. The original dedication to the Trinity and a *terminus ante quem* for the construction are established by a reference in Constantine Porphyrogenetos, *De administrando Imperio*, chapter 29 (ed. G. Moravcsik and R. J. H. Jenkins, Budapest, 1949, 138 f.), but the date of construction, whether 805 or later, remains in doubt.

327. 25. See above, Chapter 10, pp. 268-70, and Note 29.

328. 26. For the ninth- and tenth-century architecture in Bulgaria see Mavrodinov (1959), 89 f. (Pliska), 135 ff. (Preslav, palace and church), 184 ff. (churches around Preslav); more recently, Kr. Mijatev, *Architekturata v Srednovekovna Blgarija* (Sofia, 1965), *passim*, esp. 86 f. (small churches near Pliska), 110 ff. (churches around Preslav). An excellent summary of the *status quaestionis* is given by Stricevic, *XII C.E.B. ... Ohrid ... 1961*, I, 165 ff.

27. Building history and date of the successive phases of St Sophia at Ohrid are under lively discussion: Đ. Bošković, in *God. Serb. Akad.*, XLII (1933), 304; D. Koćo, in *Archaeologia Jugoslavica*, II (1956), 139 ff.; F. Forlati, C. Brandi, and Y. Froidevaux (ed. Unesco), *St Sophia of Ochrida* (1953); Đ. Bošković and K. Tomovski, in *Musée National d'Ohrid, Recueil de Travaux* (Ohrid, 1961), 76 ff. Stricevic, *op. cit.*, 189 ff., clearly sums up the discussion, and his own analysis seems by and large convincing. Of an early church of indeterminate plan and date only some foundation walls survive. Of the 'Bulgarian' church, the essential parts remain in the present structure: nave, transept, aisles east and west of the crossing, the springings of the dome, chancel and apse, and the present esonarthex on both floors. The western crossing piers are late, but the site of the original piers, slightly farther west, has been established. (The building history presented by Schmidt-Annaberg, *Deutsche Bauzeitung*, LV, 1921, 193 ff., 205 ff., is thus proved incorrect.) To these original parts, Stricevic adds the galleries above the aisles east and west of the transept; but this seems debatable. However, he convincingly dates the original 'Bulgarian' building in the reign of Czar Boris (852-89); the

galleries above the eastern aisles date from prior to 1037-56, when also the fresco cycle was painted in the chancel (A. Grabar, *Zb. R.*, VIII, 1964, 163 ff.); also the masonry of the upper absidioles would seem to be of eleventh-century date. In the fourteenth century the double-storeyed narthex was added, while transept and dome were demolished when the church was turned into a mosque. Hallensleben, *B.Z.*, LXVI (1973), 125, based on the style of the paintings, favours for the entire structure a date 1037-56. At this point the question had better be left in suspense.

329. 28. For the church of the Baptist at Nessebâr see Mavrodinov (1959), 111 ff., with a late-ninth-century date, and A. K. Orlandos, *Archeion*, IX (1961), 3 ff., who suggests the second quarter of the tenth century, and lists a number of churches of similar plan to which he assigns dates ranging from the first quarter of the tenth to the second quarter of the eleventh century; also H. Hallensleben, *B.Z.*, LXVI (1973), 124 f. In my opinion churches such as H. Germanos in the Prespa Lake (S. Pelikanides, *Mnimeia byzantina ... tis Prespas*, Salonica, 1960; also Mavrodinov, 1959, 268 f.) and a ruin near Vodoča in the Struma Valley (T. Zarko, in *Glasnik Skopsgo Nautchnog Društva*, III, 1928, 83 ff.; Mavrodinov, 1959, 107 ff.; and Orlandos, *op. cit.*, 9) may well date from the last third of the ninth century.

29. J. Strzygowski, *B.Z.*, III (1894), 1 ff.; G. Sotiriou, *Ephemeris* (1931), 119 ff.; and A. H. S. Megaw, *B.S.A.*, LXI (1966), 1 ff., pointing to building activity in Greece for political reasons at the time of Skripou and stressing the Byzantine and Constantinopolitan elements in the decoration. In my opinion, though, the Bulgarian and Sassanian linkage still remains valid. Nor am I convinced by the proposal (M. Chatzidakis in *Alte Kirchen und Klöster Griechenlands*, ed. E. Melas, Cologne, 1972, 172 f.) to view Skripou as a precursor of the quincunx type in its Greek variant substituting piers or pierced walls for the eastward pair of columns.

A church at Suvala (at the foot of Mount Parnassus) has been compared to Skripou and dated into the early seventh century by Ch. Barla in *Charistirion eis A.K. Orlandon*, IV (Athens, 1967), 303 ff., but I remain unconvinced.

332. 30. A. H. S. Megaw, *B.S.A.*, XXXIII (1932-3), 152 ff., and note; see also Orlandos, as quoted above, Note 28. Closest among churches in Greece to Skripou in plan and elevation is the Koimesis church at Episkopi in Evrytania (*ibid.*, 3 ff., 19), assigned to the first quarter of the tenth century. But there, too, the nave is short and the plan comes close to a cross-in-square.

31. K. Mijatev, *I.B.A.I.*, x (1936), 136 ff., and xiv (1940-2), 73 ff.; Mavrodinov (1959), 37 ff. The identification of the site with Pliska, the residence of Czar Krum, and hence the date of the buildings found has been recently questioned; D. Kranažalov, in *Sbornik Vysokš školy pedagogickš v Olomouci, Historie*, iii (1956), 43 ff., and v (1958), 35 ff., as quoted by Dj. Stričević, *XII C.E.B. . . . Ohrid . . . 1961*, i, 180 ff. See also S. S. Vaclinov, *C.C.R.*, xv (1968), 241 ff.

32. See however the different reconstruction proposed by B. D. Filov, *Die altbulgarische Kunst* (Zürich and Leipzig, 1919), and *B.Z.*, xxx (1929-30), 523 ff., and by Mijatev, *op. cit.*

333. 33. Apsed halls were common in Byzantine palaces from the fifth and sixth centuries; see D. Talbot Rice (ed.), *The Great Palace of the Byzantine Emperors, Second Report* (Edinburgh, 1958), 24 ff., and A. M. Mansel, *VI C.E.B. . . . Paris . . . 1948*, ii, 255 ff. The triclinium of the Magnaura, known only from descriptions (Richter, *Schriftquellen*, 294 ff.), and the throne room at Pliska have been linked by Mijatev, as above, Note 31, contrary to Filov's thesis, above, Note 32.

34. Filov represents the former, Mijatev the latter view; see, however, St. Stančev, *XII C.E.B. . . . Ohrid . . . 1961*, i, 345 ff.

35. Filov, *op. cit.*, and A. Grabar, *Les influences orientales dans l'art balkanique* (Paris, 1928), 1 ff. The penetration of Sassanian decorative motifs, pure and unassimilated, as at H. Polyeuktos (see above, pp. 230 ff.), was an isolated case as far as we can tell today.

334. 36. Substantive differences between the full stone masonry of Bulgarian palaces, customary in Armenia, and the re-used stone blocks of Skripou are clear. Nonetheless, the same appearance is aimed at.

37. G. Millet, *L'école grecque* (Paris, 1916), 84 f., regarding the resemblance in plan of Skripou to Armenian churches; as to the decoration, both Megaw (as above, Note 29) and A. Grabar, *Sculptures byzantines de Constantinople* (Paris, 1963), 90 ff., incline to view it as Byzantine and, indeed, Constantinopolitan pure and simple; however, the mingling with Sassanian elements (e.g. heart-shaped leaves, griffins) seems to me undeniable.

38. Runciman, *op. cit.* (above, Note 19), *passim*, has noted the forced resettlements of Armenians in Thrace - beginning in 755 and continuing perhaps in 784 and certainly in 872 - as well as their impact on Bulgaria, both in commerce and religion, whether orthodox or sectarian. (I am indebted to Professors Garsoian, Columbia University, and Caspary, University of California, Berkeley, for calling my atten-

tion to these points.) Runciman, *op. cit.*, 231 f., and with greater precision in N. H. Baynes and H. Moss, *Byzantium* (Oxford, 1948; paperback ed. Oxford and New York, 1961), 343 has also alluded to links between Armenian and Bulgarian architecture.

39. Dj. Stričević, *XII C.E.B. . . . Ohrid . . . 1961*, i, 165 ff.; idem, *Zb. R.*, viii (1964), 399 ff.

335. 40. N. Mavrodinov, *I.B.A.I.*, xiii (1939), 246 ff. (*mitatoria*). The ninth-century date favoured by V. Ivanova, *I.B.A.I.*, xii (1938-9), 365 ff., and Mavrodinov (1959), 92 ff., is taken up by St. Mihailov, *Actes . . . premier congrès international . . . études balkaniques*, ii (1964), 583 ff., while Stričević, *op. cit.*, 180 ff., after weighing the pros and cons arrives at a sixth-century date.

41. Regarding basilicas in Yugoslavia and northern Greece in general, V. Korać, *XII C.E.B. . . . Ohrid . . . 1961*, i, 173 ff. For H. Achilleos, Pelikanides (as above, Note 28), 64 ff., proposing a date 1020-30; Stričević, *op. cit.*, 195 ff., suggesting a ninth-century date with the exception of the supposedly eleventh-century upper chambers of the pastophories; A. Grabar, *Zb. R.* (1964), 163 ff., prior to 1002. A publication by Moutsopoulos (see *Ergon*, 1967, 37 ff.) is in preparation. For Staro Nagoričino, V. Korać, as above; for the Ljeviška church at Prizren, Stričević, *op. cit.*, 201 ff., and S. Nenadović, *Bogorodica Ljeviška* (Belgrade, 1963), proposing a ninth-century date; see also below, pp. 459 ff.

42. Stričević, *op. cit.*, 207 ff.

43. K. Mijatev, *B.Z.*, xxx (1929-30), 561 ff.; idem, *I.B.A.I.*, vi (1930-1), 187 ff.; A. Rašenov, *ibid.*, x (1936), 216 ff.; G. Millet, *C.R.A.I.* (1933), 169 ff. The older view is represented by Mijatev, Millet, Rašenov, and others. Dj. Stričević and I. Nikolajević-Stojković (*XII C.E.B. . . . Ohrid . . . 1961*, i, 212 ff. and 241 ff.) attempt to prove the correctness of a sixth-century date previously proposed by Đ. Bošković (*Starinar*, viii-ix, 1933-4, 331 ff.) and S. Radojčeč (*Zb. R.*, i, 1952, 156 f.). They reason that the classical elements of the building, both in plan and decoration, survived into the sixth century, when in their opinion the church at Preslav was built. However, it remains to be proved that structures so completely corresponding to third- and fourth-century architectural concepts were ever designed in Justinian's time; this quite aside from the improbability of a structure so complex and lavish being laid out in the sixth century in what was then the farthest corner of a frontier province. Equally implausible is the hypothesis (Millet, *op. cit.*) that round structures of the type of Preslav were common among the churches of Constantinople during Justinian's reign or later. At this point the early-tenth-

century date originally proposed for the Round Church, when Preslav became the capital of the Bulgar czars, carries to me greater conviction. **338.** 44. Mavrodinov (1959), *passim*.

339. 45. J. Strzygowski, *Die Baukunst der Armenier und Europa* (Vienna, 1918), is still basic; S. Der Nersessian, *Armenia and the Byzantine Empire* (Cambridge, Mass., 1945), V. M. Harutiunian and S. A. Safarian, *Pamiatniki Armianykogo Zodchvestva* (Moscow, 1951; in Russian), and *Architettura medievale Armena*, ed. G. de Francovich (Rome, 1968) present good surveys, the latter in catalogue form; we shall quote it henceforth as *Architettura Armena* because of its handy references to previous bibliography. The late A. Khatchatrian, *L'architecture arménienne du IVe au VIIe siècles* (Paris, 1971), examined the early phase with an eye to correcting previous misdatings of centrally-planned structures. G. J. Tchubinashwili, *Razbiskayia po Armenskoja Architekture* (Tiflis, 1967: in Russian with German summary), claims precedence for Georgian over Armenian building and assigns later dates to the latter. See also *R.L.B.K.*, I, 306 ff. on Armenia (Khatchatrian) and II, 668 ff. on Georgia (W. Ponomarew).

46. Der Nersessian, *op. cit.*, 58 f. stresses the links to Asia Minor and Mesopotamia, Khatchatrian, *op. cit.*, 93 ff. those to Syria. Clearly, both regions would exert their impact. *Architettura Armena*, esp. 17, 21, insists on the autochthonous character of Armenian building in both plan and technique.

340. 47. Ereruk: *Architettura Armena*, 78, with fourth- or fifth-century date, Khatchatrian, *op. cit.*, 43 ff., fifth-century. Both datings on stylistic grounds only seem to me early, as compared with Syrian building. I would prefer A.D. 500 at the earliest. Tekor: *Architettura Armena*, 84; Khatchatrian, *op. cit.*, 48 ff., convincingly proposes a basilican plan for the first building phase, datable 486. Eghvard: *Architettura Armena*, 77; Khatchatrian, *op. cit.*, 43 ff.

48. *Architettura Armena*, 102; Strzygowski, *op. cit.*, 108 ff. and *passim*. Zvart'nots - possibly before 652 - W. E. Kleinbauer, *Art Bulletin*, LIV (1972), 245 ff.

341. 49. Tekor, rebuilding: Khatchatrian, *op. cit.*, 48 ff. Ptghavank' (Ptghni): *Architettura Armena*, 82; Der Nersessian, *op. cit.*, *passim*; Tchubinashwili, *op. cit.*, 191, with tenth-century date. T'alish (Aroudz): *Architettura Armena*, 83; Tchubinashwili, *op. cit.*, 194, proposing a mid-tenth-century date as against the otherwise accepted date 670. Cf. also the church at Odzun, *Architettura Armena*, 85.

50. Dvin: Khatchatrian, *op. cit.*, 53 ff., distinguishing the fifth-century first basilica and the seventh-century rebuilding. T'alinn: *Architettura Armena*, 88.

51. *Architettura Armena*, 89 ff., including chapels at Ashtarak and T'alinn (St Mary), the latter dated prior to 783.

52. Gayané church: *Architettura Armena*, 87; Tchubinashwili, *op. cit.*, 181 (the church was rebuilt in 1651 on the old plan). Mren: *Architettura Armena*, 86; M. and N. Thierry, *C.A.*, XXI (1971), 43 ff., with the slight shift of date 626-40, instead of 639-40. Bagaran: *Architettura Armena*, 97; Der Nersessian, *op. cit.*, 66; Tchubinashwili, *op. cit.*, 182, refers to the similar church of Zromi in Georgia with a good date 626-34, see *idem, Zromi* (Moscow, 1969; in Russian).

53. Avan: *Architettura Armena*, 99; Tchubinashwili, *op. cit.*, 179 f., views the plan as derived from the Djuari church at Mzchet in Georgia which may date from 585/6-604/5. Hrip'simé church: *Architettura Armena*, 100; Tchubinashwili, *op. cit.*, 186 ff., with ninth-century dating.

342. 54. S. Der Nersessian, *Aght'amar...* (Cambridge, Mass., 1965); *Architettura Armena*, 103. See also Varagvank, Church of the Virgin, eleventh-century, *ibid.*, 142.

55. *Architettura Armena*, 97.

345. 56. Tchubinashwili, as quoted above, Notes 45 and 52, and *idem* in *Vseobščaya Istorija Architektury*, III, *Architektura vestočnoj Evropy, Srednie veka*, ed. J. S. Jaralov and others (Moscow, 1966), 300 ff.

57. Strzygowski's thesis, though modified, is taken up emphatically in *Architettura Armena*, 19 ff.

348. 58. Goshavank: *Architettura Armena*, 148 (related churches, *ibid.*, 144, 146, 155). Ani, cathedral: *ibid.*, 108; Der Nersessian, *op. cit.*, 73 ff. Aght'amar: see above, Note 54. Marmashen: *Architettura Armena*, 106.

59. Strzygowski, *op. cit.*, *passim*.

60. Der Nersessian, *op. cit.*, *passim*.

61. Millet, *op. cit.* (Note 37), *passim*.

PART SIX:
MIDDLE BYZANTINE ARCHITECTURE
FROM THE MACEDONIAN EMPERORS
TO THE LATIN CONQUEST (864-1204)

CHAPTER 15

349. 1. G. Ostrogorsky, *History of the Byzantine State* (Oxford, 1956), *passim*, in particular, 175 ff.

2. S. Runciman, *The Eastern Schism* (Oxford, 1955).

350. 3. The *Myriobiblion* of Photius (*P.G.*, CIII, 42 ff.; CIV, 9 ff.) has been translated by J. H. Freese, *The Library of Photius* (London, 1920). For Constantine Porphyrogenetos' writings, aside from the *Book of*

Ceremonies (above, Chapter 9, Note 15), see *De administrando Imperio*, as quoted in Chapter 14, Note 24. The continuation of Theophanes' history (*Theophanes Continuatus*), written on Constantine's behest (*P.G.*, CIX, 15 ff.; *Bonn Corpus*, XLVIII), presents the history of the Macedonian House and its immediate predecessors.

4. Michael Psellos (trans. E. R. A. Sewter), *Chronographia* (New Haven, 1953).

5. Anna Comnena (trans. E. Dawes), *The Alexiad* (London, 1928).

351. 6. See below, Chapter 16, p. 371 and Note 43.

7. Liutprand of Cremona, *Legatio ad Nicephorum*, and (ed. J. Becker) *Antapodosis* (*M.G.H. in usum scholarum*) (Hanover, 1915), *passim*; see also *The Works of Liutprand of Cremona* (trans. F. A. Wright) (New York, 1930).

8. S. Khitrovo, *Itinéraires russes en Orient* (Geneva, 1889), *passim*.

9. S. Runciman, *A History of the Crusades* (Oxford, 1951-5; paperback, New York, 1964-7).

CHAPTER 16

353. 1. Regarding Middle Byzantine architecture, see, aside from the old but still useful handbooks (O. Wulff, *Handbuch*, *passim*; Diehl, *Manuel*, *passim*), the summaries by Ch. Delvoye, *XIII C.E.B. . . . Oxford . . . 1966*, 225 ff., and by A. Grabar, *C.A.*, XVII (1967), 257 ff., esp. 261 f.

354. 2. K. J. Conant, *Carolingian and Romanesque Architecture (Pelican History of Art)*, 3rd ed. (Harmondsworth, 1974), 68.

3. Regarding the H. Sophia at Nicaea, see below, Chapter 17, Note 16. A number of rather large, old-fashioned basilicas, supported by arcades on piers and dating from the ninth to the thirteenth and fourteenth centuries, are scattered over Greece and the islands. They include one excavated near Sparta and dated 1033 (*Praktika*, 1934, 132; *ibid.*, 1939, 107 ff.); another at Vera on Crete of tenth- or eleventh-century date (*Ergon*, 1959, 153 ff.); a third at Vizarion, also on Crete, about 800 (*ibid.*, 1956, 123 ff.); finally, in the fourteenth century at Trikkala in Thessaly (*Archeion*, III, 1937, 156 ff.). The list of basilicas given in *Archeion*, IX (1961), 21 ff., suffers from the intermingling of the 'old-fashioned' with the small-scale 'Kastoria' type.

4. See G. H. Hamilton, *Art and Architecture in Russia* (*Pelican History of Art*) (Harmondsworth, 1954), 8 ff., and, for S. Marco in Venice, below, pp. 431-6 and Chapter 17, Notes 76 ff.

5. Kastoria: *Archeion*, IV (1939), *passim* (Anargyroi, eleventh-century, 10 ff.; Taxiarches, 1359/60(?), 61 ff.; H. Stephanos, fourteenth-century, 107 ff. - all barrel-vaulted). Arta: *Archeion*, II (1936), *passim* (Kato Panaghia, 1250-70, barrel-vaulted, 70 ff.; H. Theodora, eleventh- or twelfth-century(?), timber-roofed, narthex late-thirteenth-century, 88 ff.). See also below, pp. 395 ff., and S. Mihailov, *R.i.P.*, IV (1949), 171 ff., especially regarding the sociological meaning of this revival.

355. 6. A first list of Middle Byzantine triconchs and tetraconchs as given by A. K. Orlandos, *Archeion*, I (1935), 105 ff., is supplemented by S. Bettini, *V C.E.B. . . . Rome . . . 1936*, II, 31 ff., and by Dj. Stričević, *XII C.E.B. . . . Ohrid . . . 1961, Rapports*, VII, 224 ff., with rich bibliography. Regarding the Heybeliada church, see S. Eyice, *Son devir bizans mimârisi* (Istanbul, 1967; with German summary), 44 ff., and T. F. Mathews, *D.O.P.*, XXVII (1973), in press. The towering drum of the Kubilidike is entirely rebuilt; see S. Pelikanides, *Balkan Studies*, III (1962), 463 f.

356. 7. For the Kariye Camii, see the structural analysis in P. A. Underwood, *The Kariye Djami* (London, 1967): a late-eleventh-century structure, preserved only in foundations; the core of the present church, probably *c.* 1120; and the nartheces and parekklesia, 1315-20/1. For Vunitsa, see S. Stančev, *I.B.A.I.*, XVIII (1952), 305 ff., and Mavrodinov (1959), 185. The ruin of the church near Ereğli (Marmara-ereğlisi) on the European shore of the Sea of Marmara, now apparently destroyed, has been dated 'near 1000 . . . or at the time of Basil I . . . or perhaps as early as Heraclius' (J. Strzygowski, *J.Ö.A.I.*, I, 1898, Beiblatt, I ff.), or 'not after the ninth century' (Wulff, *Handbuch*, 453 f.); the similar ruin at Yuša Tepesi on the Asian side of the Bosphorus has been equally vaguely dated 'sixth or ninth century' (S. Eyice, *IX C.E.B. . . . Salonica . . . 1953*, 184 ff.). For Sige, see above, p. 302, and Chapter 13, Note 3.

8. Below, pp. 386-8 and Chapter 17, Note 12.

357. 9. G. Millet, *L'école grecque* (Paris, 1916), 105 ff., terms the type 'église à trompes d'angle'. He lists, apart from Hosios Lukas and Daphni, the Panaghia Lykodimou in Athens (ruined in a nineteenth-century restoration; see A. Couchaud, *Choix d'églises byzantines*, Paris, 1842, plates 11 ff., for the original building; the cathedral of Christianou (E. Stikas, *L'église byzantine de Christianou*, Paris, 1951); and four examples probably of late-thirteenth-century date: H. Sophia at Monemvasia (R. Traquair, *B.S.A.*, XII, 1905/6, 273 f.), H. Theodoroi at Mistra (G. Millet, *Monuments byzantins de Mistra*, Paris, 1910, plates 20 f.), the Parigoritissa at Arta (see below, p. 441 f.,

and Chapter 19, Note 9), St Nicholas-in-the-Fields, near the former Lake Kopais (*Ergon*, 1960, 240 ff.).
10. Millet, *loc. cit.*; Stikas, *op. cit.*, 34 ff.
359. 11. See below, Chapter 17, Note 14.
360. 12. The term quincunx was coined by K. J. Conant (as quoted Chapter 2, Note 38), *passim*. For the Nea, see below, pp. 376-7, and Chapter 17, Note 5; for Tirilye (Trilye), F. W. Hasluck, *B.S.A.*, XIII (1906/7), 215 ff.; for Germigny-des-Prés, P. Clemen, *Romanische Monumentalmalerei in den Rheinlanden* (Düsseldorf, 1916), 54 ff., and J. Hubert, *L'art préroman* (Paris, 1938), *passim*; for S. Satiro, G. Chierici, *La chiesa di S. Satiro a Milano* (Milan, 1942); for Tarrasa, J. Puig y Cadafalch, *VI C.E.B.... Paris... 1948*, II, 343 ff.; for S. Maria delle Cinque Torri (now destroyed), H. W. J. Schulz, *Denkmäler der Kunst des Mittelalters in Unteritalien* (Dresden, 1860), II, 106 ff.
13. Göreme, see below, p. 421 and Chapter 17, Note 56; Side, see S. Eyice, *X C.E.B.... Istanbul... 1955*, 130 ff., and *Anatolia*, III (1958), 35 ff.; Peristerai, *Archeion*, VII (1951), 146 ff.
14. J. Strzygowski, *Die Baukunst der Armenier und Europa* (Vienna, 1918), 849 ff. The status of the question as of 1925 has been summarized by Diehl, *Manuel*, II, 460 f. More recently, see K. Erdmann, in *Spätantike und Byzanz (Neue Beiträge zur Kunstgeschichte des ersten Jahrtausends)* (Baden-Baden, 1952), 53 ff., with bibliography.
15. Millet, *op. cit.*, 62, 72; Ramsay and Bell, *Churches*, *passim*, in particular, 397 ff.; and critically, Diehl, *Manuel*, II, 437, note 2.
361. 16. Wulff, as quoted above, Chapter 13, Note 4; Diehl, *Manuel*, II, 460 f.; N. Brunov, *B.Z.*, XXVII (1927), 63 ff., and *Vizantiskij Vremmenik*, XXVII (1949), 150 ff.; W. R. Zaloziecky, *B.Z.*, XXVIII (1928), 372 ff., and *ibid.*, XXIX (1929), 248 ff.
17. The structure, demolished in 1890, is known only from illustrations (C. J. M. De Vogüé, *La Syrie centrale*, Paris, 1865 f., plate 7; J. W. Crowfoot, *Early Churches in Palestine*, London, 1941, plate VIIIa). E. Weigand (*Würzburger Studien zur Altertumswissenschaft*, XIII, 1938, 71 ff.) maintained that the building was erected as a temple (not a praetorium), and that the columns and covering dated only from the fifth century, when it was supposedly - but there is no evidence - transformed into a church. The second part of his thesis carries, for me, little conviction.
18. See above, p. 277, and Chapter 11, Note 10.
362. 19. G. Ostrogorsky, *History of the Byzantine State* (Oxford, 1956), 231 f., 245 f.; Janin, *Églises*, 319.
20. O. Demus, *Middle Byzantine Mosaic Decoration* (London, 1948), 14 ff.
363. 21. L. M. E. de Beylié, *L'habitation byzantine* (Paris, 1902), though outdated has not been replaced.

T. Kirilova Kirova, *Felix Ravenna*, CII (1971), 263 ff., links Middle Byzantine to Syrian fifth- and sixth-century houses and, like de Beylié (and Diehl, *Manuel*, 423 ff.), focuses on palaces rather than ordinary domestic building. Recent Bulgarian excavations are bringing to light foundation walls of many modest dwellings of ninth- to eleventh-century date near Preslav.
22. J. Travlos, *Poleodomiki Exelixis tōn Athinōn* (Athens, 1959), 154 ff.; R. Scranton (ed.), *Corinth, Medieval Architecture in the Central Area*, XVI (Cambridge, Mass., 1957), 128 ff.
365. 23. A. K. Orlandos, *Monastiriaki Architektoniki* (Athens, 1926, reprinted 1958).
24. *Archeion*, V (1939-40), 34 ff., and *ibid.*, VII (1951), 72 ff. See also *Archeion*, VII (1951), 72 ff. (Sagmata), and E. Stikas in *Charistirion eis A.K. Orlandon*, II (Athens, 1966), 309 ff. (Moni Agrountos), both twelfth-century; and for thirteenth-century examples, A. K. Orlandos, *Hi Parigoritissa tis Artis²* (Athens, 1963), and *Archeion*, II (1936), 70 ff. (Kato Panaghia).
366. 25. See above, pp. 147, 272, and Chapter 11, Notes 6 and 8.
26. See below, p. 369 and Note 38.
27. De Beylié, as above, Note 21, *passim*; P. Kukules, *Byzantinos bios kai politismos*, IV (Athens, 1951), 258 ff.
367. 28. K. M. Swoboda, *Römische und romanische Paläste* (Vienna, 1925); G. Lorenzetti, in *Miscellanea ... in onore di I.B. Supino* (Florence, 1933), 23 ff.; J. S. Ackerman, *Acts XX Internat. Congress History of Art ... New York ... 1960*, II (1963), 6 ff.
29. Mavrodinov (1959), 38 ff., 144 ff. For the palace of Romanos Lekapenos, see R. Naumann, *Ist. M.*, XVI (1966), 199 ff.; for Dvin, Khatchatrian (as above, Chapter 14, Note 45), plates 18 f., and *Vseobščaya Istorija Architektury*, III (as *ibid.*, Note 56), 203 ff.; for Pliska, also St. Stančev, in *Antike und Mittelalter in Bulgarien*, ed. V. Beševliev and J. Irmscher (Berlin-East, 1960), 226 ff.
30. The sources, excerpted in German translation and impeccably arranged, are found in Richter, *Schriftquellen*, 253 ff. Their interpretation, over the last decades, has been undertaken by A. Vogt (as above, Chapter 9, Note 15), by R. Janin, *Constantinople byzantine* (Paris, 1950), and by R. Guilland in numerous articles, collected in R. Guilland, *Études sur la topographie de Constantinople byzantine* (Berlin and Amsterdam, 1969), I, I ff., unfortunately without taking into account sufficiently the archaeological finds.
368. 31. *The Great Palace of the Byzantine Emperors (The Walker Trust)*, I, ed. G. Brett (Edinburgh, 1947), and II, ed. D. T. Rice (Edinburgh, 1958). The mosaic pavement, originally dated after 410 and possibly

before 430 (*Great Palace,*˜1, 91), has since been assigned dates reaching from the late fifth century (*ibid.*, 11, 160) to about 530 (D. T. Rice, *Charistirion eis A. K. Orlandon*, 1, Athens, 1965, 1 ff.), to the end of the sixth century (I. Lavin and C. Mango, *Art Bulletin*, XLII, 1960, 67 ff.) and as late as A.D. 700 (P. Nordhagen, *B.Z.*, LVI, 1963, 58 ff.). For the apsed hall, see *Great Palace*, 11, *passim*, and for its (uncertain) date, 161 ff.; for the 'House of Justinian', *ibid.*, 168 ff., esp. 192 f.

32. Mango, as quoted above, Chapter 10, Note 10; Guilland, *op. cit.*, 1, 7 ff. and *passim*.

33. Richter, *op. cit.*, 294 ff.; Guilland, *op. cit.*, 1, 141 ff.

34. Richter, *op. cit.*, 342 ff.; Guilland, *op. cit.*, 1, 95 ff. and *passim*.

35. Michael Psellos, book 6, chapter 185 (translation as quoted above, Chapter 15, Note 4, 188 f.).

369. 36. Richter, *op. cit.*, 349 ff.

37. *Ibid.*, 363 ff.; A. Grabar, *L'empereur dans l'art byzantin* (Paris, 1936), *passim*.

38. Richter, *op. cit.*, 288 ff.; Guilland, *op. cit.*, 1, 82 ff. For the great Lateran triclinium, R. Krautheimer, in *Tortulae* (*R. Qu. Schr.*, Suppl. 30) (1966), 195 ff.; for the banqueting hall north of the Hippodrome, R. Naumann, *Ist. M.*, XV (1965), 135 ff.; for the *quinque dagubitas* at Ravenna, A. Weis, *Tortulae*, *op. cit.*, 300 ff.; for another one with seven niches in the Hormisdas Palace at Constantinople, N. Alemanni, *De Lateranensibus parietinis* (Rome, 1625), 18, where – as I see belatedly – the Lateran Triclinium already was linked to the Dekanneacubita.

39. On the relations between Byzantium and the Islamic world, see *D.O.P.*, XVIII (1964); M. Canard, 33 ff. (political and commercial contacts); O. Grabar, 67 ff. (Ummayad and Byzantine art); G. C. Miles, 1 ff. (Aegean area, in particular 'cufic' ornament on Greek churches); F. Gabrieli, 57 ff. (Sicily and South Italy).

40. L. Torres Balbas, *La Alhambra y el Generalife* (Madrid, 1949).

370. 41. L. Torres Balbas, *La mezquita de Cordoba y las ruinas de Medinat-al-Zahra* (Madrid, 1960).

42. A. M. Mansel, *VI C.E.B.... Paris... 1948*, 11, 255 ff.

43. Torres Balbas, *op. cit.* (Note 41), 76 f., and E. Lambert, *VI C.E.B.... Paris... 1948*, 11, 225 ff.; Canard, *D.O.P.*, XVIII (as above), 36, note 5 (but also O. Grabar, *ibid.*, 70, note 3, where the statement regarding Medinat-al-Zahra is questioned).

371. 44. Constantine Porphyrogenetos, *The Book of Ceremonies* (as above, Chapter 9, Note 15) and Liutprand of Cremona, *Antapodosis*, VI, 5 (trans. Wright as above, Chapter 15, Note 7, 207 f.), and Richter, *op. cit.*, 301 ff.

45. See, however, for the reverse dependence of Arab on Byzantine scientific manuscript illumination, K. Weitzmann, in *Archaeologica Orientalia in memoriam Ernst Herzfeld* (Locust Valley, 1952).

46. O. Grabar, *D.O.P.*, as above, Note 39.

372. 47. The interweaving of survival and revivals in the 'Middle Byzantine Renaissance' is discussed clearly and imaginatively by E. Kitzinger, *VI C.E.B. ... Paris... 1948*, 11, 209 ff., and *idem*, *XI C.E.B. ... Munich... 1958*, Berichte, IV, 1, *passim*; see also *ibid.*, *Diskussionsbeiträge*, 55 ff.

373. 48. Ch. Bouras, *Deltion Christianikis Archaiologikis Hetairias*, ser. IV, 5 (1964), 247 ff., on the existence and extent of a 'renascence' in Middle Byzantine architecture, with similar results, though with slightly greater stress on an actual revival of Late Antique spatial proportions (Nea Moni, Chios) and of the technique of stone construction (Greece, eleventh and twelfth centuries).

CHAPTER 17

375. 1. A perusal of Janin, *Églises*, Schneider, *Byzanz*, O. Tafrali, *Topographie de Salonique* (Paris, 1912), and C. Diehl, H. Saladin, and M. Le Tourneau, *Les monuments chrétiens de Thessalonique* (Paris, 1913), reveals the difficulties of correlating the monuments and the documentary evidence even in centres such as Constantinople or Salonica.

2. Schneider, *Byzanz*, 13 f., is but a first, tentative attempt.

376. 3. C. Mango, *D.O.P.*, XIII (1959), 245 ff., in particular 249 ff., also with reference to A. M. Schneider and W. Karnapp, *Die Stadtmauer von Iznik (Nicaea)* (*Istanbuler Forschungen*, IX) (Berlin, 1938). The earliest examples quoted by Mango are buildings in Kiev, the Golden Gate, the second Desyatinna church, and the church of St Sophia, all dating from 1037–9. Meanwhile, excavations have made it likely that already the first Desyatinna church, under construction since 989, was built in 'recessed' brickwork by masons called from Constantinople (H. Schäfer, *Die Gül Camii in Istanbul*, Ph.D. thesis, Göttingen, 1970, 138 ff. - but omitted from the published version, as above, Chapter 13, Note 4, p. 78 f., quoting M. K. Karger, *Drevnij Kiev*, Moscow and Leningrad, 1958–61). Another example of the technique is the façade of the Anastasis Rotunda in Jerusalem as built by Byzantine masons under Constantine IX Monomachos, about 1045.

4. A. H. S. Megaw, *B.S.A.*, XXXII (1931–2), 90 ff., and *ibid.*, XXXIII (1932–3), 137 ff.; *idem*, *Charistirion eis A. K. Orlandon*, III (1966), 16 ff.

5. The church described in Photius's Homily X has been correctly identified as that of St Mary of the Pharos (instead of the Nea) by R. Jenkins and C. Mango (*D.O.P.*, IX-X, 1956, 123 ff., and *idem, The Homilies of Photius*, Cambridge, Mass., 1958, 177 ff.), who have also established the consecration dates of both churches. For a description of the Nea, see *Theophanes Continuatus*, v. 83 (Richter, *Schriftquellen*, 354) and Anthony of Novgorod (S. Khitrovo, *Itinéraires russes en Orient*, Geneva, 1889, 98 f.). K. Wulzinger, *Byzantinische Baudenkmäler zu Konstantinopel* (Hanover, 1925), 48 ff., has attempted - unconvincingly to me - to identify the substructure of the Nea with a cistern in the Saray grounds. Other churches in the palace grounds and without are known, either in general terms or with specific reference to their decoration through consecration sermons delivered by Leo VI the Wise (886-912) (A. Frolow, *Études byzantines*, III, 1946, 43 ff.).

377. 6. Their barrel-vaults were covered with mosaics, showing martyrs thrown to wild beasts (Richter, *op. cit.*, 355) - an ecclesiastical adaptation of the old motif of circus games performed before the Emperor. (See also A. Grabar, *L'empereur dans l'art byzantin*, Paris, 1936, 61 ff.)

7. Anthony of Novgorod, as above, Note 5.

8. Van Millingen, *Churches*, 196 ff.; Schneider, *Byzanz*, 65; D. Talbot Rice, *Byzantion*, VIII (1933) 151 ff. and *Antiquity*, IV (1930), 415 ff.; Janin, *Églises*, 364 ff. The definitive monograph by C. L. Striker is forthcoming. A brief summary of his has appeared in *Istanbul Arkeoloji Müzeleri Yilliği*, XIII/XIV (1966), 110 ff. Meanwhile I base myself on Mr Striker's Ph.D. thesis, Institute of Fine Arts, New York University, 1963. From it I take the convincing analysis and reconstruction of the building, contrary to former belief without exonarthex and lateral outer porticoes, and the interpretation of the substructure as purely utilitarian. The restoration of the structure in 1965 was in the hands of the Aya Sofia Müzesi.

380. 9. Van Millingen, *Churches*, 122 ff.; Schneider, *Byzanz*, 61 f.; Janin, *Églises*, 318 ff. The conclusive study on which I depend, Th. Macridi, A. H. S. Megaw, C. Mango, and E. J. Hawkins, *D.O.P.*, XVIII (1964), 249 ff., results in a graphic reconstruction of the building, based on the observations and soundings undertaken during its restoration and consolidation directed by the late Paul A. Underwood on behalf of the Byzantine Institute Inc. and Dumbarton Oaks, 1960-3. For the ornament, see also A. Grabar, *Sculptures byzantines de Constantinople* (Paris, 1963), 100 ff. Against Megaw's reconstruction proposal, N. Brunov, *Jbch. Österr. Byz. Ges.*, XVI (1967), 245 ff.

384. 10. Outer porticoes along the flanks have been proposed for the Eski Imaret Camii (Brunov, *Byzantinisch-Neugriechische Jahrbücher*, IX, 1930-2, 129 ff.; see, however, Schneider, *loc. cit.*) as well as for the Bodrum and the Fenari Isa Camii, a suggestion accepted by me in the first edition of the present volume, *passim*. Meanwhile it has been proven that such porticoes did not exist in either the Bodrum or the Fenari Isa Camii. I still consider it possible, though not certain, that in the Eski Imaret at least the cross arm was flanked by a sheltering portico, as witness the projecting cornice above; no such traces are visible further east or west.

386. 11. The Kilise Camii wants further study. At this point, see Van Millingen, *Churches*, 243; Ebersolt and Thiers, *Églises*, 149 f.; Schneider, *Byzanz*, 77 f.; Janin, *Églises*, 149 f.; Hallensleben, *Ist. M.*, XV (1965), 208 ff. A set of drawings of *c.* 1835 (London, R.I.B.A., Sir Banister Fletcher Library, Texier volumes I, Église de St Théodore; see now C. Mango, *J.D.A.I.*, LXXX, 1965, 305 ff., esp. 323 ff.) shows the church as of that time. The colonnaded portico along the south flank, shown in these drawings, contrary to the belief formerly held, is probably a fourteenth-century addition (Hallensleben, *op. cit.*, 211 ff.; Mango, *op cit.*, 330) to the Paleologue exonarthex; see below, p. 473. Schneider, *Byzanz*, 77 f., dates the building into the tenth or eleventh century; however, the recessed brick technique and the ornamentation suggest a late date in the period 1050-1150. The exonarthex and presumably the drum of the main dome are of Paleologue date; see below, p. 473.

12. J. Strzygowski, *B.Z.*, V (1896), 140 ff., where also the text of the sources is quoted; and A. K. Orlandos, *Monuments byzantins de Chios* (Athens, 1930; only the plates have been published). A restoration undertaken some fifty years ago has rebuilt the dome and repaired the marble revetment of the naos; but it has also replaced the paired colonnettes of the ground-floor zone with clumsy half-piers.

388. 13. See above, Chapter 13, Note 4, regarding both Kalenderhane and Gül Camii. The identification of the Gül Camii as the church of H. Theodosia is questionable.

14. For the Koimesis, see above, pp. 307-9 and Chapter 13, Note 4, and particularly for its rebuilding, C. Mango, *D.O.P.*, XIII (1959), 245 ff., supplemented by the plan and elevation, Schmit, *op. cit.*, pls. IV and IX, and by Peschlow, as quoted Chapter 13, Note 4. The Fetiyeh Camii, St Mary Pammakaristos, has been discussed recently in two different studies: R. Hallensleben, *Ist. M.*, XIII/XIV (1963/4), 128 ff.; and C. Mango and E. J. W. Hawkins, *D.O.P.*, XVIII (1964), 319 ff. Both reconstruct the original core as an ambulatory church supported by a cistern and distinct

from the enveloping elements. But they disagree on the date: Hallensleben inclining towards 1067 for the foundation; Mango and Hawkins, on stylistic grounds and convincing to me, suggesting an early-twelfth-century date for the construction. See also S. Eyice, *Son devir bizans mimârisi* (Istanbul, 1967; with German summary), 17 ff., 106, though with a thirteenth-century date.

15. For the Kariye Camii, see above Chapter 16, Note 7; for Kurşunlu, C. Mango, *D.O.P.*, XXII (1968), 169 ff. A ruin at Yuša Tepesi above the Bosphorus (S. Eyice, *IX C.E.B. . . . Salonica . . . 1952*, 184 ff.), while of similar plan, need not be of Middle Byzantine times. For the church at Heybeliada, see above, Chapter 16, Note 6; the thirteenth-century date suggested by Eyice is being revised by Mathews, based on the 'recessed' brickwork, found incidentally also at Kurşunlu; for the Toklu Dede Mescidi, A. Pasadaios, *Ephimeris* (1969), 80 ff.

390. 16. A. M. Schneider, *Die römischen und byzantinschen Denkmäler von Iznik-Nicaea (Istanbuler Forschungen*, XVI) (Berlin, 1943), has established the sequence of building periods. A fifth- or sixth-century structure, built of ashlar at the bottom and of brick in the window zone, has survived in the present aisle walls. This was followed, *c.* 1065, by: the present nave, with its piers and, originally, four groups of triple arcades on columns; the apse; and, possibly, the domed chambers flanking the apse. (N. Brunov, *R.K.W.*, XLIX, 1931, 60 f., has dated these domed chambers to the fourteenth century, perhaps correctly.) A Turkish remodelling eliminated the groups of triple arcades from the nave.

391. 17. A. H. S. Megaw, *D.O.P.*, XVII (1963), 335 ff., has established the structural history of the three churches incorporated in the Zeyrek Camii and brought to light pavement, wall decoration, and fragments of the stained-glass windows formerly in the south church. The older bibliography (Van Millingen, *Churches*, 219 ff.; Schneider, *Byzanz*, 68 f.; Janin, *Églises*, 529 ff.) has become obsolete as well as my own previous statements in the first edition of this work, p. 265.

392. 18. Comprehensive treatments of Middle Byzantine architecture in the Balkan countries are: for Bulgaria, N. Mavrodinov (1959), *passim*; *idem*, *Ednokorabnata i Krbstovidnata črkva (L'église à nef unique et l'église cruciforme en pays bulgare jusqu'à la fin du XIVᵉ siècle)* (Sofia, 1931); Kr. Mijatev, as quoted above, Chapter 14, Note 26; and M. Bičev and Sv. Bossilkov, in W. F. Volbach and J. Lafontaine-Dosogne, *Byzanz und der christliche Osten (Propyläen-Kunstgeschichte*, III) (Berlin, 1968), 241 ff., all with bibliographical references to monographs and to

papers in *I.B.A.I.* and *R.i.P.*; for Yugoslavia, G. Millet, *L'ancien art serbe* (Paris, 1919), on many points obsolete, but still basic; A. Deroko, *Monumentalna i dekorativna Arhitektura . . . Srbiji* (Belgrade, 1953), with all-too-short French and English summaries and a wealth of plans, detail drawings, and photographs; V. Petković, *Pregled crkvenih spomenika kroz povisnica srpskog* (Belgrade, 1950), *passim* (in Serbian), with concise building histories; and, summarily, S. Radojčić, *Geschichte der serbischen Kunst* (Berlin, 1969), and *idem*, in Volbach and Lafontaine-Dosogne, *op. cit.*, 257 ff.; see also the running reports and papers in *Starinar* (1910 ff.), *Zb. R.* (1952 ff.), and *Godišen Zbornik filosofski Fakultet Universitet Skopje* (1947 ff.).

19. See above, pp. 335-8, and Chapter 14, Note 43.

393. 20. Half-cylindrical buttresses were found in a church (no. 1), excavated at Bial Briag near Preslav, of early-tenth-century date; V. Ivanova, *R.i.P.*, III (1949), 149 ff. Another church excavated near by and attributed to the second third of the tenth century (Avradaka, no. 1) seems to have opened into lateral porticoes and to have been provided with polygonal apses and apparently a narthex gallery; *idem, ibid.*, 13 ff. and *XII C.E.B. . . . Ohrid . . . 1961*, III, 141 ff.; also Mavrodinov (1959), 186 ff.; see, however, St. Bojadžiev, *Premier Congrès d'Études balkaniques*, II (1969), 599 f., questioning the open flanks of Avradaka, no. 1. A quincunx on piers, the 'Church of the Boyars', has been found in the citadel at Pliska, *I.B.A.I.*, XXVI (1963), 5 ff.

21. S. Stančev, *I.B.A.I.*, XVIII (1952), 305 ff., and Mavrodinov (1959), 185 ff.; St. Bojadžiev, *Byzantino-Bulgarica*, II (1966), 241 ff., proposes instead a reconstruction on the quincunx plan, so far not quite convincing to me.

22. Dj. Stričević, in *XII C.E.B. . . . Ohrid . . . 1961*, *Rapports*, VII, 224 ff.

394. 23. See above, Note 15, and Chapter 16, Note 34.

24. Đ. Bošković and K. Tomovski, *Musée National d'Ohrid, Recueil des Travaux* (Ohrid, 1961), 85 f.

25. *Archeion*, I (1935), 105 ff.

26. Mavrodinov (1959), 167 ff., with bibliography.

27. A. Grabar, *Les influences orientales dans l'art balkanique* (Strasbourg, 1928), stresses the resemblance of Bulgarian and Sassanian ornament on glazed tiles. However, tenth-century tiles of very similar type, both with ornament and figures of saints, have come to light at Constantinople (D. Talbot Rice, *Byzantine Glazed Pottery*, Oxford, 1930, *passim*; K. Mijatev, *V C.E.B. . . . Rome . . . 1936*, 266 ff.; and E. S. Ettinghausen, *C.A.*, VII, 1954, 79 ff.); see also the group of tiles acquired in 1959 by the Walters Art Gallery, Baltimore, Md., and those found in the Fenari Isa Camii (see above, Note 9). Regarding the

mosaics in the mosque of Cordova, see above, Chapter 16, Note 41.

28. *Archeion*, VII (1951), 146 ff. Professor James Morganstern has kindly provided photographs.

395. 29. S. Mihailov, *R.i.P.*, III (1949), 171 ff., who has excavated a number of these structures, discusses their implications for the political and social history of tenth-century Bulgaria.

30. The ruin of such a hall-church survives at Vračanica near Ljutibrod in the Struma region; Mavrodinov (1959), 272.

396. 31. *Archeion*, IV (1939), 1 ff.; A. K. Orlandos, in *Archeion*, IX (1961), 21 ff., lists vaulted and unvaulted Middle Byzantine hall-churches and basilicas found in Greece and Macedonia, dating from the tenth to the thirteenth century.

32. See below, p. 403, and A. H. S. Megaw, *B.S.A.*, XXXII (1931-2). A. K. Orlandos, *Archeion*, IV (1939), 125 ff., dates the Kubilidike to the end of the tenth or beginning of the eleventh century, and the Anargyroi church to the second or third quarter of the eleventh century.

397. 33. C. Diehl, H. Saladin, and M. Le Tourneau, *Les monuments chrétiens de Salonique* (Paris, 1918), 153 ff., and D. Evangelidis, *Hi Panaghia tōn Chalkion* (Salonica, 1954), with new survey. The date 1044 for the dedicatory inscription, suggested by Evangelidis, is incorrect. The date is 1028, as read by earlier students; see *Praktika* (1933-4), 88 ff. *Monuments of Thessalonike*, ed. S. Molho (Salonica, 1957; reprint 1972) is a handy little guidebook.

398. 34. See below, p. 414-17.

35. *Archeion*, I (1935), 139 ff.; for the problem of domed narthex galleries in general, S. Ćurčić, *Zb. R.*, XIII (1971), 333 ff.

36. Picture books about Mount Athos are frequent, such as R. Coate, *Mount Athos* (Grenoble-Paris, 1948), with unpleasant romantic, and F. Doelger, *Mönchsland Athos* (Munich, 1943), with equally unpleasant political, overtones. A scholarly discussion of the buildings and their history is still wanting, despite the architectural surveys included in A. K. Orlandos, *Monastiriaki Architektoniki* (Athens, 1958), and notwithstanding the pioneer work done by H. Brockhaus, *Die Kunst in den Athosklöstern* (Leipzig, 1898; reprinted 1924), and F. W. Hasluck, *Mount Athos* (London, 1924).

37. S. Ballance, *Anatolian Studies*, X (1960), 141 ff.; especially regarding St Anne, dated 884-5, and the possibly contemporary Nakip Camii.

The Katholikon of the Great Lavra itself remains problematic. The foundation of the monastery in 962/3 need not coincide with the construction of the church or, for that matter, of the parekklesia, which

may well have been completed only in the eleventh century. The thorough restoration makes it impossible to tell whether the colonnaded drum and the rippling eaves line of the domes both of main church and parekklesia are part of the original construction.

399. 38. T. Zarko, in *Glasnik Skopsgo Nautšnog Društva*, III (1929), 83 ff.; P. Milković-Pepek, in *Zb.R.*, VI (1960), 137 ff.; J. Djurić, *XI C.E.B.* . . . *Munich* . . . *1958*, Akten, 113 ff.

401. 39. For Ferai (Feredjik, prior to 1911), see T. Uspenski, *I.R.A.I.K.*, XII (1907), 24 ff., A. K. Orlandos, *Thrakika*, IV (1933), 3 ff.; for Nerezi, V. Ivanova, *G.N.M.S.* (1925-6), 430 ff.; Mavrodinov, *op. cit.* in Note 18 (1931), 66; G. Millet, *L'ancien art serbe* (Paris, 1919); V. Petković, *Pregled*, as quoted above, Note 18, 210 f., 937, showing the deformation of the plan. At Nerezi, an inscription on the murals gives the year 1164 as a *terminus ante* or *ad quem*, confirmed by the name of the founder, Alexis Comnenos, not the Emperor of this name, but presumably a relative.

40. For Studenica and the related buildings of the Rascian School (Djurdjevi Stupovi, 1170; Žiča, 1207-19) see Millet, *op. cit.*, *passim*, Deroko, as quoted above, Note 18, *passim*, and M. Kasanin, V. Korać, D. Tabić, and M. Šakota, *Studenica* (Belgrade, 1968). W. Saš-Zaloziecky, *Die byzantinische Baukunst in den Balkanländern* (Munich, 1955), 25 ff. has stressed the increasingly Romanesque and Western character of the Rascian group.

402. 41. Millet, *op. cit.*, 50 ff.; B. Vulović, *Zbornik Architekonskog Fakulteta Beograd*, III (1957), 3 ff., setting off the twelfth-century core against later additions, such as the twin-towered forechurch, once extant; Dj. Stričević, *XII C.E.B.* . . . *Ohrid* . . . *1961*, VII, 226 and note 13, refuting the possibility, considered also by Vulović, *op. cit.*, of St Nicholas' being rebuilt on Early Byzantine foundations.

42. G. Millet, *L'école grecque* (Paris, 1916), was the first to point out (and sometimes to overstress) the characteristics of Greek as against Constantinopolitan church building. While some of his theses are outdated, such as the antithesis of hellenistic and oriental roots in or the impact of Armenia on Middle Byzantine church building in Greece, his book remains basic. For the needed revisions, see, for example, *Archeion*, V (1939/40), 3 ff., or Ch. Bouras, *C.A.*, XXI (1971), 137 ff.

Information on church building in Greece, too, has grown enormously over the past fifty years. In addition to Megaw, *op. cit.*, as quoted above Note 4, see *Archeion*, I-XI (1935-69), *passim*, where A. K. Orlandos has presented single-handed his knowledge of the material accumulated over a busy lifetime. For

a handy survey, see *Alte Kirchen und Klöster Griechenlands*, ed. E. Melas (Cologne, 1972).

403. 43. Megaw, as quoted above, Note 4. I cannot do better than to summarize his results; the relative chronology proposed by him remains valid, notwithstanding the shift in absolute chronology caused by the late-tenth- rather than eleventh-century dates recently established for the buildings grouped around the Theotokos-Panaghia at Hosios Lukas.

405. 44. In general, Megaw, *op. cit.*, and R. Traquair, *B.S.A.*, XV (1908-9), 177 ff. The church of the Gorgoëpikoos (Mikra Metropolis) in Athens, contrary to A. Struck, *A.M.*, XXXI (1906), 281 ff., dates from no earlier than the late twelfth century (Megaw, *B.S.A.*, XXXII, 1931/2, 100 ff.).

Tenth-century churches on the cross-in-square plan probably survive in larger numbers in Greece than formerly assumed; see, for instance, A. H. S. Megaw, *Charistirion eis A. K. Orlandon*, III (1966), 10 ff. (Nikli near Tegea); P. L. Vokotopoulos, *Deltion Christianikis Archaiologikis Hetairias*, ser. 4, V (1966-9), 149 ff. (H. Jason, Corfu); M. Sotiriou, *ibid.*, ser. 1, II (1960/1), 101 ff. (Petraki church, Athens); Ch. Bouras, *ibid.*, 57 ff. (Episkopi, Skyros).

Regarding the survival (or revival?) of basilical types in Middle Byzantine Greece, see *Archeion*, IX (1961), 38 ff., and, starting from a small tenth-century example in the Peloponnesus, Ch. Bouras, *C.A.*, XXI (1971), 137 ff.

45. R. W. Schultz and S. H. Barnsley, *The Monastery of Saint Luke of Stiris* (London, 1901), superseded by E. Stikas, *To oikodomikon chronikon tis monis Osiou Louka Phokidos* (Athens, 1970), and M. Chatzidakis, *C.A.*, XIX (1960), 127 ff., the latter setting straight the relative chronology of the Theotokos and the Katholikon and suggesting an absolute date, 1011, or 1022, for the Katholikon. The foundation date 955, proposed for the building of the Theotokos-Panaghia, seems to me somewhat early. Michael Jacoff has pointed out to me the close resemblance of the jamb profiles of the doors in the Theotokos and the Katholikon, and I would prefer for the former a date closer to the end than the middle of the tenth century.

Mrs L. Bouras-Philippides, who kindly supplied the photos for our illustrations 339-40, is preparing a study on the Theotokos-Panaghia; see also her preliminary paper on the drum and dome, *Architektonika Themata*, V (1971), 165 ff.

408. 46. G. C. Miles, *XII C.E.B. . . . Ohrid . . . 1961*, III, 281, and *D.O.P.*, XVIII (1964), 17 ff., with long lists of Islamic elements in Middle Byzantine Greek architecture, sculpture, and painting, stresses the impact of textiles, manuscripts, and ceramics as well as Moslem craftsmen resident in the western Aegean

area; A. Grabar, *C.R.A.I.* (1971), 15 ff., focuses on architectural Islamic models, transmitted through Byzantium; Mrs L. Bouras (orally; see above, Note 45), suggests transmission through Greek workmen active in Moslem countries.

47. A. Frantz, *The Church of the Holy Apostles* (*The Athenian Agora*, XX) (Princeton, N.J., 1971).

414. 48. A. H. S. Megaw, *B.S.A.*, XXXII (1931-2), *passim*, and for the H. Theodoroi, *B.S.A.*, XXXIII (1932-3), 163 ff. An inscription of 1065 provides a *terminus ad quem*; the cufic frieze on the façade is perhaps not contemporary with the building (information kindly supplied by Professor George C. Miles). The Kapnikarea is undated, its narthex slightly later than the naos, but earlier than the parekklesia. See also J. Travlos, *Poleodomiki Exelixis tōn Athinōn* (Athens, 1960), 149 ff., and L. Philippides, *Epistemoniki Epitiris Polytechnikis Scholis Thessalonikis*, V (1970), 81 ff., on H. Sotir with a date 1050-1125. The simplification of the cross-domed octagon becomes evident prior to 1044 in the Panaghia Lykodimou in Athens; see above, Chapter 16, Note 9.

49. G. Millet, *Daphni* (Paris, 1899); A. H. S. Megaw, *B.S.A.*, XXXII (1931-2), 93 f. The cathedral of Christianou, at roughly the same time, shows the plan of Daphni with slight variations; see Stikas, as above, Chapter 16, Note 9.

417. 50. Regarding the variants on the quincunx plan in Greece, see *Archeion*, V (1939-40), 3 ff.; for Hosios Meletios, *ibid.*, 34 ff.; for H. Sotir, Amphissa, *ibid.*, I (1935), 181 ff.; for Kaisariani, *Ephimeris* (1902), 54 ff.; for St John the Theologian, A. K. Orlandos and G. Sotiriou, *Evretirion tōn Mnimeiōn tis Ellados*, I (Athens, 1927 ff.), 168 f., with the erroneous date, thirteenth or fourteenth century; for the churches at Kitta and Vamvaka, R. Traquair, *B.S.A.*, XV (1908/9), 177 ff., and A. H. S. Megaw, *B.S.A.*, XXXIII (1932-3), 137 ff.; for Ligourio, *idem*, *B.S.A.*, XXXII (1931-2), 114. For further material, *Archeion*, VIII (1955-6), 3 ff., on Andros; *ibid.*, IX (1961), 3 ff., on the provinces of Aetolia, Evretania, and Akarnania; *ibid.*, XI (1969), 3 ff., on the region around the Gulf of Ambrakikos, all in central western Greece; also, P. L. Vokotopoulos, *Deltion Christianikis Archaiologikis Hetairias*, ser. 4, V (1966-9), 149 ff., on Corfu.

51. At times, e.g. at Ligourio, the rippling eaves line was transformed into the straight type in a late rebuilding.

418. 52. D. Pallas, *Anaglyptos Stili tou Byzantinou Mouseiou* (Athens, 1961), has been the first to place the Byzantine ornament of Greece in a chronological context. We list a few examples in which foliage and geometric forms are fused: the capitals in the windows of the Kapnikarea; the ornament on doors and templa

at Hosios Meletios, *c.* 1100 (*Archeion*, V, 1939-40, 71, 97 ff.); the decoration of H. Sotir at Amphissa (*Archeion*, I, 1935, 194, figure 11), first quarter of the twelfth century. Tendril friezes of the early, freer type, still recalling the templa of the Katholikon at Hosios Lukas, are found in the third quarter of the eleventh century at Christianou (Pallas, *op. cit.*, figure 8, and Stikas, *op. cit.* in Chapter 16, Note 9, figures 36 ff.) and, perhaps later, at Kriezoti (*Archeion*, V, 1939-40, figures 8-13).

53. A. Struck, *A.M.*, XXXIV (1909), 189 ff., and A. H. S. Megaw, *B.S.A.*, XXXII (1931-2), *passim*. The church at Chonika (*Ergon*, 1960, 246 f.), to judge from its simpler masonry, may well date from the end of the eleventh century, that is, earlier than the other Argolis churches. Merbaka, because of the use of 'Gothic' jamb colonnettes in the window of the main apse, has been assigned a date after 1205, under its first Frankish bishop (A. Bon, *Charistirion eis A. K. Orlandon*, III, 1966, 86 ff.). For H. Sotir near Amphissa (the detail [357] was mistakenly identified in the first edition of the present volume, plate 163B, as belonging to the H. Moni near Nauplion), see *Archeion*, I (1935), 181 ff., and G. C. Miles, *D.O.P.*, XVIII (1964), figure 29.

420. 54. The material between Kayseri and Konya and in Lycaonia was first gathered by Rott, *Denkmäler*, and Ramsay and Bell, *Churches*; for Binbirkilise in particular, see above, Chapter 6, Note 46. Our knowledge has not advanced much farther, while the monuments are disappearing. Aisleless chapels are reported, e.g. at Viranşehir and Sarigül (*ibid.*, 325 ff., 332 ff.); cross-plan churches at Helvadere (Rott, *op. cit.*, 265 ff.), Kurşuncu (known through Ramsay and Bell, *op. cit.*, 353 ff.), and Viranşehir (*ibid.*, 363 ff.). Hall-churches with barrel-vaults, mostly of small size, were built at Binbirkilise still after 850 (no. 3, *ibid.*, 53 ff.). Perhaps at the same time a sixth(?)-century church at Tilkoïnsar (Kemerhisar) (reported on by Rott, *op. cit.*, 287 f. and G. de Jerphanion, *Les églises rupestres de Cappadoce*, Paris, 1928 ff., I, plate 22) was remodelled as a barrel-vaulted hall-church resting on heavy piers.

55. S. Ballance, *Anatolian Studies*, X (1960), 141 ff. The church of the Chrysocephalos at Trebizond, originally a basilica with galleries of tenth- or eleventh-century date(?), was transformed in the thirteenth century by inserting into its centre a barrel-vaulted cross, surmounted by a dome (*ibid.*, 146 ff.).

421. 56. Standard works are Jerphanion, as above, Note 54, and M. Restlé, *Byzantine Wall Painting in Asia Minor* (Greenwich, Conn., 1967), the latter to be supplemented by the review of S. Kostof, *Art Bulletin*, LII (1970), 88 ff. The late dating of the rock churches

and their murals once proposed (E. Weigand, *B.Z.*, XXXVI, 1936, 337 ff.) can be disregarded in the light of recent studies and new discoveries. See M. Chatzidakis, *Byzantion*, XIV (1939), 95 ff.; J. Lafontaine-Dosogne, *ibid.*, XXVIII (1959), 165 ff., also XXXIII (1963), 121 ff., and *idem.*, *C.A.*, XII (1962), 263 ff.; N. and M. Thierry, *Nouvelles églises rupestres de Cappadoce* (Paris, 1963), also *C.A.*, XV (1965), 97 ff., XVII (1967), 161 ff., XVIII (1968), 33 ff., and *C.R.A.I.* (1971), 144 ff.; finally, Restlé, *op. cit.*, *passim*. On those churches near Soğanli, see still Rott, *op. cit.*, 127 ff., 135, 139 ff., 145 ff.; on those of Göreme, *ibid.*, 210 ff. A useful picture book is L. Budde, *Göreme* (Münster/W, 1960); most handy and recently published, S. Kostof, *Caves of God* (Cambridge, Mass., and London, 1972).

57. Rott, *op. cit.*, 224 ff.; Jerphanion, *op. cit.*, I, 262 ff., points out that a small, perhaps ninth-century chapel, now the porch, was later enlarged into the present structure.

423. 58. A number of aisleless chapels, sometimes doubled and as a rule with horseshoe apses, are provided with *termini ante* through mural cycles dated by inscriptions, ranging from the early tenth century to 1060-1 (Thierry, as above, Note 56, *C.A.*, XV; Restlé, *op. cit.*, *passim*; Jerphanion, *op. cit.*, *passim*). A group of churches indeed has been assigned to the eighth and possibly the seventh century; see N. Thierry, *C.R.A.I.* (1971), as above, Note 56, and *idem.*, *C.A.*, XVIII, as Note 56.

59. Among the quincunx rock churches known so far, only the cycle in the Direkli Kilise (in the Melendiz Suyu Valley, near Belisirama) is dated, within the reign of Basil II (976-1025), the Thierrys inclining towards an early date, last quarter of the tenth century, Restlé, *loc. cit.*, towards the years 1020-5. The Kiliçlar Kilise at Göreme has been dated around or before 900 (Restlé, *op. cit.*, 118 ff., 130 ff.). The Elmali Kilise (Rott, *op. cit.*, 219 ff.; Jerphanion, *op. cit.*, I, 431 ff.; Restlé, *op. cit.*, I, 56 ff., 123 ff.), Karanlik Kilise (Quaranleg, Analipsis: Rott, *op. cit.*, 212 ff.; Jerphanion, *op. cit.*, I, 393 ff.; Restlé, *op. cit.*, 56 ff., 128 f.), and Çarikli Kilise (Restlé, *op. cit.*, 56 ff., 127 f.) are all three assigned by Restlé to the second half of the twelfth century, based on the style of the paintings. My notes taken in 1954, on the spot, mention an earlier aniconic layer with simple crosses in the Elmali Kilise, suggesting a date for the church possibly as early as the ninth or tenth century. Another quincunx, at Kepez near Ürgüp, is covered with murals that have been dated (Lafontaine-Dosogne, *C.A.*, XII, 1962, 263 ff.) shortly after 1050. Finally, the murals of a quincunx cave church at Eski Gümüş (M. Gough, *Anatolian Studies*, XIV, 1964, 147, and

xv, 1965, 157) are given dates in the late eleventh and twelfth centuries.

60. J. Strzygowski, *Kleinasien* (Leipzig, 1904), 156; Rott, *Denkmäler*, 258 ff.; Ramsay and Bell, *Churches*, 404 ff.; N. and M. Thierry, *Nouvelles églises rupestres* . . . (as quoted above, Note 56), 21 f., suggesting a tenth- or eleventh-century date for the original building, a date in the second half of the eleventh century for the narthex. The 'recessed brick' technique (or imitation?) leads me to think of an eleventh- or twelfth-century date for the original core as well.

425. 61. For Üçayak, see S. Eyice, *C.A.*, xviii (1968), 137 ff. Quincunx churches in a simple local style are known from Konya and vicinity: H. Amphilochios on the citadel at Konya (Ramsay and Bell, *Churches*, 403 ff.); the Ala Kilise on the Ali Summasi Dağ, and the Ilanli Kilise (Karadjedik Kilise) in the Ihlara Dere in the Melendiz Suyu Valley near Belisirama (known through *ibid.*, 399 ff., 418 ff.; Rott, *Denkmäler*, 274 ff.); a ruin near Fisandün (Strzygowski, *op. cit.*, 154); finally the mosque, formerly the church of H. Gregorios Thaumaturgos, at Gelveri (Ramsay and Bell, *op. cit.*, 421 f.). Except for this latter, which I visited in 1954, I do not know whether these churches survive. Another quincunx, replacing a small sixth-century basilica, with rich sculptural decoration and of tenth-century date has been excavated at Selçikler Köyü (Sebaste) near Uşak in western Asia Minor (N. Firatli, *C.A.*, xix, 1969, 151 ff.). A list of quincunx churches in Asia Minor, though both incomplete and uncritical, has been compiled by G. Dimitrokallis, *Mikroasiatika Chronika*, xiii (1967), 81 ff.

62. See Orlandos, *Archeion*, vi (1948), 55 ff., on the numerous Middle Byzantine churches on Rhodes: aisleless chapels, with barrel-vaults, sometimes tripled; atrophied Greek crosses with slightly projecting arms; a few quatrefoils; and four quincunx churches - one on Mt Phileremos, H. Yoannis in Lindos, the Panaghia in the castle (almost totally destroyed in 1943), and the Demirli Camii in the town of Rhodes. None are dated by external evidence, and stylistic evidence hardly justifies the dating proposed by Orlandos: *c.* 1000 for the Phileremos church, the thirteenth and fourteenth centuries for the other three.

426. 63. G. Gerola, *Monumenti veneti nell'isola di Creta*, ii (Venice, 1908), 79 ff.

64. G. Sotiriou, *Ta byzantina Mnimeia tis Kyprou* (Athens, 1935); A. I. Dikigoropoulos, in *Report of the Department of Antiquities, Cyprus, 1940–1948* (Nicosia, 1958).

65. G. Sotiriou, *V C.E.B. . . . Rome . . . 1936*, ii, 401 ff., has suggested a fifth-century date for the three-domed churches of H. Lazaros at Larnaka and

H. Barnabas at Salamis - a proposal which will warrant further investigation.

427. 66. See above, p. 360, and Chapter 16, Note 12.

67. É. Bertaux, *L'art dans l'Italie méridionale* (Paris, 1904); P. Orsi, *Le chiese basiliane della Calabria* (Florence, 1929); Venditti, as quoted above, Chapter 7, Note 49, *passim*. Reliable surveys and discussions of the churches at Rossano and Stilo are found in H. Teodorou, *Ephemeris Daco-Romana*, iv (1930), 149 ff.; P. Lojacono, *V C.E.B. . . . Rome . . . 1936*, ii, 183 ff.; and Venditti, *op. cit.*, 852 ff. Resemblances, perhaps of an accidental nature, to the cave churches of Cappadocia have been pointed out by G. de Jerphanion, *V C.E.B. . . . Rome . . . 1936*, ii (1940), 572 ff. The dates of construction for both churches remain in doubt. A list of South Italian quincunx churches has been compiled by G. Dimitrokallis, *Epitiris Hetairias Byzantinōn Spoudōn*, xxxvi (1968), 247 ff.

68. G. Jonescu, *Ephemeris Daco-Romana*, v (1935), 50 ff.

428. 69. *Archeion*, i (1935), 139 ff., for Monemvasia. For the 'reticulate' chequer bands and their early beginnings (e.g. the Palaia Episkopi at Nikli near Tegea), A. H. S. Megaw, *Charistirion eis A. K. Orlandon*, iii (1966), 10 ff., who suggests a tenth-century date for Stilo. Examples dating from about 1150 are found at H. Georgios near Kitta and at H. Varvara near Eremos on the Mani peninsula; A.H.S. Megaw, *B.S.A.*, xxxiii (1932-3), 137 ff., and plates 17a, b, and 19d. The links to the churches of Arta suggested by Teodorou, *op. cit.*, are less likely, given the late date of the Arta churches.

70. Links between South Italy and the Mani peninsula are also suggested by the plan of S. Pietro at Otranto, of late-eleventh-century date (for illustration, see P. Lojacono, *B.d.A.*, xxvii, 1933-4, 381). For Castro, see R. Bordenache, *ibid.*, 169 ff. For Squillace, see Bertaux, *op. cit.*, 126 ff.; Venditti, *op. cit.*, 899 ff.; H. M. Schwarz, *Röm. Jbch. der Bibliotheca Hertziana*, vi (1942-4), 1 ff., with the correct reference to Comnene building style in Constantinople.

71. G. Agnello, *L'architettura bizantina in Sicilia* (Florence, 1952); G. di Stefano, *Monumenti della Sicilia bizantina* (Palermo, 1952); and, *idem, Monumenti della Sicilia normanna* (Palermo, 1955); O. Demus, *The Mosaics of Norman Sicily* (London, 1949).

72. L. Serra, *B.d.A.*, xxx (1936-7), 253 ff.; Venditti, *op. cit.*, 666 ff. An eleventh-century date seems to me more likely than the ninth- or tenth-century dates previously suggested.

73. Demus, *op. cit.*, 73 ff.; Di Stefano, *Sicilia normanna* (*op. cit.*), 32 ff. with extensive bibliography.

430. 74. See on the contrary, E. Kitzinger, *I mosaici di Monreale* (Palermo, 1960), 174. A paper, yet unpublished, by Mrs Christine Hunniken convinces me that contrary to former belief, including my own (first edition of this book, p. 286), the cathedral of Pisa depends in plan and elevation, rather than on Byzantine, largely on French late-eleventh-century models, meaning the churches along the pilgrimage roads.

75. R. W. Schultz, *Die Kirchenbauten auf der Insel Torcello* (Berlin, 1927), 37 ff.

431. 76. O. Demus, *The Church of San Marco* (Washington, 1960), supersedes the numerous older treatments of the building and its history, which he lists. We mention only C. Boïto, *La ducale basilica di San Marco* (Venice, 1886); L. Marangoni, *L'architetto ignoto di San Marco* (Venice, 1933); and S. Bettini, *L'architettura di San Marco* (Padua, 1946).

432. 77. I am giving a simplified – and probably oversimplified – version of the complex relationships, involving Venice, Aquileia, and Grado, as presented in full by Demus, *op. cit.*, 3 ff.

78. For the first church, as known through Forlati's excavations of 1949 ff., see Demus, *op. cit.*, 64 ff., based on Forlati's reports, and B. and F. Forlati in *Alto Medioevo*, II (c. 1970), 17 ff. For the dependence of the present, 1063, S. Marco on the Apostle Church in Constantinople, as remodelled some time between 940 and 979-89, see Krautheimer, *Studies*, 197 f. (from *Mélanges Eugène Tisserant*, II, *Studi e Testi*, 232, Vatican City, 1964), 265 ff.), complementing Demus, *op. cit.*, 88 ff. and in particular, 91, note 129.

79. For the marble sheathing of the façades, see Demus, *op. cit.*, 100 ff., for the use of spoils, *ibid.*, 120 ff. The date of the outer shells of the domes and their dependence on Islamic models have been recently discussed by G. Fiocco, *Bollettino Centro Internazionale . . . Andrea Palladio*, VIII (1968), 222 ff., with reference also to U. Monneret de Villard, *Architettura e Arti decorative*, I (1921), 315 ff. See also *idem, Introduzione allo studio dell'archeologia islamica* (Venice, 1966), 201 ff. (Dome of the Rock); K. A. C. Creswell, *A Short Account of Early Islamic Architecture* (Penguin Books, Harmondsworth, 1958), 37 ff.; and *idem, The Muslim Architecture of Egypt* (Oxford, 1952), I, plate 80 and (for wooden domes), II, 237 and note 7.

436. 80. Demus, *op. cit.*, 83 f. (galleries reduced to catwalks), 76 ff. (brick façades); H. Buchwald, *Jahrbuch der Österreichischen Byzantinischen Gesellschaft*, XI, XII (1962-3), 169 ff., and XIII (1964), 137 ff. (niello inlay, plaques, capitals).

81. Demus, *op. cit.*, focuses his attention only on the capitals in the narthex. But many of those in the interior likewise date from the late eleventh or the

early twelfth century; see T. Krautheimer-Hess, *Art Bulletin*, XXVI (1944), 152 ff., esp. 172. Buchwald, *op. cit.*, XIII (1964), 137 ff., differentiates between two groups of capitals, one late-eleventh- and early-twelfth-, the other thirteenth-century.

PART SEVEN:
THE END OF BYZANTINE ARCHITECTURE

CHAPTER 18

437. 1. See however G. Ostrogorsky, *History of the Byzantine State* (Oxford, 1956).

CHAPTER 19

439. 1. O. Demus, *XI C.E.B. . . . Munich . . . 1959*, Beiträge, IV, 2, *passim*.

2. G. Babić, *Les chapelles annexes des églises byzantines* (Paris, 1969), on planning, decoration, and function of parekklesia; S. Ćurčić, *Zb. R.*, XIII (1971), 333 ff., on twin-domed nartheces and their function.

440. 3. C. Diehl, *Manuel d'art byzantin*, 2 vols, 2nd ed. (Paris, 1925-6), 735 ff., 754 ff.; G. Millet, *L'ancien art serbe* (Paris, 1919); *idem, Monuments byzantins de Mistra* (Paris, 1910 ff.), and *L'école grecque* (Paris, 1916), *passim*.

441. 4. S. Bettini, *V C.E.B. . . . Rome . . . 1936*, II, 31 ff.; S. Eyice, *Son devir bizans mimârisi* (Istanbul, 1963), 42 ff. Regarding the (doubtful) thirteenth-century date for the Mugliotissa church, see Janin, *Églises*, 222 f. The church of the Panaghia Kamariotissa on Heybeliada (Halki) has turned out to be of eleventh- or twelfth-century date: see above, p. 388 and Chapter 17, Note 15.

5. *Archeion*, I (1935), 5 ff., 41 ff.; *ibid.*, II (1936), 51 ff., 170 ff. For a brief survey and characterization of the architecture of the period in Epirus, Trebizond, Russia, and Serbia, see V. Korać, in *L'art byzantin du XIII^e siècle* (Belgrade, 1967), 11 ff.

6. Simple aisleless chapels are too numerous to list; for the group in and around Ohrid, see Ð. Bošković and K. Tomovski, in *Musée National d'Ohrid, Recueil de Travaux* (Ohrid, 1961), 89 ff.; for H. Basilios at Arta, *Archeion*, II (1936), 115 ff.; for examples in Constantinople, S. Eyice (as above, Note 4), 26 ff. (Manastir Mescidi, perhaps late-thirteenth-century; Isa kapisi Mescidi (Isa Kapi Camii), early-fourteenth-century).

7. A. Grabar, *I.B.A.I.*, I (1921), 103 ff. (Asen church at Stanimaka); *idem, L'église de Boïane* (Sofia, 1924) (Boïana: small cruciform church, eleventh-century,

enlarged in 1259 by attached double-storeyed mauso-leum church). The Boğdan Sarayi chapel in Constan-tinople, too, possibly of fourteenth-century date, may have been a funeral chapel with crypt and domed and barrel-vaulted upper floor (Eyice, *op. cit.*, 32 ff.; Brunov, *B.Z.*, XXVI, 1926, 358, note 4), whether or not attached to a monastery. The church of the Taxi-arches in Salonica (A. Xyngopoulos, *Tessares mikroi naoi tis Thessalonikis*, Salonica, 1952, 5 ff.), certainly monastic, likewise rises over a crypt - a timber-roofed nave, enveloped by a portico, open except on the north, the bema flanked by projecting pastophories.

For chapels of the barrel-vaulted and domed type in Bulgaria, serving neither monastic nor funeral func-tions, see below, p. 464 and Note 32 (Nessebâr), and Kr. Mijatev, *Architekturata v Srednovekovna Blgarija* (Sofia, 1965), 176 (Červen) – both of fourteenth-century date.

8. See below, p. 447 and Note 14, for the Fenari Isa Camii. A church of similar plan at Lampobou in Thessaly has been discussed by P. Versakos, *Ephim-eris* (1919), 108 ff.

9. A. K. Orlandos, *Hi Parigoritissa tis Artis²*, (Athens, 1963); for the other buildings mentioned, see above, Chapter 16, Note 9, for bibliography.

442. 10. Demus, as above, Note 1; see also H. Buch-thal, *D.O.P.*, XX (1966), 103 ff., for the parallel devel-opment in Sicily.

11. See above, Note 9; for the addition of the parek-klesia as an afterthought during construction, see Orlandos' supplement in the second edition, as quoted, p. 165 f.

444. 12. *The Church of H. Sophia at Trebizond*, ed. D. Talbot Rice (Edinburgh, 1968), especially *idem* and S. Ballance, 'Historical Introduction', 1 ff.; and S. Ballance, 'The Architecture', 8 ff. For other, earlier and later, churches in Trebizond, S. Ballance, *Anatolian Studies*, X (1960), 141 ff.

445. 13. G. Millet, *Monuments byzantins de Mistra* (Paris, 1910; plates only); M. Chatzidakis, *Mystras* (Athens, 1956); H. Hallensleben, *Marburger Jahrbuch für Kunstwissenschaft*, XVIII (1969), 105 ff., on the genesis of the Mistra type (his suggestions regarding the general framework seem to me all too theoretical); S. Dufrenne, *Les programmes iconographiques des églises byzantines de Mistra* (Paris, 1970), 1 ff., with summaries regarding the dates of construction or remodelling of the major churches. It still remains unclear when the Metropolis was transformed into the 'Mistra type' (the fifteenth-century date assigned to the Metropolitan Matthew who financed the re-building rests on no sound foundation); see also D. A. Zakythinos, *Le despotat grec de Morée*, II (Paris,

1953), 284 ff., giving the list of metropolitans with wide gaps in the fourteenth century as well.

447. 14. For the North Church of the Fenari Isa Camii complex, see above, p. 380, and Chapter 17, Note 9; the investigations of A. H. S. Megaw did not extend to the South Church. For this latter and its parekklesion, see Van Millingen, *Churches*, 122 ff., Janin, *Églises*, 318 ff., and Th. Macridy, *D.O.P.*, XVIII (1964), 265 ff. For the structures appended to the Kariye Camii, I refer to Underwood (as quoted above, Chapter 16, Note 7), 17 ff.

448. 15. The structures attached to the Pammaka-ristos, the Fetiyeh Camii, are discussed by both Hallensleben and Mango and Hawkins (as above, Chapter 17, Note 14): esonarthex; end corridor, and end chapel; south parekklesion, that is the funerary chapel of Michael Glabas; exonarthex and south corridor. But sequence and dating of these additions remain under discussion. Hallensleben assigns an older esonarthex, now lost, and the north corridor with its end chapel to shortly before 1294; the funer-ary chapel to the south, to 1315; exonarthex and south corridor to the years 1326–41. Mango and Hawkins, on the other hand, date the Glabas mausoleum about 1310, and consider all the rest, north corridor, end chapel, exonarthex, and south corridor, as added around the middle of the fourteenth century.

A church, composed of a domed one-bay core with chancel and apse, enveloped by narthex and flanking parekklesia, has come to light at Nicaea (Iznik) (S. Eyice, *C.C.R.*, 1971, 309 ff., esp. 314 f. and figure 2).

450. 16. Bošković and Tomovski, *op. cit.*, 87 ff.

451. 17. *Archeion*, II (1936), 70 ff., 88 ff., 115 ff., 131 ff.; and the brief survey given by D. M. Nicol, *The Despotate of Epiros* (Oxford, 1957), 196 ff.

452. 18. Early examples in Constantinople are the Fenari Isa North Church, 907; the Eski Imaret Camii, c. 1080; the apse of the Kilise Camii. For Greece, we refer to Megaw, *op. cit.*, *B.S.A.*, XXXII (1931/32), 90 ff., esp. 102 ff. For the Argolis churches, see above, p. 417, and Chapter 17, Note 53; for Bryoni, *Archeion*, II (1936), 51.

455. 19. For H. Katherini, see C. Diehl, H. Saladin, and M. Le Tourneau, *Les églises de Salonique* (Paris, 1916), 179 ff. and plate 58; for the Holy Apostles, *ibid.*, 187 ff., V. V. Laurent, *Revue Études Byzantines*, VII (1949), 149, and A. Xyngopoulos, *Thessalonique et la peinture macédonienne* (Athens, 1955). For the smaller fourteenth-century churches of Salonica, see A. Xyngopoulos, as above (Note 7); S. Pelikanides, *Balkan Studies*, III (1962), 463 ff.; V. V. Laurent, *Revue Études Byzantines*, XIII (1955), 109 ff.; and G. I. Theocharides, *Makedonika*, IV (1955-60), 315

ff., the latter two regarding the church of H. Elias and its date of construction *c*. 1360–80. The corner chapels at H. Elias were rebuilt after World War II on the extant foundations and their upper parts do not necessarily represent the original solution. The church of Chilandari is still in need of thorough study; at this time, see G. Millet, *L'ancien art serbe*, (Paris, 1919), 95 ff. (with the date 1200 for the foundation, a misprint unfortunately repeated in the first edition of the present volume), and the remarks made by Ćurčić, *Zb. R.*, XIII (1971), 333 ff.

457. 20. Examples are found, for instance, at Sv. Dimitri, in Turnovo, 1186 (N. Mavrodinov, *L'église à nef unique et l'église cruciforme en pays bulgare*, Sofia, 1931, 38 ff.), and in the Asen church at Stanimaka (see above, Note 7). See also N. Mavrodinov, in *I.B.A.I.*, VIII (1934), 262 ff., and below, Note 32.

458. 21. A. K. Orlandos, *Monastiriaki architektoniki* (Athens, 1958), *passim*; D. M. Nicol, *Meteora* (London, 1963).

22. For general bibliography, see above, Chapter 17, Note 18.

23. M. Kašanin, V. Korać, D. Tasić, M. Sakota, *Studenica* (Belgrade, 1968); other examples are the churches at Mileševa of 1234–5; at Sopoćani of *c*. 1255; at Dečani of 1327–35. See Millet, *op. cit.*, *passim*; *idem*, in *L'art chez les Slaves, Recueil Théodore Uspenski*, I (Paris, 1930), 147 ff.; and Deroko, *op. cit.*, *passim*.

459. 24. Bošković and Tomovski, *op. cit.*, in Note 6. The resemblance of the façade of St Sophia at Ohrid to Venetian and Late Antique palace façades has been often remarked on; but one wonders whether any direct link exists.

460. 25. S. Nenadović, *Bogorodica Ljeviška* (Belgrade, 1963).

26. Millet, *L'ancien art serbe*, 110 ff., and Mavrodinov, *op. cit.* (Note 20), 85.

461. 27. For Staro Nagoričino, see Millet, *op. cit.*, 98 ff.; Mavrodinov, *op. cit.*, 88; Đ. Bošković, in *L'art chez les Slaves* (as above, Note 23), 195 ff.; and Deroko, *op. cit.*, 185.

28. For Gračanica, see Millet, *op. cit.*, 105 ff.; Mavrodinov, *op. cit.*, 89 f.; Bošković, *loc. cit.*; and V. Korać, *Zbornik Svetozar Radojčić* (Belgrade, 1969), 143 ff. A monograph on the church is being prepared by S. Ćurčić, whom I want to thank for the information supplied in many talks. In particular, the suggestion of the links between the plan of Gračanica and the churches with enveloping nartheces at Salonica is due to him.

464. 29. Deroko, *op. cit.* (Chapter 17, Note 18), *passim*.

30. Millet, *L'ancien art serbe*, as above, Note 19.

31. Millet, *ibid.*, 152 ff., Deroko, *op. cit.*, 314 ff. Dj. Stričević, *Starinar*, N.S. V–VI (1954–5), 115 ff., has re-established the chronology of the Morava churches. See also W. Saš-Zaloziecky, *Die byzantinische Baukunst in den Balkanländern* (Munich, 1955), 59 ff.

For Rumanian architecture, I refer to the chapter written by G. Jonescu in: *Vseobščaya Istorija Architektury*, III (as quoted above, Chapter 14, Note 56), 453 ff.; and to V. Vatašianu, in W. F. Volbach and J. Lafontaine-Dosogne, *Byzanz und der christliche Osten* (*Propyläen-Kunstgeschichte*, III) (Berlin, 1968), 275 ff.; and to their illustrations.

32. For Late Byzantine architecture in Bulgaria, see the bibliographical references given above, Chapter 14, Note 26, and Chapter 17, Note 18; for the churches at Nessebâr, see also A. Rašenov, *Églises de Mesembria* (Sofia, 1932), and *V C.E.B. . . . Rome . . . 1936*, II, 352 ff., Saš-Zaloziecky, *op. cit.*, *passim*, I. Galabov, in Beševljiev and Irmscher, *Antike und Mittelalter in Bulgarien* (Berlin, 1960), 306 ff. St John Aleiturgitos, the Pantokrator church, and the Church of the Archangels at Nessebâr were destroyed in an earthquake in 1913 and have been under restoration ever since.

466. 33. Mavrodinov, *op. cit.*, 38 ff.

34. A. Grabar, *I.B.A.I.*, I (1921), 103 ff.; Kr. Mijatev, *Architekturata v Srednovekovna Blgarija* (Sofia, 1965), 171 ff.

35. Rašenov, *Églises*, 26 ff., 79 ff., 99 ff.; Mijatev, *op. cit.*, *passim*.

36. Early examples of barrel-vaulted and domed aisleless churches in Constantinople are the middle church in the Zeyrek Camii complex and the Toklu Dede Mescidi; see above, pp. 390 ff., 388, and Chapter 17, Notes 15 and 17. For the Boğdan Sarayi, see Van Millingen, *Churches*, 180 ff., and S. Eyice, *Son devir bizans mimârisi* (Istanbul, 1963), 32 ff. The Armenian hypothesis is proffered by Grabar, as above, Note 34.

468. 37. The importance of polychrome reticulated and chequerboard masonry in Roman Gaul and the Rhineland and its survival in the eighth and ninth centuries has been brought out by H. R. Hitchcock, *Art Studies*, VI (1928), 175 ff. N. Mavrodinov, *I.B.A.I.*, VIII (1934), 262 ff., and S. N. Bobčev, *ibid.*, XXIV (1961), 153 ff., have suggested that it was known as well in the Roman Balkan provinces and thus survived in Bulgaria, but this remains to be proven. S. Bettini, *V C.E.B. . . . Rome . . . 1936*, II, 22 ff., assumes that from the West it penetrated the Balkans via Epirus in the thirteenth century; the opposite view is taken by Megaw, as quoted above, Chapter 17,

Note 69. For Forza d'Agro, see F. Basile, *Chiese siciliane del periodo Normanno* (*I monumenti d'Italia*, XV) (Rome, 1938).

469. 38. Van Millingen, *Churches*, 288 ff.; Janin, *Églises*, 545 ff.; P. A. Underwood, *The Kariye Djami* (London, 1967), 17 ff.

472. 39. Van Millingen, *Churches*, 138 ff.; Janin, *Églises*, 217 ff.; P. A. Underwood, *D.O.P.*, XIV (1960), 215 ff.; and Mango and Hawkins, and Hallensleben, as quoted above, Chapter 17, Note 14. Regarding the date of the funeral chapel of Michael Glabas, 1310 as suggested by Mango and Hawkins, *op. cit.*, or after 1315 as generally accepted, see Hallensleben, *op. cit.*

The two capitals surviving in the parekklesion (Van Millingen, *Churches*, plate 40), are covered, one with stiff thorny acanthus leaves, the other with tendrils issuing from a pair of crossed cornucopiae – both obviously attempts at reviving the vocabulary of the sixth century. But it is doubtful whether they were carved for their present position. They may be eleventh-century spoils, comparable to capitals of that time in and near Venice.

473. 40. See above, Chapter 17, Note 11.

41. For instance, by K. Wulzinger, *Byzantinische Baudenkmäler* (Hanover, 1925), 86 ff. F. Dirimtekin, *Istanbul Arkeoloji Müzeleri Yilliği*, V (1952), 45,

assigns the ground floor of the palace to the time of Constantine Porphyrogenetos, the upper floors to a restoration of undetermined date. But as far as I can see, the structure of the palace is of one build. Schneider (B. Meyer-Plath and A. M. Schneider, *Die Landmauer von Konstantinopel*, II, Berlin, 1943, 95 ff.) believed the precinct wall of the palace to be later than the fifth- and earlier than the adjoining twelfth-century parts of the city walls. This is possible; their further intimation (*ibid.*, 99 and note 3) of an eighth- or ninth-century(?) date for the palace proper remains tentative and unproven. To me a Paleologue date seems unquestionable. C. Mango, *J.D.A.I.*, LXXX (1965), 305 ff., esp. 330 ff., arrives at the same conclusion; so does O. Feld, *Ist. M.*, XIX-XX (1969-70), 359 ff., in a study on the capitals of the Tekfur Sarayi.

475. 42. *Archeion*, III (1937), 1 ff.; also A. K. Orlandos, in *Art et société à Byzance sous les Paléologues* (*Actes du Colloque . . . Études Byzantines . . . Venice . . . 1968*) (Venice, 1971).

43. S. Eyice, *XI C.E.B. . . . Munich . . . 1958*, Akten, 150 ff.

44. O. Demus, *XI C.E.B. . . . Munich . . . 1958*, Berichte, IV, 1 (Munich, 1958), and *idem*, *Jbch. Österr. Byz. Ges.*, XIV (1965), 139 ff.

GLOSSARY

Acanthus. Architectural ornament resembling the leaves of the acanthus plant.

Aedicula. A frame, as of a niche, formed by a pair of columns, piers, or pilasters supporting a gable, a lintel, or a plaque.

Agape. In the Early Christian church, a meal of semi-ritual character shared by the Christian congregation as a whole, or, later, offered to the poor of the congregation.

Ambo. Pulpit.

Ambulatory church. A church plan in which a domed centre bay is enveloped on three sides by aisles (see also *Cross-domed church*).

Aniconic. Without idols or images.

Architrave. A lintel in stone or timber carried from the top of one column or pier to another; the lowest member of the entablature.

Ashlar. Cut stone masonry.

Atrium. In Early Christian, Byzantine, and medieval architecture, the forecourt of a church; as a rule, enveloped by four colonnaded porticoes (quadriporticus).

Baldacchino. A free-standing canopy rising above a throne, an altar, or a tomb.

Barrel-vault. A half-cylindrical vault, as in a continuous arch; also, a tunnel-vault.

Basilica. An assembly room; in Christian parlance, a church; as a rule, longitudinal and composed of nave and aisles, the former lit by a clerestory.

Basilica discoperta. A basilica type supposed to consist of covered aisles and an unroofed nave.

Basket capital. A capital of hemispherical or nearly hemispherical shape, decorated with a wicker design imitating a basket.

Bema. The chancel part of a Greek church.

Camii. In Turkish, mosque.

Catechumen. In the early church, a convert to Christianity, under instruction but not yet baptized.

Cathedra. The throne of the bishop.

Ciborium. See *Baldacchino.*

Cloisonné masonry. A decorative use of masonry in which small stone blocks are framed by bricks placed vertically and horizontally in single or double courses.

Cloister-vault. A vault composed of four, eight, or twelve curved surfaces, as would result from the interpenetration of two, four, or six barrel-vaults of equal height and diameter (Brit. *domical vault*); also, a four-sided, eight-sided, etc., dome.

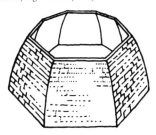

Coenobite (cenobite). In monasticism, the designation for communal life (see *Coenobium*).

Coenobium (cenobium). A monastery arranged for the communal life of a monastic congregation.

Conch. A semicircular niche surmounted by a half-dome.

Confessio. In a church, a subterranean chamber or recess located below or near the altar and sheltering a relic.

Continuous transept. See *Transept.*

Corbel. A projecting stone or brick on the face of a wall which serves as a support (see *Corbel table frieze*).

Corbel table frieze. A series of small arches resting on corbels.

Cross church. See *Greek-cross plan.*

Cross-domed church (Kreuzkuppelkirche according to Wulff, *Handbuch).* A church plan whose core, enve-

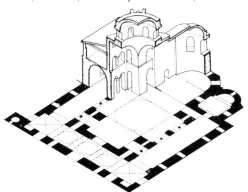

loped on three sides by aisles and galleries, forms a cross; the core is surmounted by a dome in the centre and four barrel-vaults resting on four strong corner piers; also, *église à croix* (in the older literature, sometimes referred to as ambulatory church).

Crossing. The space occupied by the intersection of the nave and transepts.

Cross-in-square (cross-inscribed). See *Quincunx*.

Cross transept. See *Transept*.

Crypt. In a church, a chamber or vaults beneath the main floor, not necessarily underground, usually containing graves or relics.

Cube capital. A capital resulting from the interpenetration of a cube placed over a hemispherical form.

Diaconicon. A room attached to or enclosed in the church; in Early Christian times, utilized for the reception of the congregation's offerings and serving as archive, vestry, and library; later used only for the latter functions (also, a sacristy).

Dome. A hemispherical vault supported by either a circular wall or, over a square space, by squinches or pendentives placed in the corners, the former transforming the square into an octagon, the latter into a circle (see: *squinch, pendentive*).

Dome on pendentives. See *Pendentive*.

Domed basilica. A church type on a square or short rectangular plan with a vaulted nave, aisles, and galleries; a dome surmounts the nave in its centre bay.

Domed octagon. A square plan, its corners bridged by squinches, which supports a dome on the resulting octagon (see: *Greek-cross domed octagon*).

Domical vault. See *Cloister-vault*.

Domus ecclesiae. A house serving the religious, administrative, and charitable needs of a congregation; a community centre (see *Oikos ekklesias*).

Drum. The circular or polygonal structure on which a dome is raised.

Dwarf transept. See *Transept*.

Entablature. The superstructure carried by columns, usually divided into three parts: architrave, frieze, and cornice (see *Architrave*).

Esonarthex. See *Narthex*.

Exedra. Any room opening full width into a larger, covered or uncovered space; a large niche.

Exonarthex. See *Narthex*.

Fastigium. Literally, the ridge of the roof or a gable; a structure, occurring in Constantinian basilicas, consisting of a colonnaded screen across the chord of the apse and centred either on a canopy or on a pedimented section.

Flos. The floral form adorning the middle of each face of the abacus of a Corinthian capital; also, *fleuron*.

Forecourt. See *Atrium*.

Frieze à billettes. A frieze composed of spool-shaped units set vertically.

Greek-cross domed octagon (opp. page, bottom). A mouthful designating the fusion of a centre bay in the shape of a domed octagon (see *Domed octagon*) with the barrel-vaulted arms of a Greek cross breaking through an ancillary belt of aisles and sometimes galleries, the whole enclosed in an outer square or rectangle; in the older literature, frequently referred to as a church with corner squinches (also, *église à trompes d'angle¹*).

Greek-cross plan. A church plan forming a cross with arms of equal or nearly equal length; may be vaulted or unvaulted.

Groin-vault. The vault formed over a square bay by the interpenetration of two barrel-vaults of equal diameter and height, the lines of intersection (the

1. I am avoiding this term, which seems to me to allude only to a technical feature while disregarding the fusion of the Greek-cross plan with that of the domed octagon.

groins) forming a diagonal cross; also known as a cross-vault.

Guilloche. An ornamental band composed of narrow strips flowing in interlaced curves with circular centres.

Haikal. Among Christian Arabs, the sanctuary part of a church.

Heliakon. A sun terrace.

Hollow tube construction. A vaulting construction consisting of cone-like hollow clay tubes, the narrow, closed end of one tube inserted into the wide, open end of another.

Hypogaeum. A subterranean tomb chamber (or group of tomb chambers) for private use.

Iconostasis. In a Byzantine church, the screen wall covered with icons which separates nave from chancel.

Impost block. A block placed between the capital of a column and the arches or vaults it supports.

Joggled. Notched.

Kyptikon. The Emperor's pew, if on gallery level.

Lavra. A cluster of cells or caves laid out for hermit monks, having in common a centre containing a church and sometimes a refectory.

Martyrium. A site which bears witness to the Christian faith, either by referring to an event in Christ's life or Passion, or by sheltering the grave of a martyr, a witness by virtue of having shed his blood; the structure erected over such a site.

Mensa. A table used for celebrating Mass; an altar table.

Mitatorium. The dressing-room of the Emperor, whether in a palace or church.

Naos. In modern Greek, a church; architecturally and liturgically, the core and sanctuary of a Byzantine centrally-planned church, i.e. the parts reserved for the performance of the liturgy.

Narthex. In Greek, a cane; architecturally, the transverse vestibule of a church either preceding nave and aisles as an inner narthex (esonarthex), or preceding the façade as an outer narthex (exonarthex); the exonarthex may also serve as the terminating transverse portico of a quadriporticus (see *Atrium*).

Nosokomion. Hospital or infirmary.

Nymphaeum. A fountain enclosure; as a rule, formed by a series of niches placed against or surmounting a wall.

Octaconch. A building composed of eight conchs (see *Conch*).

Oikos ekklesias. The Greek term for *domus ecclesia.*

Opaion. The circular opening at the apex of a dome.

Opus Alexandrinum. A pavement combining mosaic and opus sectile in guilloche design.

Opus listatum. Masonry composed of alternating (sometimes doubled) courses of brick and small blocks of stone.

Opus sectile. A covering for floor or wall consisting of marble slabs cut in a variety of shapes, generally geometric.

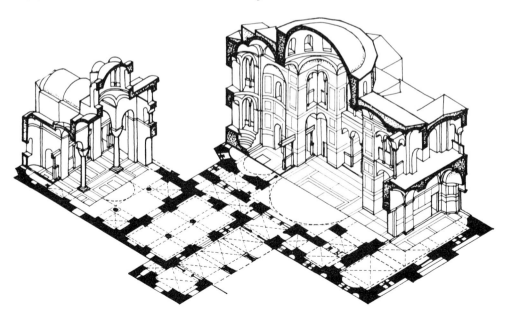

Pantokrator. Christ as ruler of the world.

Parekklesion. A chapel, either free-standing or attached.

Pastophory. A room in an Early Christian or Byzantine church serving as a diaconicon or prothesis; as a rule, flanking the apse of the church.

Pelta. A shield-shaped design composed of a convex curve joined to two concave curves.

Pendentive. Architecturally, a triangular segment of a sphere, bordered by arches and resulting from the interpenetration of a cubic space (bay or room,

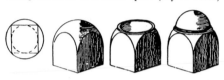

square in plan) and a hemisphere, the latter constructed from the circle circumscribed over the square of the plan. If the top of the hemisphere is cut off horizontally, spherical sections are left between the bordering arches. These triangular sections – or pendentives – terminate in the circle inscribed in the square of the plan. They thus form a base on which a dome can be placed, either directly or raised on a drum (a dome on pendentives, also termed a sail-vault). If, on the other hand, the hemisphere constructed over the circumscribed circle is continued from the pendentives to its apex, the result is a pendentive dome.

Pendentive dome. See *Pendentive*.

Pilaster. An engaged or semi-detached pier.

Presbyter. Literally, Elder; in the Early Christian church, a cleric exercising administrative and priestly functions; also, a parish priest.

Propylaeum. The entrance-gate building of a sacred precinct, whether church or Imperial palace.

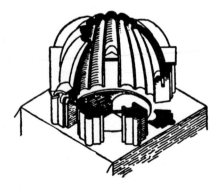

Prothesis. The room attached to or enclosed in the church and serving for the preparation and storage of the species of the Eucharist before Mass; generally used also for the storage of the Eucharist after Mass.

Protomai capital. A capital with half-figures, usually animals, projecting from its four corners.

Pumpkin dome (below, left). A dome composed of curvilinear segments; also (Brit.) umbrella dome and melon dome.

Quadriporticus. See *Atrium*.

Quincunx.[1] A structure divided into nine bays, the

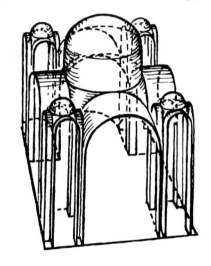

centre bay a large square, the corner bays small squares, the remaining four bays rectangular; the centre bay, resting on four columns, is domed, the corner bays are either domed or groin-vaulted, the rectangular bays are, as a rule, barrel-vaulted; also referred to as cross-in-square, cross-inscribed, *croix inscrite*.

Recessed brick masonry. Masonry in which alternating brick courses are recessed from the wall plane and covered by mortar.

Refrigerium. In the Early Christian Church, a funeral banquet offered in commemoration of a martyr or an ordinary mortal.

Respond. The wall pilaster behind a column.

Rinceau. A scroll-like pattern of floral or plant design.

1. The term is purloined from K. J. Conant, *A Brief Commentary on Early Medieval Church Architecture* (Baltimore, 1942), 15.

Salutatorium. A reception hall, in Roman terminology of the Emperor, in Christian of the bishop.

Sigma (pl. *sigmata*). In Roman and Byzantine terminology, a table of semicircular shape.

Solea. In an Early Christian or Byzantine church, a raised pathway projecting from the bema to the ambo.

Squinch. A corbelling, usually a small arch or half-conical niche, which is placed across the corners of a square bay in order to form an octagon suitable for carrying an octagonal cloister-vault or a dome.

Stoa. A covered hall, its roof supported by one or more rows of columns parallel to the rear wall; in Latin, porticus.

Stylobate. A continuous base of stone, raised above floor level, from which rise the supports of the building, whether columns or piers.

Synthronon. In East Christian and Byzantine churches, the bench or benches reserved for the clergy; arranged either in a semicircle (sometimes amphitheatrically) in the apse or in straight rows on either side of the bema.

Temenos. A sacred precinct.

Templon. In Middle Byzantine churches, a trabeated colonnade closing off the bema.

Tetraconch. A building composed of four conchs (see *Conch*).

Thermae. In the Roman Empire, a bathing establishment for public or private use.

Titulus. In the city of Rome, a *domus ecclesiae*.

Trabeation. A construction of horizontal beams, whether stone or wood.

Transept. The transverse unit of a basilican plan, as a rule inserted between nave and apse; it may be undivided (continuous transept) or divided into nave and aisles, continuing the division of the main body (cross transept); or it may consist of a centre bay continuing the nave together with wings, as high as the nave or lower, but always separated from the centre bay by colonnades (tripartite transept, or, with low wings, dwarf transept).

Tribelon. The triple arcade connecting the esonarthex with the nave, the term deriving from the three curtains (*tri-vela*) between the columns.

Triconch. A building composed of three conchs (see *Conch*).

Triconch transept. A transept with wings terminating in apses.

Tripartite transept. See *Transept*.

Twin cathedral. In Early Christian architecture, a cathedral of two halls or basilicas, their axes placed, as a rule, parallel to each other; the structures served different functions, as yet not fully understood.

Voussoir. A brick or wedge-shaped stone which forms one of the units of an arch.

SELECTED BIBLIOGRAPHY

The bibliography referring to specific periods or problems, or to individual buildings, is given in the Notes, chapter by chapter, the former usually in the first note, the latter as required. We thus dispense with bibliographies preceding the individual chapters.

I. POLITICAL, CULTURAL, AND ECCLESIASTICAL HISTORY

A. GENERAL STUDIES

Cambridge Ancient History, vol. 12, chapters 5, 6, 9, 10, 11, and 20. Cambridge, 1923 ff.

Cambridge Medieval History, vol. 1, chapters 1, 2, 4–6, 14, and 17; vol. 2, chapters 1, 2, and 9; all of vol. 4. New York and Cambridge, 1936 ff.

GIBBON, E. (ed. J. B. Bury). *The Decline and Fall of the Roman Empire*. 7 vols. London, 1900.

WISSOWA, G. *Pauly's Real-Encyklopädie der classischen Altertumswissenschaft, Neue Bearbeitung.* Stuttgart, 1894 ff.

B. EARLY CHRISTIAN

ALFÖLDI, A. *The Conversion of Constantine and Pagan Rome*. Oxford, 1948.

ALFÖLDI, A. *A Conflict of Ideas in the Late Roman Empire*. Oxford, 1952.

BAYNES, N. H. *Constantine the Great and the Christian Church (Proceedings of the British Academy, XV)*. London, 1929.

BURKHARDT, J. *Die Zeit Konstantins des Grossen.* 2nd ed. Leipzig, 1880.

DIEHL, E. *Inscriptiones Latinae Christianae Veteres.* 3 vols. Berlin, 1961.

HARNACK, A. VON (ed. J. Moffatt). *The Expansion of Christianity*. New York and London, 1904 *(Die Mission und Ausbreitung des Christentums*, Leipzig, 1924).

MATTINGLY, H. *Christianity in the Roman Empire.* University of Otago, 1955.

MOMIGLIANO, A. (ed.). *The Conflict between Paganism and Christianity in the Fourth Century*. Oxford, 1963.

PIGANIOL, A. *L'empire chrétien 325–395*. Paris, 1947.

SETTON, K. M. *Christian Attitude towards the Emperor in the Fourth Century*. New York, 1941.

C. BYZANTIUM

BAYNES, N. H., and MOSS, H. ST L. B. *Byzantium.* Oxford, 1948 (Oxford paperback, 1961).

BRÉHIER, L. *Le monde byzantin*. 3 vols. Paris, 1947 ff.

BURY, J. B. *History of the Later Roman Empire*. 2 vols. London, 1923.

DIEHL, C. *Histoire de l'empire byzantin*. Paris, 1919.

GUERDAN, R. *Vie, grandeur et misères de Byzance.* Paris, 1954 (*Byzantium*, transl. D. L. B. Hartley, London, 1956; New York, Capricorn paperback, 1962).

JONES, A. H. M. *The Greek City from Alexander to Justinian*. Oxford, 1937.

OSTROGORSKY, G. *Geschichte des byzantinischen Staates*. Munich, 1940 (*History of the Byzantine State*, Oxford, 1956).

RUNCIMAN, S. *Byzantine Civilization*. London, 1933 (New York, Meridian paperback, 1962).

STEIN, E. *Geschichte des spätrömischen Reiches*. Vienna, 1928 (*Histoire du Bas-Empire*, ed. J. R. Palanque, 2 vols., Paris, 1949–59).

TREITINGER, O. *Die oströmische Kaiser- und Reichsidee*. Jena, 1938; 2nd ed., Darmstadt, 1956.

URE, P. N. *Justinian and his Age*. Harmondsworth, 1951.

VASILIEV, A. A. *Histoire de l'empire byzantin*. 2 vols. Paris, 1932 (trans. in *University of Wisconsin Studies in the Social Sciences and History*, nos. 13 and 14, 1928–9).

D. THE CHURCH

CASPAR, E. L. E. *Geschichte des Papsttums*. 2 vols. Tübingen, 1930–3.

FLICHE, A. and MARTIN, V. (ed.). *Histoire de l'église depuis les origines jusqu'à nos jours*, vols. 1–6. Paris, 1938 ff.

HEFELE, C. J. *History of the Councils of the Church.* London, 1871–96.

RUNCIMAN, S. *The Eastern Schism*. Oxford, 1955.

E. PRIMARY SOURCES

Corpus scriptorum ecclesiasticorum latinorum. Vienna, 1866 ff.

Corpus scriptorum historiae byzantinae. Bonn, 1828–97.

EUSEBIUS (transl. J. E. L. Oulton). *The Ecclesiastical History (Loeb Classical Library)*. 2 vols.
EUSEBIUS. *Life of Constantine (Patrologia Graeca*, XX, 905 ff.).
EUSEBIUS (ed. I. A. Heikel). *Gesammelte Werke*, I. Berlin, 1898 (transl. H. Wace and P. Schaff, *A Select Library of Nicene and Post-Nicene Fathers, The Nicene Fathers*, I, New York, Oxford, and London, 1890).
Die griechischen christlichen Schriftsteller der ersten Jahrhunderte (Preussiche Akademie der Wissenschaften, Kirchenväter-Commission). Leipzig, 1897 ff.
MIGNE, J. P. *Patrologia Graeca*. Paris, 1857 ff.
MIGNE, J. P. *Patrologia Latina*. Paris, 1842 ff.

II. LITURGY

BATTIFOL, P. *Leçons sur la Messe*. Paris, 1919
DIX, G. *The Shape of the Liturgy*. [London], 1947.
DUCHESNE, L. (trans. M. L. McClure). *Christian Worship*. London, 1949.
HANSSENS, J. *De Missa Rituum Orientalium (Institutiones Liturgicae de Ritibus Orientalibus*, II, III, appendix). Rome, 1930 ff.
JUNGMANN, J. A. *Missarum Sollemnia*. 2 vols. Vienna, 1948 (trans. F. A. Brunner, *The Mass of the Roman Rite*, New York, 1951 ff.).
The Orthodox Liturgy. London (Society for Promoting Christian Knowledge), 1939.

III. ART AND ARCHITECTURE

A. GENERAL STUDIES

CABROL, F., and LECLERCQ, H. *Dictionnaire d'archéologie chrétienne et de liturgie*. Paris, 1907-53.
CONANT, K. J. *A Brief Commentary on Early Medieval Church Architecture*. Baltimore, 1942.
DALTON, O. M. *East Christian Art*. Oxford, 1925.
DEICHMANN, F. *Versuch einer Darstellung der Grundrisstypen des Kirchenbaues . . . 1932*. Halle, Wittenberg, Würzburg, 1927.
GLÜCK, H. *Die christliche Kunst des Ostens*. Berlin, 1923.
GRABAR, A. *Martyrium*. 2 vols. Paris, 1943-6.
GRABAR, A. *Archaeology*, II (1949), 95 ff.
KAUTZSCH, R. *Kapitellstudien (Studien zur spätantiken Kunstgeschichte)*. Berlin and Leipzig, 1936.
KHATCHATRIAN, A. *Les baptistères paleochrétiens*. Paris, 1962.
MACDONALD, W. *Early Christian and Byzantine Architecture*. New York, 1962.

ORLANDOS, A. *Hi Basiliki xylostegos tis mesogeiakis lekanis*. Athens, 1950-9.
Reallexikon für Antike und Christentum (ed. Th. Klauser). Stuttgart, 1950-62.
RICE, D. T. *The Beginnings of Christian Art*. Nashville and New York, 1957.
VOLBACH, W. F. (trans. C. Ligota). *Early Christian Art*. New York, 1962.
WARD PERKINS, J. B. *The Italian Element in Late Roman and Medieval Architecture - Annual Italian Lecture of the British Academy*, 1947 (*Proceedings of the British Academy*, XXXIII, 1947).
WULFF, O. *Altchristliche und Byzantinische Kunst (Handbuch der Kunstwissenschaft)*. Berlin, 1914-24.

B. EARLY CHRISTIAN

DAVIES, J. *The Origin and Development of Early Christian Church Architecture*. London, 1952.
DEICHMANN, F. *Frühchristliche Kirchen in Rom*. Basel, 1948.
KIRSCH, J. P. *Die römischen Titelkirchen im Altertum (Studien zur Geschichte und Kultur des Altertums*, IX, I, 2). Paderborn, 1918.
KRAUTHEIMER, R., and others. *Corpus Basilicarum Christianarum Romae*. Vatican City, 1939 ff.
MILLET, G. *L'école grecque dans l'architecture byzantine*. Paris, 1916.
VERZONE, P. *L'architettura religiosa dell'alto medio evo nell'Italia settentrionale*. Milan, 1942.
VIELLARD, R. *Recherches sur les origines de la Rome chrétienne*. Mâcon, 1941.

C. BYZANTIUM
AND THE EASTERN HINTERLANDS

BECKWITH, J. *The Art of Constantinople*. New York, 1961.
BECKWITH, J. *Early Christian and Byzantine Art (The Pelican History of Art)*. Harmondsworth, 1970.
BRÉHIER, L. *L'art byzantin*. Paris, 1924.
BUTLER, H. C. (ed. E. Baldwin Smith). *Early Churches in Syria*. Princeton, 1929.
DEICHMANN, F. *Studien zur Architektur Konstantinopels (Deutsches Beiträge zur Altertumswissenschaft)*. Baden-Baden, 1956.
DIEHL, C. *Manuel d'art byzantin*. 2 vols., 2nd ed. Paris, 1925.
DALTON, O. M. *Byzantine Art and Archaeology*. Oxford, 1911.
EBERSOLT, J. *Monuments d'architecture byzantine*. Paris, 1934.
EBERSOLT, J., and THIERS, A. *Les églises de Constantinople*. Paris, 1913.

HAMILTON, J. A. *Byzantine Architecture and Decoration.* London, 1933.

JANIN, R. *La géographie ecclésiastique de l'Empire Byzantin, première partie, Le siège de Constantinople et le patriarcat oecuménique, tome III, Les églises et les monastères.* Paris, 1953.

MILLET, G. *L'art byzantin,* in A. Michel, *Histoire de l'art,* I, 127-301. Paris, 1905.

MILLET, G. *L'art chrétien d'Orient du milieu du XII au milieu du XV siècle.* Paris, 1908.

Reallexikon zur Byzantinischen Kunst (ed. M. Restle and K. Wessel). Stuttgart, 1966.

ROTT, H. *Kleinasiatische Denkmäler . . .* (*Studien über christliche Denkmäler,* N.F. V, VI). Leipzig, 1908.

SCHNEIDER, A. M. *Byzanz - Vorarbeiten zur Topographie und Archäologie der Stadt* (*Istanbuler Forschungen,* VIII). Berlin, 1936.

VAN MILLINGEN, A., and others. *Byzantine Churches in Constantinople, Their History and Architecture.* London, 1912.

VOLBACH, W. F. *Art byzantin.* Paris, 1933.

D. PRIMARY SOURCES

CONSTANTINE PORPHYROGENETOS, *Book of Ceremonies* (*Patrologia Graeca,* 112; *Bonn Corpus,* 9-10; A. Vogt, *Le Livre des Cérémonies,* Paris, 1935 ff. [Book 1 only]).

DUCHESNE, L. *Le Liber Pontificalis.* 3 vols. Paris, 1881-92, 1957.

MANGO, CYRIL. *The Art of the Byzantine Empire, 312-1453* (Sources and Documents in the History of Art Series, edited by H. W. Janson). Englewood Cliffs, New Jersey, 1972.

PROCOPIUS. *Loeb Classical Library,* 7 vols, ed. H. B. Dewing.

RICHTER, J. P. *Quellen der byzantinischen Kunstgeschichte* (*Quellenschriften für Kunstgeschichte und Kunsttechnik des mittelalters und der Renaissance,* N.S. VIII). Vienna, 1897.

SCHLOSSER, J. *Quellenbuch zur Kunstgeschichte des abendländischen Mittelalters.* Vienna, 1896.

543

LIST OF ILLUSTRATIONS

1. Dura-Europos (Qalat es Sālihīye), Christian community house, shortly after 200 and c. 230. Isometric view (Lampl, adapted from J. W. Crowfoot, Early Churches in Palestine, figure 1)
2. Rome, Catacomb of S. Panfilo, third or fourth century. Gallery (Pont. Comm. di Arch. Sacra)
3. Rome, St Peter's, shrine of St Peter, late second century. Elevation (Lampl, adapted from J. C. M. Toynbee and J. B. Ward-Perkins, The Shrine of St Peter, figure 17, and E. Kirschbaum, The Tombs of St Peter and Paul, figure 32)
4. Rome, Catacomb of S. Callisto, Chapel of the Popes, c. 250 (Pont. Comm. di Arch. Sacra)
5. Rome, S. Sebastiano, triclia, c. 258. Reconstruction (Lampl, adapted from A. Styger, Römische Märtyrergrüfte, II, plate 16)
6. Bonn, memoria, c. 250 (Bonner Jahrbücher, CXXXVI/CXXXVII (1932), plate 111)
7. Rome, Catacomb of S. Callisto, cella trichora, c. 300(?), as in c. 1850 (From G. B. de Rossi, Roma Sotterranea, III, plate xxxix)
8. Rome, S. Crisogono, first church, early fourth century(?). Reconstruction (W. Frankl, in Corpus, I, figure 100)
9. Aquileia, twin cathedral, plan, stages of c. 313-19 and c. 350 or 400 (Lampl, adapted from S. Corbett, R.A.C., XXXII(1956), 101, and M. Mirabella Roberti, Studi . . . Calderini . . . e . . . Paribeni, III, 865)
10. Orléansville (El-Asnam) Cathedral, founded perhaps in 324. Plan (Gsell, Monuments, 238)
11. Rome, Lateran Basilica, as in 320. Isometric reconstruction (based on P. Waddy in Krautheimer and Corbett, R.A.C., XLIII (1967), 144, figure 111)
12. Rome, Lateran Basilica, begun c. 313. Foundation wall of apse (Pont. Comm. di Arch. Sacra)
13. Rome, Lateran Basilica, begun c. 313. Foundation wall of nave (Pont. Comm. di Arch. Sacra)
14. Rome, Lateran Basilica, begun c. 313. Reconstruction of nave erroneously arcaded; fresco by F. Gagliardi, c. 1650. Rome, S. Martino ai Monti (Pont. Comm. di Arch. Sacra)
15. Trier, twin cathedral, after 326. Plan (Adapted from Th. Kempf, in Neue Ausgrabungen in Deutschland, figures 3 and 5)
16. Rome, S. Croce in Gerusalemme, as in c. 329. Isometric reconstruction (Corpus, I, figure 117)

17. Salona, memoria precinct, early fourth century and later. Reconstruction (E. Dyggve, History of Salonitan Christianity, plate 4, figure 12a)
18. Rome, S. Lorenzo fuori le mura, basilica and underground memoria as in c. 330. Isometric reconstruction (Lampl, adapted from W. Frankl, in Corpus, II, figure 121)
19. Rome, S. Agnese, c. 350. Wall of ambulatory; drawing by B. Breenbergh (Paris, Louvre, Service de Documentation Photographique)
20. Rome, S. Sebastiano, 312/13(?). Model (Soprintendenza ai Monumenti del Lazio)
21. Rome, St Peter's, as in c. 400. Isometric view (A. Frazer, revised from J. Christern, R. Qu. Schr., LXVII (1967), 166, figure 14 top)
22. Rome, St Peter's, as in c. 400. Plan (A. Frazer)
23. Rome, St Peter's, begun c. 319-22. Shrine and baldacchino represented on an ivory casket from Pola (Gabinetto Fotografico Nazionale, Rome)
24. Rome, St Peter's, begun c. 319-22. Atrium; drawing by G. A. Dosio. Formerly Florence, Uffizi (Dis. arch. 2555; Soprintendenza alle Gallerie, Florence)
25. Rome, St Peter's, begun c. 319-22. Interior of nave facing west; drawing by M. van Heemskerck. Berlin, Kupferstichkabinett (C. Hülsen and H. Egger, Die römischen Skizzenbücher von Marten van Heemskerck, II, plate 69)
26. Bethlehem, Church of the Nativity, as in 333. Isometric reconstruction (Lampl, based on Harvey, in Archaeologia, LXXXVII (1938), plate XIII)
27. Jerusalem, basilica and Anastasis Rotunda on Golgotha: (A) Hypothetical reconstruction of basilica as c. 326 (Lampl); (B) Plan of fourth-century remains and later structures (V. Corbo, Liber Annuus, XIX (1969), plate 1 following p. 18); (C) Hypothetical volumetric reconstruction as c. 340 (E. Monti)
28. Rome, S. Costanza, c. 350. Interior (German Archaeological Institute, Rome)
29. Constantinople, triumphal arch of Theodosius I, 393 (Fototeca Unione, Rome)
30. Constantinople, palaces north of the hippodrome, early fifth century, with later additions. Plan (R. Naumann and H. Belting, Die Euphemiakirche . . . (Berlin, 1966), figure 1)
31. Bakırköy, Fildami cistern, fifth century (German Archaeological Institute, Istanbul)

252. Ankara, city walls, 859 (Olga Ford)
253. Nicaea (Iznik), Koimesis, early eighth century(?), rebuilt after 1065. Section and plan (O. Wulff, *Altchristliche und byzantinische Kunst*, figure 283)
254. Nicaea (Iznik), Koimesis, early eighth century(?), rebuilt after 1065. Exterior, as in 1906 (German Archaeological Institute, Rome)
255. Salonica, H. Sophia, early eighth century(?). Isometric view (Adjusted from O. Wulff, *Altchristliche und byzantinische Kunst*, figure 332)
256. Salonica, H. Sophia, early eighth century(?). Exterior from the north-east (Antonello Perissinotto)
257. Salonica, H. Sophia, early eighth century(?). Interior facing east, as in 1906 (Institut für Denkmalpflege, Messbildarchiv, East Berlin)
258. Constantinople, Kalenderhane Camii (Church of St Mary Kyriotissa?), twelfth century. Exterior from the south-west, as in 1972 (C. L. Striker)
259. Constantinople, Kalenderhane Camii (Church of St Mary Kyriotissa?), twelfth century, incorporating earlier structures. Plan (C. L. Striker and Y. D. Kuban)
260. Antalya (Adalia), Cumanin Camii, late sixth century. Isometric reconstruction (S. Ballance, *P.B.S.R.*, XXIII (1958), 107, figure 7)
261. Ctesiphon, church, *c.* 600(?). Plan (U. Monneret de Villard, *Le chiese della Mesopotamia*, figure 8)
262. Qartamin, monastery of Mâr Gabriel with churches and martyrium, *c.* 512(?). Plan (*ibid.*, figure 52)
263. Hah, martyrium of el'Adhra, sixth century(?); upper part of drum 1907. Exterior (J. Kollwitz)
264. Aswân, St Simeon, monastery, fourth-nineteenth centuries. Exterior (Phot. Boissonas, Geneva)
265. El Khargah, tomb chapel, fourth century(?). Exterior (Eugen Kusch)
266. Capital from Bawit, sixth century. *Cairo, Coptic Museum* (E. Kitzinger)
267. Capital from Hermopolis (Ashmunein), sixth century. *Cairo, Coptic Museum* (E. Kitzinger)
268. Pilaster and demi-column from Bawit, sixth century. *Cairo, Coptic Museum* (E. Kitzinger)
269. Cairo, Abu Sargeh, twelfth century. Plan (U. Monneret de Villard, *IV C.A.C.*, I, 313, figure 21)
270. Serreh (Serra), centrally-planned church, tenth century. Exterior (F. W. Deichmann)
271. Zadar (Zara), Sv. Donat, early ninth century(?). Plan (Reisch, *Führer*, plate 23)
272. Zadar (Zara), Sv. Donat, early ninth century(?). Exterior (Tošo Dabac)
273. Ohrid, St Sophia, late ninth and eleventh centuries(?). Exterior of apses (A. Frantz)
274. Nessebâr (Mesembria), Church of St John the

Baptist, *c.* 900. Exterior from the south-west (Courtesy Bulgarian Academy of Sciences)
275. Skripou, Panaghia, 873/4. Plan (A. H. S. Megaw, *Annual of the British School of Archaeology at Athens*, LXI, figure 1)
276. Skripou, Panaghia, 873/4. Apses, transept, and dome from the north-east (A. Frantz)
277. Skripou, Panaghia, 873/4. Interior facing east (A. Frantz)
278. Pliska, palace, 814-31. East gate (Courtesy Bulgarian Academy of Sciences)
279. Pliska, palace, 814-31. Substructure of throne room (Courtesy Bulgarian Academy of Sciences)
280. Skripou, Panaghia, 873/4. Ornament frieze, apse (George C. Miles)
281. Aboba Pliska, basilica, ninth century(?). Plan (Mavrodinov (1959), figure 83)
282. Preslav, Round Church and fortification, early tenth century(?). From the east (P. Hlebarov)
283. Preslav, Round Church, early tenth century(?). Section (reconstructed) and plan (Lampl, based on Mavrodinov (1959), figures 144 and 150)
284. Preslav, Round Church, early tenth century(?). Atrium from the south-west (C. L. Striker)
285. Preslav, Round Church, early tenth century(?). Cornice (Courtesy Bulgarian Academy of Sciences)
286. (A) Ereruk, church, *c.* 500. Plan (V. M. Arutiunian, *Pamiatniki Armiankogo Zodchestva*, figure 5); (B) Ptghavank', church, *c.* 600. Plan (*ibid.*, figure 12); (C) T'alinn, church, *c.* 662-85. Plan (*ibid.*, figure 28)
287. Zvart'nots, tetraconch church, 641-61, possibly before 652. View of remains (Josephine Powell)
288. (A) Vagharshapat, St Gayané, 630. Plan (Arutiunian, *op. cit.*, figure 20)
 (B) Bagaran, church, 621-8 or 624-31(?). Plan (*ibid.*, figure 25);
 (C) Vagharshapat, St Hrip'simé, 618. Plan (*ibid.*, figure 19)
289. Avan, church, after 611(?). Interior (Josephine Powell)
290. Vagharshapat, St Hrip'simé, 618. Interior (Josephine Powell)
291. Aght'amar, Holy Cross, 915-21. Exterior from the south-west (Josephine Powell)
292. Aght'amar, Holy Cross, 915-21. Interior facing north (Josephine Powell)
293. Nicaea (Iznik), city wall, south, near Yenišehir Gate, rebuilt after 1065 (German Archaeological Institute, Istanbul)
294. Kastoria, Anargyroi, first half of the eleventh century. From the east (A. H. S. Megaw)
295. Kastoria, Kubilidike, first half of the eleventh century. Exterior from the south-east (G. C. Miles)

Illustrations 30, 34, 35, 94, 124, 193, 227, 259, 281, 309, 312, 329, and 362 were redrawn by Sheila Gibson and Derek Martin. All other line illustrations were drawn or adjusted by Paul Lampl. Redrawing for this edition was undertaken by Sheila Gibson (illustrations 11, 30, 64, 124, 297, 309, 312, 388, 394) and Paul White (illustrations 27B and C, 41, 64, 79, 164, 275, 327D). They also made many minor corrections. Illustrations 21 and 259 were redrawn by Ian Stewart.

INDEX

Words in *italic* are intended primarily as references to definitions. References to the Notes are given only where a reading of the text will not lead directly to a subject under discussion in the Note. Such references are given to the page on which the Note occurs, followed by the number of the chapter to which it belongs, and the number of the Note. Thus 500(6)²⁶ indicates page 500, Chapter 6, Note 26. Churches are indexed within towns in alphabetical order of the most important element of the dedication; e.g., at Constantinople, St John Studios will be found under Studios, St George under George. The index includes headings concerning some of the more important types of buildings and plans, e.g., baptisteries, continuous transepts, quincunx churches, etc. The dates following proper names refer in the case of rulers and church dignitaries to the span of their reign, otherwise to the life span.

557